Henri Zerner

Renaissance Art in France

The Invention of Classicism

Flammarion

CONTENTS

INTRODUCTION

Giorgio Vasari, the first art historian of modern times, has left us an unforgettable image that sums up the Renaissance in France: Leonardo da Vinci dying in the arms of François I. Does it matter that the king was not actually present when the great painter died at the manor of Cloux on May 2, 1519? This scene, which has inspired several painters, retains its symbolic value: the cultural legacy of the Italian Renaissance received by the young king of France.

Once we investigate more closely how France actually accommodated the art of Italy, the matter becomes much more complicated. Having arrived in France late in life, Leonardo did not have the impact one might have expected. He designed some projects for the king and amazed everyone with his extraordinary mind, but he was no longer in any state to paint and soon after died, having spent less than three years in France. Andrea del Sarto, who arrived in 1517, one year after his illustrious compatriot, was unable to adapt and quickly returned to Florence. It would be another decade before Italian art—painting in particular—would have a more significant impact in France with the arrival of Rosso and Primaticcio at Fontainebleau. The idea that the Renaissance is an Italian phenomenon imported to France, even if fiercely debated at times, is still quite widely held. This is inevitable for the simple reason that the French of the sixteenth century felt constantly obliged to measure themselves against the Italians who in turn claimed cultural hegemony. Yet it is impossible to reduce the French Renaissance to the more or less successful adaptation of an Italian model.

In the middle of the sixteenth century, France experienced a moment of cultural effervescence for which there are few parallels in history. Rabelais, Ronsard, du Bellay are authors who remain living parts of our culture today. The "Garamond" typeface used today still pays homage to one of the creators of the characters that in the sixteenth century supplanted those of the Italian and German printers. Although the type used today differs slightly from the characters designed by Claude Garamond and other printers at the time of François I, it is modeled directly on them. Jean Grolier, long hailed as the prince of bibliophiles, has left his name to a very elegant style of bookbinding that spread throughout all of Europe. In the 1540s, the Milanese armorers, who had monopolized the production of parade armors, were overtaken by their Parisian counterparts. By inventing the binding of arteries, Ambroise Paré opened the door to modern surgery. As for John Calvin, he led the Reformation much further than Luther and, with the *Institution of the Christian Religion*, the French version of which appeared in 1541, he gave quasi-definitive form to both Protestant theology and French prose. France, which had long trailed behind Italy in cultural matters, suddenly took the lead.

This emancipation could give the impression of a radical rupture: everything seems to have changed at once. However, in this dazzling cultural moment, the results of which would have long lasting consequences, the visual arts seem to have lagged behind. One of the great historians of the period, Lucien Febvre, spoke of a "*retard de la vue*" (lagging behind of sight). It may well be true that the writers discussed in the *Problème de l'incroyance au XVIe siècle* were not particularly adept at description, but this does not mean that

the sense of sight was underdeveloped in a society capable of producing the châteaux of the Loire valley, the Fontaine des Innocents and Jean Duvet's *Apocalypse*. Why does the art of the French Renaissance not enjoy the same prestige as its literature? One reason, among others, is the widespread and ingrained tendency to equate art and painting. Since the seventeenth century, Poussin (whose career unfolded almost entirely in Rome) has embodied, so to speak, the national art of France. The celebrated painters of the mid sixteenth century in France, Rosso and Primaticcio, were Italians without true successors. After twenty years of activity at Court, Primaticcio called on his Bolognese compatriot Niccolo dell'Abbate to come and assist him; he had not had sufficient influence on the course of French art to produce a competent assistant locally. As for the portraitists, Jean Clouet and his son François, they seem to suffer from comparison to an artist such as Holbein.

Since the age of Giotto, Italy, or rather Florence, had granted supremacy to painting, making it the center and reference point of all artistic thought. The concept of the "arts of design," already established in the first part of the fifteenth century by Leon Battista Alberti and eloquently elaborated upon by Vasari, allowed painters to break the limits of technical specialty and to assume the role of architect or sculptor. Leonardo da Vinci and Michelangelo are the most celebrated examples of these universal geniuses, or Renaissance men. Raphael, who would become the paradigm of painting for more than three centuries, was himself for a time the architect in charge of Saint Peter's in Rome, the most prestigious building of Christendom.

Nothing of the sort took place in France. The poverty of French painting until the end of the sixteenth century—this missing center—is one of the themes of this book. I hope to show that the visual arts were vigorously and successfully cultivated, but in different media. The sculptors have left a brilliant legacy; stained glass painting was then considered a French specialty and an impressive number of windows have been saved; in France, the tapestry weavers of the Renaissance produced masterpieces of monumental decoration.

My problem has not been want of material but the necessity of choosing. I have entirely neglected Jean Bullant, architect to the constable of Montmorency. I have hardly touched upon the extraordinarily abundant sculpture of the Champagne region. And as for stained glass, I had to content myself with a few examples without being able to include artists of such high caliber as Engrand Le Prince or works as important as the windows of Conches in Normandy. The remarkable façade of Saint Michel at Dijon would have deserved detailed analysis. These are but a few of the most glaring omissions. Yet, wanting to discuss everything, I would have run the risk of lapsing into mere enumeration.

The time frame of my study, while not clearly defined, is firmly centered. It was the period 1540–60—that is, the last years of François I and the whole reign of Henri II—that saw the formation of what one can call the first French classicism, which was to serve as a model for generations to come. In order to understand the development of this art and its historic role, we are forced to go further back and occasionally even to look ahead to a slightly later period. To situate in history the cultural explosion that concerns us here, we must return to the end of the Hundred Years' War, in 1453, when, inspired by Joan of Arc, Charles VII (r. 1422–61) had recaptured the larger part of France from the English. Since the end of the reign of King Charles V, the situation had been so critical that the kingdom had almost completely disappeared under the onslaught of both the English kings who claimed the throne of France and the Burgundian dukes who aspired to sovereignty. Cast as a sinister legendary figure by the pen of Sir Walter Scott, Louis XI (r. 1561–83), was in fact a wise ruler who pursued the consolidation and reconstruction of the kingdom—with brutality for sure, but also with a political shrewdness to which Philippe de Commynes paid superb tribute in his *Memoirs*.

The guiding principle of the French monarchy was national unity under the direct authority of the king of the French (rex Francorum), as opposed to a feudal system of personal allegiances on several strictly hierarchical levels: "The vassal of my vassal is not my vassal." This maxim

clearly suggests the autonomy of each level of the system. The king of the French was also a feudal lord and, as such, had only indirect links with his subjects. This created problems and, especially in the large fiefdoms, led to the coexistence of two administrative and judicial systems. Although the principle of absolute monarchy laboriously put in place by generations of sovereigns depleted the power of the great feudal lords, the feudal system would not be legally abolished until the Revolution of 1789.

Throughout the period that concerns us, France enjoyed great prosperity. Given its growing population, it is important to note the critical role played by the vast expansion of the cities. Paris took on gigantic proportions, reaching three hundred and fifty thousand residents or more at the end of the reign of Henri II, and then declining during times of religious strife and civil war to around two hundred thousand when Henri IV prepared to retake the capital at swords' points. This social and economic dynamism must be kept in mind in order to understand the cultural upheaval of the era.

One of Louis XI's great merits was his understanding of the importance of the integrity of the kingdom as a geographic entity. However, his immediate successors, rather than consolidating their French domains, yielded to the desire to exercise their hereditary rights to certain parts of Italy. In order to claim the kingdom of Naples, Charles VIII (r. 1483–98) undertook the first of these incursions on the Peninsula, which would prove culturally fruitful, yet compromised the principles laid out by Louis XI. Louis XII (r. 1498–1515), an indirect heir from the house of Orleans (his father was Charles of Orleans, the poet), claimed the duchy of Milan through his grandmother, Valentine Visconti. These territorial ambitions incited a violent and dangerous struggle with the Habsburgs that lasted until the reign of Louis XIV.

Uncommonly tall and a brilliant conversationalist, François I (r. 1515–47) was the most prestigious monarch of his day. However, with the passage of time, he appears to us a strangely inconsistent figure. Although on occasion he could be quite farsighted and determined in his resolve to establish the monarchy on new bases, to centralize and simplify the administration, his constant needs for money frequently led him to use expedients in contradiction with such policies. At other times he seems to have been lazy and insouciant, as if lost in a chivalrous dream. His reign was ushered in with a spectacular victory over the imperial troops at Marignano in 1515. But he was incapable of retaining the duchy of Milan and, at the conclusion of the disastrous battle of Pavia in 1525, was taken prisoner by his great rival, the emperor Charles V, who took him in captivity to Madrid. "Of everything only my honor and my spared life are left me," he wrote to his mother Louise of Savoy, who became regent in his absence. This was a trying ordeal for the prince, who nearly died in prison, and for France, which had to pay an enormous ransom. Charles V, more thoughtful and calculating than François I, had his own chivalrous dreams, namely the annexation of Burgundy—the cradle of his beloved knighthood, the Order of the Golden Fleece. Under pressure François promised to relinquish the duchy by a clause of the treaty of Madrid. Yet as soon as he was free and back in his kingdom, François appeared before the Parliament of Paris and had this clause of the treaty denounced as being contrary to the fundamental laws of the land. For all his might, Charles V never succeeded in getting hold of Burgundy. In the end, the desires of these princes were chimerical because they ran countercurrent to the formation of modern states founded on national consciousness and territorial unification.

The Reformation of Luther played an influential role during the reign of François I. France had its own evangelical movement, which attracted numerous sympathizers. The sister of the king, Marguerite of Navarre, one of the most remarkable writers of her time, was close to the leader of the evangelists, Guillaume Briçonnet, and his followers. They hoped to reform the Church from within, without breaking with Rome, and they shared approximately the same spiritual positions as Luther without approving of his methods. As in many other circumstances, François I was indecisive and vacillated. Besides the question of his beliefs—and here his sympathies are not always

clear—his alliance with the Protestant princes of Germany against the emperor inclined him to tolerance. But as soon as religious dissidence seemed to turn to political opposition, repression was fierce.

One of the chief strengths of François I was his full appreciation of the potential of culture to bolster power. Even during his lifetime he was dubbed the Father of Arts and Letters. Surely this speaks, to a certain extent, of personal inclination; there is good reason to believe that the king was particularly fond of the company of artists and writers, but he was also undoubtedly aware of the political value of royal patronage.

Compared to his father, Henri II (r. 1547–59) appears to have been a rather weak character who allowed himself to be guided by those to whom he accorded seemingly boundless trust: the constable Anne of Montmorency, the cardinal of Lorraine, the marshal of Saint André and above all Diane de Poitiers, the widow, since 1531, of the great seneschal of Normandy. This woman of keen intellect, insatiable greed, and uncompromising Catholicism had become the mistress of the Dauphin around 1536, when he was seventeen and she thirty-seven. Once he had mounted the throne, she held him entranced, meddling in everything from political affairs to the education of the king's children. The sudden death of Henri at a jousting tournament in 1559 signaled the overnight end of her power. In spite of the influence exercised by his advisors, Henri II may have shown more initiative than is generally thought. He definitely did not have a good relationship with his father, who had preferred his elder son, the Dauphin François who died suddenly in 1536, and this could have been what motivated his deliberate efforts to distance himself from the patronage of François I. In any case, the change in monarch in 1547 marks a turning point in French art: the Italians lost their authority and the king appointed French architects to top positions.

After the very short reign of François II (1559–61), during which the Guises held power, Catherine de Médicis assumed the regency for Charles IX with an authority that belied her unassuming role during the reign of her husband. Even after the king came of age and during the reign of Henri III, she held considerable sway over her sons and took an active part in government. This was a devastating time for France, despite the many outstanding qualities of the powerful queen mother. The religious conflicts, combined with high inflation and a deteriorating economic situation, finally plunged the kingdom into fire and blood. In 1589, the death of Catherine and the assassination of Henri III left the throne without an heir and the country in tatters. It took the king of Navarre, Henri of Bourbon, five years of fierce civil war to conquer a kingdom that was only legally his through a distant link to the last of the Valois. In addition to dynastic change, the reign of Henri IV marked a new departure in the history of France. Therefore this rather long period, from the end of the Hundred Years' War under Charles VII to the death of Henri III—or, in the world of art, from Jean Fouquet to Germain Pilon—constitutes the widest framework of the French Renaissance.

As I have acknowledged from the start, the question of an Italian model is inevitable when one approaches French art of the sixteenth century, but what this entailed remains contested and complex. French nationalism flourished in the nineteenth century, but it was not new; much earlier, just as soon as France had had an art historian to call its own, the country had wanted simultaneously to break away from Italy and to enjoy a Renaissance of its own. This gave rise in the seventeenth century to the legend of Jean Cousin, the French Michelangelo. On the other hand, when art history was developing as a discipline, in the second part of the nineteenth century and at the beginning of the twentieth, there were no terms available that were sufficiently pejorative to describe the Italians of Fontainebleau, whose influence was considered nothing short of disastrous. The art of Fontainebleau did not come back into vogue until much later, in the wake of the reevaluation of "Mannerism" by German art historians in tune with expressionist aesthetics. As early as 1900, Louis Dimier had devoted a monumental monograph to Primaticcio reasserting the preeminence and decisive role of the Italian painter, but Dimier's was a lone and isolated voice.

My intention, at the outset, was to write a monograph on Jean Cousin, the darling of nationalist art history in the nineteenth century. Many years ago, when working on the printmakers of the Fontainebleau school, I had realized that confusion still enveloped this celebrated artist despite the discoveries of Maurice Roy and others after him. I had made several new observations and it seemed to me that the methods I had learned should permit me, through the collection and confrontation of written and visual evidence, to clarify the matter, to establish enough secure data and sound conjectures in order to sketch a convincing picture of the elusive artist's career and work. But my hero kept slipping through my fingers, and I discovered that the tools at my disposal were not suited to the task at hand. The conditions of artistic production in France at the time of Cousin made the methods at play in such a monograph ineffectual. Two long chapters of this book sort out the reasons for which it is impossible to separate Jean Cousin from all that surrounded him and to define his artistic personality, as is usually done in the type of artist's monograph handed down by Vasari to later art historians.

It seemed to me that there was an important lesson to be drawn from this failure: sixteenth-century France held a conception of art and of the artist quite different from our own—one that goes back, though of course in altered form, to the Italian Renaissance. On this basis, I have attempted to characterize a French artistic situation. Nevertheless, it is necessary to clarify one point. Taken individually, no one aspect is specifically French. In particular, the continuity of the Gothic in religious art throughout the sixteenth century—a fact that I insist upon at great length, and which must be taken into account in order to understand the particular kind of classical art that developed in France—is a continuity not unique to France. To the contrary, the Low Countries, Spain, and Germany all witnessed the same phenomenon. I could have drawn innumerable similar parallels to neighboring countries throughout the book. Besides the fact that such an exercise would largely surpass my competence, it would also have greatly lengthened an already extensive volume. Therefore it is necessary to state clearly, once and for all, that parallel phenomena and comparable forms were found outside of France.

On the other hand, the publication in 1576 of the *Premier Volume des plus excellents bastiments de France* by Jacques Androuet du Cerceau, followed in 1579 by the *Second Volume*, has neither precedent nor equivalent in any other country. In these volumes, du Cerceau, architect and popularizer, published a collection of prints representing the most beautiful châteaux, the sumptuous residences of kings and lords, which best summarize the French Renaissance. This superb work, one of the most handsome books of the period, is used today primarily as a source of information, inexact but irreplaceable, for our knowledge of destroyed or disfigured monuments. Relocated in its historic context, however, such a publication, by its title alone, evinces a very strong awareness of national identity. It seems to me that this better justifies our attempt to define what specifically distinguishes the art of France during the period under discussion. We will seek this not in isolated characteristics, but instead by trying to elicit a sense of collective identity in the complex relationships among various artistic practices. I am not one to believe in some kind of national genius as an immanent or intrinsic entity, some sort of mysteriously transmitted substance emanating from the soil. I do believe rather that the organization of labor and trades, workshop traditions, and even thinking habits are handed down in a more or less enduring fashion and thereby enable individuals to construct a collective identity. This sense of identity is not always conscious, nor does it necessarily have a strong national component. One of the characteristics of the artistic explosion of the central years of the sixteenth century in France is the combination of these two conditions. Philibert de l'Orme reveals to us that in his time Gothic construction was referred to as the "*mode française.*" This gives a specific meaning to the use of Gothic forms in the context of this country. However, this does not prevent de l'Orme's German contemporaries from seeing a German character in the same or very similar forms. The same motifs can have a totally different meaning in different contexts. In both France and Germany, however, the point of

sticking to the Gothic amounted to some extent to a common goal a rejection of Italian models. A sense of identity is necessarily linked to that of difference. In this, Italy played a privileged role; France had a sort of Oedipus complex towards Italian culture.

I have tried hard to make the reader aware that monuments, the works of the past, have come to us at the end of a long journey through time. This involves, of course, destructions and disfigurations; more elusively, but just as importantly, our understanding of these monuments is colored by that of preceding generations; connections have been made which we are forced to take into account, others have been erased. This kind of mental crust that accumulates around the things of the past alters our perception of them.

Finally, rather than simply presenting the results of my investigations and sketching a picture of the visual arts in mid sixteenth-century France as I see it, I wanted readers to accompany me on the sometimes torturous paths that have led me to my conclusions. I thus took the risk—and of this I am well aware—of wearying them and losing them along the way. I hope a few will follow me to the end.

Chapter I

THE GOTHIC IN THE RENAISSANCE

The times were still dark and rank with the infelicity and calamity of the Goths, who had destroyed all good literature. But, through divine kindness, light and dignity were returned to the arts and letters during my lifetime.[1]

Thus wrote the good Gargantua—the colorful, ribald character epitomized in the works of sixteenth-century writer Rabelais—in his famous letter to his son Pantagruel. This illustrates with perfect clarity the myth of the Renaissance—of a bright light coming to disperse the Gothic darkness. Rarely in history was discontinuity so strongly felt as at the time of Rabelais. Old Gargantua, realizing that the recent invention of printing had drastically changed the conditions of knowledge, was obviously intoxicated with the idea of inaugurating a new culture. Of course, this was presented as a "renaissance," a rebirth, rather than strictly a new beginning—yet so far removed was the antique model that the experience of rupture with the recent past was more vivid than any sense of a return to distant history.[2] Moreover, the image of antiquity entertained during the Renaissance was essentially utopian and understood as such. We need only cast a glance at the Songe de Poliphile to convince ourselves of this. In this successful volume, in which text and image are inseparable, fragments of antique culture are moralized and reintegrated into the fantastical structure of a novel of initiation. In 1547, Jean Martin, a friend of Ronsard, translated it into French as a classic of comparable status to the architectural treatise of Vitruvius.[3] Indeed, if Raphael's School of Athens is the result of a much more extensive and intimate knowledge, or a more profound assimilation of the texts and monuments of antiquity, it is no less a fabrication, an ideal or mythic model, and by no means a "scientific" reconstruction of a well-defined and localized past.

On closer examination, historians have realized that the Middle Ages were not so dark—nor was the new era so luminous and free of superstition. So much so that doubt has been cast upon the very notion of Renaissance. Without engaging in fruitless debate, suffice it to affirm that the profound awareness of rupture is in itself a historic fact of paramount importance. Furthermore, discontinuity is obvious in some aspects of culture.

The Gothic in Printed Books

The shift in graphic usage—the switch from Gothic type to Roman or Italic characters—was among the many symptoms of this discontinuity and is revealing due to its location at the juncture between visual and literary culture. What is exceptional and interesting is that this change took place virtually without transition. Once humanist writing developed, in Italy at the beginning of the fifteenth century, its adoption was the result of choice, rather than of evolution or transformation. Conversely, Gothic writing is effectively a creation of the era that we refer to as Gothic and, despite several variations over the course of three centuries, offers striking physiognomic unity, at least in retrospect. Furthermore, the angularity of the written form and the prominence of vertical strokes evoke the forms of Gothic architecture. This script served as the printers' model for

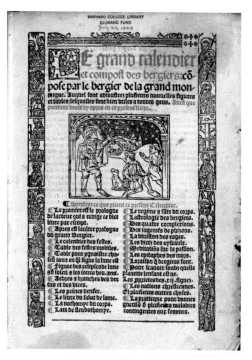

1. Shepherds contemplating the stars, from the Grand Calendrier et Compost des bergers (Kalender of Sheperdes), Lyon, J. Cantarel, 1551. Cambridge, MA: Harvard University, Houghton Library.

for the barely literate. Moreover, for economic reasons, in certain cases printers may have wanted to avoid replacing their entire stock of characters. However, these considerations alone do not account for the continued existence of the Gothic. For instance, the *Kalender of Sheperdes* (fig. 1), an almanac addressed to a rural audience, appeared in Gothic until the middle of the century and even thereafter.[4] Yet, half a century later, printers had changed their stocks of characters and new readers were able to learn from new alphabet primers. Moreover, why did these factors have such disparate effects in Italy, where the Gothic was eliminated very quickly, and in Germany, where it was never ousted? Reasons for the attachment to the old characters therefore went beyond the practical.

Thielman Kerver, a Parisian printer of German origin, used Roman for Books of Hours as early

2. Scene from the Adrian, from Grand Térence en françoys, Paris, Kerver, 1539. Paris: Bibliothèque Nationale de France, rés. g Yc.215. The anonymous woodcuts were reused from the Lyon edition published by Trechsel in 1493.

Gothic characters, just as humanist writing had engendered the Roman and Italic fonts. In France, Roman type had appeared in printed books since printing began in Paris, which is not to suggest that Gothic had abruptly vanished. On the contrary, after an initial period of popularity among Parisian printers, use of Roman diminished. It remained very rare during the fifteenth century, only slowly gaining the upper hand during the sixteenth. Some books were printed in Gothic until the reign of Henri III.

The ongoing competition between the two styles of writing was not a simple question of formal alternatives without significance; each carried its own connotations and different cultural values. To begin with, popular publications stayed with traditional characters for quite a long time. Various possible explanations quickly come to mind. A less educated public is apt to hold on to the appearance of the letters with which it had been taught to read; learning new letters is a more laborious task

3. The *Adoration of the Magi*, from *Heures à la louange de la Vierge* (Hours in praise of the Virgin), Paris, Geoffroy Tory, 1525. Paris: Bibliothèque Nationale de France, Re. 28 rés. The woodcut illustration is generally attributed to G. Tory.

4. The *Adoration of the Magi*, from *Heures à la louange de la Vierge*, Paris, Geoffroy Tory, 1527. Paris: Bibliothèque Nationale de France, B.2942.

as 1505 but returned to the traditional script in 1508 for the French edition.[5] Then, in 1539, while French typographers were already developing "Garamond" characters, his successor, Thielman Kerver II, published a bilingual edition of *Térence* (fig. 2).[6] Presented in two columns, the Latin text is in Roman and the French translation in hybrid letters that are essentially Gothic characters.[7] Indeed, the traditional forms seemed appropriate to the vernacular, while the new were suited to Latin. However, we should not expect much rigor from our printer: the title page, written in French, begins in Roman characters and then casually changes to the hybrid after two lines, right in the middle of a phrase. Furthermore, this edition, lavish but lacking true distinction, was surely aimed

at an undemanding readership: for the illustrations, Kerver merely reprinted—with a few minor adjustments—the woodcuts of Trechsel's celebrated edition, published at Lyon as early as 1493; significantly, the same image was repeated several times so as to give the impression of richness at less cost.

Geoffroy Tory, one of the greatest artists of the book, was not one to compromise and approximate. He published a series of Books of Hours; two of which, issued in 1525 and 1527 respectively, are of particular concern to us (figs. 3 and 4). The first was printed in a magnificent Roman type that specialists view as one of the earliest graphic efforts leading to the development of the Garamond font. Nonetheless, in 1527, Tory

13

5. The *Annunciation*, from *Heures à la louange de la Vierge*,
Paris, Geoffroy Tory, 1527.
Paris: Bibliothèque Nationale de France, B.2942.

manuscripts; the plates are in a Northern style that derives from Flemish painting and is completely distinct from the "antique" manner of the Hours of 1525. The hybrid letters, which Tory calls "modern" or "French," are evidently reintroduced in order to maintain aesthetic coherence in the sophisticated, visual harmony of the book. The privilege of 1524 shows that Tory is fully aware of his approach and considers these alternatives to be two distinct and viable stylistic modes.[9]

An aesthetic consciousness this sharp was probably rare at the time, and the reasons for the retention of Gothic characters were generally more ideological. Thus in 1578 a superb Gradual used by the monastery at Gaillon appeared in Gothic (fig. 6). It is hardly questionable that, in this case, the choice of characters was determined by the destination of the work. If the Gothic lent itself to a liturgical book despite its almost

6. *Graduale ordinis Cartusiensis* (Gradual for use at the Charterhouse of Gaillon), Paris, G. Chaudière, 1578.
Cambridge, MA: Harvard University, Houghton Library.

returns to hybrid Gothic letters (fig. 5). Why this exception? Since both editions are in Latin, linguistic appropriateness is not at issue. The answer takes the form of a letter of privilege that he obtained in 1524 and printed, as was customary, at the front of the volume. It informs us that Tory "has made and makes certain stories and borders in the antique manner, and at the same time others in the modern manner to print these and to be available for Books of Hours of different usages."[8] Indeed, the Hours published in 1525 offer a series of Italianate plates and ornaments still under the influence of the Quattrocento but that, to French eyes, certainly represented the latest fashion of art *"all' antica"* or "after the antique"— the "antique" being, in other words, the new style of the Renaissance. The 1527 edition is embellished with ornamental borders or "vignettes" directly inspired by the decor of flowers and animals found on Flemish and French

complete abandonment elsewhere, this is because by the sixteenth century it already carried the type of ecclesiastical associations that it would have during the Neo-Gothic era.

I have examined the survival of the Gothic in typography as a prelude to my discussion because its circumstances are relatively simple. One can easily distinguish between what is and is not Gothic, and preferences can be explained by motivations that are often fairly obvious, without being explicit. Gothic typography, which survived in Germany almost unchallenged until the twentieth century, was uncommon in Italy as early as the first decades of the sixteenth century, and had a more complex history in France where it was bound up with social, national, and religious values. A certain familiarity with these values is essential to any understanding of this history.

When approaching architecture and decoration, we are confronted with a much more confused situation. The new style *"all' antica"* combines with Gothic style in a varied and significant manner. We will begin by taking a late example around 1560, which is particularly striking because the confrontation of styles is brutal and intractable.

The Frontispiece of Rodez or the Aesthetic of the Disparate

At a breathtaking height atop a vast Gothic façade, a small pavilion of classic design of very refined taste surprises the visitor who approaches Rodez cathedral (fig. 7). Its composition is that of a church façade of two superimposed orders, Doric and Ionic. The broader lower level is interspersed with lateral bays with semicircular-arched niches, punctuated on either side by a single column. Only the central bay, flanked by double columns, extends to both levels. Consoles in the form of volutes provide the transition between the lateral parts and the second level. A pediment crowns the ensemble.

While the frontispiece was being constructed, a tower in the same style after the antique was planned for the right of the façade; however, work on this was interrupted at the top of the base of the columns of the first level. One must surely imagine something in the spirit of the bell towers planned by Bramante and Sangallo for Saint Peter's in Rome. No records pertaining to this frontispiece have survived; nor has any text from that period that would allow us to determine its author or date with absolute certainty. However, tradition ascribes it to Guillaume Philandrier. Some have put forward the name of Jean Salvanh, a mason like his father before him. Though he was in all likelihood responsible for the actual

7. Rodez (Aveyron, France), Notre Dame cathedral, façade, c. 1560 for the frontispiece.

15

construction, that Salvanh was the author of such an erudite project is more difficult to believe. After a meticulous examination of the Rodez archives, Jacques Bousquet came to the conclusion that work on the frontispiece could scarcely have lasted beyond 1562.[10] It is therefore reasonable to place the construction around 1560, since for stylistic reasons, it could not have been much earlier.

The author, if indeed it was Philandrier, was a cleric born in Châtillon-sur-Seine who served for many years as secretary to the bishop of Rodez, the cardinal of Armagnac. According to his own account, he was introduced to architecture by Sebastiano Serlio, even before the Bolognese architect had settled in France, on the occasion of a visit to Venice by the cardinal of Armagnac. Philandrier spent several years with his patron in Rome (1539–44) and was thus able to acquire a thorough knowledge of Roman architecture, both ancient and modern. He even participated in the work of the Vitruvian academy. His scholarly commentary on Vitruvius, published in 1544, would be reissued several times.[11] Philandrier was one of those men of letters turned architect, of whom Alberti was the first and most brilliant example. Although it is difficult to say to what extent he was a practitioner or whether he confined himself almost exclusively to the role of amateur and theoretician, there is no reason to call into question the tradition according to which he would have completed the Rodez façade. The curious frontispiece is an obviously learned work but not one that would demand a great deal of building experience.

Anthony Blunt judged this work severely:

> We see clearly Philander's strength and weakness; for he has simply planted a complete Roman church front on top of a tall plain Gothic façade. In its detail the design is remarkably pure and rather advanced for its date, even on Italian standards. But in its context it is preposterous. All sense of scale and appropriateness seems to have deserted Philander.[12]

The reaction of this historian steeped in the work of Mansart and in Italian treatises, on which he has written with such sensitivity and intelligence, is quite understandable. This would most probably also have reflected contemporary Italian criticism. Yet Philandrier was not necessarily less sensitive, nor indeed less educated than the modern historian. A passionate devotee of architectural theory, he had spent time in Rome, and so had firsthand experience of the major productions of his time; he had discussed architecture with Vignola and several other practitioners of the highest order, and as such, this informed amateur could not possibly have been unaware that he was straying from established practices in Italy and the elementary rules of classicism. Coming from a man like Philandrier, or even—if one questions the traditional attribution—from any architect capable of designing a work so faithful to the principles of Italian classicism, such a gesture can only be the result of a conscious and deliberate choice. Rather than dismissing the strange frontispiece as senseless, we should attempt to understand it in relation to the whole building and, more generally, in the context of the French religious architecture of the age, which differed greatly from that practiced in Italy. North of the Alps, Gothic art continued to thrive. But the Gothic of 1500 was not that of the thirteenth century, striking in its rigor and the clarity of relationships between different parts of the building. During the period that concerns us, it would seem that there was a strong sense of the distinctive character and symbolic value of the Gothic as a construction system based on ribbed vaults, also known as intersecting ribs, and that the Gothic church was considered a large and resilient framework capable of accommodating the most diverse elements—a form both strong and free. Far from cultivating homogeneity and coherence, builders now multiplied contrasts and disparities. A few examples show the opposite tendency, such as the church of Mareil-en-France, which we will discuss later, but these are exceptions.

Coherence was, on the other hand, a highly cultivated value in the Italian Renaissance: the completion, or rather incompletion, of the façade of San Petronio at Bologna (fig. 8), brilliantly discussed by Erwin Panofsky and later by Rudolf Wittkower, is an indication of the state of perplexity and, finally, paralysis to which Italian architects could be reduced, so strong was their

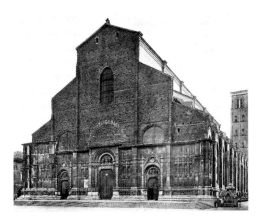

8. Bologna (Italy), church of San Petronio, façade.
The main construction dates from around 1400. The marble decoration,
begun by Jacopo Della Quercia from 1425–38,
was continued in the sixteenth century and then abandoned.

taste for unity and stylistic coherence.[13] The first level of this façade, executed in the fifteenth century, contained a masterpiece by Jacopo Della Quercia, a series of bas-reliefs around the central portal representing the episodes of Genesis. The overall design was Gothic. In the sixteenth century, the decision was made to complete the long interrupted work. In 1518 execution began on the design of the sculptor Domenico da Varignana but was quickly abandoned as unsatisfactory, after which numerous architects were consulted and plans proliferated. Essentially, three solutions were envisioned and they were clearly distinguished in the analysis of Pellegrino Tibaldi, known as Pellegrini, whose celebrity as both an architect and painter lent him great weight. These were to start over in the new classic style; to finish the existing work in the Gothic manner of the fifteenth century; to invent a hybrid solution, such as Varignana's, which would include the existing work by more or less adapting it within a rejuvenated composition. The different proposals were submitted to the unrivaled authority of Palladio, who criticized all three and recommended drawing up a new design. He returned to Bologna in 1572 and created a series of plans in which he moved towards a radically classic solution, one that would have demanded the demolition not only of the revetment begun by Varignana, but also of the fifteenth century portals and,

consequently, of Della Quercia's reliefs. Palladio would rather have demolished the existing section of the Gothic façade and replaced it with one built according to the rules. Pellegrini, an extraordinarily versatile and inventive architect, also opted for a classic façade. But if the existing structure had to be retained, he favored completion in the Gothic style; that is, he preferred a pastiche, rather than to suffer the discord of the two styles juxtaposed. Next to stylistic coherence, other considerations weighed heavily in the balance: the cost, of course, and the attachment to the past, as well as the prestige of a work of Della Quercia that Michelangelo himself had admired enough to draw inspiration from it in the ceiling of the Sistine Chapel. The result is well known: in the end, nothing was done, and the façade appears today in the same state of incompletion as it did in the sixteenth century.

Indeed, the Italians were not always able to avoid disparity and clashes of style. In the case of Bologna, even Palladio would not go so far as to suggest that the entire church be demolished in order to avoid discrepancy between the classic façade and the interior. But they surely considered such inconsistencies as make-do solutions.

In France, buildings were considered flexible structures open to additions for much longer. Churches in particular fed this tradition, due to the general reluctance to destroy a consecrated building. Similarly, if for one reason or another one wanted to get rid of a statue of a saint, precautions such as a ritual burial were necessary. Thus the statue of Saint Germain-l'Auxerrois survived more or less intact under the church in Paris dedicated to him. If one rejected demolition, a popular alternative was to add elements to the existing edifice. These were primarily chapels, which continued to proliferate from the fourteenth century on, towers, and sometimes side aisles. Jubés and choir enclosures were inserted in any number of churches. In the fifteenth and sixteenth centuries, the entire chancel was often rebuilt in order to enlarge it. But very rarely was a church rebuilt from top to bottom, unless it had been destroyed, as was the case of several churches in Troyes after the fire of 1524. Furthermore, there were many unfinished sites. Some of the

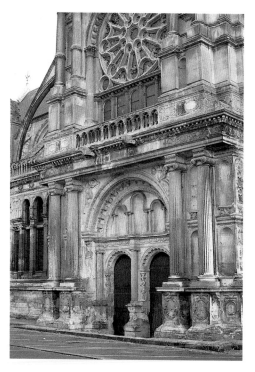

9. Le Grand-Andely (Eure, France), church of Notre Dame, north façade, third quarter of the sixteenth century.

can but wonder if the impression of disorderly growth over the centuries created by the great French religious buildings was not systematically cultivated. Philandrier's approach must be situated in the context of these sensibilities.

A more specific aspect of traditional architectural decor in French churches helps explain how Philandrier's frontispiece fits into the overall façade: the tendency to use the reduction of a building as a decorative motif. Churches are covered, inside and out, with ornamental dwarf buildings. These include, in the first place, the innumerable canopies that generally shelter statues set up against façades and pillars or on altars. The amortization of the buttresses often takes the form of a scale model of a bell tower. Adoption of the style of Italianate ornamentation only served to increase the taste for miniature buildings. On façades in particular, not only did canopies remain, embellished with new motifs; the architect also often crowned the ensemble with a classic composition in place of the traditional pinnacles. At Gisors, for example, the great portal is topped with a small edifice in the form of a triumphal arch (fig. 37).

This tendency was deeply rooted. It is, of course, in perfect harmony with Gothic art since this lacks any clear separation between structure and ornament—ornament having grown out of the progressive subdivision of the pointed arch, originally a structural element. Moreover, the ornamental use of miniaturized architecture is already a frequent occurrence in Romanesque art, with statues often sheltered by canopies in the form of small buildings. Although the motif must have originally suggested the heavenly abode of the saints, it became so widespread that it is difficult to determine whether it retained any of its symbolic value. Nevertheless, it would be imprudent to affirm that it had disappeared entirely, and this may in part have allowed the taste to persist with such vigor.

Be that as it may, the decorative use of architectural elements was fully established. Examined without prejudice—that is, putting aside the classical principles of architecture to which the Italians subscribed—the frontispiece of Rodez fits quite well into the composition of the façade,

thirteenth century's most ambitious projects, such as the cathedral of Rodez, which had languished during the troubles of the Hundred Years' War, were continued at a slow pace. The construction of numerous new churches was also undertaken under Charles VIII and Louis XII: the pilgrimage church of Saint Nicolas-de-Port, near Nancy, the great parish churches of Paris—Saint Méry, Saint Gervais, and Saint Étienne-du-Mont begun at the turn of the century—the collegiate church of Bourg-en-Bresse, and even certain cathedrals such as those at Nantes and Auch.

These circumstances favored disparities and incoherence. Yet, where there is a will, circumstances can be overcome. In fact, the taste for variety, contrast, and surprise prevailed over that for regularity, and the character of the part over the integrity of the whole. The artists of the era went very far in their contempt for unity and coherence. Although this is pure speculation, one

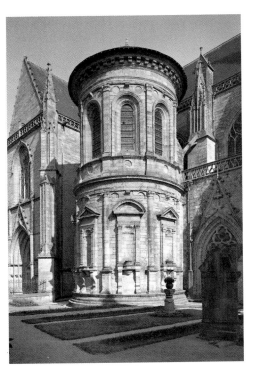

10. Vannes (Morbihan, France), Saint Pierre cathedral,
ext. chapel of the Holy Sacrament, 1537.

remote province, which in 1537 provided one of the first examples of French architecture in a resolutely classic style (fig. 10). It consists of a centrally planned chapel grafted onto the cathedral. The conception of this rotunda covered with a cupola and featuring superimposed orders and the alternation of triangular and curved pediments is unexpected. There is a somewhat straightforward explanation for this strange irruption in deepest Brittany of an architecture entirely new to France several years before Serlio arrived at court and while Philibert de l'Orme was still in the early stages of his work following his return from Rome: the commissioner, Jean Danielo, was a canon of the cathedral and had returned from a long period of residence in Rome. Had he himself prepared the design, which is simple enough, or did a local builder adapt it from drawings brought back from Rome? The fact remains that this relatively intricate design, which must have seemed very exotic to French eyes, was quite clumsily executed. Instead of accusing the resistance of granite, with which masons certainly managed to build the Escorial, the blame must be placed on the sensibility of local masons, incompatible with the tenets of Italian classicism. The interior space, which looks like a vertical tube or the excessive projection of the cornice—everything points to incomprehension rather than resolve. Here, the builders were indeed stammering in a foreign language.

At Rodez, it is an entirely different matter. The author masters his language. If the projection of ornaments is a little stronger than is customary, or if he removed the base from the Ionic order, these choices can be explained by a concern for effect dictated by the unusually high placement of the frontispiece. Superfluous details have been avoided; all is legible from ground level, save perhaps some details of the lateral cartouches, though this is difficult to assess as they are badly damaged.

Between the touching but clumsy attempt at Vannes and the frontispiece at Rodez elapsed a quarter of a century that was of paramount importance to the evolution of French art. A generation of great artists—Philibert de l'Orme, Pierre Lescot, Jean Cousin and Jean Goujon especially—were not only aware of the art on the other side of

where its role is that of a large motif, as are the rose window or the gallery of blind arches. Stylistically, it is in violent opposition to the pinnacles that amortize the lateral buttresses but, at the same time, in combination with them it comprises a carefully arranged and harmonious silhouette.[14] There is another more distant but striking relationship: as soon as one moves away from the building, the statues that stand out against the sky above the pediment echo those that crown the north tower. It should not be forgotten that, had the projected bell tower been completed, the two towers would have matched each other in height, sharing a similar massive structure, though remaining stylistically different, somewhat reminiscent of the two bell towers at the cathedral of Chartres.

It is instructive to compare the Rodez frontispiece to the astonishing rotunda at Vannes, built a quarter of a century earlier in what was also a

the Alps, they appropriated it for themselves. Economic and gastronomic metaphors dominate the discourse on relations between France and Italy during the Renaissance: borrowings, thefts, enrichment but also absorption, digestion, and even regurgitation. These expressions are not only ones of our time and the recent past; they are also those of that era, and particularly of du Bellay's *Deffense et Illustration de la langue françoyse* (*Defense and Illustration of the French Language*).[15]

Philandrier belonged to that generation. Like de l'Orme and Lescot, he was perfectly familiar with classical architecture, as his commentary on Vitruvius proves. At the cathedral of Rodez, he showed what appropriation meant for him. Many artists had sought to introduce classical organization into church façades, always ending up with some kind of compromise solution, which could be very charming, inventive and even elegant, as in the façade of the church of Le Grand-Andely in Normandy (fig. 9). Philandrier, however, refused to compromise. Insofar as classicism is introduced, it is introduced in all its integrity. As we have seen from the start, the design of this "façade" is impeccable; yet with both authority and decisiveness, with a sort of brutality, the set piece is inserted whole into a foreign syntax with the conviction that it will be accommodated. It is this boldness, this magnificent sense of assurance that Philandrier shares with de l'Orme and Lescot. And to our eyes, the *coup de force* was successful.

The visual effect of the pediment of Rodez relies on a very acute sense of scale; its dimensions are less than those of a real façade, but it is not miniaturized to the point of becoming merely an ornament. Moreover, it works on two different levels. From afar, it is a motif that integrates seamlessly into the silhouette of the church. Particularly when one approaches from the west, the pediment and the top of the tower of the north transept are juxtaposed, and the statues crowning the two parts of the edifice match each other in a sort of visual rhyme. Closer up, from about one hundred feet—namely, at an angle of about forty-five degrees—one clearly distinguishes a classic façade in blatant stylistic opposition to its environment, in particular the Flamboyant pinnacles that frame it.

Should this stylistic demonstration, this strange gesture, be understood solely as the manifestation of an aesthetic leaning, or are we to look for some ideological intent? Ecclesiastical architecture is generally imbued with symbolism, albeit at times diffuse. In the case of a cathedral, it would be surprising if such an important element—one that so insistently draws attention to itself—was not also used to convey an idea. The massive structure of the cathedral dominates the town, and the magnificent tower constructed by François d'Estaing, over two hundred fifty feet tall, is visible throughout the region. The façade itself, almost blind in its lower parts and lacking any entrance, was included in the city's system of fortifications and was thus located beyond the city walls. As such, it was directed at the outside world, which further suggests that Philandrier's gesture—necessarily approved by the bishop—was not gratuitously aesthetic. What message then could this pediment have sought to convey?

In order to propose a hypothesis, we must return to the type of façade used by Philandrier and ask what connotations it could have had in the building where it appears so incongruous. This kind of façade had been developed to adapt the vocabulary of secular antique architecture to the façade of a church with a high nave flanked with side aisles, as was most often the case in the Middle Ages. Classicism was thus introduced into a specifically Christian genre of building. Its principal source of inspiration came from Roman triumphal arches. The motif was not yet fully developed on the façade of Santa Maria Novella at Florence as Alberti completed it around 1470, and its definitive form appeared only in the mid-sixteenth century in Rome. From there, it was to spread out in an almost universal fashion, to the extent that it can be regarded as a symbolic affirmation of the triumph of the Counter-Reformation. Although this development was to come later than the Rodez façade, it nonetheless demonstrated the extraordinary eloquence of the architectural theme. At Rodez, however, this is not a case of a true façade. The building is of the type suited to this arrangement, but, as we have seen, our frontispiece is stuck on the gable with no relation to the interior structure. This rupture

between the motif and its original function only increases its symbolic and iconographic potential.

It is probable that Philandrier and his entourage had perceived this façade design as a specifically Roman motif, both in the sense of the classicism of ancient Rome and of that of Catholic orthodoxy. If the Rodez pediment acts not solely as an ornament intended to add a modern and exotic note to the old cathedral, but also as an emblem—indeed, if it is brandished as a banner—then what it proclaims is the submission of classicism to Christianity and the triumph of modern Catholicism. On the brink of the Wars of Religion, near Millau, a bastion of the Reformation, such an attitude would be completely understandable. We can begin to confirm this hypothesis. We have already mentioned the bell tower that was designed in the same style as the pediment—had its execution been carried further, this would have reinforced the effect of the latter. Its stump bears a significant inscription of unambiguous Christian triumphalism: NOS AUGUSTI SANCTAE-QUAE CONSACRA LOCI SPECIEM MIREMUR. FACESSANT AEGYPTIORUM INSANE PIRAMIDUM MOLES [...] VALLEANT ORBIS MIRACULA (Let us admire the beauty of this noble place consecrated to the Holy [Virgin]. Be eclipsed, insane masses of the Egyptian pyramids [...] grow pale, wonders of the world).

Vitality of the Gothic

Whether a stylistic phenomenon as at Vannes, where the Renaissance appears as an expression of exoticism and a badge of prestige, or a more studious ideological approach as at Rodez, the introduction of classic art in France was never the mere replacement of one system of forms with another. We have been raised on a history of art that describes an unending procession of styles: Gothic displaces Roman, the Renaissance displaces the Gothic and so on. Do any traces remain of the preceding wave? These imperfections do not call into question the model; rather they point only to the inability of certain artists to follow the required course of history. This very effective teleological vision unfortunately does not always apply in all its admirable simplicity: if it can be claimed without too much exaggeration that in central Italy the new style "all'antica" had definitely prevailed since the end of the fifteenth century to the point of becoming the only architectural possibility, in France, on the contrary, the Gothic remained a viable alternative for a long time.

The Renaissance style inspired by antiquity appeared in France as an import from Italy. We shall see that it was not always adopted without reservation. Above all, the modalities of the insertion of the new forms were extremely varied—ranging from simply tacking a few motifs onto the Gothic work that they were meant to spice up through to the large scale adoption of a foreign art by the mass importation of artists. Even in the latter case—as at Fontainebleau, where François I summoned Italian masters to decorate the château—we see that these artists adapted their art to their new environment. In the domain of architecture, customs, professional organization, and taste exert even greater pressure than in interior decoration. If it is true—and this is the crux of our argument—that the middle of the century witnessed the birth of a French classicism, in order to understand its formal elaboration and its meaning, it is essential to take into account the power and vitality of established traditions.

The Gothic of the sixteenth century is one area that needs exploring, and one that is full of surprises. Medievalists have seen in it only the senility of a style, while for historians of the Renaissance it merely elicited an intractable attitude and a hopeless incomprehension of Italian art. It is no surprise, then, that the religious architecture of the sixteenth century—which as we shall see remains essentially Gothic—is still so little studied. This is why, although this type of architecture abounds in all manner of invention and experimentation, we must content ourselves with several characteristic examples. Civil architecture was more successful, but by viewing it first and foremost as the progressive adoption of

11. *King David praying*, from the *Grandes Heures d'Anne de Bretagne*
(Hours of Anne of Brittany), prior to 1508. Illumination on parchment,
12 × 7 ¾ in. (30 × 19.5 cm). Paris: Bibliothèque Nationale de France, lat. 9474.

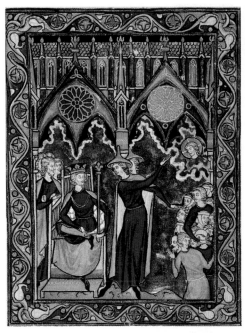

12. *Moses and Aaron before Pharaoh*, from the *Psautier de Saint Louis*
(Psalm Book of Saint Louis), 1253–70. Illumination on parchment,
8 ⅓ × 5 ¾ in. (21 × 14.5 cm).
Paris: Bibliothèque Nationale de France, lat. 10525.

13. Louviers (France, Eure), church of Notre Dame,
royal portal, early sixteenth century.

the Italian Renaissance, historians have compromised its interpretation. If the most spectacular of François I's châteaux never fails to fill its critics with wonder, their admiration shades a critical discourse that reduces the art of Chambord to the incomplete adaptation of Italian decor tacked on to a traditional architectural structure, a hybrid art.[16] A rapid reevaluation of the late Gothic is therefore essential to providing a more satisfying account of the French Renaissance.

Gothic or Renaissance? Flamboyant Art

The very term "Gothic" poses a difficult historiographic problem for the period that concerns us. Does the art of the 1500s that we refer to as "Gothic" have much to do with that of the twelfth and thirteenth centuries? Not so long ago, one would not have hesitated to qualify as Gothic the art of van Eyck and all painting north of the Alps, up to and even including Dürer. But whether grandiose, as in the work of the Master of Moulins, or trivial, as in that of Jean Bourdichon, the verbose illuminator of the *Hours of Anne of Brittany* (fig. 11), the naturalist art of 1500 seems quite remote from the rhythmic and elegant stylization of the *Psalm Book of Saint Louis* (fig. 12):

14. Abbeville (Somme, France), church of Saint Wulfram, façade,
first third of the sixteenth century: photograph predates 1940 bombing.

15. Rheims (Marne, France), Notre Dame cathedral, nave,
thirteenth century.

these are different worlds. Though we have no difficulty in calling the very abstract art of the thirteenth century painters Gothic, the term no longer seems suitable for those of 1500.[17] The Flemish painters of the fifteenth century have long been called the "Primitives," but today one speaks more readily of a Northern Renaissance. It is not unreasonable to see in the innovations of Masaccio and van Eyck clearly different, yet parallel and related phenomena. On the other hand, when one turns to architecture, the situation is ambiguous. The extravagance of the royal portal of Louviers (fig. 13), begun in 1506, and other comparable works seem totally unrelated to the limpid, "logical" compositions of the twelfth and thirteenth centuries, such as Notre Dame in Paris or the cathedral of Amiens. Nevertheless, the overall physiognomy of many buildings from around 1500, such as the churches Saint Méry in Paris or Saint Wulfram in Abbeville (fig. 14), is so close to that of thirteenth century edifices that one would be reluctant to give them a different name. Gothic building, based on the principle of the ribbed vault and the pointed arch, presents a

continuity, which seems, in the final analysis, to prevail over the differences that are nonetheless evident. Moreover Flamboyant ornamentation, which gives such a specific appearance to the art of the fifteenth and sixteenth centuries, constantly reminds us that it belongs to this system of the subdivision of the pointed arch. It would be regrettable to abandon the term Gothic for this architecture, as there are good reasons to believe that the builders themselves consciously looked to maintain the tradition that linked them to preceding centuries, even if they also sought to express their originality. The church of L'Épine is a curious case, probably exceptional, yet revealing of this attitude. Inside a magnificent and exuberant Flamboyant façade (fig. 17), the visitor is surprised to discover an extremely somber nave of not just conservative but truly retrograde design[18]: the architect had all but copied the elevation of the nave of Rheims cathedral, which predates L'Épine by more than two centuries (figs. 15 and 16). The chancel at L'Épine is closed by a *jubé* and a choir enclosure of great ornamental richness that even includes Italianate motifs next

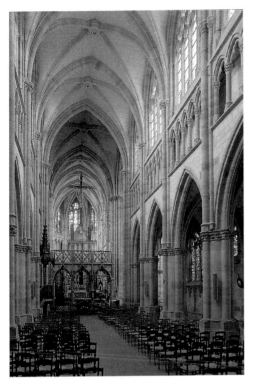

16. L'Épine (Marne, France), cathedral of Notre Dame de L'Épine, nave, mid-fifteenth century.

to the Flamboyant flourishes; there is nothing outmoded here. Why then did the architect of the nave select such an ancient model? This decision, whether emanating from the architect himself or the commissioners, was certainly in response to a definite intention. The concept is much too unusual to have been either a facile solution or a routine act. Furthermore, the very dimensions of the edifice testify to its ambition. To repeat fifty-year-old formulas would be an indication of conservatism; however, to return to a model so far removed in time is contrary to habitual practice and can only be understood as a voluntarily retrospective act with a symbolic and ideological value.

After an extended period of intense architectural invention, particularly in Champagne where the Flamboyant developed very early, the great cathedrals of the twelfth and thirteenth centuries must have appeared both imposing and a little distant, as witnesses of a glorious but past age. It is not impossible that they bore the specific imprint of the memory of Saint Louis. In the mid-fifteenth century, in any case, the Gothic was already beginning to acquire a specifically religious symbolic value. In the double-page spread in which the artist Fouquet shows us Étienne Chevalier presented to the Virgin, the architectural decor leaves little room for doubt (fig. 18). The painter has arranged the characters before an architectural backdrop after the antique, complete with Corinthian pilasters of impeccable taste, which is up to the standards of contemporary art in Italy. However, behind the Virgin, he has planted, as a mandorla, an absolutely Gothic decoration—of a type of Gothic that recalls the great buildings of the past rather than the Flamboyant fashion of the time. The contrast is striking and significant: the Gothic is the sign of the divine, of the heavenly kingdom inhabited by the mother of God.

Architectural symbolism is exclusive neither to Fouquet, nor to France. Well-known examples of

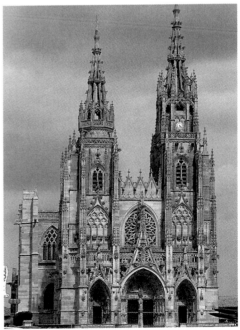

17. L'Épine (Marne, France), cathedral of Notre Dame de L'Épine, façade, 1509–24.

25

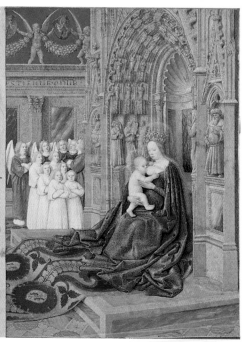

18. Jean Fouquet, *Étienne Chevalier being presented to the Virgin*, from the *Heures d'Étienne Chevalier*, c. 1450. Illumination on parchment, 6 ¾ × 4 ¾ in. (17 × 12 cm) per page. Chantilly: France, Musée Condé.

it are found in Flemish painting of the same era, though these generally call into play the opposition between the old and new Alliance, exhausted paganism and the new era ushered in by Christ. Instead, in Fouquet, the contrast is between secular magnificence and the heavenly world. This is not to say that in the mid-fifteenth century any element of Gothic architecture would have denoted the divine or even evoked its echo. The Gothic, in its broadest sense, was still the quasi-universal language of civil as well as religious construction. Yet, in certain contexts, an already old or "classic" Gothic could take on such a meaning. In the sixteenth century, this situation became more clearly marked when competing manners of construction increasingly prevailed over the Gothic, itself eventually becoming a rarity.

With few exceptions, churches continued to be built in the Gothic manner—whether enlarging an existing edifice or erecting an entirely new construction, such as the church of Saint Eustache in Paris. Yet the new classical style was not altogether excluded from religious architecture. The chapels of châteaux were built in the new style with some frequency, but these are of course specific cases since their architectural context is civil. Nevertheless, some maintained that even here only an ogival construction would be appropriate to the holiness of the place. This is the case for example at the Château of Écouen, where the chapel is

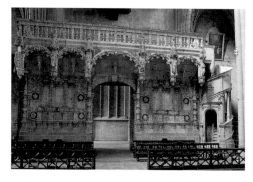

19. Limoges (Haute-Vienne, France), cathedral of Saint Étienne, *jubé*, 1533–36.

covered by a ribbed vault that has been arbitrarily inserted into the body of a building that is not at all Gothic. Private chapels attached to churches can also be conceived of *"all' antica."* We have already made reference to the exceptionally precocious rotunda of Vannes, and in Chapter IX we will examine in detail the admirable chapel constructed by Jean d'Amoncourt at the cathedral of Langres.[19] The funeral chapel of Henri II and his sons known as the *chapelle des Valois* at Saint Denis, undertaken by Catherine de Médicis but never completed, would have been the most sumptuous example, and the crowning glory of this series.

The new style also enjoyed a very early triumph, even in the center of churches, in the decoration of choir screens and in the construction of *jubés*. Thus, around 1530 an enclosure in the new style was connected to the Flamboyant *jubé* of the cathedral of Rodez.[20] The *jubé* of the cathedral of Limoges, which dates from 1533–36, stands as perfect evidence of the exuberance of the first French Renaissance (fig. 19).[21] Included in its very rich decorations, one finds the labors of Hercules, the hero of antiquity whose prowess would make him particularly attractive to an era much taken with chivalrous virtues. In 1540–45, the *jubé* itself became a privileged place for experimentation with classical forms, many of which—for instance at Bordeaux, Maillezais, and Saint Père in Chartres—were constructed on the theme of the triumphal arch. The *jubé* of Saint Étienne-du-Mont is the only one remaining in Paris, but that of Saint Germain-l'Auxerrois (studied at length in Chapter V), designed by Pierre Lescot, was reputed to be the most beautiful of all and was surely the most rigorously after the antique.

Though the clergy did not therefore feel a fundamental antipathy toward the innovations of the Renaissance, the overall physiognomy of the church—whether parochial, collegiate, or cathedral—remained Gothic. Because of its religious connotations, ogival construction never completely disappeared between the fifteenth and nineteenth centuries, between the late Gothic and the Neo-Gothic.

Nature and Function of Gothic Ornamentation

No agreement will probably ever be reached as to the origin of rib vaulting—but this is of no matter. Whatever the utility or function of the ribs might have been initially, their autonomy, part real and part fictive, must have been very quickly sensed: they highlight lines of stress more than they bear the vault. Visually, ribs appear to form the structure of the Gothic vault; the rest seems mere padding. In most cases, they create the impression of a sort of design in space, as if the artist had superimposed his working drawing on the surface of the building. Tracery also produces this effect of graphic architecture. Obviously it

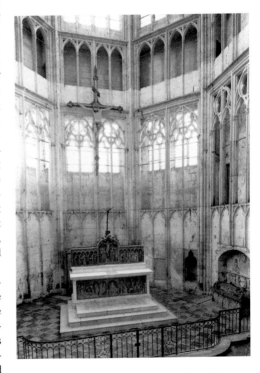

20. Saint Thibault (Côte-d'Or, France) church of Saint Thibault, choir, early fourteenth century.

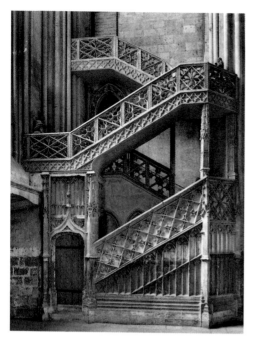

21. Rouen (Seine-Maritime, France), Notre Dame cathedral,
staircase to the library, 1480 for the lower flight
(the upper flights are from the eighteenth century).

Gothic ornamentation was directly engendered by the subdivision of the broken arc, the fundamental motif of this architecture, so that there is no separation in principle, and no neat divide between structure and ornament.

At the time of Saint Louis, we know that builders were capable of reducing a building to a glass cage supported by a stone skeleton, as is borne out by the Sainte Chapelle in Paris. But it is also notable that architects immediately returned to the use of the wall and strong architectonic elements for reasons that were probably expressive and aesthetic as much as practical.[22] The Late Gothic, in France at least, consisted above all in the development of this play between the materiality of stone, pillars, and walls with their power and tangibility reasserted, and the dematerialization of stone, rendered insubstantial by the virtuoso chisel of the mason.

Flamboyant ornamentation has a very characteristic appearance. It enjoys an unmistakable spatial arrangement via a sharp contrast between light and shadow. This is a sculptor's art—or more precisely that of a carver of stone (or of wood)—wherein the excavation of material is essential. The motifs appear independent of the background against which they stand out. At Brou, in the church built for Margaret of Austria, this stone art saw one of its most spectacular developments. A molding of the chancel, notably, bears the motto of the founder—FORTVNE INFORTVNE FORT VNE—in letters that stand in relief from the block of stone yet are imperceptibly attached (fig. 24). Besides the stupefying virtuosity of the craftsmen, this surprising piece demonstrates a rather particular conception of space; the letters of the motto sketch a sort of virtual convex molding which responds to the concave molding, defining between the two a volume, or rather a hollow, or vacant space. This detail is paradigmatic. All the richly worked parts of Brou (fig.23), and above all the tomb of Margaret of Austria, are similarly hollowed out to the point that matter seems abolished, making way for a game of light and shadow in depth, and defining a space without recourse to tangible volumes.

In certain cases, motifs of leaves, animals, and even people are treated with a very sophisticated naturalism; but what gives life to this type of

had a practical origin: the subdivision of openings in order to support the glass of windows that would be too large without it. But it was quickly to become a decorative element that could be added to a wall even where there was no opening; this is referred to as blind tracery. Since the thirteenth century, at Saint Urbain of Troyes and at Saint Nazaire of Carcassonne for example, these ribs have appeared dissociated from the surface of the wall. Detached tracery sometimes lines the wall in order to obtain a decorative spatial effect, without the least static or practical justification. At Saint Thibault in Burgundy, at the beginning of the fourteenth century, this formal game was played out over the entire chancel, one of the most audacious creations of the era (fig. 20). Thus, from the golden age of Gothic art on, ribbing has dematerialized architecture, and, in this sense, there is no break between the simple, hierarchical, and clearly organized forms of the thirteenth century and Flamboyant superabundance. Essentially,

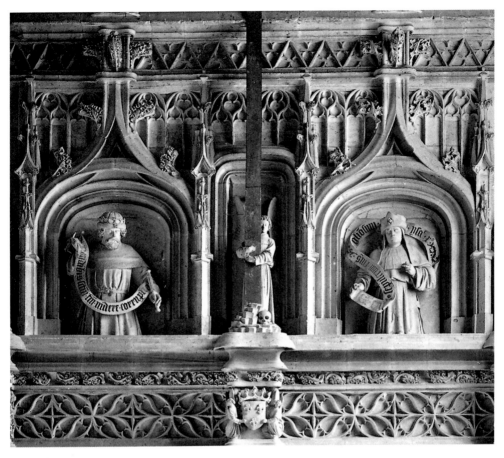

22. Solesmes (Sarthe, France), Saint Pierre abbey, abbey church, south transept, c. 1496: arches of the upper register.

ornament is essentially abstract and comes from the entanglement and, especially, the superimposition of motifs. Seen at a distance, the decor continues to function, although the details are lost. The most frequently used motif—and also the most characteristic—is a kind of semi-abstract kale leaf; a vaguely vegetal curling that creates the impression that the stone has been reduced to a fine membrane. This teeming ornamentation, the exuberance and excess of which has often been condemned, is utilized in two different fashions. In the first approach, it acts as the agent *par excellence* of the dissolution of forms. The division of the pointed arch initially defined a hierarchical order of great clarity: the elevation of naves in the

great French cathedrals, such as that of Rheims, was conceived in this manner. However, pushed to the extreme, this system can have exactly the opposite effect. When the gradation of motifs from smallest to largest reaches a certain level, relationships become confused, especially if the motifs overlap as is often the case. The result is a general superabundance—an effect that one could compare to the "overall" of Jackson Pollock's drip paintings. A phenomenon of this sort can take place on a rather large scale: the nebulous forms of the royal portal of Louviers attest to this (fig. 13).[23] The large motifs are systematically interrupted; thereby allowing glimpses of large arches through the profusion of ornamentation even if their exact

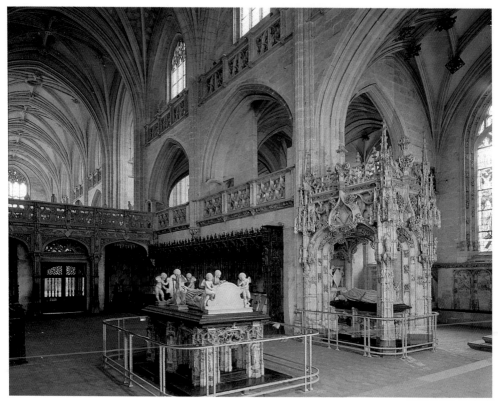

23. Brou (Ain, France), monastery of Saint Nicolas de Tolentin, abbey church, choir, 1513–32.

profile is not clear. At Saint Maclou in Rouen, the entire exterior of the building is subjected to this disintegration of boundaries.

Flamboyant ornamentation can also inscribe itself, however, within the scope of well-defined, even geometric, forms. At the cathedral of Rouen for example, the exterior faces of the stairs in the north transept, added in the fifteenth century to give access to the library, are entirely covered in ornaments (fig. 21), but these are strictly contained inside geometric shapes.[24] Something similar can be observed, though in a more nuanced fashion, at Solesmes, in the treatment of the recess or arcosolium that shelters the famous holy sepulcher attributed to Michel Colombe (fig. 378), the forms of which are clearly articulated. Ornamentation is liberally applied, but to very different ends than in the portal of Louviers or at Brou. The play of

horizontals and verticals is immediately and completely legible; the arches are uninterrupted. Here ornamentation does not serve to emphasize the articulation of the composition since it is present almost throughout. As in the staircase at Rouen, it forms the very substance of the monument. Thus, the intermediate zone between the two levels, between the arcosolium and the arcades which frame figures of the prophets is not strictly speaking an entablature but rather a large band molding, the whole surface of which is animated. The busy carving of this frieze, if one can call it that, by texturing the surface, brings out the smooth clarity of the moldings that border it. Similarly, at the top level, the delicate blind tracery emphasizes the strong projection of the powerful moldings that define three depressed arches. Two of these are surmounted with accolades that wind around them

24. Brou (Ain, France), monastery of Saint Nicolas de Tolentin, abbey church, molding around the choir with the motto of Margaret of Austria.

and link them to the coping in a manner that is both simple and ingenious. It is practically impossible to analyze the elements of this monument by applying the terms of classic architecture. One cannot speak of capitals, since these are reduced to an ornamented molding that continues throughout the work. Moldings and sculpted band moldings follow one another according to a specific system that would require a vocabulary of it own. Let us finally draw attention to the penetrations of the moldings of the arcosolium and of the accolades on the upper tier.

The spatiality of ornamentation appeared here essentially thanks to a sort of in depth terracing. The generally abstract motifs, based on the progressive subdivision of the pointed arch, are placed on two distinct planes one in front of the other. The degrees of this subdivision are thus differentiated not only by their scale, but also by the plane on which they develop. Late Gothic art is often characterized by this propensity to suggest several layers superimposed in a real, albeit very limited, depth.

One can thus identify two currents in Flamboyant decoration around 1500: one favors clearly articulated forms, tectonic or rather geometric, and the other—that of the porches of Louviers and Albi, which one could call picturesque—erases outlines and borders. The taste of the first for clear and well-defined forms can appear closer to Italian art, although there is no link of dependency in this respect. While a purely Italian motif appears at Solesmes—the candelabra adorning the lateral pilasters—it appears as an exotic touch inside a composition that has nothing to do with the art of Italy.

Ornamentation plays a major role in both approaches—one that is slightly different in each case but nevertheless completely foreign to the principles of the classic tradition. In this tradition, one never loses sight of a more or less anthropomorphic metaphor: classic ornamentation accentuates the articulations of an architectural structure understood as a large body. It appears as an addition—a more or less superfluous part that may be removed. In the Gothic tradition, ornamentation is structural: it permits the differentiation of the architectural material. All this architecture being stonework, there is no fundamental difference or clear line of demarcation between architecture and sculpture, or indeed between the mason and the sculptor. This tradition of stone carving retained a decisive importance throughout the French Renaissance.

If the Flamboyant willingly cultivated opposition between parts dematerialized by ornamentation and the tangibility of masonry, its conception of material also differed profoundly from that upheld by the Greco-Roman tradition. This divergence manifested itself through the ubiquitous taste for penetrations. The most frequent example—so banal as to be often overlooked—is that of ribs that lose themselves in pillars, as if they had been absorbed into the masonry. To take a further example, let us examine the form of the arches that shelter the prophets in the upper register of the sepulcher of Solesmes (fig. 22). They constitute a group of rather complex moldings. We have already observed that the exterior molding divides itself into two, with one branch forming a lower arch while the other rises to describe an accolade. This idea of splitting a molding already goes completely against the sense of integrity of elements that is inherent in the classic conception of the Italians. The behavior of the second molding from the outside is still more significant. It lies on a slightly deeper plane than the first; it also divides to form two distinct arches, but the branch that forms the accolade sinks into the depressed part of the exterior molding and then reappears above. Thus, this element retains its own identity while crossing another one. This implies an independence of form with respect to material, which is completely foreign to the Italian conception. According to the latter, an architectural member, regardless of whether it constitutes an ornamental motif, is a body or form assumed by the material, the integrity of which is physical and unquestionable. In the Flamboyant, on the other hand, the material—stone—is transformed into a fluid substance and yields itself to form.

The Taste for Contrast

Great pieces of bravado these works with their inextricable accumulations of ornament, are characteristic of Flamboyant art, as has been well emphasized. Moreover, they carry on a tendency that had surely existed since the golden age of the Gothic. The disposition of reliquaries in the chancel, the rich ornamentation of *jubés* since the thirteenth century, and the celebrated cross of Suger at Saint Denis are evidence of this. Nevertheless, especially during the fifteenth century, this tendency was amplified to the point of becoming a constitutive principle and marking a new phase of the Late Gothic—to the extent that the Flamboyant, as we refer to it here, can almost be considered a new and autonomous style. However, in order to understand the role of these works, another aspect of the Flamboyant— one that is intrinsically linked to them, yet draws little discussion—must be taken into account: the tendency almost to the opposite extreme, that of bareness. The contrast between the base and the adorned is one of the structural principles of this art, and this on very different scales.

Let us return for a moment to the case of L'Épine. We have already mentioned the striking effect produced by the sobriety of the nave in comparison to the exuberant façade. It is true that ever since the thirteenth century, in all great cathedrals, the façade has witnessed a vast deployment of sculpture and decoration—yet one that respects very clear outline allowing a high degree of coherence between the exterior and interior of the edifice. Conversely at L'Épine, the superabundance of ornamentation on the façade is radically opposed to the chaste organization of the nave. Should this be viewed as an accident, the more or less undesirable result of separate construction campaigns, or indeed as an aesthetic choice? The building of this great church of pilgrimage was undertaken a little before 1410, but, for financial reasons, was long interrupted. The complex history of the construction is very poorly documented.[25] It is difficult to say whether such a Flamboyant façade was anticipated when the interior elevation was developed or if this was a later decision. As no answer is forthcoming, the question may appear trifling. In fact, it can be asserted that the resulting effect corresponds to a choice, or at least to a larger aesthetic tendency that extends far beyond the case of L'Épine. Similar contrasts can be found in so many buildings built or enlarged

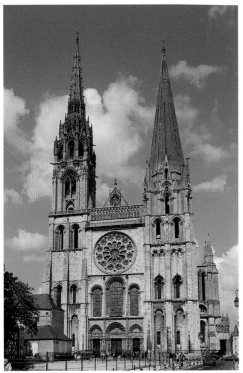

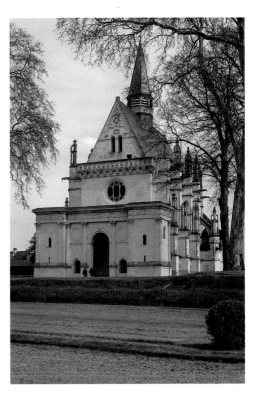

25. Chartres (Eure-et-Loir, France), Notre Dame cathedral, façade.
The north tower (left) dates from 1507–13.

26. Champigny-sur-Veude, (Indre-et-Loire, France),
chapel of the château, first half of the sixteenth century.

between 1450 and 1550 that they must be viewed as a characteristic trait. In certain cases, as at L'Épine, contrast is apparent between exterior and interior, façade and nave. The most famous example is that of Saint Maclou, at Rouen. While guidebooks never fail to reproduce its truly astonishing façade, they rarely show the interior, which, with its extraordinarily imposing pillars, is as perfectly organized as the exterior is deconstructed. The most familiar and one of the most extreme illustrations of this inquiry into opposition is that of the towers of Chartres where, from 1507 to 1513, a particularly exuberant Flamboyant spire was built over the north tower that had burned down, opposite the twelfth century south tower, "of admirable simplicity and purity" (according to the *Blue Guide,* one of the standard French historical reference guidebooks), which was surely never slated for demolition (fig. 25).

More often still, a strong contrast was cultivated between the nave and the chancel. At Saint Jean at Chaumont—a church that we will examine in detail later—the thirteenth century nave with its sexpartite vault was retained, and the church was rebuilt from the transept in a new style. Again, at Saint Pierre in Caen, Hector Sohier added a new chancel to the ancient nave. Here, the abundance of Italianate motifs renders the opposition perhaps even more striking than at Chaumont, but the principle remains the same. At La Ferté-Bernard, there is less of a chronological gap between the nave, which dates from the fifteenth century as at L'Épine, and the sixteenth-century chancel. Yet the effect is just as powerful as the nave is rather somber and the chancel, being more elevated and very open, produces a veritable explosion of light. If indeed this contrast between nave and chancel has an aesthetic value, at the same time it is of

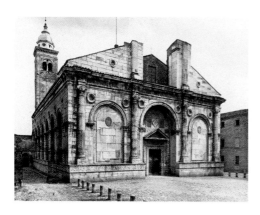

27. Rimini (Italy), Tempio Malatestiano (church of Saint Francis), façade, 1450–60. In the middle of the sixteenth century, the French often went back to Italian models from the fifteenth century rather than more recent works.

symbolic value, corresponding to social, economic, and religious realities. The nave forms the lay part of the church that is used by worshippers, while the chancel is the sacred area reserved for the clergy. Usually, the construction of the nave was financed by the parishioners and clergy, or in certain cases the lord who had founded a chapter, underwriting the costs of the chancel. However there were many exceptions; the clergy would aid the parishioners or the rich parishioners would pay for the work of the sacred enclosure (at Saint Germain-l'Auxerrois, for example, the costs of the *jubé* were covered by parishioners' funds). In some cases, such distribution of payments likely encouraged disparity between the nave and chancel, but fails to provide a full explanation, or a necessary and sufficient condition of the aesthetic expression of an ecclesiastical concept. If the opposition between the lay space and the sacred part of the edifice is thus dramatized in the architectural decor—whereas in earlier times less ostentatious signs were sufficient to mark this distinction—this is because the intensification of oppositions lies at the heart of the Flamboyant aesthetic in France.[26]

This taste for spectacular contrasts did not disappear with Flamboyant art, and something of it remained, even in some of the most classicizing works, such as the marvelous porch of the chapel of Champigny-sur-Veude (figs. 26 and 29). The château built there by the Bourbon-Vendômes has

disappeared, razed by order of Richelieu to prevent it from casting a shadow on his own residence to be built nearby. Nothing remains of it but the outbuildings, renovated in the seventeenth century by Marie-Louise of Orleans, known as "La Grande Mademoiselle," and the impressive chapel. The latter, founded in 1508 and consecrated in 1543, is an admirable example of the gracious art of the Loire where Italianate motifs—colonnettes and extravagant capitals—came to liven up an architecture whose only Gothic feature is its method of construction with intersecting ribs. A porch was added to the façade, probably directly following the completion of the principal structure. In any case, the inscribed date 1549 allows us to date the conception of this exceptional work to before 1550,[27] a precocious

28. Champigny-sur-Veude (Indre-et-Loire, France), chapel of the château, façade (detail), c. 1545–50.

date for this knowledgeable architecture in which the new classicism appeared in its maturity. The quality of the stone, white and very finely grained,

29. Champigny-sur-Veude (Indre-et-Loire, France), chapel of the château, exterior of the portico, c. 1545–50.

together with the virtuosity of the workers clearly indicates that this is an ambitious and luxurious construction.

The exterior of the porch is of an austere classicism that is more reminiscent of Alberti's Tempio Malatestiano at Rimini than the majority of sixteenth century churches (fig. 27). But, passing under the porch, one is greeted, surprisingly, with a complete change of scale and tone. One enters a narrow space, covered with a transverse barrel vault: the elevation is laid out on two levels with colonnettes placed against pilasters (Ionic and Corinthian), which radically reduces the proportion of the motifs. The profusion of ornaments covering virtually every surface stands in violent contrast with the great sobriety of the exterior.

Indubitably, we are faced here with the work of a learned artist quite familiar with his antiquity. It has even been suggested that he was inspired by the temple of Diana at Nimes, a rare example of reference to Gallic antiquity.[28] However, this effect of surprise—the element of drama created by the contrast between the barren and the teeming—is a trait of traditional sensibility. And even in the details of this refined work, some obvious Gallicisms can be found, such as the penetration of a molding into the blind oculus on the façade, probably a less striking "Gothicism" for not troubling the classicism of the composition, yet incontestably betraying the origins of the author and the persistence of mental and manual habits (fig. 28).

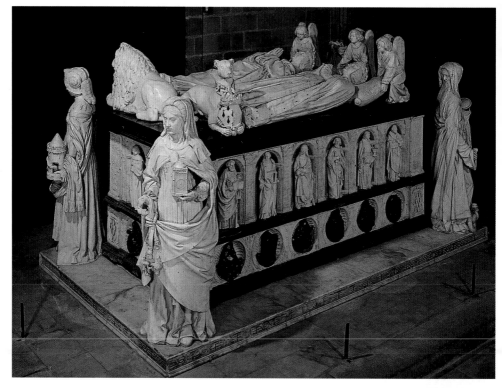

30. Michel Colombe and Jean Perréal, *Tomb of François II of Brittany and Marguerite of Foix*, 1502–07. Marble. Nantes: Saint Pierre cathedral.

Italian Ornamentation

The list of the Italians brought back to France by Charles VIII on his return from the Naples expedition in 1494 is rather entertaining: an exhibitor of exotic animals, the inventor of an incubator, a great number of gardeners and, for the most part, few artists in the sense we would understand today. Obviously, exoticism prevails over all other considerations. And it could hardly have been otherwise. The first Italian campaign was but a quick jaunt, a strange round-trip journey. Since the magnificent pages of Michelet, who gave a symbolic value to this encounter of French gentlemen with Italian culture, the importance of the Italian campaign of Charles VIII has certainly been much exaggerated. In effect, as has been well explicated, most recently by André Chastel, exchanges between France and the Peninsula were ancient and prolonged, and the contact of the French with Italian culture during this brief episode was very superficial.[29] However, the French incursion did have more extensive and profound cultural consequences than one might have expected, at least in the domain of decorative sculpture. This is because the ground had already been prepared. On one hand, the French, whose taste was informed by Flamboyant art, were certainly well attuned to this genre and made an effort to bring back workmen who were masters in the field. On the other hand, the numerous and highly skilled French stonecutters were able

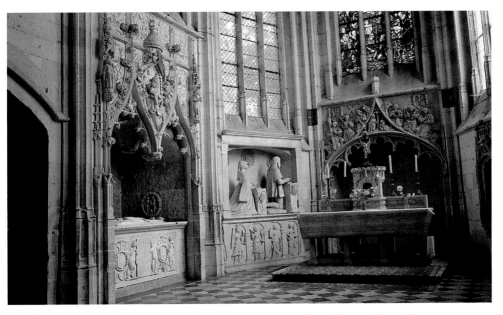

31. Folleville (Somme, France), church of Saint Jacques, choir: tombs of Raoul of Lannoy and Jeanne of Poix
and their son François of Lannoy, 1507–08 and 1524.

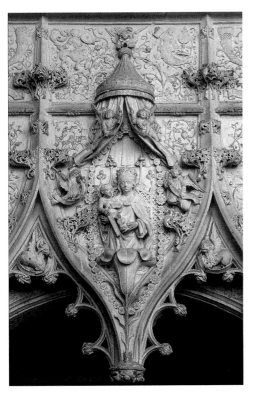

32. Folleville (Somme, France), church of Saint Jacques,
choir: *enfeu* (arcosolium) of the tomb of Raoul of Lannoy and Jeanne
of Poix (detail), c. 1520 (?).

to benefit from Italian imports and instruction. In one of the most precocious cases of the introduction of these Italian motifs, the arcosolium of the sepulcher of Solesmes discussed above, the date of 1496 suggests that it was among the direct consequences of the military excursion, and the antique candelabra were in all likelihood the work

33. Folleville (Somme, France), church of Saint Jacques, choir:
enfeu (arcosolium) of the tomb of Raoul of Lannoy and Jeanne of Poix
(detail), c. 1520 (?).

of one of the newly arrived Italians. However, before long—in the ornaments of the Château of Gaillon, for example—it became more difficult to distinguish French from Italian work.

In any case, the campaign of 1494 by no means marks the first French contact with Italy. Numerous embassies and various travelers had created cultural links. Furthermore, artists themselves traveled and works were imported. Fouquet had sojourned in Italy and his mastery of the new classicism is well known. The tomb of Charles IV of Anjou, who died in 1472, at the cathedral of Le Mans, is an Italian work of the highest order that could lead one to believe that the sculptor Francesco Laurana may have journeyed that far, rather than stopping only in Provence. These are the best-known examples—and perhaps also the most outstanding—but many others could be cited. Nevertheless, not until the return of Charles VIII did Italianism definitively set its mark on architectural decor in France. A single idea obsessed three successive French kings: to establish themselves in Italy by seizing a part of the Peninsula. Their many bids to do so intensified the contacts and exchanges.

France welcomed the Italian artists, along with their ornamental and decorative motifs; the French ordered works that were made in Italy and accompanied by workmen sometimes, to set them up. All of this made for a very complex situation, which is all the more difficult to comprehend as the facts often remain obscure. One point, however, stands out clearly: the French, guided by their taste for carved stone and ornaments, were especially interested in the sculpted decor of the Italian Renaissance. However, the Italian ornamental repertoire had been developed for an architectural usage completely different from that current in France. To what extent could this be integrated into a foreign system, and what level of alteration would be its price? Did its introduction presuppose a more profound upheaval? Far from being resolved, these questions have hardly been asked. Nationalist historians deplored the first French Renaissance's debasement of the national art—generally making sweeping condemnations of the results in the religious domain and, in civil architecture, downplaying the Italian contribution

often to the point of denying it entirely. Devotees of classicism saw there only the hopelessly late adoption of the marvelous model offered by Italy. More often than not, both reduce Italianism to an imported decor tacked on to a native structure. Only rarely does one think to see in it a specific phenomenon.[30] In fact, a variety of very different cases can arise.

The tomb that Anne of Brittany had erected for her parents, duke François II of Brittany and Marguerite of Foix, from 1502 to 1507, shows how far the assimilation of the art of the Italian Renaissance had gone since the first decade of the century (fig. 30). The two recumbent statues or *gisants* rest on a large arched sarcophagus cantoned with the Cardinal Virtues. The white marble ornaments—in all likelihood carved by Italians—are used in a perfectly correct manner to highlight the articulation of forms. The niches, the proportions of which were well adapted to the apostles and prophets that they shelter, forcefully assert their geometry. There is nothing in the design of this tomb that would have put an Italian to shame. However, nothing similar would be found in Italy and the overall layout of the monument vigorously belies its Burgundian origins at the monastery of Champmol. It is probably necessary to discern a political intention in this explicit reference to an already ancient type. The tombs of Dijon are those of the most powerful landed dukes. However, while the annexation of Brittany to the kingdom had been planned since Louis XI, it had yet to take place. François I made his entrance there still only as prince consort, after Queen Claude who was duchess through her mother, Anne of Brittany, exceedingly defensive of her rights. The latter— queen of France by marriage but duchess of Brittany by birth, and firmly opposed to annexation—had, in erecting her parents' sepulture, certainly hoped to confer upon them the splendor and insignia that would proclaim their sovereignty, and consequently her own. She sought both the connotations of an ancient model and the prestige of a new art. Nevertheless, by no means does the ornamentation create the impression of being affixed to a foreign structure. The entire tomb, while conserving its symbolic value and layout, is entirely rethought in the new forms.

We are, for once, rather well informed as to the identity of the authors of this monument.[31] At the beginning of 1500, Anne had first approached an Italian artist, Girolamo da Fiesole, and had begun to gather together marble. Then, toward the end of the year, she turned to two Frenchmen, Michel Colombe and Jean Perréal. Generally speaking, the name of Colombe alone remains attached to the tomb, but it is quite unlikely that this old sculptor, born around 1435, devised this very "modern" project. Perréal, on the other hand, a painter who did not participate in the construction, was well placed to have done so. Known as Jean of Paris, this Perréal remains an elusive figure. Yet he played a prestigious role and appears to have been an innovator. More than the disappointing miniature from the *Nature's Lament to the Errant Alchemist*, the only painting attributed with certainty to this artist, the tomb of Nantes gives us some idea of his skill.[32]

Girolamo da Fiesole had undoubtedly created an earlier plan before the intervention of the Frenchmen. However, there is no way for us to determine if any part of this remains in the monument. It is most likely that he was partially responsible for the creation of the sarcophagus, as its ornamentation conforms perfectly to that found in Italy. However, while the saints of the niches—close to the Florentine tradition—could well be the work of an Italian, the theme of mourners in the circular medallions and the interplay of black and white marble clearly reflect the Burgundian repertoire. The hand of Michel Colombe is generally acknowledged in the *gisants* and statues of the Cardinal Virtues, from which emanates a sort of melancholic grandeur.

Nonetheless, one must be wary of connoisseurs; not because they are mistaken, but because their eye is excessively sensitive to differences. What is initially striking about the tomb of Nantes is the complete coherence of the whole, despite the disparate origins of the motifs and ideas. One can only admire the perspicacity with which the author of the project—probably Perréal—grasped the specifications of the problem and the degree of ingenuity he employed to resolve them. He may even have overseen the execution of the work to assure its coherence, in spite of the diverse origins and

tendencies of the collaborating artists. The treatment, at once detailed and generic—or, if one prefers, idealized—of the figures is in keeping with the typically Quattrocento classicism of the sarcophagus. Considering this masterpiece, one can wonder why France took so long to develop its classicism. There is something here for everyone; for some, the sense of balance, of moderation, and the tempered naturalism of the figures are guarantees of a distinctly French art, while others willingly admit that the Italian contribution is not overly distorted in this instance. The fact is, however, that the tomb of Nantes remained isolated in its perfection, the artists having later engaged in very different pursuits. For instance, divergent aesthetic tendencies appear combined in another particularly curious monument found in the Picardy village of Folleville.

In all likelihood it was in 1507–08 that Raoul of Lannoy, then governor of Genoa, ordered his tomb from the atelier of Antonio Della Porta and Pace Gaggini.[33] The recumbent statues of Raoul and his wife Jeanne of Poix and the sarcophagus on which they rest are in white marble and were sculpted in Italy. They were not in place at the time of Raoul's death in 1513. His widow and son François had a funeral chapel erected, constituting the chancel of the parish church, and then consecrated in 1524 (fig. 31). The Italian tomb is placed in a Flamboyant arcosolium formed by a double accolade that superimposes itself on a depressed arch. Between the two accolades grows a great lily from which emerge the Virgin and Child under a canopy (fig. 33). The interior of the arcosolium is treated as a tiny chapel covered by two small ribbed vaults with pendant keystones. The walls are entirely decorated. Other more emphatically protrusive elements stand out from a background of foliage scroll patterns in slight relief. At the feet of the *gisants*, in particular, the beheading of Saint John the Baptist is represented inside a wreath of foliage (fig. 32). This motif, known as a "cap of triumph" in France, resumes an ornament on the sarcophagus. Although the accolades of the arcosolium with their jagged outlines and curly leafage are of a more traditional design than the interior, the exterior was obviously conceived at the same time as the interior and they are carefully

coordinated: the same network of Italianate motifs against which the tracery stand out is repeated on the exterior wall. The figures of the saints, at the back of the cavity, are meticulously aligned with the divisions of the external face.

In the present case, the disparity between the work of the Italian sculptor and the setting is obvious. However should we—indeed can we—speak of a lack of comprehension? The quality of execution and, in particular, the subtlety and ingenuity of the composition assure us that this is no mediocre artist. In fact, he was certainly very attentive to the work of Italians. The idea of the double accolade, for example, is clearly conceived according to the bipartite division of the sarcophagus. We have seen that he had taken up the "cap of triumph" around one of his motifs; he produces another, less obvious, variation with the rosary that surrounds the Virgin. The contrast between the sections with Italianate motifs in faint relief and the more protrusive, specifically Flamboyant motifs is as pronounced as that between the different parts executed by Italian and French hands. If the Master of Folleville did not conform to the somewhat insipid art of Lombard sculptors, he did integrate their work into a system of contrasts and oppositions that articulates ornamental abundance. Here it is not a matter of simply adopting the Italian Renaissance—or of an attempt at synthesis as at Nantes—but of a more ambivalent attitude and more complex adaptation. Are we then to speak of a phenomenon of resistance? We doubt that this really takes the facts into account. If the Master of Folleville did not submit to an imported art, he welcomed it with sensitivity. He was not obliged to take up the Italian motifs and he felt perfectly free to continue the old Flamboyant repertoire. He saw in the foreign art an opportunity for enrichment. What is certain is that the case of Folleville is much more representative of the tendencies of the era than that of Nantes.

Italian ornamentation was adopted in France by the first generations of the sixteenth century only at the end of a radical transformation. The French had developed formulas well suited to their purposes by liberally taking from Italian models. The stonecutters abandoned neither their taste for hollowed out material nor their ornamental verve. The sense of space remained what it had been.

One did not witness, as historians have often implied, the progressive acceptance of Italian art as artists familiarized themselves with the new forms. The idea of Italianism being established by way of an understanding and consequently adoption—ever more comprehensive and "correct"— of the art from the other side of the Alps is untenable. In fact, as Jean Guillaume rightly saw it, the pieces the closest to the Italian models are often precocious manifestations—the work of Jean Fouquet, of course, but also the tomb of Nantes or that of the children of Charles VIII at Tours— while over time, borrowings were adapted, appropriated and integrated into this art which is so strongly characteristic that it is sometimes referred to as the "style of François I" or "style of the Loire."

A remarkable trait of the gap that separates Italian and French traditions is the particular relationship between sculpture and architecture, or rather the role of stonecutting. In Italy, there is a clear discontinuity between the sculptor, the mason, and the architect, whereas in France, one passes imperceptibly from one to the next, from the carving of ribbed pillars—the exact profile of which is of the greatest importance—up to the figures of the saints, with architectural ornamentation and narrative relief along the way.

The chapel of the Virgin at Valmont in Upper Normandy seems to be made to demonstrate this continuity among the various occupations involving stone. The abbey has unfortunately come down to us in a fragmentary state: the vaults of the nave have collapsed and all that fully remains standing is the axial chapel, isolated by a wall.[34] Its ceiling is spectacular (fig. 34). Technically, it is a matter of a flat vault on diaphragm arches, that is to say a covering made of undressed slabs placed on the arches. Other examples of this system exist at La Ferté-Bernard and Saint Pierre in Caen. The idea is to constitute a coffered ceiling *"all' antica"* without abandoning the customary use of arches and ribs. Yet, in the rather late case of Valmont, the effect is new because there is no effort to disguise the Gothic aspect of the ribs, or no attempt at more or less perpendicular intersections intended

34. Valmont (Seine-Maritime, France), abbey church, chapel of the Virgin, vault (detail), c. 1540 (?).

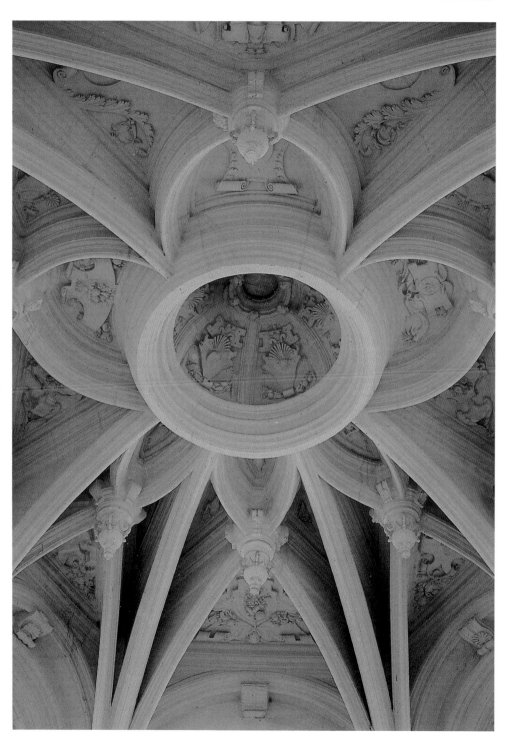

to imitate the classic coffers as at La Ferté-Bernard. However, within the traditional divisions of the vault, the artist has developed with exuberant luxuriousness a repertoire of completely modern motifs, in particular strapwork in the Fontainebleau style. The center of the composition, occupied by a circular molding, constitutes a minuscule cupola.

The most original element of the decor is the sculpted *Annunciation,* which occupies the axial bay (fig. 36). It is laid out so that the window of the chamber in which the scene is placed is in fact the window of the chapel itself, creating an ambiguity between the fictive space of the sculpture and the real space of the architecture: this is a Flemish picture translated into sculpture. The action takes place in a carefully detailed and affluent interior: to the right, near a dresser, angels hold back the curtains of a bed; to the rear are a loom and basket containing balls of wool; finally, to the left, stands a great fireplace complete with andirons and an open door that provides a glimpse of an architectural ensemble. The ceiling is composed of coffers adorned with cherubs. Mary, on the right, is kneeling on a priedieu. A stained–glass window adorns the back wall: this forms part of the axial window, the bottom of which has been shifted back to make room for the *Annunciation.*

This window helps to orchestrate the whole by introducing a new element of architectural decor: as in so many stained glass windows of the era, architecture plays an important role. Thus arises an interplay between represented architecture, sculpted architecture, and the architecture—both real and fictive—of the chapel, but one that lacks rigorous coordination. As the site appears today, this effect is further accentuated because the antique ruins that adorn the background of the window, in particular in the *Annunciation of the Shepherds,* are irresistibly reminiscent of the ruins of the chancel.

The highly skillful way in which the fictive space of the sculpted scene and the architectural space of the chapel itself are structured is all the more remarkable because the imaginary architecture with its flat coffered ceiling and its Corinthian decor is entirely classicizing, whereas the chapel clearly shows itself to belong to updated Gothic. This is particularly apparent in the vault in which strongly pronounced ribs fall very low onto the elegant culs-de-lampe, just above the entablature of the *Annunciation.*

The sculptor who carved the figures was a talented artist who knew how to combine the rendering of the body with the expressive richness of the drapery. The work is finely executed, but devoid of the superabundance of detail characteristic of the Burgundian tradition as it was still expressed in Flanders and Champagne. The nobility, simplicity, balance of the scene and the idealization of types convey a sensitive knowledge of classicizing art that exceeds the correctness of the architectural ornaments (fig. 35). At the same time, the artist called upon the northern tradition, in the taste for the familiar and domestic decor. Above all, the refusal to clearly delimit the fiction, and so deliberate an attempt to create ambiguity between spaces show just how far he kept his distance with relation to Italian art.

Variegated Designs: Gisors and Chaumont

Saint Gervais-Saint Protais of Gisors is the epitome of the heterogeneous church and one of the most picturesque monuments of the French Renaissance (fig. 37).[35]

It had been the site of a thirteenth-century chancel built by Blanche of Castile. At the very end of the fifteenth century, as in many other cases, the enlargement and embellishment of the church was undertaken. The former chancel was completed at the chevet by a flat wall. The first concern was to open a great arch in this wall and to build behind it small communicating chapels constituting an ambulatory so that processions could encircle the chancel. The transept was then reconstructed, retaining its original height (1509–25). The layout of a great chamber much

35. The *Annunciation* (detail), second quarter of the sixteenth century. Stone. Valmont: abbey church, chapel of the Virgin.

36. *The Annunciation*, second quarter of the sixteenth century. Stone. Valmont: abbey church, chapel of the Virgin.

higher than the former structure, reaching above the double side aisles, was chosen for the nave. These aisles were made as high as the lateral chapels in an obvious effort to unify the space (fig. 38). The construction of the chapels and exterior aisles was virtually finished when, in 1528, work began on the side aisles and principal chamber.

The overall effect is exceptional due to the initial conditions. In many churches, the effort of the Renaissance is brought to bear on the chancel, which is often higher and more illuminated than the nave. Here, to the contrary, it is the nave that is very bright while the sacred space, more enclosed, is somber and mysterious. The vaulting also shows the effects of this unusual situation: having been unable to concentrate on the chancel as was customary, invention went elsewhere. The central chamber is covered with beautiful star-ribbed vaults. The side aisles, equally tall, are quite different: the interior one has simple intersecting ribs and the exterior complex vaults similar to those of the chapels; this creates the impression of

continuity between the chapels and the side aisles which are, as one recalls, all of the same height.

Within this layout—on the whole rather clear—casualness and the taste for the picturesque largely prevails over the attempt at regularity. Despite a slight dissymmetry between the north and south, there has been a visible attempt to unify the tracery of the windows, whereas the custom was rather to vary them. On the other hand, the affected forms of the pillars that separate the two south side aisles are forcibly individualized: one is spiraled, while another covered in Italianate ornamentation, and so on. The work lasted until near the end of the century, and the classicizing style can be seen creeping into this totally irregular ensemble. We have unfortunately lost the *jubé* erected by Jean Grappin II in 1570–72. On the other hand, the enormous south tower, left unfinished, contains a chapel in the classicizing style. One detail in the attempt to coordinate the disparate pieces appears particularly casual:

37. Gisors (Eure, France), church of Saint Gervais-Saint Protais, western façade, 1532–70.

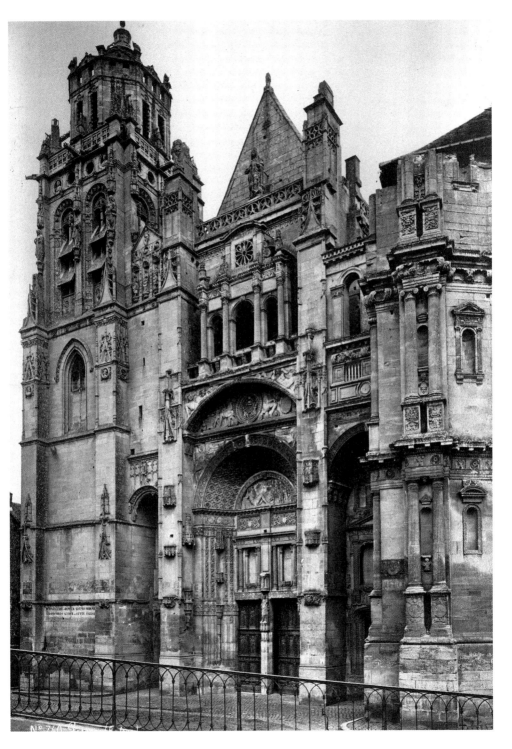

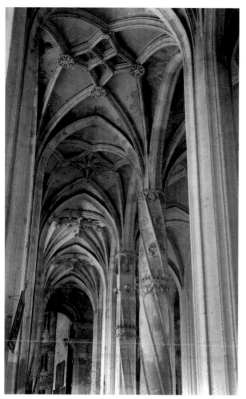

38. Gisors (Eure, France), church of Saint Gervais-Saint Protais, piers of the north side aisle, 1517–27.

dissymmetry between a rather slender Gothic north tower, where Italian ornamentation timidly makes its entrance, and a massive and ambitiously classicizing south tower with its superimposition of orders, one observes the most nonsensical juxtaposition of Gothic pinnacles, triangular frontons, cartouches in the Fontainebleau style, and even elements reminiscent of Lescot's Louvre. Despite all this, a sort of composition manages to show through. The buttresses impose a strong rhythm and define a space within which one distinguishes a succession of planes: beneath the most extreme disorder and irregularity, the organization of the great medieval façades persists.

At Gisors, work was continued for a whole century and the vicissitudes of method and style explain up to a point the incoherence of the whole but only up to a certain point. At the church of Saint Jean of Chaumont in Champagne, the chancel and the transept were entirely rebuilt under François I, in the years 1517–41; the persistent sensibility, invention, and virtuosity of the artists of the Flamboyant are very much in evidence there. One enters, whether through the façade or the Saint Jean portal on the south side, into a thirteenth

the Flamboyant arch surmounting the interior of the south door of the façade is supported by radically asymmetrical corbels; the one on the right is in the form of an angel—the traditional motif for this position—while that on the left, on the side of the chapel that follows the classic model, presents a female mask after Goujon (fig. 39).

The stylistic jungle reaches it peak especially on the exterior, on the western façade. The north tower, work on which began around 1532, was finished in 1540. In 1547 or 1548, after a false start in 1542 interrupted in 1543 by the collapse of the framework of the nave, work was begun on a much larger south tower, which jutted out strongly in relation to the façade and, moreover, the implantation of which is skewed. Within this brutal

39. Gisors (Eure, France), church of Saint Gervais-Saint Protais, inside of the façade, south portal (detail).

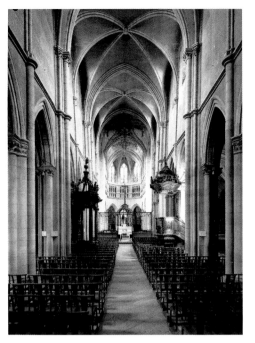

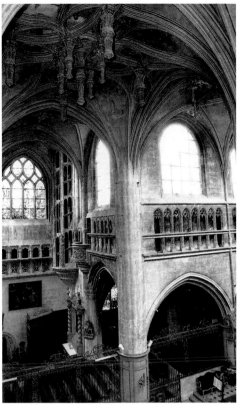

40. Chaumont (Haute-Marne, France), church of Saint Jean, nave, thirteenth century.

41. Chaumont (Haute-Marne, France), church of Saint Jean, choir and transept crossing with hanging keystones, 1517–41.

century nave with sexpartite vaults resting alternately on strong and weak main pillars of a very simple and pure type (fig. 40). The great chamber is devoid of a triforium and the high windows are rather small, whereby the wall takes up a large space; it is a far cry from a cage of glass. After entering the nave, the visitor is attracted by the ornamental elaboration and the intense illumination of the chancel, an effect that the *jubé* must have accentuated before its destruction. The opposition between the new and old parts of the church is striking. Certainly, however, there was never any intention to demolish the nave with a view to complete reconstruction, because, while seeking the effect of surprise and novelty, the artists of the chancel have carefully meshed their work with that of their precursors. The profile of the great arches of the chancel harmonizes with that of the arches of the nave, and one noticeable detail can only be explained by this concern for both contrast

and harmony. The design of the triforium changes between the transept and the chancel: in the transept, it is trefoil, but in the chancel, visible from the nave, the arcades are composed of simple pointed arches, in keeping with the forms of the great chamber. However, the tops of these arches are furnished with Flamboyant tracery, corresponding to the ornamental richness that characterizes the new ensemble: the gracious curves of the ribs of the vault, and huge complex of pendant keystones that draw the eye towards the crossing (fig. 41).

The element of surprise is at its highest when one discovers the north transept in which the fantasy of the builders is concentrated (fig. 42). The most astonishing element is a stairway turret placed in the northeast corner that, halfway up, loses itself in the vault. Entirely open, executed with all the virtuosity of a prestigious piece, this turret in fact merely provides access to the roof space. The changes of level of the triforium, or the strongly

47

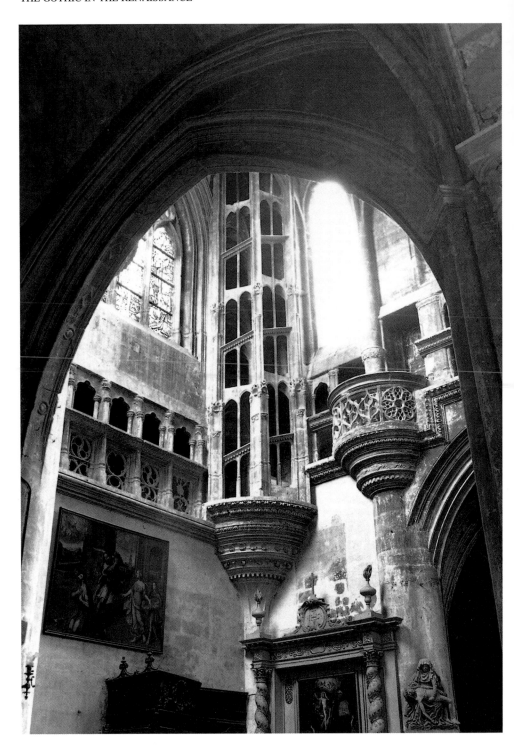

protruding molding that divides it in two all appear extravagant. Upon examination, however, one discovers the logic contained therein. The semblance of a cornice that cuts off the triforium corresponds to the height of the sill of the circulation gallery. Instead of continuing along the wall as usual, this gallery moves into a spiral staircase. The molding of the triforium continues on this staircase in a reduced form—the very protruding upper part is eliminated—but perfectly legible. Inside the staircase, the molding serves as a handrail. After a half turn, the triforium resumes its course, a little higher than before, on the east wall. At this point, the molding bifurcates, the reduced form ascending the spiral staircase while the complete molding continues along the triforium.

Upon meeting the pillar, perhaps to avoid weakening it, the triforium bypasses it by an oriel balcony, the occasion of a new piece of bravado. This balcony seems to be self-contained—like a precious object—but at the same time, its circulation function and link with the triforium are stressed by the strong lower and median moldings of the gallery that surround it. Here, however, these moldings become part of another system— a sort of ornamental fabric that defines the form of the balcony itself, a half-cylinder above a reversed and slightly truncated half-cone. Two details should be noted: the upper molding is simplified, thus marking at once the autonomy of the balcony and the continuity of circulation; the lacy tracery of the balustrade is sufficiently similar to that adopted by the triforium at the north wall to indicate a relationship, but also sufficiently different to isolate and accentuate the balcony.

The gallery then rises once again to pass above the side aisle. The lower molding ascends

vertically in order to mark its course on the surface—a detail that reveals the extent to which the authors of this device are removed from the spirit of Italian classicism, even if they do borrow motifs from the new vocabulary. Eggs and darts figure among the elements that constitute the oriel of the balcony and the cul-de-lampe of the spiral staircase. Nevertheless, instead of belonging to a clearly articulated body of moldings as in classic usage, where they in general play a major role, they lose their individuality and merely enrich this ornamental fabric—this irregular undulation that fully makes up the cul-de-lampe supporting the balcony. Above, Flamboyant lacework defines the half-cylinder of the balustrade, the sill of which continues, as mentioned above, the median molding of the triforium in a simplified form. In this context, the corner turret matches the balcony; the partitions are so completely hollowed out that the turret itself also appears to consist of an ornamental texture rather than of masonry strictly speaking, looser and more airy than that of the balustrade but of the same nature. Here the ornamentation is indeed—as at Brou and in all Late Gothic art—the architectural material, just as the masonry of the wall and the mass of the pillars are themselves vigorously affirmed and relieved of all embellishment.

The construction of the new parts of Saint Jean at Chaumont did not take very long and the execution is rather homogenous. There are thus grounds for thinking that not only did the artists love surprise and the fantastic, but that they voluntarily sought out this impression of juxtaposition of disparate elements due to the passing of time—a disorder and aura appropriate to buildings with a long history.

Toward Synthesis: Saint Eustache in Paris and Mareil-en-France

The sense of regularity, continuity, and order was not absent. We have already seen that even at Gisors, where the picturesque largely prevailed, certain elements suggested an attempt at regularity.

42. Chaumont (Haute-Marne, France), church of Saint Jean, north transept, 1517–41.

Builders were perfectly capable of carrying on the execution in the homogenous fashion of the antique layout. Accordingly, the nave of the cathedral of Rodez was finished only in the sixteenth century scrupulously following the original plan, while at the same time, works of a very different

style were being built, such as the particularly rich Flamboyant *jubé*, or the great northeast tower—"the pride of the province" according to the *Blue Guide*—the entire upper section of which was built in the Flamboyant style under the bishopric of François d'Estaing from 1513 to 1526. As at Chaumont, eggs and darts—the insignia of classicism—appear, but engulfed within the Gothic ornamental tangle. The door that opens onto the sacristy (dating from the same bishopric?) is, on the other hand, of a very pure Italianate style.

If the new ornamental style of the Renaissance has been brought into play deliberately in order to obtain an effect of contrast, one was sometimes equally mindful of its actual architectural implications in the attempt to create a synthesis between Gothic and Greco-Roman classicism. Such attempts have precedents and parallels outside of France. In Italy, at Pienza, Rossellino was pressured by his patron, Pope Pius II Piccolomini, into building a church covered with ribbed vaults but supported by pillars featuring columns of the classicizing type. The solution is relatively satisfying because of the rather low proportions of the building and the equal height of the naves. But it had no future in Italy: the prestige of the antique basilicas, a rather large number of which remained, was able to drive out the Gothic. The situation was very different in other countries where the Gothic persisted in religious buildings until a much later date. The cathedral of Granada, built by Diego de Siloe from 1528, remains the most brilliant example of this hybridization due to the ideological attachment to the Gothic combined with the taste for novelty and modernism that classical antiquity represented.

In France, the only undertaking as systematic and ambitious is the church of Saint Eustache in Paris.[36] Begun in 1532, this is the only great Parisian church, and one of the rare French ones, to have been entirely conceived during the sixteenth century. The former parochial church stood on the site now occupied by the chancel. Exceptionally, the decision was made to build an entirely new building, even if this meant retaining the existing structure during the construction in order to hold services, as at Saint Peter's in Rome. The work went on for some time; the former church remained in place until the seventeenth

century. The new building was consecrated only in 1637, but remains faithful to the original plan.

Saint Eustache was a royal church and François I wanted to equip his capital with a sanctuary worthy of his reign. In order to do so, the builders sought to vie with the great edifices of the past, while remaining in line with current tastes. Not only did they build a Gothic church, but also they closely followed the model of the cathedral. For the design, they returned to the plan adopted for other great parochial Parisian churches, with double side aisles and a non-projecting transept. For the exterior and especially the chevet, with its forest of flying buttresses, rounding the profile of the arches rejuvenated the elegance of Notre Dame, probably so that they would match the semicircles of the windows and their traceries. The result of this hybridization is original and gives these Gothic arches curves reminiscent of Art Nouveau.

In the interior, the central chamber, barely interrupted by the crossing of the transept, is long and very slender, flanked with double side aisles of equal height (fig. 43). A complete row of chapels surrounds the church, progressively reduced from the transept to the façade because of the terrain (this irregularity is hardly noticeable). They are sufficiently low to make room for a great window in the exterior side aisle which, seen from outside, presents a beautiful terraced effect.

The novelty consisted in designing the arches and windows in semicircles and in providing the supports with ornaments of a classic vocabulary. The piers of the crossing, for example, are adorned with pilasters that bear transverse arches that have been given a flat profile so that they harmonize with the whole. In the corners, on the side of the great chamber, a superimposition of orders is achieved by a fluted Corinthian colonnette.

Architect and theorist Viollet-le-Duc's diatribe against this blending of genres remains famous:

> The Renaissance had effaced the last vestiges of the old national art, and so, for a long time yet, in the construction of religious edifices, the layout of French churches of the thirteenth century was followed, the genius that had presided over their construction was extinct, scorned. One wanted to apply the forms of antique Roman architecture, which were

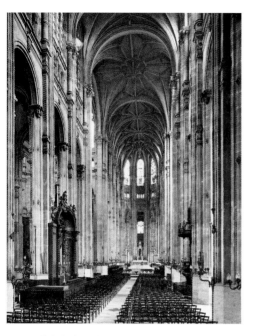

43. Paris, church of Saint Eustache, nave, 1532–1637.

Flamboyant style, nor the plastic qualities of the strictly classic ornaments such as would be introduced by the great architects of the 1540s—in particular, Lescot and de l'Orme. The little Corinthian capitals of the nave, with their meager acanthuses situated more than sixty-five feet high, are almost imperceptible. It is indeed necessary to pay sustained attention to the narrow bands that run along the principal pillars in order to understand that they are pilasters. The superimposition of orders merely serves as faint contradiction to the sweeping lines of the supports, like a slight noise that disagreeably interrupts a melody. Even the ribbing does not produce the effect anticipated, despite the care it was accorded. It is true that the apsidal vaulting presents a dazzling and explosive display. However, it is not so very striking because complex ribbing is present almost throughout—yet it does not attempt, as in certain German or English churches, to unify the space of the nave by a continuous grid that would efface the compartmentalization of the Gothic vaults. Thus a distinction is established between the five bays of the central chamber and those of the chancel—three full bays in length— before it reaches the apse. Star-ribbed vaults cover the nave while the chancel is divided lengthways, the starred vaults extending on one side and the other from a central groin. Apart from the fact that this last arrangement is not very felicitous in itself (as it corresponds poorly to the structure of the vaulting), it does not produce a decisive contrast, one of those striking effects of which the Flamboyant architects had the secret. The doubling of the density does introduce a distinction for the attentive eye, but the general impression is that of a richness of ribbing spread throughout.

Saint Eustache is indubitably a very ambitious undertaking, not only in terms of its dimensions, which do not fail to impress, but also of the complexity of its architectural elaboration. We do not feel however, that the success is quite equal to the loftiness of this ambition. The one discordant note is the introduction of the pointed arch in the apse, encouraged by the narrowing of the pillars at this location, but otherwise unjustified in a building where the semicircle reigns supreme. Apart from this awkward juxtaposition, the architects first and foremost sought coherence, or rather regularity,

poorly known, to the system of construction of Gothic churches, which one scorned without understanding. It is under this indecisive inspiration that the great church of Saint Eustache of Paris was undertaken and completed, poorly conceived monument, poorly built, confused heap of debris borrowed from all sides, without connection or harmony; a sort of Gothic skeleton dressed in Roman rags put together like the pieces of a harlequin's outfit.

Viollet-le-Duc condemned the very idea of a hybridization of the Gothic and the Renaissance. However, we find only the particular solution attempted here unfortunate. On the one hand, one wanted to retain the proportions of the thirteenth-century Gothic while arranging the supports according to the classical system. The architects have therefore borrowed an extreme regularity from classicism and perhaps from certain "classic" Gothic buildings. The ornamentation, in particular, is distributed evenly throughout; all the supports are treated in a similar fashion, with just a few variations.[37] On the other hand, the motifs themselves displayed neither the verve of the picturesque

51

probably thinking that this was the essence of the art on the other side of the Alps, and despite the length of the work, this fundamental principle remained intact. It results in a certain sense of monotony and, upon entering this celebrated monument, I always feel somewhat morose. This is compounded, though not caused, by the unappealing paintwork and the light, too diminished by nineteenth century stained glass windows.

One may wonder what compelled the architect of Saint Eustache—as we are clearly in the presence of a unified conception—to tread this apparently solitary path.[38] The beginning of work on this vast church is contemporary with that of several royal residences in the Ile-de-France region, as well as the Paris City Hall (Hôtel de Ville). It was part of a vast architectural campaign that followed the decision of François I to reside henceforth near his capital. This was an era of intense experimentation, but also often of hesitation. At Fontainebleau or even at Saint Germain-en-Laye, one already feels that the architects were cultivating a certain austerity, probably to attain the regularity of classic art. At Fontainebleau, the superimposition of pilasters that give a rhythm to the façades and allow Italianate ornaments to be introduced has been maintained, as has even the superimposition of orders, while retaining strong traditional vertical accents. This principle, though effective in the articulation of the wall of a château, becomes cumbersome in a nave where the pillars of the great arches immediately impose a strong rhythm. The retrospective aspect of Saint Eustache leaves no doubt. Perhaps one turned to an old Gothic that seemed native, not just for the ideological reasons suggested with regard to L'Épine, but because one already saw there a sort of classicism? The cathedrals of the thirteenth century possess a sense of regularity—in particular in their ornamentation— which may have appeared more compatible with classic usage than Flamboyant options. Had one hoped, through this pairing, to give birth to a national classicism? Be that as it may, Saint Eustache did not develop a following.

Other attempts at the adaptation of the forms of the Renaissance to a traditional ecclesiastical architecture were made on different bases. The sense of space in the Gothic churches of the fifteenth and sixteenth centuries differed greatly from that of the thirteenth: buildings were less compartmentalized, proportions less vertical and arches much more open. We have seen this tendency clearly expressed at Gisors, a more promising starting point for the classicizing of the Gothic than Saint Eustache. Most of the experiments were partial. We can cite, among innumerable examples, the north aisle added to Saint Maclou of Pontoise or the church of Cravant in Yonne, the chancel of which was restored from 1543.[39] However, at Mareil-en-France, Nicolas de Saint Michel had the opportunity to build a church from top to bottom (fig. 44).[40] For once, we have an entirely homogenous and regular monument. The plan is simple: a large nave surrounded by side aisles that continue into an ambulatory around the chancel (fig. 46). The side aisle is sufficiently large to accommodate the chapels lodged between the buttresses that are concealed in the interior of the church and do not interrupt its exterior outline. The pillars are treated as a bundle of four Doric columns attached to a square newel in which they are hardly engaged. A rather elevated stylobate and a complete entablature allow the side aisles to attain a sufficient height for the start of the vaults, while still giving satisfying proportions to the columns. The design of these supports is particularly careful and felicitous. The four pedestals, quite detached, clearly articulate the base of the pillar in a Greek cross. In the entablature, of very sober ornamentation, the strong projection of the cornice clearly marks the staging and support function. Above, an Ionic column backed against the wall rises until the beginning of the vaults of the nave. The pillar seems to have disappeared and is continued only by the single column, which clearly differentiates the levels.

Nicolas de Saint Michel showed much skill in reconciling the semicircular arch and the Gothic ribbed vault; this is an obstacle that builders often came up against. Not only did he use a system of spacing that solved the problem encountered in the Saint Eustache apse, but he also invented a highly skilful design for the ribs. The transverse ribs, strongly marked, are flat and classicizing. On the other hand, the ridge ribs, less protruding than the others, have a traditional profile. The ribbing is entirely homogenous and although the vaults

44. Mareil-en-France (Val-d'Oise, France), church of Saint Martin, nave, c. 1581.

45. Mareil-en-France (Val-d'Oise, France), church of Saint Martin, pier (detail).

46. Mareil-en-France (Val-d'Oise, France), plan of the church of Saint Martin.

are Gothic, the architect was able to find a geometric layout that is not disharmonious with the classicizing effect of the ensemble.

Of course, the success of Nicolas de Saint Michel where the architects of Saint Eustache failed is explained in part by the much more modest dimensions of the building, as well as by the difference in date. If these solutions suggest his personal genius, they are also, around 1580, the fruit of fifty years of accumulated reflections and experiments. Between the two dates, the middle

of the century had witnessed the invention and the triumph of a French classicism. The most remarkable episodes of this adventure constitute the subject of the chapters that follow. However, it was essential to show that the Lescots, Bullants, and Cousins of the art world represent only one aspect of the art of an era which must be understood in the general context of artistic activity if one is to avoid relapsing into the clichés of a linear history of art: the progressive assimilation of a style that one would have had only to learn.

Saint Étienne-du-Mont

Saint Étienne-du-Mont in Paris is a work of the very first order, yet rarely figures in our usual historic outlines. We discover in this vast edifice the successful realization of the new treatment of space

that developed in the Late Gothic. The classicizing art of the middle of the century intervened in an already existing space and appropriated it—though this appropriation was possible because the initial

47. Paris, church of Saint Étienne-du-Mont, nave, after 1547.

layout lent itself to this. It would, we feel, have been impossible at Saint Eustache.

The first impression on entering the church is striking (fig. 47). This very luminous, large space divided lengthwise by a screen of giant columns interrupted in their center by a classic balustrade supported by an arcade does not at all produce the effect that one expects from a Gothic church. This perspective guides the eye to the famous *jubé*, the brilliant decoration of which belongs to the new classicizing repertoire of the middle of the century (fig. 48). The Renaissance has indeed triumphed. Yet, from the entrance, the pointed arches of the apse and the windows of the chancel with their typically Flamboyant tracery are quite noticeable. The intersecting rib reigns throughout the roof and even the vaults of the *jubé* are ribbed. In this strict sense, the church is entirely Gothic.

The work, begun in 1492, took more than a century. The taste of each era is distinctly apparent, but with a sharp sense of the coherence and unity of the monument. This vast parochial church belonged to the Saint Geneviève abbey, which was very protective of its authority. Only in 1606 did it grant independence to the parish and direct access to the church without passing—as had been necessary before—through the abbey church placed parallel to the length of the south side. Then, finally,

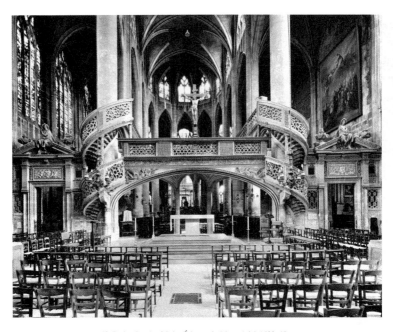

48. Paris, church of Saint Étienne-du-Mont, *jubé*, 1530–45.

the great portal of the façade could be tackled. The site began with the apse and, at the other end, to the northwest, the base of the bell tower. The character of the church was determined to a certain extent by these early works directed until 1500 by Étienne Viguier. The proportions of the church must go back to the original conception: a rather wide principal chamber, flanked by wide side aisles, high and very open on the great nave and a nonprojecting transept, these various elements articulating a unified and very luminous space. A parapet walk perched halfway up the pillars introduces a strong horizontal accent. Corbeled rings make it possible to skirt the pillars on the aisle side (fig. 50). They constitute a series of balconies comparable to those of the transept of Chaumont (in the chancel, the balustrade was taken up again much later, whether around 1570–80, or even after 1600).

The nave was only begun after 1547. The architect faithfully followed the choices of his predecessors in the chancel, while equally skillfully accommodating his own classicizing taste. The pillars, which were already round in the building's original plan, took on the appearance of giant columns

much more distinctly. The sub-foundation is no longer octagonal but square, and the base adopts a classic profile. Above all, the architect has introduced the outline of a capital adorned with eggs and darts below just where the great arches begin; the motif of the capital appears yet more asserted at the beginning of the vaults of the nave. The ogives have a more or less traditional profile; the transverse ribs, on the other hand, are of depressed but not pointed arches and no longer present a prismatic profile. The parapet walk, interrupted by the transept, is taken up again along the length of the nave. However, the arches that bear it have nothing of the Gothic: they are segmented and semicircular, of a classic design. The intrados is flat and adorned with a coffered motif that is very simple, but which suffices to mark the discontinuity between the arch and the pillar; in other words, penetration is abandoned. The bases of the balconies, while retaining the same overall aspect, are much more strongly articulated, thanks especially to a row of small ancones. The balustrade, finally, is of a design that would not have displeased an Italian architect.

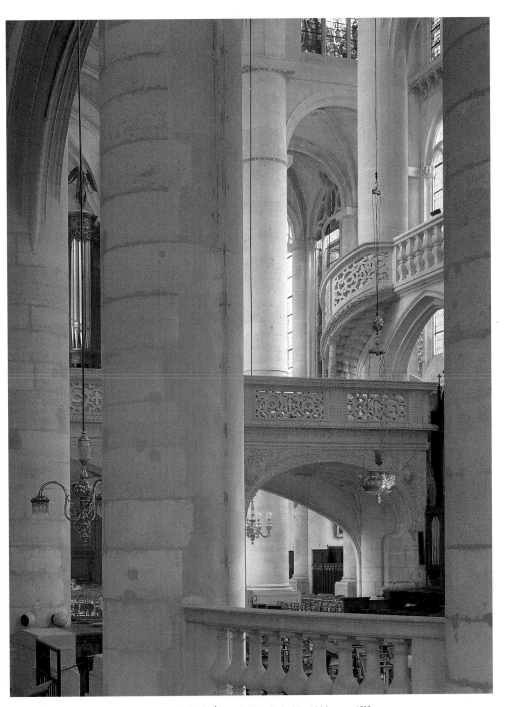

49. Paris, church of Saint Étienne-du-Mont, back of the *jubé*, begun c. 1535.

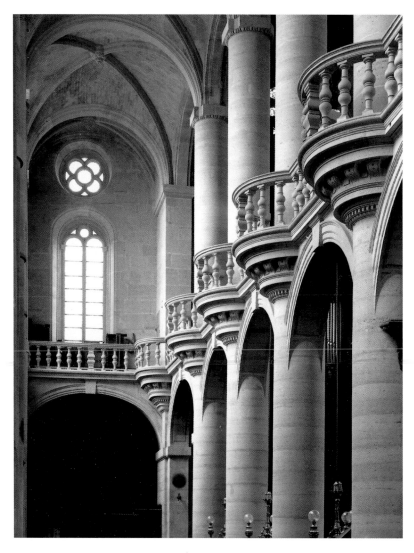

50. Paris, church of Saint Étienne-du-Mont, south aisle, after 1547.

The whole building is covered with simple intersecting ribs with flat keystones, save at the extremities and the transept. The chapels of the chevet are each vaulted with three triangular sections. This slight variation is explained by the form of these shallow and very wide chapels (and this because the number of pillars of the ambulatory is the same as that of the apse). The vault of the first bay of the nave, wider than the others, is more elaborate, with liernes and intermediate ribs. As for the transept, it provides a powerful contrast: a staggering star-ribbed vault with a complex of pendant and flat keystones. This vault was not erected until after 1580, but perhaps the design had existed much earlier. In 1540, the chancel and ambulatory were covered "according to the drawing and contract formerly established for said Church of Saint Stephen."[41] Was the same plan

used forty years later for the transept? It could well be that the design for the whole of the vaulting had been established rather early on. In any case, the effect is carefully orchestrated: this luxurious covering, which contrasts with the sobriety of the other vaults, is more or less at the center of the church, just above the exuberant *jubé*, which focuses attention with an extraordinary vigor.

There is no reason to believe that the plan was seriously altered in the course of its execution. The stylistic transformation—"degothicization"—was carried out essentially through the handling of the decorative details. Though the motifs changed, traits remained of a profound sensibility, the taste for surprise and contrast, the play between fantasy and a sort of second rationality, which are so evident at Chaumont.

The famous *jubé*, the only one still in place in Paris, never ceases to astonish with its virtuosity. The ensemble is so dynamic, so perfectly executed that one is tempted to suggest that it was born of a single flourish. However, it also underwent a stylistic inflection in the course of its execution, and examination shows that it must have been conceived in two stages. Its masonry is joined with the pillars and must consequently date from the years 1530–35, as does the singular layout of the vault that supports the platform: a great depressed arch on the side of the nave and, on the side of the chancel, three arches, one semicircular and the other two depressed and lopsided. The ribbing and ornamentation of Gothic inspiration of this vault conform moreover to the art of the 1530s. On the other hand, the classic moldings of the balustrade and of the staircases that wind around the pillars and especially the figures in flight—all Roman—that embellish the spandrels on the side of the nave belong to the new classicizing language introduced by de l'Orme and his contemporaries. All elements of decor above the arches must be later than 1540.[42] Yet, although the ornamental vocabulary belongs decidedly to the new classicism and is so well mastered that one would like to attribute it to Philibert de l'Orme himself, it is utilized exactly as in Flamboyant art.[43] Ornamental motifs cover everything, to the point that even the underside of the steps is finely worked. Despite the classicizing

repertoire, ornament is used here in a manner contrary to Italian classicism; it is the substance of the architecture itself, a brilliantly varied texture that defines the form, as in Flamboyant art.

This *jubé* is not only a masterpiece in itself—in a sense, it organizes the entire building by means of its balustrade and staircases that wind around the pillars in two complete revolutions. The first climbs to the platform of the *jubé*, the second to the parapet walk. This quite remarkable, arrangement is certainly less utilitarian than it is aesthetic. It dramatizes the sense of circulation. The crossing of the transept forms the central, striking episode of this architectural scenography. The balustrade of the parapet walk is so strongly emphasized that it must indeed mark the continuity of the central chamber. Its lateral flight is abruptly interrupted at the crossing of the transept, but the motif is taken up again by the balustrade of the *jubé* that arrests the eye and, after this brilliant event, the lateral ramps lead one's gaze in a movement that spreads out in the depth of the chancel.

As much as at Saint Eustache the confrontation between the Gothic and the Renaissance is more or less irreconcilable despite an obvious effort at synthesis, at Saint Étienne-du-Mont an impression of blurring is created. Undoubtedly each element can be assigned to one style or another—the pointed arches to the Gothic, the eggs and darts to the Renaissance—as long as one holds to a repertoire of motifs. Is the church Gothic? The question, here, no longer seems to have much meaning. A new conception of space developed in religious architecture of the fifteenth century, far removed from the compartmentalization characteristic of "classic" Gothic. More open arches, less vertical proportions on the whole engender a more fluid and unified space, the formal definition of which is not that—strictly measured and so to speak volumetric—of Italian classicism, but moves closer to its expressive qualities: a sense of human measure and freedom of movement. Work later than 1540 both respected and transformed the spirit of the chancel. In the nave of Saint Étienne-du-Mont, the intersecting ribs are hardly anything but a symbolic attribute: the notion of the French Renaissance is imperative.

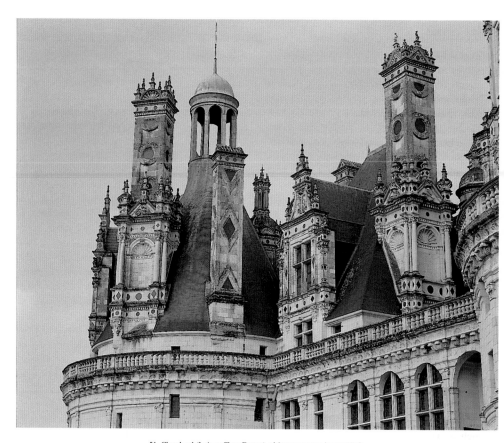

51. Chambord (Loir-et-Cher, France), château terraces, begun 1519.

Chapter II
FONTAINEBLEAU, ROSSO,
AND THE GALERIE FRANÇOIS I

The Château in the Renaissance

In order to analyze the continuity of the Gothic during the Renaissance, we have until now limited ourselves to ecclesiastical art, not only because continuity is much more obvious in the domain of religious architecture than elsewhere, but also because the term Gothic itself is more clearly applicable there than in civil construction. So much so that one of the great historians of Gothic architecture, Paul Frankl, refused to use the term Gothic apart from religious buildings.[1] This position implies entirely different principles and aesthetics for the two domains, which is shocking to our sense of historical coherence. Without taking so radical a position, however, most historians have tended to assimilate the history of medieval architecture to that of ecclesiastical buildings. Such a way of thinking corresponds to a very widespread view of the Middle Ages as the age of faith (or of superstition, according to the ideology one embraces). Though overly simplified, this view is efficient: it offers a striking image of the medieval era that, although not completely justified, is not absolutely false. In contrast, the Renaissance appeared as the awakening of lay culture. Therefore, in the collective imagination, the château symbolizes the French Renaissance just as the cathedral symbolizes the Middle Ages. I say French Renaissance, because in Italy the term Renaissance tends first and foremost to evoke painting, or more specifically the names of a few canonical painters: Leonardo da Vinci, Raphael, and Michelangelo. The difference is crucial.

The Renaissance took shape in the city-states of central Italy. The city, which was fortified, took on military defenses. From then on, the architects in the service of the great patrician families abandoned the castle for two types of residences: the urban residence or palace, a massive block turned toward an inner courtyard, and the country house or villa (a term borrowed from Roman antiquity), which was often simply a place of leisure, but sometimes also a farming concern. It was above all the villa—free of defensive installations, luxuriously comfortable and largely open onto the countryside—that struck the French.

Traditionally, historians have explained the transformation of the château in the sixteenth century by the Italian experience of the French nobility, although important signs of renewal had appeared before the Naples expedition. The medieval castle (*château fort*) suggests a massive and somber building, cantoned with towers, pierced with loopholes—narrow windows that permitted archery without exposing the archer. It is generally conceived with a strong keep and massive walls crowned with crenels and machicolations—in short, a military installation serving as a lordly residence.[2] At the beginning of the sixteenth century, the French retained the layout of the *château fort*, including the towers and even the crenels and machicolations, but these only took on a symbolic significance as insignia of privilege and nobility. Little by little the ramparts lost their military function, the château turned outward and the residence opened progressively onto nature, which was becoming an object of contemplation. The high functionaries of the kingdom set the example, beginning with cardinal Georges d'Amboise, the

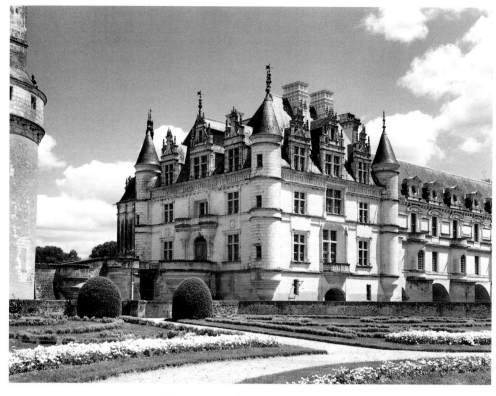

52. Chenonceau (Loir-et-Cher, France), château, 1515–22.

all-powerful minister of Louis XII. At his death, in 1510, the château that he had built at Gaillon, in Normandy, in close proximity to his bishopric of Rouen, was almost completed and of such celebrated splendor as to pique the curiosity of Isabella d'Este, the marchioness of Mantua and an insatiable art lover.[3] The advance of Italianism in the first ten years of the century is clearly visible on the building. Nevertheless, its sources lay not in the classic Renaissance of Florence and Rome, but in the exuberant, slightly provincial and still somewhat hybrid art of Lombardy and Genoa, parts of northern Italy periodically occupied by the French.

Gaillon inaugurated a whole series of residences with lively silhouettes and picturesque ornaments—sham castles that rose one after the other along the Loire valley. Beginning in 1511, Florimond Robertet, one of the royal secretaries, built the château of Bury. It has been completely

destroyed, but its appearance is well enough documented to give us a sense of its novelty. The overall plan is not very different from that of Le Plessis-Bourré, a château built during the reign of Louis XI by Jean Bourré, one of the king's advisors: it is organized around a courtyard with the main block in the back, two side wings and a monumental entrance gate. Yet at Bury there is no true system of defense; the great staircase is at the center of the main building and strongly emphasized in the façade; the symmetry is much more complete and the decoration entirely new. For a long time Bury served as a model.

What Thomas Bohier, general of finances of Normandy, built at Chenonceau around the same time (the construction must have begun no earlier than 1513 and no later than 1515) uses a totally different plan (fig. 52). After acquiring the lordship in 1513, he immediately leveled the old château

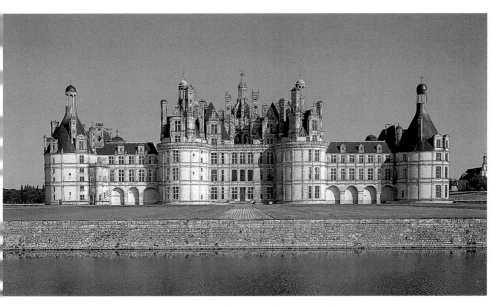

53. Chambord (Loir-et-Cher, France), château, begun 1519.

located next to the river Cher; he saved only the keep, which he embellished with a covered way with decorative machicolations and pierced with larger openings. He then built a new château by the river, on the foundations of an old mill. This unusual situation dictated a traditional compact plan, a square block with corner turrets. The innovation lay in the introduction of a straight staircase inside the main block instead of the usual spiral staircases jutting out, and especially in the exuberant sculpted decoration of the huge dormers, where Italian and Flamboyant motifs freely mingled. Just a few years later, Gilles Berthelot, president of the revenue court, erected the delightful château of Azay-le-Rideau (fig. 56), perhaps the most original of all these luxurious residences that reveal the cultural dynamism and social ambitions of the new bourgeois class made rich by the royal administration.

François I was an insatiable builder; at the beginning of his reign, he erected a wing at Blois where his predecessor had already built a structure in brick and stone. But it was at Chambord that the king was truly able to build a château that was up to his ambitions: an immense, extravagant château, fit to astound the whole of Europe (fig. 53).[4] The

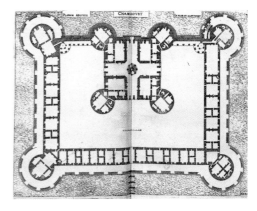

54. *Plan of the château of Chambord*, from *Les Plus Excellents Bastiments de France*, Jacques Androuet du Cerceau, 1576. Paris: Bibliothèque Nationale de France, rés. V 390.

place was chosen for the game-rich forest that surrounds it, hunting being the great passion of the king and also sometimes, we gather, a trick to escape the ambassadors hounding him. A plan must have been in place from 1519. Work began shortly thereafter and continued throughout the reign of François I and even under Henri II. François I practically never stayed at Chambord—

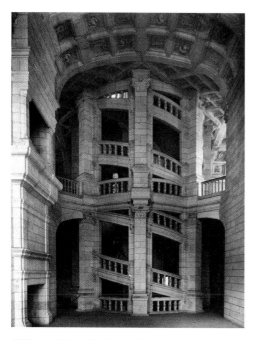

55. Chambord (Loir-et-Cher, France), château main staircase, after 1519.

from one ramp to the other: the ascending visitor is surprised to see another descend without meeting him. This stunning virtuoso piece inevitably attracts attention, but it is difficult to figure out how it functions. Chambord is a maze, and this contributes to its enchantment.

The treatment of the roof is also spectacular (fig. 51). It bears terraces with magnificent views and which are animated in the most fantastic fashion by pinnacles, dormer windows, chimney stacks—a forest of small pavilions in which the exuberance of the ornamental motifs is further stressed by the polychromy of the inlaid stones. The principle is the same as that of the miniature buildings we have found decorating churches.

For the historian and the critic, Chambord is quite disconcerting. The château, made up of disparate parts, was built over a long stretch of time, in a period when taste was changing rapidly. Within the rigorous layout that the builders respected, irregularities abound. The elevation of the main façade is asymmetrical, although one cannot be sure that there was a change of program. In other cases, such as the chapel built under Henri II and the elevation onto the court of the wing in which it is found, various initiatives in the course of the execution are obvious. In spite of it all, even in the inconsistencies of the execution, the initial vision seems perfectly respected.

How was this done? That is what is difficult to understand. A scale model of the keep with its towers, known as the *château de bois* (lit. château of wood), which is known through seventeenth century drawings, provides some inkling of an answer (fig. 57). This model was the work of a certain Domenico da Cortona, known in France as "le Boccador," one of the Italians brought back to France by Charles VIII. The overall plan was that of the actual château with one fundamental difference: instead of the staircase that was built, it shows a straight staircase in one of the wings of the Greek cross. Another even more striking divergence is in the elevation: the *modello* presents semicircular bays regularly distributed over the entire structure. Evidently this plan was more clearly Italian in spirit than that which was retained.

That Boccador was a true architect is unquestionable, since he served in this capacity at the

he spent only thirty-six days there in the thirty-two years of his reign[5]—but he had the satisfaction of receiving Emperor Charles V in this dream château, which was already compared at the time to the palace of Alcina. The victor of Marignano had put together there the ideal decor for a tale of chivalry.[6] The layout is that of a *château fort* (fig. 54). A square keep flanked with corner towers backs against one side of a great rectangular courtyard, also cantoned with towers. The side and rear wings of the courtyard are set low. The entire château is surrounded by a water-filled moat. This extremely regular layout follows closely that of the château of Vincennes built by Charles V.[7] The keep itself is perfectly symmetrical, in the form of a Greek cross. An exceptionally large spiral staircase that offers two parallel ramps occupies the intersection of the four main halls, or, so to speak, two interlaced staircases within the same well (fig. 55). The stairs are open on the exterior towards the large halls of the château, as well as towards its newel, which is well lit by a lantern at the top. The arrangement is such that one can see

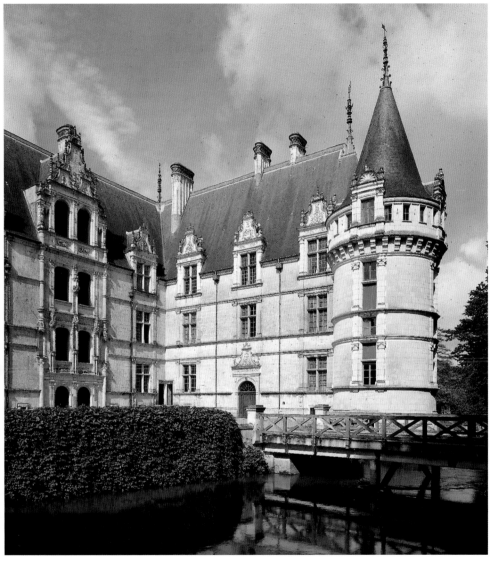

56. Azay-le-Rideau (Indre-et-Loire, France), château, courtyard façade with staircase frontispiece, begun 1518.

city hall (Hôtel de Ville) of Paris, a building still little studied, but of undeniable importance and originality. With regard to Chambord, however, it is uncertain whether the *modello* reflected Boccador's own invention or if he only built it on the basis of someone else's ideas. Leonardo da Vinci, whom François I had lured to France in 1516, died at Clos-Lucé near Amboise on May 2, 1519, and at the end of his life he was working on various projects for the king. His inventions, even if not necessarily intended for the site, were taken up again for Chambord. In fact, one of the weaknesses of the wooden model—the monotony of the interminable semicircular arches of the elevation—is found in some of the great artist's sketches (fig. 58). This leaves intact, on the other

57. The *Château de bois*, after the model created in 1519 by Domenico da Cortona. Drawing from the seventeenth century, at Cheverny: château.

58. Leonardo da Vinci, *Palace Perspective* (project of a château for François I?). Black chalk, 7 × 9 ¾ in. (18 × 24.5 cm). UK: Windsor Castle.

hand, the problem of the double spiral staircase. This virtuoso piece, as was pointed out before, was absent from Boccador's model. Yet staircases with four parallel ramps figure in the manuscripts of Leonardo, obsessed as he was with symmetry. Such a device, placed at the center of the layout of Chambord and serving each arm of the Greek cross, would have given it absolute geometrical perfection. Unfortunately, this piquant invention was more or less impracticable. Is the staircase of Chambord then a simplified adaptation of this idea, less satisfying to the mind yet a feasible alternative?[8] The hypothesis is appealing, but it is not the only one. There were, in fact, earlier examples in French architecture of spiral staircases with a double revolution, whereas a monumental straight staircase was decidedly contrary to local

habits. We do not know what these double spiral staircases looked like, but it is unlikely that they were as spectacular as that of Chambord. It was not unusual, however, to make the staircase the main showpiece of a building, with an immediate precedent in the magnificent spiral staircase at Blois or, further back in time, the celebrated grand spiral staircase of Charles V's Louvre. The staircase of Chambord could then be seen not as an invention of Leonardo da Vinci, but rather as a French motif introduced into an Italian layout. The merit of the chosen solution is precisely that it responded to very diverse demands.

Who was the architect of Chambord? One cannot maintain that it was Leonardo. Even if some of his ideas—notably in the layout and in the central staircase—could have passed into the monument, the overall physiognomy of the château is at odds with the aesthetic that comes through so forcibly in the great painter's drawings. On the contrary, it is perfectly in keeping with the spirit of the châteaux of the Loire—Bury, Chenonceau and Azay—which provided a useful model. Who deserves credit for the exceptional cohesive force, the visionary quality of this immense building? Is it the master masons? Must the imagination of the king himself be recognized here? None of these solutions is entirely satisfactory. We must resign ourselves to the idea that there is no single architect of Chambord, no artist whose vision and design took material form in the monument.

The château was probably developed in the same way as the great Gothic religious edifices that we have examined—that is to say, by means of a large and strong outline within which one proceeded through successive adaptations, taking into account the existing parts, but without establishing in advance a finalized and detailed project. Why does this phenomenon, which does not seem to unduly preoccupy us in the case of churches, put us ill at ease in the case of Chambord? A new sentiment emanates from the château of François I, a desire for monumentality and rigor in fantasy—a sensibility that, if it is no longer that of the Late Gothic, is not yet the classicism emerging after 1540. We see a work of the Renaissance there, but search in vain for the kind of individual aesthetics that we associate with the beginnings of modern times.

Fontainebleau: The King at Home at Last

The château of Fontainebleau was the favorite residence of François I, "which he enjoyed so much that, when he wanted to go there, he would say that he was going home."[9] The location was chosen, like Chambord, for the surrounding hunting grounds when, upon his return from captivity in Madrid, the king decided to reside principally in the vicinity of the capital of the kingdom. He owned an old château there, more or less in ruins. Louis VII had already stayed at Fontainebleau and, after him, Philip Augustus and Saint Louis, who gave his name to the chamber that François I took as his own. For reason of economy, the old walls were used in the construction of the new residence. The mass of the old keep is still quite visible in the Cour Ovale (Oval Court), the irregular shape of which recalls the medieval château (fig. 59). From the outset of the work, a long and narrow building was planned, a sort of umbilical cord linking the royal château to the convent of the Mathurins located to the west. The Galerie François I would eventually find its place in this wing. It is difficult to say at what point it was decided to enlarge the layout radically by adding an entire complex of constructions to the west where the convent was located, while greatly expanding the area it occupied. This resulted in what is now called the Cour du Cheval Blanc (lit. White Horse Courtyard) or Cour des Adieux (lit. Courtyard of Farewells) in memory of Napoleon's departure for Elba; sixteenth century documents called it the "large low court" because of its function.[10]

At Fontainebleau, the program overrode architectural concerns. It was above all a practical building, as opposed to Chambord or the château of Madrid (at the Bois de Boulogne) where an intense effort was made to renew architectural forms. Construction was managed very speedily and efficiently, and the fitting out of the interior was being contemplated as early as 1531–32. Under François I, this is where all efforts were brought to bear. The king, undoubtedly through inclination but also for political reasons, addressed himself to Italy, which remained the source of artistic innovations at the time. One of the principal arbiters of taste, the famous Aretino, notorious for his polemical and scandalous writings, who boasted of enforcing his judgment upon all the courts of Europe, intervened to recommend Rosso. The latter arrived in France in 1530, where he was called "Maître Roux" (lit. "Master Red"). Slightly thereafter, Giulio Romano, student and heir of Raphael, too busy in the service of the Duke of Mantua to come to France himself, dispatched the young Primaticcio, who quickly revealed himself more than worthy of such trust. In order to round out the teams necessary to execute their huge decorative projects, Rosso and Primaticcio recruited various compatriots, such as Luca Penni, a Florentine whom Rosso may have met in Rome, and Antonio Fantuzzi, a native of Bologna like Primaticcio. However, they also hired Frenchmen, particularly sculptors, and several Flemish, among whom the figure of Léonard Thiry stands out.

The distinctive character of the art of Fontainebleau is due in part to both the château's location and the recruitment of artists. The distance of forty or so miles that separates Fontainebleau from Paris meant a full day's traveling at the time. It is therefore necessary to imagine the Fontainebleau site as an isolated community that was somewhat inward looking. Artists often came from far and wide, as did the leaders of the team, Rosso and Primaticcio—neither of whom probably spoke French upon their arrival. Nor were the Flemish and artists from other parts of the kingdom necessarily French-speaking. These people had no previous ties locally and must have constituted a small, rather closed world. At Fontainebleau they found artificial living conditions, not unrelated to the life of the court for which they worked. A phenomenon of seclusion, therefore, but at the same time a European one—because the teams were international, of course, and also because the king expected to be provided with a marvelous living environment, capable of dazzling other sovereigns, whether in person, as when Emperor Charles V visited in 1540, or via their representatives who would pass through Fontainebleau.

Three phases of activity can be distinguished at Fontainebleau. The first, dominated by Rosso,

59. Fontainebleau (Seine-et-Marne, France), château, *Cour Ovale*, 1528–30.

60. Rosso Fiorentino, *Château of Fontainebleau*, 1536–40. Fresco,
Fontainebleau: château, Galerie François I.

61. *Perspective of the château of Fontainebleau*, from *Les Plus Excellents Bastiments de France*, Androuet du Cerceau, 1576.
Paris: Bibliothèque Nationale de France, rés. V 390.

lasted until his death in 1540. The disappearance of the most brilliant artist on the site was not the only thing at stake; it coincided with a more general change in the cultural climate. Jean Clouet, the official portraitist of the court, died in the same year and was replaced by his son François. Then it was the turn of Guillaume Budé, humanist, scholar and librarian of the château to pass away. In short, it was as if witnessing the replacement of one generation by another. Nevertheless, the new direction that was taken by the art of Fontainebleau at this precise moment surely owed much to Rosso's death and Primaticcio's assumption of control over the site. This second phase had no neat conclusion. The death of François I in 1547 marked a considerable slowing down in the work. Other spectacular undertakings, the Louvre and Anet, marginalized Fontainebleau, where artistic activity continued until the 1570s but without the incomparable energy that it had known under François I. Moreover, the arrival of Niccolo dell'Abbate in 1552 introduced a new note, and perhaps the beginning of the third phase should be seen there, rather than with the start of the new reign. It is then, as Louis Dimier indicated, that one can speak of a school of Fontainebleau, in the sense that a group of artists reared on the lessons of the château enjoyed independent production.[11]

Rosso Fiorentino

Rosso arrived in France already a celebrated artist, although his career had not always been easy.[12] He had certainly been around. Born in 1494, Giovanni Battista di Jacopo de' Rossi, known as Rosso Fiorentino in reference to the color of his hair and his city of origin, had witnessed in his youth the great developments of the classic Renaissance. Excessively critical and of unstable temperament, he trained in Florence under several masters, without attaching himself to any of them. It seems that even Michelangelo, whom he admired without having been his pupil, was not spared by his acerbic wit. In a letter to the illustrious master, Rosso assures him that he had been given false reports and that he, Rosso, would never have permitted himself to criticize the master: some of the young man's malicious remarks therefore must have reached Michelangelo. His early works were extremely bizarre and contrasted violently with the peaceful, all too perfect art of Andrea del Sarto, who at the time reigned indisputably over Florentine painting. Rosso's often disconcerting manner sometimes exposed him to the displeasure of his clients. In 1524 he settled in Rome where, in contact with students of Raphael and Parmigianino, he softened and perfected his manner. He was, like many other artists, profoundly affected by the sack of Rome in 1527 and, in the years that followed, his instability only increased. With the altarpiece of Città di Castello, his art reached a paroxysm of strangeness.

69

It seems that he was summoned by François I thanks to Aretino, but Vasari, who in his early youth had known the astonishing artist during his stay in Arezzo, asserts that already at that time Rosso had expressed a desire to find a position in France. Perhaps he was inspired by the adventure of Leonardo da Vinci, another restless personality, to whom he must not have been indifferent. In Venice, he composed a superb drawing for the king in which, under the guise of Mars and Venus, he celebrated the repose of the warrior disarmed by love (probably on the occasion of the Treaty of Cambrai [Paix des Dames] concluded between Emperor Charles V and François I). Aretino sent this drawing to the French king by way of an introduction.[13] It was a sophisticated piece, sensual, gracious and extremely refined, the formula of which Rosso had perfected in the atmosphere of Clementine Rome (fig. 63). However, the king may already have been acquainted with his art. Recent discoveries suggest that the marvelous painting of *Moses and the Daughters of Jethro* had been sent to the monarch by his Florentine agent, Battista Della Palla, preceding the artist to the country he was to call his own in the future (fig. 62).[14] A very abstract work of frozen and erotic violence, this painting was of a different register from the playful drawing of *Mars and Venus*. François I may therefore have been aware of the strength and strangeness—as well as the grace—of which the artist was capable.

In Italy, in an intensely competitive climate, Rosso had executed altarpieces and easel paintings. He had drawn extensively, in particular for the engravers, but had little experience with large-scale commissions. François I offered him exceptional conditions. In the French kingdom the painter found a safe haven after his tribulations.

62. Rosso Fiorentino, *Moses and the daughters of Jethro*, c. 1523. Oil on canvas, 63 × 46 in. (160 × 117 cm). Florence: Uffizi.

Here, the uncontested master, he could operate as a universal artist in the manner of his great predecessors, at once painter, sculptor, and architect. He was provided with the means to give free rein to his inexhaustible inventiveness. All sorts of works of art were entrusted to him, from great monumental decorations to miniatures and the design of luxury objects. However, despite these advantages, which brought him the prestige of genius, Rosso had not lost his restlessness. On November 14, 1540, he took his own life.[15]

The Galerie François I

The Galerie François I is Rosso's major work in France and one of the most remarkable decorative ensembles of the era.[16] It poses numerous problems, in part because it is the work of an Italian entering into a French context very different from the conditions to which he was accustomed, but also because it appeared in a milieu that can be called modernist, in the sense that one sought to do something new and different. Consequently, the foundations of invention, the links with tradition, the conventional bases essential to comprehension were more tenuous than usual.

Even the term "galerie" (gallery) is problematic: it has been asserted that the word was as French as the space that it designates, a long room that provides passage onto the second floor between the wings of a building. This national specificity is probably exaggerated, for Rosso was familiar with rooms, such as the corridors of the Belvedere in Rome, which were not unrelated to the gallery of Fontainebleau. Nevertheless, when Cellini spoke of it in his memoirs, he felt obliged to give an explanation: "This was, as we would say in Tuscany, a loggia, or actually a wide corridor; it could more properly be called a corridor, since we call a room open on one side a loggia."[17] As for the 1528 contract, it specifies "a gallery thirty-two fathoms long or thereabouts and three fathoms wide inside the walls in order to go from the room that will be adjoining the big old tower to the abbey."[18] The term gallery and its circulation function are clearly spelled out in this text. But a simple corridor was not envisioned and the interior space of this entirely new construction was not originally meant to be continuous. Dividing walls were anticipated in order to create a chapel on the residence side and a "cabinet" on the abbey side. The text also mentions two small cabinets measuring "two square fathoms," more or less thirteen feet to a side, opening onto the gallery in its center. It is therefore necessary to imagine a series of spaces articulated on a rigorously symmetrical plan, destined surely to serve for more than circulation, although it is impossible to specify—save for the chapel—their purpose or the anticipated interior arrangements. In the definitive plan, the chapel and the cabinet on the west side were removed to give the gallery the entire length of the wing and, in the end, only one of the two side cabinets was retained, on the north side.[19]

The Galerie François I has been terribly disfigured. We may begin with the wear and tear and ravage of successive restorations. The frescoes are all but ruins. At least we are told that the last stripping done after 1960 lets us see the debris from the sixteenth century. Clearly the stuccos are in a better state, but they have certainly lost some of their finish, and the disparity between their condition and that of the painted parts impairs a carefully calculated equilibrium. What connection can there be between these unprepossessing surfaces, often difficult to decipher, and the work in all its freshness? Other alterations, though equally severe, are less obvious at first sight. The light was entirely distorted in 1786 when Louis XVI built a new wing to the north of the gallery doubling the existing one. This entailed the blinding of all the north-facing windows,[20] as well as the demolition of the cabinet, the decoration of which had been an integral part of the ensemble. The decorators of Louis-Philippe and Napoleon III, for their part, designed false casement windows with slightly cloudy skies, and in the center, in place of the entrance to the vanished cabinet, invented a compartment whose principal tableau is the *Nymph of Fontainebleau*, painted by Alaux after Pierre Milan's engraving. As the engraving also furnished the design of the stuccos, the latter are an exact replica of those around the *Danae* facing them, and form a flagrantly absurd repetition. On the south side, on the other hand, the openings were enlarged through the conversion of the casement windows into French doors.

63. Rosso Fiorentino, *Mars and Venus*, 1530. Pen and black ink, brown and white wash, white heightening and traces of black chalk, 17 × 13 ⅝ in. (43 × 34 cm). Paris: Louvre.

64. Fontainebleau (Seine-et-Marne, France), château, Galerie François I:
wainscoting panel with the royal salamander.

Just as disastrous was the opening of the large doors (the original ones did not exceed the height of the paneling). The first was set at the western end in 1639. It displaced a large oval tableau by Rosso. Next was that which opened onto the great staircase ordered by Louis XIV in 1686: the western end of the north wall was ripped open and the left part of the stuccos that surrounded *The Sacrifice* were shattered in order to frame the large door, in stark

contradiction to the original decor. In the eighteenth century, the architect Jacques Ange Gabriel entirely destroyed the eastern wall in order to create yet another large door to the left and to feign another symmetrically, placing a bust of François I in a niche in the center. Thus vanished the setting of the other large vertical oval painting by Rosso, already replaced in 1701 by a more modest canvas by Louis de Boulogne. Nor did the ceiling escape alteration. It was raised by about twenty inches under Louis - Philippe. Modern restorers have re-lowered it, but not to its original level, for fear of cutting into the stuccos of the sixteenth century. The ceiling is today about eight inches too high, so that the beams do not rest as they should on the lateral decorations, which is particularly noticeable where there are caryatid-type figures, as in the stuccos of *Danae* and *Ignorance Dispelled*: the decor of the walls was originally much more intimately associated with the architecture of the room. Finally, the original parquet floor has entirely disappeared. Commissioned, as was the wainscoting from the celebrated Scibec de Carpi, it was a luxurious piece of woodwork, an interplay of oak and walnut. The motifs—square and diamond-shaped—mirrored those of the ceiling.

One must imagine a completely controlled environment—a decorative scheme that animated all surfaces, constituting an enclosed capsule, like

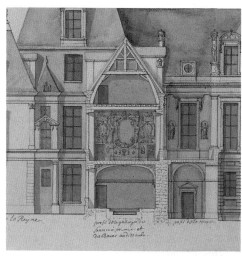

65. François d'Orbay, *Section plan of the Galerie François I.*
Drawing from 1682. Paris: Archives Nationales.

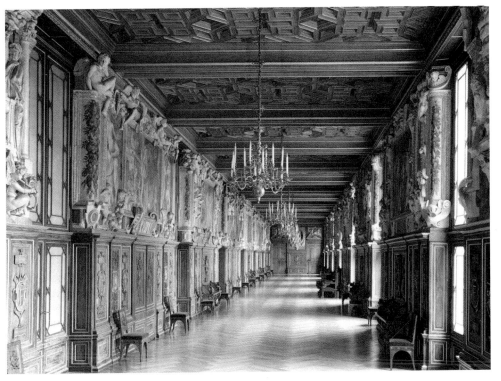

66. Fontainebleau (Seine-et-Marne, France), Galerie François I, after 1528.

a precious chest, the ornamentation of which would be turned inside. Oak and walnut woodwork, partially accented with painting and gilding, covered most of the surface. The report to Henry VIII by Ambassador Henry Wallop insisted specifically on this aspect of the gallery:

> The rowff therof ys seeled with walnott tree, and made after an other forme then Your Majestie useth, and wrought with woode of dyvers cullers, as before I have rehersed to Your Majestie, and is partly gilt; the pavement of the same is of woode, being wrought muche after that sort; the said gallerey is seeled rownded abowte, and fynely wrought three parts of it; upon the fourthe part is all antique of such stuff as the said Modon makith Your Majesties chemeneyes.[21]

This summary description clearly brings out the interplay of materials and the enclosed character of the room.

Thus the tangle of paintings and stuccos which is the principal attraction of the gallery for us was deployed only in the upper parts of the wall above a paneling approximately six and a half feet from the floor. The large tableaux, one per bay, regularly punctuated the very long and awkwardly proportioned room. The ends of the Gallery and the center of the south wall set themselves apart from the rest by presenting oval rather than rectangular tableaux, vertical at the ends, horizontal in the center. In total, there were twelve rectangular and four oval tableaux. The vertical oval tableaux on the small sides of the gallery stood out for their technique: oil on canvas, and not fresco. Vasari expands on these oil paintings at length, in particular on *Venus and Bacchus*, a faithful copy of which has been found, that might even be the original (fig. 84).[22] The sensuous side of Rosso's art, already apparent in the drawing of *Mars and Venus*, is developed here to the full.

On the low walls at either end, the stuccos over-lapped the paneling, further accentuating the impression of enclosure. The only significant rupture in this rhythm was the lack of a tableau in the center of the north wall, occupied instead by an opening onto a small room or "cabinet." Above this door, or rather passage, was a bust of François I flanked by Victory and Fame. Inside the cabinet, the chimney on the west side was decorated with paintings and stuccos per the same principle as the compartments of the gallery, with a large horizontal oval tableau corresponding to the oval of the south wall. As the paneling was continuous, the cabinet was visibly integrated into the decoration of the gallery. An obvious visual connection was established between the ends and the middle, inscribing a diamond within the rectangle of the room, a composition whose symmetry was disturbed only by the north cabinet in the center of the gallery. It is essential to keep in mind the original arrangement to understand Rosso's work.

The precise function of this sumptuous room is unknown. The gallery had lost its circulation function under François I, at least under normal circumstances, since it remained closed and the king kept the key on his person. Moreover, another exterior way had been established: the kitchens built along the south flank of the wing on the ground floor supported a terrace which provided passage between the Cour Ovale and the Cour du Cheval Blanc.[23] The very long and narrow proportions of the room lent themselves poorly to the gatherings of the court, particularly balls. Perhaps the gallery was nevertheless used in this manner, for want of anything better, before the completion of the ballroom under Henri II.[24] Yet its principal purpose would probably have been to serve as a private walkway. In any case, we are certain that François I had his distinguished guests visit the gallery. A report from Henry VIII's ambassador allows us to imagine such a visit and even mentions how Wallop would climb on a footstool to examine certain details more closely. The benches, which were part of the original woodwork, invited the leisurely contemplation of the composition opposite, and undoubtedly this marvelous place was visited specifically for its artistic value, although this did not prevent some business being conducted there.

Stuccos and Frescoes: Techniques and Modes of Representation

The Galerie François I, with its tangle of paintings and stuccos, produces an impression of richness, abundance and unbridled fantasy, bordering on disorder. In fact, the entire work is meticulously assembled. Each compartment follows the same general scheme: a large tableau in the center flanked on both sides by related motifs, constituting a sort of triptych. A cartouche is placed below each composition, and a salamander, the favorite emblem of the king, surmounts each tableau. The result is a tripartite composition both horizontally and vertically in which the only stable elements are the form of the frame of the large central tableau and the salamander motif. Rosso did not improvise the endless variations of the scheme as the execution proceeded. They are arranged within the gallery in a very carefully concerted fashion. The distribution of painting and stucco in the lower cartouches, for example, in intertwined triangles, suffices to show with what precision the scheme must have been planned before its implementation.[25]

Writers on the subject have seen that the connection between sculpture and painting seen here is unparalleled. However, they have not quite understood the concept that underlies this union of techniques. This is because the deterioration of the work—and of the paintings in particular—renders the *concetto* difficult for the eye to grasp, forcing us to a more minute examination and slightly abstract discussion. A point that has been neglected and should be emphasized is the fact that not only is there an interplay between sculpture and painting, but also between two sorts of sculpture and two sorts of painting which must be distinguished. In the case of sculpture, the pieces in full relief, such as the great satyrs of the southwest end or the triple caryatids in the center,

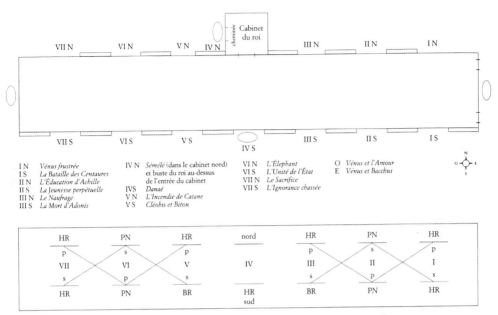

Les majuscules indiquent la technique des panneaux latéraux : HR = haut-relief de stuc ; BR = bas-relief de stuc ; PN = peinture naturelle.
Les minuscules indiquent la technique des cartouches du bas : p = peinture ; s = stuc.

67. Diagrams of the Galerie François I. Distribution of the modes of representation (above), and of the subject matter with numbered key (top).[26]

contrast with the bas-reliefs. This effect escapes no one. On the other hand, the equivalent dichotomy in painting is much less apparent today due to the deterioration of the frescoes. Yet it is critical to an understanding of the arrangement imagined by Rosso. A distinction must be drawn between what I will call natural painting—that is to say tableaux in perspective—and the motifs painted on a background of the fake gilded mosaic. The motifs painted on the mosaic background play the same role in the decorative system of the gallery as the high relief pieces: these are decorative elements—festoons, *putti*, architectural motifs, "strapwork"—whereas the bas-reliefs serve, like the natural paintings, to accommodate the narrative subjects inserted into the decorative scheme. We are faced with a system of binary oppositions that cut across each other, between the two techniques, painting/sculpture, and two modes of representation, which I will call tableau/figure.

If the technical alternation—the opposition of stucco to painting—is the most obvious, that of the modes of representation is just as essential to an understanding of Rosso's imaginary universe. The tableaux, whether painted or in bas-relief stucco, are in perspective; the objects and figures are located in a space of feigned depth, which consequently extends behind the plane of the tableau. The figures detach themselves, projecting in front of a plane materialized either by the surface of the stucco or by the fake gold mosaic. What is unexpected and rather strange in Rosso's work is the fact that the figures painted on the mosaic background occupy the same space as the stuccos in high relief, while the physical contrast between flat paint and modeled stucco is blatant. This collision of techniques attracts attention to the fictional character of the space represented, even when the execution is actually three-dimensional. Later, in Baroque art, it would be otherwise. In the ceiling of Gesù in Rome, for example, the transition from the stucco in actual relief to flat painting is almost unnoticeable. The effect here is truly that of a conjurer—the manipulation of perception, rare in art, in which the eye is effectively tricked. This is possible only by means of

75

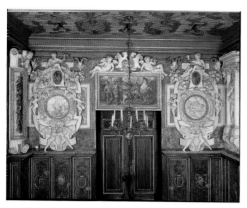

68. Fontainebleau (Seine-et-Marne, France), Galerie François I,
west wall. The central door replaced a painting by Rosso,
but the stucco reliefs to each side are original.

the distance, the ceiling being very high. At Fontainebleau, the visitor is very close and, consequently, is left in no doubt. Even if, when newly applied the painting suggested the third dimension much more convincingly than it does today, so that the equivalence between the painted motifs on mosaic ground and the sculpted motifs would have been obvious to the mind, the eye would still have easily distinguished the paint from stucco. The effect appeared as a mental game, a *concetto*.

Perspective is not just the projection of a three-dimensional space on a plane surface, it is also an unobtrusive and powerful method of composition, a means of defining the relationship between the various elements of the image. It imposes a virtual

69. Rosso Fiorentino, The *Elephant* (detail). Fresco and stucco.
Fontainebleau: Galerie François I.

grid on the surface of the picture in which each object finds its place at the same time that it is installed in the fictive depth. The connection between the coordinates of the surface and the depth enliven and justify the formal organization. Perspective being excluded from the space of figures, it was necessary to provide for their linkage by other means. The laws of gravity supplied the solution. Some of these figures are of an architectural and abstract type: consoles, corbels, and especially frames. They give the impression of being anchored in the wall and suggest architecture capable of bearing other motifs—figures, animals, or garlands—which ostensibly rest on these supports. These are, of course, relations between fictional rather than real forces, founded on the impression of plasticity and weight produced by the elements of the decor—imaginary forces given a psychological reality by the suggestive power of art. Rosso stresses these links; thus, on either side of *The Unity of the State*, the youths, standing on a sort of block, are held up by one leg with muscles tensed and lean insistently on the large frame of the central tableau (fig. 81). The painted female figures that accompany the large satyrs in the panel of *Ignorance Dispelled* (fig. 83) have the same effect. One will also note the detail in the lower right of the same compartment, where a painted rodent rests its paw on the curved form of the stucco, drawing attention both to the continuity between painting and stucco, and to the support of the animated motif by the inert structural motif.[27]

In order to mark the distinction between the two modes of representation more clearly, Rosso made use of another element: the frame. Tableaux, whether painted or in stucco, are always surrounded by a frame; figures never are. The frames of the principal tableaux have a rich classic profile taken up again by the curving frames in the embrasure of the window containing garlands. As the only motif repeated without variation throughout the gallery, these frames play a major unifying role and insure the stability of each compartment. Everything finds its place in relation to the large frames of gilded stucco. The smaller frames are in general less sumptuous, yet, even reduced to their simplest expression—a string of pearls that usually comprises the innermost motif of the molding's profile—they are

able to delimit and mark out the tableau, differentiating it from the decorative motifs and figures.

The frames have two different roles. On one hand, they define the space of the tableaux. On the other hand, by their plastic reality, they form an integral part of the decorative repertoire—that is, the figures—and constitute one of the architectonic motifs that order the whole composition. In a discrete but explicit fashion, Rosso presents his narrative scenes—the *istorie* of Leon Battista Alberti—as inserted framed pictures in the tradition of antique Roman frescoes. Thus the small view of Fontainebleau is given a frame excessively bulky for its size, placed at an angle and overlapping that of the principal tableau. This artifice has the advantage of providing a better viewing angle for the very detailed little painting, but at the same time it highlights the tangible and detachable materiality of the tableau. Similarly, in another example analyzed below, the frames of the side panels of *The Elephant* pass behind the large tableau, proving that it is necessary to understand this not as an opening in the wall but as an inserted picture, a work of art (figs. 69 and 80). Nevertheless, it is also clear that the expected reaction of the viewer faced with these large tableaux is to behave as if before a painting—as if there lay before his eyes a window open onto an imaginary world. The large frames, the only completely stable elements in the gallery, provide the mediation between both aspects of this ambiguity. Indeed the decorative conception of the gallery hinges upon them.

The use of the frame to distinguish tableau and figure, narrative and decorative registers, is redundant, since the differentiation of the modes of representation would suffice to do so. This gave Rosso the opportunity to indulge in some playful moves characteristic of the formal humor that reigns in the gallery. Once understood by the viewer, the system creates a sense of anticipation: the visitor expects to find the coupling of natural painting/frame, both of which are associated with the tableau. Rosso sometimes appears to confound this expectation and to infringe upon the established rule, but the surprise of seeing the system abandoned only prepares the viewer for another: that of seeing it applied with such dexterity and panache. For instance, the side compositions of *The Elephant* (*The Abduction of Europe* and *Saturn and Phylira*) are painted tableaux whose figures detach themselves from a background of sky and a rudimentary landscape (fig. 80). But at first sight, they seem unframed. However, upon closer examination, there are fragments of frames at top and bottom; these are to be understood as part of a frame that disappears behind the large frame of the *Elephant* and reappears above it, as indicated by the beautiful adolescent figures that rest their arms on it.[28] This expectation, apparently frustrated and then satisfied, recalls the musical technique in which an unexpected false cadence is resolved by a subsequent true cadence.

One of the truly distinctive aspects of the gallery is the extremely loose application of the laws of repetition, alternation, and symmetry that generally governed ornamental art. I have already mentioned that the only motifs repeated exactly were the principal frames and the salamander, the celebrated emblem of François I, which is found at the top of each panel. However, the legendary creature adopts very diverse and expressive attitudes.[29] We are dealing with a thematic rather than formal recurrence. Other repetitions are more occasional and approximate: even an inattentive visitor cannot fail to notice an echoing effect—an obvious correspondence between the heroic nudes of the northeast end and the satyrs of the southwest, diagonally opposed along the length of the gallery. The other oblique, linking the southeast to the northwest, is also marked, but in a much more discrete fashion: the side sections of the southeast bear herms of priests and at the opposite end scenes of sacrifice are represented. The connection here is more thematic than morphological. One witnesses a sort of contamination and unexpected interchangeability of the formal and thematic aspects of the motifs, many other examples of which could be given.

Two disconcerting traits peculiar to the gallery arise from this examination: on the one hand, an interplay of reminders or similarities of very variable degrees of obviousness crisscrossing the gallery in all directions; on the other hand, this is based on mental categories that include and confound motifs and themes, morphology and semantics. A major consequence is that, in order to grasp the meaning of the gallery, we will need to take its formal organization most attentively into account.

Reading Problems

A decorative cycle such as the Galerie François I comprises numerous distinct subjects which must constitute a coherent and intelligible whole. At least our experience of other examples allows us to assume this. And the method of iconographic reading, which consists not only in identifying the subjects but also in understanding their linkage and their metaphoric significance, is one of the great successes of modern art history. Thus, the frescoes of the Palazzo Schifanoia at Ferrara, painted in the fifteenth century for the Estes, appeared only as an eccentric mélange of mythological subjects and familiar scenes, until Aby Warburg, upon more intense scrutiny of the monument and the culture which produced it, figured out that it was a systematic exposé of the influence of the planets on human destiny according to the perfectly attested beliefs of the era.[30]

The great ensembles of Italian decoration are generally both narrative and allegorical. Raphael was the master of these semantic overlaps: in the Sala di Costantino (Hall of Constantine) in the Vatican, executed by his students, the life of the emperor forms the main thread. Yet the scenes were not chosen simply for their narrative interest, but according to certain symbolic themes that had moral and political value. The most striking example is *The Donation of Constantine*, in which the emperor hands over to Pope Sylvester I an official document making him a gift of the city of Rome. This charter was preciously preserved, but a century before the execution of the fresco, Lorenzo Valla, one of the founders of humanism, had denounced it as a crude forgery. This scholarly demonstration, damaging for the Roman Church, was widely broadcasted by German reformers. The choice of such an episode around 1520 was consequently a particularly aggressive manner of reasserting the legitimacy of the temporal power of the pontiffs against the assertions of the innovators.

Narrative painting of the Renaissance was the figuration of a historic theme, often of an antique text or a combination of texts. The example—and it was indeed the exemplary aspect that mattered here—was chosen because the story substantiated an abstract structure also encountered in the contemporary world: antiquity thereby appeared as an image of the present, or, better still, the present was seen as a resurrection of antiquity. The typical case of this mechanism can be pointed out in the chamber of Madame d'Étampes, at Fontainebleau itself (fig. 115), which will be discussed later. On the walls, Primaticcio depicted some episodes of the life of Alexander while insisting upon the connections between the hero and women: Campaspe, Roxane, or Timoclea. The lesson is quite clear: François I, celebrated for his gallantry, was a new Alexander. The destination of this room, made to accommodate the official mistress of the king, perfectly justified the program. Two principal discourses run through the entire decorative cycle and coincide sufficiently so as to render it difficult to prioritize one over the other: the historic narration—that is, "Alexander and women"—or the modern application, "François I is a new Alexander;" the allegorical abstraction, "the loves of a great prince," bridges the two discourses.

The implication of the contemporary world has its limits, which are not always clear, and therein lie the poetry and enjoyment of this genre. In Pliny's text, where one finds the episode represented by Primaticcio, *Apelles Painting Alexander and Campaspe*, the magnanimous Alexander hands over his beautiful mistress to the painter who has fallen in love with her (fig. 113).[31] Some commentators have struck up an intrigue, quite improbable but titillating, between Primaticcio, the new Apelles, and Madame d'Étampes as a modern Campaspe. How far should one go? The dangers and the pleasures of such invitations are not only those of modern interpretation; they were already current at the time.

An iconographic reading of the gallery poses three kinds of problems: the identification of the scenes represented; the nature of the semantic connections between each large fresco and the motifs that surround it; and finally the iconographic program, that is, the discourse that underlies and justifies the distribution of subjects within the whole room. Huge progress has been made in the decipherment of individual tableaux, mainly

70. Rosso Fiorentino, *Venus Frustrated*. Fresco and stucco. Fontainebleau: Galerie François I.

71. Rosso Fiorentino, *Combat of the Centaurs and Lapiths*. Fresco and stucco. Fontainebleau: Galerie François I.

thanks to Charles Terrasse, Guy de Tervarent, and Erwin and Dora Panofsky, who have successively tackled the issue. Although certain subjects, such as the death of Adonis (III S) are very easy to identify, others have long resisted.[32] The case of *Perpetual Youth Lost by Men* (II S) is symptomatic. Only eccentric hypotheses had been proposed before Terrasse understood that the subject was the loss of perpetual youth by men,

a widespread legend in antiquity, and found its precise literary source in the *Theriaca* of Nicander of Colophon.[33] The choice of this rather obscure antique text is explained by its rediscovery shortly beforehand, and in particular by the fact that François I had acquired the manuscript for the library at Fontainebleau.

Other themes continue to elude us, such as that of the northeast end (I N) which earlier authors,

79

72. Rosso Fiorentino, *Education of Achilles*. Fresco and stucco, Fontainebleau: Galerie François I.

73. Rosso Fiorentino, *Perpetual Youth Lost by Men*. Fresco and stucco. Fontainebleau: Galerie François I.

beginning with Father Pierre Dan in his *Trésor des merveilles* of 1642, dubbed "Venus Punishing Love for Having Abandoned Psyche." This reading does not hold up to examination. Among other difficulties, in the story of Psyche, Cupid can hardly be represented as a child and no explanation is forthcoming for the little cupids who carry arms. Tervarent understood that Mars had left the scene and that the cupids were bringing him his arms before he went to war. Love does not writhe, as Dan would have it, rather he sleeps and Venus seeks to wake him up. The Panofskys developed this interpretation by drawing a parallel between the fresco and Rosso's great drawing, *Mars and Venus,* sent from Venice to François I, in which conversely the cupids relieve the god of war of his weapons before his repose in the arms of the goddess. The large book to the right would

74. Rosso Fiorentino, *Shipwreck* or *the Revenge of Nauplius*. Fresco and stucco. Fontainebleau: Galerie François I.

75. Rosso Fiorentino, *Death of Adonis*. Fresco and stucco. Fontainebleau: Galerie François I.

suggest the familiar theme of the book and the sword. More recently, attention has been drawn to the fact that Venus—assuming it is indeed her—is at her bath, and to the importance of the mauve tritons that adorn the fountain. André Chastel has entitled it "Fontainebleau Venus." The turn of phrase is appealing, but no textual source or iconographic tradition can be put forth to support this hypothesis.

What puts us ill at ease is the disparity of register between a subject such as *Perpetual Youth*—undoubtedly esoteric but well documented in a literary source—and a *Fontainebleau Venus* that seems to have been a pure invention. It is not impossible that one day a discovery will reveal to us the literary origin and exact reading of the scene, but this is becoming less and less likely. It is even less so in the case of the fresco usually

76. Léon Davent, *Jupiter and Semele*, after Primaticcio, c. 1543. Etching, 8 ¼ × 11 ½ in. (21 × 29.1 cm).
Paris: École Nationale supérieure des Beaux-Arts.

77. Rosso Fiorentino, *Danae*. Fresco and stucco. Fontainebleau: Galerie François I.

known as *The Elephant* (VI N), which has partic-
ularly intrigued commentators and in which it
seems difficult to see something other than a motif
borrowed from the emblematic register, an issue
I will elaborate later.

The identification of *Perpetual Youth Lost by
Men* may be extremely satisfying, but it does not
explain the reason for this charming fable here. In
order to understand its presence and significance
within the context of the gallery, it is essential to
understand the linkage of the images—the overall
idea, the common thread that holds them together,
giving them a meaning that transcends and trans-
forms the textual source. Due to the formal

78. Rosso Fiorentino, The *Burning of Catania* or *Filial Piety*. Fresco and stucco. Fontainebleau: Galerie François I.

79. Rosso Fiorentino, *Cleobis and Biton*. Fresco and stucco. Fontainebleau: Galerie François I.

arrangement of the gallery, the organization of the subjects appears to be on two levels, one within each "compartment" or panel (a fresco and its surrounding motifs) which obviously constitutes a unit, and the other on the scale of the entire gallery. Furthermore, interpreters have detected a thematic unit in the bays—that is, the two panels that face each other across the gallery. The Panofskys, whose interpretation is the most complete and sophisticated, worked very effectively on these limited units (the compartment and the bay) within which they discovered multiple significant connections.[34]

Their observations are revealing, though somewhat disconcerting, to the extent that these semantic connections do not seem at all systematic: narrative continuity, semantic complementarity, antithesis, and example arise in a most unpredictable fashion where a regular principle would be expected. Let us take, for instance, panel V S

80. Rosso Fiorentino, The *Elephant*. Fresco and stucco. Fontainebleau: Galerie François I.

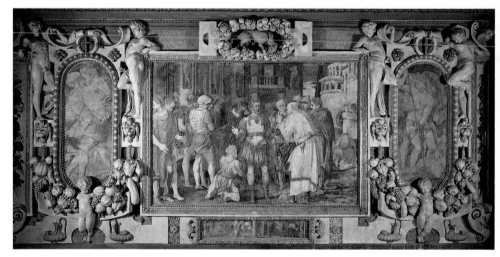

81. Rosso Fiorentino, *Unity of the State*. Fresco and stucco. Fontainebleau: Galerie François I.

(fig. 79). The principal fresco represents the story of Cleobis and Biton, the sons of Cydippe, priestess of Juno. The oxen having died in an epidemic, the two brothers pull the chariot of their mother so that she can report to the temple of the goddess. Cydippe then prays that Juno will grant her sons the greatest of blessings; they immediately fall asleep, never again to wake. The abbot Guilbert recognized the related subjects as early as the eighteenth century. To the right, is the plague that killed the oxen, and to the left, the death of the two brothers. We are presented here with a straightforward narrative going from right to left. But the cartouche in bas-relief below the principal tableau displays *Roman Charity*, otherwise known as the story of the imprisoned Cimon, whose daughter

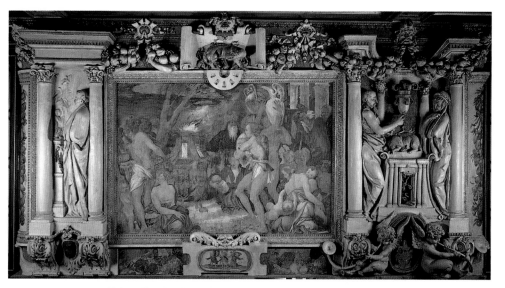

82. Rosso Fiorentino, The *Sacrifice*. Fresco and stucco. Fontainebleau: Galerie François I.

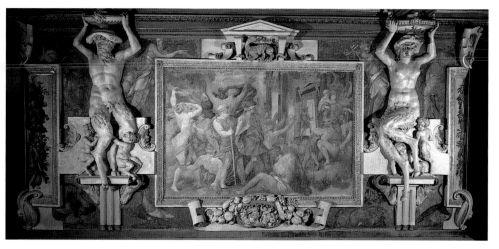

83. Rosso Fiorentino, *Ignorance Dispelled*. Fresco and stucco. Fontainebleau: Galerie François I.

Pero fed him from her own breast. This subject has no narrative link with the central theme, but the thematic connection, filial piety, is obvious. We should perhaps recognize yet another symbol of fidelity in the dogs placed on either side of the lower cartouche. If we now move to the opposite panel (V N), we are faced with a very different situation (fig. 78). The principal fresco, which represents people fleeing a city in flames, has lent itself to controversy. In the past, authors have generally recognized in it the somewhat hackneyed subject of the burning of Troy with Aeneas carrying the old Anchises. But in the eighteenth century, Pierre-Jean Mariette, having sensed the difficulty posed by the second figure carrying an old woman, recognized the much more rarely encountered subject

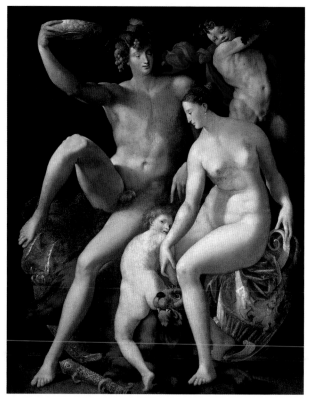

84. *Venus and Bacchus*, copy after Rosso Fiorentino, c. 1532. Oil on canvas,
82 ¼ × 63 ½ in. (209 × 161.5 cm). Luxembourg: Musée national d'art et d'histoire.

of the burning of Catania with the twins Amphinomus and Anapias saving their parents. The majority of modern authors have accepted this identification, while noting that certain aspects of the representation distinctly recall the Trojan episode.[35] Rosso may have sought this ambiguity, inspired perhaps by Seneca who, as has been pointed out, cites the two examples one after the other. The viewer thinks he recognizes the banal subject, then realizes he is looking at something more recondite, which nonetheless retains echoes of Virgil's familiar story. The expressive value of the principal motif—a young man carrying his father—is liberated from its precise narrative context to function more generically as a visual rhetorical formula. Although the exact narrative subject might be slightly unclear, the theme of filial piety, made explicit by the caption of an engraving by

René Boyvin, leaves no room for doubt. The link of three generations in the central group affects us, even if we are unfamiliar with the textual source.

The stuccos arranged on both sides of the fresco present large figures in niches: to the right a young man, to the left a bearded old man. There is apparently no narrative link between the lateral sections and the central fresco, yet the old man/young man contrast obviously relates to the generational theme central to filial piety. The contrast of costumes has also been remarked upon: the old man wears the *braies* (breeches) characteristic of "barbarians," and in particular of the Gauls, while the young man is classically draped which places him in the Greco-Roman world: this may be a reference to the legendary double origin, both Greek and Celtic, of the French dynasty. Even the ornaments of the niches participate in and enrich this

play of oppositions. That of the young man is framed by caryatids that appear as aged and bearded figures; that of the old man by young women. The opposition young/old thus finds itself repeated within the niche, doubled by the additional man/woman contrast. Yet the opposition of the sexes is also quite marked in the principal fresco, in which the two old people carried by their children are a man and a woman. The small tableau of the predella, lastly, shows a burning city, probably Catania, or possibly Troy depending how we read the central narrative. In any case, this time it is the predella that would present a narrative continuity with the large fresco. As for the angels or genies above, they are part of a population that seems to lack a very precise semantic role, but is differentiated, as one finds figures from infancy to maturity, some winged and others not.

The thematic unity—in other words the ordering idea of the bay—is perfectly obvious: filial piety. But defining what distinguishes the two sides is not so simple. It has been proposed to view the north, with its *Twins of Catania*, as insisting on the dynastic aspect of generations, whereas *Cleobis and Biton* would represent rather the pietas due to the divinity. However, the small relief of *Cimon and Pero* hardly fits this pattern.

As one scrutinizes the gallery, one weaves a complex network of connections between the scenes that span the whole range from the most obvious to the most tenuous, without being able to find any stable system in these connections. One has the impression that the difficulty and uncertainty of interpretation have been deliberately introduced in order to foster the multiplication of possible connections. Shearman has rightly insisted upon the temporal element of a work that, through its own physical configuration and exceptional length, implies long examination and the exercise of memory.[36] The gallery demands sustained attention, invites long reflection and stimulates in the mind of the visitor invention and fantasy corresponding to those of the creators.

The overarching problem remains that of the program—the ordering thought of the ensemble, the very existence of which has been called into question. However, that a pictorial cycle this important could be only a more or less incoherent gathering of disparate subjects seems quite unlikely, to judge by the habits of the era. The fact remains that we have neither indication, nor hypothesis on this subject before the publication of Father Dan in 1642. According to him, Rosso "through the diverse stories and subjects of his tableaux, wanted to represent the principal deeds of the life of the great King François, such as were his inclination toward the sciences and the arts, his piety, his skill, his loves, his victories; notably the battle of Cérisoles expressed by the combat of the Lapiths. Just as one believes his disgraces are represented by the tableau in which appears a shipwreck; and appropriately and out of modesty, all this is brought out and represented through emblems and the fictions of ancient poets."[37] This text is hardly limpid or explicit, and our anxiety only heightens when we read, "these are sundry subjects that have no coherence."

The Panofskys pushed the idea of a sort of *roman du roi François* to its limits. Thanks to their staggering erudition and mental agility, they succeeded in recounting a biographical itinerary by proceeding from west to east. Thus in the *Sacrifice* (VII N) they saw an allusion to the birth of the king, which was credited to the miraculous intervention of Saint Francis of Pola, to whom Louise of Savoy had turned when troubled by her lack of children. The *Death of Adonis* would be an allegory for the death, in 1536, of the Dauphin François, the elder and favorite son of the king. Since the scheme did not seem very rigorous, they concluded that there was no well-predetermined plan and that some episodes had been chosen as the execution of the work proceeded. This conclusion was rendered necessary by the fact that in some cases they discovered references to events posterior to the beginning of work, such as the death of the Dauphin.[38]

The vision of the Panofskys is very attractive. In three long chapters, the life and character of the king are grandly displayed on the walls of the gallery thanks to a series of scholarly and witty allusions. Their method is quite graceful and their approach is perfectly justified in some ways. When they show that the *Metamorphoses* of Ovid do not suffice to account for certain details of the *Death of Adonis* (III S) so that it is necessary to refer also to the *Adonidos Epitaphios* of Bion of

Smyrna, their evident satisfaction is not just the triumph of pedantry. Erudition was a pleasure for them, as certainly it was for the creators of the gallery and, contemporaneously, the Rabelais of *Pantagruel*. But in the end their hypothesis does not stand up to examination. They spoke only of the twelve rectangular frescoes and their *inquadratura* without concerning themselves with the *Danae* which, in their opinion, would have replaced the *Nymph of Fontainebleau* of Rosso's original project, nor the *Semele* found in the north cabinet, nor the two large tableaux of the small east and west walls. For thematic reasons, they divided the cycle thus constituted into three groups of four panels each, so that the second group straddled the central caesura. As André Chastel pointed out, such a reading is immediately problematic because it is made in defiance of the formal organization.

One should remember that before the restoration of the 1960s, the monument, disfigured by nineteenth century repainting—itself already very faded—had completely lost its prestige. Scholars worked mostly from early reproductions. In her 1951 thesis on Rosso, Paola Barocchi hardly took into account the frescoes themselves. In the case of a divergence between them and the numerous graphic documents, drawn or engraved copies, she would consistently put her trust in the secondary document. The restoration campaign revealed that Louis-Philippe's painters had proceeded very scrupulously and that even if the frescoes had suffered greatly, the layout was almost always retained. Consequently more attention was paid to the monument itself.

A 1972 collective publication was the successful conclusion of both the restoration campaign, of which it provides a detailed report, and the ensuing reflection.[39] In it, André Chastel proposed an overall interpretation that he had outlined as early as 1968.[40] First of all the idea of an itinerary going from west to east had to be abandoned. This itinerary was actually dictated by the organization of the château that we know today—that is, according to the axis of the Cour du Cheval Blanc. But under François I it was very different: entrance was made through the Porte Dorée; the main part of the residence was grouped around the Cour Ovale and since the apartment of the king adjoined the east end of the gallery, this is where one entered. Therefore, if the gallery had an orientation, it could only have been from east to west. André Chastel's very fruitful intuition was that the fundamental idea that gives meaning to the program is not a narrative but rather a doctrinal structure—a configuration of concepts. Rosso knew important examples of similar systems, not only in medieval allegorical cycles, but also in his immediate predecessors and particularly in the *Stanza della Segnatura* at the Vatican decorated by Raphael in the years 1509–11.[41] Under the name of a "monarchic program," Chastel studied the twelve principal compartments separately (already isolated by the Panofskys). Thus the "principles of the French monarchy" were developed, whereas the compartments with oval composition (ends, center of the south wall and north cabinet) constituted a distinct "mythological program."[42] It is true that the large ovals contrasted with the rest through their decidedly sensual and even erotic tone, as well as by their form. The recent discovery of a surely very faithful copy of *Venus and Bacchus*—one of the two oval tableaux executed on canvas by Rosso—gives us a better idea of this (fig. 84). Certainly, the oval compositions, physically distant from one another, constituted a separate ensemble that set itself apart from the rest by its tone. Yet this does not imply a division radical enough to make it necessary to speak of two independent "programs." Although the frames are oval, they have exactly the same profile as the rectangular frames, and the layout of the compartments is identical. What we encounter here is more in the nature of an inflection—a contrast in tonality—than a rupture between two independent ensembles. The formal integration, the intertwining of two series of tableaux, presupposes a thematic integration. In addition, the proposed terms correspond poorly to the work: on one hand, mythology plays a preponderant role in the program dubbed "monarchic," and on the other, Jupiter, who dominates the center of the gallery, is explicitly associated with the idea of monarchy as the king of gods.

It was partially the destruction of three of the four large oval tableaux that pushed interpreters to disassociate them from the rest and to neglect them, but it was also due to what we know of the

genesis of the decor. Art historians sometimes have the tendency to believe that they have made a major step in the understanding of a work once they have reconstructed the progress and circumstances of its elaboration. Although this genetic study sometimes brings valuable information to the work of interpretation, it is advisable to distinguish the two approaches. The preparatory drawings of Rosso have all disappeared, but drawn or engraved copies preserve their memory and seem to indicate important hesitations in the elaboration of the project.[43] It would be surprising moreover that an ensemble this complex had been assembled in one fell swoop. If, as there are reasons to believe, the composition of *Venus Frustrated* was originally conceived vertically, this implies a considerable change in the project and perhaps a connection, in the mind of Rosso, to the drawing of *Mars and Venus* and the oval compositions of the ends.[44] If the *Education of Achilles* was initially conceived as an oval, as in a drawing attributed to Léonard Thiry, did Rosso envision adopting this format throughout the gallery? The large oval tableaux of the ends were painted on canvas, rather than as frescoes like the others, and had been executed rather early: had

they initially been intended for the gallery, or for another destination? John Shearman, who opts for the second solution, concludes that the gallery had no truly coherent program.[45] While there may be no definitive answer to these various questions—interesting as they are—it is also true that their solution would not necessarily provide clues for an exegesis. Even if the ovals of the ends were separately conceived at an earlier date, this does not preclude the hypothesis of a homogenous program; a program could very well have been elaborated later integrating the preexisting elements.

I am therefore convinced, for reasons of plausibility, that a coherent discourse existed that underlay the ensemble of subjects of the gallery; once known, this would allow us to make an account thereof. Having said that, it is necessary to admit straightaway that this discourse is strangely resistant to decipherment. What is particularly disconcerting is the heterogeneous aspect of the subjects: mythology, fable, history, the most diverse original texts have inspired these images. This juxtaposition is without precedent at the time except in one genre that may have played an important role in the conception of the gallery—the book of emblems.

The Emblem

This genre was immensely successful in the sixteenth century, particularly in France. Moreover, Andrea Alciati, known as André Alciat, the author that gave it its definitive form, was a very influential teacher of law in France from 1529 to 1534. The program of the gallery must have been elaborated toward this latter date, and it is not impossible that the great jurist participated in its development. The question as to the author or authors of the program—assuming that there is a program—remains open. All that can be said is that Rosso surely had a voice in the matter, for several reasons: the formal organization of the gallery is so complex, so unusual, and so obviously linked to the semantic connections, that the two aspects could hardly have been envisioned independently, inevitably implying Rosso's intervention in the

choice and distribution of subjects; the artist's reputation as a scholar, his taste for difficult and obscure subjects, already revealed during his Italian career, all lead us to think that he was involved in the conception of the program.

Apart from the question of Alciati's personal intervention is that of whether the emblem, or more generally emblematic thought, inspired the semantics of the gallery. The Renaissance particularly applied itself to the search for a form of expression that both reveals and hides its meaning, and, in the specific case of the emblem, the result depends on the indissoluble interdependence of an image and a text.[46] In the traditional emblem, a small phrase—strictly speaking a device (*motto* in Italian)—is juxtaposed with an image (fig. 85). Thus in that of François I, the

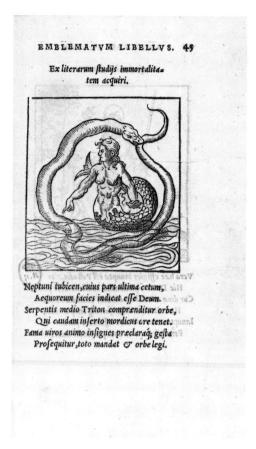

85. *Attaining immortality through the study of Letters*, from Andrea Alciati, *Emblematum libellus*, Paris, Christian Wechel, 1534. Paris: Bibliothèque Nationale de France, rés. V 2511.

motif of the salamander is accompanied by the expression *nutrisco et extinguo* (I feed and I extinguish), which lends itself to various interpretations.[47] The system conceived by Alciati is more complex: it consists of an image surmounted by a device or *motto* and followed by a *subscriptio*, namely a small poem that clarifies the idea embodied by the emblem, an idea that does not entirely fall under the rubric of either the image or the text but must arise from their collision.

In the Galerie François I the images juxtaposed to each principal fresco seem to function as the verbal elements of the emblem, as an indirect commentary that produces a meaning all the more rich because the gloss is not explicit. In certain cases, notably the cartouche of *Cimon and Pero* below *Cleobis and Biton*, the connection is relatively obvious and the designers have given us enough examples of this kind so that it is legitimate to assume that such a relationship exists. However, most of the connections leave us perplexed. It seems as though we are invited to search without being quite given the means to find the solution. This approach is not foreign to the spirit of emblems in which, quite often, it is impossible to reconstruct the link between *motto* and image without the author's explanation. It seems likely to me that the program of the gallery was based on this principle, and that it was a matter of a coherent discourse connecting disparate images— coherent but more or less impossible to penetrate without help because the logic therein had been elaborated specifically for each individual case. This permitted the king, who personally escorted visitors to his gallery, to dazzle his distinguished guests because he himself held the key to the enigma as well as to the door.

The report that Ambassador Wallop made to Henry VIII in 1540 is very precious because it reveals to us the actual course of such a visit.[48] It began in the king's chamber, to which Wallop had been summoned. As the ambassador had during a preceding interview expressed some disappointment in the material used for the decor—being less sumptuous in gilding than that made in England— François I begged him to ascend a footstool to examine the work more closely. Wallop insists on the fact that the king helped him to ascend and descend from this perch, thus expressing his consideration for him and consequently for his king, but he neglects to communicate to his master the result of this examination. Next, they moved on into the gallery, admired it very attentively, then descended to the lower floor in order to visit the apartment of the baths where the convalescent Madame d'Étampes was resting in the company of Madame d'Aubenay. Wallop's report is precise as to the protocol of the visit, and the ambassador is very attentive to the details of the life of the court, but *ekphrasis* is not his strength. The visitor had been charmed by the interplay of materials (even if he felt one had skimped on gilding), but he took so little interest in the subjects that the only one he

mentions in the gallery is the story of Lucretia, for which one would seek in vain. Moreover, aware of his ignorance, he leaves the responsibility for further enlightening the king to Niccolo da Modena, who was better informed for having worked at Fontainebleau before moving to England.

A surprising document, previously under-appreciated, sheds an entirely different, albeit indirect, light on the personal involvement/investment of François I in the work that he displayed for admiration. This time it is Marguerite, the sister of the king, who writes to him:

> I am going to meet you to obey your commands as it shall please you, and would have left earlier, were it not for my great desire that I had to see Chambord, which I have found such as no-one is worthy of praising it but he who made it, who by his perfect works makes his perfection visible. Thanking you humbly milord that you agree that I should be able to see Fontainebleau, which I had myself decided, although you spent Christmas in Paris. But I praise God that you will stay there until then, because to see your buildings without you, it is a dead body and to look at your buildings without hearing your intention about them, it is like reading Hebrew.[49]

Allowances must of course be made for hyperbole, constant under the pen of Marguerite when writing of her brother. It nonetheless remains that in her opinion, the creations of François I were beautiful and indeed, and completely, his own work, in which his own "intention" is legible. And, above all, this intention can only be received in all its purity from the king himself. According to her own words, Marguerite strongly experienced the complete appropriation of the work by the king. It seems to me that the gallery was conceived deliberately in order to achieve the perfect conditions for such an appropriation by devising a program that would be effectively impenetrable without initiation. That the "intention" which the gallery both reveals and hides had been whispered to the king by one or more humanists and artists is hardly called into question. For, as cultivated as he was, François I was not in a position to juggle with erudite references in this manner. Nevertheless this did not prevent hermetism from rendering the gallery a privileged intellectual domain reserved for the prince.

If the program was, as I believe, impenetrable from the start without the key, this is not to say that the work had no meaning for the less privileged visitor who did not benefit from the complete explanation. If the solution was this difficult, the investigation must necessarily have had its own charm and rewards. And today as then, without advancing a sustained and coherent reading of the gallery, a few suggestions can be proposed as to the possible methods of reading and the themes that emerge.

The question as to the order of reading remains undecided. Where to begin? How to orient oneself within the space? Since the nineteenth century, it has been customary to start in the west, beside the Cour du Cheval Blanc, because it was, as it is today, the beginning of one's visit. We have seen however that under François I, the gallery was entered through the other end, on the side of the king's apartment, and Chastel reasonably concluded that the point of departure would be better placed there. But is a linear reading thus oriented imperative? A vanished but important element has been neglected: the bust of the king above the entrance of the cabinet, in the center of the north wall, at the sole place where the rhythm of the compartments was interrupted. Of course, François I is present throughout the gallery, in particularly in his emblems: the F's are distributed in abundance; the salamander crowns each compartment and is repeated again and again on the paneling. The likeness of the king can even be recognized in the central figure of the *Unity of the State* (VI S). However, the bust is quite another thing. The portrait, in the full sense of the term, such as is a sculpted bust, still had at the time of François I a much stronger value than it does for us; it was a substitute for the person. Through this bust, the king was effectively present in the gallery. It is therefore not unreasonable to assume that the reading organized itself from this privileged point rather than proceeding from one end to the other. This comes out again clearly in the contrast between the two parts of the room. The west side celebrates the virtues and majesty of the monarch. Even if their textual sources escape us, even if our reading

is approximate, compositions like *Ignorance Dispelled* (VII S), the *Unity of the State* (VI S) and the *Elephant* (VI N) clearly belong to this register. On the contrary, in the eastern part, the tone is very different: the *Death of Adonis* (III S), *Perpetual Youth Lost by Men* (II S), scenes of combat and shipwreck—the *Shipwreck of Nauplius* (III N) in which has been seen an allusion to the disaster of Pavia and to the betrayal of the constable of Bourbon—are somber subjects that reflect the problems, anxieties, and tragedy that always menace a reign. This opposition is better understood when considered as the right and left of the king, the good and the bad (sinister) side, according to a traditional symbolism that ecclesiastical art rendered familiar because the right and left of Christ have always retained a very strong value.

The dissymmetry introduced by the fact that there was a cabinet only on the north side finds itself justified and enhanced by the presence of the royal effigy. The portrait of the sovereign that marks its entrance gives a privileged character to the restricted space, perhaps used by the king for private interviews. The subject represented in the large oval tableau above the fireplace—Jupiter revealing himself in all his divinity at the request of Semele to the point of consuming her—takes on a more specific meaning in connection with the presence of the king at the entrance to the room (fig. 76). This moment, both erotic and mystical, appeared as the culminating point in the exaltation of the royal person. How are we to understand, in contrast, the *Danae* tableau facing the king? Traditionally, the vulgar, venial love of Danae has been contrasted with the transcendence of the burned Semele thus purified by divine fire. In the context of the gallery, we are invited to read a contrast between the quasi-divine aspect of the king and his humanity, which expressed itself, as was common knowledge, through an unbounded sexuality; the rain of gold should perhaps be understood as a sign of royal munificence. Be that as it may, it is abundantly clear that the subjects of Jupiter's love for Danae and Semele are complementary. On the other hand, as Bacchus is Semele's son, a mythological connection is established between the center and the large oval tableau of the end, *Venus and Bacchus*.[50] There we pick up on parts

of a discourse whose coherence escapes us. It must be, roughly, that of royalty embodied in the person of the sovereign, and it includes the oval as well as the rectangular tableaux; the salamander, lest we forget, crowns all the compartments.

The hypothesis of a deliberately indecipherable program with which the king could dazzle his visitors raises a question as important as that of the existence of such a program: to what extent is it necessary to an understanding of the work? In the margin of, or rather underlying a learned discourse—whose logic unfortunately remains inaccessible to us, and that we discover only in a fragmentary fashion—there are other pointers to the meaning of the gallery. We have seen that certain subjects were easily identifiable, which both encourages and frustrates the more or less literate visitor. In addition, we should not neglect a range of more immediate meanings, offered to a more intuitive comprehension. Even the least informed person would be affected: the fiction constructed by Rosso transports the visitor to an imaginary world, mythical and poetic, simply by the force and coherence of the representation. One enters without necessarily possessing the literary culture needed to decipher the subjects. The great heroic nudes, the troubling expressiveness of the *putti*, the gesticulation of an entire population of ephebes and young women animate a sort of pagan mystery, the exuberance of which still captivates us. We can imagine the exalting effect that these wholly new forms might have produced on eyes used to *mille fleur* tapestries and the hangings of the *Amours de Gombaut et Macée*, which had hardly changed since the fifteenth century. There is an explosive expressiveness of the human body in its full splendor and, without even caring about the subjects represented, it would have been hard to avoid the feeling that one was faced with a conception of existence completely different from that passed down by preceding generations. Something serious and almost painful in the evocation of sensuous pleasure drastically called into question the principles that traditionally regulated life.

The *Death of Adonis* is one of the easiest subjects to identify in the gallery (fig. 75). Venus is recognizable enough in her chariot pulled by doves. The slightly cultivated visitor must thus

have oriented himself here, though he could have been surprised as we still are by the winged figures that support Adonis. But the analogy between the figure of Adonis and the traditional representation of the dead Christ could not have escaped him, even if it left him perplexed. As for the lyricism of the scene, the great movement of the composition, the kind of tenderness in pain that comes out of the gestures, could he have been indifferent to all of this? And what was he to think of the stucco relief of the right side? We are told that we should recognize therein the followers of Cybele whose chariot is to be seen in the corresponding left side relief pulled by Hippomenes and Atalanta in lion form.[51] Quite a disturbing procession this is, judging by the singular action of the two main figures, especially in combination with the entwined male couples painted above the frame. The abbé Guilbert saw "the effects of love" in the procession of Cybele![51] Even if the decidedly esoteric subject remains impenetrable, the scene exudes a sensuous violence that contrasts in quite a disturbing fashion with the almost sentimental emotional tone of the central tableau.

The obstacles into which commentators on the Galerie François I have run are linked to the nature and manner of Rosso, who clearly enjoyed disconcerting the viewer. At the same time, the gallery is an extreme case that brings out certain aspects of the art of the era that are usually disregarded. The iconographic program, whether or not it is known, never exhausts the meaning of the work. There is in fact no one meaning, but rather the possibility of multiple understandings. In every work of art there remains a degree of indeterminacy because of which the discourse of interpretation can only have a relative value (which does not mean that all interpretations are of equal merit). The work addresses itself in different fashions to various publics. It is necessary to consider several registers of apprehension, from that available to a rapid and even distracted glance to intuitions nourished by long contemplation and to the decryptions of the scholar. Ultimately, each person understands in her or his own way, which is not to say that interpretation is arbitrary or purely subjective, but that it varies more or less according to the perceptions of the individual. By deliberately frustrating the spectator, by refusing to inscribe in the gallery the principle of its coherence, Rosso highlighted this process. How then is one to envision the function of the program? If it was destined to make the king shine, is it otherwise more or less superfluous? It seems to me that it plays here, as in many other Renaissance cycles, a role comparable to that of the argument of a ballet. Very important in the genesis of the work, as a decisive point of departure, it finds itself at the end of the journey almost effaced by the expressive charge of the music and dance. I am not saying that reading of the argument of *Giselle* or *Swan Lake* beforehand does not clarify numerous details of the choreography that would otherwise escape the spectator, but in a satisfying performance the memory of this reading wears off as the expressive reality of the danced drama imposes itself and largely exceeds the potential of the text.

The more or less insurmountable difficulty of decoding the principles that guided the choice and linkage of the subjects of the gallery did not prevent contemporary viewers from appreciating a work whose enigmatic aspect was one of its charms; their admiration is obvious. Although we have hardly any verbal evidence of their reactions, the repercussions of the gallery in the art of the sixteenth century speak well enough of the impression that it produced.

The Vienna Tapestry: A Duplicate of the Galerie?

Admired in situ, reproduced and paraphrased through prints, the masterpiece of Rosso echoed throughout the whole of Europe, and the fashion in which it was received, assimilated, interpreted and exploited by artists well reflects the multiple, always partial, ways of understanding it. We will see in particular in a subsequent chapter how the engravers extracted from it a new ornamental style.

In its integrity, almost monstrously complex, the gallery was inimitable. However, a sort of

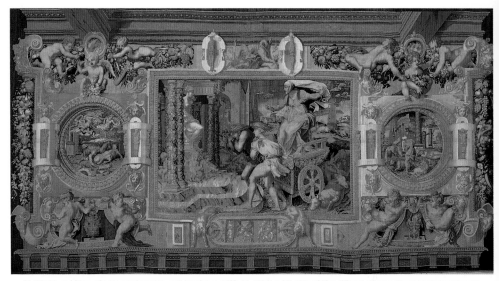

86. *Cleobis and Biton*, after Rosso Fiorentino, wall hanging, c. 1539–44. 130 ¼ × 251 ¼ in. (332 × 638 cm). Vienna: Kunsthistorisches Museum.

portable copy was created during the era. The Kunsthistorisches Museum of Vienna has six pieces of tapestry which each reproduce a compartment of the gallery, permitting the reconstruction of all the decoration of the south wall, with the exception of the last compartment to the west, that of *Ignorance Dispelled*. This is the only known example from the Renaissance of a woven replica of a monumental decor. Certain mural compositions by Raphael or his school had been converted into tapestry, but what was unique about the Vienna hanging was the desire to recreate the architectural setting. It takes up not only the stuccos and frescoes, but also the cornice of the paneling and the beginning of the beams. The hanging, relatively well preserved,[53] can create the impression of transmitting a vision more faithful to the intention of the creator than the monument itself.[54] While the restorations of the nineteenth century covered the frescoes, the woven copy was often referred to in preference to the original. The tapestries of Vienna have on the whole been studied mostly for documentary purposes, in order to reconstruct the spirit of the original sixteenth century appearance of the gallery.

This approach was doomed from the start. The authors of the tapestry, by which I mean the authors of the cartoons, felt themselves very free

in relation to the monument. The very classicizing, sumptuous cornice that adorns the bottom of the pieces, for example, has no resemblance to the rather simple molding that crowns the paneling of the gallery, and the difference certainly does not correspond to a later alteration.[55] The differences between the tapestries and what one sees at Fontainebleau should be understood otherwise. In the detail, the differences between the stuccos and frescoes and the woven replica are innumerable and sometimes important. Generally speaking, a greater ornamental richness is observable in the tapestry and in the interior of the tableaux than in the decorative apparatus.[56] In *Cleobis and Biton* notably, the columns of the temple are covered with foliage scrolls that did not appear in the fresco. The cartoonists took great liberties in representing the connection between fresco and stucco. Thus, in the woven version, the side bas-reliefs of *Cleobis and Biton* are in color, as if painted, but the cartouche at the base, *Cimon and Pero*, is monochromatic, to suggest stucco (figs. 86 and 87). The cartoonists perfectly understood the equivalence between the painted figures on gold mosaic background and the high-relief pieces of stucco, and they even insisted upon them: the tapestry maintains the contrast between the stuccos treated monochromatically and the

painted *putti* at the bottom treated in color; but in order to denote the fact that they occupy the same space and form a projection in relation to the surface of the wall, the heads of the *putti* overlap the stucco, obviously an impossible feat for the gallery's painted figures. This recurs in the framing of *Danae*, but here, to complicate matters further, although the caryatids are represented as sculptures, the garlands of fruit resting on the large frame, which were also executed in stucco, are colored in the tapestry.

The development of the cartoons of these tapestries presupposes an immense material and mental effort. It was not sufficient to copy an existing work more or less mechanically, and the preparatory drawings and cartoons for the gallery could have been only of limited assistance. For each compartment, the stuccos were put in perspective so that their projection could be appreciated. The light was carefully distributed. Above all, the complex connections of the painting and stucco were rethought and meticulously reshaped in detail in order to furnish a woven equivalent that maintains the overall effect of the fiction. The Vienna tapestry introduces yet another level of complexity into the already intricate game of metaphoric displacements between material and representation which is essential in the intellectual conception of the Gallery—but this is not apparent as long as the tapestry is viewed only as a documentary source; it must be appreciated on its own terms.

The destination of this hanging and the reasons for which it was undertaken remain unknown. Was the original intention to reconstruct the ensemble or only a part—in this case in all likelihood the ensemble of the southern wall? Have we preserved all that was executed or have some pieces been lost? It has been assumed without proof that they were sent to Vienna on the occasion of the marriage of Charles IX to Elizabeth of Austria. Perhaps the original idea was to make a gift of them to the Emperor Charles V, as a souvenir of his visit to Fontainebleau, of which the gallery must have been one of the principal attractions.[57]

On the other hand, the circumstances of its manufacture are rather well documented. It was woven for the king, at Fontainebleau itself, by an atelier of which it is the only certain production. After 1540,

87. Rosso Fiorentino, *Cleobis and Biton* (detail), Fresco and stucco. Fontainebleau: Galerie François I.

the accounts list several payments that designate Claude Badouin, Rosso's former aide in the gallery, as the principal author of the cartoons. It was long believed that this singular undertaking had been decided upon after the death of Rosso, and that this duplication of his masterpiece was a sort of posthumous homage. It is nothing of the sort. Catherine Grodecki has discovered a payment several months prior to the death of Rosso for the purchase of silks undoubtedly destined for the tapestries.[58] It is therefore likely that Rosso had been directly associated with the project and that he had been responsible for the development of the overall layout. The execution is posterior to his death, but the *concetto* that renders this hanging as exceptional in the history of tapestry as the gallery is in that of mural decoration goes back in all likelihood to the master himself.

95

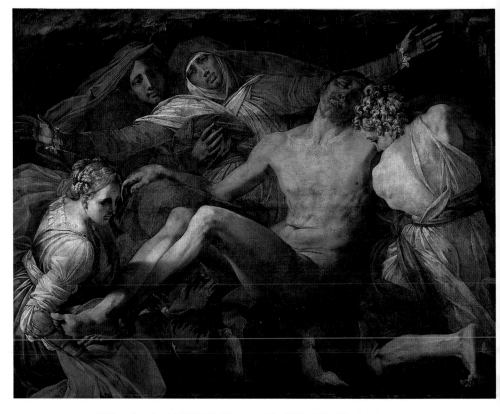

88. Rosso Fiorentino, *Pietà*, 1530–35. Oil on canvas, 50 × 64 ¼ in. (127 × 163 cm). Paris: Louvre.

If this is admitted, it is then necessary to connect the hanging of Vienna with the well-known practice of feigned tapestries in mural decoration in Italy, particularly in the productions of Raphael's atelier. Could Rosso not have remembered, for example, the background of the *loggia* of Psyche at the Farnesina, where the *Wedding of Psyche and Cupid* is represented as a tapestry set up as a vellum against the blue of the sky; or, better still, the Hall of Constantine, where fiction seeks to present the whole set of frescoes as a series of tapestries hanging around the room. Was it not clever to invert the roles and to conceive a reversed and formidably luxurious fiction, in which a set of tapestries would evoke a fictive architectural space with its painted and sculpted decoration? It would be difficult to surpass the hanging of Vienna in the game of imaginary displacements.

Rosso in France

The Galerie François I is Rosso's major work in France and certainly absorbed a good portion of his energy during the last six or seven years of his life. But it was not his only one. As Vasari asserts, his inventiveness was applied to all domains, the festival decorations, architecture, *objets d'art* and even miniatures. Destructions have been so radical that it is more or less impossible, given the

96

current state of our knowledge, to give an overall view of his complete works in France. However, numerous prints and drawn copies make it possible to discern the multiple facets of his inexhaustible imagination.[59]

Among Rosso's decorations at Fontainebleau that have been destroyed—some as early as the sixteenth century—the only one that can be reconstructed with any precision from graphic evidence, drawings and prints, is the pavilion of Pomona. This was a small structure open on two sides that occupied a corner of the enclosure of the Garden of the Pines at Fontainebleau. The two full walls were decorated with frescoes surrounded by stuccos. One represented Vertumnus, the Roman god of gardens, disguised as an old woman in order to seduce Pomona, the divinity of fruits. In the other, Ceres teaches agriculture to humanity. These are obviously appropriate subjects for the location. The framing in stucco was roughly the same for the two compositions and consisted of satyr couples, creatures associated with the state of nature. Rosso was the author of the first fresco, Primaticcio of the second. In each composition, a pergola in perspective continued the path of the garden, thus imaginatively extending this place of pleasure through the wall. This implies that one of the artists had conceived the overall scheme and, since Rosso obviously designed the framing stuccos, it is surely he who had established the basic design. Although the layout, with a tableau surrounded by stuccos in high relief, is close to that of the compartments of the gallery, the work was simpler, more accessible, even if the subjects were just as sophisticated (that of Ceres is taken from Ovid's *Fasti*, which was not as widely read as *Metamorphoses*). Such is the most appealing and approachable aspect of Rosso's genius.

Further proof of his activity, a panel survives from this period, the Louvre *Pietà* (fig. 88), which comes from the chapel of the château of Écouen and was painted for the constable of Montmorency. This somber painting, with its intense emotional climate and figures that hardly confined within the frame but seem to want to encroach upon the space of the spectator, continues the series of religious pictures Rosso had made in Italy on the theme of the dead Christ. The precise subject is very close to that which Pontormo treated in the altarpiece of

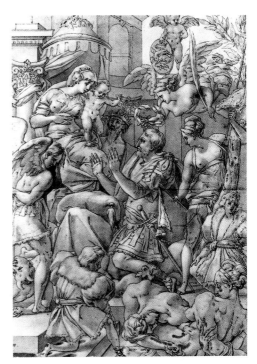

89. *François I and his sons adoring the Virgin Mary*, copy after Rosso Fiorentino, original c. 1535. Pen and ink-wash with white heightening, 15 ⅞ × 15 ⅝ in. (40.3 × 39.2 cm). Private collection.

Santa Felicità in Florence, and the execution should perhaps be placed rather soon after the artist's arrival in France.[60]

Through a fateful coincidence difficult to explain, only a few drawings from the hand of Rosso during his French period have survived, among them not a single original study for the Galerie François I, though there must have been many. The engravings, which will be discussed in a later chapter on the school of Fontainebleau, and the drawn copies have preserved for us the memory of numerous Rosso compositions whose destination is not known. Were there any paintings of the *Pieta* and the strange *Holy Family* (entitled the *Washing of Christ* by Franklin) engraved by Fantuzzi? Recently a drawing resurfaced that is clearly a copy after Rosso (fig. 89); it is an astonishing religious allegory, apparently conceived as an altarpiece showing François I and his two elder sons praying before the Virgin, surrounded

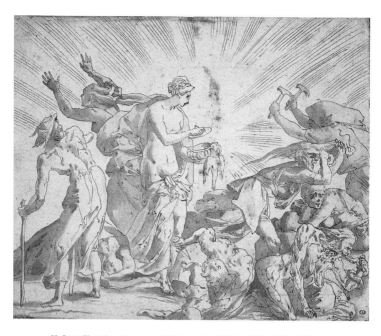

90. Rosso Fiorentino, *Pandora*, c. 1535. Ink and wash 9 ½ × 11 ½ in. (24.2 × 29.3 cm).
Paris: École Nationale supérieure des Beaux-Arts.

by several allegorical figures. Was it ever realized on a large scale? It is a very ambitious conception in which one can see the beginnings of the hyperbolic language that would have such success in the following century.[61] What was the purpose of the beautiful drawing of Pandora at the École des Beaux-Arts (fig. 90)?[61] There is almost no end to the list of questions that remain unanswered. However, some answers do arise from time to time. Madame Grodecki has discovered documentary evidence that Rosso had given the drawings of a new arrangement of the chancel of Notre Dame of Paris, of which he was a canon.[63] An original drawn project for metalwork, to which I will return later, has been recovered in recent years. We are heading little by little toward a more complete and detailed image of the activity of Rosso in France, but the time to draw a full picture has yet to come.

This does not prevent us from realizing that his success was absolute. The social ascension of Rosso in France was rapid and spectacular. Not only did he receive a very high salary, but he was also made a canon of the Sainte Chapelle after 1532; in 1537, the king granted him another

canonical office at Notre Dame of Paris. These gifts brought him additional revenue but above all they constituted a social distinction. As a canon, he attained the rank of the privileged. We have evidence of his grand style of living, not only from Vasari who wrote by hearsay, but more directly from Antonio Mini, a student of Michelangelo who, finding himself in France at the beginning of 1532, wrote to his master: "Rosso goes around with numerous servants and in clothes of silk in the manner of a great lord."[64]

Rosso had seen his numerous projects come to fruition. The production of the Vienna hanging was an extraordinary tribute to his talent. When we discuss the impact of the art of Fontainebleau, we shall see that his compositions were engraved in great numbers after his death and that his monumental decorations served as a starting point for a new type of ornamentation. Nevertheless, it cannot be said that a "*rossesque*" style emerged in France. Rosso was too singular an artist and too hermetic for his manner to become widespread and shape what one would call a period style; this role was reserved for Primaticcio.

Chapter III

THE ANTIQUE-STYLE OF CLASSICISM IN THE 1540s: CELLINI, SERLIO, AND PRIMATICCIO

Benvenuto Cellini: Goldsmith, Sculptor, and Adventurer

In the frenetic narrative of his own life, Benvenuto Cellini left us a picturesque image of his visit to France and of the artistic activity at the court of François I.[1] A shameless boaster and an inveterate paranoiac, the famous goldsmith hardly enjoyed his visit. With the exception of the great King François, for whom he had nothing but kind words, the French were all scoundrels. Actually, the rest of the world's population fared only slightly better in his estimation and even among the Florentines, his compatriots, there were only a few people—generally dead—who found favor in Cellini's eyes. Were it not for his great sword and fearful short dagger, his numerous enemies would surely have either killed or starved him. Benvenuto would roar, threaten, smash the enemy, and in the end thank God for having saved him. Despite his exceptional talent for narration, such stories, too often repeated in his autobiography, become tiresome. One comes to doubt all he has to say.

The presentation of his silver *Jupiter* at Fontainebleau is, along with the casting of the famous *Perseus* in Florence, one of the best-known passages of the *Memoirs*. The artist had received as his first royal commission an order for twelve giant chandeliers representing the twelve Olympian gods and goddesses of— according to Cellini—the exact size of François I. They were to be set around the king's table. Only the *Jupiter* was completed. According to Cellini, its unveiling took place at Fontainebleau in Rosso's gallery. The artist's bitter enemy, Madame d'Étampes, mistress of the king and protector of Primaticcio his great rival,

plotted to prevent the masterpiece from having the desired effect. Installed in the gallery, the bronze copies that Primaticcio had made of the most celebrated statues of antiquity, such as the *Laocoon*, would lay bare Cellini's inferiority. This treacherous woman managed to delay the visit until dark, thinking that the poorly lit work would pass unnoticed. But the cunning Florentine parried the blow and placed a torch in the raised hand of the god that held the thunderbolt, thus illuminating the work in a spectacular fashion. Cellini had equipped the pedestal with excellent wheels, thanks to which one could push the statue towards the king, as if it were alive. One can imagine the result: the king's amazement and the rage of his mistress, who tried in vain to play up Primaticcio's bronzes. She also claimed that the artist had covered his work with a veil in order to hide its flaws.

> This was a very thin veil, which I had draped very gracefully around Jupiter in order to increase its majestic appearance: I heard her remark, I took the veil, and lifting it up from below, revealed its fine genital organs, and with a touch of obvious annoyance I ripped it off completely. She thought I had uncovered that part of the statue to mock her. When the King noticed her indignation[2]

To the fair lady's indignation, the king praised the artist to the skies.

The scene as told by Cellini is so improbable that Dimier at first assumed it to be complete fabrication. By a rather extraordinary piece of luck, he recovered another narration dated January 29, 1545, in a letter of Giulio Alvarotti to the Duke of

99

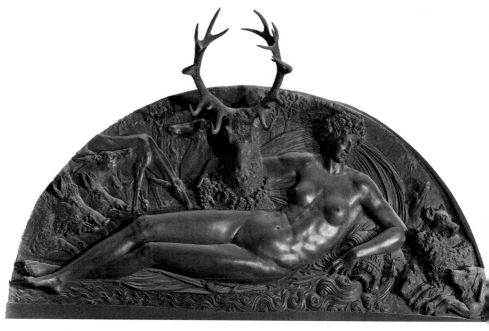

91. Benvenuto Cellini, *Nymph of Fontainebleau*, 1542–45. Bronze, 80 ¾ × 161 in. (205 × 409 cm). Paris: Louvre.

Ferrara.[3] The event did actually take place and, generally speaking, the document confirms Cellini's story. A venomous altercation had in fact erupted between the goldsmith and the royal mistress, during which Cellini was quite insolent. The *Jupiter* had been covered with a cloth and its disrobing must have been quite comical.

> One of the great personages who found himself with His Majesty said (turning towards Madame d'Étampes), "What is this shirt he has placed here supposed to mean?" Madame d'Étampes responded, "It was made to cover some defect." Benvenuto then said, "I have no need to cover defects in my works, though I have discovered quite a few in those of others. I placed this shirt on him out of modesty, but since you do not like it, please do without it," and he pulled away the shirt and said, "Does he seem to you well enough endowed?" The king burst out laughing...

All this corresponds rather precisely with Cellini's story. But in Alvarotti's version, there is no mention of Primaticcio's castings in the antique style, as is neither a competition with

Primaticcio, nor the delay plotted by Madame d'Étampes. Moreover, the ending is not quite so favorable to the artist: after being amused by the scene, the king silenced both parties.

Was the unveiling held at night because of a delay? Alvarotti says nothing of the kind. Cellini presents the act of hiding a torch inside the thunderbolt brandished by Jupiter as an ingenious last-minute maneuver intended to foil Madame d'Étampes's intrigues. He neglects to mention that the silver *Jupiter* was actually a candelabrum and that, consequently, lighting was one of the requirements of the commission. One can therefore wonder if the nighttime presentation was not, on the contrary, planned simply in order to ascertain the effect of the torch. If this was the case, why does Cellini fail to insist instead on the perfect adaptation of the object to its purpose? This is part of a strategy that clearly emerges from his autobiography, although Cellini does not state it explicitly. François I had taken him on as a goldsmith and the spontaneous commission for twelve candelabra of the gods pertained to this skill, although on a large scale, they were works of

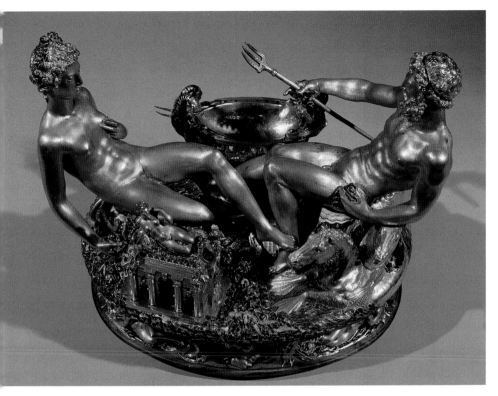

92. Benvenuto Cellini, *Saltcellar of François I*, 1540–43. Silver and enamel, ebony base, 10 ¼ × 13 ¼ in. (26 × 33.5 cm).
Vienna: Kunsthistorisches Museum (stolen May 2003).

goldsmithery. François I was extremely fond of such luxury objects. But Cellini, a Florentine raised in Michelangelo's entourage, made a clear distinction between the artist strictly speaking and the artisan who makes such trinkets, even if they were very large, very beautiful, and very expensive. One can understand then why he wanted to gloss over the fact that his *Jupiter* was destined to hold a lighting device and tried to pass it off as a statue in the same category as the antique works cast by Primaticcio.

Shortly after Cellini's arrival in France, in 1540, Rosso died, opening up a top position, and one can easily imagine that the Florentine goldsmith, who was not lacking in ambition, hoped to succeed his compatriot. To this end, he sought to distinguish himself from individuals such as Matteo del Nassaro, a very talented gem carver and dealer in rare and precious objects—a very prosperous figure

appreciated by the king, but one who was not an artist in the sense to which Cellini aspired.

From this point of view, his stay in France was a success. He obtained the commission for a group of large bronzes for the Porte Dorée at Fontainebleau, part of which at least was actually cast, though not installed: the celebrated *Nymph of Fontainebleau* that Henri II later gave to Diane de Poitiers to decorate the entrance to the château of Anet which can now be admired at the Louvre (fig. 91), and the two Victories for the spandrels. Two large satyrs that would have supported the lintel were carried only as far as models (fig. 93).[4] Thanks to these works Cellini attained his main goal: to prove himself as a true sculptor. The larger than life *Nymph of Fontainebleau* is an imposing bronze, and the nude is treated with distinction. It is undeniably a work of sculpture and even a masterpiece. Having arrived in France a goldsmith,

101

Cellini left as a sculptor. As a result he was commissioned to work on the *Perseus* on returning to Florence, and this statue would be the crowning of his career. When he left, a number of Cellini's important works remained in France. In addition to the aforementioned bronzes, he had executed several pieces of goldsmithing, of which only the famous saltcellar is preserved, but it was his most spectacular accomplishment in that type of work (fig. 92). An astonishing tour de force, it pays homage to the boldness of both Benvenuto Cellini and François I, who had been seriously warned against the difficulties of such an undertaking.

In the end, the artist and patron parted ways little satisfied with one another. Cellini describes an encounter with the king—surely one of the last—that seems to have been stormy. The king says:

> There is indeed something important, that you artisans, even though you may be talented, must understand—that you cannot demonstrate such talent without the assistance of others; and you demonstrate your greatness only when you receive the opportunity from us. Now you should be a bit more obedient and not so proud and capricious. I remember having given you express orders to make me twelve silver statues, and that was all I wanted.[5]

Yet the artist had busied himself with all sorts of productions and neglected the commission. Cellini obviously had a silver tongue and the king, who was not always the most practical of rulers, let himself be charmed by the artist's proposals. When five years had gone by, he regained his senses and decided to put the goldsmith back in his place. The latter, for his part, had not, despite the king's generosity, found the total freedom and almost unlimited means that he judged necessary to the full blooming of his incomparable genius. In short, he had not managed to fill the vacancy left by Rosso; despite their splendor, his works and projects had not produced the result he had hoped for. Cellini would have us believe that the reason for his partial failure was the conflict between his inalienable sense of artistic freedom and the demands of his patron. His status as an artist was probably also at stake. Besides, he was not alone: another artist had established himself in the place.

93. Benvenuto Cellini, *Satyr*, c. 1543. Pen and ink with sepia wash, 16 ⅓ × 8 in. (41.5 × 20.2 cm). Washington D.C.: National Gallery of Art, Woodner Collection.

One finds in Cellini's memoirs a rather unclear story concerning a commission for a fountain that he claimed Primaticcio attempted to steal from him, only giving up when confronted by the terrifying threats of the Florentine. Which part of the château the fountain was destined for is unknown, rendering its identification difficult. It is unlikely that he is referring to the monument that gave its name to the Jardin de la Fontaine; it was indeed Primaticcio who was given this task (though its principal ornament was the marble *Hercules* by Michelangelo which has so oddly disappeared). Cellini had shown the king a project for a fountain, the center of which was to be occupied by a giant statue of François I as Mars. It is certain that the artist made a plaster model on the scale of execution of this more than fifty feet tall *gigante*, since after his departure in 1545, there was concern to prevent its deterioration.[6] This does

not mean that this was a commission; Cellini himself declares that he had begun the work at his own cost for the glory of the king and his own, hoping of course to be remunerated later. It is quite possible, on the other hand, that he had received encouragement from the king, because in 1543 there was talk of casting the *Mars* in bronze,[7] a totally fantastic undertaking.

According to his own account, Cellini called on Primaticcio to make a scene about this commission. The painter behaved as courteously and moderately as the visitor was furious and aggressive. Here is the preamble to the quarrel:

> Having heard that I had been harmed and greatly wronged in this fashion, and seeing myself deprived of a work I had earned with my enormous efforts, I was disposed to commit some serious act with my weapon, and I went swiftly to find Bologna. I found him in his chambers and immersed in his studies: he had me called inside, and with some of his Lombard expressions of welcome he asked me what fine business had brought me there. Then I said: "An extremely fine and important business." The man directed his servants to bring us something to drink, and he said: "Before we discuss anything I want us to share a drink

together: that is the custom in France."[8]

In contrast to the aggressive chauvinism of Cellini, who never missed an opportunity to rail against the French and their barbarity, Primaticcio declared his integration in his adopted country. This difference in attitude was certainly in part responsible for their unequal successes. Thus, upon leaving Primaticcio's house after the altercation, Cellini had a meeting with the king in the presence of the Counsel on the subject of coinage, which fell within his competence. It is clear from his statements that it was his intransigent refusal to take into consideration local conditions that resulted in his being dismissed from the task.

> [And] with His Majesty I discussed the making of his coinage for some time,] about which we were in full agreement, but because his Council was present there, they persuaded him that the coins should be minted in the French style, as they had been minted up to that time. To this I replied that His Majesty had brought me from Italy to execute works that were good, and if His Majesty ordered me to do the contrary, I would never in good conscience agree to do it.[9]

For Cellini, there were no beautiful works outside the habits and practices of his own country.

Serlio: Architect and Theorist

Rather different is the case of Serlio, who was called to France at almost the same time as Cellini. Quite a lot older than Primaticcio and even Rosso, he belonged to the heroic generation of Michelangelo and Raphael, but had not enjoyed as brilliant a career. He was a painter by training, although little is known of his early work, and as an architect he only rarely had the opportunity to build. His primary vocation was scholarship—perhaps out of convenience rather than by choice—and his publications had an enormous impact throughout Europe. In Rome, he was attached specifically to Peruzzi, another painter who collaborated with Raphael and then turned to architecture; he gave definitive form to the antique-style classicism of the Italians.[10] Peruzzi had probably planned some treatise, but he did

not see it through to publication. Serlio got hold of his papers and drawings, and used them to his own advantage; in this sense, he continued Peruzzi's work and the studies of classic antiquity conducted in Rome in Raphael's circle.

After the sack of Rome in 1527, Serlio established himself in Venice, a leading artistic center with Titian as its protagonist, but also home to the Aldine press, which had given an immense prestige to Venetian editions. It was there that he developed his treatise of architecture, an extremely novel work perhaps more in its form than its content, though one must not underestimate the originality of the author's thought. To be sure, he was not an intellectual on the same level as Alberti, who had entirely redefined architectural thought. Still, his personal theoretical

94. Sebastiano Serlio, *Goldsmiths' Chapel: plan*, c. 1550.
Drawing, 22 ⅝ × 15 ¾ in. (57 × 40 cm). Paris: Archives Nationales.

95. Sebastiano Serlio, *Grand Ferrare: plan and elevation*, c. 1550.
Drawing. New York: Columbia University, Avery Library.

96. Sebastiano Serlio, *Ancy-le-Franc: elevation*, around 1550. Drawing.
New York: Columbia University, Avery Library.

contribution was very significant in two domains: he attempted, on one hand, to systematize the ancient orders on which Vitruvius had left a confusing exposé that contradicted the practices of antiquity as they could be observed from Roman ruins; on the other hand, the very idea of dedicating a volume, Book VII, to "accidents," that is to say to integrate into his treatise the practical contingencies of specific cases considerably enlarged the field of architectural thought.

Serlio's originality also resides in his method of presentation, in the coordination of image and text. He adopted a visual approach to architecture. It has often been repeated—indeed, I have done so myself[11]—that his book was more a practical manual or a collection of models than a theoretical work. This is not completely true, but visual effect, or in other words the eye's judgment, plays a role in his work that it certainly did not have in the work of Alberti. In fact, Serlio

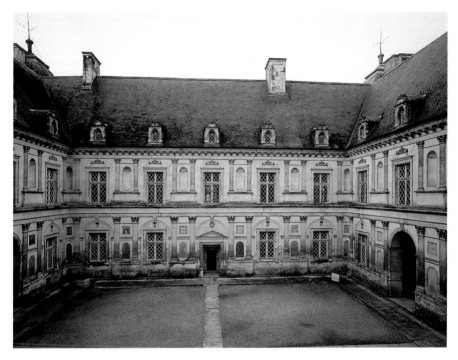

97. Ancy-le-Franc (Yonne, France), château, courtyard façade, 1545–50.

began his scholarly career as early as 1528 by publishing images in collaboration with the engraver Agostino Veneziano, a series of nine burin engravings representing the bases, capitals and entablatures of the Greek orders (Doric, Ionic and Corinthian) with no accompanying text. The original project, known from the letter in which Serlio requested a "privilege" or copyright for its publication, was more ambitious: the text mentions a series including the Tuscan and the Composite orders, plates for which never appeared. This point is far from insignificant: the distinction between the Tuscan and the Doric was one of the stumbling blocks of architectural theory. As for the Composite, it did not figure in Vitruvius; it was audacious to make it a canonical order against the authority of the Roman theoretician (Alberti himself mentioned the Composite but did not give it the status of a separate order).

It is this work on the orders—fully argued and abundantly illustrated with woodcuts—that constitutes the subject of the first volume published by Serlio, the *Quarto libro*. Serlio began his publication not with the first part of his treatise, but in the middle, with the very backbone of his theory: the volume on the orders. He had, of course, read Vitruvius and Alberti, but, following Peruzzi and the Raphael circle, he paid particular attention to archaeological remains. It was on the basis of their authority that he established the Composite order, the legitimacy of which would no longer be questioned. Already in this first publication Serlio announced the overall plan of the work, that was to be divided into seven books, and he applied himself with remarkable persistence to the fulfillment of this program throughout the rest of his life. The architecture of antiquity is the subject of the third book, the *Terzo libro*, which appeared in 1540, again in Venice, bearing a dedication to François I. It was as the representative of antiquity rediscovered that the king of France summoned Serlio to France. Dealing with geometry and perspective, Books I and II were published in Paris in 1545, with a French translation by Jean Martin, as

105

was Book V on temples (that is, religious architecture). Books VI on dwellings (civil architecture) and VII on accidents remained unpublished at the time of his death.[12]

Serlio's stay in France had been a series of frustrations. He bore the title of architect to the king, but for lack of a position in the administration of the Crown's buildings, he was unable to impose his ideas. He did devise a very elaborate project for the Louvre, but in the end, Lescot's was preferred to this (as we will see in Chapter V). It also appears that the goldsmiths' guild of Paris asked him to draw up plans for its chapel. Some of his drawings of an extremely brilliant and forward-looking design have been found (fig. 94). In the end, however, a much more modest and traditional plan was selected, of which he was surely not the author.[13] In Lyon, he was solicited to design a stock exchange that was never built.

Serlio nevertheless had the satisfaction of witnessing the construction of two buildings he had conceived for private individuals. The château of Ancy-le-Franc is the only evidence left standing of his practical talents as an architect, although he had to conform to the constraints imposed by his patron, the count of Clermont-Tonnerre, of which he very gently complained (figs. 96 and 97). In the manuscript for Book VI, he presents a project for Ancy that is quite different from what was built. The château, which is rather well preserved, remains nonetheless a remarkable monument. The plan is simple: a quadrangle with four corner towers in the modernized form of pavilions. On the exterior façades, all the aesthetic effect comes from the harmony of proportions. The much richer decoration of the courtyard—typical of Serlio—with its rhythmic bays and contrasts of polychromatic stones, does not seems to have been what the architect had intended: the manuscript

proposes a more austere elevation. Serlio was apparently more satisfied with the residence he built for the Cardinal of Ferrara at Fontainebleau; unfortunately only the entrance portal remains, but a drawing has survived (fig. 95). Although commissioned by an Italian prelate, the building did not conform to the usual types of palaces or villas on the peninsula. The result is a very novel construction, based partially on French habits but shaped by Serlio's aesthetic demands. Jean-Pierre Babelon has shown that the *"Grand Ferrare,"* as it was called, was a key model for the development of a new Renaissance type of Parisian *hôtel* or urban residence through the intermediary, in particular, of the Hôtel Carnavalet.[14]

There were other undertakings smaller in scope. François Dinteville, the bishop of Auxerre, asked Serlio for a design for the façade of the church of Varzy; no trace of it remains, though it must have been realized.[15] Lastly, our architect mentions his intervention in a château that he calls Rosmarino (perhaps Roussillon on the Rhône).

One must therefore not belittle Serlio's role as a practicing architect, but this is not the essential point, at least in the present context. The French venerated him as a great teacher who had given them access to classic architecture and its principles. In Venice, before even coming to France, he had already instructed Philandrier, who paid homage to him in his learned commentary on Vitruvius. De l'Orme and Goujon readily acknowledged his importance. Though de l'Orme himself had indeed gone to the source around 1535 and visited Rome, Serlio possessed such a thorough knowledge, the result not only of his personal observations but also of the collective experience of the Italian Renaissance, that a visit, even prolonged, was no substitute. Above all, he had managed to give shape to antiquity, to explain it and make it accessible.

Primaticcio: His Career and Role at Fontainebleau

Primaticcio worked in France for forty years. Arriving young to the French court, he integrated seamlessly and served under four successive kings. The painter, whom Vasari considered to be

one of his most eminent contemporaries and whom Félibien saw as the true founder of French art, would deserve a detailed study beyond the admirable work that Louis Dimier dedicated to

98. Primaticcio, *Project for the king's bedchamber*, after Giulio Romano, 1532. Drawing, 11 ⅞ × 30 ¼ in. (30 × 76.8 cm). Paris: Louvre.

him a century ago. Our concern here can only be to define his role in the development of a classicizing art in France and because of this, I will focus especially on his activity in the last years of the reign of François I.

We know Primaticcio primarily as a draftsman. Whereas all the drawings by Rosso for the decorations of Fontainebleau have disappeared, those of Primaticcio have come to us in rather large numbers.[16] They allow us today to follow the artistic evolution of the master from his beginnings at Fontainebleau, where he remained faithful to the manner of Giulio Romano. At the time he preferred to draw with pen and wash; later, red chalk highlighted in white became his technique of choice, and he practiced it with a virtuosity that rivals even Parmigianino's. Primaticcio proved to be a tireless and prolific inventor in a supple graphic language, showing admirable ease and great naturalness even in extreme artifice.

Having come to France slightly after Rosso, he was able to establish himself at his elder's side. Vasari is unambiguous: "although, as has been said, Rosso, the Florentine painter, had gone the previous year into the service of this same king and had executed quite a few pieces for him, [...] nevertheless, the first stuccos made in France and the first works in fresco of any consequence had, they say, their origin in Primaticcio."[17] If Vasari is so insistent about this priority and also gives the precise year, 1544, when Primaticcio received

the abbey of Saint Martin of Troyes, it is because these points were particularly important to the artist himself, who must have passed on the information during an encounter in Bologna in 1563. Archival documents confirm Vasari's assertions. The first important ensemble, executed before even the Galerie François I at Fontainebleau, the king's apartment, no longer in existence, was indeed entrusted to Primaticcio.

It may seem surprising that, for this task, the king turned to him rather than Rosso. Though a brilliant executant, he had virtually no experience as an inventor, even if he was already an admirable draftsman. But in fact, as we now know, he arrived at court as the representative of Giulio Romano, armed with a project conceived by his master. This is in any case the prevailing understanding of an important drawing that has received a wide range of interpretations (fig. 98).[18] Although the sheet bears the name of Giulio Romano in a sixteenth century script, it is in all likelihood drawn not by him but instead by Primaticcio whose hand is recognizable in the handwritten notes. However, all the motifs were indeed designed by Giulio Romano. It has now been established—as Sylvie Béguin has shown—that the drawing was a definitive project for the king's chamber.[19] The wall is punctuated by large herms and features two framed tableaux of the story of Psyche. As these subjects were not, to the best of our knowledge, used anywhere else in Giulio's works, we can suppose that

Primaticcio did not simply reuse drawings by his master intended for another purpose, but instead that he arrived at Fontainebleau bearing a project conceived by Giulio Romano specifically for the king of France.

The decor, which we can reconstruct from texts and graphic documents, was surely of quite a different character than the gallery: the gilded stuccos, the slightly insistent classicism displayed more wealth and less vitality. However, an original formula was apparent: the alternation of stuccos in high relief with paintings, all placed above a high wainscoting. There was nothing similar at the Palazzo del Te in Mantua. In the decorations of Giulio Romano wood plays no role, and though there are indeed stuccos at Mantua, some executed by Primaticcio himself, they are in low relief, in the manner of antique works. It is completely unlikely that these innovations specific to Fontainebleau had their origin in Giulio Romano; in all likelihood they resulted from an adaptation to the local conditions and French habits. In particular, it is not clear that the drawing necessarily implies the combination of stuccos and painting. Giulio Romano was in the habit, in comparable decorative schemes, of rendering relief in painting. Nothing in the drawing suggests the presence of paneling, whereas woodwork had long played an essential role in interior decoration in France. Was Primaticcio alone responsible for the adaptation of the project that he had brought? This is uncertain. Rosso had already been interested in stucco in Italy and could well have been consulted about the king's chamber, even if he was not directly in charge of the project. Be that as it may, Vasari's text allows us to believe that Primaticcio considered it within his rights to claim a major part in the development of the new decorative system invented at Fontainebleau.

Dimier clearly defined the two artists' respective situations. Each had his own team and Primaticcio did not work under Rosso. Yet as the younger man—less experienced and without a well-established reputation—he was paid less and definitely ranked second. The two artists had very different upbringings and temperaments. Primaticcio had received a very classicizing and Romanizing version of the Raphaelesque tradition with Giulio Romano in Mantua, whereas Rosso was typically Florentine—thoroughly anticlassical, at least in his early years, and always drawn to the bizarre and the enigmatic. Primaticcio comes across as an adaptable man, conciliatory and diplomatic, and gifted with an exceptional power of assimilation comparable to that of Raphael himself. In six years at Mantua, he became Giulio Romano's most important, or at least highest paid, collaborator. Nevertheless, his contribution is completely lost within his master's work. Despite numerous efforts to identify his hand here and there in the decorations of the Palazzo del Te, nothing clearly emerges and only Vasari's, certainly authoritative, testimony enabled Dimier to attribute to him the frieze in the Room of Stuccos.[20]

Between his arrival and 1540, Primaticcio was able to capitalize on his experience, to grow in authority and to devise a manner of his own. He learned more at the side of Rosso than the contrast between their artistic personalities would lead one to believe. Tending more toward grace than strength of expression, he quickly discarded all that was grating in the art of Giulio Romano, and retained the sensual side of Rosso over the fantastic. At the time of the Florentine's death in 1540, he was ready to show what he was made of. The last seven years during the reign of François I were probably Primaticcio's most productive and the most intense for the Fontainebleau site. Later on, the death of the king in 1547 would mark a shift in the artist's situation. Fontainebleau ceased to be the uncontested center of the art of the court. At the same time, Henri II appointed Philibert de l'Orme to the superintendency of the king's buildings. This post, traditionally occupied by an administrator, passed for the first time to a professional, giving unprecedented importance to the architect. More generally, the era witnessed a wave of nationalism. The young poets of the Pléiade, then taking their first steps, made their position clear in this regard. The Italians lost their authority. This did not mean that Primaticcio ceased to produce. Less sought after for various tasks, he could dedicate himself more assiduously to his work as a decorative painter. A good part of the Galerie d'Ulysse (Gallery of Ulysses), his most extensive work, dates, I believe, to these years, and the entire Ballroom was executed under Henri II.

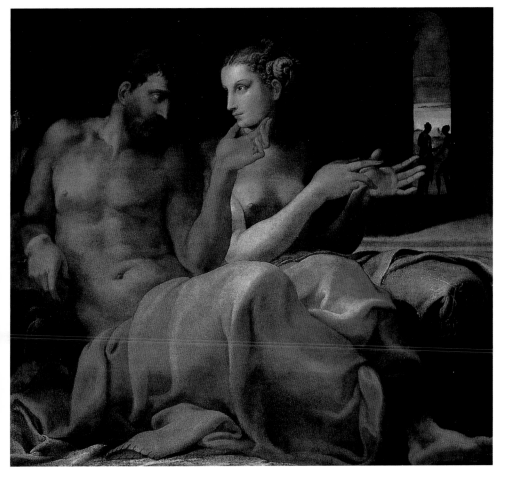

99. Primaticcio, *Ulysses and Penelope*, c. 1560. Oil on canvas, 44 ⅞ × 48 ⅞ in. (114 × 124 cm). Toledo, Ohio: Museum of Art.

With less work from the king, Primaticcio could during these years also work for other lofty patrons, in particular for the House of Guise.[21] For the cardinal of Lorraine, he conceived and decorated a retreat at Meudon, a kind of *folie* or country house that was ahead of its time: the "grotto of Meudon." The tomb of the Duke and Duchess of Guise at Joinville was executed under his direction. Again for the Guises, he built and decorated a chapel at their Parisian *hôtel*. All the painted decoration—the ceiling, the arching, and even the altar—comprised a great, unified fiction representing the Adoration of the Magi. Primaticcio was obviously pushing his Emilian taste for illusionism

to its limits, knowing that he would be well served for the final execution by Niccolo dell'Abbate. The latter was himself a master of the genre before coming to France, as his decorations at the Palazzo Poggi in Bologna still demonstrate.

After the death of Henri II, Catherine de Médicis took on an important role in government; favor returned to the Italian master and, with it, increased responsibilities in an era ever more troubled by religious conflicts. The digging of a moat around the Cour du Cheval Blanc at Fontainebleau for reasons of security was one of the Primaticcio's numerous tasks: this makes it quite clear that the problems and anxieties of the moment had

compromised the great cultural vision of preceding reigns. Nevertheless, Primaticcio continued to practice his art with the same brilliant inventiveness. Entrusted in his turn with the direction of the king's buildings, he had to intervene in many projects and was particularly sought after as an architect. The superb Aile de la Belle Cheminée at Fontainebleau remains the principal evidence of this activity. He designed the tomb of Henri II, the monument of his heart and also in all likelihood the funeral chapel intended to contain the grave of the last of the Valois at Saint Denis (fig. 410). Towards the end of his career, Primaticcio found in Germain Pilon, whose talent rivaled or exceeded that of Niccolo dell'Abbate in painting, a sculptor capable of realizing his intentions with as much virtuosity as feeling. The painted works of these years were reprises rather than new projects: the completion of the Galerie d'Ulysse and new compositions for the chamber of Madame d'Étampes when it lost some of its windows, blinded by the Aile de la Belle Cheminée. For some unknown reason, he was also asked to execute new frescoes in the king's chamber, the story of the Trojan War replacing that of Psyche, so that at the very end of his life, Primaticcio had the opportunity to rejuvenate what had been his first work at Fontainebleau.

Constantly occupied in his capacity as a decorator, then later as an architect and administrator of royal patronage, Primaticcio painted, it seems, only a few easel paintings and altarpieces. A supposed self-portrait at the Uffizi in Florence is difficult to judge because of its condition and has never provoked much enthusiasm. There is general agreement—albeit with some reservations—as to the attribution of two paintings. The *Holy Family* kept in Saint Petersburg, dating to around 1540, displays a sharp sensibility and diverse affinities: the influence of the school of Raphael, as well as that of Parmigianino and of Rosso, is apparent.[22] *Ulysses and Penelope* in the Toledo Museum (Toledo, Ohio), which partially repeats the composition of a fresco from the Galerie d'Ulysse at Fontainebleau, dates from about twenty years later (fig. 99). Although worn, the picture remains impressive. Is it truly by Primaticcio's hand? It is difficult to decide for lack of points of comparison. All this makes for a rather meager harvest.[23] Besides, there are no commissions or mentions of easel paintings in period documents to suggest the existence of lost works.[24] It has been claimed that Primaticcio painted a portrait of François Dinteville, but the artist's letter on which this hypothesis rests may only refer to a drawing.[25] The composition of the *Mystic Marriage of Saint Catherine*, engraved by Giorgio Ghisi, which is in the same vein as the Saint Petersburg *Holy Family*, may preserve the memory of a lost panel, but again this is uncertain.

Primaticcio was a decorator even more exclusively than his master Giulio Romano or Raphael, who both produced a good number of easel paintings and altarpieces. Responsible mainly for mural painting, he was content to invent and entrusted the execution to his assistants. Like his predecessors, he extended his activity to architecture and the direction of all decorative work. There is hardly any question that he reproduced the type of artistic dictatorship that Giulio Romano had established at Mantua, on the model of Raphael's atelier, that he had inherited. The genius of Raphael, indeed, had consisted in part in extending his action in an extraordinarily effective manner by establishing a new kind of studio organization and discipline that multiplied his power of execution. He was not, of course, the first painter to have assistants, but the new awareness, around 1500, of artistic personality as a value had changed the situation. This new factor had transformed the conception of the atelier: the members were no longer apprentices assisting the master, but rather extensions of himself.

So few of Primaticcio's decorations have survived and they are in such poor condition that it is almost impossible to assess the quality of execution, especially with regard to the works that predate the arrival of Niccolo dell'Abbate. As concerns painting, Primaticcio seems to have placed his trust almost exclusively in this exceptional executant, to whom he gave considerable leeway. But prior to Niccolo's arrival, he directed an entire team of unequally gifted painters and it certainly fell to him to impose the control that he himself had learned to respect under Giulio Romano. This went of course for the stucco as much as for the painting. Rosso had not had this type of experience and must have benefited from Primaticcio's example. It is this above all, I believe, that gives weight to the fact

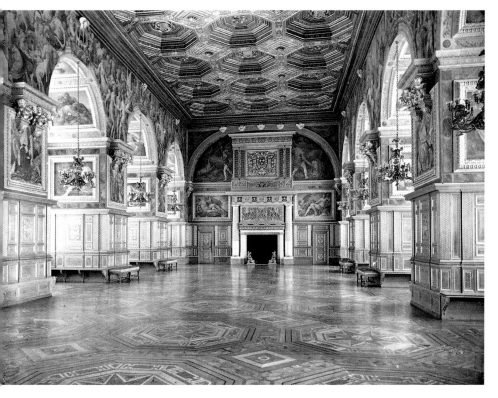

100. Fontainebleau (Seine-et-Marne, France), château, ballroom. The decoration dates from 1552–56.

that the first decorations at Fontainebleau were Primaticcio's. He was able, before Rosso, to establish a working discipline on the site that allowed the imprint of the master's personality to be vastly extended by means of a homogenous and rigorously supervised execution.

After the reign of François I, Primaticcio's manner became more animated and his conception of space more complex. The artist distanced himself from the classicizing style of the 1540s in favor of a more intense style of art that was more difficult to popularize. It is not impossible that the arrival of Niccolo dell'Abbate in 1552–53 played a role in this stylistic change, by reinforcing the Bolognese artists' memories of Correggio and Emilian art.[26] Primaticcio's lyricism had already intensified in the Ballroom (fig. 100). The interior space of the room had a scale not found in earlier constructions at Fontainebleau. Philibert de l'Orme, who completed the work, designed a coffered

ceiling (instead of the vault intended by Le Breton) and high wainscoting. Scibec de Carpi, who had already proved himself in the Galerie François I, executed all the woodwork in a very classical manner. A large chimney decorated on both sides with bronze satyrs cast after antique models rounded out the architectural decor conceived by Philibert. Above the paneling, the painter was left to complete the large spandrels, the back of the musicians' gallery and the deep vaulted embrasures of the large semicircular bays. In the embrasures, Primaticcio placed tableaux in stucco frames— rather simple compositions with one or two figures. The spandrels and the back of the musicians' gallery featured more complex compositions with readily recognizable mythological subjects, such as Philemon and Baucis, but the overall program still awaits a satisfactory interpretation. Although the frescoes were irreparably damaged, the grandeur, the ease, and the lyrical inventiveness

101. Primaticcio, The *Nile*, project for the Galerie d'Ulysse, c. 1545–47. Pen and ink wash, white heightening, 7 ⅓ × 10 ⅔ in. (18.7 × 27 cm). Paris: École Nationale supérieure des Beaux-Arts.

102. Primaticcio, *Ulysses and Telemachus attacking the suitors*, project for the Galerie d'Ulysse, 1556–60. Red chalk with white heightening, 9 ½ × 13 ⅓ in. (24 × 33.9 cm). Vienna: Albertina.

103. Primaticcio, *Ulysses and Penelope*, project for the Galerie d'Ulysse, 1556–60. Red chalk with white heightening, 10 × 13 in. (25.5 × 33 cm). Stockholm: Nationalmuseum.

104. Primaticcio, *Ulysses and the Sirens*, project for the Galerie d'Ulysse, 1556–60. Red chalk with white heightening, 9 ¾ × 13 ¼ in. (24.7 × 33.7 cm). Vienna: Albertina.

characteristic of Primaticcio still come through in an impressive fashion, as does, to some extent, the vividness of Niccolo dell'Abbate's brushwork.

The Galerie d'Ulysse was the most celebrated work of Primaticcio.[27] Approximately the same width as the Galerie François I, it was two and a half times longer, at around five hundred feet, and occupied the entire south wing of the Cour du Cheval Blanc on the second floor. The decoration of this interior promenade was undertaken under François I, whose reign saw the completion of about half of the vault, decorated with mythological and allegorical scenes inserted into a network of grotesques according to the system developed

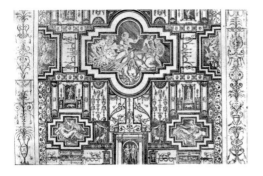

105. Jacques Androuet du Cerceau, *Panels of grotesques inspired by the vault of the Galerie d'Ulysse*, 1566. Etching, 6 ¼ × 9 ⅞ in. (15.9 × 24.9 cm). Paris: Bibliothèque Nationale de France, Ed. 2 g.

Primaticcio at the End of the Reign of François I (1540–47)

When Rosso died on November 14, 1540, Vasari informs us that Primaticcio was away. François I had sent him to Rome to bring back various antique works. His movements are difficult to pin down precisely, but we know that he journeyed there several times in the years 1540–47.[29] Classical antiquity was the principal object of his voyages, which furthermore allowed him to reconnect with his Italian heritage and to bring himself up to date with artistic developments on the peninsula. It is more or less certain that he passed through Mantua, that he looked at Giulio Romano's latest decorations and that he even brought back new drawings from his old master. He probably also visited Parma, and Blunt has rightly remarked that his voyage coincided with a more thorough knowledge of Parmigianino.

by Raphael. It was only much later, after the completion of the Ballroom, around 1555, that the walls received sixty tableaux from the story of Ulysses taken from Homer. His adventures unfolded from east to west on the north wall and continued in the opposite direction on the south wall. To avoid monotony in such a long series was a veritable tour de force. A set of rather mediocre prints etched in the seventeenth century by a student of Rubens, van Thulden, and a good number of the marvelous original drawings give us an idea of the variety and liveliness of these compositions (figs. 101, 102, 103, 104). More contorted figures, more elaborate and strained spatial constructions than Primaticcio had previously conceived, enabled him to sustain the viewer's attention.

This brilliant art had an impact considerably later, under Henri IV, when Toussaint Dubreuil, in particular, turned in this direction to revive decorative painting. And later still, in the middle of the seventeenth century, the Galerie d'Ulysse would, according to Poussin, be a veritable school for painters. It was then that the entire cycle was reproduced in prints.[28] However, from the perspective of the renewal of art in the middle of the sixteenth century, it had few immediate repercussions and it was the preceding phase in Primaticcio's oeuvre that was decisive. We must therefore focus on this period to conclude the chapter.

106. Antonio Fantuzzi, *Ancient Statue*, after Primaticcio, 1543–45. Etching, 8 ⅔ × 3 ¼ in. (22 × 8.1 cm) (for the figure). Paris: Bibliothèque de l'Arsenal.

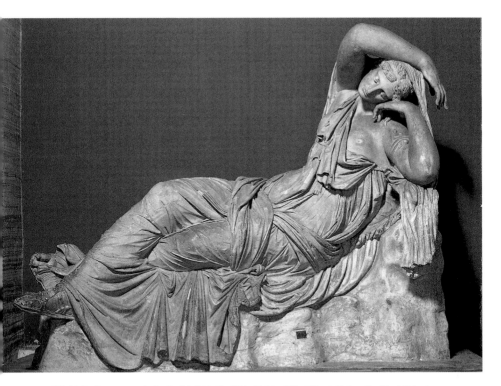

107. *Ariadne*, Roman copy of a Greek original. Marble, 63 ¾ × 76 ¾ in. (162 × 195 cm). Vatican City: Musei Vaticani. Note that the statue's pose is significantly altered in the Fontainebleau version, despite the fact that it was cast from it.

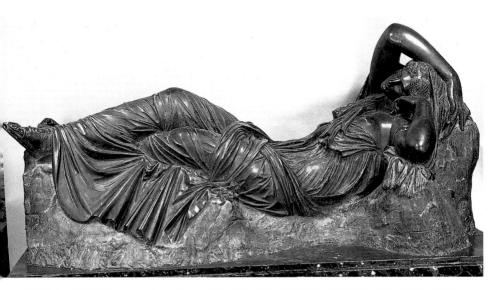

108. *Ariadne*, 1540–47. Bronze cast made under the supervision of Primaticcio, 44 ⅞ × 94 ½ in. (114 × 240 cm). Fontainebleau: château.

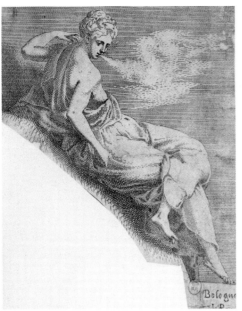

109. Léon Davent, *Polyhymnia*, after Primaticcio, c. 1543.
Etching, 86 ⅔ × 68 ½ in. (220 × 174 cm).
Paris, Bibliothèque Nationale de France.

110. Benvenuto Cellini, *Victory*, 1544–45. Plaster cast with patina,
54 × 54 ¾ in. (137 × 139 cm). Paris: Louvre.
The bronze original disappeared in the nineteenth century.

In Rome, he clearly paid attention to recent decorative works. While enriching his experience, this renewed contact could only have made more apparent to the artist the originality and merit of his work at Fontainebleau. Yet the essential gain of these repeated visits to Rome was the new sustained and attentive examination of classical antiquity that his mission required. In Rome, Primaticcio was not content to collect a few antique works; he also designed numerous statues. We still have as evidence several drawings and an entire series of etchings by Fantuzzi and Léon Davent, executed between 1543–45, which reproduce Primaticcio's drawings (fig. 106).[30] These interpretations show a spontaneity and fluidity in the draping, a slightly languid grace very revealing of Primaticcio's vision of antique art.

The most important and original aspect of the artist's mission to Rome was to oversee the molding of the most celebrated works of antiquity: the *Laocoön*, the Belvedere *Apollo*, the *Ariadne* (then known as the *Cleopatra* because of the snake that encircles her arm), the *Venus of Knidos*—in all ten masterpieces including the reliefs of Trajan's Column and the horse of the equestrian statue of Marcus Aurelius, the plaster copy of which gave

its name to the Cour du Cheval Blanc.[31] The molds, carefully packed in crates, were dispatched to Fontainebleau. In their preparation, Primaticcio was assisted by the young Vignola, a Bolognese like himself, destined to become the most influential architect of the end of the century; he was summoned to Fontainebleau to collaborate on the casting of the bronzes. The five that remain allow us to appreciate the results of all this enterprise. Although they are casts of ancient works, the statues are the result of an important process of adaptation, from the preparation of the molds up to the extensive repairs to the bronze, the casting of which was imperfect. In the case of the *Ariadne*, even the articulation of the figure was transformed (figs. 107 and 108). These superb bronzes have at times been judged severely; their value seems better recognized today. In any case, it was a difficult and costly undertaking, conducted with the greatest of care, which tells us how deep was the passion for antiquity.

One recalls that, according to Cellini, his enemies—Primaticcio's supporters—had attempted, in vain of course, to denigrate his *Jupiter* by confronting it with these casts. Though the fact is improbable, there is a grain of truth to the fantasy.

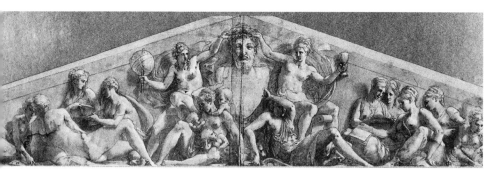

111. Primaticcio, *Pediment with the bust of François I*, 1540–47. Pen and brown wash with white heightening. 8 ⅓ × 26 ¾ in. (21.2 × 68 cm). St. Petersburg: Hermitage.

It could be said that at that precise moment, Primaticcio had fully espoused antiquity in order to turn Fontainebleau into "a new Rome," according to Vasari's well-known expression. It was, of course, Primaticcio's own antiquity, flexible, fluid, now nervous, now languid, but always gracious. Cellini, very Florentine and a follower of Michelangelo, kept his distance from antiquity. His *Nymph of Fontainebleau* and even his saltcellar contain an element of violence and ferocity, which evokes the *terribilità* of the master. This stands in sharp contrast to Primaticcio. It is interesting in this context to examine the Victories that Cellini had intended for the Porte Dorée at Fontainebleau (known today only from casts). They refer, quite obviously, to various antique models such as the arch of Septimius Severus, and Primaticcio had certainly drawn from the same sources. But the difference is striking. Despite some fluidity in the drapery hugging the body and the nervous inflection of the hips, Cellini's composition is almost rigidly geometrical. The body, far from espousing the curve of the spandrel, is rectilinear and forms a very pronounced obtuse angle with the torch. The effect is highlighted by the contrast with the wind-blown drapery that fills out the spandrel in an almost perfect circle. These figures of a crystalline hardness are ostentatiously artificial. Primaticcio's attitude was entirely different, as is shown by the twelve figures—muses and goddesses—conceived for the spandrels of the Galerie Basse, known from several original drawings and a series of etchings. They possess as much malleable ease as Cellini's Victories do geometrical rigor (figs. 109 and 110).

Time has been particularly hard on the decorative work from Primaticcio's most productive years; all that remains is the chamber of Madame d'Étampes, and even that has been disfigured by its transformation into a stairwell. The paintings of the Porte Dorée were so damaged that they can almost be considered modern reconstructions. The bathhouse has completely disappeared. The king's cabinet, the Galerie Basse, the vestibule of the Porte Dorée, the decoration of the grotto of the Jardin des Pins, and a large part of the vault of the Galerie d'Ulysse, as well as other decorations whose location escape us, all belong to these years. Several compositions known from engravings by Léon Davent, such as *Rebecca and Eliezer* (fig. 112), certainly reproduce paintings from the château, although their destinations are unknown.[32] Was the "large female figure" for which Primaticcio had prepared a mold expected to be cast in bronze and placed on one of the doors of the château?[33] What was the purpose of the large and admirable drawing in the Hermitage (fig. 111)?[34] The idea was probably to execute this pediment in stucco. It is amazing how close Primaticcio came in such a work to the feeling of classic Greek art, although he only knew Roman copies. The subject is hard to make out. The nine figures that occupy the outer sections are probably the Muses. The four that crown and support the bust of François I are more disconcerting. On the right, Faith is easily recognized above Diana; the combination is surprising but well within the taste of the period and in the spirit of humanist efforts to reconcile classic antiquity and Christianity.

112. Léon Davent, *Rebecca and Eliezer*, after Primaticcio, c. 1543–44.
Etching, 11 ⅔ × 10 ⅔ in. (29.5 × 27 cm). Paris: Bibliothèque Nationale de France, Da 67.

The other side is more problematic still. If the woman surrounded by children immediately brings to mind Charity (and the idea is necessarily implied), her position is incomprehensible as a pendant to Diana. It has been suggested that she may be viewed as Venus, the mother of love, so could these be wingless cherubs? The subject may be a fertile divinity in contrast to the chaste Diana. Above this, does the woman holding an armillary sphere embody Astronomy? One would have expected Science instead as a pendant to Faith. The drawing in any case preserves an ambitious and original project, but one would be hard pressed to say whether or not it was ever carried out.

The grotto of the Jardin des Pins is today but the shadow of its former self. The interior retained nothing more than a few indecipherable remnants of the original decoration before it was entirely restored in recent years. The façade on the garden still preserves its rusticated atlantes that barely emerge from the squared blocks (fig. 114), and there we can still appreciate what Primaticcio owed to Giulio Romano and the way in which he tempered and lightened the somewhat brutal fantasy of his master.[35] It is difficult to form an idea of the interior, but the play of natural elements, aragonite, and shells, the frescoes where mythological figures were seen *di sotto in sù* against the sky, certainly produced the same strange and enchanting effect as the façade.

The number and variety of the projects carried out in those few years must be stressed. An entire vast palace found itself suddenly transformed, and a constant preoccupation with antiquity comes through in all of these works. The memory of the celebrated baths of antique Rome must have played, as we will see, an important role in those of Fontainebleau. The vault of the Galerie

113. Léon Davent, *Apelles painting Alexander and Campaspe*, after Primaticcio, c. 1544.
Etching, 13 ½ × 9 ½ in. (34.1 × 24 cm). Paris: Bibliothèque Nationale de France, Da 67.

d'Ulysse marks, in relation to Rosso's gallery, a clear return to classic sources—to antiquity viewed through the atelier of Raphael—because it was indeed in its grotesques that the Renaissance took most closely after Roman art. This system of decoration, of which Androuet du Cerceau in particular produced numerous engraved models, enjoyed huge, long-lasting success in mural decoration and in all ornamental art in France.[36]

Faith in antiquity was one of the great themes of the middle of the century. At the end of his life, the humanist Guillaume Budé had partially renounced the classical studies that he had so magnificently promoted, or at least he had warned against the danger they could pose to Christian faith. But the younger generation would embrace antiquity more fervently than ever and, in France, there was a turn specifically towards Greek culture, the culture that the puritans of ancient Rome already regarded as dangerous and corrupting. The poets of the Brigade, with Ronsard at their head, took their worship of antiquity to great lengths, as evidenced by the astonishing procession in which they walked a goat garlanded with ivy through Arcueil to offer it to Jodelle on the occasion of the triumph of his tragedy *Cleopatra* in 1553. Ronsard evokes this masquerade in the *Dithyrambes a la pompe du bouc de Jodelle poëte tragiq.* with an exuberant excess of archeological fantasy.[37] Before the poets, however, the artists had already brushed in the decorations.

114. Fontainebleau (Seine-et-Marne, France), château, façade of the grotto of the *Jardin des Pins*, 1540–43.

Despite extensive losses, the chamber of Madame d'Étampes still gives us an idea of the monumental decoration that Primaticcio conceived in these years (fig. 115). The contrast between the relaxed elegance of this room and the rather frenetic splendor of the Galerie François I is glaring. The stuccos have become more strictly ornamental; the large figures of slender women, the *putti*, and the garlands are repeated with slight variations and punctuate the decor with a clear and simple rhythm. The formal organization corresponds to an equally limpid iconographic style. Primaticcio abandoned Rosso's inextricable mélange of painting and stucco, of narrative subjects and framing devices, for something easier to grasp. As we saw in the preceding chapter, the episodes in the life of Alexander, most of which concern heroes' relationships with women—Campaspe, Roxane, and Thalestris—are perfectly suited to the chamber of the king's official mistress. The sculpted framing is not devoid of meaning, but its semantic density is weak: the large nudes glorify feminine beauty and the children and flowers evoke abundance and pleasure; the stuccos establish the tone or mood of the decor

without entering into competition with the frescoes. What emerges from the ensemble is a cultivated hedonism, at once sophisticated and playful. It is without a doubt the most instructive example of how decoration allowed the court to live out its mythology. The handling of forms plays an important part: the subtle variation of ideal types, an intentionally artificial character, everything works together to create an atmosphere completely distinct from ordinary living conditions. The setting itself suggests a way of living and a self-expression that sought to be stylized, ritualized. To what extent did reality submit to this ideal of life? To what extent was it a conscious adaptation in antique style of late medieval *courtoisie*? A little later, under Henri III, the sense of "distinction" would certainly be highly developed and we know that Catherine de Médicis placed enormous importance on etiquette. But had the same been true under preceding reigns? The *Princess of Clèves*, a novel by Madame de Lafayette in which feelings themselves are so completely stylized, imposed an image of the court of Henri II that reflects perhaps as much a seventeenth century ideal as the sixteenth century

115. Fontainebleau (Seine-et-Marne, France), château, bedchamber of Madame d'Étampes, 1541–44.

reality. Under François I, manners were surely much less refined than in the age of his successor.

Despite its often ribald and sometimes even slightly unsophisticated behavior, as well as a protocol still lacking in rigor, the French court of the Renaissance remained, in the consciousness and imagination of subsequent generations and for a long time thereafter, the model of court life formed the image of a way of being different from the ordinary—formalized, poetic, one might say affected—of a veritable art of conduct. The song of the poets contributed largely to this persistent image. But these poets were those of the Pléiade, that is to say, a literary phalanx that manifested itself only with the reign of Henri II. Under

François I, Clément Marot, the court poet, chose a deliberately familiar tone. Antoine Héroët and others continued the sophistication and the convoluted feelings of an earlier courtly tradition, but their verbal art was not sufficiently powerful to be remembered. On the other hand, the decor of Fontainebleau was essentially in place by 1545. Therefore, during the reign of François I artists had already created the visual environment that was one of the necessary conditions to make the French court a living myth. In this sense Primaticcio contributed decisively not only to the history of decoration, but also to the formulation of a model of aristocratic living that was to haunt the following centuries.

121

116. Juste de Juste, *Nude man*, c. 1543. Etching, 7 ⅔ × 3 ¼ in. (19.4 × 8.3 cm).
Paris: Bibliothèque Nationale de France, AA 1 rés. (Viset).

Chapter IV

THE LESSONS OF FONTAINEBLEAU

Must we still speak of a school of Fontainebleau? What does the phrase mean? What lessons did the French take from the examples set by the Italians whom François I had summoned to his favorite residence? This more general question necessarily runs throughout the present volume. The pages that follow must confine themselves to a more specific question: can one define some kind of coherence among the collaborators and imitators of Rosso and Primaticcio? It is not always easy, however, to separate the two sides of the issue.[1]

Louis Dimier neatly distinguished two phases in what could be called the school of Fontainebleau. The first revolved around the meeting of artists of very diverse tendencies at the worksite: "A school if you like, provided that this signifies nothing more than a studio where their work intermingled." In the second period, the younger artists would synthesize these tendencies. "From this mélange was born, it is true, a style whose uniformity of traits justifies the use of the named school, but it was only later and through the work of a second generation in which the divergent teachings of the masters merged."[2] We must, however, keep in mind that the nineteenth century often confused the works of Primaticcio and Rosso, indicating that it was at one time possible to sense a great coherence within the work site of the château, though this may surprise us today.

It remains crucial to draw as effective as possible a distinction between the art of Fontainebleau in the strict sense, and the very diverse and poorly defined phenomenon that has been baptized the "school of Fontainebleau." Having become hugely fashionable, this unattested appellation now covers the most disparate works, some of which have almost no connection at all to the art of Fontainebleau. It is no less true that the decoration of François I's palace had an immense impact, thanks in particular to prints. The two known painted versions of the *Nymph of Fontainebleau*, both executed after a famous engraving, are characteristic of the way that forms created by the king's artists were taken up throughout much of Europe (fig. 117).[3] In this case, the process of derivation breaks down into two stages. The invention of the motifs was clearly intended for Fontainebleau: the decorative framing is that of the central bay of the Galerie François I and, though the origin of the nymph itself still escapes us, it must indeed be sought at Fontainebleau according to the inscription on the print itself. On the other hand, Parisian artists were responsible for the engraving: Pierre Milan, who began the work, and René Boyvin, who completed it in 1554 (fig. 118). The technique—elegant but a little cold—pertains to an aesthetic that is not exactly that of Fontainebleau. As for the paintings, which relate to Fontainebleau only insofar as they repeat the motifs of the print, their origin is unknown and it is not even certain that they were made in France.

The notion of a school of Fontainebleau has a much more rigorous application if it is limited to artists, some of them French and others from Flanders and elsewhere, who learnt from the decorators summoned from Italy at the king's demand. Several of the artists who worked at the château left the site to pursue an independent career, particularly when the pace of work slackened after the death of François I in 1547.

Of course, both phenomena—the diffusion of Fontainebleau forms through prints and the training of artists as they worked—reinforced one another. The art of Fontainebleau thus played a

117. Anonymous, *Nymph of Fontainebleau*, second half of the sixteenth century. Oil on canvas, 26 × 47 ¾ in. (66 × 121.3 cm). New York: Metropolitan Museum of Art.

primary role in the development of classicism in France. Twentieth century taste favored the most exaggerated expressions of Mannerism and the name "school of Fontainebleau" was often given to works with excessively elongated and languid forms, like the rather disparate paintings once grouped under the arbitrary name Master of Flora.[4] The concept of Mannerism—so important to modern criticism and notably to the renewed taste for Fontainebleau art—designates a style in opposition to the classicism of the Italian Renaissance embodied above all by Andrea del Sarto in Florence and Raphael in Rome. Such a concept is definitely useful and legitimate within a history of Italian painting.[5] To French eyes, however, Primaticcio was Raphael's successor.

118. Pierre Milan and René Boyvin, *Nymph of Fontainebleau*, after Rosso Fiorentino, prior to 1553. Engraving, 12 ¼ × 20 ¼ in. (31.1 × 51.4 cm). Paris: Bibliothèque Nationale de France, Ed 3.

Giulio Romano, the favorite student and heir of the master, too busy in Mantua to relocate, chose Primaticcio to bring the Raphaelesque tradition to François I. If in Italy Rosso definitely cut the figure of an anticlassicist, in France, he surely appeared not as a somewhat violent rebel, but as the highly cultivated artist that indeed he was and the herald of classical principles that he understood and mastered even if he had contested them. A sufficient familiarity with these principles on the part of amateurs, as well as the artist, was required to understand the license he took. This is why the implications of Rosso's art were very different in France and Italy, and the inflection of his style at the court of François I betrays his sensitivity to his new environment.

The Role of Prints

It was, it seems, to prints that the term school of Fontainebleau was first applied, and this was only fitting.[6] It was printmaking that capitalized, so to speak, on Rosso's art and extracted from it an ornamental language that it passed on to all sorts of artists and craftsmen. It contributed no less effectively to the diffusion of the classicizing manner of Primaticcio and his circle.

Vasari had already been struck by the publication of Rosso's French works and it would be impossible to comprehend the importance of the Galerie François I to sixteenth century art without the role played by prints. Two aspects must be considered: first, prints spread knowledge of Rosso's art and are for us a documentary source on the gallery and its genesis; second, they give us information as to how the work was understood, interpreted, exploited, and betrayed. Because of technical conditions, publication immediately broke the integrity of the model. The engravers performed a sort of dissection on it, a veritable dismemberment, and it was the fragments that they spread far and wide.

Most of the prints that disseminated the art of Fontainebleau in the sixteenth century fall into two distinct groups: the first relates to a very active graphic studio that was in operation at Fontainebleau even if only for a few years, approximately from 1542 to 1548.[7] A few of its artists were known by name: in particular Antonio Fantuzzi, one of the painters employed in the decoration of the château under the direction of Primaticcio; Jean Mignon, also employed as a painter at the château; and Léon Davent. Others marked some plates with monograms. It is difficult to say how many artists were active in the studio, which primarily produced etchings. The second group, composed of engravers settled in Paris, was marked by the personalities of Pierre Milan and René Boyvin. Unlike that of Fontainebleau, their production continued for many years. It began in 1540 or thereabout and lingered at least until around 1580. The two groups of prints differ clearly in their style.

The practice of etching at Fontainebleau is a surprising phenomenon. In a few years, from 1542 on, a mass of prints appeared that had a particular character and a technique that was still rare if not entirely new. Most of the Fontainebleau etchings were rapidly executed, if not to say botched. The drawing is brisk, sometimes summary and even brutal—obviously the work of occasional etchers who were not professional printmakers. The impressions were irregular, often from poorly wiped plates. The tint of the ink varied greatly; the proofs in red and bistre clearly indicate that this was a matter of experimentation and not simple negligence. What is clear is that the production was abundant, apparently without much commercial concern, particularly during the years 1542–45. After that point, things seem to have changed somewhat: the prints, probably published in smaller numbers, became more painstaking. Certain engravers may have left Fontainebleau in order to settle in Paris. It is very difficult to determine when production ceased at Fontainebleau itself, but it probably did not go on very long after the death of François I. Primaticcio could not have been a stranger to this venture, as he must have controlled the circulation of a good number of the

119. Antonio Fantuzzi, *Pietà*, after Rosso Fiorentino, c. 1543.
Etching, 11 ⅔ × 13 ½ in. (29.7 × 34.2 cm).
Paris: Bibliothèque Nationale de France, Ba 12.

drawings that served as models to the printmakers—his own of course, but surely also those of Giulio Romano that Fantuzzi exploited extensively, and perhaps also those of Rosso. The repertoire of Fontainebleau printmaking was restricted to these artists, at least in the first years, until around 1545; after that, Luca Penni would play a dominant role.

The engravings made in Paris, on the contrary, were carefully executed, with regular and elegant cuts. The contours were firmly outlined. This craft that had something of a cottage industry could be taught so effectively that it was impossible to distinguish between the works of Pierre Milan and René Boyvin. The Parisian engravers had begun to engrave Rosso's works as early as 1540 or a little before and it is not impossible that the painter, who had so actively participated in the production of prints in Rome, had himself taken the initiative. However, the majority of these prints were issued after his death and the engravers continued to mine his art long after the middle of the century, whereas at Fontainebleau it was completely abandoned in favor of Primaticcio's and that of Niccolo

120. Jean Mignon, *Alexander and the Priests of Amon*, c. 1544. Etching, 6 ½ × 8 ⅔ in. (16.6 × 22 cm).
Paris: École Nationale supérieure des Beaux-Arts.

121. Master I♀V, *Landscape in an ornamental frame*, c. 1543–44. Etching, 10 ⅓ × 15 ½ in. (26.2 × 39.5 cm). London: British Museum.

dell'Abbate, who arrived in France in 1552. At Fontainebleau, the vast majority of prints after Rosso date from the years 1542–43. In this brief period one has the impression of a moment of enthusiasm in which the engravers were engaged in the intensive and almost systematic publication of the drawings left by the master, and particularly the motifs of the gallery—although not to the point of envisioning a homogenous and thought-out set of prints as the Italians would do several years later. This was also the time, one may recall, that the Vienna hanging that reproduces the south wall of the gallery was woven. Rosso's presence was obviously still very strong in the years immediately following his death and Primaticcio must have been partially responsible for this phenomenon.

The absence of Cellini from the engravers' repertoire must be addressed. The explosion of printmaking in Fontainebleau corresponded precisely with the period of his activity in France. Yet the engravers do not seem to have published a single composition or motif of his invention. Perhaps he had not wanted them to do so, since sixteenth-century Florentines were not very attracted to prints. However, I have trouble accepting this as a sufficient explanation for an era in which artistic property was very poorly protected. Must his absence be viewed as a sign of hostility on the part of Fontainebleau artists and of Primaticcio in particular? The fact remains that Cellini did not benefit from this powerful mode of distribution, and, despite his merits, he had hardly any impact on what one can call, albeit with reticence, the school of Fontainebleau.[8] There is probably some reminiscence of his *Nymph* in Cousin's *Eva Prima Pandora*, but this is an exceptional example (fig. 238). Cellini's stay in France, though rather long and fruitful, had few reverberations and his exclusion from the world of the prints accounts at least in part for this fact.

We know practically nothing of the circumstances that governed the production of etchings

127

122. Antonio Fantuzzi, *Hercules and Cacus,* after Rosso Fiorentino, c. 1543. Etching printed in red, 10 ⅔ × 8 ⅔ in. (27 × 22 cm). Paris, Bibliothèque Nationale de France, Ba 12.

outside of what can be deduced from the prints themselves. Three etchers appear to have been the most important. Two of them, Fantuzzi and Mignon, were among the painters employed at the château, but Léon Davent is known only as a print-maker. All the known prints made by Fantuzzi—a Bolognese like Primaticcio—are etched and it seems that he introduced the technique to

Fontainebleau, probably in 1542. His prints hardly go later than 1545. In this very brief period, he etched more than a hundred plates that display rapid, often careless, workmanship, but are firmly drawn, always vigorous and produce an effect sometimes brilliant in its ardor. His manner changed a great deal during this short period of time, as did the models he interpreted. At the

123. Master I♀V, *Landscape with two cheetahs*, 1543. Etching, 12 × 17 in. (30 × 43.3 cm). Paris: Bibliothèque Nationale de France, AA 3 rés. (Dupérac).

beginning, it was chiefly Giulio Romano and Rosso that he transcribed, with a surprising roughness (figs. 122 and 119). Later his touch became more delicate and he interpreted Primaticcio more often, and by extension, antique sculpture and occasionally Parmigianino. He thus remained strictly circumscribed within the work at Fontainebleau and Primaticcio's sources of inspiration.

Jean Mignon signed only two prints: an adaptation dated 1544 of the stuccos in the chamber of Madame d'Étampes, and *Alexander and the Priests of Amon* (fig. 120). Thus the reconstruction of his oeuvre is hypothetical. Most of what is attributed to him seems to have been made after 1544. It may be that before that date his etchings were confused with those of another engraver whom we will discuss below, the Master I♀V. Mignon was an assured draftsman, elegant though not ostentatious, and a restrained artist whose temperament agreed perfectly with that of his principal—and almost exclusive—model during these years, the painter Luca

Penni. Their very fertile collaboration produced several of the most beautiful and characteristic sheets of the school of Fontainebleau (fig. 139).

Léon Davent engraved as early as 1540 but then converted to etching, of which he was one of the great masters. He was primarily the engraver of Primaticcio, although he had begun with several compositions by Giulio Romano. In 1543–46, his interpretations of Primaticcio are amazingly sensitive and faithful. It may be that he left Fontainebleau for Paris around 1547. For models to interpret, he then turned to Penni (fig. 140), Léonard Thiry, who like Penni had worked at Fontainebleau but probably settled in Paris, and also Jean Cousin, who was himself quite established in the capital.

More difficult to define, but rather engaging, is the personality of an etcher who signed with the monogram I♀V.[9] The sixteen sheets thus marked are in very contrasting styles and it is difficult, on this basis, to define the limits of his engraved oeuvre with any precision. Nevertheless, it seems that

124. Master I♀V, *Nude man tied to a tree*, c. 1543–44.
Etching, 12 ¼ × 8 ½ in. (31.2 × 21.7 cm).
Paris: Bibliothèque Nationale de France, Ed 13b.

a rather large number of anonymous plates belong to him. His manner sometimes comes close to Mignon's but he is a more uneven and independent artist, capable of great correctness in drawing—for example in the paraphrase of *Marcus Aurelius* after Jean Cousin (fig. 265). He could also turn to brutal distortions that somewhat recall Jean Duvet. His principal originality resided in ornamentation and landscape. His talent revealed itself best through his variations on the theme of a landscape within a cartouche (fig. 121). He was particularly sensitive to spatial fiction and pushed it quite far, by insisting on the picture as a window onto the world and on the ambiguities of fictive space. His point of departure, like Fantuzzi's, had been Rosso, but we will see below the cavalier fashion in which he allowed himself to manipulate the motifs of the Galerie François I. Fantuzzi creates the impression that landscape is simply a filler, while the Master I♀V elaborates it with more care. He also signed a small, close-knit oval

landscape, the novelty of which should not be underestimated. Another sheet dating to 1543 is impressive by its very dimensions, greater than those of the landscapes engraved by the Danube school and had no equivalent—before the large landscapes of Bruegel published by Cock—other than Venetian woodcuts (fig. 123).

Our artist's most surprising work is a strange male figure attached or rather affixed to a tree (fig. 124). Indeed, one of the oddities of the image is the fact that the figure is not bound, though obviously imprisoned. Only the ornamental treatment of the print enchains the victim through the force of its formal logic. The motif goes back to the *Crucifixion of Aman* on the ceiling of the Sistine Chapel. There are several known engraved interpretations of this figure, one of which probably served as the intermediary between Michelangelo and the Fontainebleau engraver. These prints do not pose the same barriers to interpretation as does the Master I♀V's, because they come across as the graphic transcription of one of Michelangelo's thoughts intended for the use of artists and onlookers. What is particular to the Master I♀V's version is that not only does he adapt the drawing loosely, he also completes it with a framing of landscape, turning it into a tableau without however defining a subject. The agony of Aman would have been quite an unexpected subject for a single sheet, and nothing indicates this to be the case. The engraver could have very easily transformed the figure into Saint Sebastian; a single arrow would have sufficed. The absence of bindings is also highlighted and rendered significant by the finish of the print and the wealth of details distributed throughout, in particular in the foreground vegetation. The expressiveness of the figure is further accentuated by the exaggeration of its muscles and gesture, the stretching of forms, and even the ecstatic expression of the face, which is partially hidden in Michelangelo. This pathos is all the more troubling because no reassuringly familiar narrative justifies it. On the other hand, the engraver seems to insist on the parallel between the man joined to the tree and the isolated column on the right in order to emphasize the column/tree/man metaphor that recurs, in a haunting way, throughout the architectural discourse of the Renaissance.

Original Printmakers

is fitting to give a separate mention to Domenico
el Barbiere, not only because he was an engraver
nd not an etcher, but also because he was a major
rtist who played a considerable role as a sculp-
or.[10] He was one of the principal artists of Troyes,
vhere he was married; one finds him there inter-
1ittently from around 1540 on. Nevertheless, it
vas in all likelihood at Fontainebleau that he made
nost of his prints, alongside Fantuzzi and Davent.
s an engraver, he was able to interpret both
Michelangelo and Primaticcio brilliantly, but his
nost beautiful productions were the prints that
ore only his name or monogram and were prob-
bly of his own invention: a *Cleopatra Taking Her
ife*, an *Amphiaraus* (one of the princes in league

against Thebes) and an astonishing asymmetrical,
ornamental cartouche that frames a nocturnal
landscape occupied by a military encampment and
has a powerful and unexpected effect (fig. 125).

Similarly, the twenty-six pieces etched by
Geoffroy Dumoûtier dating 1543–47 give the
impression that they were made at Fontainebleau,
although the painter disappears from the château's
accounts after 1540. His graphic technique is
closely connected to Fantuzzi's. Some of
Dumoûtier's proofs seem to have been signed by
the artist's pen, something most exceptional at the
time. His most successful prints, which show an
extremely free handling, consist in a series of
variations on the theme of the Nativity (fig. 126).

125. Domenico del Barbiere, *Cartouche*, 1542–47. Burin and etching, 7 × 9 in. (17.5 × 22.6 cm).
Paris: Bibliothèque Nationale de France, Ba I XVIᵉ (Barbiere).

126. Geoffroy Dumoûtier, *Nativity*, c. 1543.
Etching, 9 ½ × 7 ¾ in. (24.2 × 19.7 cm).
Paris: Bibliothèque Nationale de France, AA 1 rés. (Dumonstier).

127. Juste de Juste, *Human Pyramid*, c. 1543.
Etching, 10 ⅔ × 8 in. (27 × 20 cm). Paris, Private collection.

In these etchings Dumoûtier cultivated an unusual vehemence of expression and luminosity. It is difficult to imagine for what function or purpose Dumoûtier could have intended these sheets, if not simply to demonstrate his expressive and inventive power, with no care for commercialization. They seem addressed to a few artists and informed amateurs.

Under a very different, but equally free graphic style, one discovers a related sensibility in the etchings of the artist called, though without too much conviction, Juste de Juste. Five plates display strange pyramids of nude men in acrobatic positions (fig. 127). Another series of twelve isolated figures is almost even more bizarre, since the expressiveness of the body is pushed to its extreme limits without the justification, admittedly quite tenuous, of extravagant gymnastics (fig. 116). I can think of nothing that approaches the existential anguish of these emaciated bodies before Egon Schiele.

If all these prints do indeed belong to the Fontainebleau milieu, this indicates that around 1545 radically different tendencies existed side by side—in particular a taste for expressive violence, probably the legacy of Rosso. But this current is secondary. It was in fact the classicizing art, the slightly relaxed style of Primaticcio that dominated these years and channeled the course of French art in a lasting fashion. In their tamed Parisian adaptations, even Rosso's inventions are subsumed under this aesthetic.

The Publication of Rosso and the Ornamental Style

The documentary interest of Fontainebleau prints after Rosso, especially those of Fantuzzi, is uneven. Some preserve for us the memory of lost compositions, such as the astonishing *Pieta* (fig. 119), or

128. Master I♀V, *Birth of Venus*, after Rosso Fiorentino, c. 1543. Etching, 13 ½ × 20 in. (34.3 × 50.8 cm).
Paris: Bibliothèque Nationale de France, Ba 12.

Meleager Brings Atalanta the Head of the Wild Boar, which was surely a mural composition, given its lunette form. After nineteenth century repainting compromised the monument itself, it has often been believed that the prints convey the frescoes' original state. It is now maintained that the differences separating the prints from the paintings and stuccos are generally not due to alterations to the monument, but rather to the fact that the printmakers reproduced preparatory drawings rather than the finished work. Their prints therefore do indeed have a documentary value, but this value pertains to the preparatory drawings that have all disappeared. They do, however, also preserve for us the approximate appearance of several decorations that have been destroyed: Léon Davent's very beautiful etching of the *Semele*, for instance, reproduces Primaticcio's composition for the mantelpiece in the north cabinet while the main figure of the stucco cartouche below *Ignorance Dispelled* can be roughly reconstructed from Master I♀V's *Birth of Venus* (figs. 76 and 128).

It has often been asked why engravers constantly disassociated the compositions from their framings. The question turns to a great extent on knowing what they used as models to prepare their plates. In Italy, it was only in the middle of the century that Giorgio Ghisi, a Mantuan engraver trained in Giulio Romano's entourage, was the first to make prints based on the actual frescoes of Michelangelo and Raphael. Before that time, Marcantonio Raimondi and the reproductive engravers who succeeded him took preparatory drawings as models, and never the finished paintings.[11] The Fontainebleau printmakers did likewise. There are good reasons to believe that for the Galerie François I—excepting presumably very rough quick sketches that have left no traces—each fresco was drawn separately and the decorative apparatus in stucco was elaborated on other sheets.

133

129. Antonio Fantuzzi, *Cartouche of Venus Frustrated*, c. 1543. Etching 9 ⅔ × 19 ½ in. (24.4 × 49.7 cm). London: British Museum.

This is normal, since the paintings could only be executed once the stuccos were finished. The printmakers who used these preparatory drawings were thus led to engrave the narrative scenes and framings independently, even if this sometimes meant filling in the latter with landscapes.

The famous *Nymph of Fontainebleau* engraved by Milan and Boyvin is generally considered to have been an exception (fig. 118). This would be the only case of a compartment rendered in its integrity; today, as we have seen, the stucco framing that corresponds to the engraving surrounds Primaticcio's *Danae* and not the nymph we see in the engraving; yet it is maintained that the print reproduces Rosso's original project for the center of the gallery, a project either modified in the course of execution or even, according to some, completed and then destroyed by Primaticcio who would have replaced Rosso's work by his own composition. This hypothesis was so well-established that nineteenth century restorers applied it to the monument itself: in the center of the north wall, where the cabinet had disappeared, they reconstructed a compartment from the print in which Alaux painted the *Nymph of Fontainebleau*. Nevertheless, the inscription on the print clearly contradicts this fabrication. It asserts that the work was a sculpture (in all likelihood in low relief) made to be set below an

unfinished statue of Diana in François I's palace. Thus I do not see how the engraving could reproduce the original appearance or even an abandoned project for the gallery. One must give up viewing the print as the reproduction of a complete compartment: as usual, the framing surrounds a motif for which it was not originally intended. Here again, the print shows important differences with the actual stuccos, and consequently the engraver had, once again, used preparatory drawings—though judging by the manner in which the curved frames at the extremities and the upper molding with the insertion of the beams are represented, it is not impossible that he had also taken into account the monument or a drawn copy. In this respect, Milan and Boyvin's print is completely exceptional; unlike other engravings, and somewhat like tapestries, it attempts to suggest a complete monumental decoration, even if it is in fact a composite.

Antonio Fantuzzi and the other Fontainebleau printmakers proceeded in a very different fashion. When they reproduced the narrative compositions of the gallery, they left them without decorative framings and stayed rather close to the preparatory drawings; despite the disappearance of all the originals, in several cases, copies of these drawings allow us to verify how faithful the prints were.[12] The printmaker probably took a few small

130. Antonio Fantuzzi, *Frame for the Twins of Catania*, c. 1543. Etching, 9 ½ × 19 ½ in. (24.3 × 49.5 cm).
Paris: Bibliothèque Nationale de France, Ba 12.

liberties on occasion, often in order to complete the image, but nothing substantial.

It was quite a different matter for decorative framings, where the etcher could take much more initiative. Fantuzzi, for example, filled his cartouches with landscapes neither connected to the gallery nor after a model by Rosso. Other important departures separate the etchings from the stuccos. Some are certainly due, as in the narrative compositions, to divergences between the final decoration and the preparatory drawings used by the engravers. Thus, in the cartouche of the etching reproducing the motifs that surround *Venus Frustrated*, on both sides of the large nudes are *putti* that are not found in the stuccos (fig. 129). It is likely that they existed in a preparatory drawing used by Fantuzzi and were eliminated by Rosso in order to avoid too literal a reference to the ceiling of the Sistine Chapel. Other differences, on the contrary, were certainly introduced by the etcher. First of all, in three out of five cases, he composed his cartouche by repeating one half symmetrically, even if this meant introducing variations in the detail between the right and the left—for example a bald *putto* on one side and one with a crop of hair on the other. Yet it is clear that he had access to a drawn project for half of the framing: in the cartouche based on the framing

of the *Twins of Catania*, the old man wearing breeches is repeated in a mirror image in place of the young Roman (fig. 130). In addition, the grotesque motifs on the pilasters, which would have been completely incongruous in the gallery, were surely the etcher's invention.

The etching after the framing of *Venus Frustrated* is a more complicated case. The dissymmetry of the decor is maintained, in reverse, with the large nudes, one male and the other female. This is not to say that when Fantuzzi used a complete drawing as a model he was content simply to reproduce it. An examination of the print leads us to the opposite conclusion. One notices at the top, where the salamander should be, a rather complicated horizontal composition featuring a nymph and a sea monster. This can hardly refer to a preliminary project by Rosso. The decision to surmount each compartment with the royal salamander must have been made relatively early; it is unlikely that, once the compartment had been so precisely developed, Rosso would not have known that a salamander would occupy this place. Moreover, the articulation between the side sections and the central cartouches by means of simple garlands is uninspired and clumsy. Fantuzzi therefore probably had separate drawings for the motifs of the right and the left, which he united by improvising as best he

131. Antonio Fantuzzi, *Landscape in the frame of Ignorance Dispelled*, c. 1543. Etching, 10 ⅔ × 21 in. (27 × 53.6 cm).
Paris: Bibliothèque Nationale de France, Ed 8b rés.

could, and I believe that the small composition at the top is his own invention rather than Rosso's. If I am correct, we are far from the simple transcription of a preparatory drawing and the intervention of the etcher is of paramount importance.

We are touching on an important point. Fontainebleau ornament, which enjoyed European success, was to a great extent based on Rosso's inventions—but it was as much the product of the printmakers who interpreted him as that of the painter himself. The compartments of the gallery and the decorations of Rosso at Fontainebleau were in no way ornaments, if one takes this to mean the arrangement of motifs of sufficiently weak semantic density to be applicable in a great variety of contexts—all-purpose motifs. We have seen on the contrary that almost every decorative element in the gallery was chosen in relation to its neighbors, for reasons of meaning as much as of form. Through graphic homogenization, the reduction of size and the dislocation of the semantic context, the engravers performed a transformation that put Rosso's inventions into circulation as an ornamental repertoire.

Let us take as an example the Fantuzzi etching based on the framing of *Ignorance Dispelled* (fig. 131). Why in the first place did the engraver replace

the central tableau with a landscape? In a graphic version of limited dimensions and without the opposition between fresco and stucco, the contrast between the central panel and the complex framing would probably have become unclear. In the sixteenth century, landscape was commonly associated with ornament because both were non-subjects. In any case, as a result the complex system of complementary semantic relationships invented by Rosso was destroyed and the border reduced to an ornate frame. In view of this, one can understand that Fantuzzi did not reproduce the side frames; the garlands were retained, but they are hanging, held by the leaning women above, which gives these figures a different role and integrates the garlands into the composition. Should this be viewed as the reflection of an abandoned project? It was more likely an adaptation by the printmaker. Similarly, it was definitely Fantuzzi who introduced an additional architectonic element between the existing stuccos and the garlands, a motif that replaces the frame and closes the composition: a sort of pilaster, supported by a console and crowned with an atrophied entablature. On this pilaster appears an ornamental candelabrum, a motif foreign to Rosso's repertoire. A similar element is found, framed this time, on the tall console that supports the large side

figures, where the stucco in the form of triglyphs have a very simple fluting.

We can understand these arrangements if we consider the fact that the disappearance of the stucco/painting contrast seriously altered the formal order of the gallery and that Fantuzzi's summary graphic style prevented him from creating an equivalent contrast through rendering (as did the tapestries). The pilasters' candelabrum motif, through its purely surface value, introduces the opposition necessary to indicate that the other motifs are in relief. The same solution is adopted, more frankly and successfully, in the print rather loosely inspired by the ornaments of the *Twins of Catana*. The frame of the tableau was completely abandoned this time and the central opening treated in perspective to suggest a fictional window onto the scene. Additional pilasters on both sides of the central landscape match the exterior pilasters covered with foliation; this redoubling of the motif lends it a sense of assurance, so that it no longer appears to have been introduced into a system alien to it.

In his ornamental prints taken from the gallery, Fantuzzi was faithful to certain essential aspects of Rosso's decoration: the space, the connection between animated figures and architectonic elements, the rhythm, and the manner of linking motifs. One could even say that these sheets retain part of the work's meaning; even if Fantuzzi did not retain the iconographic connection that linked the motifs to the central panel, something remains of the mythological atmosphere and exuberance of the original.

Master I♀V was even more radical than Fantuzzi in his adaptations. He, for example, so transformed the motifs of the framing of the *Unity of the State* that Félix Herbet, a specialist on the château of Fontainebleau, did not recognize them (fig. 132). The side paintings were replaced with reliefs in the antique style while the center, radically narrowed, was furnished with a statue contained within the semblance of a niche. Master I♀V chose to emphasize the frames, while Fantuzzi had reduced or discarded them. The whole surface is

132. Master I♀V, *Motifs framing the Unity of the State*, 1543–45. Etching.
Paris: Bibliothèque Nationale de France.

137

133. *Grotesques*, after Cornelis Floris, 1556. Etching, 12 × 8 ¼ in. (30 × 21 cm). Paris: Bibliothèque Nationale de France, AA² Floris.

laden with motifs and punctuated with vertical accents. The linking elements, strapwork, and volutes, are highly developed and establish a hierarchy and unity within the composition that is more pronounced than in Rosso. The ensemble is rich and ponderously classical. Despite the undeniable borrowing of motifs, one is far removed from Rosso.

Fontainebleau ornament has been related historically to two other types that were used and in vogue in France at the same time. One was the type known as "grotesques," developed in Italy—particularly in the studio of Raphael—on the model of antique Roman paintings. According to some historians, these would lie at the origin of Fontainebleau ornament. On the other hand, the Flemish had developed another kind known as the Floris style, after Cornelis Floris who was apparently one of its main inventors. The latter has been viewed as the outgrowth of Fontainebleau ornament.[13]

The filial connection between Italian grotesques and Rosso's work at Fontainebleau is dubious. It is true that a few elements belonging to the grotesque repertoire are found in the Galerie François I, notably in the framing of the *Shipwreck of Ajax*. But this is an exceptional case. On the other hand, the syntax of grotesques is entirely different from that which governs Fontainebleau ornament. Grotesques are based on the assertion of the adorned surface. This surface value is strong enough to bring together motifs through simple juxtaposition. However, more often it is the graphic development of vine branches, of tendrils, indeed of every kind of linear motif that arbitrarily links the elements of this fantastic and playful world. The numerous architectural elements are pure graphic signs with no suggestion of space in depth and when they are put in perspective it is in a contradictory manner, as if to insist on their artifice and irrationality.

The effect of Rosso's gallery is very different because it depends above all on the sense of volume and the suggestion of gravity, and this is what the ornament engravers understood and retained. Nonetheless, the borrowing of certain motifs proves that Rosso was interested in grotesques, and this may have suggested the cross contamination between the organic and inanimate, between the figure and support that is found in the Gallery. We can understand this artistic playfulness as a means of toning down the excessive sublimity of the Sistine Chapel—Rosso's point of departure for the formal conception of the gallery—and adapting it to a profane decoration. Despite this suggestion, we should not forget the fact that it is only in its graphic reduction that the art of the Galerie François I can effectively be related to the fashion for grotesques.

The Floris style itself—apparently elaborated in the frame of the drawn and printed sheet without heed for immediate application—had obvious connections to the Italian grotesques and, besides, frequently bore the name grotesque in the texts of the day (fig. 133). Nevertheless, a cursory glance suffices to reveal that the difference is profound. Was this due simply to national taste? Or was it, as has been maintained, Fontainebleau ornamentation that introduced the decisive departure and constituted a

link between the Italian formula and the Flemish manner? It is true that in the work of Cornelis Bos— one of the principal and first propagators of the Floris style—one finds motifs borrowed from Fantuzzi and the Fontainebleau repertoire that are alien to Italian grotesques. However, it is possible that such borrowings came after the development of the Floris style, since it seems that Cornelis Floris himself had invented it around 1540–42—that is, before the prints of Fantuzzi and his imitators had disseminated Rosso's manner. In any case, in ornaments of decidedly Flemish appearance, all that is foreign to Italian grotesques and could consequently have originated at Fontainebleau, is in fact particular to the Floris style: its original treatment of space. The radical innovation lay in the introduction of elements that define a three dimensional space. It is largely immaterial whether they derive from Fontainebleau strapwork or the bands that divide grotesques, since they serve an entirely different function. On the other hand, it is worth noting that they are highly metaphorical, whereas the bands of grotesques and even the so-called strapwork remain very abstract; hence the names given to their diverse varieties: *Rollwerk*, *Eisenwerk*, *Spannwerk*. While in Fontainebleau ornament, their counterparts, called strapwork, acquire value through their shape and their real (stuccos) or suggested (paintings) tangibility, Flemish ornamentation inscribes itself within a so-called illusionist tradition: it creates a fictive

space that can be expanded at will. The figure that best illustrates this is the cage; it simultaneously defines an interior and an exterior space in which the eye roams freely. Even when it appears flat, Floris ornament is not only a surface, but also a grid, which we see through. Rather than echoing Fontainebleau, where ornamentation was developed in relief against a plan of reference, these Flemish motifs conveyed the persistence of the visual habits of Flamboyant art, which had a particularly sustained success in these regions in the first third of the sixteenth century. We have already seen that Flamboyant ornament was always developed in a hollowed out space. The Floris style was thus the result of new motifs stimulating a traditional sensibility.

These three forms—the Italian-type grotesques, which are surface ornaments; the Fontainebleau ornament, which develops in relief; and the Floris style—are quite distinct and coexisted in France. Grotesques enjoyed a good deal of success there. We have already noted that they were part of the Raphaelesque heritage of Primaticcio: Domenico del Barbiere, Marc Duval and above all Jacques Androuet du Cerceau (fig. 105) diffused models of it through prints and there are numerous echoes of the grotesque, especially in mural decoration and textile art. The Floris style was less pervasive, but caught on very rapidly in France, and we will see Jean Cousin inspired by it as early as 1545 in a model of goldsmithing.

The Popularization of Fontainebleau Ornament

Léonard Thiry, a Fleming who had worked on the Galerie François I under Rosso, did not himself— as far as we know—make prints, but drew extensively for printmakers. His numerous paraphrases of the master contributed effectively to the spread of Fontainebleau art.[14] In particular his *Livre de la conqueste de la Toison d'or*, engraved by Boyvin, was widely disseminated and used (fig. 135). It comprises twenty-six narrative compositions in elaborate framings that closely follow the scheme of the gallery, while lacking the original's iconographic rigor. The large number of compositions

134. Pierre Milan or René Boyvin, *Ship*, after Léonard Thiry, 1540–45, burin engraving, 5 × 7 in. (12.4 × 17.4 cm). Paris: Bibliothèque Nationale de France, Ed 3.

135. René Boyvin, *Medea invoking the gods*, after Léonard Thiry, from the *Livre de la conqueste de la Toison d'or*, 1563. Burin engraving, 6 × 9 in. (15.5 × 22.8 cm). Paris: Bibliothèque Nationale de France, Ed 3.

along with the reduced format also introduced some monotony into the exuberance of this fantasy world.

Thiry also designed a series of prints showing decorative objects (fig. 134). These have long been attributed to Rosso's invention, but the type of figures—slightly squat and not very well articulated—conforms to the style found in the *Livre de la conqueste de la Toison d'or*. Thiry was a skillful ornamentalist with a perfect mastery of his repertoire, which he used very productively and with much verve. The decorative objects that he proposed were often quite bizarre. In them one

discerns purely graphic exercises where fantasy is let loose, freed of the constraints of a specific purpose. The application of the motifs he borrows from Rosso seems arbitrary and slightly mechanical. As a good follower, he is much more indiscriminately "rossoesque" than Rosso himself. If it has long been believed that these inventions were indeed by Rosso, this is because Thiry stuck very closely to the formal vocabulary of his model. His abundant graphic production participated fully in the ornamental popularization of the Galerie François I.

Rosso, Designer of *Objets d'Art*

Rosso himself had a rather different conception of ornamental art. An original project by his hand for a decorative object made in France has recently been found (fig. 136). It is a very rare

example of the drawings that were attached to contracts made before a notary, almost all of which have disappeared. It is the model for a *bâton de chantre* or cantor's staff for Notre Dame

in Paris where Rosso was, as we know, a canon. The style is obviously his and archival documents have shown that he himself supervised the work. There is no doubt as to his involvement. As for the precious object itself, made of gilded silver, it survived until the Revolution.[15] Absent here is the characteristic vocabulary that we associate with Fontainebleau ornament, in particular strapwork. We are faced with a rather rigorously architectural ornamentation that reveals how attentive Rosso actually was to local tradition. The form of the piece, a staff crowned with an image of the Virgin placed in a miniature structure, evidently followed a preexisting scheme for this type of object, which the artist rejuvenated with Italian architectural forms. In fact, the documents specified

136. Rosso Fiorentino, *Project for a cantor's staff*, 1538. Pen and ink wash, red chalk, 20 ½ × 11 ⅔ in. (52 × 29.6 cm). Paris: private collection.

137. Rosso Fiorentino, The *First Vision of Petrarch*, c. 1544 (?). Pen and ink wash, white heightening, 16 ¾ × 21 ¼ in. (42.6 × 53.8 cm). Oxford: Christ Church Picture Gallery.

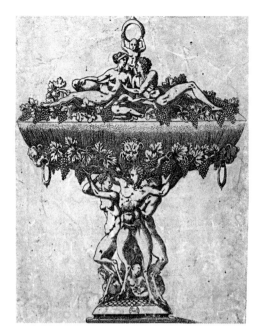

138. Antonio Fantuzzi, *Covered Cup*, after Rosso Fiorentino, c. 1543.
Etching, 10 ¼ × 7 ⅞ in. (26 × 19.8 cm).
Paris: Bibliothèque Nationale de France, Eb 14d.

that it was the "remaking" of the baton, and thus the modernization of an object whose appearance had to remain recognizable. Compared to the objects proposed by Thiry, Rosso's staff is both more traditional in its structure and more classical in the ornamental repertoire applied.

An etching by Fantuzzi presents, I believe, another example of an object designed by Rosso. Here again, the shape of the vessel—a cup with a lid—is familiar (fig. 138). The artist adorns it by distributing motifs, figures and natural elements that articulate its forms in an almost architectural fashion; there is something natural, almost rational, in the fantasy of the invention. Here again, the strapwork that we generally associate with Fontainebleau ornamentation is absent.[16]

There is however a drawing by Rosso, illustrating Petrarch's first vision, in which one finds the vocabulary of the gallery (fig. 137). Its design is very strange: a panel featuring the text that it illustrates interrupts the main representation. From a formal point of view, one will notice that the image is not presented as a movable framed picture, as is the case in the gallery, and that the surrounding molding is relatively flat. The whole decorative apparatus is not truly conceived in relief; the contorted nudes at the bottom rest on their supports in an unconvincing fashion and, in particular, the *putti* at the top could not possibly be supported by the molding which, as represented, appears to be only a couple of inches deep. Though the repertoire of motifs is similar to that of the gallery, the general conception is very different. The ample development of the coats of arms, the treatment as a surface, and the introduction of a long inscription all lead us to believe that this drawing was a tapestry project.

To judge by these few examples, Rosso, when designing a model, was very attentive to the purpose for which it was intended. It is true that he had a manner all his own in terms of graphic style and the representation of human types, but his fantasy, the license he took, were always adapted to the particular case in question, and he did not systematize an ornamental language. In his approach to the decorative arts, Rosso's practice was more varied than that of his followers, and he always showed himself as being more attached to classical principles, even when playing with them.

Luca Penni

Thanks to prints, Lucca Penni undoubtedly played a decisive role in the formation of what one may legitimately call the school of Fontainebleau. He was the younger brother of Francesco Penni, the heir, with Giulio Romano, to Raphael's studio. After training in Rome, Luca worked with Perino del Vaga in Genoa. Thus he had deep roots in Raphael's studio and, though of Florentine origin, signed himself Luca Penni Roman. Having arrived at Fontainebleau as assistant to his compatriot Rosso, he must have felt closer to Primaticcio, who had a strong influence on him. His was a very

DOMINVM
COGNOSCITE
VESTRVM

139. Jean Mignon, The *Metamorphosis of Acteon,* after Luca Penni, 1545–50. Etching, 17 × 23 in. (42.7 × 57.6 cm), Vienna: Albertina.

antique-style, in which Primaticcio's sensuality reappears under a slightly heavier form. His figures are fleshier, less supple. There is nothing impulsive here, none of Rosso's irony; but it remains a sophisticated art. We have one painting by his hand and numerous meticulously finished drawings. His art is accessible, addressing itself to a cultivated public, certainly, but without demanding the greatest discrimination. Penni knew how to capitalize on the classicizing style of the 1540s, somewhat as Thiry had popularized Rosso's language.

After 1545, perhaps when he left the Fontainebleau site to pursue an independent career, Penni took the printmaking activity of Fontainebleau in hand, so to speak. It may be that Primaticcio himself had lost interest in it. In any case Fantuzzi, who continued to work on the Fontainebleau decorations, produced no more etchings. Léon Davent, on the other hand, who had been Primaticcio's principal interpreter, turned more and more toward Penni

for models, while Jean Mignon—another renegade from the royal site—seems to have dedicated himself almost exclusively to reproducing his drawings. Furthermore, one witnesses a slight change in the character of their production: more carefully bitten etchings, neater and more uniform printings. The series of *Deadly Sins,* the plates of which Penni owned at the time of his death, were extensively reworked with the burin and display a precision and technical discipline in complete contrast to Fantuzzi's practice.

Jean Mignon remains the principal engraver of Penni. Their collaboration must have endured over several years. Some of the drawings he etched still exist and allow us to appreciate his contribution. He was very faithful to his model and scrupulously followed the draftsman's instructions. But he introduced landscape backgrounds and diffused a subdued light that render somewhat mysterious and slightly strange an art

140. Léon Davent, *Wrath*, after Lucca Penni, 1547–50. Etching, 12 × 18 in. (30 × 46 cm).
Paris: private collection. This rare proof in mint condition predates the engraved changes.

141. René Boyvin, *Satyr Raping a Nymph*, after Lucca Penni, 1550–56. Engraving, 7 ½ × 11 in. (18.8 × 28 cm).
Paris: Bibliothèque Nationale de France, Ed 3.

hat, despite its classicizing affectation, tended towards the prosaic. His plate depicting the *Metamorphosis of Acteon* was one of the most successful of the era and epitomizes for us the slightly rarified atmosphere and preciousness that we associate with the art of Fontainebleau (fig. 139). Penni must have befriended the Mantuan engraver Giorgio Ghisi when the latter passed through France.[17] Around 1555, before Penni's death in 1556, Ghisi engraved several compositions that rank among his finest works and that Penni had probably drawn specifically for him. Ghisi also engraved some of the compositions for the vault of the Galerie d'Ulysse and was able to render the very distinctive light in Primaticcio's drawings with great virtuosity. Obviously, his training in Giulio Romano's entourage prepared him for the task. It was his interpretations of Penni, however, that met with the greatest success—in particular his plate of *Parnassus*, which was endlessly copied and adapted. Undoubtably towards the end of his life Penni drew a good deal for engraving, like Rosso in Rome, and this must have represented a significant part of his income. Whether he simply furnished the drawings or was his own publisher, as was the case at least for the important *Deadly Sins* series (fig. 140), it is amply clear that Penni systematically exploited printmaking; he understood its economic potential so well that he apprenticed his son Laurent to René Boyvin. Installed in Paris, Penni did not confine himself to the circle of his former companions at Fontainebleau. He also maintained connections to the Parisian milieu and entrusted drawings to Boyvin. This engraver, who lacked genius but was as assiduous as he was technically expert, became Penni's principal interpreter after Jean Mignon. The fruits of this collaboration were of uneven value. However, a print like *Satyr Raping a Nymph*, the playful tone of which thinly veils a deeper anxiety, exudes a troubled sensuality that rises above simple licentiousness (fig. 141).

In short, Penni served as the connection between the strictly Fontainebleau print and the Parisian engravers, thereby providing a certain cohesion to what is called the school of Fontainebleau as far as printmaking is concerned.

Painting

Penni was also a painter. His posthumous inventory listed several paintings, some of them unfinished, but all are portraits, which leads us to believe that he did not paint much else in his later years.[18] This confirms the weak interest the French had in painting outside of this genre. A commission for a religious painting for Nicolas Houel has nevertheless been found in the archives and the *Pseudo-Justice d'Otho* (fig. 143), thus titled in the Louvre because the subject remains incomprehensible, is the only painting that can be attributed to Penni without hesitation.[19] The dimensions, as well as the precious finish, imply a cabinet painting. It passed for a Primaticcio in the eighteenth century, indicating its strong Fontainebleau flavor, but Penni's personal character is clearly in evidence. The extremely regular physiognomic types, the ruptures of a space constructed on successive planes, the very strong insistence on the decorative composition of the surface and certain details such as the ornamentation of the canopy are also found in other works such as the *Calumny of Apelles* engraved by Ghisi (fig. 142).[20]

What did Penni's portraits look like? It has been suggested—rightly so, I feel—that his invention may be detected in Boyvin's engraved full-length portrait of Henri II.[21] The portrait of the Cardinal of Châtillon at Chantilly has also been attributed to him, but for no specific reason. I wonder if his name should not be put forward in connection with the painting long considered, on the sole authority of Charles Sterling, to be the portrait of Jean de Dinteville as Saint George by Primaticcio.[22] This large composition, impressive for the grandeur of its design and its very firm execution, can hardly represent Jean de Dinteville (fig. 146). The identification of the sitter was the chief indication in favor of Primaticcio. However,

142. Giorgio Ghisi, *Calumny of Apelles*, after Luca Penni, 1569.
Engraving, 14 × 12 ½ in. (36.1 × 31.6 cm).
Paris: Bibliothèque Nationale de France, Ba11.

143. Luca Penni, *Pseudo-Justice of Otho*, c. 1550 (?).
Oil on canvas, 40 × 28 ⅓ in. (102 × 72 cm). Paris: Louvre.

one of the distinguishing features of Dinteville, whose physiognomy is well known from Holbein's *Ambassadors*, was his black hair and red beard, a characteristic that no portraitist would have neglected. Thus the sitter unfortunately remains anonymous and we are reduced to making an attribution on the basis of formal considerations. The manner in which the outline of the figure is maintained in the picture plane seems to me more compatible with Penni than Primaticcio, who always rotated his figures in space (as shown in the drawn portrait of François I as Julius Caesar at Chantilly,[23] fig. 147). In addition, the ornamentation of the helmet is close to that found in Penni's framings. This is put forward simply as a tentative suggestion for what remains—whoever its author may be—one of the finest easel paintings from the Fontainebleau milieu.

The Toilette of Venus in the Louvre is characteristic of all that evoked the name school of Fontainebleau at the middle of this century (fig. 144). It combines a reference to Rosso—the kneeling woman on the left comes from the *Challenge of the Pierides*—with a Venus in the

spirit of Primaticcio whose forms recall Luca Penni. The painter had had direct contacts with Fontainebleau painting. In this work characteristic of our "school," Roman heritage dominates and it approaches the sensuality of the Palazzo del Te. But the same name school of Fontainebleau is also applied to works that have slender forms, more supplely articulated compositions and a more ethereal sensuality. The arrival of Niccolo dell'Abbate in 1552 was not unrelated to this development. The *Birth of Love* (New York, Metropolitan Museum of Art) and other works grouped rather arbitrarily under the name Master of Flora[24] deploy willowy forms, sinuous fingers, and weightless bodies. In these, the unreality of dreams prevails over the evocation of an imaginary antiquity. Primaticcio's style and the impact of Niccolo, whose mannerism has been exaggerated in these secondary works, both played their role in the so-called school of Fontainebleau, but it is not necessary to view these two tendencies as

two successive phases. François Clouet's *Lady in the Bath* reveals that some painters long remained faithful to the more robust forms and classicizing taste of the middle of the century (fig. 213).

Thus, we are gradually able to form a more coherent and articulate idea of what one can call the school of Fontainebleau; it was a matter of lessons taken from the Italian examples of the château inflected by divergent personalities. We should not forget, however, that we are on dangerous ground since the term is applied to a limited group of paintings of very uneven merit, generally without a truly identifiable author or known origin. Furthermore, certain painters' names do not correspond to anything: who were the Rochetels, Carmoys, and Patins who figure so prominently in the accounts of the royal work sites? A fairly recent discovery urges us to be extremely circumspect.

The *Christ Descended from the Cross* kept today in the church of Sainte Marguerite in Paris, but which comes from the chapel of Orléans at the Celestins monastery in Paris, had since the

144. Anonymous, *Toilette of Venus*, 1545–50 (?). Oil on Canvas, 38 × 50 in. (97 × 126 cm). Paris: Louvre.

eighteenth century passed for a work by Salviati, thus for a Florentine painting executed by one of Primaticcio's most celebrated contemporaries (fig. 145). The attribution had already been called into question when John Shearman connected the work to a 1548 commission given to the painter Charles Dorigny, one of the names that appear prominently

145. Charles Dorigny, *Christ Descended from the Cross*, 1548. Oil on wood, 82 × 85 in. (208 × 217 cm). Paris: church of Sainte Marguerite.

146. Luca Penni (?), *Portrait of a Man as Saint George*, c. 1550. Oil on wood. Private collection.

147. Primaticcio, *François I as Julius Caesar*, 1541–45. Pen and ink wash with white heightening, 9 ½ × 4 ¾ in. (24.4 × 12.2 cm). Chantilly: France, Musée Condé.

in the texts, but which previously had not been attached to any known work.[25] This identification, which is hard to refute, is both important and disconcerting. Without it, would we have thought of the Fontainebleau school at all? The traces of Andrea del Sarto are more appreciable than those of Rosso and nothing recalls Primaticcio. In retrospect, it is true, one notices the blunders, or rather incongruities, that would be surprising coming from an Italian—such as the bizarre manner in which the very geometric Magdalene is inscribed between the legs of the soldier to the left. Perhaps there is also something slightly over demonstrative, or schoolish in the interplay of gestures and gazes. In any case, the painting, which was in all likelihood painted by one of the French artists who worked at the château in the 1540s, corresponds quite poorly to the idea we have fashioned of a Fontainebleau style.

Such a warning prevents us from forging an overly homogeneous opinion on the art that emerged from Fontainebleau or that was inspired by its examples. Thirty years after the death of Primaticcio, Henri IV's decorators, Toussaint Dubreuil, Antoine Dubois, and Martin Fréminet, constituted a much more coherent group. In their efforts to revive a tradition that had been interrupted by religious strife—efforts whose ideological implications for the new dynasty are hardly mistakable—they deliberately turned towards the art of Fontainebleau, already half a century old, to confer on them an identity as a group. There was no such concerted effort under the last of the Valois. However, Fontainebleau was for a long time, thanks to the actions of François I, an extraordinarily dynamic center sending out models that were innovative for France and even, in some cases, for the artists of Italy. It was in this manner that the château became a major relay of European art—a new Rome where the men of the North met Italy halfway, and which the Italians

148

themselves had to acknowledge.

Nevertheless, despite François I's initiative, the grand painted decorations of the Italian tradition did not catch on immediately in France and, outside of Fontainebleau, did not have the success one might have expected. The example set by the court was surely most decisive. The reign of painters at Fontainebleau was the result of François I's preferences. Henri II, having never had the best relationship with his father, inevitably sought to keep his distance in artistic matters, as he did in everything else. At Fontainebleau itself, Primaticcio was able to continue his work, but the residence was not favored by the new king, who was more interested in the Louvre and especially in the château of Anet built at great cost for his mistress. He placed his trust in new French architects: Philibert de l'Orme, whom he charged with the superintendency of the king's buildings, as well as the direction of Anet, and Pierre Lescot, chosen by François I but kept on at the Louvre with full authority, independently of Philibert. From then on, they had the upper hand on royal patronage, and large narrative mural painting played no role in their conception of decoration.

All the same, several great lords followed the example of François I. The most complete illustration of this is the gallery of Claude Gouffier's château at Oiron in the Poitou (fig. 150).[26] The room is decorated with vast frescoes in framings painted in trompe l'oeil. We know the name of the painter, Noël Jallier, who executed the ensemble in 1546–49, but is not known from any other source. He clearly had in mind the precedent set by the Galerie François I, but it can hardly be considered an imitation. He seems in fact to have been drawn more to contemporary Roman decorative projects, though we do not know whether or not he had had the opportunity to view certain frescoes in the Palazzo Sacchetti where Ponce Jacquiot, one of the principal French sculptors of the era, worked. What is striking about the Oiron decoration is its complete independence with regard to the models that provided only very sketchy suggestions. This is true of the painted compositions as well as the decorative system. Jallier represented the episodes of Trojan history beginning with the Judgment of Paris without relying, as one might have expected, on engraved models. He sketched large figures

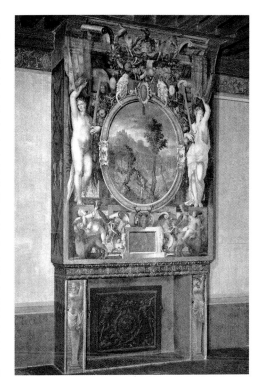

148. Anonymous, *Esau Hunting*, 1555–60, Fresco.
Écouen: château, fireplace mantel in the constable's bedchamber.

placed in several groups that make up distinct episodes of the narrative and distributed them throughout a vast landscape conceived in a scenographic manner. This isolated work, without parallel or sequel, remains an enigma.

We are left less confused by the paintings at Écouen, where we find an obvious adaptation of Fontainebleau decoration.[27] In accordance with French habits, only the fireplaces were made objects of permanent decoration, save for a narrow ornamental frieze painted along the beams, leaving most of the walls free for tapestries (fig. 148). The mantel of the large Salle d'Honneur received a decoration sculpted in stone whose principal ornament is the famous, though not very beautiful, *Victory* inspired by Domenico del Barbiere's *Gloria*. On the other fireplaces, painting was substituted for more costly sculpted decoration, which can give the impression that the constable wanted to economize. The Fontainebleau decorative system of the years

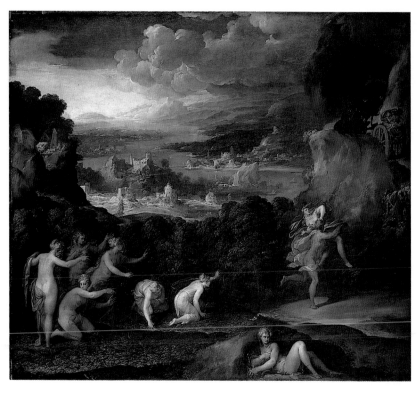

149. Niccolo dell'Abbate, The *Abduction of Proserpina*, c. 1578. Oil on canvas, 77 × 84 ⅔ in. (196 × 215 cm). Paris: Louvre.

150. Noël Jallier, The *Siege of Troy*, 1546–49. Fresco, 106 ⅓ × 224 ½ in. (270 × 570 cm). Oiron: château, second floor gallery.

151. Antoine Caron, *Massacre of the Triumvirate*, 1566. Oil on canvas, 45 ⅔ × 76 ¾ in. (116 × 195 cm). Paris: Louvre.

152. Antoine Caron (?), *Massacre of the Triumvirate*, c. 1560 (?). Oil on canvas, 56 × 69 ¼ in. (142 × 176 cm). Beauvais: Musée départemental de l'Oise.

153. Antoine Caron, *Bathagan and Thares*, c. 1570 (?), Pen and ink with white heightening and gray and brown wash, 9 ⅔ × 15 in. (24.5 × 38.6 cm). Munich: Staatliche Graphische Sammlung.

1535–45, with its mélange of painting and stucco, was adopted, but entirely transposed into painting. For the most part, Fontainebleau motifs were repeated and at the same time supplemented by a few borrowings, such as a nymph copied almost exactly from the Fountain of the Innocents in Paris. The rather lively palette animates the ensemble, which shows fantasy in its inventiveness though lacks the rigor or depth of Rosso. The tableaux that fill the centers of these decorative compositions were treated in a style very different from that of Fontainebleau: they are landscapes animated by narrative subjects featuring very elongated little figures. This style, which is rather close to the art of Antoine Caron whom we will discuss later, is probably the most innovative aspect of the Écouen paintings.

The painted decorations of Ancy-le-Franc are clearly later and for the most part of lesser interest. The most celebrated part is the Chambre des Arts (lit. Chamber of Arts), the paintings of which Dimier first attributed to Primaticcio himself, before changing his mind and assigning them to an imitator after 1570. At Ancy, perhaps the most interesting if not the most attractive, is the Galerie des Batailles (lit. Gallery of Battles), which features painted combats whose participants have elongated forms, standardized physiognomies and the angular poses of Antoine Caron's figures, although they are not by this artist. Caron, who died in 1599, for the most part lies outside our period, yet must be addressed because he was the first painter of historic subjects to whom one could attribute an important ensemble of easel paintings. There remain many uncertainties as to his career and the parameters of his oeuvre. The *Resurrection* and the *Massacre of the Triumvirate*, two important works in the Beauvais museum, have both been contested. Experts agree, however, on roughly a dozen paintings and numerous drawings.[28] They display a new style of which Caron may or may not have been the inventor, but which in any case was widespread and successful around 1560.

Antoine Caron was born in Beauvais; we know nothing of his training or formative years. The surest point of reference in his career is the *Massacre of the Triumvirate* in the Louvre, a work signed and dated to 1566 (fig. 151). All the principal monuments of Rome known from the prints published by Antoine Lafrery appear in it as if on a stage, the center of which is articulated by the Belvedere's

characteristic staircase. There, a soldier, sword in hand, brandishes a decapitated head. The triumvirs are seated at a very great distance, in the axis of the painting, in the center of the Coliseum. The frantic agitation of the tiny figures contrasts almost comically with the meticulous symmetry of their placement. The gaiety of the vivid and light palette, in complete contradiction to the horror of the scene, adds a strange and incongruous note. The gesticulating figures, of very elongated proportions, seem engaged in a surrealist choreography.

Compositions with numerous but miniscule actors being developed in a vast space are frequent in Caron's oeuvre. Yet this genre did not belong to him exclusively. We have already come across it in the paintings on the Écouen mantels, which date to the reign of Henri II. It is constant in the oeuvre of Bernard Salomon and frequent in that of Étienne Delaune, who may have received it from Jean Cousin. Was this style, which was quite in vogue, connected to Fontainebleau? It is not impossible. Caron himself had been at the château, as his name appears twice in the accounts—first in the overall account for the years 1540–50, during which he was paid only fourteen *livres* a month (top-ranking assistants received twenty *livres*), then again in 1559–60 when he was paid for "*rafraîchissements*," that is to say the restoration of decorations such as that of the king's chamber, which were already about twenty years old. Niccolo dell'Abbate was probably no stranger to this taste for tiny figures; his landscapes of mythological subjects such as the superb *Abduction of Proserpina* in the Louvre may have served as a point of departure (fig. 149). Furthermore, one finds Niccolo and Caron side by side: indeed it seems that Niccolo contributed a few original projects for the *Story of Artemisia*, a series of drawings executed for the most part by Caron and commissioned for Catherine de Médicis by a curious figure, Nicolas Houel, to be woven into tapestry.

It is in the context of these contacts that one must place the *Massacre of the Triumvirate* (Beauvais museum), a painting considered the work of Caron by Jean Ehrmann, while for Sylvie Béguin it belongs to Niccolo's following (fig. 152). To tell the truth, so little is known in this instance that it is quite difficult to decide. The woman on her knees in the right foreground is certainly a clearly Fontainebleau type, and Niccolo liked the half-length male motif, already frequent in Primaticcio's later compositions, which appears in the left corner. On the other hand, the group of two soldiers near this last motif is indeed quite reminiscent of a Caron drawing, *Bagathan and Thares* (fig. 153). Such a painting, whoever its author, is indicative of the connection between Fontainebleau and Caron, but also of their differences. The spatial conception of the painting—the impression that it creates of derisory little figures, lost in a vast space that remains empty though strewn with a thousand different objects—is in a style quite specific to Caron and his generation. Whether one understands it as the heritage of a Northern sensitivity to open space dating back to Patinier and Flemish painting, and still recognizable in the inventions of a Vredeman de Vries, or as expressing the anguish of a generation engulfed in civil war—and the two are not mutually exclusive—one senses that the optimistic humanism of the Italians of Fontainebleau had lost its grip. Can one still place Caron in a school of Fontainebleau? Yes, if we understand this to mean that he took certain lessons and motifs from this source; no, if it must refer to a community of principles and convictions. Caron renounced the classical tendencies of the 1550s in favor of a sort of grating "archaeologism," characteristic of the tormented period during which his career unfolded.

Once again, we must insist on the difficultly with which painting, as it existed for the Italians and Flemings, took root in France. Limited to painting, the lessons of Fontainebleau were in the end rather ineffectual, despite a few fine exceptions. But other professions made good use of them. Sculptors, numerous and much in demand, tapestry makers, glaziers, goldsmiths, enamellers, potters, and even locksmiths, everyone found models there. The knowledge of the sources was rarely direct; sometimes it came through the intermediary of a painter who provided drawings, as we shall see in the case of Jean Cousin; in most cases prints served as go-betweens. It was thus through diverse and sometimes unexpected pathways that the art of Fontainebleau achieved its huge success.

154. Paris, Louvre palace, Cour Carrée, façade (detail), 1547–49.

Chapter V

PIERRE LESCOT, JEAN GOUJON, AND THE LOUVRE

The Louvre has been an almost constantly active construction site since the sixteenth century. Every reign, every regime, has sought to leave its mark on this national monument. Nearer to our own time, after a period of respite during most of the twentieth century, activity resumed with renewed vigor, like a volcano pronounced extinct, whose eruption is all the more spectacular for being unexpected. More successful than Bernini, whose project was ultimately discarded by Louis XIV, Ieoh Ming Pei was the first foreign architect ever to build on the site of the Louvre. One can understand why passionate debates surrounded this enterprise, insofar as the Louvre is still an important symbol of national identity and pride.[1] If the palace of Henri II appears as the decisive work of the sixteenth century, this is not solely on its own merits, which have often been harshly judged. Its importance is due rather to the fact that it served as a model, touchstone, and constant reference, first within the sprawling palace complex that developed over the centuries out of the Louvre and the Tuileries combined; and beyond, in the development of architecture in Paris and the rest of France. The mansard or "broken" roof, later generalized to the point of becoming one of the most distinctive features of buildings "in the French style," was created at the Louvre.[2] However, the overall physiognomy is what counts most, and certain traits—particularly an original and characteristic relationship, though difficult to define, between sculpted ornamentation and architecture—have marked the course of high architecture in France since 1600.

The Louvre of the sixteenth century was but a small part of the vast edifice we know today; it consisted of the section of the Cour Carrée (lit. Square Courtyard) between the Pavillion de l'Horloge, or clock tower, and the south wing, and also the corresponding part of that wing, which is now seriously disfigured. Such is the core, the determining starting point. The scale has changed, of course, and the clock tower erected by Lemercier creates a shift of emphasis in the courtyard that subordinates Henri II's wing, crushing it a little. The magnificence of the decoration loses some of its impact because it is repeated over too great a surface. The great respect with which the seventeenth century regarded the Louvre of Henri II, however, is visible in the truly extraordinary care that was taken to make the symmetrical wings harmonize well with the original decoration, and the assiduity with which the style of Goujon's sculptures was scrupulously imitated.

The sculpture on the upper story of the clock tower, hovering over the earlier Louvre, is rather different from that of the adjacent wings. It asserts itself aggressively as high relief, in keeping with an architecture where chiaroscuro is accentuated. Nevertheless, its relationship between ornamentation and architecture takes into account the precedent set by Lescot, an ornamentation both rich and integrated into the structure. The clock tower is a kind of a meta-pavilion that seeks to impose itself over the composition defined by the Lescot wing and its symmetrical counterpart. The change in scale and the strong presence, height and mass of the central pavilion necessitated a change in decorative style in order to preserve a scaled relationship in which the sculpted ornamentation affirms itself almost equally with the structural elements.

Even the Gare d'Orsay, a railroad station built at the end of the nineteenth century and now converted into the Musée d'Orsay, attempts to respond to the Louvre-Tuileries complex on the other side of the Seine. There, the mansard roof, articulation of pavilions, and affirmation of decorative elements

take place on a colossal scale thanks to the greater means of the industrial century. Gone is the delicacy of Goujon's fine reliefs; yet the principles that continue to govern decoration trace their ancestry back to Lescot's Louvre, giving a sense of unity to Parisian architecture.

The Louvre of the Renaissance has perhaps suffered more from continued veneration, than has the château at Anet from negligence and indifference: at Anet, repair work to the building in the seventeenth century was undertaken without regard for its initial character, and modifications are readily apparent. A substantial portion of Diane de Poitiers's château was even demolished after the Revolution, but what remains of Philibert de l'Orme's edifice is present in all of its originality. At the Louvre, enthusiasm encouraged successive generations to build bigger and better in what appeared to be the spirit of the original core. It was love that suffocated Lescot's masterpiece.

The Louvre of the Renaissance and its Authors

The history of the palace in the sixteenth century is complex and problematic.[3] A few points of reference, however, should suffice for our purposes here. The decision to replace the old fortified castle with a modern royal residence goes back to François I, who decided after returning from his imprisonment in Madrid, that he would reside mostly in Paris and its region. Initial measures were taken in 1528, when he dismantled the *"grosse tour,"* that is, the former keep, a huge piece of masonry that encumbered the courtyard of the old castle and blocked the light from the royal quarters. In addition to the improvement in comfort, the destruction of the tower had great symbolic value. The keep of the Louvre housed the king's treasury; it was the concrete manifestation of feudal power, and was still

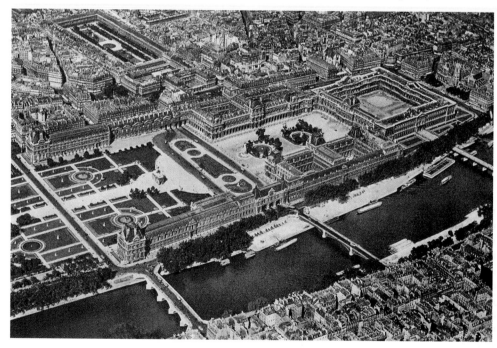

155. Aerial view of the Louvre palace and the Tuilerie gardens.

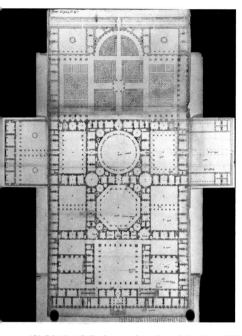

156. Sebastiano Serlio, *Louvre palace: plan and elevation, c.* 1545. Pen and ink wash, New York: Columbia University, Avery Library.

well remembered in the seventeenth century, as the words of Pierre Sauval, the great seventeenth-century historian of Paris, clearly attest:

> There is no tower more often spoken of in history or in the world, than the keep, or great tower, of the Louvre. From it issued all the great fiefs and nobles of the kingdom, and though it no longer stands, they are still issued from it; its name and plan endure for them and it is to this name, this plan, what one might call its shadow, that our princes, dukes, and nobles, pay homage.[4]

After the tower was demolished, it was only at the very end of his reign, in 1546, that François I undertook the construction of a new residence within the city walls. In all probability he had been thinking about it for several years[5]—there is no doubt that Serlio, who came to France as a royal architect in 1540 or early 1541, had prepared a project specifically for the Louvre. It was to be a grand axial composition around a series of courtyards (fig. 156).[6] The elevation featured a superimposition of the orders, but Serlio accommodated French taste and custom by adopting the traditional large

dormers and stone mullioned windows. In the end, despite the prestige of the old Italian, his proposal was not adopted and work began on the site under a French architect. On August 2, 1546, Pierre Lescot was commissioned to oversee the construction. The old castle was a cardinally oriented rectangle, and the task at hand was to rebuild the west wing while preserving the outside wall, as was done at Fontainebleau, both for the sake of economy and to hasten completion. François I died within months, but Henri II retained Lescot in his original position. This is all the more remarkable as the king was at the same time entrusting the general direction of his building projects to Philibert de l'Orme. But the Louvre was an exception, and Pierre Lescot remained wholly responsible in matters both administrative and artistic.

Lescot had planned a monumental staircase with straight flights for the center of the main building. Henri II, however, wanted a great hall, and the design was revised to this end. The staircase was moved to the northern end of the wing, bringing with it a change in the organization of the façade, which originally had a central frontispiece

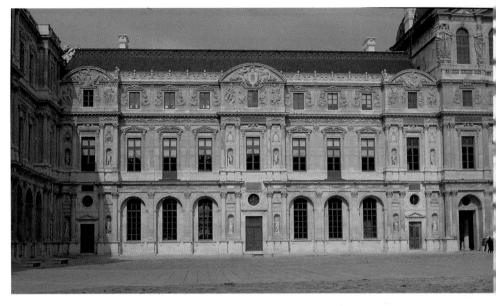

157. Paris, Louvre palace, Cour Carrée, Lescot's façade, 1549–55.

comparable to the one at Anet. The displacement of the staircase inspired Lescot to make its presence felt on the outside of the building by a slight outward projection which he repeated in the symmetrical south end, corresponding there to the "Tribunal" of the great hall. The result was a composition articulated by three slight advances, or pavilions. Later still, an attic was added to the two original stories; only then did the façade take on the characteristic appearance familiar to us.

It is not known what Lescot had in mind as a general plan for the palace. He may have planned the sumptuous façade for one side only, at the rear of the courtyard. Did he intend to follow the traces of the old castle within the moat? We cannot tell for lack of evidence and we cannot even be sure that there was a clearly conceived project for the whole. In a second phase, the old south-west tower of the castle was demolished to erect the king's Pavilion, a rectangular building unit projecting slightly forward, and rising one story above the rest to evoke a corner tower, but in a modernized manner. While the space available for the residence was enlarged, the outline of the old Louvre was respected. This construction allowed the king to reside immediately next to the new west wing. This consisted of two

large halls, a ballroom on the ground floor, and another hall on the second story. Above, in the attic, were apartments for the ladies. By 1556, all this work was more or less complete. According to Androuet du Cerceau, it was then that Henri II decided to repeat the western façade all around the courtyard: "As King Henri was highly gratified at the sight of such a perfect work, he decided to have it continue along the three other sides, to make the courtyard without equal." This decision, unfortunate perhaps, must then have come from the king himself—not an exactly implausible scenario. Thus, four similar wings were intended at that time, but the Valois succeeded in completing only two, still roughly within the perimeter of the old medieval Louvre.

Did Henri II already intend to quadruple the area of the courtyard to give the Parisian residence of the monarch a scale it would know only in the seventeenth century?[7] This remains doubtful, to say the least. What is certain, on the other hand, is that shortly after Catherine de Médicis decided, in 1563, to build on the site referred to as the Tuileries, a junction of the two palaces along the Seine was envisaged. However, what was first installed was only a utilitarian walkway inspired

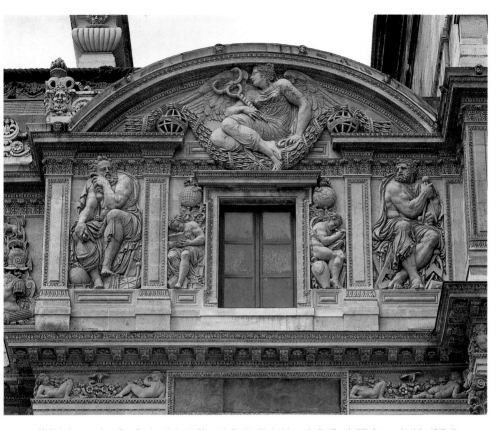

158. Paris, Louvre palace, Cour Carrée, attic level of Lescot's façade with the joint to the Pavillon de l'Horloge on the right, 1547–49. The bas-reliefs were executed by Jean Goujon.

by the corridor that Vasari had established between the Ufizzi and the Pitti palace in Florence (Catherine kept abreast of developments in her native city). Under Henri IV, a "Grand Design" took shape; the idea of uniting the two palaces into a vast, coherent compound comparable to Bramante's Belvedere. Thus the Grande Galerie was built. It would not be surprising to find that the radical amplification of the Cour Carrée also dated from this period of grand urban projects, rather than from the architectural reign of Lescot.

The Louvre of Henri II is original in its organization, and in keeping with French attention to layout—the *"commodità francese"* to which Serlio himself paid homage. From this perspective, the coordination of the west wing with the royal pavilion is particularly ingenious and shows that Lescot was not concerned solely with decoration. The architect takes advantage of the different levels of the contiguous parts of the building, placing the king's chamber above the Salle du Conseil (lit. Chamber of the Council), while the antechamber—an innovation at the time—is above the Tribunal, adjacent to the great hall of the upper floor. At the very top of the pavilion, a belvedere provided the king with an unparalleled view over the capital. Work began shortly after on the South wing, allowing the Queen's apartments also to be situated close to the most public parts of the residence.

The most spectacular portion of Henri II's palace, the courtyard façade of the west wing, appears as much a work of sculpture as architecture—so important are the relief panels to its effect. They were carved by Jean Goujon, whose

name has traditionally been attached to that of Pierre Lescot as co-author of the decoration. Goujon having himself worked as an architect, gives cause to wonder whether he was not—at least as much as Lescot—the creator of this masterpiece and the style of ornamentation it engendered in architecture. François Gébelin suggested as much in 1923,[8] and Pierre du Colombier leans towards this theory in his handsome book on Jean Goujon. Since then, there are some who have gone so far as to say that Jean Goujon was the true architect of the Louvre, while Lescot was simply an administrator.[9] In this extreme form, the argument is untenable, but it is interesting that anyone should have tried, should have wished to sustain it. The origin of this problem lies in both the exceptional amount of sculpture and its perfect integration as part of the architectural composition. The impression one gets from the façade of being designed specifically to show off the sculpture, and the fact that Goujon, who was a great sculptor, had worked as an architect, all tended to tip the scales in his favor. Were there really two great artists working in a perfect communion of ideas, or is Lescot's glory for the most part usurped by a brilliant but socially disadvantaged partner?

This matter of attribution is not as futile as one might think: it has a significant impact on the way we perceive the work itself. Is the façade of the Louvre a sort of backdrop surface that permits the sculptor to express himself, or should one see it as a specific conception of architecture in which sculpture is an integral part? This is the question that lurks behind the Goujon/Lescot alternative; at stake are contemporary ideas of art and the artist, and the relationship between invention and execution.

The *Jubé* at Saint Germain-l'Auxerrois

For once it is possible to determine with some degree of accuracy, where and when a new conception of architectural ornamentation appeared— a question of great significance for the art of the Louvre. It was on the *jubé* (rood screen) at Saint Germain-l'Auxerrois. By a stroke of luck, we are in possession of fairly complete documentation for this destroyed work. It is therefore of the utmost importance to establish a strict chronology. We shall see that a close examination of our sources allows us better to understand the interactions between the responsible parties and their respective contributions.

Because it appeared more or less irresolvable, this problem has not, until now, been approached head on. Indeed, outside of the Louvre, there is no work whose authorship we can attribute with certainty to Lescot, unless it be the aforementioned *jubé* at Saint Germain-l'Auxerrois where he had already collaborated with the famous sculptor Jean Goujon. Except for the latter's relief panels, nothing now remains of the *jubé*. Nevertheless, a detailed analysis of the documents makes it possible to form a relatively complete idea of this formerly renowned piece of architecture from which we can formulate an hypothesis as to the respective input of Lescot and Goujon. Now preserved at the Louvre, the four evangelists and the *Deposition* that adorned the balustrade of the *jubé* are breathtaking (figs. 159, 160 and 180). The fluid drapery, the demarcation of planes within a very low relief, the way in which volume is evoked by a mere inflection and contours are engraved as in an architectural drawing, and a grace so characteristic of the nymphs adorning the Fontaine des Innocents (Fountain of the Innocents) already to be found in the female figures of the *Deposition*—all bear the mark of Goujon's skill. He appears, at once, to be the uncontested master of pictorial relief sculpture. But what is to be said of the rest of the monument, which disappeared entirely in the eighteenth century? We can get an idea of it from descriptions and commentaries. It was a particularly imposing and complex *jubé*. On each side of the central arch, an entire little chapel was tucked beneath the platform. Sauval, a connoisseur of architecture, especially admired this piece of work. "The *jubé*," he wrote, "is not only magnificent, but furthermore, connoisseurs hold it to be the most admirable in the kingdom." Great praise indeed!

159. Jean Goujon, *Saint John* and *Saint Mark*, bas-reliefs from the *jubé* at Saint Germain-l'Auxerrois, 1544.
Stone, 31 × 22 in. (79 × 56 cm). Paris: Louvre.

Sauval claimed to express not only a personal judgment, but also the distinguished opinion of the community of amateurs. So it seems that at the time of architect François Mansart, when French classicism was in full swing, the *jubé* at Saint Germain-l'Auxerrois was still a model for the genre. We may therefore assume that the panels that have come down to us intact were in keeping with the rest of the monument. Sauval's unequivocal approbation makes it impossible to imagine the work as hybrid, timid, or incoherent.

It was believed for a long time that there survived no pictorial evidence for the *jubé*, but this is not exactly true. In 1934, Pierre du Colombier drew attention to a drawing preserved at the École des Beaux-Arts, which without being beautiful, is nonetheless quite interesting (fig. 162).[10] An almost illegible inscription at the top right corner indicates: "It was what separated the choir from the nave at the Cordeliers." As the good historian that he was, du Colombier decided to verify the inscrip-

tion, though there was no reason a priori to doubt it. He gathered together all the documentation on the *jubé* of the Cordeliers: Sauval's description, which Pigagnol simply repeats; an inventory carried out by Doyen and Mouchy in 1790; and most of all a drawing of the half dismantled church, from the Bibliothèque Nationale, with the *jubé* still standing (fig. 161). Pierre du Colombier came to the conclusion, after examining the materials, that the Beaux-Arts drawing did indeed represent the *jubé* of the Cordeliers. At the same time, he noticed a disturbing resemblance between the drawing and what is known of the *jubé* of Saint Germain-l'Auxerrois. From this, he deduced the *jubé* at the Cordeliers to be an approximate replica of the one at Saint Germain. His method was impeccable, his conclusion absolutely false.[11]

Even the most cursory examination of the drawing from the Cabinet des Estampes (the Destailleurs drawing) cannot fail to reveal the critical differences between this jubé and the one represented in

161

160. Jean Goujon, *Deposition*, bas-relief from the *jubé* at Saint Germain-l'Auxerrois, 1544. Stone, 31 × 76 ¾ in. (79 × 195 cm). Paris: Louvre.

the drawing from the École des Beaux-Arts (the Masson drawing). First of all, it is sufficient to show their incompatibility; it is clear that on each side of the central door in the Destailleurs drawing there are two columns framing a niche, rather than paired columns. Furthermore, it is possible to distinguish a statue in the right hand niche. The drawing has been confirmed by Doyen and Mouchy, whose inventory description reads: "On one side of the door, Saint Peter, colossal and sculpted of stone, on the other Saint Paul." Another essential distinction is the flanking arcades, which quite clearly open onto genuine chapels in the Masson drawing, while it is obvious from the Destailleurs drawing that this

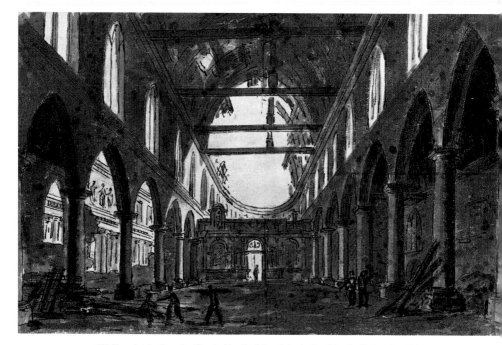

161. Pierre Antoine Demachy, *Church of Les Cordeliers during its demolition* (detail). Drawing, 1802.
Paris: Bibliothèque Nationale de France, Destailleurs collection.

was not the case at the Cordeliers. On the left side, especially, one can discern a molding at the height of a railing. The whole arcade even appears to contain a large painting whose composition is vaguely outlined in the drawing. In addition to these huge divergences, Pierre du Colombier had to assume that the niches springing from the parapet of the *jubé* of the Cordeliers were a later addition, which is unlikely. The conclusion is inevitable: the inscription on the Masson drawing is incorrect; it does not represent the *jubé* at the Cordeliers. Pierre du Colombier had already remarked on the nearly exact coincidence between this drawing, the descriptions given of Saint Germain-l'Auxerrois—especially Sauval's—and the floor plan of the *jubé* made in 1739, before its demolition (fig. 163). The paired columns, the angels bearing the instruments of the Passion in the spandrels, the subjects of the relief panels (even if the compositions are not absolutely identical), in addition to the chapels under the platform; the weight of the evidence allows us to affirm that the drawing does indeed depict the famous *jubé* of Saint Germain, the only work prior to the Louvre known to be by Pierre Lescot.

This is not to say that the drawing is precisely accurate in every respect. Among other things, we should note that the plan shows the central arcade as slightly larger than the flanking ones, represented as identical in the drawing. It indicates a deep arch with a niche, but only on the right side, an asymmetry that seems improbable. However, if we turn to the eighteenth century plan, we do see this kind of a niche, but inside the chapel; it probably held the sort of hand basin commonly placed near the altar. The author of the drawing appears to have made a mistake. Furthermore, he appears to have a poor grasp of the space within the small chapel. This blunder allows us to infer that we are dealing with a view of the building itself, rather than a copy of the designs for it, since it is hard to imagine the draughtsman making this miscalculation under the latter circumstances. Lastly, we should notice that the central relief panel is very different from Goujon's, a pieta with angels on either side in the drawing, which also presents the evangelists in a different order.

These faults in the drawing cannot simply be dismissed, but they do not discredit the document,

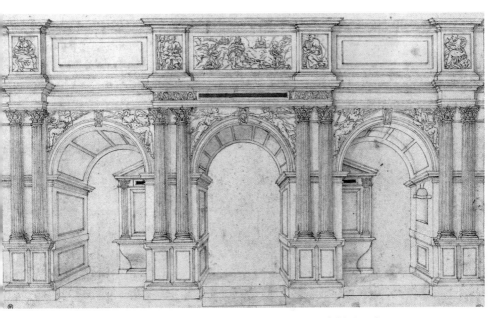

162. The *Jubé of Saint Germain-l'Auxerrois*. Anonymous drawing, second half of the sixteenth century.
Paris: École Nationale supérieure des Beaux-Arts, Masson collection.

163. *Plan of the church of Saint Germain-l'Auxerrois* (detail), 1739. Paris: Bibliothèque Nationale de France, Va 223a.

which presents no more discrepancies than one commonly observes in others, du Cerceau's for instance, and on which we still rely. In any case, another drawing, less detailed but more reliable, from the seventeenth century, confirms the Masson document on all essential points.[12]

This quantity of documentation provides enough material for us to get a sense of the monument and its style. As Sauval's description leads us to believe, it was certainly a work in which the classicizing style had reached maturity. Looking at the rich ornamentation, the integration of the relief work into the architectural conception, and even the use of colored stone for accentuation, it is not too much to say that the art of the Louvre's façade was very clearly prefigured in the *jubé* at Saint Germain. However, once again, we might well ask ourselves whether Jean Goujon did not intervene as more than simply a craftsman. Archival materials give us a reasonably detailed account of the enterprise. There remains a recapitulation of the accounts concerning work at the *jubé*, which extended over a course of several years. The document, first published in 1850 by Leon de Laborde, is confirmed by recent discoveries in notarial archives.[13] First and foremost, it clearly indicates the nature of Lescot's involvement. The fact that his name appears only once in the parish accounts was used to uphold the claim that he oversaw construction only from a distance, but an official contract with a mason for the completion of the

monument explicitly states that everything is to be done "according to the word, opinion, and order of monsieur de Clagny." In fact, monsieur de Clagny—that is, Pierre Lescot—had no reason to appear in the bookkeepers' register of the church since he was not paid by the parish. His name would have been entirely absent from the parochial document, were it not for a curious incident that occurred while the *jubé* was under construction. Here are the facts: the project was undertaken in 1541 and a mason by the name of Louis Poireau was commissioned for its execution. Payment to him began on April 13, 1542 and continued through November. But for reasons unknown to us, "the aforementioned Poireau had abandoned the responsibility of the aforementioned pulpit," and more importantly, had ceased payment to his workmen. The treasurer of the works was therefore obliged to pay them directly for a period of one hundred nineteen weeks. Every week a receipt was signed to show that the payment had been made. On April 15, 1544 there was a certificate, a receipt probably, signed by "master Pierre de Saint Quentin, overseer of the journeymen, and director of the pulpit in question under Monseigneur de Clagny." It was only as an explanation of the position held by Pierre de Saint Quentin in these exceptional circumstances that Lescot's name was invoked. He was probably the one who hired or recommended Saint Quentin for the position of foreman after Poireau's departure. In any case, Pierre de Saint Quentin was granted a retroactive raise, from a daily wage of eight *sous* to ten, reaching back two hundred seventy-five days, making it effective around the beginning of 1542, the same time that payments began to the workmen abandoned by Poireau.

Pierre de Saint Quentin, who started at the site as a simple workman and ended up as foreman, was evidently a young man whom circumstances offered an opportunity to make himself useful to Lescot. The latter probably appreciated not only his leadership and organizational skills but also his artistic talent, since he was in charge of carving the ornaments. As on the façade of the Louvre, the effect of the *jubé* depended not only on the figures and relief panels, but also on the quality of the sumptuous Corinthian capitals, the complex moldings, and the lavish ornamentation.

Jean Goujon became involved only very late, as the project was nearing completion, to work on the reliefs for the balustrade. The contracts for these sculptures were signed on January 12, 1544, at which time construction was well underway. The angels bearing the instruments of the Passion, sculpted in the spandrels, had been ordered in May 1542, and the last payment for them was dated December of the same year. An artist who had worked at Fontainebleau, Laurent Renaudin, who was probably an Italian brought over by Rosso, was responsible for the *patron* (a drawing) and for the model. The execution was entrusted to Simon Leroy in an agreement dated May 16, 1542. This was yet another artist who had worked at Fontainebleau, but he disappeared from the records of the château after the general settlement of 1537–40, and the Saint Germain accounts list him as residing in Paris. He probably left Fontainebleau after the completion of the Galerie François I. Clearly these reliefs were the object of considerable attention, and Lescot turned, for their execution, to artists from Fontainebleau. Judging by the Masson drawing, or even that from the Bibliothèque Nationale where they also appear, the angels were in a fully developed style prefiguring the victories that adorn the spandrels at the Fontaine des Innocents (fig. 166). Yet they could owe nothing to Goujon, who was still in Rouen in 1542.

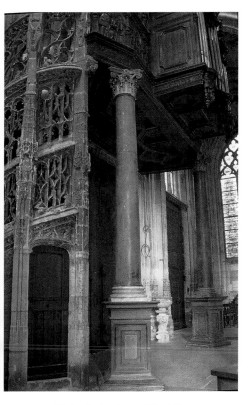

164. Jean Goujon, *Column*, 1541. Marble.
Rouen: church of Saint Maclou.

Goujon in Rouen

Jean Goujon was not a legend in his own time; the only sixteenth-century authors to mention him are Le Fèvre de la Boderie, who published his *Gaillade* in 1578, and Blaise de Vigenère.[14] In the next century, Sauval was his greatest champion; the historian had a special devotion to him and held him to be among the greatest sculptors of all time. Since then his reputation has remained untarnished, but continues to be exclusively linked with his Parisian works all done in association with Lescot.

What exactly is known about Jean Goujon before his work at Saint Germain-l'Auxerrois? In 1540, he appears in the archives of Rouen and nothing is known of his prior activities. He is then mentioned in several documents at Rouen, the last of which is from October 11, 1542. Sometimes he is described as a "stonecutter and mason" others as "sculptor *[ymaginier]* and architect *[architecteur]* sworn in at the city of Rouen." These terms encompass a wide range of activities from laying stones to architectural design, with sculpture somewhere along the way. Here we see Goujon providing architectural drawings, as well as sculpting the head of the funerary statue for the tomb of Georges II d'Amboise in the cathedral of Rouen. He was also employed as an appraiser and consultant for the cathedral bell tower. The term *"architecteur"* which figures in the last document

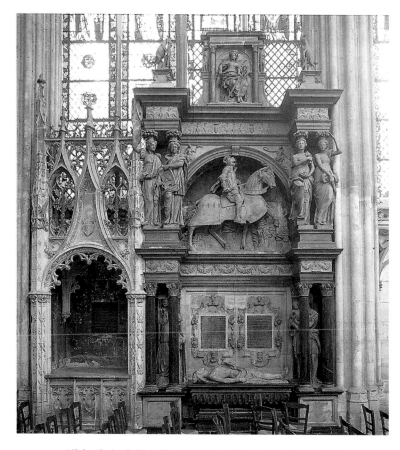

165. Jean Goujon (?), *Tomb of Louis de Brézé*, c. 1544. Rouen: Notre Dame cathedral.

166. *Victories from the Fontaine des Innocents*, after Jean Goujon, plaster cast from the nineteenth century. Paris: Musée des Monuments français.

cited, was relatively new, and corresponds well to the artist's modernism. At the same time, it would be foolish to make too much of this, since the same title was accorded to another expert who was summoned, one Noel Quesnel who does not appear to have been an innovator.

Only one piece of work that can with certitude be attributed to Goujon subsists from his stay in Rouen. On August 30, 1541 the workshop of Saint Maclou commissioned two columns, which still support the organ loft in the church (fig. 164). The care taken over the arrangements for this project is rather surprising, considering it was ostensibly a minor commission. Goujon was first called upon to draw the project design, only afterward was an agreement reached regarding the work itself. As specified in the construction documents and accounts, the base and capital of each column were of white marble, while the shaft and pedestal were of black marble. While the color contrast is hardly classical, the capital is impeccable in its design. It has the peculiarity of following to the letter the proportions suggested by Vitruvius, a rare occurrence because this is not in keeping with examples seen in Roman ruins, which have more elongated capitals. The quality of the execution and the sense of organic unity show an exceptional understanding of the antique. Are they, however, enough for us to agree with Pierre du Colombier that "the 'Goujon style' appears suddenly in the columns at Saint Maclou?"[15] I think this is something of an overstatement. However remarkable they are for their date, would these two columns have fascinated us so much were Goujon's name not attached to them? If chance had not furnished proof that he made them, would we even have thought to attribute them to him? Striking to me is the fact that, on the contrary, we see no trace of a Goujon style in Rouen while he was there. It has been suggested, not unreasonably, that he had a hand in the architecture of La Fierté de Saint Romain, a strange little monument in the antique style. However, the important thing is to determine whether he was the author of an assertive work, one that affirms itself as a veritable manifesto of the new classicism: the tomb of Louis de Brézé at the cathedral of Rouen (fig. 165).

This large monument, set against the wall, has the appearance of a façade with three tiers. On the

167. *Tomb of Louis de Brézé.* Seventeenth-century anonymous drawing. Paris: Bibliothèque Nationale de France, collection Gaignières, Pe 11b rés.

first level, supine on a black sarcophagus, a *transi*—sculpture of the deceased—is framed by paired Corinthian columns bearing a complete entablature with a garland frieze. Above, caryatids representing the Virtues are substituted for the columns. Under a wide central arch, a knight in full armor rides through the countryside, sword in hand. In the spandrels, Victories hold out crowns. Here is the triumph of the hero, the military leader. A jutting cornice would seem to complete the composition, to which a third level was nevertheless added; animals bearing coats of arms stand atop the columns and in the center is a frame that resembles a dormer window. The figure filling this space is a Virtue with multiple attributes.

Louis de Brézé, grand seneschal of Normandy, died on July 23, 1531. He had expressed the wish to be buried in the Lady Chapel at Rouen's cathedral next to his ancestor Pierre de Brézé—a friend of Agnès Sorel—whose Flamboyant monument

still exists, though it was much restored in the nineteenth century. On March 27, 1536, Louis's widow, the illustrious Diane de Poitiers, wrote to the chapter stating that she had decided to erect a tomb for her husband in the cathedral. Nothing more is known about the course of events, except that the monument appears to have been completed by 1544.[16]

The lower tier is very surprising. At one end of the *transi* is a statue of a woman in prayer, generally thought to be Diane de Poitiers herself, and at the other the Virgin and Child. These sculptures are hardly visible, placed as they are behind the paired columns. Also, the Virgin, too large for the space, obscures almost completely a very beautiful angel carrying the arms of the deceased. It is hard to imagine that this was the original intention of the artist. Could these sculptures have actually been intended for some other project? This would also explain the disparities in workmanship. As for the large bust behind the supine figure—now missing, it is known from the drawing made in the seventeenth century for Gaignières—was it indeed a portrait of Louis de Brézé as previously assumed? Might it not be an addition foreign to the initial design?[17] As it stands, the tomb has neither precedent nor successor, and is altogether difficult to comprehend.

The value of the monument lies as much in its architectural character as in the originality of its conception. Moreover, this architecture is perfectly compatible with everything we know about Jean Goujon. As at Saint Maclou, the shafts of the columns are black with white capitals, and while the proportions of those of the tomb are a little different, they are nevertheless similarly drawn. The caryatids are in keeping with those Goujon

later drew for the 1547 edition of Vitruvius, which we will come back to. It seems to me most probable that Goujon was the author of this project. As for the execution—very unequal in quality—it is difficult to voice an opinion, since the only admissible comparison is with the columns at Saint Maclou, which provide very slim evidence. Although severely damaged, the *transi* remains an impressive piece, and the blazon-bearing angels have a great deal of charm.

The tomb of Louis de Brézé employs a highly developed classical style for its date, with its wide arch and paired columns that herald the frontispiece at Anet. But it has little in common with the *jubé* at Saint Germain-l'Auxerrois, or for that matter, with the Fontaine des Innocents, at least with respect to the relief work. If, for instance, we compare the Victories occupying the spandrels at the Fontaine des Innocents (fig. 166) with those adorning the tomb in Rouen, there is a world of difference between the two. The intervention of an incompetent craftsman would suffice to explain the excess of relief in the sculptures of the tomb, but even their design is abrupt; too crudely antique, it bears little resemblance to the delicacy of Goujon's work in Paris. The author of the columns at Saint Maclou would appear to be a stoneworker turned architect in the new style—knowledgeable, and even slightly pedantic. The tomb of Louis de Brézé does not contradict this image in the least, and there is every reason to believe that it was designed by Jean Goujon—though we cannot know for certain the extent to which he was also responsible for its realization. Yet nothing in the works from Rouen that we can associate with Goujon really heralds the "Goujon style" as it reveals itself in Paris.

Pierre de Saint Quentin and the "Goujon Style"

At one point, in the church of Saint Méry, there was a very large altarpiece of sculpted stone.[18] There is no precise description of its appearance before it was dismantled and moved to the Musée des Monuments Français (Museum of French Monuments), but we do have a drawing (fig. 168)

made after its reassembly and installation in Alexander Lenoir's museum. Reincarnated as a tomb in the drawing, it is unaltered except for the addition of a funereal statue of Guillaume Douglas, and the substitution of a terracotta Trinity taken from the church of Saint Benoit for

the original sculpture on the upper level, probably Christ on the Cross. The altarpiece was about twenty-five feet high by just over eight feet wide. It was composed of three levels defined by the orders and was crowned with a pediment. Relief panels presented scenes from the Passion of Christ and its symbolic prefigurations from the Old Testament (the *Gathering of the Manna in the Wilderness* and *Sacrifice of Isaac by Abraham*). In Lenoir's drawing we discover a majestic work, one that demonstrates full knowledge of even the most recent artistic developments.

The altarpiece was acquired at the time of the Revolution by Alexander Lenoir for his museum; its remains have found their way to the Musée Carnavalet after a series of misadventures.[19] We learn from Lenoir that the monument bore the following inscription: "Pierre Berton, native of Saint Quentin completed this task in 1542." Nonetheless, we should be wary of Lenoir, who was perfectly willing to resort to his imagination in order to corroborate his hypotheses. However, since the name of Berton was completely unknown at the time, Lenoir can hardly have invented the inscription, and we can give him credence here. Today, we know Berton to be none other than the skillful stonecutter and mason who oversaw construction of the *jubé* at Saint Germain-l'Auxerrois before becoming one of the principal contractors in the building of the Louvre.

Pierre du Colombier dismissed the altarpiece as very mediocre, and left it at that.[20] Crudely reassembled and severely damaged, the piece certainly leaves a poor impression, which explains such a summary judgment. Most of the heads, grossly redone, give an almost grotesque appearance to the reliefs. And yet, a close examination of the less disfigured portions reveals a work of high quality. Not only does the architectural decoration suggest a familiarity with classical vocabulary exceptional for the date, but bearing in mind only the elements which escaped restoration like the figure at the far right of the *Last Supper* (fig. 169), or saint John leaning on Christ (fig. 170), one realizes that the sculpture is in fact far from mediocre. As a whole, the reliefs are classicizing in manner, comparable to what someone like François Marchand was capable of producing at the same period on the *jubé* at Saint-

Pere-de-Chartres. Still, one angel (fig. 171) holding the column of flagellation sticks out in a disturbing way (it is exhibited separately in the museum, but the drawing from Lenoir's album clearly shows where it was placed). The gracefulness of the face with its artfully disarranged curls, the ease of the pose, and the fluidity of the drapery cannot but bring to mind the name of Jean Goujon, as many have pointed out, some going as far as to situate the work in that artist's entourage.[21] However, in 1542 Goujon had left no model that could have been followed—certainly none exists in Paris. Pierre Berton, on the other hand, must have been aware of the angels bearing the instrument of the Passion that were then being made for the *jubé* at St.-Germain. As the figure responsible for masonry there, he certainly saw the model before the final realization. Perhaps this was the origin of the peculiar vibrancy that runs through the angel on his altarpiece.

Here we find ourselves faced with a paradox. One the one hand, we have a sense of Jean Goujon's artistic personality prior to his arrival in Paris and his collaboration with Lescot. He does not appear to have been a virtuoso of pictorial relief, but a dogmatic student of the antique style, with more austerity than grace. On the other hand, the "Goujon style" seems to make its appearance at Saint Germain before even the arrival of Goujon at the site.

Goujon has been suggested as the veritable author of the Louvre. Why not then Pierre de Saint Quentin, who was at Saint Germain from the start? This is not, of course a serious suggestion, but two points are worth making here. First of all, Pierre de Saint Quentin certainly played a role that has been perhaps unfairly neglected. At the Louvre, he was probably in charge of the architectural ornaments, as he had been at Saint Germain-l'Auxerrois, supervising the carving of all the magnificent capitals, the lush-seeming vegetation, the surfeit of chiseled stone, unbelievably fine and precise. Obscured by the prestige enjoyed by Goujon's reliefs, the non-figurative elements of the façade make a significant contribution to the effect produced by the Louvre. The second—and crucial—point to make is this: at Saint Germain, Lescot assembled a team that followed him to the Louvre.[22] The success of his undertaking depended entirely on the bond between the

168. The *Altarpiece of Saint Méry*. Drawing from the album of Alexandre Lenoir, c. 1800. Paris: Louvre.

169. Pierre de Saint Quentin, *Altarpiece of Saint Méry: Disciple*, 1542. Stone. Paris: Musée Carnavalet.

170. Pierre de Saint Quentin, *Altarpiece of Saint Méry: Saint John*, 1542. Stone. Paris: Musée Carnavalet.

171. Pierre de Saint Quentin, *Altarpiece of Saint Méry: Angel*, 1542. Stone 29 ⅓ × 20 ½ × 6 ⅔ in. (74.5 × 52 × 17 cm). Paris: Musée Carnavalet.

172. *Courtyard façade of the château at Vallery*, from *Les Plus Excellents Bastiments de France*, by Jacques Androuet du Cerceau, 1576. Paris: Bibliothèque Nationale de France, rés V 390.

executants. The mere fact that the vaults of the main staircase had long been attributed without hesitation to Jean Goujon and his workshop, though the documentation now reassigns them to their rightful authors, is powerful evidence of the visual coherence of the Louvre. Lescot acted as a sort of orchestra conductor, whose conception could be realized only through the talent of other artists. We must now ask if this new artistic style, this "Goujon style" which appears at Saint Germain and comes into its own at the Fontaine des Innocents and the Louvre, was indeed his initiative.

Pierre Lescot

Who was Pierre Lescot exactly? He is perhaps an even more elusive figure than Jean Goujon. We do, however, possess an exceptional and undervalued witness: the poet Pierre de Ronsard, who in 1560 dedicated his *Second Livre des poèmes* to "Pierre l'Escot, councilor and ordinary chaplain to the King, abbot of Cleremont, and seigneur of Clagny." The opening *Élégie* is addressed to Lescot; it is a poem whose theme is the irresistible character of the artistic calling. In the first part—which occupies one hundred four lines of the one hundred fifty-eight line poem—Ronsard gives us an account of his own life, describing his father's fruitless efforts to redirect him from poetry towards a more lucrative career. But, he says, "the more he chided me/ the more did fury incite me to write verse." Then he comes to Lescot with whom he draws an

exact parallel: "never could anyone go against your nature [. . .]" He tells us of Lescot as a schoolboy, incorrigibly filling his copybooks with drawings, just as the young Eugène Delacroix would later. Ronsard also gives us one precise biographical detail: Lescot, who had first studied painting, turned to architecture when he was twenty. The poet may not be exaggerating when he places the artist in Henri II's close circle. Nor can we doubt his sincere admiration for Lescot's talent. Ronsard was, of course, capable of flattery, but he accords to Lescot what he refuses men of power, the very function that made himself indispensable: the ability to make their memory lasting, and thus procure an earthly immortality. According to Ronsard, Lescot had in turn consigned his admiration for the poet to the façade of the Louvre:

I remember one day while at table the Prince/ Praising your virtue as astonishing/ Said that you had on your own learned your trade/ And still among all the prize you could claim/ As did my Ronsard, who to poetry/ In spite of his family his fancy did follow/ In memory of which you had carved atop the Louvre/ A goddess forever accompanied by/ The wind with full cheeks blowing into a horn./ You showed it to the King and said it was made/ A figure representing the power of my verse/ Which did his name, like the very wind, throughout the universe bear.

Thus Ronsard's poetry is forever celebrated by the art of Lescot, whose genius is likewise immortalized for generations to come by the dedication of the *Poèmes*. Ronsard addresses Lescot as an artist, an equal, and suggests complete reciprocity in the relationship.[23]

Aside from this impressive testimony, we know very little. Lescot belonged to a well-off parliamentary family. One of his brothers, Guillaume, was a priest at Lissy-en-Brie. Another, Léon, was on the parish council at Saint Germain-l'Auxerrois.[24] Given his social class, we may assume that Lescot was an educated man, and La Croix du Maine, "who compiled a sort of biographical dictionary of French authors in his *Bibliothèque Françoise,* stated that Lescot wrote a book on architecture, though no other trace of it remains. About his training we have absolutely no information. It seems fairly certain that he was a painter. Several brief but explicit references confirm this important fact, and according to Jean Bodin, his canvasses were highly valued.[25] Nonetheless, at present, no attributions have been made to him, nor do we possess a single one of the innumerable drawings that must have been made for building the Louvre. Not even in the form of copies have they survived.

Until a few years ago, Lescot's artistic career was associated almost exclusively with the Louvre—almost, but not entirely. Very early, Sauval recognized his manner in the Hôtel Carnavalet. Indeed, sculptural ornamentation is substantial at this prestigious Parisian townhouse and Jean Goujon could have played a decisive role. However, aside from the uncertain nature of such an attribution, it fails to resolve the basic question of authorship. It is now established that Lescot was

173. Vallery (Yonne, France), château, courtyard façade, c. 1555.

also the architect for the Marshal of Saint André, the favorite of Henri II, who showed him a partiality almost as flagrant as that he had for the beautiful Diane de Poitiers.[26] His château at Vallery—now virtually in ruin and little known—was, according to du Cerceau, even more sumptuous than the king's residences (fig. 172). This important work considerably expands our conception of Lescot beyond merely the architect of the Louvre.

Only two wings of the château were built before the violent death of the marshal put an end to construction in 1562. Here, using an entirely modern idiom, Lescot preserved some of the symbolic features of the fortified castle; of this remained the moat, causing the château to stand on an awe-inspiring pedestal whose angles are accented by rusticated stone quoins, or *bossages en harpe*. As at the Louvre, a rectangular pavilion evokes a corner tower rising one story higher than the adjacent wings. Strongly emphasized on the outside, the motif was more discrete in the courtyard. At Vallery, Lescot did not rely on sculpture for effect. He played on contrasting building materials,

mostly brick and stone (fig. 173). Brick was used for the main parts of the wall but the stone accents—the window frames, moldings, and cornerstone chains—are so large and refined that the brick is obviously used not out of economy but sophistication. Indeed, it seems that on the exterior, at least, only the imposing corner pavilion presented this contrast, accentuating its stature next to the wings where the brickwork was covered with light stucco.[27] While Gébelin wrote only briefly of Vallery, he perfectly understood its important features and his analysis is worth citing at length:

> On the outside, these chains of stone carved in relief effectively inspire awe. On the courtyard they are smooth, and the gentler architecture is also richer: the stone mullions on the ground floor are surmounted by pediments, the upper windows have straight cornices with discretely tasteful ornamentation; exquisitely carved. The piers are furnished with niches or marble plaques; on the ground floor, a few arcades bring variety to the façade. The aristocratic luxury of Vallery resides at the same

174. Vallery (Yonne, France), château, façade, c. 1555.

time in the choice of materials and quality of the workmanship, and in the majesty projected by the composition. It is, in its own way, a monument that closely approximates perfection. We can well understand why du Cerceau compared it to the royal pavilion at the Louvre, which shares these same qualities and invests in the same architectural austerity.[28]

Indeed, stone is here put to use in its most pure form: abstractly. The only figurative motif is a series of masks that embellish the keystones of the arcades in the courtyard. These are charming, and perfectly in keeping with our conception of the "Goujon style." This aside, every effect is one of surface, texture, or color contrast. The big window frames on the exterior façade play off of the juxtaposition of brick, smooth, and textured stone; on the ground floor the smooth stone mullions appear as if imprisoned by the rusticated stone blocks, above on the second story, they have sprung free. Thus with astonishing vitality takes shape the idea, the *concetto,* of an architecture that progressively emancipates itself from nature as the building rises from the ground. In this ornamentation the architect also manipulates very precisely the creation of distinct planes defined by a minimum of relief. Ultimately, this is the same spatial stacking we have already encountered in Flamboyant art; it is an extension of the same sensibility, the same taste for virtuosity in stone working. In another sense, one may see it as the abstract equivalent of Goujon's relief as it appears at the Louvre: planes subtly differentiated within a very shallow depth. This parallel clearly brings out the extent to which relief sculpture is an integral part of architecture at the Louvre.[29]

Though little is left of the interior at Vallery, one can still see the remains of the loggia that opened onto the courtyard. Here, Lescot avoided ornamentation altogether, the better to show off smooth stone, thus revealing another facet of his skill that one might not have suspected (fig.449).

Where then did Lescot get the elements for this sophisticated art? We know nothing at all about his background. However, it is telling that prior to employing Goujon, Lescot should have called upon two sculptors from the works at Fontainebleau to execute the *jubé* at Saint Germain. This implies—to me at least—that he drew his conception of art

from this, and his idea of how to run a construction site. Our man may have been largely self-taught, as Ronsard would have it in claiming that Henri II "said that you had on your own learned your trade." Nevertheless, he must have had models to give shape to his understanding of art and the function of the artist. Lescot, who was not born into the profession as was Philibert de l'Orme, but was instead a gentleman of good stock to whom the artistic vocation beckoned, could not have been insensitive to the seduction exerted by the ideas of the Italians at Fontainebleau who brought with them to France a humanistic, intellectualized view of their craft. These ideas he tried out at Saint Germain, aided in part by a staff already trained by Rosso and Primaticcio. The great decorative painters of Fontainebleau served as his models not only aesthetically, but intellectually and in administrative matters as well: Goujon's stylistic debt to Primaticcio has been evoked time and again. For Lescot, however, the most important legacy was ultimately that of Raphael as regards the discipline of the site—the example of an organization permitting the master of the works to realize his personal vision through the executants whose individuality was diminished, but whose very real talents contributed to the result. To this supportive framework, Lescot brought an original conception of decoration, one that was more sensitive to French practices and tastes. The Fontainebleau sculptors were quickly replaced with stonecutters on whom Lescot could doubtless impose his will more effectively. It was on these that he relied when embarking on the great adventure that was to be the Louvre.

Goujon without Lescot

What do we know about Goujon independent of Lescot after 1544? In fact, very little. Jean Goujon himself claimed the illustrations to Jean Martin's translation of Vitruvius' *Architecture,* published in 1547, and there is no reason to believe that Lescot was in any way involved in the project. Our artist borrowed a large number of illustrations, near literally copied from previous editions, but the new plates are sufficiently numerous to offer precious information. The work is that of an adept of antiquity, passionate about Vitruvius, but it lacks sparkle and there is nothing that hints at the later Fontaine des Innocents, or the allegories at the Louvre. The plate showing the order of caryatids allows for close and significant comparison with both the tomb of Louis de Brézé and with the caryatids at the Louvre (figs. 176, 177, and 178). The resemblance of the Brézé caryatids to the plates is often used to confirm the attribution, and is indeed convincing: the same feminine type, and the same taste in the drapery. The Louvre figures, on the other hand, are profoundly different. They have a shapeliness and fluidity in the drapery, a plenitude and ease in their forms that is nowhere to be found in the tomb at Rouen, or in the plate from the *Architecture*. In fact, the wording of the agreement with Goujon for the figures at the Louvre specifies that the figures were to be "sculpted in he round, according to and following a plaster model previously made and delivered to him by the aforementioned sieur de Clagny." Lescot, then, must have given the sculptor a three-dimensional model, which indicates just how precise the instructions were that he provided to Goujon. Various attempts have been made to explain this text in such a way as to protect the sculptor's autonomy. However, a comparison with the caryatids Goujon drew to illustrate Vitruvius suggests, on the contrary, that the originality of the Louvre figures is due to the architect. Furthermore, the subtlety and skill of these colossal figures tends to overwhelm the audacity of the general concept; in order to prevent these gigantic and graceful figures from appearing absurd, Lescot had to carefully control their integration into the scenography he created in the royal hall.

There is no other work between the *jubé* at Saint Germain and the Fontaine des Innocents that we can confidently attribute to Goujon. Yet, in the preface to his translation of Vitruvius, Jean Martin affirms that Goujon had been the architect for the constable (*connétable*) of Montmorency

175. *Entrance to the château of Écouen*, from Jacques Androuet du Cerceau, *Les Plus Excellents Bastiments de France*, 1576. Paris: Bibliothèque Nationale de France, rés. V.390.

before serving the king. It is probable that this activity falls into the period in question.[30] But what did Goujon do between 1544 and 1547 in the service of Montmorency? The most plausible hypothesis is that he worked on the château of Écouen where he would have designed, in particular, the entry wing that no longer exists (fig. 175). The fragments of sculpture we still possess—two angels holding swords—conform to a somewhat rigid classicism well in keeping with the Vitruvius illustration. Moreover, the frontispiece that enhances the entry to the château, with its equestrian statue, presents obvious similarities with the de Brézé tomb (figs. 179 and 165).

Was the decoration of the chapel his work as well? The altar (now reassembled at Chantilly) consists of relief panels representing the evangelists, which bear an obvious resemblance to those at Saint Germain-l'Auxerrois (fig. 181). What relationship can we establish between these two works? Anthony Blunt thought Goujon had himself executed the reliefs at Écouen between his time in Rouen and his arrival in Paris in 1544. This seems highly improbable, given how disappointing they are compared to those at Saint Germain (fig. 159). It makes more sense to accept du Colombier's hypothesis and consider these reliefs to be later than those at the *jubé*. While they may draw inspiration from these latter, they also diverge from them. Not only is the execution much inferior, but the drawing is also less sophisticated. Also, as Pierre du Colombier pointed out, the artist avoids difficulty in the sculpture. While the *Saint Mark* at Écouen is not inexpressive the lost profile in the Saint Germain version is infinitely more audacious. The entire composition at Chantilly seems, in comparison, scattered and insignificant. If we assume—as does du Colombier—that the altar at Écouen was designed by Goujon and executed by another sculptor of his following, then

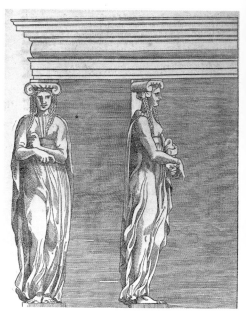

176. Jean Goujon, *Caryatids*, from Vitruvius, *L'Architecture ou Art de bien bastir*, Paris, J. Barbé, 1547.
Paris: Bibliothèque Nationale de France, Ha 11a.

we must confess the artist was far from outdoing himself. However, prototype aside, the altar at Écouen is admittedly a quality work. Du Colombier is right to note that the architectural conception is in perfect harmony with the entire decoration of the chapel, especially the magnificent woodwork. Visibly, a single artist orchestrated the project; his taste, highly antique, seems close enough to what remains of the entry wing of the château for us to think that the author could be the same in both cases—perhaps Goujon himself.[31]

Using the Vitruvius illustrations as a starting point, there is another possible line of speculation. The Musée Condé at Chantilly contains two stone reliefs, *Phaeton's Fall* and *Departure,* which may be from the château at Écouen. These bear a striking resemblance to two wooden reliefs of the same subject preserved in Rouen. The compositions are different, but the formal characteristics, the conception of the nude figure, and the relief work are

177. Jean Goujon, *Caryatid*, 1550–51. Stone.
Paris, Louvre: Salle des Caryatides.

178. Jean Goujon (?), *Tomb of Louis de Brézé: Caryatids,* c. 1544.
Rouen: Notre Dame cathedral.

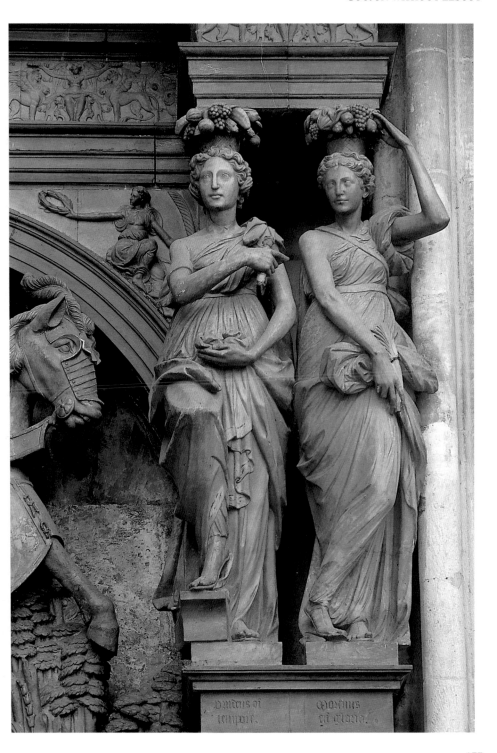

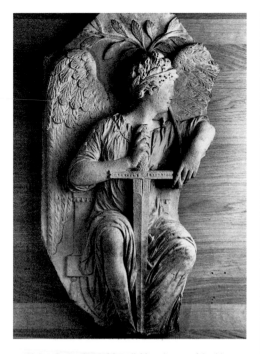

179. Jean Goujon (?) *Angel*, bas-relief from the entry of the château
at Écouen, c. 1545. Stone, 72.5 × 42 cm.
Écouen: Musée national de la Renaissance.

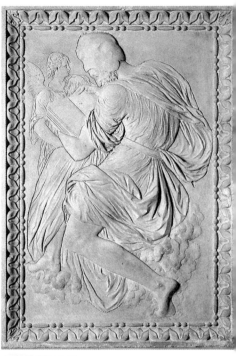

180. Jean Goujon, *Saint Matthew*, bas-relief from the *jubé*
of Saint Germain-l'Auxerrois, 1544. Stone, 31 × 22 in. (79 × 56 cm).
Paris: Louvre.

181. Anonymous, *Altar of the chapel at the château of Écouen* (detail), mid-sixteenth century. Stone. Chantilly: Musée Condé.

very similar. Furthermore, it seems to me that the plate from Vitruvius representing primitive humanity expresses a similar sensibility (fig. 182). In these works we are far from the delicate and refined Goujon of Saint Germain-l'Auxerrois and the Fontaine des Innocents. Nevertheless, if we accept that the Vitruvius plates are his—and his alone—could the panels at Chantilly be the work of Goujon the independent sculptor, freed from the demands of Lescot? I hardly dare put forth such an hypothesis, so contrary it is to the idea we have of Goujon. Yet, the coincidence relating the sculptures discovered at Écouen to those in Rouen leaves one perplexed, and I find it difficult to neglect the features they share with the Vitruvius illustration.[32]

Does this suffice for us to postulate the nature of a Goujon without Lescot? It seems to me that in these few and scattered clues, we glimpse an unexpected artistic personality, very different from the sculptor-genius forged by tradition into myth out of the reliefs at Saint Germain-l'Auxerrois, the Louvre, the Fontaine des Innocents, and also—let us recall—out of the marvelous *Diana* from Anet, which is not by him. But this Goujon without Lescot remains at best a ghostly figure. So decisive was the encounter with Lescot that only then was Goujon's genius fully revealed.

The Fontaine des Innocents

The Fontaine des Innocents in Paris is Goujon's signature piece. His lithe nymphs with their marvelously sinuous curves are the very quintessence of the French Renaissance and bear comparison only with the most beautiful sculptures of ancient Greece. We now know this fountain only as a work of sculpture. After many disasters, the monument we see today bears little resemblance to one inaugurated in 1549 for the triumphant entry into Paris of Henri II. It was not the freestanding little structure that it is today, but a construction designed to square off the street corner between the rue Saint Denis and the rue aux Fers and lend it architectural definition. The fountain properly speaking was part of a tall base, while the space above formed a loggia with two arcades on one side and a single one on the other. The probably excessively picturesque view engraved in the seventeenth century by Israël Sylvestre best evokes the general appearance of the monument, while a plate from du Cerceau gives us its designs with greater precision (figs. 184 and 186).

The fountain was not, in itself, new; it had served for a long time as one of the stops for official entry processions, where the parade would halt to watch some performance. For the entry of Henri II, the document specifies that the fountain, having received a new decor, "was embellished inside by the presence of noblewomen, young ladies, and bourgeoisies, and similarly noblemen and other citizens of the city, so well arranged as to be greatly beautiful."[33] The sort of loggia defined by the arcades on the upper level was

SECOND LIVRE

182. Jean Goujon, *Life of Primitive Men*, from Vitruvius, *L'Architecture ou Art de bien bastir*, Paris, J. Barbé, 1547. Paris: Bibliothèque Nationale de France, V 326.

179

183. Israël Sylvestre, The *Fontaine des Innocents: imaginary view*. Etching, 1652. Paris: Bibliothèque Nationale de France, Ed 45c.

184. Israël Sylvestre, The *Fontaine des Innocents*.
Etching, seventeenth century.
Paris: Bibliothèque Nationale de France, Vx 15.

obviously a privileged position from which to view the arrival of the royal procession. Conversely, the Parisian gentry, arrayed in their finery, formed part of the decoration with which the city greeted its king. This was, after all, the principle of such a solemn entrance: the encounter of two social groups, the court and the urban elite showing off for each other. However, the fountain was not only an ephemeral decoration, existing solely for the festival. It stood in permanent proclamation of the city's munificence. Paris had always had water problems and the flow of the fountain was not terribly impressive, but the

185. Jean Goujon, *Nymph with Genie*, bas-relief from the *Fontaine des Innocents*, 1547–50. Stone, 28 ¾ × 76 ¾ in. (73 × 195 cm). Paris: Louvre.

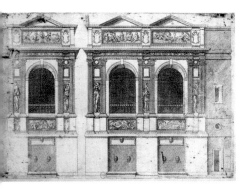

186. Jacques Androuet du Cerceau, The *Fontaine des Innocents*,
third quarter of the sixteenth century. Etching.
Paris: Bibliothèque Nationale de France, Va 229e.

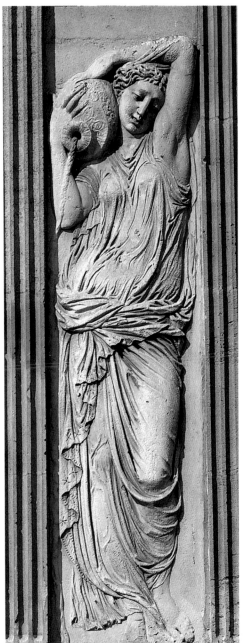

187. Jean Goujon, *Nymph*, 1547–50. Stone.
Paris: *Fontaine des Innocents*.

rhetoric of art took up where reality fell short. The miserliness of the taps on the base is compensated for by the overflowing allegory: nymphs, tritons, and sea horses, forming a whole aquatic world, writhing and splashing.

There is no denying that the genius of the sculptor is responsible for the successful enchantment that the work never fails to inspire. Cut by a less knowing or less sensitive chisel, these figures would have no life. One has only to compare them with the *Four Seasons* at the Hôtel Carnavalet to see how true this is. However, at the same time, Lescot's contribution may have been decisive, even in this work, which seems so completely characteristic of Goujon. Today we are able to admire some of the sculptures—those surviving the carelessness with which they were treated, deprived of their original context at the Louvre museum (fig. 185). In the eighteenth century, when the Cimitière des Innocents (Cemetery of the Innocents) was destroyed, their architectural setting was itself transformed with the obvious intention of setting off the sculptures to advantage. Nonetheless, originally, they were to be seen quite differently.

Lescot's intervention, invoked on a regular basis since the eighteenth century, is considered probable by modern authors such as Pierre du Colombier and Naomi Miller.[34] Having expressed this opinion, however, they proceed to speak of the work as though it were an intimate expression of the sculptor. "In this allegory of water," writes du Colombier, "allegory so transparent that the

181

nymphs take part in the fluidity of the element they represent, he [Goujon] encountered, with a good fortune that usually strikes but once in the life of an artist, the subject that had been destined for him from the beginning of time."[35] Perhaps, but du Colombier insisted particularly on the subjugation of these reliefs to their architectural setting, and cites with approbation a text by Quatremère de Quincy, the great neoclassical critic to whom we owe the preservation of the fountain when the cemetery was dismantled: "Should one detach these figures from the architecture that frames them, if one placed them at different distances and different angles, one would see them lose the greater part of their merit, their lightness would become length, their delicacy would become thinness, their finesse seem dry, their elegance perhaps mannered."[36] If this is true, the adaptation—or rather, integration—of the figures into the architectural setting is of the highest importance; and if one admits that Lescot conceived the architecture of the project, the question of modality in the collaboration between the two artists necessarily reemerges. Should we suppose that Lescot provided Goujon with an empty architectural frame within which he could give free rein to his genius? Such architecture is meaningless without the reliefs. At the Fontaine des Innocents, as at the Louvre, the reliefs constitute

an integral part of the architecture. Furthermore, this conception of architecture that comes to life, so to speak, through the animation of stone under the chisel of the sculptor, seems to me appropriate for a painter-turned-architect such as Lescot.

It is difficult for us to accept such a division between conception and execution, especially in a masterpiece. Our idea of the inspired work of art demands a complete identity of hand and mind. We are used to accepting the fountain as a work of sculpture and hence, the work of a sculptor. In fact, it is a product of architecture and even urbanism. One detail that has been ignored by commentators seems particularly significant to me. In the etched rendition drawn and published by du Cerceau, one can see that on the side facing the rue aux Fers, he has taken the trouble to show the adjacent building. The moldings continue along the neighboring wall in order to integrate the monument fully into the continuity of the urban façade. This fact is confirmed by the view provided by Israël Sylvestre, who in another print represented the fountain in an imaginary perspective: detaching it from the adjacent houses, and in this sense isolating it (fig. 183). At the same time, he symmetrically doubled it, giving it colossal proportions to create a grand architectural perspective. To seventeenth century imagination, the celebrated fountain clearly evoked an urban theme.

The Louvre as Architectural Decor

At the Louvre, there is no doubt about it—Lescot was in charge. The sculpture, though inspired, was conceived as an element of the architecture. Analyzing the courtyard façade—fortunately in fairly good condition—one realizes how true this is. The ensemble consists of three articulated pavilions. The idea must have come from an old French custom: a large edifice was made by joining several building units each of which is treated separately, and each having its own roof. By submitting this kind of articulation to systematic regularity, the experiments of 1530–45 in Île-de-France (the Hôtel de Ville or City Hall of Paris, and the Château de Madrid are the most striking

examples[37]) adapted it to the new sensibility. Lescot's innovation consisted in reducing the pavilion to a mere change of plane, all the more discrete because it progressed only by successive stories. In order to make the movement of his façade clearly readable, Lescot plays off the actual projection against the distribution of ornamental sculpture. Jean Guillaume and François Charles James have well described how "from one level to the next, the volume of the projecting pavilion affirms itself more and more (up to the pediment which distinguishes itself from the roof) while the ornamentation becomes more and more similar to the neighboring parts (reliefs uniformly cover the

attic, while only the entryway is adorned on the ground level)."[38]

The façade lends itself to another analysis, however, especially if one's eye pauses first on the ground level. Here, in fact, there is no projection of the pavilions. The only distinction of plane relative to the arcades is that of the pairs of columns, above which the entablature protrudes slightly. The plane of the wall, however, is continuous along the entire width of the wing. The entablature, on the contrary, is interrupted above the doors and marks a vertical accent compromising the horizontal division, the complete autonomy of levels traditional in classical architecture. It is crucial to note that this interruption is not present all across what becomes the *avant-corps* in the floor above, but only in line with the door jambs, and that it recedes rather than advances relative to the plane of the façade. Furthermore, the windows are cut in the wall behind the exterior façade of the building, at the back of what the construction documents refer to as the *"arceaux."*[39] The ground floor thus presents two distinct planes across the entire width of the façade. On the upper floors, the *avant-corps* advance against the continuation of the receded plane, by

extending the forward plane of the ground floor (fig. 190). This reading, however, is rendered ambiguous by two elements. For one thing, the continuity of the planes is partially compromised due to the fact that they recede from one floor to the next.[40] Additionally, the orders of the pilasters create a tie between the forward face of the ground floor and the wall itself; by this I mean that the pilasters of the second story are superimposed above those of the ground floor but move from the forward plane to the wall plane. The result of this ambiguity is that the façade seems to detach itself, so to speak, from the building and does not appear as a rhythmic articulation of the wall (or the expression of an interior space). Instead it is like a screen in front of the edifice: purely decorative.

It is worth mentioning some other unconventional details that characterize Lescot's architectural thinking. At the attic level, a frieze of acanthus extends the decoration of the pilaster capitals over the entire length of the wall. The choice of this motif, inconsistent with the architectural fiction of the orders, can be understood as a reminiscence or persistence of the grid pattern recurrent in very late Gothic architecture and almost

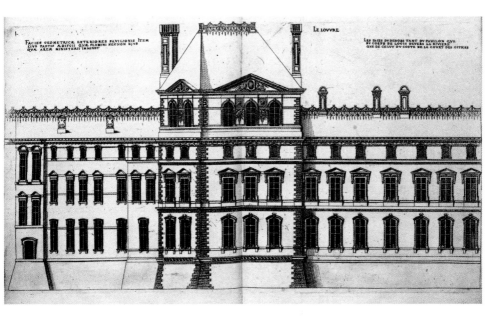

188. *Façade with the Pavillon du Roi*, from Androuet du Cerceau, *Les Plus Excellents Bastiments de France*, 1576. Paris: Bibliothèque Nationale de France, rés V. 390.

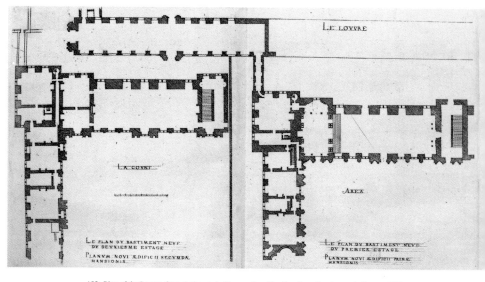

189. *Plan of the Louvre*, from Androuet du Cerceau, *Les Plus Excellents Bastiments de France*, 1576. Paris: Bibliothèque Nationale de France, rés V. 390.

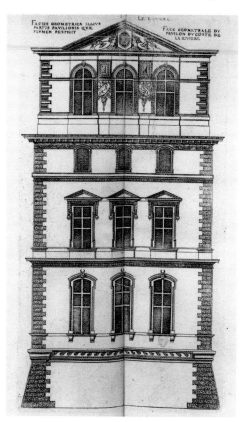

190. Paris, Louvre palace, Cour Carrée, Lescot's façade with the *Pavillon de l'Horloge*, 1547–49. The view along the wall shows off the slight advances articulating the façade.

systematically applied during the early Renaissance as it was, for instance, at Blois on the courtyard façade of the François I wing. Similarly, on the lower level of the Louvre façade, the astragal extends the length of the wall between the paired columns. Though a rare theme in Roman architecture, this does appear in certain triumphal arches, such as the one at Ancona and was made available through a plate in Serlio that was particularly popular in France. Lescot uses this motif— as he does the rest of the decoration—to stress the presence of the *avant-corps,* even though at this level there is no change of plane. However, as in the case of the acanthus frieze, we may see this as a reference to Flamboyant grid work. Of great interest here is the way Lescot has rethought this

191. The *Pavillon du Roi*, from Androuet du Cerceau, *Les Plus Excellents Bastiments de France*, 1576. Paris: Bibliothèque Nationale de France, rés V. 390.

192. Paris, Louvre palace, Cour Napoléon: exterior wall of the Lescot wing in its original condition. Photograph by Baldus (detail), 1854–55. Paris: Musée Carnavalet.

idea in terms of classical architectural reasoning. Not only is the round molding retained, but also the articulation between the column's body and its capital. The impression is not of a molding applied to the wall, but of the wall itself bending slightly, as the column does, at the point of pressure. In this section, the engaged column is to be understood as an inflexion of the wall's surface. It is obvious that Lescot gave a great deal of thought to the meaning of the orders, but the conclusions he drew are very different from those traditionally accepted. This may be why academic critics of the seventeenth century, in spite of their admiration for Lescot, accused him of innumerable "errors."

The exterior façades as Lescot designed them have been completely destroyed. Nevertheless, we still possess early descriptions and even photographs taken before the reconstruction under Napoleon III (fig. 192). The wall was powerfully affirmed as at the Farnèse palace. However, at the Louvre the relationship between the outer wall and the ornamentation of the courtyard was of an altogether different nature. The striking contrast

between the austere exterior and the ornamental exuberance of the courtyard responded to a preference deeply entrenched in French building habits. Lescot had also decorated the upper stories instead of halting them with the abruptness favored by the Italians. Roman palaces have no roofs, at least to the eye; the cornice closes the composition without ambiguity. In France, builders remained faithful to the slate roofs whose changing color provided a transition to the sky. At the Louvre, Lescot eliminated the dormer windows that traditionally cut into such roofs, though in the pediments of the courtyard façade he did retain the principle of one level infringing on the other. The upper floor of the king's pavilion, rising above the adjacent wing, was given a sculpted decoration on the outside. Finally, a rich jagged rooftop ornament was outlined against the sky, as in many Gothic buildings. This treatment of the upper parts of the building spins a thread between Lescot's Louvre and that of Charles V, via Chambord and the châteaux of the Duc de Berry as pictured in the *Très Riches Heures*.

The Interior Decoration

Lescot was in charge of the entire Louvre project and was responsible for the interior decoration as well as the building in the strict sense. Though a painter, he did not rely at all on large murals at the Louvre. What painting there was remained modest, a simple coat of paint relieved by a few ornaments or emblems—we will look at an example shortly. Within, as without, the feeling of luxury was conveyed by the carved decorations of wood and stone; woodwork played an important role in the king's apartments. Tapestries would have completed the decoration. In this, once again, Lescot remained faithful to French traditions while adapting them with his classical taste.

The staircase had always been considered an element particularly suited to showing off ornamental sculpture. While the taste for Italian style replaced the Flamboyant, this habit persisted.[41] At the château of Villiers-Cotterets, two straight staircases have elaborately carved ceilings. The new Louvre could

hardly dismiss this tradition, especially considering how famous the grand staircase had been in the old château of Charles V, which it had replaced.[42] Lescot designed a staircase of imposing dimensions, whose vault was covered with exquisite ornaments in the "Goujon style." Once again Pierre du Colombier attributed them to the atelier of that great artist (fig. 194), but the existing documents for two of the flights prove otherwise: they were commissioned from two different workshops, neither of which was Goujon's.[43] Yet, looking at the work, it is extremely difficult to distinguish different manners, and the dominating impression is one of complete coherence. This implies two things: first, a tradition of workmanship which had lost nothing of its usual discipline despite the change of style; second, a single stylistic will, a strict control of execution that imposed a completely unified vision. Everything points to Lescot being the candidate for this pivotal and decisive role. It may be that, at first, works born

193. Workshop of Scibec de Carpi, *Door panel of the bedchamber of Henri II*, c. 1556. Wood. Paris: Louvre palace.

the drawings for this wonder, and provides a list of the executants: Rolland Maillard, Biart the Grandfather, the Hardouyn, Francisque and Maitre Ponce. Discovered by Maurice Roy, the contract for the ceiling in this room lays the argument to rest, Lescot is named as the author of the drawing and the master in charge of the execution is in fact Francesco Scibec de Carpi, whom Sauval refers to as Francisque.[46] The document goes over the ornamentation in minute detail. The cabinetmakers worked from drawings by Lescot that were presumably extremely precise, but they did not do all the cutting. For the figurative elements they only prepared the panels, which were then cut by sculptors and returned to the cabinetmakers for final assembly. It is worth mentioning a payment to Estienne Carmoy, a sculptor, "for having made several enrichments of figures and other ornaments of sculpture, at several different times, on the models of the ceiling of the antechamber and chamber

of the precocious and unusually harmonious collaboration between Lescot and Goujon provided a model for other executants—but that must have been the extent of Goujon's role. Goujon was not in a position that gave him any authority at the work site; furthermore, the artist probably worked for nothing, receiving no remuneration for the considerable task of preparing drawings and overseeing his colleagues' workshops.[44] On the other hand, Lescot received a handsome salary to perform exactly these tasks, which all documentation attributes to him.

The king's apartment was given a decor of breathtaking woodwork. Two ceilings, of which one is fairly well preserved, some door panels, and reassembled pieces of wainscoting attest to these wonders (fig. 195). Sauval described the parade bedchamber at great length: "Connoisseurs and musicians find it so accomplished, that they not only call it the most beautiful room in the world, but claim that of its kind, it is the realization of every perfection that the imagination can think of."[45] He also informs us that in his time it was debated whether Lescot or Primaticcio provided

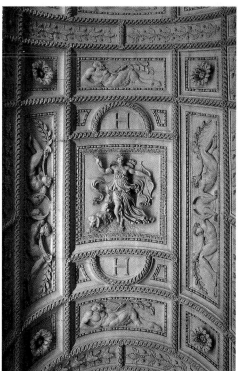

194. Paris, Louvre palace, ceiling of the Henri II staircase, shortly after 1553.

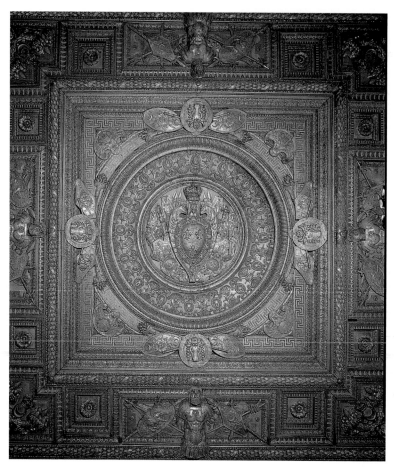

195. Workshop of Scribec de Carpi, *Ceiling of the king's bedchamber*, 1556. Varnished and gilded wood. Paris: Louvre palace.

of the king at the said château of the Louvre. "[47] In addition to the drawings, there was then a very elaborate model for the woodwork. Though they had already been commissioned and considerable work had been done on them, the principal motifs were still being elaborated. This shows just how great an importance was attached to this decoration, justifying the veneration expressed by Sauval.

Here once again, Pierre du Colombier would see an intervention by Jean Goujon and attribute to his workshop some of the door panels that Sauval mentions as particularly admirable (fig. 193): "Others [connoisseurs] might never tire of contemplating

two Centaurs galloping, as well as two Neptunes dominating sea horses. They admire the spirit and fancy of the sculptor who shows them all at once from a single place these very things, which in a sculpture in the round may be discovered only in different lighting, by changing place, and from different angles."[48] It is not at all certain that Goujon, a stoneworker, ever carved in wood.[49] In any case, it is the coherence and unity of the work that is above all striking. The task of execution was distributed between the cabinetmakers and the sculptors, just as it was between the masons and the sculptors in the case of stone. Everywhere,

however, careful surveillance ensured perfect unity: "it seems at first encounter," wrote Sauval, "that the ceiling of the room is one great piece of bronze"[50]—as if it were cast of a single mold. Sauval's comments are especially significant when he writes, "The ceiling is not blemished by a confusion of those paintings, those stucco reliefs, those ill placed cavities with which our modern [decorators] spoil the most beautiful chambers and fascinate the eyes of ordinary people and simpletons."[51]

He is struck by the combination at the Louvre of opulence and a kind of simplicity, which he contrasts with what he sees as the vulgarity of his own time; he disparages the technical disparity and semantic excess of the ceilings with their deep recesses and painted compositions in the manner of Simon Vouet and his contemporaries. Not that he is indifferent to the symbolic meaning of the motifs—but he insists that this should not compromise the formal decorative coherence.

The Ballroom

Lescot's most original invention is perhaps the great hall on the ground floor, today much changed, and known to us as the Salle des Caryatides (fig. 196). This is a vast room, with at one end a balcony for the musicians above the door opening onto the royal staircase. The famous caryatids support the balcony. At the other end of the hall, the space is divided. The last bay of the wing at the back,

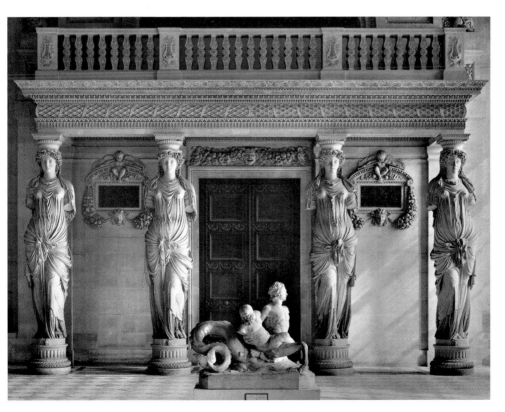

196. Paris, Louvre palace, the ballroom known as the *Salle des Caryatides*, 1550–56.

189

corresponding in the plan to the staircase, and like it comprising a slight protrusion of the façade, delimits a separate volume, which is nevertheless continuous with the ballroom. The floor is raised by three steps (whence the name Tribunal given in documents), and the space is separated from the rest of the room by a kind of triumphal arch, composed of four groups of four columns each.

Since the hall was completely reworked, first by Lemercier around 1630 and then in the nineteenth century, we must once again resort to archival documents in order to reconstruct what it would have looked like in the sixteenth century. A series of drawings and etchings by Androuet du Cerceau shows the decoration of the hall in detail (fig. 197). If Androuet du Cerceau was indeed representing an existing state of the building, the publication of *Les Plus Excellents Bastiments de France* would provide us with a date of completion prior to 1576. It is generally assumed, in fact, that the decoration was installed under Henri II. We also possess a series of documents for this part of the Louvre dated between 1550 and 1558. Unfortunately, the discrepancies between the documentation and Androuet du Cerceau's representation are so significant that a detailed analysis is unavoidable. I have already stated that the new Louvre did not take shape from the start. It was precisely in order to accommodate a ballroom that Henri II had profoundly changed the composition of the wing, at the price of considerable demolition. The construction of the new project is detailed in the general contract of April 1551, at which date much of the masonry must already have been in place, since on December 1, 1550 a contract was signed for the covering of the ballroom and Tribunal (already named as such in the document) with a beamed ceiling. The division of the space and the change of level are clearly indicated. Eight columns were intended to bear an arch in the center and an entablature on the sides; above this, a wall about two feet thick was to extend up through the second floor, dividing the king's antechamber from the second floor formal hall. These must have been built by the time a second carpentry contract was settled on June 26, 1553, for the covering of the upper stories. This document also mentions eight columns, while Androuet du Cerceau's drawing shows sixteen, grouped in fours

between the hall and the Tribunal, with a further twelve around the Tribunal. Furthermore, the twenty extra columns support a vault rather than a ceiling. If we assume that Androuet du Cerceau has depicted what was actually there, considerable changes were made to the original project.[52] However, when would this have been? Important information is contained in an account summary for the masonry dated February 8, 1556. The document is an update of the accounts, and refers specifically to the contract of April 17, 1551. It mentions all changes in detail, including, for instance, changes in materials when hard stone was employed instead of *pierre de liais* (a kind of limestone). The decoration of the door between the ballroom and the staircase, not planned in 1551, is described in detail with its frame, flanking niches, and marble slabs. No mention is made of enrichment to the Tribunal, and the masons would certainly neither have provided the twenty columns nor built a vault (real or false) without payment. Hence, we may be fairly sure that the sumptuous decoration of the Tribunal was still incomplete in 1556.

The fireplace poses the opposite problem. Androuet du Cerceau shows it as exceedingly simple. However, on December 10, 1551, Jean Goujon signed a contract for two large figures that were to adorn the fireplace of the Tribunal. If these are indeed the figures that Percier, the architect at the Louvre under Napoleon, found in the rubble of the Salle des Caryatids and reused, they must have been executed. Are we to believe that in 1576, they were not yet installed? Though not impossible, an unadorned fireplace at the center of such a luxurious decor would be surprising.

Finally, the date at which the caryatid portico itself was installed is not easy to determine. We have already seen that the commission for the figures was arranged with Jean Goujon as early as September 15, 1550. On the 17th of the same month, the blocks of stone were ordered, and there was considerable pressure to expedite the task, since two of the blocks were to be delivered within ten days, the two others in the five following weeks. In these two documents, the function of the statues is stated beyond doubt:

> . . . four figures of women in hard stone of
> ten feet in height or thereabout, serving as

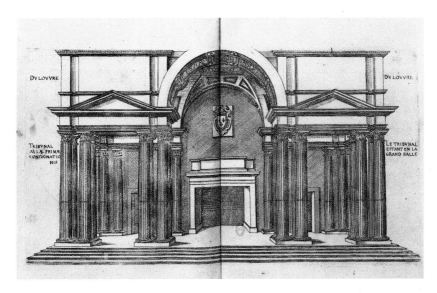

197. The *Tribunal of the ballroom at the Louvre*, from Androuet du Cerceau, *Les Plus Excellents Bastiments de France*, 1576. Paris: Bibliothèque Nationale de France, rés V. 390.

columns to be used in a small portico inside the great hall of the château of the Louvre in question, at the end of the lower aforementioned great hall, which portico above the entrance to the same great hall is to serve as a place to receive and place the oboes and musicians.

However, the masonry contract of April 17, 1551 makes no mention of the portico. The summary account of February 1556 is equally mute. It does, however, describe the decoration for the entrance door, though without mentioning that it is under the portico. The contract with Goujon is for the figures only, as is usual, so the rest of the edifice—bases, entablature, balustrade—being a work of masonry, must have appeared in the documents pertaining to this specialty. We must presume, then, that at the time of the summary account of 1556, the portico was not yet assembled. We will see that there is reason to believe that this was still the case in 1558.

Among the accounts published by Laborde, there was a payment for painting at the Louvre in 1558 that provides interesting information as to the kind of painting that must have completed the decoration of the hall.[53] Its greatest merit, however, is to provide us with an idea of the inventory of

fixtures at the time. All around the room, under the ceiling, a band had been painted in wood color, as wide as the beams of the ceiling. Below, were painted a six-foot wide garland of ivy with gold, and the emblems of Henri II wreathed in ivy against a white ground. The corbels (inserted into the wall to carry the beams) were painted and partially gilded, below each was placed a pressed paper faun's face, also partially gilded. The Tribunal was similarly decorated, but the *"fons de dessus le tribunal"*—namely, the ceiling—was white rather than painted in wood color around the beams. This would seem to indicate that the ceiling in the Tribunal was different from that of the room. Such would indeed have been the case if the arrangement represented by Androuet du Cerceau had been installed between 1556 and 1558. We may suppose that the carpentry ceiling commissioned for the Tribunal had been executed. Under these conditions, the vault in Androuet du Cerceau's picture was presumably a false vault and it is therefore not surprising that it was painted. Lastly, the document states that they had "painted with white the scaffold for the musicians and enriched it with garlands of ivy and with the same of gold, and, in the middle on the front, applied a mask gilded with

191

fine gold." Not only would this task be incomprehensible if applied to the caryatid portico, but the term "scaffold" could only designate a work of carpentry. It was presumably one of the "floorings and other works" that Jean le Peuple executed at the Louvre on the same account of 1558, "to be used for the marriage and feast of Monseigneur the dauphin." We already had reason to believe that the caryatid portico was not yet assembled in 1556. Such was probably still the case in 1558, which explains the installation, painting, and decoration of a provisional wooden structure. Supposing Jean Goujon fulfilled his contract promptly—a tenuous assumption—the caryatids remained unused for a rather long time. When they were actually installed we cannot determine, only that they appear to have been there when Androuet du Cerceau drew them.

It seems that the general composition of the great hall—that is the articulation of the space into two parts: the ballroom proper and the raised Tribunal screened by columns, as well as the portico bearing the musicians' balcony—was established in the architect's mind as early as 1550. However, the full development must have taken place throughout the reign of Henri II, at least, and the project was considerably enriched through the years, becoming more spectacular and acquiring greater definition. As in the architecture of the west wing, Lescot found his definitive solution only as he felt his way through the execution of the project.

With these caveats in mind, let us examine this showpiece a little more closely. Lescot took a considerable area in the middle of the royal palace and transformed it into a grandiose stage set. The Tribunal as a motif was traditional, a sort of platform on which was raised the dais necessary for the king's public appearances. More or less temporary, it was usually wooden, but permanent ones of stone did exist. A spectacular example dates back to the time of Jean de Berry; it is preserved in the great hall of the old ducal palace in Poitiers (fig.200). Generally speaking, the great hall with its heraldic decoration was an important theme in northern European architecture: Lescot succeeded in preserving its character, fairly different from that of the ceremonial rooms in Italian palaces, while giving it a new form through the perfectly mastered classical vocabulary of a Renaissance style.

Lescot's great invention remains the screen of columns that separated and clearly differentiated the space into two distinct parts. He established a powerful contrast between the relative simplicity of the great hall—an impression fortified by the vernacular aspect of its beamed ceiling—and the extreme opulence of the Tribunal where he unleashed an orgy of columns almost without parallel in contemporary architecture. The vault lends added dignity to the space while at the same time contracting it. Between the raised floor and the incursion of the vault, the height of the Tribunal is much less than that of the hall, creating a more intimate space. With its *apse* to the west, the Tribunal appears in the plan as a separate volume, perpendicular to the axis of the ballroom. But here, once again, the reading is ambiguous. To the extent that the whole consists of a single space divided into two parts (the masonry contracts are clear about this), there is only one axis: North-South, which remains clearly defined by the fireplace and caryatid portico facing each other from opposite ends. For the visitor entering either directly from the courtyard by the central door, or from the staircase, the east-west orientation of the Tribunal was invisible. Only within the privileged space of the Tribunal itself would the change of axis become apparent. What did all this mean? The general function of the decor is relatively clear: to emphasize the appearance of the king, whose apartments were just above the Tribunal. It is from that side that he would have made his entrance, while others entered the ballroom by either of the aforementioned doors. I believe the royal appearance should be thought of as occurring in two phases. Presumably, the king arrived by the spiral staircase that descended into the apse of the Tribunal. In the first phase, then, he was visible only to those who were granted access to the Tribunal itself. The dais was in all probability centered in front of the fireplace so as to be seen from the hall. The king would then proceed along the axis of the Tribunal to the dais, where he would then appear to the rest of the spectators within the general north-south axis of the room.

Architectural historians have looked for the origin of the screen of columns in Italy, and at the Palazzo del Té in particular, because of the grouping by fours. But this motif was established only

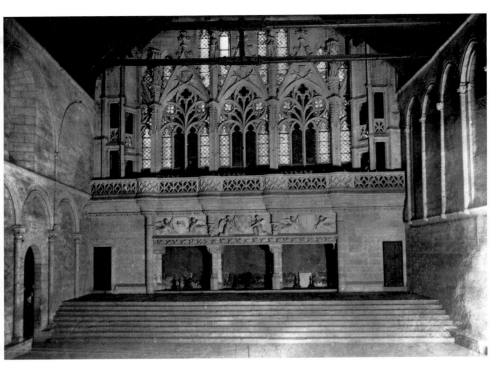

198. Poitiers, courthouse, great hall of the old ducal palace, thirteenth-century construction, 1393–1415 for the decoration at the back.

later in the project, as we have seen, since originally there were to be only eight columns in a single line.[54] It seems to me that in conceiving this arrangement Lescot was thinking of his own work at Saint Germain-l'Auxerrois. The idea of a triumphal arch set up as a screen to separate a privileged space is in fact the entire principle of a *jubé* or rood screen. The transference of a structure specific to church choirs for the secular use of a prince may seem astonishing. However, the rhetoric of monarchical power insists unambiguously on the divine aspect of kingship. It was thus legitimate for the royal ceremony to appropriate the dispositions characteristic of religious ritual.

It is the decoration of Lescot's Louvre that above all makes its originality and lends it eloquence. It does not, for that matter, simply reflect a personal preference of Lescot's, since Philibert de l'Orme had similar concerns in his *Livre d'Architecture*. It may be that the directives were handed down from the court. Everything about the ornamentation proclaims the power of the king and of the monarchy.

It is affirmed on the courtyard façade by the iconographical program of relief sculpture, and in the motifs of the parade bedchamber, as Sauval discerned so well: "On all sides there are nothing but shields, armor, swords, breastplates, halberds, trophies that appear to pay homage to the victorious fleur de lys."[55] Yet that power is already implied in the surfeit of ornamentation, and enhanced by the austerity of the exterior façades. Before even glancing at the iconography of the figurative decoration, there is no mistake possible: this original and sumptuous manner, both antique and innovative, this art at once universal and incontestably French is a proclamation of sovereignty. It is to the entire work that Sauval's exclamation should be extended, "The parade chamber is a truly royal room."[56] Moreover, when he records criticism of the celebrated façade, one senses he shares the sentiment of those who believe "that this great assembly of ornaments is proper for the houses of kings and great princes: their buildings, as much as their actions must always be remarkable for superfluous expense."[57]

193

199. François Clouet, *Portrait of Pierre Quthe*, 1562. Oil on wood, 36 × 27 ½ in. (91 × 70 cm). Paris: Louvre.

Chapter VI

THE CLOUETS

The Court Portrait

There is not an important museum anywhere in the world that fails to hold some French portrait from the sixteenth century. The astonishing vogue for portraiture that began during the reign of François I is no longer contested, and as a result we are not as sensitive as we should be to the novelty of the phenomenon. We will therefore be concerned here with the spectacular success of a genre, as much as with individual works and their authors.

Is the portrait a typically French genre, as has been sometimes claimed? Such an assertion is somewhat vacuous. The fact remains that the panel painted around 1360, which depicts King Jean le Bon ("John the Good") is the earliest independent portrait in Western art after classic antiquity that we have, and probably one of the first executed (fig. 200). Its relatively large dimensions are surprising. The image is somewhat rough but powerful. The painter insists on the morphological characteristics of the face, which is presented strictly in profile: the high and almost vertical forehead, the strongly accentuated notch at the beginning of the very long and sinuous nose. The costume is rudimentary and the form of the bust barely indicated. No crown or jewels: simply, a head, a man. Royalty is expressed solely through the presentation of the individual, through the invention of portraiture itself.

Two centuries later, the situation had changed radically. Several hundred paintings and several thousand drawings ranging from the most exquisite to the clumsiest parade before us all the figures in the public view of an era.[1] They are generally presented without affectation, somewhat as in nineteenth century photographic albums in which the monotony of format and pose brings out individual characteristics, family resemblances and, perhaps most strikingly, a period flavor. Several different waves have been distinguished in these portraits.

200. Anonymous, *Portrait of Jean le Bon*, c. 1360 (?). Oil on wood, 24 × 16 in. (61 × 41 cm). Paris: Louvre.

201. Jean Clouet, *Portrait of Odet de Foix, Lord of Lautrec*, 1516–19. Black and red chalk, 10 × 7 ¼ in. (25.5 × 18.3 cm). Chantilly: Musée Condé.

First came the companions of the victor of Marignano, such as Lautrec (fig. 201) or Boissy, with their flat hats decorated with medals, their broad features and determined air. Towards the middle of the century, the look changed; there was a greater sense of reserve, and the king, having grown older, appeared wiser and more prudent. It was in the portraits from the last years of the reigns of François I and Henri II that the faces most resembled one another. Later, essentially under Henri III, features became thinner, and faces pinched; here we see more rigidity and at the same time, curiously, more monotony and eccentricity in the expression. It is of course tempting to read into this the anxieties of one of the most difficult moments in the history of France, but we should be cautious and stick to appearances.

To what extent did these differences result from the succession of the artists who recorded those faces? Jean Clouet, known as Janet, was the memorialist of the early years of the reign of François I. His son François, at the time also called Janet like his father,[2] dominated portraiture in the mid century. After his death in 1572, other artists—the Quesnels, the Dumoûtiers—carried on the tradition. Of course, the temperament of the portraitist does come across, and the graphic style particular to an artist can explain in part the "family resemblance" that pervades certain groups of portraits. The firm and emphatic stroke of Jean Clouet is distinct from François's more nuanced and tonal manner. The use of stump drawing gives a particular inflection to the productions attributed to François Quesnel. Nevertheless, we are not dealing with artists who imposed strong personalities on their works, and indeed one has the feeling that it was the models that changed—in their fashions, attitudes, and expressions. We should not, however, exaggerate these differences whether due to execution or to sitters. The format, layout and manner of structuring the face remained unchanged. We must insist on this point: what is particularly striking about this production, which extended throughout the entire century, is precisely its monotony, so great that the name Janet was applied to almost all portraits drawn in France from François I to Henri III. This monotony has quite understandably been viewed only as a shortcoming; above all else, we admire variety and invention, and anything that feels like routine shocks our sense of artistic merit. And yet, the development of this routine was Jean Clouet's great contribution: he established the basic language, the ABC of portraiture.

In the fifteenth century, the genre remained relatively rare, both in Italy and northern Europe. The great artists of the Renaissance rethought the portrait at every turn. Neither Leonardo da Vinci nor indeed Raphael ever kept to an established formula. Moreover, before Jean Clouet, there were no portrait painters—but only painters who occasionally painted portraits. Bernhardt Striegl, the portraitist of the emperor Maximilian, came the closest to true specialization, but his repertoire also extends beyond the genre.

Though France may have been particularly precocious in the development of portraiture as an independent genre, one meets few examples of it

before the reign of François I. Jean Fouquet has given us an unforgettable image of Charles VII (fig. 202) and, while still very young, had the opportunity to paint the portrait of Pope Eugene IV, which for a long time remained on display in Rome in the sacristy of Santa Maria sopra Minerva. These are indeed independent portraits, whereas the Louvre's magnificent *Jouvenel des Ursins* (fig. 204) was clearly the left tablet of a diptych comparable to that of Melun in which Fouquet depicts Étienne Chavelier, advisor to Charles VII, in prayer (left panel, Berlin Museum) before the Virgin nursing the Infant Jesus (right panel, Antwerp, fig. 219). Even at the end of the century, the Master of Moulins—that is, Jean Hey, a Fleming established in France whose physiognomic art was of the highest order—seems to have only rarely practiced independent portraiture.[3] It is not impossible, on the other hand, that Jean Perréal, whose artistic personality remains extremely vague (see Chapter I), made himself a sort of specialty out of the portrait.[4] However, most of what we know of him is contained within the pages of books, such as the charming miniature of his friend Pierre Sala (fig. 205), or the almost expressionist image of King Charles VIII. He is known to have painted a portrait of Louis XII. In any case, towards 1500, portraits became more numerous and small panels multiplied in France as in other northern European countries, though they were often of mediocre quality.[5] The genre of the painted portrait also had considerable success in Venice.

Jean Clouet's beginnings remain obscure. He was foreign, probably Flemish,[6] and made his first appearance in archival documents in 1516, as one of the painters employed by François I.[7] The first drawings attributed to him date to around the same time.[8] Jean Clouet appears to us all of a sudden at the beginning of François I's reign in full possession of his faculties. How old was he? What was his training? We are completely incapable of describing his activity prior to the reign of François I.[9] It is unlikely that he was at the beginning of his career in those years, since one finds him immediately in a rather prominent place on the list of painters employed by the king. But no work has been attributed to him that can be earlier, perhaps because an abrupt change in his art relegated

his beginnings to obscurity. The works grouped together under his name manifest a new conception of the portrait, in which facial features are completely subordinated to the overall physiognomy. In spite of the monotony, and within modest formats, Clouet attained a harmony and equilibrium in the representation of individuals that had hardly any equivalent other than in the masters of the High Renaissance in Italy.

Where did Clouet pick up the elements of his art? Through the technique of drawing *aux deux crayons* (red and black chalk), he is connected to Fouquet: this rare method is that of the preparatory drawing the latter used for the portrait of Jean Jouvenel des Ursins (fig. 204). But Clouet's graphic style is very different. In his drawings, the integration of the physiognomy is linked to a disciplined modeling rendered through rhythmic parallel hatching, which recalls the method of certain Italians. Had Clouet visited Italy? Or was it contact with Leonardo that helped him shape his original style? Other circumstances probably also played a role: the intensification of court life; the enthusiasm of a new reign that, thanks to the victory at Marignano, had begun so brilliantly. But one cannot resist noting the correlation between Leonardo's arrival in 1516 and Clouet's development of a style of drawing and a type of portrait. The pictorial side of his drawings strikes us—the way in which the artist establishes the surfaces of the face, modeling it with chiaroscuro while not insisting on the contours. In this, the contrast with Holbein is striking: the German's approach is much more linear. However, the difference diminished somewhat with time and it is generally admitted that it was the Frenchman's example that introduced Holbein to the combination of red and black chalk.

THE INVENTION OF BANALITY

Jean Clouet's two major contributions are linked: one is the establishment of what I will call the standard portrait; the other, the novel exploitation of drawing, to which he granted an independence it had never previously known.

The drawings of Clouet and the portraitists of the French court who succeeded him have come down to us in large numbers. Perhaps already for

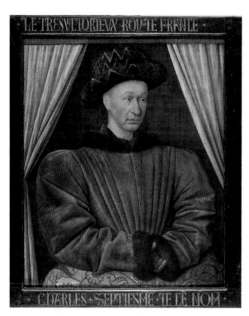

202. Jean Fouquet, *Portrait of Charles VII*, c. 1450 (?).
Oil on wood, 34 × 28 in. (86 × 71 cm). Paris: Louvre.

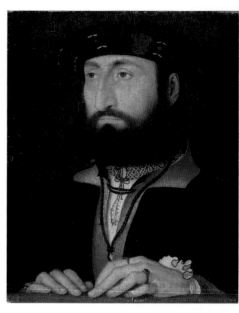

203. Jean Clouet, *Portrait of Louis de Clèves*, c. 1533–35. Oil on wood,
8 ⅓ × 8 ½ in. (21.1 × 21.6 cm). Bergamo: Accademia Carrara.

204. Jean Fouquet, *Portrait of Jean Jouvenal des Ursins*, c. 1460.
Black chalk and colored chalk accents, 10 ½ × 7 ¾ in. (26.7 × 19.5 cm).
Berlin: Staatliche Museen, Kupferstichkabinett.

Jean Clouet and definitely for his son and successor François, the drawing itself was sometimes, indeed often, the finished product. A well known letter of Catherine de Médicis leaves no doubt in this regard: an anxious mother, she asks the painter for a portrait of her children in order to ascertain their health; she specifies that chalk will suffice, to expedite the process. The request certainly pertained to a polished drawing, while the preparatory drawing would have remained in the studio for reuse at a later date. What is most significant, perhaps, is that these drawings circulated in numerous copies that were gathered into albums; this fashion persisted throughout the century. It is clear that the systematic use of drawing, quickly produced and less costly than a painting, by facilitating the multiplication of portraits, was intimately linked to the development of an efficient method: this consisted in recording the physiognomy of numerous individuals by means of a formula established once and for all with little variety. In a word, this is the standard portrait.

A portrait by Jean Clouet is first and foremost a face. In a certain number of drawings, it is only this. The subject is presented three-quarter face—that is,

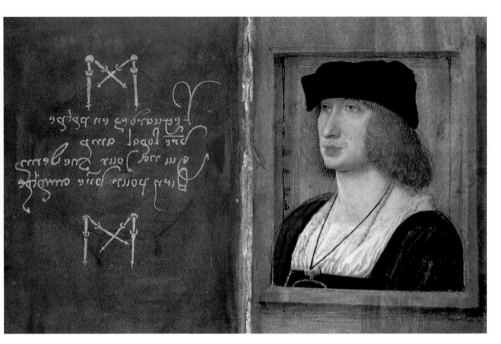

205. Jean Perréal, *Portrait of Pierre Sala*, c. 1500–05. Illumination on parchment, 5 × 4 in. (13 × 10 cm). London: British Library, m.s. Stowe 955.

in a familiar pose. The full-face portrait always tends towards the hieratic. The pure profile, which precludes all ocular contact with the viewer, is distant and objective, and its traditional association with the medal confers upon it a slightly solemn air. The three-quarter pose, on the other hand, gives more mobility to the face and allows the artist to capture more fleeting expressions. In drawings, costume is often indicated, but by rapid and summary notations.

Jean Clouet's paintings, of which we have a few examples, are carefully finished. Hands are introduced, yet as these are not half-length portraits like the *Mona Lisa* and the majority of Italian portraits that include hands, but instead are confined to the bust, the effect is rather artificial. The figures in *Portrait of a Banker* in the Saint Louis museum and *Louis de Clèves* (Bergamo, Accademia Carrara) lean on a high parapet for which many fifteenth-century precedents could be found in northern Europe as well as in Italy (fig. 203). The right hand of the *Duc de Guise* in the Palazzo Pitti in Florence emerges strangely from under his garment, as if he had his arm in a sling. All these solutions give a

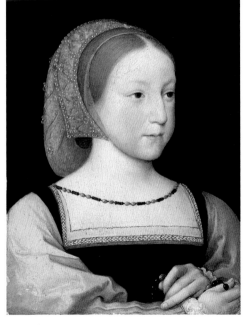

206. Jean Clouet, *Portrait of Charlotte de France*, c. 1524. Oil on wood, 7 × 5 ¼ in. (17.7 × 13.4 cm). Minneapolis: Minneapolis Institute of Art.

slightly archaic feeling to the paintings.[10] The costume is carefully executed, but without ostentation; even in portraits of royal children, despite the richness of the fabrics, pearls, and jewels befitting their station, the face always dominates (fig. 206).

The great exception is the portrait of François I in white, in the Louvre (fig. 208). This painting has elicited the most diverse opinions not only as to its author, but also as to its merit. Traditionally considered the work of "Janet" during the seventeenth century, the painting lost this attribution in Bailly's 1709 inventory. Since then, although the attribution to Jean Clouet is the most frequent, it has also been considered as possibly the work of a Fleming, a third-rate Italian, or an unknown German painter.[11] Most recently, Charles Sterling suggested it could be the work of a young François Clouet in his father's studio. The difficulty of the attribution is perhaps more interesting and revealing than the various solutions proposed. It draws attention to the exceptional character of the painting: exceptional because of its dimensions, which are much larger than those of other known paintings by Jean Clouet; the disparity between the face and costume; and, above all, the ostentatious execution of the latter, which assumes a dominant place and importance.

This is obviously a state portrait comparable not to the small paintings of Jean Clouet, but rather to Fouquet's *Charles VII* or Holbein's half-length portrait of Henry VIII from 1539–40 (Rome, Galleria Nazionale, fig. 209). It is within this frame of reference that the problem of attribution should be envisioned. We have no useful point of comparison, no other state portrait emanating from the French milieu during the reign of François I. We must wait for the large full-length portraits painted by François Clouet, *Henri II* (Florence, Uffizi) and *Charles IX* (Vienna, Kunsthistorisches Museum, fig. 210). If this portrait came out of Jean Clouet's studio,[12] it means that the particular genre or mode of painting had a determining effect on its appearance. It may be that Jean Clouet's range was much broader than previously thought. Conversely, if this very exceptional portrait of François I is by Jean Clouet, it invites us to reflect on the reasons for the regularity and monotony of his other portraits—a monotony that is itself novel and, I dare to say,

original. Indeed the persistence of this monotony long after the disappearance of the painter seems to indicate that it answered an expectation, a need.

Clouet was the first court portraitist in the full sense of the term—the first who dedicated himself almost exclusively to portraiture. This new specialization should be understood within the framework of the division of artistic labor, but it also corresponded to a transformation of the role and organization of the court. Here is not the place to elaborate on the political reasons that led François I to gather the nobility around his person. What matters in this instance is the phenomenon itself—that of a king without a fixed residence, moving from place to place in his kingdom with his entire entourage. The portrait of Jean le Bon, as we have seen, was unusual and royal by virtue of its very existence, whereas that of François I needed to distinguish itself, through its dimensions, pose and the splendor of the accessories, from a multitude of small portraits all more or less similar, more or less equal, which were individualized only on closer inspection. These "ordinary" portraits nevertheless still constituted a mark of distinction, setting apart the "court"— that is, the little world that surrounded the king, living off and for him. A strange phenomenon was this ambulant society, without local roots, that moved around with its attendant services. A train of several thousand people and some eighteen thousand horses accompanied the sovereign everywhere: an entire population of domestics, but also merchants, craftsmen and even prostitutes *"filles de joie suivant la cour."* The court strictly speaking—that is, the sovereign's immediate entourage—was a much more limited society. The courtiers lived to the rhythm of intrigues, favors, and disgraces. It is understandable that among this handful of men and women completely preoccupied with one another, the portrait would have undergone a new development. The force of the system invented by Jean Clouet was that within the extremely narrow limits of a conventional formula, each inflection of the face, each nuance of expression became significant.

The reading of these portraits even became a society game. One of the earliest collections of drawings, assembled around 1525 and now kept

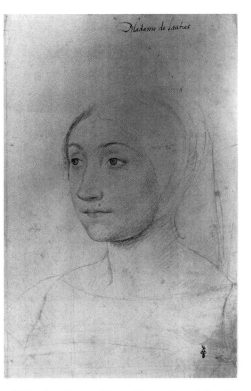

207. Jean Clouet, *Portrait of Madame de Lautrec (Jeanne de Crussol)*, c. 1525. Black and red chalk, 11 × 7 in. (27.5 × 18 cm). Chantilly: Musée Condé.

at the Méjane library in Aix-en-Provence, attests to this. It includes not only the names of the figures but also a few lines under the portraits (fig. 212). According to an anecdote told by Charles Sorel, the seventeenth-century novelist, François I himself inscribed these lines in the album. Furthermore there were removable cards that allowed one to cover up the inscriptions as well as the names of the figures, in order to guess who the sitter was from the image alone, then to reveal the text.[13] This innocent pastime implies of course a small society, withdrawn unto itself, and whose members were almost obsessively occupied with each other's appearance and character.

The monotony of Clouet's paintings was the very condition necessary to their true functioning, because belonging to this restricted social group trumped the desire to distinguish oneself. These portraits constituted a mark of prestige, a sign of belonging to the world of the court. While there were numerous drawn portraits in the France of the last Valois, this formula was reserved more or less exclusively for the court. The king himself appeared in the standard format, differentiated only by his distinguishing features—his large nose and almond eyes. In certain circumstances he wanted to appear as only the first among his courtiers, even if at other times he imposed himself as both unique and royal, as the state portrait manifests on the symbolic register.

The great Holbein, the portraitist of the English court, was not above borrowing from Jean Clouet, but unlike the latter never applied any formula: he avoided repetition, varied his poses and sought striking effects. This has been viewed as proof of his superiority, and Clouet's narrow practice as the result of limited talent. The oeuvre of François Clouet, who succeeded his father in 1540 as the official portraitist of king and court, encourages us to be circumspect. With more complexity in his execution and subtlety in his observation of physiognomies, François conscientiously carried on his father's formulas, using the same three-quarter position of the bust and maintaining the very same placement of the figure. It is clear, however, that he had an imagination as well as the pictorial means to allow him to venture well beyond these narrow confines. The *Bath of Diana* at the Rouen museum is an admirably composed painting that manifests a very rich pictorial culture, turning towards both Italy and the Netherlands (fig. 230). Some prints of theatrical subjects reveal another aspect of his talent. Even as a portraitist, François Clouet had unexpected outbursts. The Louvre's magnificent *Pierre Quthe* revealed at the time of its discovery in 1907 that, far from being as limited as one had thought, Clouet was well acquainted with European developments, and particularly with Florentine portraiture (fig. 199). Strangely enough, this portrait, the most sumptuous and imposing that we have by the painter outside of the large state portraits of the king, depicts not a member of the court but an apothecary, a neighbor and friend of the painter. We must, of course, take into account that many works have been lost; nevertheless, a sufficient number of paintings, original or copies, survives to support

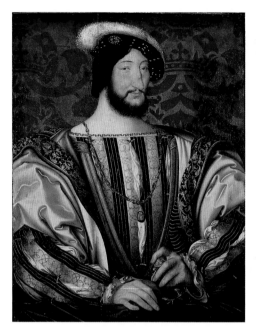

208. Jean Clouet, *Portrait of François I in white*, c. 1535. Oil on wood, 38 × 29 in. (96 × 74 cm). Paris: Louvre.

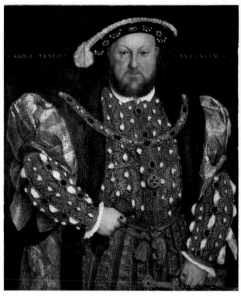

209. Hans Holbein the Younger (?), *Portrait of Henry VIII*, 1539–40. Tempera on panel, 34 ¾ × 29 ½ in. (88.3 × 74.9 cm). Rome: Galleria Nazionale.

our belief that, with regard to the court portrait, François Clouet confined himself to the strict formulas of his father—to which he added one, the full-length ceremonial portrait, reserved for the sovereign.[14] It is, I believe, precisely because his subject was not a courtier that François Clouet could paint a completely different type of portrait of Quthe. It was neither a lack of talent nor the limits of his means or pictorial culture that restricted François Clouet to a narrow practice of court portraiture. It surely must be viewed not as a personal decision, but rather as the result of social pressures, through the intermediary of a protocol of portraiture whose rules were probably never explicit nor perhaps entirely conscious, though no less rigorous or effective for that.

The standardization of the portrait was not limited to the personal practice of Jean and François Clouet, and the production of such works continued without any noticeable change after the latter's death. It is true that under Henri IV, with the

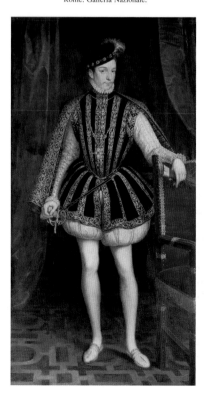

210. François Clouet, *Full-length portrait of Charles IX*, 1566 (?). Oil on wood, 87 ½ × 45 ¼ in. (222 × 115 cm). Vienna: Kunsthistorisches Museum.

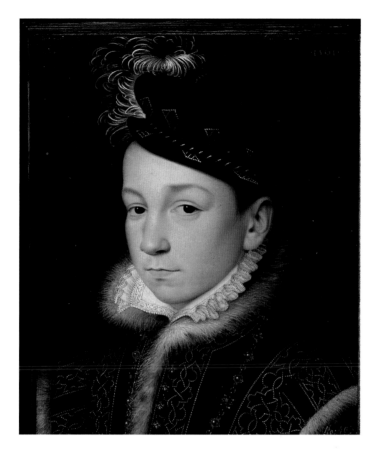

211. François Clouet, *Shoulder-length portrait of Charles IX*, 1561. Oil on wood, 10 × 8 ¼ in. (25 × 21 cm). Vienna: Kunsthistorisches Museum.

Quesnels and Dumoûtiers, the style of drawing changed slightly and there was no longer any possibility of confusion with Clouet; the portrait formula, however, remained astonishingly stable. Some variations were apparent, notably in a very numerous group of portraits that generally circulate under the name of Corneille de Lyon (see Chapter IX). However, this was no longer court art in the specific sense in which it was practiced by the Clouets and their immediate successors under the last of the Valois.

In the last decades of the century, a new phenomenon came to replace the drawn portrait: engravers, Thomas de Leu and Léonard Gaultier, diffused the Clouets' formula in a much more effective fashion, passing it on to the next century.[15]

212. *Agnès Sorel*, from the *Recueil Montmor*, c. 1525. Aix-en-Provence: Bibliothèque Méjane. Such albums of portrait sketches sometimes functioned as a parlor game.

203

In the wake of these masters, an uninterrupted series of portrait engravers, the most brilliant of whom was Robert Nanteuil, rose to prominence. The development of the engraved portrait was one sign among others that the Clouets' standard portrait had spread beyond the limits of the court and that its role had changed. Drawing sufficed for the Clouets because their production circulated within a very limited society. During the troubles at the end of the century, the portrait became an instrument of propaganda and its multiplication through engraving responded to the curiosity of a wider public eager to know the protagonists of the events of the day. At the same time, the aspirations of the bourgeoisie to imitate the court came gradually to devalue the drawn or painted portrait by opening it up to the well-to-do classes. And from devaluation to devaluation, it would end up being available to all in the form of photographic identification.

Lady in Her Bath: Portraiture with a Difference

The curtains are open. They reveal to my indiscreet gaze a lady soaking in a bathtub. She is turned so that her bust faces three-quarters to the left, her face and gaze turned clearly to the right, as if someone other than I had attracted her attention. A dish of fruit and flowers sits before her. Nearby, a wet nurse giving her breast to a newborn returns my gaze directly, while a richly clothed little boy stretches his hand towards the fruit. The interior is luxurious. In the background, near a fireplace, a servant carries a vessel probably containing warm water to heat up the bath. An open window reveals a few branches, an ultimate glimpse of nature.

François Clouet's surprising, even disconcerting painting, *Lady in Her Bath* (Washington, National Gallery), has thrown off many a commentator (fig. 213). It is a rather large panel of accomplished execution. The rendering of the curtain, satin on one side, velvet on the other and fringed with gold thread, is astonishing; it displays the meticulousness of Flemish painting, for example in the indications of the folds so like fabric that has just been put up, but with also a touch of Italian brio in the freedom of the brushwork.

Before we enter into the scene and interrogate the resplendent body in the foreground, let us linger on the *proscenium*. The curtain is one of the most banal accessories of European portraiture. François Clouet himself uses it in a totally arbitrary manner, as in the portrait of Pierre Quthe. It was originally a triumphal motif going back to antiquity, the significance of which is still felt in Fouquet's portrait of the "very victorious" Charles VII, where it functions like a royal dais, accompanying every appearance of the king.[16] Yet Clouet gave the motif an additional meaning, for it is not a simple pictorial artifice: it is also the functional curtain of a fitted bath as was customary during the sixteenth century. At the time curtains would always have surrounded a bathtub, just as they did a four-poster bed; this piece of furniture appears in inventories, along with, in the case of that of Catherine de Médicis, several sumptuous spare draperies.[17] To the right, the curtain behind the bathtub is quite visible; to the left, on the contrary, the painter has arbitrarily removed it in order to reveal the interior of the house; a contemporary viewer, though, would certainly have had no difficulty in understanding this arrangement. We have here a manipulation of reference; a way of making pictorial symbols coincide with the exterior world, which is exceptional and seems to be in the service of an almost mythical rhetoric of idealization. For in the last analysis, what comes across is the hybridization of the portrait and the heroic nude—that is to say, the exaltation and even, literally, the apotheosis of this unknown beauty.

The scene seems both informal and slightly solemn. The woman's face is extremely regular in its features. Clearly, the painter has rendered her as close as possible to the feminine ideal of his era. Yet almost all commentators have viewed the work as a portrait, the representation of an individual. This is due not as much to the characterization of the figure or the individuation of her

features, which—as we have just observed—are hardly emphasized, but rather to the pose and the way the model is presented.

Dividing the painting vertically along its center we obtain two halves, each of a totally different character. This is indeed surprising (fig. 214). In the Renaissance tradition, half of a painting, like half of a musical phrase, allows one roughly to anticipate the other. But in *Lady in Her Bath*, there is nothing of the sort. The right portion is filled almost entirely and solely with the protagonist, whose right forearm and hand alone are cut off. This almost frontal, isolated figure, turned towards the viewer, is in a typical portrait pose, with the difference, of course, that the lady is nude. On the other hand, the left part, with its multiple figures placed within a very precisely described setting, corresponds to what we would call a genre scene.

This peculiarity of the painting, in itself curious and interesting, explains why one has usually attempted to find a model for the lady in her bath: the right half of the painting is presented as a portrait and calls for identification. But, before we proceed, it must be stated that we do not know who this woman might have been. All the hypotheses are problematic and a new one will not be advanced here.

The traditional designation, as might be expected, is Diane de Poitiers. Unfortunately, costume historians assure us that the lady's elegant bonnet cannot be much earlier than 1570, the year of the famous Diane's death. Such a depiction of the dazzling royal mistress could hardly have come after 1559, when the death of Henri II relegated his favorite to an obscure retreat. Even if the chronology agreed, the physiognomy renders this identification unlikely. The lady in the painting at Washington had extremely regular features, and may have been idealized or even rejuvenated, but her long and rectangular visage bears no resemblance to the confirmed portraits of Diane which reveal a triangular face and an attenuated chin (figs. 215 and 217).

Even if the physiognomy of the sitter would allow this identification, it would still be necessary to explain the scenario. Who are these two children that seem to play an important role? Instinctively, we assume they are the protagonist's. But Diane de

Poitiers had only daughters. It has been suggested they be viewed as the king's children.[18] While it is true that the imperious Diane did not hesitate to meddle in their education, from this to depicting her nude and in their company is quite a large step to take. Clearly, too many arguments preclude this appealing identification. The more likely name of Marie Touchet, Charles IX's mistress, has also been put forward. The date tallies with the costume and Marie Touchet did bear the king two children, but the first one died in infancy and the second was not born until after François Clouet's death. Thus the hypothesis cannot be accepted, unless some kind of convincing explanation can be found for this strange scene. Besides, Marie Touchet's rather retiring personality hardly lent itself to such an ostentatious representation.

Roger Trinquet, a literary historian, suggested a new identification associated with an interpretation of the work that differs radically from those implied by earlier attempts.[19] For him, the lady would be Mary Stuart (Mary, Queen of Scots), the unfortunate queen of Scotland who was queen of France during the brief reign of François II (fig. 216). Attempts to recognize Diane de Poitiers or Marie Touchet in the Washington painting rest on the idea that the picture is a visual dithyramb in praise of the woman. Roger Trinquet, on the contrary, believed it to be a political satire, a virulent diatribe against the Cardinal of Lorraine's niece, commissioned by the Protestant party of the Colignys at the time when the Scottish queen was in the hands of Elizabeth I of England. Shortly before Saint Bartholomew's Day, the Catholic party plotted to free Mary; the Protestants, of course, supported Elizabeth I. Mary Stuart was famous for her beauty. The Washington painting, far from praising it, would in Trinquet's view be denouncing it having been put to wicked use. As for the child, it would be Mary and Darnley's son, the future James I of England, the painter having represented him twice: once as an infant with his mother disguised as a peasant, a second time at the age he was when the work was painted. Trinquet rests his thesis on a vast scholarly apparatus. Each detail of the painting furnishes him new clues. Without discussing in turn each of the problems posed by this teeming erudition, we must first ask whether or not such a

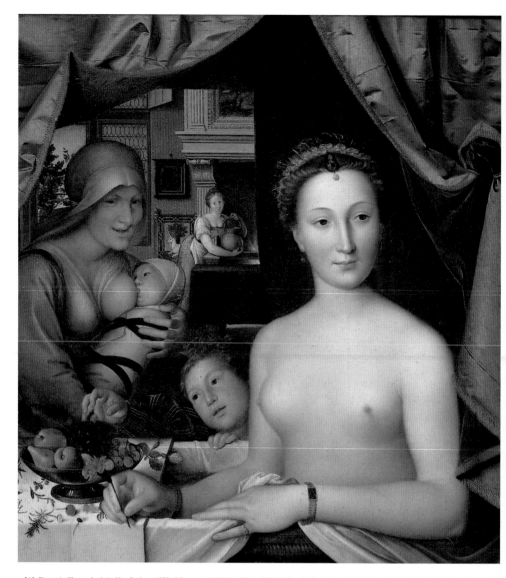

213. François Clouet, *Lady in Her Bath*, c. 1570. Oil on wood, 36 ¼ × 32 in. (92 × 81.5 cm). Washington D.C.: National Gallery of Art, Kress Collection.

hypothesis is even remotely likely. The fact is that the appearance of the painting itself vigorously contradicts it. In its presentation, there is absolutely no indication that would lead us to believe that the work is a satire. On the contrary, the atmosphere is poetic and the tone, what one could call the painting's mode, is elegiac, or rather Petrarchan. Besides, why would one have commissioned a painting of this kind? Where would it have hung? For what public was it intended? A large panel by the premier portraitist in the kingdom would have represented a considerable expense, one that seems difficult to justify, even for propagandistic purposes, if it was intended as caricature. Moreover, the finished execution of a painting of this size always requires a significant delay. To commission

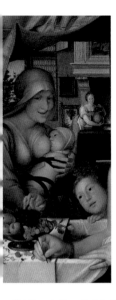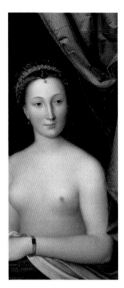

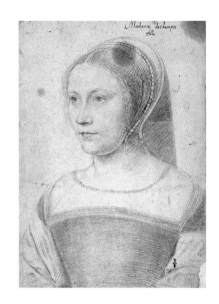

214. François Clouet, *Lady in Her Bath*. Washington D.C: National Gallery of Art, Kress Collection. Dividing the painting vertically into two halves brings out the disparities between the two sides.

215. Workshop of Jean Clouet (?), *Portrait of the young Diane de Poitiers*, c. 1530. Black and red chalk, 13 × 8 ¾ in. (32.8 × 22.3 cm). Chantilly: Musée Condé. The old inscription identifying this as Madame d'Étampes is erroneous.

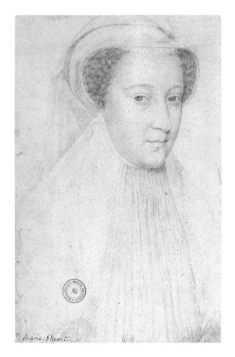

216. François Clouet, *Mary Stuart in white*, c. 1560. Black and red chalk. Paris: Bibliothèque Nationale de France, Na 22 rés.

217. François Clouet, *Portrait of Diane de Poitiers as an old woman*, c. 1555. Black and red chalk, 13 ¼ × 9 in. (33.6 × 22.9 cm). Chantilly: Musée Condé.

a satiric painting, the meaning and effectiveness of which are by definition linked to an ephemeral situation, would have been to expose oneself almost inevitably to the risk that the work would be outdated before it was even completed. This hypothesis would be conceivable in the case of a festival decoration, rapidly brushed in and itself ephemeral like the political situation, but not for Clouet's meticulous masterpiece.

Trinquet's overly ingenious idea has everything against it. There remains, nevertheless, a point on which his work calls for reflection. He assembled an impressive array of texts condemning nudity. Throughout the Christian tradition, theologians and moralists have never tired of vilifying the body and forbidding the sight of it. The text of Genesis, confirmed by other passages of Scripture, amply justified this categorical prohibition.

RONSARD AND JANET

In fact, the situation was not that simple. If the moralists continually, sometimes violently, condemned nudity, other evidence permits us to believe that this condemnation was not universal. One piece in particular must concern us here because it touches on our subject quite closely. In his *Élégie à Janet peintre du Roi* published in the *Mélanges* of 1555, Ronsard asked François Clouet to paint the portrait of his *"amie"* or lady friend from his description.[20] After a brief preamble in which the poet recommends the painter not to flatter his mistress—this being unnecessary in her case—he meticulously details the woman's body beginning with her hair and descending all the way to her toes. He describes her in the nude. The scenario has the curious feature that within the fiction of the poem, the portrait is explicitly an imaginary one. The model is absent. Moreover, having never had the good fortune of seeing his mistress undressed, the poet is obliged to describe her body "by conjecture."[21]

It would be too naive to treat the poem as a documentary source and to view it as the straight record of a real-life event, a sort of reportage. Besides, already at the time, Ronsard's commentator, Rémy Belleau rather than the knowledgeable Marc-Antoine Muret,[22] noted that the poet had "expressly imitated in this Elegy two odes by Anacreon, one of which orders a painting of his *amie* and the other of his *mignon*." This imitation itself was surely one of the poem's attractions: at the time Ronsard was composing his *Élégie*, there was a stir around Anacreon in the milieu of Ronsard and the Pléiade[23] However, Ronsard's literary references were not limited to Anacreon. Not content to combine the two odes, he integrated other reminiscences, from Virgil and Ariosto for example. At the same time— and this is characteristic not only of Ronsard but of the whole French Renaissance—his poem has its place within an uninterrupted tradition of Latin poetry that traverses the medieval era on the theme of the erotic description. Most significantly, it functions as a recapitulation of the *blasons* of the female body, a genre that had experienced a huge vogue. These little poems, which celebrate fragments of the female body, on the model of Clément Marot's *Le Beau Tétin*, found themselves grouped in collections ordered along precisely the same lines as the *Élégie*, from top to bottom, as were earlier erotic descriptions. Ronsard thus explicitly combined an antique model, a medieval tradition, and a genre that, though slightly old-fashioned in 1555, was still decidedly contemporary.[24]

Ronsard played with these themes very skillfully. Thus the common starting point, the recommendation of naturalism, is immediately contradicted since the painter must execute the portrait not in the model's presence, but from the poet's description, which is at least partially the product of his imagination. The latter is phrased in terms of the mythological dithyramb that the initial invitation to realism condemned in advance; its very excess, linked to a deliberate naïveté, denounces the absurdity of it. Ronsard dismantles the fiction by exposing the artifice.

We do not know how close the poet was to the painter. The dedication was only natural, since Clouet was by far the most prominent portraitist in France. The Italian painters at court only occasionally painted portraits and, in any case, Ronsard, who never mentions them, seems to have been hostile to foreigners and particularly to Italians, who were the most prominent. Thus we must not draw too many conclusions from this dedication, other than courteous relations at least between the prince of poets and the chief portraitist of the court.

The *Élégie à Janet*, as a literary text, has antecedents and aims that have nothing to do with the artist to whom it is addressed. This does not mean, however, that the poem is irrelevant to the study of our painting. Although it imitates antiquity, the sensibility that it expresses is obviously that of Ronsard and, through him, his contemporaries. Ronsard, for example, by no means felt himself obliged to compose a masculine pendant to his female nude, as the Greek poet had done. On one level—probably naive but not negligible—the *Élégie* belongs to Petrarchan love poetry. The text at least reveals that, within the code of courtly love that Ronsard treats with irony but which was current at the time, the idea of a nude portrait of the beloved was by no means repugnant and was certainly not understood as an insult. Are not poetic texts as relevant as those of theologians in understanding a mentality?

THE VOGUE FOR THE NUDE PORTRAIT

One may be wondering to what extent the fictive nudity that haunted the poet's fantasies could have been realized in actual pictorial practice. We should not underestimate the difference. Nevertheless, the nude portrait is a genre or sub-genre, which indisputably experienced a certain vogue during the Renaissance. Under what circumstances? This delicate point leads us to a somewhat lengthy digression.

The most usual case was not, as one might have expected, the mythological portrait, later a very widespread formula, in which a person lends his/her features to an antique divinity or a legendary or historic figure. There is evidence, however, for the existence of one important example of this in France during the Renaissance. According to a seventeenth-century inventory, on display in the gallery of the château of Anet was a painting representing Diane de Poitiers, "painted as a huntress, in the form of and nude like the Diana of the Ancients."[25] Were there any Italian antecedents? Bronzino's allegorical male portraits—Andrea Doria as Neptune, Francesco de Médicis as Orpheus and even Cosimo as Saint John the Baptist—which are heroic nudes, have no female equivalents. Now and then there have been attempts to recognize the Duchess of Urbino in Titian's *Venus*, but nothing supports this unlikely hypothesis.

A precedent of sorts could be found, on the other hand, in France. Fouquet's nursing Virgin is thought to be a portrait of Agnès Sorel, Charles VII's mistress, who played a role comparable to that of Diane de Poitiers, a century earlier (fig. 219). Agnès was the first of the great and powerful royal favorites, and she remained famous into the following century, during which she was credited with having had a beneficial influence and important role in the restoration of the kingdom under Charles VII.[26] Though not strictly speaking nude, Fouquet's Virgin largely uncovers the breast she presents to the Infant Jesus. Did the painter really represent the king's mistress in this manner? It seems surprising if not preposterous and, at first sight, one is tempted to view this as a romantic invention. Yet the idea is much older. "Some people would say that this image was painted after the figure of Agnès Sorel, *amie* of Charles VII," as Denis Godefroy had already cautiously written, in 1661. In fact, in the series of celebrated beauties with which Bussy-Rabutin decorated his château, the fair Agnès was represented by a portrait indirectly derived from the Virgin of Melun. It was based on an earlier type in which Fouquet's Virgin is transformed into a half-length portrait but retains the unlaced bodice and nude breast. The copy that was at the château of Mouchy seems to have been a sixteenth-century painting.[27]

Far from being an invention of the last century, the identification of the fair Agnès in the Melun Virgin is therefore very old. Is it well founded? There is a tradition that says that the diptych resulted from a vow made by Étienne Chevalier upon Agnès's death.[28] As Pierre Champion has observed, the Virgin's rather particular physiognomy is perfectly compatible with that of the effigy on Agnès's tomb preserved at the château of Loches. It remains for us to examine an important piece of the puzzle, the drawn portrait of Agnès found in several collections of sixteenth-century drawn portraits, in particular the one in the Aix-en-Provence collection as described above, which is dated to around 1525 (fig. 212). Charles VII's mistress is depicted here three-quarter face according to Jean Clouet's

218. Anonymous, *Diana the Huntress*, c. 1550–60. Oil on canvas, 75 × 52 in. (191 × 132 cm). Paris: Louvre.

formula, but there is a great resemblance to Fouquet's Virgin. The following quatrain appears below the portrait: "Plus de louange son amour sy méryte / Étant cose de France recouvrer / Que n'est tout ce qu'an cloistre peut ouvrer / Clause nonnayn ou an désert ermyte."(Love deserves more praise, being the cause for France's recovery, than all a cloistered nun can do in a hermit's desert.)

These lines, whether or not written by François I, as Charles Sorel has claimed, certainly date from his era and prove that some did attribute the role of liberator of the kingdom to Agnès Sorel, in competition with Joan of Arc. This opinion was never universal and the moralists have always condemned Agnès Sorel. However, her prestige remained remarkably persistent. The present case

219. Jean Fouquet, *Melun Diptych: the Virgin nursing the Christ child*, c. 1450–60. Wood panel, 36 × 32 in. (91 × 81 cm). Antwerp: Musée des Beaux-Arts.

is not a matter of a correspondence based solely on physiognomy. One notices in the drawings a sort of ribbon that emerges from Agnès's bonnet in a rather incomprehensible way; this motif is also found on the forehead of the Virgin, where it is justified as part of the headdress that extends above the crown. It seems likely that the drawing does not

copy a fifteenth-century original, but instead that, the era of François I having already recognized Agnès Sorel in the Melun Virgin, a sixteenth-century artist adapted the face of the Virgin to the standard format of drawn portraits. In any case, Fouquet's Virgin and the drawings of the following century are so closely connected that there are

220. Entourage of Leonardo da Vinci, *Portrait of a woman, known as Nude Mona Lisa*, early sixteenth century. Cardboard, 28 ½ × 21 ¼ in. (72.4 × 54 cm). Chantilly: Musée Condé.

Be that as it may, we can assume that the cartoon of the portrait called *Nude Mona Lisa* preserved at Chantilly conveys the initial invention (fig. 220).[30] A painted version, perhaps by Melzi, a student of Leonardo who had accompanied him to France, shows the bust more frontally and consequently in a less animated pose.[31] The idea was extraordinarily audacious: the half-length portrait of a woman proudly displaying her radiant nudity. The atmosphere, poetic and *all' antica,* completely avoids any feeling of impropriety. Brown was probably correct to seek its justification in the imaginary recreation of an antique prototype: the portrait of Campaspe by Apelles.[32]

Raphael, for whom Leonardo always remained a major reference, obviously made use of the latter's invention when he undertook the Palazzo Barberini's *Fornarina.*[33] This famous painting, discredited by Morelli at the end of the last century, has since recovered its prestige (fig. 221). Even if it seems a little romantic, there are no grounds to question the tradition that views it as the portrait of the painter's adored mistress. The painting is very classically inspired. The figure is presented against a simple background of vegetation that is decorative and probably also emblematic, as in Leonardo's *Ginevra de' Benci,* in which the juniper refers to the model's name. There is nothing to indicate a specific time or place. The description of the body is both naturalistic and noble. The entirely arbitrary drapery and the modest gesture of the hand draw attention to the *pudenda,* but without excessive insistence. The facial features are regular. Nevertheless, this woman with enormous dark eyes, a very small chin and a slightly flat nose is quite individuated, and she was surely recognizable.[34]

Another painting attributed to Giulio Romano (Moscow, Pushkin Museum) depicts a lady seated at her toilette in a Renaissance style palace (fig. 222). The setting is specific and contemporary; the model was posed in front of a decor that she dominates massively; the gesture of the right arm holding a veil is borrowed from ancient statuary and the ambiance is emphatically antique in style. The theme of the woman occupied with the care of her body and her finery, which this painting introduces, was taken up in France, probably by Clouet himself.

only two possible explanations: either the Melun Virgin is in fact a sort of commemorative portrait of Agnès Sorel, or François I's era fantasized about this eroto-religious apotheosis and drew from it her legendary image. Anyway, as far as we are concerned, the result is the same. In the imagination of the sixteenth century, this Virgin with one nude breast paid homage to the illustrious royal mistress and provided a worthy historical precedent.

Nothing similar is to be found in Italy, yet on the other hand, one does come across there a whole series of women depicted nude without any mythological or allegorical pretext. Leonardo da Vinci provided the prototype[29]—although in truth, the affair is far from clear, as is always the case concerning Leonardo. It seems that the artist conceived for Giuliano de Médicis the portrait of one of his mistresses presented nude from the waist up. The painting was probably not completed. Did Leonardo have time to carry the project only to the stage of a cartoon? Or even that of drawings?

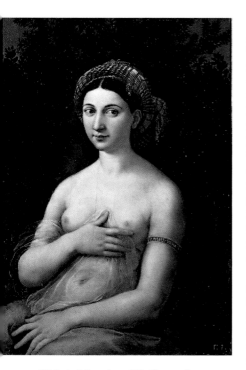

221. Raphael, *Fornarina*, c. 1519. Oil on wood,
33 ½ × 23 ⅔ in. (85 × 60 cm). Rome: Barberini palace.

Leonardo's invention enjoyed a curious success north of the Alps. Among a good dozen located variants, some are truly portraits, others figures of fantasy. A superb painting by Barthel Bruyn the Elder is one of the most successful.[35] Not only is the face individuated, but the physical type, with its ample and slightly sagging breasts, breaks decidedly with the Italian ideal (fig. 226). But let us be cautious; this should not necessarily be viewed as a manifestation of more exact observation of the model, but rather as a different type, or a desire to distance oneself from Italian art, a sort of Germanism—different, though perhaps just as conventional, as "ideal" as Leonardo's prototype.

François Clouet certainly knew a copy of the *Nude Mona Lisa* because one finds indisputable traces of it in the Washington painting. He retained the antique-style ideal: a bust with high and almost spherical breasts, with skin at once marmoreal and pearly. It is generally agreed that Clouet produced at least one other nude portrait

(fig. 223). Whether a very damaged original, a studio replica or a period copy, the painting in the Worcester museum (Mass.) does appear to be related to one of the great portraitist's compositions.[36] The artist returned to the theme—the woman at her toilette—established in the Pushkin Museum painting while integrating the model more completely into a setting. Whereas Giulio Romano had placed the objects behind the figure, the French artist installed the woman behind her dressing table, within the decor; the frame of the mirror, in order to leave no doubts as to the painting's symbolic register, is supported by the nude figures of a man and a woman facing in opposite directions. In the background, a servant is kneeling next to a chest where she has gone to find the dress that her mistress is going to wear.[37]

Here again, we have a portrait; this is indicated not only by the pose and physiognomy, but also by the composition, which served as a model for other paintings in which the figure changes. If the Dijon copy remains faithful enough to the prototype (fig. 224), the painting in the museum in Basel, in all likelihood slightly later, is much cruder: the painter was not content to support his mirror with a passive couple and entwined them in a passionate embrace.[38] One is much more surprised to see that the Washington composition, the scenario of which seems so necessarily linked to particular circumstances, was also taken up again several times. Gabrielle d'Estrées may appear in the version kept at the Condé museum at Chantilly (fig. 227), and it is definitely she who gazes at us proudly in the most famous and unusual variant, the Louvre's astonishing painting in which the two compositions, reversed, are combined into one: two ladies are together in a bathtub, one pinching the other's breast (fig. 225). This gesture, which has elicited a wide range of commentaries, is rather clear on one level. Gabrielle d'Estrées is indeed rather easily recognized in the figure on the right, and should we have any doubts, her name is inscribed on several early copies. The companion is her sister, the Duchess of Villars. We are familiar enough with the circumstances to understand some aspects of the scene. Having met Gabrielle in November 1590, Henri IV took her as his mistress several months later, though not becoming particularly

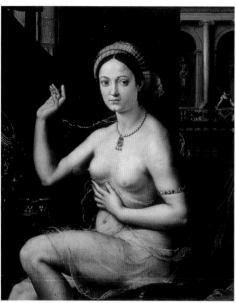

222. Giulio Romano, *Lady at her Toilette*, c. 1525. Oil on canvas (transferred from a panel), 43 ¾ × 36 ¼ in. (111 × 92 cm). Moscow: Pushkin museum.

attached to her, and in June 1592 he married her to Nicolas d'Amerval. Worried about his fertility, the king was very excited when Gabrielle became pregnant and gave birth on June 7, 1594, to little César, the future Duke of Vendôme. As early as August 25, a procedure was initiated that was conducted very brutally to annul Gabrielle's marriage; the sentence was pronounced on January 7, 1595. The king therefore must have considered the possibility of marriage with Gabrielle quite early on and probably made promises, but actually remained undecided for some time. Finally, in early 1599, with Gabrielle pregnant for the fourth time, the king resolved to marry her, fixed the date of the marriage for Quasimodo Sunday (the first Sunday after Easter) and placed on her finger the coronation ring, with which he had espoused France. Gabrielle must have been definitely reassured. But her health was deteriorating and she died on Holy Saturday, April 10, 1599.[39] When exactly the painting was executed is uncertain. The ring, which one could view as evidence, is taken from the Worcester prototype and thus cannot be used to

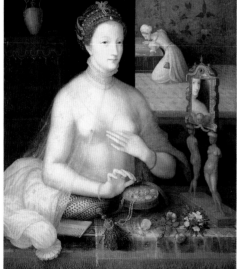

223. Workshop of François Clouet (?), *Lady at her Toilette*, third quarter of the sixteenth century. Oil on wood, 44 × 34 ½ in. (111.7 × 87.6 cm). Worcester: Museum of Art.

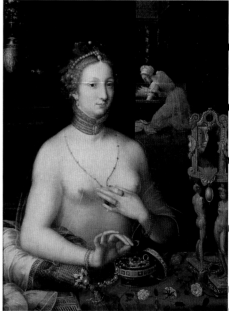

224. Anonymous, *Lady at her Toilette*, 1585–95. Oil on canvas, 41 ⅓ × 30 in. (105 × 76 cm). Dijon: Musée des Beaux-Arts.

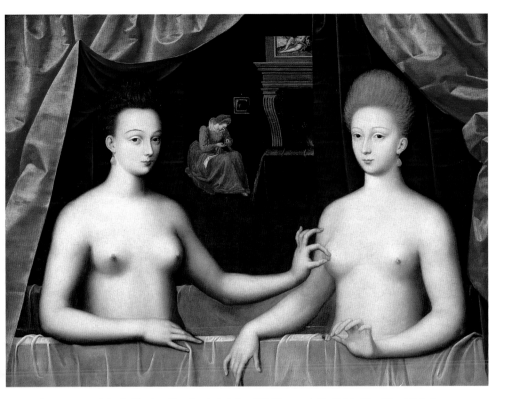

225. Anonymous, *Gabrielle d'Éstrées and her sister in the bath*, c. 1595. Oil on wood, 38 × 49 ¼ in. (96 × 125 cm). Paris: Louvre.

support the assertion that the painting is later than early 1599 and the presentation of the sacred ring. It may manifest a less ceremonial, earlier promise. On the other hand, it can hardly be doubted that the gesture of the sister who holds the breast refers to Gabrielle's pregnancy and to lactation, just as the servant in the background is surely preparing the newborn's swaddling clothes.

This return of Gabrielle's painter to rather old models is characteristic of the court culture of the first Bourbon king. The founder of the new dynasty, who wanted to restore the kingdom after long years of religious troubles had torn it apart, was anxious to confirm his own legitimacy and consequently did all he could to express a continuity between his reign and those of Henri II and especially François I, when the last Valois had been at their brightest. The king's painters, Ambroise Dubois and Toussaint Dubreuil, were constantly and explicitly inspired by the examples

left by the art of Fontainebleau at its peak and above all by Primaticcio. Henri IV in particular had the *appartements des bains* (bathing quarters), to which I will return, carefully restored. Under these conditions, we can understand why these models that belonged to an already prestigious past were sought out in order to be adapted for Gabrielle's benefit. There are good grounds to believe that they were not chosen at random but because they were relevant: after about forty years at most, the meaning of these paintings was in all likelihood still remembered.

The history of the nude portrait in the Renaissance is far from being completely clear. Nevertheless, if one can be allowed to draw conclusions from a very limited number of examples, the well confirmed cases lead us to believe that it was a genre reserved for very particular circumstances, that is to say women whose social position was exceptional. Indeed in every instance the

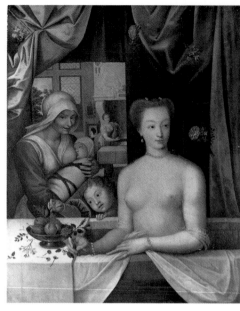

226. Barthel Bruyn, *Portrait of a lady in the nude*, 1535–36. Oil on panel, 28 × 21 ¼ in. (71 × 54 cm). Nuremberg: Germanisches Nationalmuseum.

227. Anonymous, *Gabrielle d'Éstrées in the bath*, c. 1595. Oil on canvas, 45 ¼ × 40 ½ in. (115 × 103 cm). Chantilly: Musée Condé.

model was a mistress, the heart's elect. If she was not a spouse, neither was she a courtesan. It is generally thought that Raphael's mistress, who only acquired the name Fornarina in the nineteenth century, was of modest circumstances and that this is probably why the painter, who according to Vasari envisioned a brilliant marriage with Cardinal Bibbiena's niece, had no intention of marrying her. But there are no grounds to believe that she was a woman of loose morals. As for the royal mistresses—by which is intended the official mistresses, and not the women, perhaps relatively numerous but obscure, with whom a king like François I may have had sexual relations—these were most often noblewomen, sometimes of high rank, who had their places at court. If Agnès Sorel was "a poor demoiselle," she was nevertheless a "gentlewoman."[40] Though Anne de Pisseleu, for whom Primaticcio conceived an appropriately sumptuous decor at Fontainebleau, became Duchess d'Étampes through François I's favor, she belonged to a noble family and was descended from Louis VI through her grandmother. As for Diane de Poitiers, daughter of Saint Vallier, she was descended from one of the oldest houses in France. The daughter of an apothecary from Orléans, Marie Touchet was of more modest circumstances; this did not prevent her from marrying François de Balzac d'Entraigues several years after the death of Charles IX.[41] Gabrielle d'Estrées, finally, was from a family whose fortune dated only to the reign of François I, but which had been known among the Picardy nobility since the fourteenth century. Henri IV's promise of marriage says enough about her position.

These nude portraits depict women whose love life played a determining role. Through their hold over a man, they could ascend to real power. But their position was precarious. Flattered by some, their conduct gave rise to the most violent attacks. There were always moralists to curse the kings' mistresses and their influence.[42] In the paintings that we have examined, on the contrary, one has the impression that the body was sanctified and became a veritable cult object, as if to legitimize the power that it conferred.

BEYOND THE PORTRAIT

That Clouet's *Lady in Her Bath* is in fact a portrait is, as we have seen, not at all unlikely. And yet, we are unable to identify the model, which is all the more frustrating since, if our observations are correct, the woman in question must have belonged to a very limited set. Be that as it may, this failure has its value, since it forces us to interrogate the painting much more insistently than we probably otherwise would, had we known the sitter's identity. There is a tendency to believe that identification "explains" a painting, so that, too often, the correct identification of the subject takes the place of interpretation. Thus let us proceed a little further with our investigation—though not in the hope of recognizing the model.

If it is true that Clouet's *Lady in Her Bath* is linked to a documented pictorial tradition of the nude portrait, it remains no less an exception within an exceptional series. The scenario is still disconcerting and the portrait obviously situates itself at the genre's limits. Some attempts have been made to explain it by recourse to mythology or allegory. To the extent that this amounts to an evasion of the problem of portraiture and the model's identity, it should not be considered. A portrait, however, is never just a likeness, the recording of an individual's distinctive physical marks, or it would only be of documentary interest. Yet in this case the limits of the genre are pushed so far that the very category the painting belongs to is momentarily called into question and one may wonder if *Lady in Her Bath* is not a genre painting—that is, a scene of daily life in which, appropriately, the anonymity of the figures is the rule. On the other hand, we might perhaps be dealing rather with a scene from a novel, featuring fictional characters; or again, as in Titian's *Venus of Urbino*, a mythological figure, a Venus that the artist has imagined in a contemporary setting,[43] just as in the fifteenth century the Flemish deliberately placed the holy figures of Christian imagery in the decor and costumes of their own time.

Even if, upon reflection, we are perfectly convinced that we are dealing with a portrait, with a woman whose identity has yet to be discovered, these doubts and ambiguities indicate that the

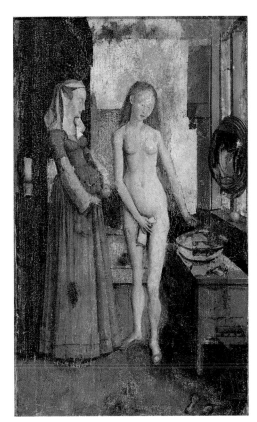

228. Anonymous, *Lady at her Toilette*, copy after van Eyck, fifteenth century. Oil on wood, 11 × 6 ½ in. (27.5 × 16.5 cm). Cambridge, MA: Harvard University, Fogg Art Museum.

painting exceeds the usual mode of portraiture in the sixteenth century, particularly if one considers the often very routine practice of Clouet himself.

Several elements enter into play: above all, the nude. The heroic nude, of which this woman is an example, presents a body to us, but a fictional body, one that is transfigured, impervious to decay, radiant, at once sensuous and dematerialized. Such a nude in the sixteenth century is automatically mythological, not because it denotes a particular divinity, but because it places the figure in a world of antique references. Ronsard himself, in the *Élégie à Janet*, attributed to his mistress "the elbows and arms of Juno / And the fingers of Minerva," and her stomach was "like that of Venus." If the poet made use of such expressions

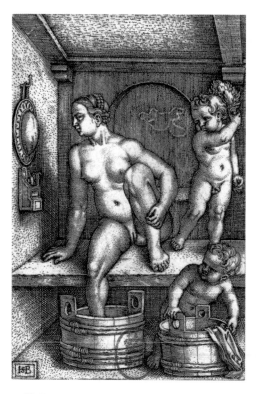

229. Hans Sebald Beham, *Lust*, c. 1540. Engraving, 2 ⅔ × 1 ⅔ in. (6.7 × 4.2 cm). Paris: Bibliothèque Nationale de France, Ec 4b rés.

routinely, the painter may well have found something equivalent. Mythology is implied here not as a system of precise equivalences, but as a global reference. This is what authorizes the nude portrait: the mythological ambiance removes the body from the ordinary world in which it is subjected to the humiliation of nakedness. We have seen, besides, that Leonardo's initial invention should probably be viewed as containing a specific reference to the legendary story of Alexander. Was this reference understood at the French court? It is all the more likely that the episode of Apelles painting the nude portrait of Campaspe for Alexander was specifically represented in the chamber of the king's mistress in the château of Fontainebleau and disseminated by Davent's etching (fig. 113).

It has also been suggested that Clouet's nudes be viewed as moral allegories, as representations of lust or vanity.[44] Once again, the question is not whether this hypothesis should replace that of the portrait, but rather if it should be superimposed, so to speak. At first glance, this seems to be in contradiction with the dithyrambic tone, which leaves hardly any doubts. One must not be too hasty, though, in excluding this possibility. In the case of the woman at her toilette, the ostentation of body care and the almost emblematic way in which the mirror is isolated render the allegorical allusion and moral reflection almost inevitable. Here we are referred to an entire series of images that go right back to a painting by van Eyck—now lost, but at one time famous and described at length by van Mander. It depicted a nude woman busy with her ablutions and included a mirror that played a large role. Van Mander viewed this above all else as a demonstration of the optical possibilities of painting, but surely it pertained to something else. If the original theme of the painting remains contested— some wish to view it as a ritual scene—it is clear that it later served as a starting point for allegories of *Luxuria* and *Vanitas*.[45]

A later version—a small engraving by Hans Sebald Beham, the explicit subject of which leaves no doubts (fig. 229)—will help us understand how this reflection, apparently incompatible with the eulogy of a beautiful woman, could all the same have been introduced. If Beham's engraving belongs formally to the genre of moral allegory, *Vanitas* or *Luxuria*, the work's real purpose is obviously not moral instruction, but rather the complacent exhibition of female body parts in order to titillate a masculine and lewd clientele. The example is instructive insofar as the intention is clear and the disparity between its declared subject and actual meaning glaring. Other representations are more troubling because more ambiguous. The numerous variants on the theme of the young woman and death by Hans Baldung Grien, Nicolas Manuel and others have an erotic value as overt as their didactically orthodox subject. Here, the equilibrium of the two aspects is much more precarious. Though the flesh is very enticing, its dangers are also vigorously emphasized.

The theme of the *memento mori* is not alien to portraiture where the hourglass and the skull are rather frequent accessories. Indeed, by definition, is a portrait not a means of placing the individual outside of time and its ravages, while by the same

230. François Clouet, *Bath of Diana*, c. 1550–60. Oil on wood, 52 ⅓ × 75 ½ in. (133 × 192 cm). Rouen: Musée des Beaux-Arts.

stroke reminding us of mortality? Because Clouet's painting concerns a woman whose physical charms are unreservedly on display, the harrowing theme of ephemeral beauty and, more generally, the triumph of Time rendered universally popular by Petrarch's *Triumphs,* are more or less inevitable. Ronsard's *Amours,* too, return to it over and over again. "Gather today the roses of life," "Gather, gather your youth . . ." Such expressions recur in a haunting fashion. The anxiety that they express was not new. Whether or not as a result of the great plagues, death obsessed what we call the late Middle Ages. The contemplation of one's ultimate destination was then supposed to encourage one to renounce the world, its ephemeral delights and illusory promises. It was one of the characteristics of the new era, the Renaissance, to draw different conclusions from the same premises. The rose blooms only for a brief moment, but what perfume and what splendor! The rocks hardly change, but they are numb! In his love poetry at least, Ronsard

231. *A public bath,* from Valère Maxime, *Faits et dits mémorables,* c. 1470. Illumination on parchment. Berlin: Staatsbibliothek.

219

232. Jean Mignon, *Women bathing*, after Luca Penni, 1547–50. Etching, 17 ⅓ × 24 ½ in. (44.1 × 62.4 cm).
Paris: Bibliothèque Nationale de France, AA 4 (Primaticcio).

233. Pierre Milan, *Jupiter and Callisto*, after Primaticcio, 1543–45. Engraving, 7 × 11 ¼ in. (18 × 28.6 cm).
Paris: École Nationale supérieure des Beaux-Arts.

transformed the *memento mori* into a frenetic *carpe diem*. Clouet surely did not remain insensitive to the metaphors in play around him, which were probably sung in Paris as they were at the court.

Moral reflection on time and the pleasures of earthly existence is found at the origins of still life as an independent genre in the same years in which Clouet painted *Lady in Her Bath*.[46] In his painting, the artist has carefully inserted a veritable still life before the beautiful bather. Must we decipher the objects one by one according to a precise iconographic code, as Roger Trinquet has attempted to do? Without being impossible, this approach does not really seem necessary. Yet how can we doubt that these fruits and flowers, which are so attractive, evoke the joys of the senses and the enjoyment of existence? The young boy's gesture, so spontaneous and so naturally eager, is quite calculated to underscore the message. On the threshold of life, this gourmand discovers pleasure and, beyond these cherries and peaches, we can guess at other delights, other experiences, and perhaps forbidden fruits.

THE MULTI-FACETED MEANINGS
OF THE BATH

We must lastly inquire as to why Clouet placed his model in a bathtub. The idea, which seems rather unseemly to us, was probably equally surprising at the time. Therefore we will seek not to dissipate the troubling strangeness, but instead to capture the echoes that it may have found in the minds of contemporaries.

The metaphoric potential of the bath is multiple and contradictory. On one hand, it is an act of purification and, in the Christian tradition, easily recalls that symbolic ablution par excellence, baptism. Though this is indeed not exactly at play in the present case, we must not be too quick to dismiss this register. The unicorn embroidered on the back of a chair, which is quite conspicuous near the center of the painting, implies a discourse on virginal purity that must at least be mentioned, though it may seem incongruous here. An allusion to the ritual bath that accompanied marriage ceremonies is not improbable. But this is surely not the main point. In the iconography of the fifteenth and

sixteenth centuries, the bath is associated above all with sexuality and eroticism.[47] Let us look at only one illustration of the motif's popularity. In the well-known series of Florentine engravings representing the planets and their effects on humanity, a sort of iconographic manual, the artist has placed a group frolicking in a sort of rustic bathtub among the "children of Venus."[48]

In sixteenth-century French art, one finds numerous examples of erotic baths, whether or not they have a mythological pretext as do the bathing Venuses or Dianas. Brantôme has given us a charming description of a painting of this kind. There was, he tells us, in the gallery of the Count of Chasteauvillain, known as Adjacet, "a very charming scene, which showed most fair ladies in their bath, caressing, stroking and generally pampering one another and, indeed, divesting themselves so beautifully and finely of their garments to reveal all of their charms, that even a cold recluse or hermit could not fail to be warmed and moved."[49] An etching by Jean Mignon after Luca Penni helps us imagine what such a painting might have looked like (fig. 232). Other, more decorous works, such as the admirable *Bath of Diana* by François Clouet, are nevertheless very sensuous (fig. 230). The theme was particularly popular in France.

AT THE BATHS

The bath was not only an iconographic motif; it was also a reality of life at the time. In modern Italian, *un bagno* still means a brothel. This is an eloquent testimony to the reputation enjoyed by the public baths—one that is as old as their splendor and goes back to Roman antiquity. Everyone is aware of the magnificence of the great thermal establishments of Rome. The baths of Caracalla and Diocletian count among the city's most imposing ruins, covering more than twenty-five acres each. Even in Paris, the Cluny thermae reveal that the Empire introduced its habits into the distant provinces.

Towards the end of antiquity, these immense buildings fell into disrepair, but the custom of public baths and their social role would not disappear for quite some time, persisting throughout the Middle Ages. As this period came to a close,

particularly in the fifteenth century, there were ordinances in various cities intended to separate male and female visitors to the baths. But it seems that this concern did not surface until quite late and that the measures taken were rather ineffective. Although the public baths may have had a very bad reputation, visiting them was probably, on the whole, an innocent activity.[50] There were, for example, four public baths in Dijon, and if they were meeting places, they also served other purposes. In a very curious proceeding initiated in 1464 by a distinguished figure, Madame de Molême, against a certain Douhet Mercier, it emerges that for a lady of quality to frequent the steam rooms was not in itself shocking. Rather it was the fact that she went there precisely on the days and hours reserved for men, and the revelations of the mistress of the baths as to her improprieties were overwhelming. Several fifteenth-century miniatures represent such establishments[51]: men and women are busy merrily drinking and eating, installed in long communal bathtubs. Couples draw aside from the company, obviously in order to indulge in more intimate pastimes (fig. 231).

Public baths declined in popularity during the sixteenth century. In the fifteenth century, ordinances intended to separate the sexes and avoid improprieties and abuses multiplied. These became more and more strict towards the end of the century and during the sixteenth century the Dijon public baths disappeared one by one, the last in 1569. In England, Henry VIII abolished public baths. Was this solely for reasons of public morality? After all, the problem was not new. It was representative, perhaps, of a more profound phenomenon concerning the experience of the body. Today we well realize that sensibilities change. It would have been unthinkable some twenty years ago for a woman to bathe topless on a public beach—a perfectly usual spectacle in France today. Though nudity had always been forbidden by the Church, it long remained a commonplace reality. Several people slept together naked in the same large bed. This custom rules out the type of taboo that has weighed on the bodies of others since the Renaissance. Yet other indications reveal that modesty existed as well. These phenomena of the conscience and their evolution

are extremely difficult to apprehend. It is obvious, however, that there was a change of attitude towards the body and nudity, and this evolution seems to have been more precocious in Italy than north of the Alps. The public baths disappeared there earlier and one testimony in particular is striking. In 1415, the humanist Gian Francesco Poggio Bracciolini described the baths of Baden, in Switzerland; there, men and women were separated, but only by a fence through which they could freely see each other and converse.[52] The Italian was clearly surprised and somewhat shocked by this liberty of conduct.

It is against this anthropological background, so to speak, that one must envision the installation of the Fontainebleau baths, which were unexpectedly grand. The entire ground floor below the Galerie François I was dedicated to them. Not only did the bath complex occupy a good deal of space, but it was installed and fitted out very early on, directly after the king and queen's apartments and the gallery.

This ensemble, surely unique in Europe, has entirely disappeared, but old descriptions and several iconographic documents enable us to glean at least a rudimentary idea of what it would have been like. It occupied the entire basement for the length of the wing—the umbilical cord linking the Cour Ovale, that is, the rebuilt old château, to the immense new court. The sequence of the rooms can be largely reconstructed from contemporary accounts. They began to the east, next to the king's apartment, with two actual steam rooms. The first served as a dry heat room, what we today call a sauna, intended for sweating. The minimal space occupied by this relatively small room—normal given its purpose—made it possible to add another room in the thickness of the wing which served, according to Goelnitz, "pro tondendis capillis et redenda barba," that is, as a barber and hairdressing establishment.[53] Father Dan specified that the dry heat was produced "by means of a large, well-set up stove, which exhales its heat through certain small openings in the pavement." Next came the hot bath, the water of which was brought to the right temperature by the aforementioned stove. The hot bath was followed, in a larger room, by the cold bath; it was a sort of

234. Primaticcio, *Diana discovers Callisto's pregnancy*, 1541–47. Pen and brown ink, brown wash with white heightening on beige paper, 8 ½ × 13 ½ in. (21.5 × 34.5 cm). Paris: Louvre.

small pool surrounded by a wooden railing. The basin was three and a half feet deep and measured fourteen by ten feet.[54] The water thus came up above the waist level of an average person, and several people could bathe there at the same time. Next came three relaxation rooms, of which the last and largest was called "the conference room" by Dan and *camera consiliorum* by Goelnitz.

Several rare graphic documents help us imagine the decoration of this spectacular ensemble. Dimier succeeded in identifying a good portion of the cold bath's frescoes. Primaticcio had developed the story of Jupiter and Callisto on the vault and in the lunettes. The principal episode was the discovery of Callisto's pregnancy (fig. 234). The place's function had probably elicited the choice of subject: an important bathing scene featuring the numerous figures of Diana and her nymphs was particularly appropriate. A beautiful engraving by Pierre Milan preserves the memory of the scene in which Jupiter takes on the appearance of Diana in order to approach Callisto, a good pretext for a scene of lesbian eroticism (fig. 233). Another lunette depicted Callisto transformed into

a bear by Diana. On the vault, lastly, Callisto could be seen placed among the stars, allowing the ceiling to be transformed into a starry sky.[55]

We are quite poorly informed as to the rest of the decorations that Father Dan describes very summarily and which were renovated under Henri IV. Nevertheless, they must have been very brilliant, and the mélange of stuccos and paintings—the rule at Fontainebleau in those years—was deployed in all the rooms, including the dry heat room. By all accounts, these decorations had an erotic character. Primaticcio's charming composition engraved by Fantuzzi in which Venus joins Mars in a large bathtub could hardly have been conceived other than for this setting (fig. 237).[56]

The most surprising thing about the Fontainebleau baths is that the most precious paintings in the king's collection were installed there. It was to the baths that one went to admire Leonardo da Vinci's *Saint John the Baptist*, Andrea del Sarto's *Charity* and other masterpieces of the Italian Renaissance, some of which are still among the prize jewels of the Louvre.[57] These paintings—though we do not know their exact

223

235. Antonio Fantuzzi, *Mars and Venus bathing,* after Primaticcio, c. 1544. Etching, 9 × 17 ¾ in. (22.5 × 45 cm). Paris: Bibliothèque Nationale de France, Eb 14d.

placement—were framed by stucco ornaments designed by Primaticcio.[58] The decision, so unexpected to us, to install the king's museum in the bath complex is certainly important to understand the significance of the ensemble. One element that must have been in play was the memory of the antique baths where, as the humanists who surrounded François I surely knew, there had been works of art. But this explanation is not sufficient. If sensuality turned too often to lasciviousness—and the bath to a brothel—the culture of the senses did have legitimate aspects. Bathers are almost constantly shown drinking and eating in the imagery of the bath that proliferated during the era. It seems that the bath was understood as the site of the exaltation of the senses, the aesthetic locale par excellence. I see confirmation of this in the book of the *Songe de Poliphile,* which was very popular at the time. Shortly after the novel begins, Poliphilo encounters five beautiful maidens who pull him into a bath. These lovely creatures are none other than the five senses. In the magnificent French edition translated by Jean Martin, while the illustration is almost entirely copied from the 1499 Aldine edition, the bath scene is the object of an additional image (fig. 236). Thus in 1546, this episode was particularly interesting to the French.

236. *Poliphile with the five senses at a bathhouse,* from the *Songe de Poliphile,* 1546. Paris: Bibliothèque Sainte-Geneviève.

There was no equivalent to the Fontainebleau baths in sixteenth-century Italy—not that bathrooms were unknown there or that their decoration had always been neglected. Cardinal Bibbiena's famous *stufetta* in the Vatican and Pope Clement VII's bathrooms at the Castel SantAngelo are exquisite, but these are small and intimate fittings. To find a more important ensemble, one must go back to the villa Poggio Reale.

There were, on the other hand, large installations in certain princely palaces in the Burgundian domains. At Dijon, in particular, in the palace of the Burgundian dukes, the baths occupied a separate building. This leads us to assume that they occupied a place in court life similar to those of Fontainebleau. Probably less important, the baths of Philippe de Clèves within the château of Wynendaele, described in a 1527 inventory, were decorated in a fashion that prefigured Fontainebleau: one could see embedded in the wall there a large painting of Diana and Acteon with several nude women, as well as other paintings in which the nude dominated.[59] Without iconographic documentation, it is quite difficult to tell what these installations and their decor might have looked like. It does seem, however, that Fontainebleau is inscribed within a northern European cultural tradition in which the bath occupied a more significant place in the life of the court than in urban customs. However, what was new was certainly the very obvious desire to recreate classical antiquity. The Fontainebleau baths resulted from the aristocratic synthesis of vernacular customs and humanist culture.[60]

These considerations allow us to understand more fully the strange impression produced by Clouet's painting. The radical disjuncture that we observed at the beginning between the two halves of the painting—portrait on one side, genre scene on the other—also corresponds to a collision between the heroic nude and familiar or naturalistic representation, a contrast doubled within the painting by the social disparity between the lady and the servant, the attractive and the useful breast.

This long gloss does not by any means exhaust all there is to say about this strange painting. I have not even raised the question that feminist studies oblige us to pose today, that of the role of women in society. The implications of our painting are obviously great from this point of view, but they are, to my mind, far from being simple or obvious. It would be tempting though quite imprudent to apply to such a work the notions forged by authors such as Laura Melvey to critique our visual culture. *Lady in Her Bath* is perhaps an instrument of power for the woman represented more than it is a submission to a reified male gaze. Though I believe that the preceding observations help us make sense of a particularly difficult work, I also admit that it remains impenetrable in many respects. Just as Clouet's "ordinary" portraits in their apparent banality make us feel close to the men and women of the sixteenth century, the *Lady in Her Bath* makes us conscious of the distance that separates us from them and of what is irreducible and strange about the culture of sixteenth-century France.

237. Jean de Gourmont (?), *Descent into the Cellar*, 1537, Oil on wood, 22 ½ × 22 in. (57 × 55.5 cm). Frankfurt: Städelsches Kunstinstitut.

Chapter VII

JEAN COUSIN AND PAINTING

So much legend had accumulated over time around the name of Jean Cousin that, by the beginning of twentieth century, Louis Dimier would find it hopeless to try and find whatever glimmer of historical truth might be hidden behind this strange figure whose career lasted for most of the sixteenth century and whose innumerable works, in the most diverse techniques—painting, sculpture, drawing, stained glass, illumination, tapestry, copper and wood engraving, enamel—display the most unlikely stylistic disparities.[1] Yet for a long time this "French Michelangelo" had been the very symbol of the French Renaissance. Then in 1909, in a dramatic gesture, Maurice Roy would declare: "All that has been written, since the seventeenth century, on the biography of Jehan Cousin was almost nothing but a web of errors."[2]

On the basis of a handful of archival documents,

he destroyed a monster that had grown by increments. If I linger rather extensively over my precursors' flights of fancy, it is in order to show how their frustration induced them to fantasize. They sought ceaselessly to account for the art of the French Renaissance with ideas furnished by a historiography adapted to Italian painting—a historiography in which a certain type of artistic personality and a precise definition of art played a primary role. We will see with what ardor they hoped to discover a painting for their country comparable to that of Italy, but possessing a distinctly French character. It was out of this double and vain desire that an almost entirely imaginary Jean Cousin was born. One can even pin down the time when this strange creature came into being: his creator, his true father, was the admirable writer on art often called the French Vasari, André Félibien.

Félibien and the Beginnings of Painting in France

As Félibien was the first historian of painting in France, it is altogether normal that he was the first to be concerned with its origins. What he had to say on the matter was to remain authoritative for more than a century. His great work, *Entretiens sur les vies et sur les ouvrages des plus excellens peintres anciens et modernes*, (Conversations on the works of the most excellent painters both ancient and modern) has the particular feature of having been a double project: it is both a theory and a history of painting at once. Each "conversation" consists of a long discussion of one aspect of pictorial art: drawing, color, the expression of passions, etc. The historical and biographical sections are introduced as illustration, even though

they do have their own dynamic within the discourse. Félibien's attempt to coordinate his two designs—the one theoretical, the other narrative—enriches his critique of painters, but occasionally gives rise to some confusion as to the chronological order.

Félibien's attitude towards French art prior to the seventeenth century is rather ambivalent. The classicizing taste of Poussin's unconditional admirer drew him towards the art of the Italian Renaissance. But at the same time, he was concerned with the national origins of his history, and the fact that he knew nothing about French painting before the sixteenth century allowed him to formulate a complaint that would become a

commonplace: France, out of disregard for its own glory, had had neither a van Mander nor Vasari.

Félibien by no means underestimated the role of the Italians at Fontainebleau, particularly Primaticcio and Niccolo dell'Abbate. He wrote:

[. . .] one can say that they were the first to bring to France the Roman taste, & the beautiful idea of Painting, & antique Sculpture. Before them all the Paintings still held to the Gothic manner, & the best were those, that in the Flemish manner, seemed the most finished, & with the most vivid colors. But as Primaticcio was very experienced at drawing, he made such a large number of drawings, & had under himself, as I have told you, so many able men, that all of a sudden there appeared in France an infinity of Works of better taste than those that one had seen before. Because not only the Painters quit their old manner, but even the Sculptors, & those who painted on glass, the number of which was very large. This is why one still sees windows of a very exquisite taste, and also any number of Limoges Enamels, & painted & enameled earthenware vases, that were made in France as well as in Italy. One even finds Tapestries designed by Primaticcio.[3]

One would be hard put to trace more vigorously the tableau of the stylistic revolution performed by the Italians of the court. But then Félibien launches into an exposé on the parity of genius in the different nations and on the advantage presented to the Italians by the remnants of antiquity, so that all considered it was somewhat by accident that Italy had played such a dominant role in the renewal of art. "When Cimabue and Giotto began to revive it, one practiced it on this side of the Alps as well as in Italy, where one can say that since Constantine the Works of Sculpture & of Painting were not of a better taste in Rome than those made here."[4] After considering a twelfth century manuscript,[5] he continues:

A long time ago one practiced Painting in France; our old windows are proofs of it, & I would even tell you that the first who painted in Rome on glass was a native of Marseilles. Also since the Painters of France worked a lot on glass, & were both Painters & Glaziers, one sees that as early as the year 1520, there were many windows in the Churches of a very excellent taste, & whose colors are admirable; I say this not only for the beauty & splendor of the material, I intend the mixture of colors, & that the Craftsmen call *l'apprest*. The names of these excellent men, however, have not come to us, & one does not know which were those who worked before King François I. had summoned from Italy Me. Roux, & the other Painters that I have named.[6]

This development is introduced in the fourth conversation. Having asserted Primaticcio's immense role, Félibien immediately sought to insist on the fact that the Italian was not preaching in a complete wilderness. He attempted in particular to bring out one of his own country's specialties, stained-glass painting. One will note that he insists here on the date 1520, while in general he hardly ever gives precise dates. The point is to emphasize that these admirable windows of a "very excellent" taste were decidedly prior to the arrival of Rosso and Primaticcio.[7] After this important digression, the author turns his attention towards the old painters of northern Europe, beginning with the van Eyck brothers and Dürer.

In the fifth conversation, Félibien tells us in a little more detail about the French painters of the sixteenth century. In particular, he enumerates the secondary figures of Fontainebleau, whose names he obviously drew from the copy of the accounts that he had at his disposal. He dispatches the portraitists in a few phrases. "There was also JANET, who made portraits very well" And after having cited two or three paintings without commentary, he concludes: "Ronsard spoke favorably of him in his poetry."[8] Similarly, he seems to have known of Corneille de Lyon only through reading Brantôme.

This purely bookish and documentary science seems already severed from any familiarity with the works themselves and from orally transmitted studio lore. In less than a century, tradition had died out and the memory of sixteenth-century art had vanished. Van Mander, who was writing at the end of the sixteenth century, was much better

informed on the beginnings of Flemish painting, and in 1550 Vasari received a rich tradition not only of the Quattrocento, but also of Cimabue, Giotto and his school; even if with time history had often become embellished by legend, a living memory of painting still existed. Félibien, himself, had not even collected the name of Jean Fouquet. One must keep this deficiency in mind to understand the role that Jean Cousin played for Félibien. The passage is worth quoting in its entirety.

But one of the most considerable of all the French Painters that worked then & whose reputation is probably still not as great as he deserves, was JEAN COUSIN. He was from Soucy near Sens, having applied himself since his youth to the study of the fine arts he became an excellent geometer and a great draftsman. As in that time one painted much on glass, he gave himself particularly to this sort of work, & came to establish himself in Paris. After having made several works, & made his reputation, he traveled to Sens where he married the daughter of Mr. Rousseau who was Lieutenant General there. Having brought her to Paris, he continued the works he had begun & made a number of others. One of the most beautiful that one sees by him is a painting of the universal judgment that is in the sacristy of Minimes in the Bois de Vincennes, & which was engraved by Pierre de Jode, an excellent Flemish draftsman. From this painting one readily sees that he was accomplished as a draftsman, & abounded in beautiful thoughts & in noble expressions; also it is difficult to imagine the large number of works that he made, principally for windows, as one can see in Paris in several Churches, which are either by him or after his drawings. In the windows of the Choir of Saint Gervais he painted the Martyrdom of Saint Laurens, the Samarian Woman, & the story of Paralytic.

His possessions being situated in the area of Sens, he spent a good part of the year in that city, & this is why one sees there several paintings in his making. There is a window in the Church of Saint Romain in which he represented the universal Judgment; & in the Church of the Cordeliers he also painted on a window Jesus Christ on the Cross, & the story of the Bronze Serpent; And on another a miracle that happened through the intercession of the Virgin.

In the Chapel of the Château of Fleurigny which was only three leagues from Sens, he represented the Sibyl who shows to Augustus the Virgin who holds between her arms her son surrounded by light, & the kneeling Emperor who adores him. One also sees in the city of Sens several paintings by his hand, & a quantity of portraits, among others that of Marie Cousin daughter of this excellent painter, & that of a canon named Jean Bouvier.

There is in the residence of a Counselor of the Presidial court of Sens[9] a painting by this Painter, in which is represented a nude women lying on her side. She has one arm rested on a skull, & the other stretched out onto a vase surrounded by a snake. This figure is in a grotto open in two different places. Through one of the openings one sees a sea, & through the other a forest; above the painting is written *Eva prima Pandora*. All these different works are quite important enough to make one think that Jean Cousin was one of the ablest Painters ever. Nature and study had contributed equally to render him skillful; because one sees in what he did an ease & a creativity that one cannot acquire through study alone, & one notices a correctness in the drawing, an exact observation of perspective & other aspects of art that Nature does not give by birth. He has in fact left the marks of his knowledge in the books that we have by him, in which he gives rules of Geometry for perspective, & of the foreshortening of figures. This last was judged so useful to learn the principles of Painting, that it is in the hands of all those who profess this art; & the great quantity of editions that one sees of it, is testimony to its value, & the esteem that it commands.

Besides all these talents necessary in his profession, he also had that of pleasing at Court where he was quite beloved, & where he passed some of his days around the Kings Henri II. François II. Charles IX. & Henri III. As he worked very well in Sculpture he made the tomb of Admiral Chabot, which is at the Celestins of Paris in the Orleans Chapel. There are some

238. Jean Cousin the Elder, *Eva Prima Pandora*, prior to 1550. Oil on wood, 38 ⅓ × 59 in. (97.5 × 150 cm). Paris: Louvre.

who would make us believe that he was of the so-called Reformed Religion, because in the stained glass window which I have mentioned in which he represented universal judgment, he painted the figure of a Pope, who appears in Hell in the midst of devils; but this is quite a feeble foundation to have caused an unfavorable opinion of this Painter's faith; he was not the only one, as we have remarked elsewhere, who painted similar things, to tell everyone that there is no condition at all that can be exempt from punishments in the other life, in addition to all his other works, in which he took pleasure in representing pious subjects; & particularly the life that he always led exempt him from these suspicions so weak and so poorly founded. The esteem that one must have for such a great man has induced me often to inform myself of his life & his morals, but I have only heard him spoken of most favorably: I was unable to find out in what year he died, only that he was alive in 1589, indeed quite aged.[10]

Anxious to document an artistic tradition native to his own country, but frustrated by the lack of materials he was presented with, Félibien viewed Jean Cousin as an opportunity to rediscover a French painter comparable to the great Italians of the Renaissance, an intellectual and universal artist. As would a modern historian, he went on location to inquire into traditions preserved at Sens, where the painter was from. He consulted documents. He made a special study of works kept under the artist's name and critiqued them. On the basis of these findings, he sketched a figure with heavy ideological implications.[11]

From the start, almost all the themes of the legend of Jean Cousin were in place. Having already confused two artists of the same name, father and son, Félibien gave his hero a disproportionately long career and very disparate works. This Cousin was not only a great painter, but also a great sculptor and a learned theoretician—in sum, the universal artist of the Italian Renaissance. However, at the same time, he was specifically French, since stained glass—a national specialty—made up a large part of his production. The French Michelangelo was born.

230

239. *Scenes from the Apocalypse*, 1551–55. Stained glass. Vincennes, Sainte Chapelle of the château.

240. Nicolas Beaurain, *Angel*, fragment from the Sainte Chapelle of the château at Vincennes, 1551–56. Stained glass. Paris: Louvre.

Growth of the Legend and Nationalist History

The idea launched by Félibien made its way slowly, quietly but effectively. Historians of painting—Roger de Piles, Dézallier d'Argenville, et al—were content to summarize Félibien. In an era when triumphant classical theory tended to efface any sense of local identity, Cousin was disregarded, and Poussin was there to take on the part of a great role model following Raphael and Annibale Carracci. But the myth of Cousin fell on fertile ground elsewhere, more secretly, in the science of the great century's *"curieux"* collectors, which was completely different from that of the historiographers. Cousin's name was decidedly in vogue among amateurs of drawings, as one finds it inscribed on numerous sheets in eighteenth-century script. Sales catalogues also attest to the interest that he elicited (whether these attributions were correct is of little import for us at the moment). Dézailler d'Argenville, whose notice on the artist is otherwise nothing but an impoverished version of Félibien's, echoed this new curiosity:

His drawings, which are so sought-after, are outlined in pen, and washed with bistre or Indian blue, with some spare crosshatching in pen. Despite the correctness of his drawing, the expression of his heads, and the imitation of Parmigianino, and of the old masters, Jean Cousin acquired a very dry manner, with a certain Gothic taste, which will always make it possible to set him apart from the other masters of his day.[12]

In this peremptory fashion of characterizing a graphic style without mentioning a single example, one sees the science of the *"curieux"* emerge in the totalizing discourse of historians. On the other hand, the representatives of two dying arts who had felt the need to record traditions and stories of their craft—Pierre Le Vieil for stained glass and J. M. Papillon for woodcut—did contribute to the enhancement of the legend surrounding Cousin. With limited success, Papillon attempted to revive the art of woodcut, which had been sorely neglected

231

since the end of the sixteenth century and also made an attempt to sum up all his professional knowledge.[13] Although this excellent practitioner was able to set out the processes quite precisely, he did not show much talent as a historian and I am afraid Firmin-Didot greatly exaggerated the authority of the "traditions" which he received in his family. Still he zeroed in on Jean Cousin as a major figure, probably following in this regard what was then being said among bibliophiles. He went so far as to claim that "almost all the illustrations of the books printed in Paris during the reigns of Henri II, Charles IX, and Henri III are of his drawings or wood engraved in woodblocks by him." Papillon was in fact convinced that Jean Cousin had not only drawn for publishers, but that he himself had manned the woodcutter's knife. His attributions are capricious and his knowledge of the works very uneven.

The heir to a dynasty of stained-glass painters, Pierre Le Vieil, who occupies in that craft a place comparable to that of Papillon in woodcut, showed himself to be the better historian; his overview of the stained-glass art remains a beautiful exposé and a goldmine of technical information.[14] He also invested heavily in Cousin. Like Papillon, he claimed him for his own profession, not surprising since he had Félibien's authority for this. He assembled a considerable oeuvre for him. In addition to the windows already mentioned by Félibien, Le Vieil also attributed to him, among famous works partially preserved today, the monochromatic windows of the château of Anet and the windows of the Sainte Chapelle of Vincennes (figs. 239 and 240), which our artist would have painted "after the drawings of Luca Penni and Claude Baldouin."

Stained glass and woodcut, two "minor arts" from the classical point of view, had not known great developments in Italy but could lay claim to a glorious past in France.[15] We see the gradual flourishing of a theme established by Félibien: Cousin excelled prolifically in particularly French domains.

After the Revolution, the outburst of nationalism established Jean Cousin's fame on an entirely new scale. The chief artisan of his newfound glory was Alexandre Lenoir, the illustrious organizer of the Museum of French Monuments, the savior and martyr of national art. Louis Dimier certainly exaggerated when he wrote ironically in *Les Impostures*

de Lenoir: "Lenoir cherished Jean Cousin to the point of providing him with the works he was missing."[16] In fact, almost all of Lenoir's attributions had been proposed earlier, though in isolated instances. He grouped them together, backed them with his authority and, most importantly, he publicized them widely through his museum and publications, the audience of which greatly exceeded that of the specialized works of his predecessors.

Lenoir had brought together a large number of works at the convent of the Augustinians. It served in principle as a sculpture depot, but he also acquired other objects: stained-glass windows, enamels, and even a few paintings. The originality of this student of David, who was too busy and perhaps insufficiently gifted to make a real career as a painter, is undeniable, and his Museum of French Monuments held a completely pivotal place in the development of the museum as a cultural institution. Lenoir showed a particular devotion to Jean Cousin, which he expressed as early as 1797 in succinct and precise terms: "The French school was founded in 1540, and François I after having received the last breaths of Leonardo put his trust in Jean Cousin, the celebrated painter-sculptor and geometer. Jean Cousin was the founder of this immortal school that has since drawn the eyes of Europe."[17]

Lenoir brought to Augustins the famous tomb of Admiral Chabot, a masterpiece already attributed to Cousin, one recalls, by Félibien (fig. 279). He did not hesitate, furthermore, following Millin, to give him credit for the tomb of Louis de Brézé in the Rouen cathedral, a tomb he considered to be that of Jacques de Brézé, Louis's father (fig. 165). This provided the occasion for one of his most romantic of explanations. Jacques de Brézé did indeed stab his wife Charlotte, the illegitimate daughter of Charles VII and Agnès Sorel, and his huntsmaster Pierre La Vergne, having caught them in flagrante delicto. Lenoir recognized the lover in the tomb's *gisant*—Charlotte kneeling near the corpse of her lover—and facing her would be the little Louis de Brézé in the arms of a nurse. The horseman, lastly, would be "Jacques de Brézé, armed from head to toe, fleeing and abandoning his lands."[18] Lenoir also acquired the windows of the Sainte Chapelle of Vincennes, two of which were put on display in his museum. Finally, the attribution to our artist of a

bronze bust of François I—today in the Louvre—allowed him to associate the names of the greatest sovereign and the greatest artist.[19] It was to the rooms of Lenoir's museum that one went to learn to understand and to love Jean Cousin.

In a book highly admired at the time, *Trois siècles de la Peinture en France*, a work as disappointing for the poverty of its contents as for the weakness of its critical discourse, Gault de Saint Germain extols Cousin with a new rhetoric[20]: "Under the veneer of the Gothic," he writes, "the works of this great artist already give us a glimpse of the territorial qualities of the French genius, of this suppleness that renders one so adept at imitating grave and serious objects and which belies this frivolous character of which the entire nation has often been accused." With the notion of "territorial qualities," we can spot the beginning of a strictly nationalist discourse according to which artistic production is truly a product of the soil. But far from viewing his still "Gothic" aspect as that which was most profoundly French in Cousin, as would be done later, Gault, steeped as he was in neoclassicism, considered this particularity to lessen—if not entirely obscure—Cousin's national qualities; to his eyes, Cousin was truly French to the extent he was something of a Poussin, not to say a David, ahead of his time. Another critic of the beginning of the century, François Miel, explicitly established the Cousin-David connection: "Strength and simplicity, such are the predominant qualities of Jean Cousin; they characterize genius; they are shared by the founder of the school and its illustrious restorer."[21] In the neoclassical atmosphere, Cousin's prestige was even sustained by an Italian critic, the famous Conte Cicognara, who was an authority on sculpture. He had of course paid an attentive visit to Lenoir's museum and it was certainly there that he acquired such a high opinion of Jean Cousin, whom he viewed as the only Frenchman of the Renaissance capable of measuring up to the great Italians.[22] It is curious to see the reversal of French ideas in this foreigner's assessment. For him, Cousin would have been better served by working in marble rather than painting on glass; he would have made a much greater name for himself.

Ambroise Firmin-Didot was the first to bring all these efforts and enthusiasms together and write a full-fledged scholarly monograph. Heir to an illustrious family of printers and publishers to whom is owed the reform of typography in France, a great bibliophile and collector of prints, he endeavored in particular to bring together illustrated books and prints around Jean Cousin's name. Today it is easy to denigrate his *Étude sur Jean Cousin* (supplemented by an album of illustrations) and to view it merely as an absurd jumble of completely heterogeneous works.[23] Firmin-Didot was, however, knowledgeable and insightful, as is shown by his numerous astute parallels and especially by the manner in which he understood the reform of illustrated books in Paris. Yet he built his edifice on foundations that were too poorly established and, for lack of rigorous criteria, he was led to accept more or less all of his predecessors' attributions without being able to submit them critically to a principle of coherence. His book is a summation, but it is not a synthesis.

The Englishwoman Mrs. Mark Pattison drew lessons from it in *The Renaissance of Art in France*, a work long considered an authoritative account of the French Renaissance and which remains interesting to read. The image that she sketches of Cousin and his oeuvre is all the more forceful because she claims to submit her attributions to the screening of a severe critic and she lends to the nationalist French hypotheses the presumed impartiality of a foreign author.[24] An amazing woman, who played an important role in Victorian society, Mrs. Pattison, later known under the name Emilia Dilke, was for a long time the main spokesperson for French art in England.[25] She had a keen eye and sound judgment; she expressed herself with precision and vivacity. Impressively skilled, she knew how to combine in the same breath the details of erudition with broader views on the aesthetic value of art and its social engagement.

The construction of the book itself is significant. It is divided into two volumes; the first concerns architecture, sculpture, and painting—the fine arts in the traditional sense of the term; the second is dedicated to the "minor" arts (rather than "applied" arts, since these include printmaking). The name Jean Cousin appears as the subtitle of the first chapter of the second volume, which deals with stained glass. The most famous artist in France ("her most celebrated artist"), he is at

the turning point of Pattison's intellectual construction. Sculptor and painter, but also glazier and engraver, Cousin illustrates the unity of the plastic arts, precisely what the burgeoning Arts and Crafts movement was seeking to restore. Without being explicit, the book is thus not only a retrospective survey: it implies a deliberate engagement in contemporary debates and fights. Through this, Mrs. Pattison brings a new view to bear on Cousin and gives some sense to a collection of works that, in Firmin-Didot's compilation, produced only a jumbled impression. We will see that she retained the idea of an artist who intervened in very diverse domains. But the author's late Romanticism, à la Ruskin, prevented her from accepting anything as authentic artistic expression unless its execution was autographic and quasi-artisanal; Cousin is therefore presented as a practitioner of techniques that were, as we shall see, foreign to him.

Maurice Roy and Archival Documents

Art history took shape as a discipline in the nineteenth century and it was in Germany that the movement asserted itself the most forcefully. There, the meeting of an extremely powerful philosophical tradition with the new methods stemming from positivism was particularly productive.[26] In France, there were first-rate art critics—like Baudelaire or Gustave Planche—but there were no historians comparable to Schnaase and later Wickhoff, Riegl,

241. Jean Cousin the Elder (?), *Charity*, 1540–50 (?). Oil on wood, 38 ½ × 30 ⅓ in. (98 × 77 cm). Montpellier: Musée Fabre.

or Wölfflin to shape the great principles of art history, although there was an original school particularly attached to the study of archival documents. There was a reason for this particular direction of scholarship. Unlike in Italy or the Low Countries where the art of the fifteenth and sixteenth centuries—that is, the very origins of so-called modern art—had known early historians, such as Vasari or van Mander, France needed to reconstruct a history that had never been recorded on the basis of archival documents. It was this rupture with the past, already consummate in Félibien's day, that imposed particular conditions on historians of French art. The devastation of archives, which had been extensively destroyed or dispersed during the Revolution, rendered the task all the more difficult, but also more urgent. As for painting, the rarity of works and the extreme difficulty of connecting them to texts that had been retrieved led these historians to constitute a veritable history of art by means of documents. Philippe de Chennevières understood this clearly. "But, then," he wrote when founding the *Archives de l'art français*, "perhaps the same thing will happen for art history as did in the case of civil and political history: the work of the systematic historian will hardly be possible any longer because of its own immensity, and in the future the best, indeed the only history will be the collections of historical documents themselves."[27]

The German historians' methods, Wölfflin in particular, were criticized as potentially leading to a history of art without artists[28]; with Chennevières' "little chapel of documentaries," one could have

242. Jean Cousin the Younger, The *Last Judgment*, c. 1585. Oil on canvas, 57 × 56 in. (145 × 142 cm). Paris: Louvre.

envisaged the possibility of a history of art without artworks.

The most eminent figure of this documentary school was indisputably Léon de Laborde, who was particularly involved in the study of the French Renaissance. It was he who discovered and published most of the documents that still today form the foundation of our knowledge of Fontainebleau art, he who managed to distinguish François Clouet from his father Jean, and he as well who quite by chance discovered documents concerning the collaboration of Pierre Lescot and Jean Goujon at Saint Germain-l'Auxerrois. Bored while waiting in a ministry, his eyes fell on a binding of the *Journal des débats* made up of old parchments in which the precious document was hiding.

To Laborde's great disappointment, all the archival collections he went through in order to compose his *Renaissance des arts à la cour de France* were silent on Jean Cousin. He remained no less convinced, however, that Cousin had worked for the kings.[29] Republicans conversely

saw this absence as a manifestation of the artist's pride: if Laborde did not find him in the royal archives, it was because the great painter had never consented to work for the court.

Local scholars in Sens continued to search for traces of their hero. Without much success: one or two exhumed documents revealed only that Cousin had had a daughter—just enough to sustain the dreamers. Maurice Roy was one of them, a member of the higher administration and amateur archivist. "For more than twenty years," he recalled, "I have dedicated part of the leisure of my vacations to exploring the old notarized acts of Sens for various historical works" but without ever stumbling, alas, upon the hoped-for document concerning the great artist. Then one day in October 1907, he came across the name of Christine Rousseau, Jean Cousin's wife, in a notary's document. The document gave him not only the name of several Cousin children whose existence had

been previously unknown; it also referred to an act passed in a Parisian notary office. As luck would have it, the sixteenth-century archives of this office were still in existence, allowing Maurice Roy to discover a whole series of pieces that entirely reopened the study of Jean Cousin—or rather of the Jean Cousins, since these papers showed definitively that there had in fact been two distinct artists under the same name. One, who must have been born before 1500 (the exact date remains uncertain) and who died in 1560 or 1561; the other, his son, studied Latin in 1542 and died in 1594 or 1595.[30] It was therefore with understandable satisfaction that Maurice Roy began the paper he read before the Académie des inscriptions et belles-lettres on January 22, 1909, with the resounding phrase I have already quoted: "All that has been written, since the seventeenth century, on the biography of Jehan Cousin was almost nothing but a web of errors."

Jean Cousin and the "Primitives"

These spectacular discoveries did not, however, have quite the effect one might have expected: in fact, the glory of Jean Cousin was on the ebb. Dimier, in his important *French Painting in the Sixteenth Century* of 1904, had assigned him only a very modest place.[31] Reacting against the dithyrambic excesses of his predecessors and their uncontrolled attributions, he claimed to have restricted himself to what had been positively established. His conclusion is scathing: "His manner reveals a mediocre knowledge, a rather unrefined taste despite much application, and an imitation of Primaticcio, which compels us to include Jean Cousin among those with whom the school of Fontainebleau at last became a reality."[32]

In 1904, this passage had a distinctly polemical resonance. Jean Cousin had been the hero of nationalist historians. For them, to place him in the school of Fontainebleau, among Primaticcio's followers, was an abomination. Even among the nationalists themselves, Cousin had lost some of his prestige. Notably, Henri Bouchot, who organized the exhibition of French Primitives that took place precisely

in 1904 with immense success, showed little enthusiasm for Cousin. He figured in the exhibition, but with little fanfare. Taste had turned towards the fifteenth century, and the *Avignon Pieta*, revealed to the public at the exhibition and acquired by the Louvre in the same year, eclipsed *Eva prima Pandora* (fig. 238) as a national icon.

Cousin was crushed under the weight of his legend. Even to very favorably disposed eyes, the *Last Judgment* was not of sufficient merit to support the traditional comparison to Michelangelo (fig. 242). Furthermore, the nationalist discourse felt too overtly entangled within the contradiction between the so-called naïveté of a Jean Cousin still faithful to national Gothic traditions and the obviously Italianate mannerism of his most famous work.[33]

The estrangement also came from another direction. As Mrs. Pattison strongly emphasized, Jean Cousin's greatness was traditionally attached to stained glass. The decorative arts movement and the modernism of the end of the nineteenth century condemned the stained glass of the Renaissance. Far from being applauded as the apogee of that

branch of art as in Le Vieil, Renaissance stained glass was now despised as the decay of a craft that had betrayed its vocation: stained glass was by nature a mosaic of glass and in the sixteenth century it had allowed itself to become enslaved by painting. The glory of Cousin suffered terribly at the hands of this modernist aesthetic and French Renaissance stained glass still suffers today from the clichés that were in vogue at the turn of the century.

In sum, except for a few specialists nobody much cared about Maurice Roy's revelations.

The Dearth of Sixteenth-Century French Painting

Thanks to Maurice Roy's efforts and to several more recent discoveries, we are now familiar with a relatively large number of archival documents concerning the works of Jean Cousin the Elder. He furnished tapestry makers and embroiderers with cartoons. He executed painted cloths—that is to say, economical substitutions for tapestries. He certainly supplied drawings to glass painters. He was also entrusted with temporary decorations, ephemeral decorative paintings on the occasion of festivals or theatrical productions. Not a single document concerns painting in the strict sense—I mean easel painting or murals. Examining surviving works does not offer much more encouraging results. Since the famous *Last Judgment* indisputably goes back to Cousin the Younger, practically the only painting definitely by the elder Cousin's hand is the *Eva prima Pandora*, which remained in his family and may therefore have been painted for himself. The *Charity* in the Montpellier museum is attributed to him, though not without hesitation (fig. 241).[34] He may have been, rather than his son, the author of the *Sacrifice of Polyxena* (fig. 274). I see no other painting for which one can seriously consider giving him credit.

Thus we have a rather meager harvest as far as easel painting is concerned: no documentation of a commission, one single definite painting kept in the family and, at most, two possible attributions. Should destructions be held responsible?

This question extends beyond the particular case of Jean Cousin and concerns all French art of the Renaissance. Had there been an important pictorial production in France, comparable to that of Italy, Flanders, or Germany? This was the hypothesis of the promoters of the 1904 exhibition of French Primitives. According to them, if so few French paintings from before the seventeenth century were known, it was due to the carelessness with which they had been allowed to be destroyed or disappear. They believed that all sorts of French works would eventually reappear hidden under more prestigious foreign names. The effort at assembling fourteenth and fifteenth-century French painting orchestrated by Henri Bouchot was truly stunning. The exhibition was spectacular and immensely successful. With time, it is true, not everything remained France's: Belgium, for example, quickly reclaimed the Master of Flémalle as obviously a Flemish painter. On the other hand, little was added to the corpus established in 1904, and one could probably count on one hand the outstanding works that have been rediscovered since.

Furthermore, the geographic distribution of these fifteenth-century "French Primitives" is significant. The most important group of works came from Avignon and Provence, where the Italians had established a pictorial tradition during the era of the exiled Avignon popes. There was still a demand for painting in the fifteenth century, but one has the impression that it was not easily satisfied by local painters, so that Northern European masters—such as Enguerrand Quarton or later Josse Lieferinxe—came to settle in Provence. Picardy and the north of France came in second, but appears to have been an extension of the Flemish school. If Burgundy played an important role in the development of painting in the fifteenth century, it was because its dukes maintained close relations with Flanders, over which they reigned. After the departure of the court for the Low Countries, Dijon lost its role as a capital. In other regions, painting was almost completely absent. Jean Fouquet is the exception that confirms the rule. Though surely a very great artist, he seems

243. Nicolas d'Ypres, *Meeting of Saint Anne and Saint Joachim at the Golden Gate*, c. 1499. Oil on wood, 15 × 17 ¾ in. (38 × 45 cm). Carpentras: Musée Duplessis.

mainly to have been a miniaturist, making paintings only occasionally. At the end of the century, the only eminent French painter was Jean Hey, the Master of Moulins, in all likelihood a Fleming trained in the entourage of Hugo van der Goes.[35]

In the sixteenth century, the situation was even more disappointing. Portrait painting, as we saw in the preceding chapter, was certainly abundant. Consequently we have preserved a large number of examples, despite considerable losses and deliberate destructions (revolutionary zeal having targeted the portraits of aristocrats as well as religious paintings). It is true that French paintings, such as François Clouet's magnificent *Pierre Quthe*, were

for a long time hidden under the more flattering name of Holbein (fig. 199). But the patriotic ardor of several generations of scholars has sufficed to rectify most of these errors. In any case, studies have amply confirmed the tradition—confused but correct—which assigned a dominant role to the Clouets and Corneille de Lyon.[36] The relative abundance of portraiture can but throw into relief the dearth of painting in other genres.

A large exhibition organized at Marseilles and Avignon in 1987–88 allowed us to take stock of Provençal painting.[37] Up until around 1530, one finds quality works that are a continuation of fifteenth-century Provençal painting—hardly

abundant in comparison to the Italian or Flemish production of the same era—but nonetheless significant. If Josse Lieferinxe, who passed away in 1508, belonged to the fifteenth century, the career of Nicolas d'Ypres came largely under the sixteenth. Installed in Avignon from 1495 on, this artist from Paris clearly adopted the Provençal tradition; in particular in the *Meeting of Saint Anne and Saint Joachim* at the Carpentras museum, the face of Saint Anne still shows evidence of the aesthetic of Enguerrand Quarton through a sort of nervous dryness and the way in which volumes are constructed with large planes (fig. 243).

A few isolated works demonstrate the possibilities for renewal in the first quarter of the sixteenth century. The astonishing *Adoration of the Child* (Avignon, Petit Palais museum) of around 1515 has a fullness in its forms that approaches Italian classicism. As for the altarpiece of the Aix Parliament, kept in the church of the Holy Spirit, if it must indeed be dated to the years 1520–25, it is an extremely ambitious work (fig. 244). Not only are its dimensions imposing (the side panels are more than ten feet tall), but additionally the pictorial quality of certain sections reveals an art informed by the most progressive tendencies of the era, both in Italy and the Low Countries.[38]

After 1530, this production flagged and the promises of the first decades of the century were not kept. The principal painter during this period, if we are to believe the documents, was Simon de Châlons, to whom local nineteenth-century scholars attributed almost all the known paintings from this period in Provence and the Comtat, just as in Paris everything was attributed to Cousin. The exhibition that was held in Marseilles in 1987–88 allowed one to reconsider this question and the authors of the catalogue relieved the artist of several works, such as the two panels from the antechapel of the White Penitents of Avignon, which, although their style derives from his, are of an inferior quality and, besides, date to 1563, after the artist's death. The Grilhet family altarpiece, whose rather Northern European style differs from his, suffered the same fate. We have surely lost many works by this native of Champagne who was active in Provence for thirty years, but enough of them remain to allow us to judge his art.[39] Simon de Châlons was a maker of

244. Anonymous, *Altarpiece of the Parliament at Aix: The Nativity and the Adoration of the Magi* (interior of the left wing), 1520–25. Oil on wood, 123 ⅓ × 54 in. (313 × 137 cm). Aix-en-Provence: church of the Holy Spirit.

pious paintings. He collected a certain number of motifs from here and there in European art, which he assembled as best he could to compose an image. It has been suggested that prints played a large role in his artistic culture, but this does not entirely explain his repertoire. The paintings by Solario that he copied in 1543 (Rome, Borghese Gallery) had not been engraved. In *The Holy Kinship* (fig. 245), the best painting preserved, the cradle is taken from Giulio Romano's *Virgin with a Cat* with such precision that we are led to believe that the artist knew a painted version rather than a print.[40]

The little we know of his career is significant. In 1532, he was to be found in the studio of Henri Guigues, who died shortly thereafter. Simon married his widow and must have inherited his studio, according to what was a rather common scenario in the artisanal milieu. He worked assiduously for thirty years in his adopted country. One must also note that in Guigues's studio, he was in the company of a certain Laurent from Rotterdam—probably a passing Netherlandish Romanist, as was also Karsten van Limbos, a product of Marten van Heemskerk's studio though lacking in any great talent, who spent five years in the Comtat from 1537 on. It is indeed with the Romanists that Simon de Châlons had the most affinities, and his painting, absolutely foreign to the art of Fontainebleau, borrowed from Italy as well as from Northern Europe. Yet he did not belong to a pictorial tradition that would have allowed him to integrate the results of his looting. His painting was irreparably eclectic. His technique itself seems to vary in an unpredictable fashion. We are disconcerted by this production because, despite its appearances, despite the borrowings from Raphael or Dürer, it does not approach what one might call the high art of painting practiced in Italy even by a painter of no great genius like Girolamo Sisciolante da Sermonetta or in Flanders by Pieter Coek, whose studio produced numerous routine altarpieces. The concepts of coherence, personal style, and originality, which Vasari so brilliantly articulated and which were the spirit of this high painting, were absolutely foreign to Simon de Châlons. If he seemed to approach the painters of the Italian *maniera* when he cited Raphael, it was according to a totally different logic. The Italians resorted to borrowing in order to bring out artifice. He manipulated the expressive formulas that he arranged on his painting in a similar way to a preacher manipulating his formulary.

Is this to say that Simon de Châlons was totally lacking in talent? Not at all. There is something heroic in his attempt to appropriate the effects of high art; he had a sense of the ornamental organization of motifs on the surface of a painting; one notices the freshness of his observation in the details of the foreground, animals or objects. Certain passages show evidence of a true dexterity in execution, such as the Raphaelesque visage of the holy woman who holds the Crown of Thorns in the *Entombment* of Villeneuve-lès-Avignon (fig. 246). He clearly lacked Jean Duvet's genius or vehemence—a personality so powerful it gave life and coherence to the most heterogeneous material—but he did belong to the same culture. He practiced a vernacular art that borrowed its motifs liberally from high art, yet was unaware of its basic principles.

Simon de Châlons disappeared in 1562 and the next two decades seemed poorer still, perhaps because of the serious troubles caused by the religious conflicts raging in Provence as elsewhere. Then, at the end of the century, even if the quality of works was not very high, there was a noticeable increase in their quantity. In Provence, as in Paris, the seventeenth century was a great century for painting.[41]

The case of Provence is the best known today, but one could make observations along similar lines for other regions. In Burgundy, for example, and in the east of France, in the first third of the century, there were religious painters who continued the Northern European tradition, producing not very numerous but engaging works, even if they do seem awkward compared to Flemish or Italian productions. I am thinking of, among others, the altarpiece of the *Eucharist* in the Autun museum (fig. 248), or the side panels of the main altar of Bourg-en-Bresse (displaced today into a side chapel).[42] Nevertheless, after 1530, production flagged here as well. Few of these paintings survived and those that did are mostly so mediocre that one is hard put to even take them into account. A Dijon painter, Florent Despêches, warrants mention, especially since a certain number of prints—generally Fontainebleau

245. Simon de Châlons, The *Holy Kinship*, 1543. Oil on wood, 74 × 105 ½ in. (188 × 268 cm). Avignon: Musée Calvet.

school etchings—bear his signature, not as author but as collector.[43] Though this gives firsthand evidence of the type of documentation that a provincial artist could have had at hand, it nevertheless does not allow us to prejudge his own works. The Narbonne museum holds a triptych of the *Holy Family* signed by Florent Despêches. Without this signature, it could be taken for a third-rate Flemish work, and without the donor's costumes—which point to the era of Henri IV—it could easily be placed in the middle of the sixteenth century, whereas it was painted in or after 1600.[44]

In Picardy, painting production was sustained throughout the sixteenth century, though its quality fluctuated with the times. The series of the *Puits d'Amiens* (a set of pictures given yearly to the cathedral by a literary association) shows an art that did not change much. As for the middle of the century, Champagne was, after Provence and Picardy, the region where the most paintings have survived. Yet this number is minimal in comparison to sculpture,

of which we have innumerable works and artists whose fame was traditionally well established: Domenico del Barbiere, the Italian who passed through Fontainebleau, but also Jacques Julliot and François Gentil (see Chapter IX).

By canvassing the churches of other regions, we find, here and there, a few unpublished paintings from the sixteenth century,[45] but these are usually modest works, which suggest a small production of average quality probably spread throughout France. *The Adoration of the Magi* of 1539 (Angers), which was commissioned by Françoise Auvé, the abbess of Ronceray from 1529 to 1549, for the chief altar of her church, seems characteristic of this art (fig. 249). The overall conception derives ultimately from some *Adoration of the Magi* in the Low Countries, where this theme was immensely successful. The composition is simplified, the number of figures reduced to a minimum, the space flattened. Yet the painting, summary as it is, is not without its charm. The precision

241

246. Simon de Châlons, *Entombment*, 1552. Oil on wood, 68 × 68 in. (173 × 173 cm).
Villeneuve-lès-Avignon: Musée de la Chartreuse.

and brilliant color of the Flemish have been abandoned in favor of a more insistent graphic style and a range of somber tones dominated by dull browns and greens. The physiognomy of the Wise Man in the center of the composition has the charm of the small portraits of the court of François I. Such paintings, which could not possibly hold their own next to great Italian or Northern painting, were probably neglected, replaced on altars and destroyed in large numbers. This hypothesis would account for the many painters' names mentioned in municipal archives. Insofar as they did not rise above a high quality artisanal production, it is not surprising that their wares were destroyed and their names forgotten like those of the leatherworkers or locksmiths whose productions were perhaps of no less aesthetic value than insipid paintings. Even in the case of the famous Fontainebleau school, we have seen that quality paintings of French origin were hardly numerous. It is significant that at the end of his life, once settled in Paris, Luca Penni

primarily painted portraits and dedicated most of his efforts to drawing for engravers.

The Dintevilles clearly exercised a patronage to which several preserved paintings can be linked, most of which have been improperly attributed to Félix Chrestien.[46] The most active patron of the family must have been the bishop of Auxerre, François. A large altarpiece, owed to his generosity, is still on display in the Varzy church (fig. 247). It is probably the work of a passing Netherlandish artist. The large panel of *Moses and Aaron* (New York, Metropolitan Museum of Art), an imposing allegory of the Dinteville family, may be by the same artist. On the other hand, the panel of the *Stoning of Saint Steven*, in the Auxerre cathedral, is a more mediocre work, probably by a Frenchman. As for the *Deposition of Christ*, also in the Auxerre cathedral, it is probably the work of an Italian.[47] It is possible that an engraving of the *Stoning of Saint Steven* by Domenico del Barbiere, bearing the Dinteville arms on the saint's tunic,

242

247. Anonymous, *Altarpiece of Saint Eugenia* (left wing), 1535. Panel transferred to canvas and laid down on board, 54 ⅓ × 40 ½ in. (138 × 103 cm). Varzy: church of Saint Pierre-aux-liens.

248. Anonymous, *Altarpiece of the Eucharist*, 1515. Oil on wood, 79 × 165 in. (201 × 419 cm). Autun: Musée Rolin.

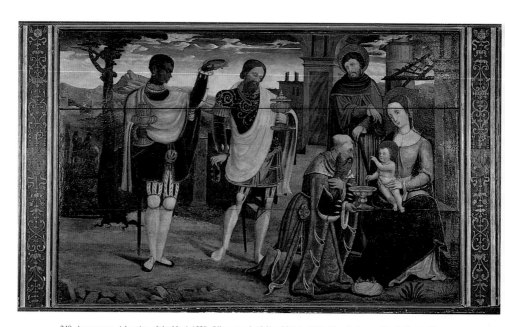

249. Anonymous, *Adoration of the Magi*, 1539. Oil on wood, 19 ¾ × 35 ½ in. (50 × 90 cm). Angers: Musée David d'Angers.

reflects a lost painting. Lastly, the most surprising and beautiful painting owed to the Dintevilles's patronage—besides Holbein's *Ambassadors*—is the exquisite *Descent into the Cellar* for which has been suggested, albeit quite timidly, the name of Jean de Gourmont (fig. 237).

It may be, however, that important destructions affected a particular category of mural painting, which one could call vernacular as opposed to high painting as it was practiced especially in Italy and the Low Countries. Such murals were particularly vulnerable because in all likelihood they did not seem worth preserving. Here and there one finds traces of a painting, which is not necessarily bad, awkward or deprived of inspiration, but which does not conform to the criteria of high painting. The famous *Danse Macabre* of La Chaise-Dieu—more a sort of mural drawing or monumental graffito than a fresco—possesses extraordinary verve and vigor (fig. 250). Technically, it can be linked to the curious decorations of the church of Saint Marcel (Indre) that must date to around 1530, large graffiti that do not seem to have been painted. Were these a particular type of work or were they meant to be painted over and left unfinished? Both answers are surprising. The secular decor preserved at the château of Rochechouart is even more disconcerting; the layout of the scenes in the Chambre des Chasses seems completely arbitrary. This poorly known vernacular art, which was closer to tapestry than to high painting, seems to have been the heir to medieval murals, which certainly played an important role. Was such art extensive during the Renaissance? It is impossible to say for lack of graphic or documentary traces. The best examples are generally those of the fifteenth century and the beginning of the sixteenth, after which one gets the impression that this traditional art lost its vigor and character.

All things considered, the total harvest of painting we know to have been made in France during the central decades of the sixteenth century is remarkably small. The hypothesis that lays the blame on destructions is fragile. Protestant iconoclasm did as much damage in the Low Countries as in France. There was no reason for the Revolution to go after the painting of the sixteenth century more than that of the seventeenth.

250. *Danse Macabre*, fifteenth century. Mural painting. La Chaise-Dieu: Saint Robert abbey.

Indeed were not stained-glass windows, which are quite fragile, broken in large numbers? Nevertheless many of them remain today. The archives of almost all French cities name a good number of painters—but were they busy producing easel paintings or murals? Judging from the contracts that we have, these painters were generally engaged in heraldic decorations, the painting of sculptures, and other tasks that do not exactly come under what we call painting. In short, despite known destructions, there is still a profound and fundamental difference between France and countries such as Italy, the Low Countries and Germany where a prolific and highly ambitious painting had gained great prestige.

Given these circumstances, we may be less surprised to find so few paintings associated with Jean Cousin's name, and must become accustomed to the idea of a painter who painted little. By examining the sources in this light, we begin to see a type of artist emerge that differs from that of the painter, such as the term is usually intended. Though Cousin did not paint much, his great prosperity, the important commissions he received,

the terms of his contracts, all point to a very busy figure of great renown. But Cousin was generally asked for projects—projects for tapestries or embroideries, for windows, and probably for all sorts of other objects, such as goldsmithing and armor. These projects could range from a simple drawing for a window—from which the glazier would then prepare the full-size model—to carefully finished tapestry cartoons. But even in the latter case, final execution eluded him and the particular aesthetic of each technique, its conventions and its physical properties, interposed themselves between Cousin and the final result of the commission.

It is therefore necessary to envision resituating Cousin's work in a context in which execution by the artist himself does not have the value it came to have in Italy during the Renaissance, and in which there are not the same expectations of integrity between making and thought, hand and eye. While it is true that Primaticcio himself hardly painted, especially after 1540, his relation to the execution of a work was all the same very different in that he was still responsible for it: even if he did not personally execute the frescoes, he was capable of doing so, he supervised the work and could make corrections as needed. His collaborators functioned as extensions of his own body thanks to the studio discipline introduced by Raphael in order to satisfy the ever-growing demand for manifestations of his "genius." However, the tapestry maker, glazier, or goldsmith possessed a skill to which an artist like Cousin could make no claim: their intervention was independent, they literally took the model home with them and, in their own studio, the work would enter a final phase of its elaboration beyond the reach of the painter's authority. It is true that Raphael produced tapestry cartoons and a few models for craftsmen, but these were exceptions in a career filled with paintings. In the case of Cousin, the proportions are inverted with major consequences.

The Works and Style of Jean Cousin the Elder

Such were the circumstances that account for the exceptional difficulty one encounters in assembling a body of works for our artist. There is no choice but to proceed in the usual fashion—that is, from the best-documented and most certain works, in order to make conjectures founded on formal analogies and circumstantial probabilities. Nevertheless, we will see that these methods are not very effective here.

What do we have in the way of reference points, works offering reliable guaranties of authenticity sufficient to serve as a point of departure? One painting, *Eva prima Pandora*, belonged to the artist's family up until the twentieth century and although its date is open to discussion, it is acknowledged to be by the father rather than the son. The first documented and dated work—and the one that offers the most complete guaranties— is a series of tapestries on the life of Saint Mamas; the cartoons were commissioned from Cousin in July 1543 and the weaving was probably finished in 1545. Three of these tapestries have survived.

We should also cite two undated engravings signed with his name that are considered to be works executed by Cousin the Elder himself (figs. 252 and 253). Four etchings that bear his initials were executed after his drawings, but not by him: two of them date respectively from 1544 and 1545 (figs. 254 and 251). Lastly are the illustrations of his *Livre de perspective*, which, according to the text of the book itself, Cousin drew directly on the woodblocks so that they could then be cut by specialists (fig. 255). Though not extensive, this harvest presents us with a heterogeneous group. The disparity consists especially in the nature of the objects that must be taken into account. Executed in various techniques, some of these works can be considered to be by his hand—*Eva prima Pandora*, for example—while others are interpretations that range from what is probably extremely faithful, in the case of the *Livre de perspective* (the engravers that cut into the wood seem to have scrupulously respected the draftsman's lines), to more important departures in the tapestries, whose

makers inevitably interpreted the models. We should also stress a stylistic disparity between the severe art of the tapestries (fig. 257) and the more sensual works. How is one to reconcile all this? Must one view the years that separate the production of the tapestries (1543–45) and the publication of the *Livre de perspective* (1560) as an evolution in the artist's style? Is it possible, from these few works, to define an artistic personality with enough precision to allow one to extend the circle of attributions?

At the two extremes, so to speak, of this group, may be placed the two works that offer the most definite guaranties—the Saint Mamas tapestries on one side, the illustrations of the *Livre de perspective* on the other, especially the large plate representing a landscape with antique ruins. The tapestries are rather austere in appearance, despite the decorative richness of the draperies and antique

251. Master N.H., *Goldsmith's model*, after Jean Cousin the Elder, 1545. Etching, 9 ¼ × 6 ⅔ in. (23.5 × 16.8 cm). Paris: Bibliothèque Nationale de France, Ed 8.

252. Jean Cousin the Elder, The *Annunciation*, c. 1544. Engraving, 5 × 7 ¾ in. (13.1 × 19.7 cm). New York: Metropolitan Museum of Art.

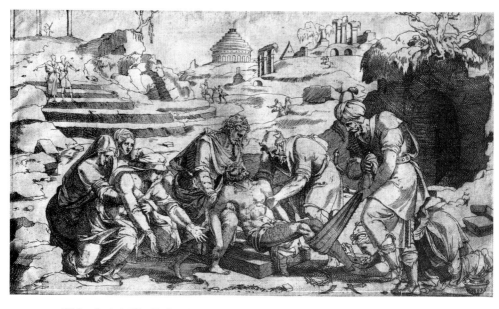

253. Jean Cousin the Elder, The *Entombment*, c. 1544. Engraving, 6 ⅔ × 11 ¾ in. (16.8 × 29.7 cm). Vienna: Albertina.

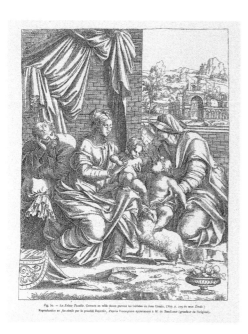

254. Anonymous, The *Holy Family*, 1544. Dujardin facsimile of a lost etching, from A. Firmin-Didot, *Oeuvres choisies de Jean Cousin*, Paris 1873.

architecture. The gracious art of the plate from the *Livre de perspective* seems radically different. Although the dimensions are rather reduced, the figures are quite typical: the plump children with curly hair, the woman in right profile, whose hairstyle is as elaborate as the drape of her costume; even the small male figures have a characteristic aspect, "*bien d'aplomb*" (meaning steady or well-balanced, the expression is Renouvier's), which is found in the better documented works. Of course, it is difficult to compare a book illustration to a tapestry. Nevertheless, as they are the most secure points of references, we are forced to situate the rest in relation to them.

The two signed engravings fit rather well with the Saint Mamas tapestries. The *Annunciation* in particular was conceived in a monumental fashion despite its small format. Nevertheless, the artist was not at ease in these engravings: their rudimentary technique creates the impression of a lack of know-how rather than an economy of means. Other prints that were executed not by Cousin himself but after his drawings allow us to fill out our image of him slightly more. One of these, a *Holy Family*, is unfortunately known only through the

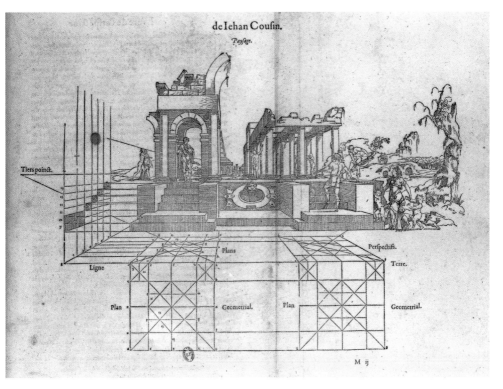

255. Jean Cousin the Elder, *Landscape*, foldout illustration from the *Livre de perspective*, Paris, Jean Le Royer, 1560. Paris: Bibliothèque Nationale de France, rés. gr V.246.

reproduction published by Firmin-Didot.[48] The inscription I. C. INVENTOR 1544 ensures that Cousin was indeed the author of the composition (fig. 254). The execution is difficult to judge from the reproduction, but it was obviously made by an etcher of the Fontainebleau group, perhaps Jean Mignon. The type of figure offers a complete resemblance to those in Cousin's engravings. This indication is invaluable because it confirms that the engravings were indeed by Jean Cousin the Elder and encourages us to date them to around 1544.

Three etchings signed with two monograms, N.H. and I.C., reveal a new aspect of Cousin's art. Furthermore, one of these, technically the most accomplished of the three, bears the date 1545 (fig. 251). Herbet described it as a "small mausoleum," but it should be viewed instead as a decorative object, perhaps a table centerpiece.[49]

IEHAN COVSIN AV LECTEVR.

256. Jean Cousin, *Decorative band*, from the *Livre de perspective*, Paris, Jean Le Royer, 1560. Paris: Bibliothèque Nationale de France, rés. gr V.246.

Another piece in the same genre, undated but certainly from a closely neighboring period, represents a sort of salver (fig. 258).[50] The execution is very fine and gives the impression that the etcher has remained very faithful to the graphic style of the original drawing. These inventions show astonishing ornamental verve, a repertoire of original motifs, an exceptional skillfulness in the linking of these motifs, with a life that pervades the plastic concept and animates all its details—in short, the mark of a first rate master. But is the name of Jean Cousin, which Herbet did not retain in his catalogue, appropriate here? To be sure that we are dealing with the same artist, suffice it to compare our etchings with the ornaments in the *Livre de perspective*, published fifteen years later (fig. 256). We find in both exactly the same peculiar and rare motif of satyrs with long floppy ears falling onto their shoulders. This is not the only thing; the satyrs' very particular anatomy—their dynamically rhythmic bodies, with accentuated muscles, well-turned legs, finely tapered extremities, shoulders rounded in a very specific way—is also that of the male figures of the frontispiece; the number of morphological similarities leaves hardly any doubts.

Another etching bearing the same monograms is in a slightly different genre. It represents *Deucalion*

258. Master N.H., *Small salver*, after Jean Cousin the Elder, c. 1545. Etching, 9 ½ × 6 ⅔ in. (24 × 16.8 cm). Amsterdam: Rijksmuseum.

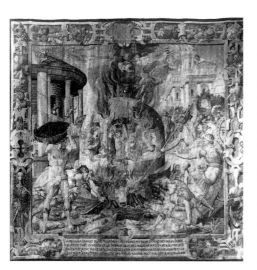

257. The *Martyrdom of Saint Mamas*, after Jean Cousin the Elder, 1544–45. Tapestry, 171 ⅓ × 187 in. (435 × 475 cm approx.). Langres: Saint Mammès cathedral

and Pyrrha busy repopulating the earth after the flood by throwing stones behind themselves, stones that turn respectively into men and women, (fig. 259). Cousin found his inspiration for the format in the cartouches with landscapes of Fantuzzi and the Master I♀V, but he handles it differently as he has other concerns. In the Fontainebleau examples, it was the cartouche that counted first and foremost; the landscape without a narrative subject was only filler. Cousin's efforts were brought to bear not so much on the ornamental frame, which is elegant but somber, as on the integration of a narrative subject into a landscape. The protagonists are in the foreground but do not stand out against a backdrop. The groups of secondary figures and the motifs of the landscape are subtly fitted to insure the continuity and complexity of the imaginary space.

It remains to situate *Eva prima Pandora*, the only reliable evidence of Cousin's activity as a painter (fig. 238). The painting has suffered; it has

259. Master N.H., *Deucalion and Pyrrha*, after Jean Cousin the Elder, c. 1544–45. Etching, 6 ½ × 22 in. (16.5 × 22 cm).
Paris: Bibliothèque Nationale de France.

been abraded, damaged, and the darker parts are no longer legible, but it remains nonetheless impressive. It is a work of high painting from any viewpoint: in terms of the pictorial tradition in which it is inscribed, that of the large humanistic nude, or the sophisticated theme and the numerous references with which it plays.[51] The pictorial handling, the treatment by means of large patches of contrasted values, the panoramic landscape animated with antique ruins, all bring Cousin close to the painting of Netherlandish Romanists and more specifically of Jan van Scorel's circle. However, he had a more austere feeling, was more faithful to Italian models and above all else had a powerful simplicity in his conceptions, a geometry of the body, the proportions of which are precisely defined through a very clear articulation of anatomy. Other distinctive traits of Cousin—his taste for straight profiles, landscapes with drooping vegetation, certain particularities of anatomy,

the configuration of drapery, found in the works that we have listed as the most indisputably his— all reappear in *Eva Prima Pandora*. This is an ambitious painting, by a painter who was well versed in various trends of European art, but who still retained a very personal character.

The painting is difficult to date. If one believes that it was partly inspired by Cellini's *Nymph*, it could not have been prior to around 1543.[52] More significant is its connection with one of the decorations for Henri II's entrance into Paris in 1549. On display before the Châtelet was a "spectacle of flat painting" that represented a portico of the Ionic order with a woman kneeling in the center whom an inscription designated as *Lutetia nova Pandora* (fig. 262). Jean Cousin was among the artists who prepared the decorations for the festival, which was, as Gébelin has stressed, a veritable manifesto of classicizing art in Paris.[53] Could Cousin have been the author of this decoration?

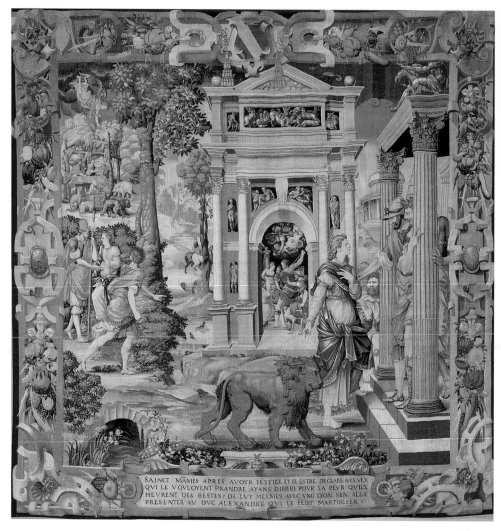

260. *Saint Mamas Surrendering to the Governor of Cappadocia*, after Jean Cousin the Elder, 1544–45.
Tapestry, 173 ¼ × 177 ¼ in. (440 × 450 cm). Paris: Louvre.

The illustrations of a booklet published on the occasion are insufficient as a basis for judgment, but certain details noted in the description are revealing. The text specifies that "the bases and the capitols represent bronze according to the manner of several antiques" and this relatively unusual feature is one of the more triking traits of the superb architectural decor of the tapestry of *Saint Mamas Surrendering to the Governor of Cappadocia* (fig. 260). Lutetia had "her hair spread over her shoulders, and also braided around her head, in a wonderfully graceful fashion"—striking in his confirmed works is Cousin's predilection for very elaborately arranged hair. These are but slight clues, yet enough to suggest that, of the two principal painters employed in the decorations, Cousin rather than Charles Dorigny was probably in charge of this piece.

261. Jean Cousin, *Frontispiece* from the *Livre de perspective*,
Paris, Jean Le Royer, 1560.
Paris: Bibliothèque Nationale de France, rés. gr V.246.

262. *Ionic portico with Lutetia nova Pandora*, from the booklet
for the triumphal entry of Henri II to Paris, 1549.
Paris: Bibliothèque Nationale de France, rés. Lb31.

The connection between these two new
Pandoras is obvious, not only because of the
theme, but also the motif of the title inscribed on
a tablet above the figure. Having said this, in what
order did the two works appear? I would suggest
that the panel followed the festival decoration. In
the case of festival decorations, in which the polit-
ical stakes were capital, the iconographic program
was not left to the discretion of the artists and, in
this specific case, was assigned to Jean Martin,
Vitruvius's translator. The idea of Eve being an
early Pandora, in a humanist adaptation of the old
Christian typology, today seems more expected
than for Lutetia. But the Panofskys showed that
the theme of *Roma prima Pandora* already existed
with the idea of a non-evil Pandora. Obviously,
the step from this to a *Lutetia prima Pandora* is
easily taken. It is not impossible that Jean Martin
had been inspired by a preexisting Cousin paint-
ing, nor even that the painter might have chosen

to suggest a humanistic theme, but it is more likely
that the humanist first prescribed the theme for
Henri II's entrance, and that *Eva* followed *Lutetia*.

Be that as it may, the juxtaposition of the two
themes is critical as a guide to interpretation and
encourages us not to look for overly negative asso-
ciations in the painting from the Louvre. It is obvi-
ous that the festival decoration, paid for by the
Parisians, would not have slandered Lutetia; more-
over, the booklet assures us that she "appears to
open with one of her hands an antique vase filled
only with all the happy gifts of the celestial pow-
ers, not misfortunes" If Eve was indeed a first
Pandora, one must not forget that the Virgin her-
self was thought of as the new Eve. It is the role
of woman that is suggested by the Eve-Pandora-
Mary association. Cousin's idea was not only
novel (how many representations are there of Eve
outside of a Biblical narrative context?) but also
audacious: to associate Eve with the mythological
nude is to situate her in a pantheon in which one
meets above all Venus. If it seems that Titian's
Venus of Urbino might have inspired Clouet, it is

253

certain that the figure of Giorgione's *Sleeping Venus*, inaccessible and pure, was also known in France, since Davent made an etching of it.[54] Cousin's Eve is not at all immodest; turned in profile, her gaze does not invite the viewer, and the two vases are quite closed. Good, evil, all is potential here: if her sin brought us death—the very emblem of which serves as her armrest—Eve as Pandora also presides over all civilization, heralded by the luminous vision beyond the cavern.

Problems of Attribution

Such is the starting point for our knowledge of Jean Cousin: on the one hand, we have at our disposal a painting that reveals that he had the talent of a great painter and the technical ability to realize his pictorial vision. On the other, this painting remains unique and all the evidence leads us to believe that the bulk of his production lay elsewhere, in works, like the Saint Mamas tapestry, executed by specialists in techniques to which Cousin himself was a stranger.

Two avenues are open to pursue this inquiry. One is the study of the drawings. Indeed, drawing was a necessary stage in Cousin's enterprises, the more or less unavoidable intermediary between his inventions and their realization by those who executed them. This aspect of our study is well within the habits of modern art history, which is so often obsessed with autographic execution as the surest revelation of artistic personality.

The attribution of works of art that are not documented and whose authenticity is not guaranteed by extrinsic qualities—what is called connoisseurship—is founded on rather uncertain postulates. We like to believe that there are set characteristics specific to an author that can be found in all his authentic works, at least in those executed by his hand. The science of connoisseurs is, de facto, very closely linked to graphology, another "science" (of the identification of handwriting) that, despite its legal status, is far from being unanimously recognized as such. The hypothesis of a sort of drive, a distinctive individual rhythm, is attractive. Modern biology encourages this view somewhat since it has established the existence of a biological code transmitted by cells that guarantees the identity of each individual throughout his/her existence despite the total renewal of his/her constituent particles. The history of art unfortunately has yet to reach this point and we do not have at our disposal a tool with which one could identify the scattered fragments of an artist's production. Whatever our theoretical hypotheses are, in practice, we proceed by slight, successive shifts in a game of similarities and differences. In short, we reason in a fashion that resembles caricaturist Charles Philipon's exposé in the celebrated drawing in which he moves by successive stages from the portrait of Louis-Philippe to the image of a pear. How can we decide if the similarity between two works is sufficient to conclude that the author is the same? Where should we draw the line? The problem is difficult enough in the case of autographic works where graphological criteria, despite their dubious status, are all the same very useful. Drawing is in principle the domain in which these criteria can be applied most effectively; but even there, for lack of a well-determined test like that of the biologists, the frequency of reference points that punctuate a career—that is to say works whose authenticity is established on external evidence—necessarily plays an important role; for the elder Cousin, we have only one drawing that is more or less certain. Without a neat conception of the parameters of his stylistic evolution, we lay ourselves open to an uncontrolled flow of attributions.

Another possibility consists in searching for what remains of the artist in the final product after those who execute the work have intervened. We are then obliged to define his manner less by a graphic style, or special technique, than by a repertoire of forms and motifs, types, compositional habits. This approach, perhaps more perilous, is better adapted to the conditions of production under which Cousin operated. Indeed, these particular conditions, which today complicate the work of the modern connoisseur, certainly

affected the artist's attitude towards his production and the way it was received by his contemporaries. The success of his art required that there be a Cousin style, a distinctive "look," to speak the language of contemporary design, independent of individual technique. Thus, Cousin was certainly an ornamentalist of the first order using a personal repertoire recognized and appreciated as such. Yet his very success exposed him to imitation, which poses the difficult and perhaps unsolvable problem of discriminating between his own work and his sphere of influence.

The acknowledged, dated works of Jean Cousin all belong, with the exception of the *Livre de perspective*, to the years 1543–45. One is struck by the diversity, not to say the disparity of character that they present despite this chronological proximity. I do not think that this should be viewed as evidence of a very rapid stylistic evolution, but as the effect of a particular attention given to genre and the destinations of works. Cousin treats a luxury object, like the goldsmith project engraved by the Master N.H., in a completely different fashion from a religious tapestry like the Saint Mamas hanging. This sense of function, this sensitivity to exterior pressures and demands, compromised the stylistic and expressive coherence that we expect of an artist, in particular a painter. In this way, too, Cousin's art runs counter to our habits. I will attempt in the pages that follow to delimit Cousin's artistic physiognomy by sketching a body of his works in the different domains in which he applied his talent, but it is in the next chapter that we will examine the fashion in which he may have intervened in the production of tapestries, stained-glass windows, and armor, in connection with a whole range of craftsmen who appealed to his inventiveness in order to enrich their own repertory.

Let us begin with painting, which he practiced at least occasionally. One painting offers rather striking similarities with what is known of Cousin, such that one could seriously consider attributing it to him: the Montpellier museum's *Charity* (fig. 241). The conception of the nude, the dark vegetation silhouetted against a light background, the composition by means of juxtaposed surfaces, the rectilinear profile, all push for this attribution. On the other hand, the drawing seems a little weak, the forms thin in comparison with those of *Eva prima Pandora*. Besides, the painting is very abraded and what we see may be largely underpaint originally covered with glazes. We are left undecided; indisputably, it belongs to Cousin's following, but is it by him? It may also be the work of the younger Cousin, or another collaborator (for example, one finds Cousin associated in a commission for painted cloths with a certain Loys du Brueil of whom we know nothing).

Let us continue with the prints. Certain engravings that bear either Cousin's full name or his monogram are crucial, as we have already seen, for us to get an idea of his manner. It is possible to extend this evidence a little beyond the few pieces thus signed. I have already mentioned that the technique of the two engravings signed Jean Cousin showed an unconventional use of the burin, which leads us to believe that he executed them himself. This idiosyncratic technique has allowed us to see his hand in two other sheets: the *Conversion of Saint Paul*, a composition which is ambitious but whose execution is more awkward than that of the signed engravings and, consequently, can be considered earlier; and an allegorical figure, a *Nude Man Holding a Oar*, which is on the contrary the most accomplished of these plates.

To the group of etchings monogrammed I.C. and N.H. one can without hesitation add *Jupiter and Antiope* (fig. 263). The technique is identical and the satyr Jupiter with his disproportionate ears is the exact replica of those described earlier; as for Antiope, she is a close relative of Eve, as well as of the women with whom Pyrrha repopulates the earth. This humorous invention breaks abruptly with the tradition, which always represents Antiope lying down or even asleep, as in Correggio. One senses in this remarkable composition a sort of underlying violence contained by a sophisticated elegance that is equal to the Italian *maniera* at its best.

Other etchers may have borrowed from Jean Cousin's compositions. In the oeuvre of the Master I♀V, for instance, one sheet contrasts with the other prints for the correctness and precision of its drawing: it shows a small nude horseman in a landscape of ruins, a sort of variation on the theme of the equestrian statue of Marcus Aurelius (fig. 265). The exact significance of the subject

263. Master N.H., *Jupiter and Antiope*, after Jean Cousin the Elder,
c. 1545. Etching, 7 ¼ × 4 ¾ in. (18.4 × 12.1 cm).
Paris: Bibliothèque Nationale de France, Bd 19.

264. Maître IℓV (?), *Vulcan's Forge*, after Jean Cousin the Elder,
c. 1545. Etching. Paris, private collection.

escapes us and its strangeness only accentuates
the poetry that emerges from this antique fantasy.
The type of landscape and the anatomy of the fig-
ure coincide perfectly with Cousin's manner.[55]
The Master IℓV was perhaps also the author of an
unpublished *Vulcan's Forge* (fig. 264), the inven-
tion of which evidently goes back to the same
draftsman as the *Nude Horseman*. The figure of
Vulcan on the left looks exactly like the horse-
man whose position would have been changed
slightly, and the ornamental frame displays
Cousin's characteristic motifs. Let us bring to a
halt, for the moment at least, this exercise which
risks falling into gratuitous speculation.

265. Master IℓV, *Nude Horseman*, after Jean Cousin the Elder, c. 1545.
Etching, 8 × 6 in. (20.2 × 15.1 cm).
Paris: Bibliothèque Nationale de France, Ed 13b.

Like Father, Like Son? The Question of the Drawings

If Jean Cousin made only a few paintings, he certainly drew a great deal since all his projects were necessarily elaborated and transmitted through drawings. Common sense suggests this and archival documents confirm it. It would be surprising if none of these drawings survived, but can they be identified? Until now, not a single original drawing has been found for the compositions of Jean Cousin the Elder that I have mentioned as being the most certain. Fortunately, at least one sheet can be assigned to him with quasi-certainty (fig. 266). Not only does this large and beautiful pen and wash drawing present all the characteristics that we have recognized in Cousin—the types, landscape motifs, organization

of space—but also the subject, the *Martyrdom of Saint Mamas*, is sufficiently rare to lead us to suppose that this drawing belongs to the preparation of the Cardinal of Givry's tapestries, even if the composition does not appear in the three surviving pieces.[56] Furthermore, when one compares the kneeling saint in the foreground of the drawing to that found in the background of the tapestry in which the saint preaches to the animals, there are only a few slight variations. The sureness of the hand, the complete spontaneity of the line, all point to an original by the artist himself. With the aid of this example and the general idea we have of Cousin's art, it must be possible to find other drawings. Several sheets have been successively

266. Jean Cousin the Elder, *Martyrdom of Saint Mamas*, 1543 (?). Pen and ink wash, 10 ⅔ × 13 ½ in. (27 × 34.5 cm).
Paris: Bibliothèque Nationale de France.

put forth that come close enough to the drawing of Saint Mamas to credit them convincingly to Cousin: a charming composition of the *Virgin and Child with Saint John and Saint Luke* (fig. 267),[57] two projects for stained-glass windows—the *Crucifixion* and *Saint Francis and Saint Jerome* which will be discussed in the next chapter (figs. 291 and 290). From attribution to attribution, where are we headed?

Before we proceed any further on this slippery ground, another problem must be confronted, that of Jean Cousin the Younger. We know that he was a student in Paris in 1542 and that he died around 1594. It seems that he practiced almost the same activities as his father, whose studio he probably inherited; like his father, he continued to maintain close ties with the city of Sens. In the case of the son, like that of the father, only a few disparate works constitute the rather uncertain basis for the study of his art. The Louvre's

267. Jean Cousin the Elder, *Virgin and Child with Saint John and Saint Luke*, 1540–60. Pen and ink wash, 14 ¼ × 11 ⅔ in. (36.1 × 29.5 cm). Paris: Louvre.

268. Jean Cousin the Younger, *Fortune, Love, Time, and Place* and *Fortune and Favor*, from the *Livre de Fortune*, 1568. Paris: Bibliothèque de l'Institut.

269. Jean Cousin the Elder (?), *Children playing among Ruins*, c. 1545–50. Black chalk and pen, 6 ¼ × 9 ¼ in. (15.9 × 23.4 cm). London: British Museum.

270. Anonymous, *Children playing among Ruins*, c. 1550. Etching, 6 × 9 in. (15.5 × 23.3 cm). Paris: Bibliothèque Nationale de France, Ed 8b rés.

271. Jean Cousin the Elder, or the Younger (?), *Children playing among Ruins*, 1540–70.
Brown ink and brown wash, 16 ¼ × 23 in. (41.1 × 58 cm). Paris: Louvre.

Last Judgment (fig. 242), engraved on a large scale as early as 1615 by Pieter de Jode, has always remained a celebrated work, partially responsible, because of its subject, for the name often attached to Cousin, the French Michelangelo. Although disappointing and lacking in character, this painting is saved mainly by the elegance of its execution, which can still be appreciated in its best-preserved parts, and for the charm of its lively and sophisticated palette as revealed by recent restoration; nothing could be further from the simple and classically grand art of *Eva*. A *Vulcan's Forge* engraved by Léonard Gautier presents an academic conception of the nude and a lack of personal accent for which the engraver is only partially responsible. The same impression, or almost, is given by the younger Cousin's *Livre de pourtraicture*, a drawing manual published by Jean Leclerc in 1595, the success of which continued into the twentieth century.[58]

One might believe from all this that dividing up the works between father and son would be rather easy. However, this is where things become more complicated, because the foundation of the drawn oeuvre of Jean Cousin the Younger such as we understand it today does not rest so much on these painted or engraved realizations as on the drawings of a handwritten book of emblems entitled *Livre de Fortune* (fig. 268). The title page is dated 1568, though we do not know exactly what this date refers to. The author of the emblems, Imbert d'Anlezy, tells us that he did not draw the images himself but that he handsomely paid the artist who executed them, thereby making them his own. The author does not name this artist, but there is no reason to doubt the name of Jean Cousin, inscribed on the title page; not only does the same page bear the date 1568, but furthermore the costumes from the era of Charles IX that can be recognized in several drawings precludes the

272. Jean Cousin the Elder (?), *Pan and Syrinx*, c. 1545–60. Pen with mauve wash, traces of black chalk, 7 ⅔ × 7 ⅔ in. (19.4 × 19.5 cm). Paris: Louvre.

father as the draftsman; it can only have been the work of the younger Cousin.

On the basis of this collection, Otto Benesch made the first grouping of drawings in an article that marked a milestone.[59] Since then, a good number of drawings have come to enlarge the oeuvre, but as the body of works increased, doubt set in. In particular, it became clear that a whole series of landscapes etched by Léon Davent and another anonymous etcher had very close links to Cousin. The discovery of an original drawing for one of these prints confirmed this impression (figs. 269 and 270). But the prints were probably earlier than 1560 and one might wonder about the son's intervention. Another large and superb drawing in the Louvre representing children at play among antique ruins

has given historians pause for thought (fig. 271). First considered to be the son's work, it was then given to the father. This is Sylvie Béguin's opinion in the catalogue of the School of Fontainebleau exhibition in 1972, while retaining for the son the *Pan and Syrinx* (also in the Louvre) which Benesch himself had already attributed to him, two drawings that seem to me to display a very similar technique (fig. 272). In short, to decide between father and son is not so easy after all, and Benesch's construction needs to be entirely reconsidered.

More recently, George Wanklyn introduced a crucial element by showing that a beautiful drawing with watercolor inventoried at the École des Beaux-Arts under the name of Cousin the Younger, through analogy with the drawings assembled by

273. Jean Cousin the Elder, *Project for the Gift to Henri II from the City of Paris*, 1549. Pen and ink wash, India ink with watercolor on vellum, 12 × 8 in. (30.2 × 20.1 cm). Paris: École Nationale supérieure des Beaux-Arts.

Benesch, was the project for a piece of goldsmithing offered to Henri II on the occasion of his entrance into Paris in 1549 (fig. 273).[60] At that date and for a commission of such importance, there is every reason to assume—as does Wanklyn—that we are dealing here with a work by the father.

Through a chain reaction, another question crops up. Étienne Delaune engraved two compositions that bear the name of Jean Cousin, a *Conversion of Saint Paul* and in particular a large plate—the largest he ever signed—of the *Bronze Serpent* (fig. 275). Maurice Roy, followed by most authors, assumed that one should see in these the mark of Jean Cousin the Younger.[61] But is this quite so sure? Unfortunately, the chronology of Delaune's oeuvre being totally uncertain, it does

not help to provide a reliable answer. Only a very few of his engravings are dated. He was born in 1518; in 1546, at his father's death, he was a journeyman goldsmith. He may have begun engraving well before 1560. It should be noted that his prints after Cousin are atypical in his oeuvre. They come closest to two plates that are unsigned but were surely engraved by Delaune after Rosso. They may very well date to the beginning of his activity as an engraver. And if these plates are earlier than 1560, they are as likely to reproduce the conceptions of the father as those of the son. It is quite difficult to settle the argument.

It seems obvious to me, on the other hand, that the artist who conceived the *Bronze Serpent* was also the author of the *Sacrifice of Polyxena*, an important painting that remains more or less

unpublished (fig. 274). Here we find the same conception of space, the same types, and the same costumes. The execution of the painting is of a high standard. A few other works make up, with these two precedents, a homogenous group. I will mention in particular an etching preserved, probably correctly, under the name of Androuet du Cerceau and which represents the birth of Adonis (fig. 276). We find in it the repertoire which is now familiar to us: curly-haired children, women with elaborate coiffures, men with rhythmic muscles, and trees with weeping foliage. The subject is treated with a certain sense of tragedy, as is suggested by Ovid's text, which insists—though with humor—on the painful aspect of the birth. These works exude a slightly exotic poetry, different from the grandiose simplicity of *Eva*. Was Jean Cousin the Younger, whose

274. Jean Cousin the Elder or the Younger, *Sacrifice of Polyxena*, c. 1560 (?). Oil on wood, 43 ⅓ × 53 in. (110 × 134.5 cm). Private collection.

275. Étienne Delaune, The *Bronze Serpent*, after Jean Cousin the Elder or the Younger, c. 1560 (?). Engraving, 11 ¼ × 15 ½ in. (28.6 × 39.3 cm). London: British Museum.

276. Jacques Androuet du Cerceau (?), The *Birth of Adonis*, 1545–50 (?). Etching, 7 ⅝ × 11 in. (18.8 × 28 cm). Private collection.

emblems of Fortune have a slightly trivial charm, capable of this more intense expression? I would suggest, though with the greatest circumspection, that these exceptional works belong to the father.

We should insist on one point: we can only at best formulate hypotheses, and quite fragile ones, at that. Works that can reasonably serve as reference points are very rare; they are very different from one another in genre; lastly, we know very little about the circles that either Cousin moved in. In the case of Raphael, one manages more successfully to delimit a body of work because the prominent figures in his entourage—Giulio Romano, Polidoro, and Perino del Vaga—are rather clearly defined today. We know nothing of the artists of the Cousins' group. As for Jean Cousin the Younger, he probably carried on his father's manner. Did he not publish at the very end of his life a *Livre de pourtraicture* that his father had announced as early as 1560 in his *Livre de perspective*? Was the son's publication a completely independent work, or did it make use of material that the elder Cousin had passed on to him thirty-five years before? As if the distinction between father and son was not thorny enough, one must also take into account other artists, collaborators, emulators, or imitators who might have exploited the same formulas. Thus one passes imperceptibly from a few autographic works to others that probably reflect the Cousin style only from a distance.

The Cousin Genre?

Jean Cousin does not belong to the type of artist to which the Italian Renaissance and the supremacy of painting in recent centuries have accustomed us. Although he certainly made paintings, this was not his primary activity. He was a thoroughly multi-faceted artist. Early on one sees him serving as an expert geometer and drawing up property limits for a legal dispute. He repaired and painted a statue, brushed in decorations for theaters and festivals and created all sorts of projects for tapestry makers, glaziers, goldsmiths, and armorers.

This range of activities was not without precedent in France. In the previous generation, Jean Perréal may well have been an artist of this kind—more a provider of models than a painter. That one experiences such extreme difficulty when attempting to rediscover the production of a painter this famous is an argument in favor of this position. Around 1500, an artist whose identity is unknown and who has been baptized the Master of Anne of Brittany had a very diversified activity, as one recognizes his manner in the admirable tapestries of the *Unicorn Hunt* (New York, Metropolitan Museum of Art) as well as in the illustrations of printed books of hours, the miniatures of manuscripts, and stained-glass windows such as the large rose window of the Sainte Chapelle in Paris. And in the middle of the fifteenth century, Henri de Vulcop, who furnished cartoons for a stunning hanging on the history of Troy, was probably in a somewhat similar situation.[62]

With this in mind, to apply oneself exclusively to defining the personal oeuvre of Jean Cousin, either father or son, risks blinding oneself to the originality of the conditions of artistic production in sixteenth-century France. It is appropriate instead to envision a stylistic field—what may somewhat loosely be called the Cousin genre— just as one speaks generically of the school of Fontainebleau. It would comprise the exploitation, sometimes sophisticated, sometimes almost popular, of Jean Cousin's inventions. This art had a considerable proliferation and a great longevity, as one still finds traces of it in the picture Bibles that Jean Leclerc printed far into the seventeenth century (fig. 323).

This hypothesis will be the guiding thread in the following chapter where we shall trace the marks that Jean Cousin may have left on artistic productions by furnishing suggestions to various artistic professions. The purpose is not only to discover what is hidden behind a famous name and to restore an artistic physiognomy—however attractive—but also better to weigh the importance of the various professional groups in the system of art operative in sixteenth-century France.

277. *Altar cloth*, mid-sixteenth century. Embroidery, 11 ⅔ × 10 ¼ in. (29.5 × 26.1 cm). Écouen: Musée national de la Renaissance.

Chapter VIII

JEAN COUSIN AND THE ARTISTIC

PROFESSIONS

Without relinquishing his base in Sens, where he continued to maintain a residence, Jean Cousin went to live in Paris around 1538 or 1539. He prospered and became a bourgeois of the city, establishing close relationships with many artisans in the capital. Two of his sons-in-law were armorers in Paris, one of whom was also related by marriage to Jean Le Royer, the bookseller who later published Cousin's *Livre de perspective*. His third son-in-law was a locksmith, and yet another, Barbe Cousin's husband Élie Lincre, was a goldsmith merchant (*marchand orfèvre*). In 1566, Lincre was living in Nuremberg, and had a Parisian colleague represent him in a matter of family inheritance. Archival documents outline a complex web of relationships and their professional consequences essential to an understanding of Cousin's situation. The different crafts with which he was associated by family relationships sometimes required "pourtraicts" for important commissions—that is, drawn models of the project that demanded the skill of a painter. Cousin's family relationships could be the cause, as well as the result, of professional engagements. This intermingling of private and professional life characterizes Cousin's participation in the artisanal society of the capital.

Paris had a highly protectionist structure of professions, the opposite of liberal policies practiced in cities like Lyon, which was an accessible, European city, eager to attract foreigners. The status of different crafts in Paris is well documented, and their transformation can be traced to as early as 1268, when Étienne Boileau, provost of Paris, assembled his *Livre des Métiers*.[1] The trade organizations were intent on maintaining their independence from centralized power and fiercely defended their prerogatives against incursions by other professions into their spheres of activity. The many conflicts between the goldsmiths and *merciers* (haberdashers) are a perfect example. The goldsmiths' guild was extremely powerful, and much envied; it was also closely monitored by the king's men because of its handling of precious metals, especially gold as coinage, was at stake. In the sixteenth century, goldsmiths were placed under the supervision of the masters of the mint, representatives of the king to whom they were obliged to swear an oath of fealty. This constituted an infringement upon the principle of independence so important to the guilds. The goldsmiths would have liked to control not only the creation, but also the commerce of all objects made from precious metals. But the *merciers*, who were merchants in the strictest sense—their name comes from the Latin, *mercator,* meaning "merchant"—sold all kinds of luxury items, including grooming accessories which were often partly gold or silver. Numerous conflicts ensued, resulting in highly detailed rulings specifying the domain of each group. The *merciers* succeeded in guaranteeing some of their privileges, but in doing so, found themselves under the supervision of the mint.

In addition to the guilds, there were the so-called liberal professions, among them new crafts such as printmakers. Since they were not incorporated, access to the practice was open to all. While occasionally found in documents from the period, the title *maître graveur* (master engraver) was merely an expression of status with no legal significance.[2] The primary function of guilds was to guarantee the competence of their members by defining the conditions of apprenticeship and the requirements for the status of master—length of

apprenticeship, completion of a "masterpiece," etc. The system made it possible to limit the number of masters and so restrict competition. Some of the large trade organizations in Paris encouraged a dynastic recruitment, favoring sons of masters, who were sometimes exempt from some of the requirements such as the masterpiece, and could undertake their apprenticeship in the family establishment without any formal arrangements. This was the case for the goldsmiths, who furthermore obtained from Henri II the right to limit the number of masters to three hundred (at least in principle). Under the circumstances, access to master status became exceedingly difficult for anyone outside the profession. The glaziers' guild, on the other hand, attained official status only in 1447, and remained very open, even during the economic slowdown in the second half of the sixteenth century, a fact suggesting exceptional prosperity. For the strictly regulated professions, the system demanded that there be few apprentices and many journeymen, a poorly protected class of artisans. It also provoked a large amount of unlicensed work, often performed by foreign artisans whom the Parisian masters exploited.

There were also specialties within guilds, and occasionally a group would seek to become independent, lodging a request with the provost to be incorporated on their own. However, such efforts had their risks. The advantage to be gained was a protection of the specialty from infringement by other members of their initial organization, but it also prohibited members from practicing any other aspect of their original craft. For this reason, in spite of increasing specialization in the sixteenth century, stained glass painters remained part of the glazier corporation, thus allowing a veritable artist like Nicolas Beaurain to install ordinary windows as well. It is interesting to note that painters and sculptors never parted company. They probably had too many common interests. Examining the documents published by Ms. Grodecki, it appears that a great deal of the painting commissioned between 1540 and 1580 involved the application of color to sculpture.[3] Painters in France did not have the same outlets as those in Flanders or Italy. As for the sculptors, while their position was perhaps more favorable, it was in their interest to preserve the option of painting their work themselves, as polychrome sculpture remained the rule rather than the exception.

Within the context of these extremely powerful professional organizations, Jean Cousin, a painter, was able to carve out a place for himself as supplier of artists' models. Naturally, the situation had significant implications as to the effects of his participation. He was asked to provide designs for a wide variety of productions, allowing his art to extend to almost every aspect of the visual environment. However, the execution of these projects was entrusted to members of other professions over whom he had no authority. This contrasts with the practice in place at the great workshops of Italian artists, where the master's inventions were realized under his direct supervision. The resulting effects are necessarily different, more diffuse, and more difficult to grasp.

Was Jean Cousin a Sculptor? Dead Stones Do Tell Tales . . .

As early as the late sixteenth century, Jacques Taveau claimed that: "Besides this [painting], he [Cousin] was competent in marble sculpture, as testifies the monument to the late Admiral Chabot in the chapel of Orléans at the Celestins monastery in Paris, which he carved and installed, which work shows the excellence of the workman."[4] Félibien says the same thing, "As he worked well in Sculpture, he made the tomb of Admiral Chabot, which is at the Celestins in Paris, in the Orléans chapel."[5] The tradition maintaining that Jean Cousin was a great sculptor has rarely been questioned. It was a particularly important one for Alexandre Lenoir, who was a passionate admirer of the artist and whose establishment had been created specifically as a museum of sculpture. But in spite of his enthusiasm, and a relaxed historical method, he never succeeded in associating a significant number of

278. Anonymous, *Funerary statue of Admiral Chabot:
The Figure of the Admiral*, 1545–60 (?), Alabaster. Paris: Louvre.

sculptures to the name of Jean Cousin, leading him
to the touching explanation that:

> Jean Cousin, as a sculptor, was a rival of
> Jean Goujon, with whom he became friends,
> and for whom he had a respect governed by
> this noble sentiment. Jean Cousin, regarded as
> a sculptor, had a less elegant style, and less
> finesse as a practitioner than did the sophisti-
> cated author of the *fontaine des Innocens*
> [sic]. He accepted, without jealousy, the supe-
> riority of his contemporary in this art which
> he passionately loved; modest as well as wise,
> he undertook very little sculpture, devoting
> himself primarily to painting on glass, and
> thus rendered even more scarce the sculptures
> we have by his hand.[6]

In spite of its persistence, the tradition was
never very sound. It is likely that Félibien him-
self merely repeated the testimony of Taveau,
gathered in Sens. In Paris, Sauval observed that
in his time connoisseurs wondered about the

author of Chabot's monument: "Perlan attributes
it to Maître Ponce; Sarrazin disagrees. All concur
that its sensibility is forceful and magnificent."[7]
Regarding Cousin, not a word; everything rests
on Taveau's testimony, which is the oldest by
many years and must be taken seriously. It is dif-
ficult, however, to it accept without question. Not
only was Sauval generally well informed, but the
execution of a work like the statue of Chabot also
implies considerable experience with statuary.
Was Cousin really a sculptor? To complicate
matters even more, there was also another Jean
Cousin in Paris during the 1540s who *was* a
sculptor. He obtained a commission for several
statues from the Celestins monastery before
dying, probably quite young, in or around 1549.[8]
The coincidence of the two names has promoted
confusion, even among recent scholars.[9]

It is certainly possible that Jean Cousin occa-
sionally practiced sculpture. The fact that he
repaired a statue of the Virgin in his youth tells us
next to nothing, but a document dated August 4,
1545, refers to him as a *"maistre painctre et
tailleur d'ymaiges"* (a master painter and carver of
images).[10] The latter term usually designates a
sculptor, but not always, as the name *"tailleur
d'images"* or *"tailleur d'histoires"* (image or story
carver) was occasionally used at the time for wood-
cut engraving, another technique Cousin might
have practiced. Perhaps the reference is no more
than a legal designation indicating his membership
in the guild of sculptors and painters. Whatever its
meaning, this evidence is completely isolated; Jean
Cousin's name does not appear on a single one of
the many sculpture contracts in the notarial
archives of Paris. Early authors did not attribute
any works of sculpture other than Chabot's tomb to
him. If Jean Cousin did practice the art, he must
have done so very sporadically.

Since the monument to Chabot can only be
the work of an accomplished sculptor, Mon-
taiglon and Courajod dismissed Cousin as lack-
ing the mastery for a piece of such magnitude.
Maurice Roy adopted their opinion and sug-
gested attributing the statue to Pierre Bontemps,
who had experience with this kind of work. In
order to integrate Taveau's statement, he pro-
posed that the admiral's statue and the heraldic

269

279. Anonymous, *Tomb of Admiral Chabot* (remaining elements), shortly after 1543. Alabaster. Paris: Louvre.
The overall project for the monument was by Jean Cousin the Elder, but the execution remains anonymous,
though the effigy has been attributed to Pierre Bontemps.

lion, sculpted by Pierre Bontemps, were erected in 1565, and that the remainder of the monument was the work of Jean Cousin the Younger around 1570–72.[11]

The hypothesis has become generally accepted, but with variations and hesitations. In the school of Fontainebleau exhibition of 1972, Jacques Thirion ascribed the funerary genies to Jean Cousin the Younger. He left open, however, the possibility that the father might have been involved and asked the decisive question: "Should one grant Cousin the Elder the title of sculptor, or see him only as the author of the monument's design?" Michèle Beaulieu appropriates the question, but applies it to the son. She retains the broad lines of Roy's argument but ascribes only the design of the ornamental portions of the tomb to Jean Cousin the Younger, keeping Bontemps as the author of the statue.[12]

Let us turn now to the monument itself. It was dismantled after the Revolution, but the Louvre possesses the statue of the reclining admiral—it had always been a highly admired piece of

sculpture—two angels bearing torches, a personification of Fortune, and finally, a lion that remained for a long time at the École des Beaux-Arts, and found its way back to the foot of the statue thanks to the efforts of Courajod (fig. 281). Trustworthy visual records have made it possible to understand how these pieces fitted within the original composition: a large oval cartouche inscribed in a square frame. The oval opened into a cavity, inside of which the statue of the deceased reclined on top of his sarcophagus. In order to fit the space, the sarcophagus, unfortunately never recovered, was an elongated oval raised up on lions' paws, its feet resting on a curious element with rolled extremities like those of Fontainebleau strapwork.[13] Between this little platform and the underside of the sarcophagus was tucked the statue of Fortune with her broken wheel. A large, classicizing frame contained the oval,[14] and was itself surrounded by a rich ornamental composition where the genies carrying inverted torches stood on consoles decorated with the head and paws of a lion. Anchors laced

with banderols occupied the spandrels. Centered on the upper frame, Chabot's coat of arms was surmounted by a crested helm, while a second pair of funerary genies perched on top of the frame to either side. The artist skillfully combined the profusion of ornament with a multiplication of heraldic and funereal symbols. He also made brilliant use of the contrasting black marble and white stone.

One must insist on the peculiar, even bizarre character of this unprecedented arrangement. Though many tombs were destroyed during the Revolution, we have a record, thanks to Roger de Gaignières, of a large number of these lost monuments.[15] Wall tombs figure prominently and frequently employed the arcosolium—a hollow recess in the wall, generally enriched with a decor of architectural sculpture ranging from the dour to the extravagant. The most striking thing about Chabot's monument is that it resembles absolutely none of them. Even Louis de Brézé's

281. Primaticcio, *Mantel of the Queen's Bedchamber*, 1534–37. Stucco and fresco. Fontainebleau: château.

TOMBEAU *de marbre contre le mur a droite dans la Chapelle d'Orleans aux Celestins de Paris .*

280. *Tomb of Admiral Chabot*, anonymous drawing, seventeenth century. Paris: Bibliothèque Nationale de France, Gaignières collection, Pe 11.

tomb, while highly innovative, recalls certain aspects of previous designs. The admiral's, on the other hand, appears to be the pure fantasy of an ornamental designer, an artist used to working on paper, and little concerned with the customs or conventions that generally weigh so heavily on funerary art. It would be hard to imagine a sculptor acting this way, whereas an artist like Jean Cousin could certainly have come up with the project. Nonetheless, to fit the statement by Taveau, it must have been Jean Cousin the Elder who designed the tomb. Since Taveau was writing in Sens, at a time when Cousin the Younger was still alive or recently deceased, he must have known they were two different artists, and his remarks pertain clearly to the father, whose date of death he gives as 1560. The issue is then to determine when the monument as a whole was designed.

Admiral Chabot, a great statesman, died in 1543. He had been disgraced in 1541, but was soon rehabilitated, and his relatives obtained permission from François I to bury him in the chapel

of Orléans at the Celestins monastery, based on his relationship by marriage to the illustrious family. It is utterly unlikely that a funerary statue was commissioned before there had been an approved project for the whole monument. Of course, the project may have been modified, but there is no particular reason to believe that this was the case. The oval shape of the sarcophagus—unprecedented to my knowledge—is justified only by the peculiar shape of the monument. Since the statue was obviously intended to rest on top of the sarcophagus, it seems logical to assume that the design for the final project was complete before the work began.

For reasons I will not go into at length, scholars have maintained that the ornamental portions of the tomb suggest a later project, not long before the monument's installation in 1565. It seems to me that, on the contrary, the composition is more readily comprehensible as a much earlier design. Turning away from the dismembered sculptural elements, which could have been executed later, and focusing on the general design of the monument as it appears in a drawing from the Gaignières collection or the engraving published by Millin, there is a striking resemblance between this composition and ornamentation at Fontainebleau. For example, the idea of an ornate frame, while disconcerting in a tomb, was almost universal in the decoration at Fontainebleau around 1540. There is even a close parallel between the Chabot monument and the fireplace in the Queen's bedchamber (fig. 281)—rather a baffling comparison perhaps, but I have found no more convincing example among the drawings of the decor at Fontainebleau. This adaptation of a fireplace to the composition of a funerary monument is a far cry from the decorum generally presiding over the creation of a tomb. It is easier to understand in the context of widespread enthusiasm for the new art, when the Fontainebleau style was fresh and exciting, than to accept it as coming ten or twenty years later. Additionally, it would be surprising if the family, and more specifically the admiral's widow, did not make arrangements for building a monument in the prestigious Orléans chapel as quickly as possible after the king granted permission to do so. Cousin would not have been a terribly surprising choice of artist, considering that in the year of Chabot's death, he was working for the widow's uncle: the powerful Cardinal de Givry. We have also seen elsewhere that Cousin was in touch with print makers from Fontainebleau around 1544. Every indication suggests that the project was planned shortly after the admiral's death.

Construction of the tomb, on the other hand, appears to have stretched over many years. Was Bontemps actually the one to carve the statue of the admiral? It is not easy to determine, though there is no dearth of work by the artist. The funerary statue of Charles de Maigny is a well-documented work by Bontemps, and as it is also in the Louvre, makes an excellent point of comparison (fig. 405). Chabot's statue is suppler, more at ease in its pose than is Maigny's, but this difference could be attributed to Jean Cousin's participation in the project. Judging from the actual execution alone, the two statues may well have been created by the same person, though the details are better integrated in the Chabot figure. Our difficulty derives not from a shortage of documented work by Bontemps, but from our complete lack of information about other sculptors of comparable reputation. The famous master Ponce Jacquiot survives in name only. Laurent Renaudin and Simon Leroy, employed by Lescot at Saint Germain-l'Auxerrois, and the Lheureux brothers who worked at the Louvre: these and many others practiced funerary sculpture with great distinction, yet we have no idea what their works looked like. Nothing rules out the presumption that one of these men carved the Chabot statue. As for the funerary genies from the frame, their execution is somewhat mannered and they are probably by a different hand. Might it be that of the second Cousin? Since there is no reason to believe that the son was a sculptor any more than his father, such an attribution is unfounded—not even Taveau's text supports it.

Jean Cousin's role in the creation of the Chabot tomb is the same as that played by Jean Perréal at Nantes (see pp. 38-39). In Cousin's case, his contribution is all the more noticeable because of its greater eccentricity. Nevertheless, it is difficult to know how detailed his project actually was. The Chabot statue has a powerful

rhythm; its treatment lends the figure greater expressivity than others of its kind, such as Guillaume du Bellay's funerary statue at the cathedral of Le Mans. It is not impossible that Cousin's inspiration was influential in this magnificent effigy. Another project for which Cousin was almost certainly responsible is the more modest monument of Philippe Hodoart at Sens cathedral.[16]

Dating from 1552, it is a simple epitaph framed by a large cartouche whose ornamentation is straight from Cousin's repertoire. There is, of course, no reason to believe that Cousin carved the sculpture himself, but in this instance where only ornament is concerned, design is more important than stonework, and his artistry transcends the skillful but uninspired execution.

Tapestry

The comfort and splendor of French interior decor depended in large part on the art of textile. From the many cushions and pillows necessitated by rudimentary furniture to great woven murals, every aspect received careful attention. In wealthy homes, and even in churches, tapestries occupied a large portion of the space devoted to frescoes in Italy. In a frequently quoted passage, Philibert de l'Orme asserted there was no point in creating elaborate architectural decoration around the interior doorframes of rooms, because it would be hidden by the wall hangings. The same would be doubly true of painting on the walls. As seen in Chapter IV, the impact of the Fontainebleau mural paintings was strictly limited, and one must imagine the halls of French châteaux almost completely blanketed in tapestries, except in summer, when cooler leather wall hangings might replace them. Occasionally, embroidery work was substituted for tapestry—a minor variation.

The inventories of great houses list hundreds of wall hangings—the wherewithal to cover vast surfaces. One advantage of tapestry was the possibility of updating the decor without destroying it. Old or decaying hangings were carefully repaired and preserved, and used in private apartments and lesser rooms, while the new and most sumptuous were displayed in the halls of state or reserved for grand occasions. The tradition of tapestry as monumental art had a long history in France. The *Apocalypse* wall hangings, woven around 1377–80 for Duke Louis I d'Anjou and later bequeathed by King René to the cathedral of Angers, are a reminder of these great figural ensembles that rivaled their Italian frescoed counterparts.

Embroidery was much admired, but was reserved primarily for smaller objects: cushions, soft furnishings for the bed (canopies and curtains), and of course, clothing, especially church vestments, which were adorned not only with ornamental designs, but also with figures and narrative scenes. Occasionally, a whole room might be completely fitted with embroidery, including the wall decoration. As in tapestry, the use of rare silks and gold or silver threads made these accessories extremely costly. Wall coverings of painted cloth ("*toiles peintes*") on the other hand, were a less expensive alternative to weaving. To judge from the documentary evidence, they seem to have been used largely for decorating churches.

Many tapestries were imported from Flanders. The weavers of Tournai, Brussels, and Arras had a great reputation throughout Europe, so much so that in Italy the word *arrazi*—weaving from Arras—became a generic term. The Brussels workshops specialized in a low-warp tapestry,[17] enabling them to make especially faithful reproductions of the cartoons. However, France was by no means excluded from the art of tapestry. First of all, textiles woven in the Netherlands could be executed from French models. Raphael and his assistants painted cartoons for the wall hangings of the Sistine chapel; though the design was put to the loom in Brussels, no one would consider the result a work of Flemish art. Likewise, the famous *Unicorn Hunt* may have been woven in Flanders, but it is generally accepted today that the design came from a Parisian workshop. Second, there were many textile looms in France, and archival records prove beyond a

282. The *Unicorn Defends itself*, from the *Unicorn Hunt* tapestry cycle, c. 1500. 145 × 158 in. (368 × 401 cm). New York: Metropolitan Museum of Art.

doubt that Parisian weavers were both plentiful and powerful. The documents provide a vibrant portrait of their activities, with tapestry merchants acting like capitalists on a small scale, investing in, and profiting from the labor of journeymen or less fortunate masters who were obliged to work for them.

The most interesting question is where the models for the textiles came from. A tapestry merchant would have had a reserve of ready-made cartoons he could use either for pieces of average quality to put on the market, or to suggest a range of models for clients who wished to have a custom-woven piece, or a whole series.

A copy of an existing piece could also be requested. However, larger commissions—given that in sixteenth-century France, tapestry was on a par with painting as an art—demanded an original model executed by a painter.

It has often been claimed that the Renaissance betrayed, or even killed, the aesthetic peculiar to tapestry, reducing the art to merely woven painting. This erroneous belief has distracted attention from a major aspect of French Renaissance art. It is correct to say that a tendency to imitate the effects of painting in woven material emerged, but it was principally a feature of the looms in Brussels. Even there, actual woven tableaux were the

283. *Life of Saint Rémi*, 1520–30. Tapestry, 210 ⅔ × 210 ⅔ in. (535 × 535 cm). Rheims: church of Saint-Rémi.

exception rather than the rule, although production began as early as the fifteenth century. In France, this kind of virtuosity was restricted to the Fontainebleau hangings, and as we saw previously (see Chapter II, pp. 94–95) it is a mistake to consider them as straightforward reproductions. On the contrary, their creation entailed a complex interplay of the woven appearance and the effects of painting and stucco. In any case, they were thoroughly exceptional, and tapestry in France remained essentially faithful to customary methods of composition and spatial organization, which were very different from those of Renaissance painting. This is not to say that the Renaissance

had no effect on tapestry. Dating from about 1500, the *Unicorn Hunt* (New York, Metropolitan Museum of Art, fig. 282) does not exactly belong to the medieval period. But this is not the result of a few Italianate motifs timidly making their appearance; instead it derives from a new sense of physical reality, of the spectacle of the world, corresponding to what we may call the Northern Renaissance (see Chapter I). Reims possesses two tapestry cycles characteristic of the early 1500s and completed around 1530; one depicts the *Life of the Virgin*, the other *Life of Saint Rémi* (fig. 283). Each panel represents several episodes, separated by architectural elements that combine Flamboyant

forms with Italianate motifs. The divisions distinguish and articulate the episodes without compartmentalizing the scenes, whose three-dimensional space remains fluid and unsystematic, subordinated to narrative requirements. The artist makes no attempt at creating a coherent fiction like that of Italian painting; the nature of the medium precludes it, as the visible texture and flexibility produce a strong tactile effect independent of the representation. The image is not *on* the textile, but *in* it. A continuity of surface and material prevents the borders in a tapestry from framing a central composition in the manner of so-called illusionist painting—thus the Renaissance metaphor of painting as a window or mirror fails to exert its full power. Jean Cousin, attracted though he was to Italian art, could hardly have escaped these intrinsic conditions.

On July 14, 1543, "Jehan Cousin" signed a contract with the "Reverendissime cardinal de Givry," for tapestry cartoons.[18] The work in question was to be a series of eight wall hangings representing the life of Saint Mamas, for the cathedral of Saint Mammès in Langres, where the cardinal was bishop. A commission of this scale could only be the product of extensive negotiations, and work was clearly underway already, since the painter agreed to "execute the said Patterns according to a small paper project that has been made, which has been signed by the notaries listed below, [and] which has remained in the possession of the aforementioned Cousin." Few such legally signed drawings from the sixteenth century have survived, but they were a common feature of contracts at the time. In this case, since there was a single sheet, we may assume that the drawing showed the ensemble, both in order to establish the relationship of borders to composition, and to settle the placement of the heraldry. This last feature, always of paramount importance, was in fact subjected to changes not reflected in the documents. The contract calls for three escutcheons with the arms of his Most Reverent Lordship: the tapestries have only one, centered at the top. Minor accommodations like these could be arranged by mutual agreement between the two parties.

The contract does not specify precise subjects, stating only that Cousin should depict "the life of Saint Mamès according to the legend and description of Saint Mamès that has been handed to him." The painter was entrusted with a life of the saint, possibly an extract from the *Légende dorée*, rather than a specific list of scenes prepared for the series. This element presumes great confidence on the part of the cardinal as to his choice of artist, and for Cousin, considerable freedom. It is unlikely, however, that he had a completely free hand. Again, there were probably additional instructions outside of the contract, or, in the absence of such directives, later consultations. The document specifies that the cardinal was present for the signing, not always the case for a man of his exalted station. He probably had a personal agreement with the artist covering many points not listed in the contract.

The painter was given a year to finish the work, but was to submit the first three cartoons within three months, probably so that weaving could begin as soon as possible. However, the contract with the tapestry masters was signed only in January of the next year (1544), at which point they received a single cartoon, suggesting that the two others had not been not finished on time. Similar delays appear to have been the rule rather than the exception. The two hundred *écus* Cousin received for these cartoons made a handsome sum, though considerably less than the cost of making the tapestries, which amounted to six hundred forty *écus*. Weaving was a major endeavor that involved considerable expenditure for supplies, paid for by the tapestry merchant.

The weaver's contract provided for the wool and silk to be used. Since the colors of the silk are not mentioned explicitly they were probably blue, yellow, and green. Like gold and silver thread, all other colors were specified, sometimes even furnished separately by the client. All eight pieces were to be ready within sixteen months, not an unusual length of time. As was often the case in such contracts, a standard of quality was established by comparison, in this case a tapestry of "fantasies and devices" belonging to a lawyer, which the tapestry merchant Blacé showed to the cardinal—perhaps a work awaiting delivery.

This particular contract contained one rather unusual clause. The tapestry makers "are enjoined

to preserve and keep as well as they can," the cartoons by Cousin, "and in the end return them to the aforementioned Most Reverent Lord." Why this clause? Does it express an admiration for Cousin's handiwork? Was it so that the series could be woven anew should it prove necessary? Or, on the contrary, could it have been to prevent the tapestry merchant from using the models to make copies. The second and third hypotheses seem unlikely: the cult of Saint Mamas was uncommon, and there was little hope of finding other buyers for a cycle of tapestries devoted to him. Whatever the reason, the cardinal seems to have attached a great deal of significance to the ownership of these cartoons since the contract with Cousin already stipulates that the "models will remain with, and belong to the said Most Reverent Lord."

Another contract signed by Jean Cousin for tapestry design has completely different clauses. On January 6, 1541, the confraternity of Saint Geneviève commissioned three tapestry models representing the life of the saint.[19] They were part of a series of eight, one of which was already woven, while four were postponed. Unlike the cardinal's models, these were not painted on paper, but on cloth as was usual. The contract specifies that Cousin would reclaim them once the tapestry had been executed. He was to be paid forty *livres* for each cartoon, but would reimburse fifteen *livres* each when the models were returned to him. It is difficult to know what to make of this seemingly exceptional arrangement. Were the cartoons to serve for further weaving? I believe it more likely that Cousin intended to sell them as *toiles peintes*. There was probably little difference between a tapestry model painted in distemper on cloth and a painted cloth hanging. Cousin also produced this type of work, which we will address in more detail later.

Embroidery was not as important as tapestry, but could still result in sizable commissions, and Cousin did provide models for embroiderers. During the thirteenth and fourteenth centuries, the English dominated this kind of work; their astonishing creations were prized throughout Europe, and certain pieces number among the most impressive works of art from the period. By the sixteenth century, however, Parisian embroidery

was reputed the best. In 1550, Cousin was commissioned the models of a fully embroidered bedchamber for the duchess of Nevers.[20] It consisted of twelve sections, each with five subjects framed by grotesques, plus the canopy and side hangings of the bed. The first model was to be painted with distemper cloth, like the tapestry models for Saint Geneviève, the rest simply "of gray paper, and drawn and modeled in black and with white heightening." Clearly, there was a single basic model, with subsequent subjects modestly sketched on tinted paper. The duchess did not attend the signing in person. Her representative was none other than the young Blaise de Vigenère, the humanist and writer known today for his annotated translation of Philostratus, who at that time was the duke's secretary. It is clearly stated that he was responsible for "devising" the subjects, making the allegorical content an aspect entrusted to a man of letters. Evidently, an embroidered work of such magnitude received the same treatment as any other monumental endeavor.

Archival documents prove that textile arts were an important, possibly even a predominant part of Cousin's production. But these accounts tell us little about the resulting objects, or how much Cousin's artistry was visible in these prestigious showpieces. One thing seems clear: once the model left his hands, the painter had no part in the project's implementation; at least, no records suggest he was ever invited to review the execution for accuracy.

Fortunately, three of the tapestries from the Saint Mamas cycle still exist. Two remain in the cathedral of Langres (fig. 257). Permanently exposed, most of their color has faded, and they are hung so high up that it is almost impossible to see them. Acquired by the Louvre from a private collection, only the third tapestry is in good condition, and must therefore serve as the basis for our opinion (fig. 260). While it unreservedly adopts the pictorial language of mature classicism—the idealized figures, the antique architecture inspired by Serlio, and references to Raphaelite engravings[21]—this tapestry remains in other ways close to the traditional system of representation as it appears in the *Life of Saint Rémi* in Rheims. Most obvious, is the introduction of texts that impinge

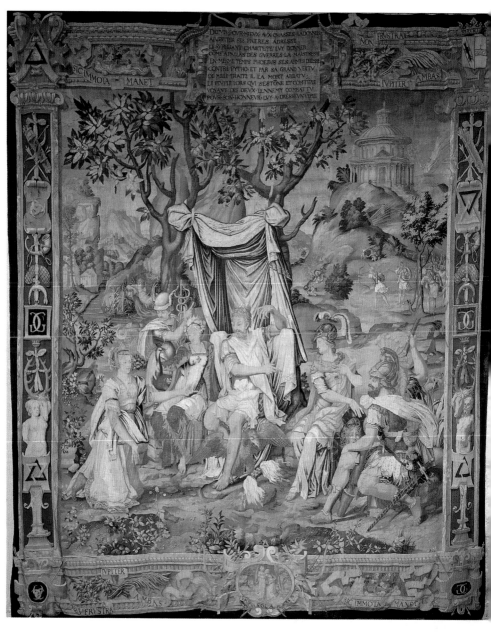

284. *Diana Begs Jupiter for the Gift of Chastity*, from the *Story of Diana* tapestry cycle, 1549–52. 182 ¾ × 160 ¼ in. (464 × 407 cm). Rouen: Musée départemental des Antiquités.

on the field of the image, but the organization is also traditional, despite the use of one point perspective. The magnificent buildings serve less to create a unified space than to articulate the different episodes cohabitating in the tapestry. The same is true of the tall tree on the left that echoes the columns on the right. There is a compromise, or rather reconciliation between the kind of coherent space found in the perspective stage of Italian theater, which was taking shape at the time, and the "mansions" of mystery plays. I do not wish to suggest a causal relationship between theatrical performances and tapestry or painting, but instead draw attention to their parallel manifestations of a common conception of space and organization of the visual field.

The original colors of *Saint Mamas Surrendering to the Governor of Cappadocia* (Louvre, Paris) are well preserved: blues and greens dominate on a background of earth tones, with the brighter colors reserved for accentuation. The limited range of shades, subtly nuanced, is employed to great effect, notably in the architectural elements, where "bronzed" elements—capitals and bases of columns, sculpture—evoke ancient decoration at its most magnificent.

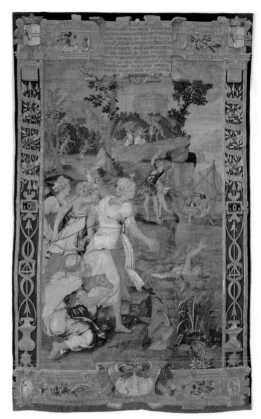

286. The *Drowning of Britomartis*, from the *Story of Diana* tapestry, 1549–52. 183 × 115 in. (465 × 292 cm). New York: Metropolitan Museum of Art.

285. Jean Cousin the Elder, *Landscape with Two Trees*, mid-sixteenth century. Black chalk, ink, and violet wash, 6 × 5 ⅜ in. (15.7 × 13.7 cm). Rotterdam: Boymans van Beuningen museum.

How much of this were the weavers responsible for? Their contribution resides above all in the handsome workmanship and seductive appearance of the material. Even without literally touching the surface, one feels it reach out like a caress. In the matter of color the textile artists' impact is significant, and positive, since they were the ones to determine the precise relationships: the painter had to respect the technical constraints, and predict the visual effect. The color possibilities of tapestry were very different from the chromatic complexity of oil painting or fresco. Where drawing is concerned, the effects of execution were inevitably negative, but the greater the weaver's skill, the less the model suffered in translation. The painter, for his part, had to be aware of, and contend with the inevitable simplification and dulling of his lines.

287. Jean Cousin the Elder (?), The *Death of Meleager*, c. 1550.
Drawing, 16 ¾ × 9 in. (42.5 × 23 cm).
Paris: École Nationale supérieure des Beaux-Arts.

played a role in designing the cartoons for this work. The drawing for the left hand side of the *Death of Meleager* (École Nationale des Beaux-Arts, fig. 287) may not be the Cousin original Brugerolles believes it to be, but certainly originates from his entourage. It is probably the work of an assistant, rather than a copy produced later.[23] More significant than the drawing itself is the striking similarity of the general composition to that of the *Martyrdom of Saint Mamas* (fig. 257). The close resemblance between a small drawing of trees by Cousin, and an element in the *Drowning of Britomartis* provides additional support for the hypothesis (figs. 285 and 286). However, even if Cousin was involved in creating the cartoons, he may not have been their sole author: a good example of the complexities facing attribution in a work of weaving.

We possess few examples of embroidery from this period. The Victoria and Albert Museum in London has acquired one panel of a wall hanging that has motifs of grotesques appliquéd in white on a blue background. Their design recalls the grotesques published by Marc Duval, confirming the origins of this extraordinary piece, which textile specialists have identified as French. The corporal now exhibited at Écouen (fig. 277) belongs to an entirely different genre. The exquisitely fine embroidery is lavishly enhanced with gold threads, and depicts the descent from the Cross, in an unmistakably Italianate manner. Dimier attributed its design to Primaticcio, but this seems unlikely today. On the other hand, the figural types, especially the men, and details of the costumes are remarkably similar to those found in Jean Cousin's work, notably his engraving of the *Entombment*. Did he design the pattern? As a theory, it has considerable appeal. The composition is imaginatively organized, and the design, so finely embroidered that it hardly suffers, is highly distinguished and makes use of virtuoso foreshortening that could only be the work of a master perfectly at ease with the new idiom of court classicism. We know that in 1551, the cathedral chapter of Sens asked Cousin to provide drawings for ecclesiastical embroidery;[24] at the very least, this magnificent altar cloth gives us a sense of what those vanished works might have looked like.

Cousin clearly had an acute sense of what would remain of facial features; he played skillfully with generous contour, decorative contortions of the bodies, and abundant draperies to give volume to the figures, instead of relying on shaded flesh tones, which would entail subtle color gradations that he could not control.

Cousin may also have been involved in preparing another set of wall hangings, even more illustrious than the Saint Mamas cycle: the *Diana* tapestry, woven for Diane de Poitiers, and presumably destined for her château at Anet (figs. 284, 286, and 288). Eight tapestries and one fragment survive.[22] Evidence suggests that Jean Cousin

288. The *Death of Meleager*, from the *Story of Diana*, tapestry, 1549–52. 183 ½ × 166 ½ in. (466 × 423 cm). Previously Anet: château, destroyed.

Toiles Peintes: Painted Hangings

In a contract dated September 7, 1549,[25] Cousin agreed to paint the history of Saint Germain on six pieces of cloth for the chapter of Saint Germain-l'Auxerrois. The cloths were to decorate the choir of the church. The terms of the contract, as well as the destination, clearly indicate that these works were a substitute for tapestries. It was customary for church choirs to be adorned with tapestries, and declarations such as "well made and of as good fabric and color as are the three stories which have been shown and exhibited to them" are characteristic of tapestry contracts. Payment was by the *aune* (one *aune* was equal to

about forty-six inches) and was made as the work progressed.

The details of the contract are revealing. Jean Cousin signed jointly with another painter, Louis Dubreuil, who had worked at Fontainebleau and elsewhere, though the latter is clearly considered an assistant only. Cousin was required to provide the design of the compositions himself, and to execute the "faces, hands and feet of the said figures," the most important and difficult portion of the work (this is the sort of clause that appears even in some of Rubens' contracts).

281

289. Anonymous, *Diana and Acteon*, mid-sixteenth century. Tempera on cloth, 104 ⅓ × 144 ½ in. (265 × 367 cm). Paris: Louvre.

Not only have the Saint Germain hangings disappeared, which is hardly surprising, it is difficult even to ascertain much about what they might have looked like. Yet it was not an unusual type of commission. These painted cloths were hung like tapestries, and, like them, had borders.[26] In some cases they might have been stretched on a wooden frame, as tapestries occasionally were.[27] The boundary between woven and painted materials was permeable. Some tapestry and embroidery merchants specified that nothing should be painted, indicating that woven or embroidered hangings could be painted, especially skin tones, which were hard to render in any other medium. Finally, as seen earlier, tapestry models known as cartoons were often painted on cloth using distemper, probably when tapestry merchants expected to keep them on hand and use them several times over.[28] There must have been little difference between such models and the painted cloths made for decoration. However, nearly all these fragile works have perished over time. The only substantial group remaining is one that originally hung at the hospital in Rheims.[29]

Hanging in the Louvre is one large distemper painting in rather poor condition, depicting the metamorphosis of Acteon. The cloth may well be an example of these *toiles peintes*, but there is no way to tell for certain (fig. 289). It is even possible that this work could have been a product of Jean Cousin's workshop. The group of women in the middle ground is reminiscent of the middle ground figures of *Deucalion and Pyrrha*, if a comparison may be drawn between such a large canvas and such a small etching (fig. 259). Regardless, this decorative painting of unusual workmanship and classicizing style, where hints of Fontainebleau mingle with Raphaelesque motifs, surely gives us an idea of the work Cousin produced in the medium.

Stained Glass

Every author since Félibien has considered stained-glass painting the principal activity of Jean Cousin. Reading their work, one would think him the very archetype of a painter-glazier. Indeed, we know thanks to Le Vieil that this belief circulated among stained-glass workshops, where a particular red pigment (*rouge de décantation*) was referred to as "*jeancousin.*" It was a technique used to warm up flesh tones, invented long before the sixteenth century.[30] This and other marks of respect conferred by artists, indicate that they thought of him as a great predecessor. It was said, for example, that Jean Cousin had painted the windows at the Vincennes chapel from designs by another artist. Admiration for these masterpieces led some to suggest Raphael as the author for the models, but the hypothesis was too obviously improbable and most eventually settled on the less illustrious name of Lucca Penni.[31]

Despite all this, Taveau does not mention stained glass as one of Cousin's activities. Glass was a highly specialized craft that had its own guild. Since no document ever refers to Jean Cousin as a "glazier," and no contracts have been found in which glasswork devolves to him, it is unlikely that he painted any stained-glass windows, regardless of what has been said. By no means does this signify that he was not involved in the art, however, and one archival document sheds considerable light on his role. On July 16, 1557, Jacques Aubry, master glass merchant, signed a contract with the masters and guardians of the wealthy goldsmiths' guild for the central window of the chevet in the chapel they had recently built.[32] The glazier undertook to paint a Crucifixion, the traditional subject for that location, and below it Abraham's sacrifice of Isaac "according to and following the portrait (*alias* the small scaled drawing called the modelle) which is to be done by Monsieur Jehan Cousin or another such as may be chosen"). The goldsmiths were to have this model executed at their expense, while Aubry was responsible for rendering it "in large size" at his own. The glazier, who

had three months to finish the window from the time he received the design, must have completed his work in a timely manner, since the goldsmiths ordered the iron fittings necessary for installing it on November 26, and on November 29 signed a new contract with Jacques Aubry, this time for the lateral bays of the chevet. The second contract also stipulates that the drawings were to be by Jean Cousin or another.[33]

These contracts permit several interesting observations. Firstly, the formula specifying that the small-scale model—namely, a drawing—be to be made by Jean Cousin "or another" strongly supports Maurice Roy's idea that Jean Cousin was the first name that came to mind. He would have been the fashionable designer for anyone commissioning a stained-glass window who had the means to pay a first-class artist, as the goldsmiths certainly did. The second, extremely important point is that the contract proposes asking Cousin to provide only a small model, a drawing. The glazier was the one responsible for enlarging it and preparing the full-scale cartoon or pattern for the window. Of course, this was not the only possible arrangement. In some cases, the glazier was responsible for the entire project from initial concept to finished window. The great stained-glass window painters of the Northern tradition worked this way—such as Arnoult de Nimègue who was for a long time the greatest artist in Rouen, or Engrand Leprince of Beauvais. It was also the usual, though not systematic, practice of Jean Chastellain, an artist well known in Paris during the 1540s. For other projects, a glazier might be asked to copy a window from an existing building, adapting it as needed. Exceptionally, a painter may have been responsible for providing cartoons, which the glazier only had to execute, but I know of no documented instance in sixteenth-century France.

The glazier, as he was then called, was an artist, but he was not at all a painter in the usual sense of the word.[34] He selected the pieces of colored glass, but did not himself make glass;

290. Jean Cousin the Elder, *Saint Francis and Saint Jerome*, 1540–60. Pen and brown ink, 14 × 6 ¾ in. (36 × 17 cm). Paris: Louvre.

291. Jean Cousin the Elder, The *Crucifixion*, 1540–60. Pen and ink wash with black chalk, 14 × 7 in. (36 × 18.1 cm). Angers: Musée David d'Angers.

his artistry lay primarily in their arrangement. Otherwise, his palate was strictly limited, and his work as a painter consisted mostly of grisaille, a gray or brown substance applied with a brush, allowing him to draw lines and create shadows on the different pieces of colored glass. Yellow made of silver salts was also available, and generally applied on clear glass in combination with grisaille. It could, however, be used to modify colored glass, for instance to produce green when applied to blue glass. The process of laying down colored enamel on glass was known, but employed only rarely.[35]

A stained-glass cartoon had to include a cut-line indicating the shape of each piece of colored glass, or *coupe*; it was their configuration that would make up the image, once they had been jointed with lead. The cartoon had letters indicating the color of each piece, within a narrow range predetermined by the glassmaking process.

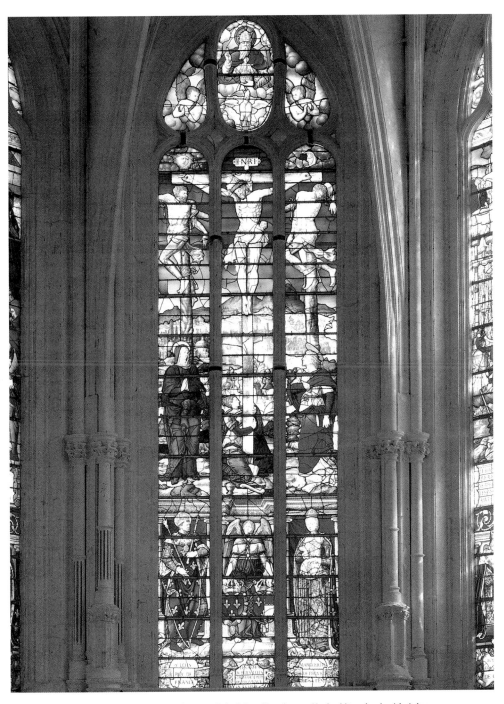

292. The *Crucifixion*, mid-sixteenth century. Stained glass. Champigny-sur-Veude: château chapel, axial window.

293. Geoffroy Dumoûtier, *Stained-glass Window Project*, 1545–50 (?).
Pen and brown ink with brown wash on parchment,
18 × 15 in. (46.8 × 37.7 cm). Paris: Louvre.

Given these constraints, it is understandable that practices governing the production of cartoons for glass differed from those prevalent in tapestry. Compared to stained glass, weaving was relatively mechanized. Naturally, a weaver had to have a good eye and sound judgment. A certain amount of interpretation was involved, since his array of shades was limited, and he had to account for the opacity and tactile qualities unique to textiles. However, his influence over the outcome was restricted, leaving him all the more obliged to make a faithful reproduction of the complete model as provided by the painter. Stained glass required a cartoon more specifically geared to the glazier's technique since the definitive drawing had to follow the outlines where the separate pieces of glass had to be cut.

While the document pertaining to the goldsmiths' chapel bears witness to Cousin's great prestige, it also demonstrates that the author of the design was not the crucial factor in stained-glass production. The contract with Jacques Aubry was signed first, and in it, he is clearly considered the author of the window. Aubry was also perfectly

capable of exercising his craft without the intervention of a painter. In some contracts, he had prepared the patterns himself, before the signing.[36]

Clearly, the planning and execution of a stained-glass window could encompass a wide variety of legal arrangements. But for major projects, the glazier was generally constrained to abide by an initial project like the ones Jean Cousin undoubtedly supplied on a regular basis. The question remains: What impact did such a drawing have on the finished product? Which aspects, other than the general composition, found their way into the window itself? It is difficult to respond in the absence of a specific drawing and the corresponding window. Some conclusions, however, may be tentatively advanced. To begin with, a few of these small patterns still exist, including one thought to be by Cousin himself: a stained-glass window project consisting of two sheets. One of them, at the Louvre, depicts Saint Francis and Saint Jerome (fig. 290). The drawing is handsome and has sophisticated, fluid lines. The saints are skillfully presented as a single group, while their individual attitudes are contrasted. One senses that the artist gave thought to their realization in glass; he has planted the figures on a background rather than incorporating them into a more complicated visual nexus. The second sheet, in Angers (Musée David d'Angers), represents a Crucifixion designed to fill another lancet of the same window (fig. 291). The figure of Saint John especially is characteristic of Cousin's manner, and confirms the attribution of the Louvre drawing. A huge distance remained to be covered between a drawing of this kind and the finished stained-glass window it was expected to become. The effectiveness of the window depended heavily on the adaptation of the drawing to full-scale, the pattern of the lead joints, and the application of color—all aspects determined by the glazier's skill.

We must now turn to the stained-glass windows themselves. Can we identify any for which Cousin provided drawings? Félibien asserts that:

It is difficult to imagine the great number of works he made, principally for windows, as can be seen in several Paris churches, which are by him or according to his design. In the church of Saint Gervais, he painted on the

294. The *Nativity*, c. 1545. Stained glass. Écouen: church of Saint Acheul.

295. The *Annunciation and Visitation*, c. 1547 (?). Stained glass. Écouen: church of Saint Acheul.

windows of the choir the Martyrdom of Saint Lawrence, the Good Samaritan and the story of the Paralytic.[37]

These are the only Parisian stained-glass windows by Cousin he refers to specifically—and fortunately, they have not entirely disappeared. However, they are located in the upper windows of the choir, making them difficult to examine and practically impossible to photograph. Worse still, they have been extensively redone. The parable of the paralytic is an attractive composition, but the principal figures were almost entirely reworked in the nineteenth century. On the other hand, the landscape, with its picturesque ancient style of buildings, appears to be in better condition. What remains visible is consistent with Cousin's manner, allowing for the intervention of a glazier.[38] The light tonal register with rich violet tints in the shadows is a new invention employed to great effect. The stained glass in Sens that Félibien mentions is gone, but

the window showing *Augustus and the Sibyl* at the château de Fleurigny still exists.[39] Jean Cousin could have provided a drawing for this minor work, but it might have been Jean Cousin the Younger instead, whom documents place at Fleurigny in 1563.

The identical subject, Augustus and the Sibyl, is depicted in a window of the cathedral of Sens. The head and bust of the sibyl—shattered by a cannonball and subsequently replaced—are by no means the only restorations. Jean Cousin may possibly have supplied the design, but the stained glass has suffered too much to reveal anything about his contribution. Félibien makes no reference to the window of Saint Eutrope at the cathedral in Sens. Yet local tradition has attributed it to Cousin since the seventeenth century. What should be made of it? The window, dated 1530, is characteristic of the early French Renaissance. Obviously, Cousin's classicizing art as he practiced it after 1540 was very different, but it could

hardly be otherwise. Since we lack any documented works by Cousin that can be dated to the period before he moved to Paris, it is currently impossible to determine what they were like, or if the window is his. An in-depth study of sixteenth-century stained glass may someday shed light on the matter. Archives yield the names of other artists active in Sens—in 1526, the cathedral chapter appears to have had more faith in one Jehan Hympe than it did in Cousin—but nothing is known about their individual styles. Without such reference points, it may never be possible to connect these names to specific surviving works.

It is, however, possible to affirm with the utmost confidence that the classicizing tendencies of the mid-sixteenth century had a significant impact on stained-glass art, and that Cousin cannot have been the only artist implicated in this development. We still possess, for example, a beautiful drawing, whose iconography is anything but clear,[40] for an imposing window with five lancets, by Geoffroy Dumoûtier (fig. 293). The idealized figural types, with their straight profiles, are characteristic of the Fontainebleau style. Rosso's influence is very perceptible in the slightly angular figures; his follower applies the lesson somewhat mechanically, but not without skill. Dumoûtier's name has been suggested in connection with several vibrantly colored, classicizing windows that adorn the church of Saint Acheul at Écouen. However, a panel such as the *Annunciation*, situated just above the *Visitation*, in which scholars claim to recognize Dumoûtier's style, seems to me more reminiscent of Jean Cousin (figs. 294 and 295). In either case, it is impossible to determine whether the similarities derive from direct involvement by these painters or if the glazier was simply inspired by their works.[41]

The chapel of Champigny-sur-Veude possesses some of the best-preserved stained glass from the sixteenth century, and the central window of the chevet is particularly beautiful (fig. 292). The general composition of this Crucifixion is traditional, but the artist has placed the crucified figures very high up, dramatizing their relationship to the witnesses and allowing the horizon and a broad landscape to unfold between the two groups of figures. The figural types are similar to Cousin's, and I wonder if he did not contribute a model for them, but this only a tentative suggestion.[42] If so, this work in fine condition would provide the best testimony existing of what a stained-glass window might be when Jean Cousin supplied the drawing.

Although much damaged, the two large windows decorating the chapel of the Passion at Saint Maclou in Pontoise belong to the same grandiose style (figs. 296 and 397). However, the agitated figures inhabiting them are different in character from the stained glass at Champigny, and they are probably attributable to a different artist. Nonetheless, there are similarities between these three works produced around the same time in different places: an ease and grandeur of composition rarely found in stained glass. They also share a distinctive contrast between the saturated colors reserved primarily for the figures, and the more diffuse, airy tints of the landscapes. Comparing them with the stained-glass window with scenes from the childhood of Christ in Gisors (church of Saint Gervais, fig. 298)—another classicizing work from the same period—it is easy to see that they embody a very different trend. The classicism of the Gisors image is more formal, colder, and slightly stiff. In choosing grisaille, rather than the dazzling and expressive colors that make the windows at Écouen or at Pontoise so striking, this master reveals very different allegiances.

Given that chronograms are relatively rare in stained-glass windows, a striking number of them bear the dates 1544 or 1545. This makes me wonder if, as I suggested in the case of etching at Fontainebleau, the unexpected care with which these windows are dated does not reflect the artists' feeling that they were participating in an historic moment. Were the window makers aware of a stylistic revolution taking place in their art? In other domains, such a consciousness was explicit—notably in literature, especially with Geoffroy Tory, and a few years later with Ronsard and the other poets of the Pléiade. Whether or not it was perceived as such at the time, stained glass underwent a spectacular stylistic renewal in which Cousin certainly played a role. It is, however,

virtually impossible to be more specific about his individual contribution, partly because of incomplete documentation, but also because these changes took place within conditions peculiar to an art that had its own traditions and dynamic.

At the end of the nineteenth century it became commonplace to say that stained glass, like tapestry, had lost its unique character in the Renaissance, becoming an avatar of painting. The introduction of perspectival space was the considered the principal culprit, guilty of reducing windows to paintings on glass. This assumption is still firmly rooted and exceedingly difficult to extirpate. Actually, stained glass has always been more in league with architecture. As early as the twelfth century, there have been monumental windows, and an aesthetic of colored light, which Abbot Suger eloquently put into words. The art evolved with the passing centuries, but without abrupt change. The thirteenth century discovered a unique balance between representation and ornament in narrative windows. The works in question are those rich compositions where figural subjects are integrated like medallions in a dense ornamental armature. It was a felicitous balance, certainly, but is too frequently treated as a norm, and presented as the perfect and unsurpassable expression of art in stained glass. Thus conceived, the stained-glass window is like a sustained chord, played across the visual spectrum. Examining the subjects portrayed takes second place, and in the case of windows placed high on the wall, deciphering them is often difficult. Artists in the fourteenth century perfected a more distilled formula, which met with great success: a holy personage surrounded by a grand architectural setting. Sometimes a scene replaces the single figure. This arrangement is essentially that of—and may even be derived from—canopied statuary, which was already frequent in Romanesque sculpture. Lacking real volume, however, stained glass produces a different effect, and the figure appears mounted in an elaborate ornamental apparatus that often claims the greater part of the window.

A predilection for these imaginary, exuberant, and luminous constructions thrived until the sixteenth century. But with time, the makers of windows also developed narratives unconfined by architectural decor. The fifteenth century saw the birth of a new type of window destined to achieve great popularity throughout the 1500s: this window was divided into compartments in which the episodes of a narrative like the life of a saint, or the scenes of the Passion of Christ appeared in sequence. The effect is reminiscent of a comic strip, especially so because each panel usually had an inscription at the bottom, indicating its subject. The genre undoubtedly descends from the medallion stained glass of the thirteenth century, but the ornamental structure has receded, and the narrative scenes have invaded the entirety of the window, or nearly: only a modest architectural frame subsists in most cases, and even that was sometimes eliminated.

A great artist such as Jean Lécuyé managed to galvanize attention in spite of the insipid format. A good example would be his window at Bourges Cathedral depicting the martyrdoms of Saint Steven and Saint Lawrence (fig. 297). The architectural framing is reduced to a plain molding below the scenes, which otherwise fill the glass panels. However, within these panels Lécuyé relies on architectural decoration to structure his image. Without it, he would have trouble organizing the composition. These architectural motifs are already highly classicized, and his use of them recalls Cousin's compositions for the life of Saint Mamas. But his talent is visible in a whole different light when the entire window becomes a single scene.

The Tullier family window in the same church is one of the most extraordinary in the history of stained glass (fig. 299). It consists of one large scene in which the members of the family are presented to the Virgin by their patron saints. The artist succeeds in combining the concept of a single composition unifying the entire window with the formula of canopied saints described previously. Although the figures are quite large, the architectural decor predominates. Each lancet is treated as an architectural unity open at the back onto a landscape whose horizon extends the width of the window. The figures are integrated through the rhythm created by the grandiose symmetrical composition of four arcades corresponding to the lancets. This fictive architecture

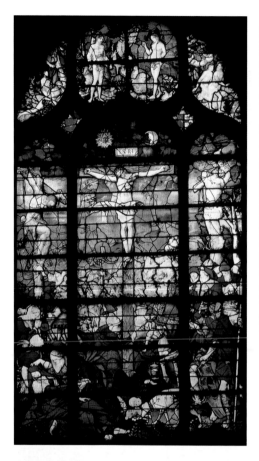

296. The *Crucifixion*, 1545. Stained glass. Pontoise: church of Saint Maclou, chapel of the Passion.

297. Jean Lécuyé, The *Martyrdoms of Saint Steven and Saint Lawrence*, 1520. Stained glass. Bourges: cathedral of Saint Étienne.

affects the ornamental style of the Early French Renaissance, but fundamentally it is not different from Flamboyant art with its foliaged luxuriance. In fact, Lécuyé closely followed the organizational structure of a century-old model from the cathedral itself, the window of Pierre Trousseau (fig. 301). By eliminating the brocade backdrop and pedestals, which made the figures look like sculpted groups, the artist has suggested exterior space by patches of blue sky, and most importantly he has given his figures weight and volume following the example of Italian classicism; through these adaptations he succeeded in creating a strikingly original window.

One can only admire the artist's skill in preserving the architectural integrity of the lancets, while filling the entire window with a single figural composition. Yet, the concept of balance

298. The *Infancy of Christ* (detail), 1545. Stained glass. Gisors: church of Saint Gervais-Saint Protais.

299. Jean Lécuyé, The *Tullier Family Window*, 1532. Stained glass.
Bourges: cathedral of Saint Étienne.

300. Auch: Saint Marie cathedral, axial chapel:
overall view of stained-glass windows completed 1513.

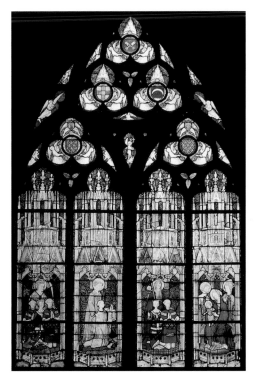

between a refreshed architectural decor and large figures was already well established. The most spectacular example, and among the best preserved, is one of the great masterpieces of French art: the stained-glass decoration of the chevet in Auch cathedral, completed in 1513 by Arnaud de Moles. All the chapels surrounding the choir are fitted with a coherent ensemble of large windows (fig. 300). The greater part of each window is filled with a vast scene in which the figures, larger than life, are positioned in an architectural setting where Italian motifs dominate without entirely eradicating the Flamboyant. In the axial chapel, the tracery of the upper part of the window is configured as a giant fleur-de-lis with the stained glass designed to highlight the floral motif; the result is breathtaking. The artist has kept his compositions simple, such that a single

301. *Window of Pierre Trousseau*, 1404–06.
Bourges: cathedral of Saint Étienne.

figure occupies each lancet. Smaller, more ani-
mated, narratives run as a predella, or sometimes
along the upper part of the imaginary architec-
ture. More impressive than the precocious
appearance of Italian motifs, is the sense of mon-
umentality presented here at Auch. All the
chapels of the choir participate in a grand and
unified formal concept organized by the fictive
architecture and the bold use of color, in the ser-
vice of a coherent iconographic program balanc-
ing the Old and New Testaments, the prophets
and the sibyls. Stained glass has rarely produced
a work so powerfully inspired.

As the Renaissance developed in France, one-
point perspective conquered the visual arts. Nev-
ertheless, the representation of space remained
much more ambiguous in stained glass than in
painting. In the magnificent *Judgment of
Solomon* at Saint Gervais in Paris, dating from
1531, the canopy over Solomon melts into the
architectural background of the characters instead
of being clearly suspended over the king (fig.
303).[43] The architectural molding at the bottom of
the composition is likewise ambiguous: it
appears to refer as much to the structure of the
window as to the space of the representation.[44]
The eye immediately relates this lower motif to
the extensive architectural elements above the
figures that share the same colors, a combination
of grisaille and silver yellow. It is difficult to
determine whether this structure is behind, or
rather above the figures (notice the molding
within the scene that echoes the lower one, espe-
cially visible starting with the second lancet from
the left). Does the scene occur inside, or out-
doors? It gives the impression of taking place on
a sort of platform or scaffold, as though it were a
staged spectacle rather than a historical reality,
though there is no reason to assume that it liter-
ally reflects a mystery play of the kind performed
at that time.

In the 1550s, artists adapted the formats typi-
cal of stained glass to accommodate court classi-
cism, rather than transposing the pictorial tradi-
tion onto glass. While less extensive than in the
Tullier window, the architectural motifs at the
chapel in Vincennes strongly order the rhythm of
the decoration (fig. 239).[45] Probably designed by

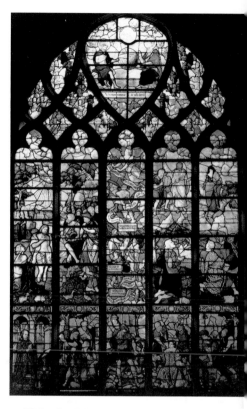

302. Jean Chastellain, *History of Saint Steven*, 1540. Stained glass.
Paris: church of Saint Étienne-du-Mont.

Philibert de l'Orme, they represent the height of
classicizing stained glass. As early as 1540, how-
ever, Jean Chastellain, who died a year later, had
developed a classical manner, derived essentially
from Raphaelite prints. The compositions he cre-
ated for Saint Étienne-du-Mont (figs. 302 and
304), the *Stoning of Saint Steven* and *Pentecost*
are, with their slightly stereotyped figures, char-
acteristic of this narrative style.[46] From 1530 to
1545, a classicizing art founded on Italian models
developed in stained glass, primarily through
prints, and independent of art at Fontainebleau.

It is a fact that during the 1540s large figural
compositions progressively appropriated the
entirety of stained-glass windows, but this hardly
reduces them to paintings on glass.[47] The painters
requested to provide models were sensitive to the
particular conditions imposed by glasswork.

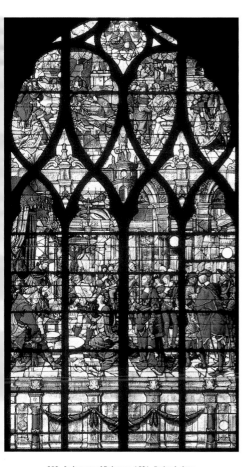

303. *Judgment of Solomon*, 1531. Stained glass.
Paris: church of Saint Gervais-Saint Protais.

304. Jean Chastellain, *Pentecost* (detail), c. 1540. Stained glass.
Paris: church of Saint Étienne-du-Mont.

Dumoûtier's drawing, described previously (fig. 293), leaves no doubt of this. On the one hand, he strove to unify the window as a single large composition, while on the other preserving some autonomy in the lancets, each of which is carefully composed. In the rightmost of these, he also engineered an opportunity for the glazier to flaunt a spectacular effect of light in the form of a radiating Christ. As for the glaziers, they adopted new forms, idealized Grecian profiles, ancient-style draperies, and a new emphasis on expressive gestures. Yet for them, stained glass remained the art of colored light, even if they abandoned certain conventions. They enthusiastically experimented with strong contrasts between fragments of saturated color—often used for rich drapery on figures—and the lightly shaded glass that began to occupy a much larger portion of the window than previously. Far from bringing stained glass closer to painting, the light shining through these works increased their difference: dazzled, the eye has trouble focusing on the content.

Huldrych Zwingli, the reformer of Zurich, was an iconoclast sternly opposed to religious images. However, he discouraged the destruction of narrative windows, saying: "I have never seen anyone pray before a stained-glass window." In all likelihood, he was rationalizing a practical measure—avoiding the cost of replacing all the glass in churches rededicated to Reformed services. But the observation, which could be extended to include tapestry, remains both accurate and highly

revealing. Painting became the defining medium of art as we know it, precisely because it succeeded in forging a privileged relationship with the spectator: riveting the attention, absorbing the viewer, and inviting contemplation. It is thus construed that art became the sole avatar of spiritual and religious experience. Since the Italian Renaissance, painting has presupposed an attentive spectator whose imagination allows him to step into the scene so clearly separated by its frame from its surroundings. On the contrary, the eye flits over the surface of a tapestry, whose border is not a framing barrier; similarly sight cannot sustain lengthy attention on a stained-glass window because of the glare. Stained glass and tapestry are arts that transform the environment, while painting invents its own and draws us in.

Contemplation and decoration are distinct—and to a certain extent contradictory—values. At least, they have been considered so at times. Particularly in the modernist artistic tradition that ushered in abstraction at the beginning of the twentieth century, the decorative often had a negative connotation in any discourse on art. Painting, in its quest for expressive intensity, insisted on distinguishing itself from ornament, which was perceived as lacking in meaning. While it has more or less governed artistic experience since the seventeenth century, this hierarchical relationship had no currency in sixteenth-century France.

Armor and Goldsmithing

As the military industries developed along with the technology of war, the creation of armor became an art—according to Bruno Thomas's excellent formulation—halfway between costume and sculpture. During the Renaissance, as the utility of armor for defense waned with the ascendance of firearms, aesthetics took over and the artistry of armorers creating parade or decorative armor reached unprecedented levels of virtuosity and brilliance. These magnificent carapaces were never intended to be worn in battle: at most, they might have served in tournaments, when they were not designed exclusively for display. Jousts had once had real relevance as preparation for armed conflict, and constituted a form of training in times of peace. But in the sixteenth century, this aristocratic sport had become a complete fiction, though still brutal and dangerous. The nobility engaged in the enactment of a chivalric lifestyle that was in reality no more than a nostalgic reverie. The remarkable vogue for novels of chivalry—the kind Cervantes would take such delight in mocking at the end of the century—began with the publication of *Amadis de Gaule* in 1540, a date also corresponding to the height of armor as art.

At the end of François I's reign, and under Henri II, France assumed a leading role as an innovator in luxury armor, as it did in many other domains. Museums possess a large group of suits of princely armor, some of which belonged to Henri II. These pieces share a new style, an elegance, and incomparable finesse of workmanship (fig. 305). Until then, Milan had been the primary source for high-class armor. Appearing around the middle of the century, the new type could be distinguished from Lombard creations not only by the shift towards motifs borrowed from the art of Fontainebleau, with an increased role for figures extending to narrative scenes incorporated within the ornament, but also by its significantly less pronounced relief work. It would be hard not to see a link between this original kind of armor and the new style of architectural relief as practiced by Jean Goujon. Sadly, and surprisingly, we know next to nothing about the production of these extraordinary masterpieces; not the names of the artisans, nor to what extent the skill of other artists was called upon, not even, in truth, whether these works were made in Paris. It was always assumed that they were—however, documents have shown that a collection of armor not unlike that of Henri II, produced for Eric XIV King of Sweden, was the work of one Elisaeus Libaerts, who practiced his craft in Antwerp from 1557 to 1564, then in Stockholm until 1569. Does this mean, as some have concluded, that all these works originated in

305. *Armor of Henri II: Helmet*, 1555–59 (?). Steel. Paris: Louvre.

Antwerp? The current belief is that Libaerts worked in Paris before his career in Antwerp (which began only at the end of Henri II's reign) and that he continued an art he had learned in France from those who had perfected it there.

No tradition or document ascribes a role in the art of armor to Jean Cousin. It is one of the rare domains where not even his most ardent admirers see his hand. However, there are reasons to believe he participated—not, of course, as a smith, but by providing models. For one thing, two of his daughters married armorers, of whom at least one, Jehan Nozieulx known as Daussone, was prominent in his profession. It would be surprising if such a close family relationship had had no professional repercussions. Furthermore, there exists a drawing for a chamfron (an armored headstall for a horse), whose graphic style as well as ornamental repertoire are consistent with what is now known about Jean Cousin

the Elder (fig. 312). The figural type of the seated woman in it is very close to the one in *Eva prima Pandora*. The masculine nudes in acrobatic poses recall the figures on the frontispiece of Cousin's *Livre de perspective*. I believe this magnificent drawing to be by him also, while admitting that the claim may seem precarious. The drawing is only one sheet from a large collection—currently in Munich—of drawings related to the production of luxury armor at the court of France.[48] It is, however, exceptional within the group: freer, more vivid, more quickly executed though quite detailed. Contrary to most of the drawings, it is not a final template but a project proposing different alternatives on either side of the central axis, a customary practice in ornament and architectural drawings. One figure (from the upper oval) is reproduced almost exactly in another drawing from the collection, but in a very different hand (fig. 310). The latter

306. Étienne Delaune, *Project for the shield of Henri II*, c. 1555 (?).
Pen and brown ink, gray wash, d. 4.3 in (10.9 cm).
Munich: Staatliche Graphische Sammlung.

307. *Shield of Henri II*, c. 1555 (?).
Steel, gold, and silver, 25 × 18 in. (63.5 × 45.7 cm).
New York: Metropolitan Museum of Art.

is a carefully finished technical drawing for a single element of armor, while Cousin's project comprises several articulated segments.

Bruno Thomas, the great armor specialist, has carefully studied all these drawings and attributed a large number to Étienne Delaune, including the second chamfron. No one has questioned the attribution. If the first project were indeed by Jean Cousin, it would mean that Delaune formalized the project on the basis of ideas provided by the painter. Another of the drawings in Munich raises interesting questions. It is among the most beautiful of the whole collection (fig. 311), and once again, Cousin's name is suggested by the

characteristic repertoire, in spite of the lack of figures. However, it lacks the freehandedness of the previous project. It is evidently not a technical drawing for execution, since each articulated section, like the movable visor, would have had to be drawn separately. It could be a clean copy made by Cousin or at his workshop, and I am inclined to believe that it is: in spite of the careful presentation, the plumed motifs remain very freely executed, and the use of tonal gradation to integrate secondary motifs betrays the sensibilities of a painter. It is, in any case, unlikely to be the drawing of an armorer—neither is it by Delaune. However, his hand is recognizable (or at least,

309. Étienne Delaune, *Mascaron*, c. 1555 (?). Pen and brown ink, gray wash, white heightening, 4 × 3 ⅓ in. (10.1 × 8.4 cm). Munich: Staatliche Graphische Sammlung.

308. Anonymous, *Mascaron*, c. 1555 (?). Black chalk, 4 ¾ × 3 ¾ in. (12 × 9.4 cm). Munich: Staatliche Graphische Sammlung.

the same one that made the washed ink drawings) in three masks (fig. 309) that are not drawings for specific pieces of armor but rather studies for a multipurpose motif of which variations find their way into several separate projects.[49] Three loose preparatory drawings in black chalk are also part of the collection; they have been pressed with a stylus for transfer (fig. 308). Their thick lines and picturesque manner suggests a painter—might they be Cousin's? Or was Delaune their author? Or someone else entirely?

When comparing the many drawings in Munich, two significant inferences can be made: the extraordinary care with which these projects for armor were developed, and the involvement of a full-fledged artist, apparently a painter, working alongside the artisan. Delaune's role in this process seems likely, but difficult to pinpoint. All of his activity is linked to metalwork. Though best known to us as an engraver (see Chapter VII), he was a goldsmith by training and preserved that title throughout his career. However, in spite of his fame he never became a titled

master of the trade. We possess a wealth of projects by him, for medals, coins, and tokens, but it is not clear that he was always or ever the engraver for them—although this was well within his skill. As for armor, it is not possible to determine whether he participated in the final execution, or if he was confined to the role of a draughtsman, an intermediary between the artist's sketch and the project's realization. The technical drawings attributed to him imply a high level of specialization. Without being an armorer, he might have taken part in the chasing, gilding, and inlay of these precious objects, which so resemble goldsmithing in their workmanship.

Delaune's relationship with Cousin was not restricted to the domain of armor. From the previous chapter, we know that he engraved several compositions by Cousin, which seem more likely to have been by the father than the son. However, other clues suggest a sustained relationship between the two artists. A superb drawing on parchment, enhanced with watercolor has long been attributed to Delaune (fig. 313). There is no

311. Jean Cousin the Elder (?), *Helmet Project*, c. 1545–50.
Pen with white heightening on gray paper, 15 x 15 ⅓ in (38.8 × 39.1 cm).
Munich: Staatliche Graphische Sammlung.

310. Étienne Delaune, *Chamfron Project*, c. 1550–60. Pen and gray ink wash,
23 × 8 in. (58.2 × 20.3 cm). Munich: Staatliche Graphische Sammlung.

312. Jean Cousin the Elder (?), *Chamfron Project*, c. 1550–60.
Pen and black chalk, 23 × 16 ⅓ in. (58.4 × 41.5 cm).
Munich: Staatliche Graphische Sammlung.

313. Étienne Delaune, *Allegory of Religion*, mid-sixteenth century. Watercolor on parchment, 13 ¼ × 17 in. (33.5 × 43.5 cm). Paris: Louvre.

reason to revisit the attribution. However, the complex and almost monumental composition of this page, the figural types, landscape motifs, all bring to mind Cousin, and it is probable that Delaune was carrying out a model by the painter.[50] The drawings for armor under discussion here may represent only one aspect of a wider collaboration. Cousin, if he did indeed draw the chamfron, had sufficient grasp of armoring to extend his suggestions to the shape of the object as well as its ornamentation. But it would be unwise to exaggerate this knowledge, as the innovative qualities of these extraordinary pieces rests primarily on their decoration, rather than on their functional shape as armor. Only the eventual discovery of documents pertaining to the conception and execution of this piece would permit an understanding of the working relationships

in place and specific roles assigned to each author. Nonetheless, these drawings are evidence of one of the most characteristic and precious manifestations of classicizing art at the French court. Encased in their gleaming shells, the king and his gentlemen transformed themselves into antique heroes as imagined by poets and painters.

Goldsmithing is a similar kind of profession. Once again, no documentary evidence or traditional lore associates Jean Cousin with this art. However, we may now confidently affirm that the painter did indeed provide models to goldsmiths. George Wanklyn has identified a watercolor drawing on parchment that is visibly a project for the table centerpiece offered to Henri II by the city of Paris on the occasion of his official entry in 1549; and as Wanklyn has demonstrated, the drawing is by the hand of Jean Cousin (fig. 273).[51] Although

his name is not mentioned in connection with this splendid piece in any of the existing documents pertaining to its creation, the painter was one of the principal authors of the festival decorations, and his involvement in the city's gift is in no way surprising. Furthermore, the project bears such a close resemblance to two etchings monogrammed N.H. and I.C. from the mid-1540s (see Chapter VII for a discussion of these works), that one can hardly view them too as anything but models for goldsmiths (fig. 251).[52] It is impossible to know whether these projects were realized, except the gift of the city, regarding which there is no doubt. Unfortunately, the very nature of these exceptional objects made them particularly vulnerable: since the value of their workmanship was considered negligible next to the price of the silver and gold they were made of, it was often little more than a costume by which to disguise a tax as a spontaneous gift. Thus, with the exception of a few survivors, like the Cellini saltcellar, our knowledge of this art of high luxury is almost entirely indirect.

Illustrated Books

Bookmaking also underwent remarkable renewal and change around 1540. These pages address illustration primarily, but the appearance of books was altogether transformed. The French overtook the Italians in the matter of typography. A new kind of binding was also invented in France, with a type of decoration known as Grolier, named after a great bibliophile of the period (fig. 314).

The circumstances surrounding this metamorphosis are not entirely clear; however, several individuals must have been involved—notably the booksellers Denis Janot and Jean Groulleau, the font engraver Claude Garamond, and a curious personage named Gilles Corrozet who was at once a poet, bookseller, editor, and historian. However, the path they trod had already been suggested by a man well ahead of his time: Geoffroy Tory, who was also an author, illustrator, editor, and publisher. He was a passionate lover of books who wished to renew them in every aspect, orthography and typography as well as page layout, ornament, and illustration. This great figure of French culture from the reign of François I, known primarily to historians of literature for a passage in his *Champ fleury* that clearly heralds the language of Rabelais, is a complex character still awaiting full investigation.[53] Current knowledge makes it difficult to determine the extent of his activities as an artist. It is said that he worked for Jean Grolier. If indeed Tory cut the punches used on bindings intended for him, it could certainly not have been in the elegant style that bears the famous bibliophile's name, since the artist's death, in 1533, preceded the appearance of this distinctive interlaced decoration.[54] In typography, Tory's research paved the way for the development of what is called Garamond typeface, whose balance and refinement continues to win favor among publishers in our own time. However, the fonts employed in the editions he printed are without great distinction. In illustration, Tory applied his talent to a particularly brilliant genre of sixteenth-century Parisian publication: the book of hours. The publishers took over from the copyists' workshops that prepared the luxury manuscripts hoarded by fifteenth-century bibliophiles. It has been maintained that Tory directed such an enterprise.[55] While a few sumptuous manuscript books of hours were produced for the high nobility in the sixteenth century, the principal innovation was the move toward printed material. Though by no means universally accessible, printed volumes became available to a clientele that was comfortable without being rich. As early as the last decade of the fifteenth century, and continuing throughout the first quarter of the sixteenth, an impressive succession of illustrated books of hours appeared, adapting the magnificence of manuscripts to the printed book. They preserved from their antecedents the full-page illustrations and the sometimes fantastical borders, where sacred and profane scenes often cohabitated. In the first chapter, I wrote about the publications of 1525 and 1527, in which Tory

modernized the genre with an extraordinarily lucid artistic consciousness. A later book of hours, published in 1529, and unfortunately very rare, presents illustrations of uneven quality, but the best plates—the *Annunciation* or the *Nativity*—can be counted among the most astonishing woodcuts of the period. Was Tory himself the author of these drawings, in which one seems to feel the influence of the Danube school, mingled with echoes of Flemish and Italian art? And if not, who was the artist in Paris capable of such a confident drawing on the eve of Rosso's arrival? French art of the period still has much to reveal.

Tory remains a disconcerting artist for historians. The relatively well-known vignette of the Gallic Hercules—an illustration from his *Champ fleury*—is a sensitive, elegant, and distinctly French adaptation of Venetian illustrations from the beginning of the century. In 1530, it was an isolated occurrence, but after Tory's death, the idea was soon applied almost systematically.

Special attention must be accorded the 1534 publication of the emblem book, *Emblematum libellus*, by Alciati. The celebrated Italian jurist came to teach in France in 1529. Dissatisfied with the edition of his work published in Augsburg by Heinrich Steyner (1531), he entrusted it to Chrestien Wechel, who ran a large publishing house significantly named "*À l'écu de Bâle.*" For the most part, woodcuts for the new edition recycled compositions from the Augsburg volume, which are probably the work of Jörg Breu; however, they were redrawn and corrected. In one entire section of vignettes, Tory's legacy is unmistakable (fig. 85). Above all, the editor substantially improved page layout: each emblem occupies a separate page, preserving its integrity, an effect also achieved by the fusion of text and image. The picture is inserted between the words of the device, or *inscriptio*, above and below the *subscriptio*, a short explanatory poem. Not only did Alciati's work run to innumerable editions, not only was it the inspiration for a genre whose success never wavered for over a century, but it defined a formula for publications that gave priority to the image and threw open the door to the reader's imagination. A flood of such publications was unleashed all over Europe.

314. Binding with the arms of the constable Anne de Montmorency on a book by P. Legendre, *La Mer des Histoires*, c. 1550. Paris: Bibliothèque Mazarine.

Wechel did not play a major role beyond publishing Alciati's book. Denis Janot was the central character in the reform of illustrated books in Paris. *L'Hecatomgraphie*, the emblem book by Gilles Corrozet, published in 1540, is typical of the works that came off his presses (fig. 315). The images are small line drawings with little or no crosshatching—often simple compositions, but classicizing and drawn with authority and grace. In the years that followed, they would accumulate shading and become more complex, more nuanced, but remain in essence unchanged. Robert Brun accurately captured the artistry of these Parisian books: "The figures have slender limbs and present an elongation, a nervous grace, and slightly affected poses that contrast strongly with productions influenced by the art of Basel."[56]

Amidst all this, what role did Jean Cousin play? Firmin-Didot listed all the best books of the

315. Gilles Corrozet, *Beauty, the Companion of Goodness*, from *Hécatomgraphie*, Paris, Denis Janot, 1540.
Paris: Bibliothèque Nationale de France, rés. Z 2598.

1540s under his name. "By this reckoning" Robert Brun correctly noted, "he would have been directing the illustration workshops of Denis Janot and Groulleau."[57] But Firmin Didot's claim was not as extreme as that of Papillon, who, as we have seen earlier, maintained that: "almost every one of the prints in books going to press in Paris under the reigns of Henri II, Charles IX, and Henri III [were] from his drawings or his woodcuts." Strictly speaking, the only book indisputably known to have been illustrated by Jean Cousin is his own *Livre de perspective*, published in 1560 at the very end of his life. In his preface, the publisher Jean Le Royer declares that Cousin provided him with "figures necessary for understanding it, drawn by his hand on wood blocks." Royer engraved them himself (or finished them

after they had been partially cut by his brother-in-law Aubin Olivier). Cousin announced a "second work: in which will be represented the figures of all kinds of bodies, even people, trees, and landscapes, in order to understand and know in which placement, form and size they should be represented according to this art." His son brought the project to fruition (though only partially as he restricted himself to human figures), at the end of his own career in 1595, in the form of the *Livre de pourtraicture*, which had long-lasting success.

Are these well-documented works as far as we may venture? It is not hard to recognize Cousin's art in the illustration of the *Usage et description de l'holomètre*, a handsome scientific volume from the period by Abel Foullon.[58] Like Firmin-Didot, I believe that Cousin did draw the full plate that

316. Orus Apollo, *Hieroglyphs of the Dove and the Cicada*, from *Sculptures ou Gravures sacrées d'Orus Apollo*,
Paris, Kerver, 1543. Paris: Bibliothèque Nationale de France.

illustrates the *Henrici II Galliarum Regis elogium* by Pierre Paschal, published by Vascosan in 1560. I have no doubt that Cousin designed a magnificent woodcut, preserved at the Cabinet des Estampes and reproduced in Firmin-Didot's *Atlas*, a veritable masterpiece of ornamental art. The power of the drawing, the characteristic motifs, everything converges in support of this attribution (fig. 318).[59]

I find myself treading a dangerous path. It is easy to glimpse Cousin's hand in this or that book of hours, or bookseller's insignia. Compiling such attributions, one easily slips, like Didot, into including everything. Flitting from one attribution to the next, the artist becomes, as he does for Didot, a sort of catchall. If I followed my intuition, I would be tempted to recognize Jean Cousin's imagination at work in a delightful book that

Kerver published in 1543, *De la signification des notes hiéroglyphiques*, by the legendary Orus Apollo (fig. 316). Masquerading as an elucidation of the mysteries of Egyptian hieroglyphics, it is a volume in the tradition of emblem books. The best pages of the booklet contain an exceptionally refreshing and original view of the world. The minute engraved tableaux show a control of space and a fresh sense of rural landscape such as Delaune would later exhibit in his engraved series of the *Months* (fig. 433). As Robert Brun has observed, "this series denotes an uncommon knowledge of drawing and mastery of execution."[60] This is not the work of a routine illustrator.

The *Hypnerotomachie ou discours du songe de Poliphile*, translated by Jean Martin in 1546, has always entranced booklovers, and for the last

LIVRE PREMIER DE

Poliphile r'acompte comme il luy fut aduis en songe qu'il dormoit, & en dormant se trouuoit en vne vallee fermee d'vne grand closture en forme de pyramide, sur laquelle estoit assis vn obelisque de merueilleuse haulteur, qu'il regarda songneusement, & par grande admiration.

A forest espouentable aiant esté par moy passée, & apres auoir delaissé ceste premiere region par le doulx sommeil qui m'auoit lors espris, ie me trouuay tout de nouueau en vn lieu beaucoup plus delectable que le premier, car il estoit bordé & enuironné de plaisans cotaulx verdoians, & peuplez de diuerses manieres d'arbres, comme chesnes, faux, planes, ormes, fraisnes, charmes, tilleulz, & autres, plantez selon l'aspect du lieu, & abas atrauers la plaine, y auoit de petitz buyssons d'arbrisseaux sauluaiges, côme genestz, geneuriers, bruyeres, & tamarins, chargez de fleurs, parmy les prez croissoient les herbes medicinales, a sçauoir les trois consolides, enule, cheurefueil, branque vrsine, luesche, persil de macedoine, puyoyne, guymaunes, plantain, betoyne, & autres simples de toutes sortes & especes, plusieurs desquelles m'estoient incôgneues. Vn peu plus auant que le mylieu de ceste plaine, y auoit vne sablonniere meslee de petites mottes verdes, & pleine d'herbe menuette, & vn petit boys de palmiers, esquelz les Egyptiés cueillent pain, vin, huille, vestement, & messrain pour bastir. leurs fueilles sembloient lames d'espees, & estoit chargees de fruict, il y en auoit de grandes, moiennes, & petites, & leur ont les anciens donnée ce

POLIPHILE. 4

donné ce tiltre qu'elles signifient victoire, pourautant qu'elles resistent a toute charge & pesant faiz sans qu'on les puisse prosterner. En ce lieu n'y auoit aucune habitation, toutesfois en cheminant entre ces arbres sur main gauche m'apparut vn loup courant la gueule pleine, par la veue duquel les cheueux me dresserét en la teste, & voulu crier, mais ie ne me trouuay point de voix. Aussi tost qu'il m'eut apperceu, il s'en fuyt dedás le boys. quoy voiát ie retournay aucunemét en moy, & leuát les yeulx deuers celle part ou les môtaignes s'assembloient, ie vey vn peu a costiere vne grande haulteur en forme d'vne tour, & la aupres vn bastimét qui sembloit imperfaict, toutesfois a ce que i'en pouoie iuger, c'estoit de structure antique.

Du costé ou estoit cest edifice, les cotaulx se leuoient vn peu plus hault, & sembloit ioindre au bastiment qui estoit assis entre deux montaignes, & seruoit de closture a vne vallée: parquoy estimant que c'estoit chose digne de veoir, i'adressay mon chemin celle part: mais tant plus i'en approchoye, plus se descouuroit cest œuure magnifique, & me croissoit le desir de la regarder, car elle ne resembloit plus vne tour, ains vn merueilleux obelisque, fondé sur vn grand monceau de pierres, la haulteur duquel excedoit sans coparaison les montaignes qui estoient aux deux costez. Quand ie fu approché tout pres, ie m'arrestai pour contempler plus a loisir si grãde insolence d'architecture qui estoit a demy demolie, côposée de quartiers de marbre blãc assemblez sans cyment, & si bien adiousté, que la ou elle estoit encores entiere, la pointe d'vne aiguille n'eust sceu entrer entre deux pierres. La y auoit de toutes sortes de colonnes, partie tumbées & rompues, partie entieres: & en leurs lieux, auec leurs chapiteaux, architraues, frizes, cornices, & soub assemens, de

A iiij

317. *Poliphilus Asleep* and *Poliphile Contemplating Ancient Ruins in his Dream*, from *Hypnerotomachia Poliphili* or *Discours du Songe de Poliphile*, Paris, Kerver, 1546. Paris: Bibliothèque Nationale de France, rés. g Y² 41.

318. Jean Cousin the Elder, *Landscape in a Cartouche*, mid-sixteenth century. Woodcut. Paris: Bibliothèque Nationale de France, Ea 25d rés.

arbofcelli,&di floride Genifte,&di multiplice herbe ucrdiffime, quiui
uidi il Cythifo,La Carice,la commune Cerinthe. La mufcariata Pana-
chia el fiorito ranunculo,&ceruicello,o uero Elaphio,&la feratula,&di
uarie affai nobile,&demolti altri proficui fimplici,&ignote herbe& fio
ri per gli prati difpenfate. Tutta quefta læta regionede uiridura copiofa-
menteadornata fe offeriua. Pofcia poco piu ultra del mediano fuo,io ri-
trouai uno fabuleto,o uero glareofa plagia, ma in alcuno loco difperfa-
mente,cum alcuni cefpugli de herbatura.Quiuial gliochii mei uno io-
cundiffimo Palmeto fe appræfento,cum le foglie di cultrato mucrone
ad tanta utilitate ad gli ægypti,del fuo dolciffimo fruéto fæcúde&abun
dante.Tralequale racemofe palme,&picolealcune,& molte mediocre;
&laltredrite erano &excelfe,Eleéto Signo de uiéctoria per el refiftere fuo
ad lurgente pondo.Ancora&in quefto loco non trouai incola, ne altro
animale alcuno.Ma peregrinando folitario tra le non denfate, ma inter-
uallate palme fpeétatiffime,cogitando delle Rachelaide, Phafelide,& Li
byade,non effere forfaa quefte comparabile. Ecco che uno affermato &
carniuoro lupo alla parte dextra,cum la bucca piena mi apparue.

319. *Poliphile Contemplating Ancient Ruins in his Dream*,
from the *Hypnerotomachia Poliphili*, Venice, Alde, 1499.
Paris: Bibliothèque Sainte Geneviève.

two centuries, they have ascribed its illustrations
sometimes to Jean Cousin, sometimes to Jean
Goujon. Most of the images are copied from the
famous Aldine edition of 1499—an important
monument in the history of illustrated books.
However, the appropriation is made with such
freedom and intelligence that every aspect has
been rethought. Firmin-Didot insisted specifi-
cally on the vignette from the fourth sheet, where
the French artist added a background landscape
filled with ancient ruins (figs. 317 and 319). The
motifs preferred by Cousin are clearly recogniz-
able—especially a half-buried arch, which is so
often repeated in his works it would seem to pos-
sess some particular significance for him. On the
other hand, the frontispiece, with its female fauns,
appears completely unrelated to what we know of
Cousin's art. Already, Pierre-Jean Mariette
believed he saw in it the style of Jean Goujon,

probably in comparison with the Vitruvius edi-
tion also translated by Jean Martin and published
the following year. The idea is seductive, but it
would be unwise to limit the alternatives to these
two great names, when the solution may lie else-
where. Nonetheless, it is difficult to ignore the
similarities between landscapes in the 1543 *Orus
Apollo* and those of *Poliphile*, published by the
same editor, only three years apart.[61] If Cousin is
not their author, then we must assume the
involvement of some other outstanding artist,
whose name we do not know, and who certainly
played a major role in establishing the new style.

Jules Renouvier, followed by Firmin-Didot,
attributed to Cousin one of the most handsome
illustrated books of the period, the account of Henri
II's entry into Paris, published by Jacques Roffet in
1549 (figs. 320 and 321). However, Maurice Roy's
discovery of an archival document convinced
scholars that Jean Goujon was their author and that
the question was settled.[62] The authority of Pierre
du Colombier on matters relating to Goujon defini-
tively confirmed the theory; however, the great
scholar was somewhat hasty in his conclusion. Jean
Goujon was paid forty-five *livres* "for having had
painted on the wooden blocks the figures of the
arcs, obelisks, Notre-Dame bridge, and other things
for the entries, for their printing."[63] Maurice Roy
went so far as to claim that the text "causes one to
presume that Jehan Goujon must have cut the
wood-blocks for these handsome engravings him-
self."[64] This is highly improbable. In his work on
Goujon, Pierre du Colombier does not attribute the
woodcutting to the artist—it would surely have
been entrusted to professionals—but does credit
him with drawing on the blocks. Unfortunately, to
the extent that it is at all explicit, the document's
text affirms exactly the opposite of what it is said
to mean: Goujon was *not* paid for *painting* the
blocks, but for "having had painted" the wood in
question. In fact, the plates in the book are not very
consistent. Did Goujon do part of the work him-
self? Not impossible, but nothing proves that he
did. His responsibility as described in the docu-
ment was strictly to ensure that the work was
done—and done well.[65]

Jean Goujon, Jean Cousin, and Charles
Dorigny were the principal artists in charge of

320. *Arch of the Saint-Denis Gate*, from the booklet
for the triumphal entry of Henri II into Paris, 1549.
Paris: Bibliothèque Nationale de France, AA1 rés. (Goujon).

321. *Fontaine du Ponceau*, from the booklet
for the triumphal entry of Henri II into Paris, 1549.
Paris: Bibliothèque Nationale de France, AA1 rés. (Goujon)

decorations for the exceptional festival marking the entry into Paris of Henri II. That Goujon should have drawn directly on those blocks representing decorations for which he was himself responsible, such as the Fontaine du Ponceau, is perfectly logical. Others are probably not by him. Some of the images share characteristics that definitely belong to Cousin's style. However, does this result from his having drawn the illustration, or is it merely that he designed the decorations represented? In some cases, the individual in charge of illustration may simply have transcribed onto the block (the payments are specifically for this labor) a drawn model. With these precautions in mind, it seems to me that the plate depicting the captain of the children of the city has a graphic style, and several motifs—like the lion masks—which are so close to what we know of Jean Cousin that it is difficult to refuse him their authorship. The carving is so skillful that

the print clearly remains faithful to the hand that drew it (fig. 322). Was Charles Dorigny also involved in preparing the book? Our ignorance concerning this highly placed artist is more extreme than in the case of Cousin.

This magnificent book has a twofold importance; first as a work of art in its own right, and also because it represents the only visual testimony from an event of capital importance. Henri II's triumphal entry into Paris in 1549 was the occasion for a veritable manifesto of classicizing art.[66] Temporary decorations were one of the most significant art forms of the Renaissance both in France and elsewhere.[67] I do not treat the subject in detail in these pages because the present volume is founded on visual analysis: such decorations have often left little or no visual record of what they looked like. They were the occasion for artists temporarily to transform the

322. *Captain of the Children of the City*, from the booklet
for the triumphal entry of Henri II into Paris, 1549.
Paris: Bibliothèque Nationale de France, rés. 4° Lb³¹ 20c.

323. *Figures de la sainte Bible*, published by Jean Leclerc, 1614.
Paris: Bibliothèque Nationale de France, rés. A 1401.

city according to their imagination. At a time when the Louvre was just beginning to rise from the ground, these ornaments allowed them to show off what a Paris of the future looked like in their dreams. At the same time, the Fontaine des Innocents, inaugurated on this occasion, was already an important promise of things to come.

As an illustrated volume, and documentary evidence of the proceedings, the book commemorating Henri II's triumphal entry into Paris, is characteristic of Jean Cousin's role, as we understand it. He was at the center of the effervescent cultural and artistic milieus transforming France during the sixteenth century. However, the form and extent of his involvement are practically impossible to determine—not only for lack of sufficient documentation, but also because the nature of collaboration renders arbitrary such a precise attribution of responsibilities. This is true for all of Cousin's relationships with publishing. He may only have participated occasionally. His son continued the

same range of activities, and probably made drawings for book illustrations. The *Livre de la Fortune*, though it remained a manuscript, was surely intended for publication in print: the title page even includes the name of a publisher. In fact, the manner of the drawings follows the paternal hand so closely that I have wondered if this protracted effort had not been initially undertaken by the elder Cousin. After all, in the last year of his life the younger Cousin published the *Livre de pourtraicture* that his father had announced thirty-five years earlier.[68] His relationship with the publisher, Jean Leclerc, may not have been limited to his *Livre de pourtraicture*. What one may call the Cousin style persists in the illustrated Bibles published by Leclerc after the turn of the century and reprinted frequently thereafter (fig. 323). Perpetuated by his son, coarsened by the woodcuts of semi-popular editions, the faint but distinct echoes of an art Jean Cousin developed in the mid-sixteenth century reverberate well into the seventeenth.

Chapter IX

PARIS AND THE PROVINCES

Paris enjoyed a position of enormous importance during the Renaissance, as it had in the Middle Ages, due to its status as a capital, its wealth, and its European-wide reputation for luxury. Its preeminence, however, had faltered somewhat during the Hundred Years' War and under English occupation. Even after the struggle's end, the kings of France long continued to shun their capital. But as the modern state took shape under François I, it demanded centralization of power and consequently an increased role for the capital. Significantly, after his return from captivity in Madrid François I announced that he would establish his residence in and around Paris. From this point forward, the Île-de-France acquired a greater importance, eclipsing the Loire regions where the court had primarily remained since the reign of Louis XI. Thus we see Jean Clouet, who enjoyed a title of *valet de chambre* to His Majesty, leave Tours and make his way to Paris around 1526.[1]

I stated earlier that the château of Fontainebleau was one of the consequences of François I's decision to settle near Paris. However, in the sixteenth century, Fontainebleau was still far away, a long day's journey from the city. This isolated residence became a center of artistic activity thanks to intense patronage on a scale probably unprecedented outside a city. It became "a new Rome," in Vasari's words. According to van Mander, the biographer of Netherlandish artists, those making the all but mandatory visit to Paris on their way toward Rome frequently stopped at Fontainebleau, and in some cases, went no further.

It was also in Paris that Benvenuto Cellini set up his workshop. As early as 1532 a constant flow of artists went back and forth between Fontainebleau and the capital. It is certain that the death of François I marked a decrease in production at the Fontainebleau site, and it may have been at this time that artists such as Luca Penni and Jean Mignon chose to leave the château for Paris. However, they were continuing a trend that we can see emerging earlier: the sculptor who carved the angels for the *jubé* at Saint Germain-l'Auxerrois, Simon Leroy, was already living in Paris not long after 1540. Nor was the lure of the capital restricted to Fontainebleau. Jean Goujon, working in Rouen between 1540 and 1542, appeared in Paris during 1544 and settled there definitively in 1547. Jean Cousin, as we saw previously, probably established his studio in Paris before 1540, though he continued to be active in Sens.

This inflow of artists toward the capital was counterbalanced by a radiation of Parisian and court art throughout the kingdom. This does not mean, however, that the provincial centers lost all their originality or independence.[2] Two distinct meanings may be attached to the word provincial and both apply here. One celebrates distinctiveness, the rich inflections of a language deeply rooted in local culture: the slightly harsh quality of Burgundian sculpture, the languorous sweetness of art from the Loire. However, the other is often condescending or even pejorative, designating a marginalized culture, one falling behind the great centers of activity, a lesser reflection of the capital or the court. To the extent that the classicizing culture of the Renaissance, as represented in particular by Vasari, is a universalizing creed, it tends to uproot local traditions; even the strong

324. Jean Duvet, *Suicide of Judas*, c. 1560 (?). Engraving, 9 ½ × 6 ¼ in. (24.3 × 16 cm). Paris: Bibliothèque Nationale de France, Ed 1b rés.

contrast between Venice and central Italy was threatened by academicism in the middle of the century.[3]

At this time in France, there was as yet no artistic academicism. The great figures of classicism were dynamic, highly individualized, excited by the shifting assumptions around which a new culture was taking shape. The art produced by these innovators was closely tied to centralized power. In the middle of the sixteenth century, the Fontainebleau classicism of Primaticcio, that of Lescot, Goujon, and de l'Orme, became the dominant art of the capital and of the Île-de-France, but it was above all a royal style. A situation arose in which provincial art was defined by its relation to the 'center'; this center encompassed both the court and capital whose culture, without being exactly identical, was closely bound to the king's entourage. The prestige of court art thus spread everywhere, tending to erase local traditions and character. However, when the circumstances were favorable, the situation could also generate dynamic new relationships between a style with royal connotations and art felt to be local, vernacular, perhaps even in certain cases a popular expression.

Local Specialties

By local specialties I mean those productions specific to a city or a region whose clientele is not entirely local, sometimes hardly at all. Pottery has a strong propensity for becoming such a specialty, at least in part due to its reliance on quality mineral deposits. Beauvais is one instance, winning renown for producing earthenware of a beautiful color. A bottle bearing the arms of the constable of Montmorency, on display at the Louvre (fig. 325) shows that the high nobility placed orders there, and a flask with English arms preserved in the British Museum confirms that it was an international clientele. Naturally, these were not vulgar articles but carefully decorated, quality ceramics.

The west of France especially (Poitou, Charente, Saintonge) was rich in potters, and from there emerged a strange figure at the fringe of our investigations: Bernard Palissy, the artisan-philosopher. His legend so successfully captured popular imagination that he became one of the principal heroes of the sixteenth century.[4] His dense writings are a less vivacious—the French, Protestant equivalent of those by Benvenuto Cellini, but with less verve. The scene where the potting genius throws his last remaining furniture into the kiln in a final attempt that at last breaks the secret of enameled ceramic, bears a strange resemblance to the palpitating narrative of the Florentine sculptor burning everything he has to complete the cast of his *Perseus*, the crowning achievement of his career. One might, of course, ask oneself why Palissy had so much trouble—when high-fired faïence had already been made in France for quite a while—using the Italian technique. Is the narrative purely mythical? In any event, documents confirm that Italian potters

325. *Bottle with Montmorency arms*, after 1551. Terracotta with green enamel, Beauvais or Saintonge, 12 × 10 ¼ in. (30 × 26 cm). Paris: Louvre.

326. Bernard Palissy, *Frog*, fragment from the *Fontaine des Tuileries*, c. 1570. Enameled terracotta, 3 ¾ × 4 ¼ × 2 in. (9.5 × 10.6 × 4.9 cm). Écouen: Musée national de la Renaissance.

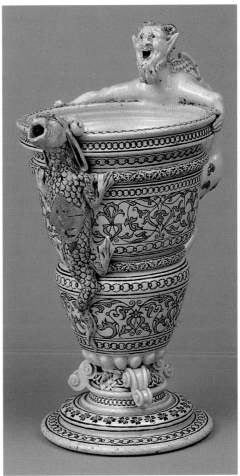

327. *Ewer*, mid-sixteenth century. Saint Porchaire faïence. Perhaps by Bernard Palissy. Écouen: Musée national de la Renaissance.

were established in Lyon by 1512, though we have not identified their works. What *is* clear is that they quickly gathered disciples. Early production in Lyon is indistinguishable from Italian ceramics, whether the potters be themselves Italian or French. Only later did the characteristics peculiar to French faïence begin to appear. In this domain, as in ornamental sculpture, the practitioners did not gradually succeed in imitating the work of the Italians: the imitation was initially faithful and only later differentiated itself.[5] As for Palissy, by the time he appeared onto the artistic stage, French cultural independence was a fait accompli—no offense intended to his originality either as an inventor of forms, or as a thinker. But the height of his art came after the moment we are examining. It belongs to the frenzied culture of the Wars of Religion, and to a time when classicism was being challenged, and not to that of its formation. Though we lack a very precise notion of the grotto he made for Catherine de Médicis at the Tuileries (fig. 326), we can perceive in it an exalted attitude towards nature, very different from the enlightened hedonism that inspired Primaticcio's "grotto in the Jardin des Pins" at Fontainebleau.

Masséot Abaquesne produced glazed faïence in Rouen during the 1540s. While it would be difficult to call regional specialty what was really an individual initiative, a few words are in order regarding his work, which played an important role.[6] He knew how to make glazed faïence of the Italian type long before Palissy's experiments. But Abaquesne was already distancing himself from Italy, notably by exploring new outlets. Italians made hardly anything but crockery: apothecary jars, platters, or the sets of display tableware that Urbino made a specialty of. Indeed, Abaquesne did make objects of this kind—a gourd with his signature on it has survived, Italianate in its ornament but of a traditional French shape. Yet his most original work consisted in providing tiles for the floors of luxury buildings. The staterooms at the château of Écouen were thus tiled, and there

are some remaining examples of this paving. The Amoncourt chapel at Langres cathedral (discussed in detail below) comprises tiling of this kind that appears to have come from the same workshop (fig. 370), as does the Bâtie d'Urfe. These decorations incorporate heraldic signs and were custom-designed. Here, as in the professions examined during our consideration of Jean Cousin, an artist would draw up a project, which Abaquesne then executed in Rouen (or sometimes in Paris). Thus, a great part of his production belonged to the radiation of court art and had no specifically local character. A few narrative panels have also come down to us, indicating that such ceramics could be used as wall decoration. Was this innovation inspired directly by the Ottoman Empire where Isnik pottery was at its dazzling zenith? Or did Spain supply this idea? In any case it is clear that these French ceramics have little but technique in common with their Italian antecedents.

What we call—rightly or wrongly—Saint Porchaire earthenware (fig. 327) are the ceramics most characteristic of the cultural metamorphosis of the mid-century. These consist of highly elaborate decorative objects—saltcellars, incense burners, small ewers—of extremely limited usefulness. Their often complex forms are not those associated with ceramics but rather evoke a transposition of the goldsmith's art. The virtuoso potters often applied separately modeled pieces: masks, small figures, and others. The decoration is of exceptional elegance; the background is cream-colored; in the ornamental motifs, consisting primarily of tracery and arabesques, the dominant colors are ocher and brown with some brighter accents, usually green or yellow. Here again, the coats of arms on certain items, and the mention of such objects in the inventory of Montmorency demonstrate that great lords did not disdain the genre. However, it does not seem unlikely that these less expensive adaptations of high luxury articles were made to satisfy the aspirations of a lesser class.

The painted enamels from Limoges require a more sustained discussion. That of Limoges is the most distinctive of the provincial productions, and one of the most popular contributions of the French Renaissance. Manufactured in a remote provincial city, these painted enamels were prized throughout Europe. The history of enamelwork in Limoges goes quite far back. From the twelfth to the fourteenth century there was a massive production of liturgical accessories in cloisonné enamel or champlevé (reliquaries, pyxes, bishop's crosses).[7] There was no continuity between the workshops producing these items and the manufacture of the painted enamel under discussion here, but the memory of this brilliant period was surely still alive. The new technique introduced in the fifteenth century was not a local invention. Jewelers employed comparable translucent enamel at a variety of centers in Italy, as well as in Northern Europe. A pax donated in 1434 to the church of Saint Germain in Rennes is considered to be the earliest example known employing a technique approximately that of the Limoges enamels—that is, enamel over copper. Two medallions by Jean Fouquet are also earlier than the Limoges workshops. The copper support, in contrast with the translucent enamel over precious metal, distinguishes the new technique from that practiced earlier by goldsmiths. It would allow for the creation of much larger enamels, first little pictures with which to create portable triptychs; later on it was used for tableware and there were even occasionally plaques large enough for monumental decoration.

The enamel workers of Limoges are often called goldsmiths in period documents, but sometimes also painters, and some of them practiced stained glass—an art not unlike enamel in both technique and effect. Painted enamel lies at the intersection of these three techniques. Vitrification produces a transparent and luminous material applied in uniform areas on which modeling is achieved by crosshatching akin to the grisaille used in stained glass. Also, as in stained glass, hematite is used for flesh tones. Nonetheless, the crafting of metal and the nature of the objects produced draw the enamel worker close to the goldsmith.

During a first phase lasting approximately from 1480 to 1530, the subjects of these enamels were almost all religious, and the compositions display a vernacular style which appears to be derived from a simplification of Franco-Flemish manuscript illumination. The manner is reminiscent of

that of woodcuts, although very few instances from this period have been found whereby enamelers used such prints as models. The effect produced by certain enamels is close to that of a colored woodcut, although the hues are more intense. Yet, this manner of indicating the folds of drapery by means of monochromatic lines superimposed on the color is also a principle of stained glass.

Throughout this period, various workshops produced small triptychs, medallions, and plaques to adorn box lids and other objects in this semipopular style. All were anonymous except for that of Léonard (aka Nardon) Pénicaud. Then, after 1530, there was a complete transformation of the production by a new generation of enamelers whose names are known and who often signed their work. The most important of these are: Jean Pénicaud (known in documents as Jean Pénicaud II and occasionally signed as Pénicaud Iunior), Léonard Limosin, the most famous among them, and Pierre Reymond. Around 1540 new uses for their craft arose—especially display tableware. The subjects also changed, with secular themes as well as more diverse Biblical subjects, such as Old Testament scenes that may have appealed to a Protestant clientele. All this was dressed in a new repertoire of classicizing forms. The renewal of Limoges enamels was complete.

The advent of a new generation certainly played an important role in this sudden transformation, but credit is also due to the efforts of Jean de Langeac, bishop of Limoges at a decisive period from 1533 until his death in 1541. The prelate belonged to the king's entourage and was an active patron. Two monuments at the cathedral bear witness to his generosity. The magnificent *jubé* (today displaced and serving as an organ loft) must have been commissioned almost as soon as he took office since one can read the date 1533 on the monument itself. It perfectly exemplifies the ornate style of the early French Renaissance (fig. 19). At the other end of his tenure, the bishop's tomb, commissioned in his lifetime, exhibits early elements of a fully developed French classicism.[8]

The exceptional standing accorded to Léonard Limosin was due to Jean de Langeac, who introduced the enameler to the court. The consequences of this for Léonard were immense. For one thing, he secured important royal commissions; for another, this brought him into direct contact with court art. He specialized in enamel portraits; using Clouet's drawings, or copies of them, he produced versions that, if they betrayed a certain stiffness, were, however, highly durable and had scintillating colors. In this genre we still have a portrait of the constable of Montmorency in a frame inspired by the Galerie François I (fig. 328), one of Queen Eleanor, dated 1536, and many others that cannot always be identified. The court artists made special drawings in the case of enamels executed for the king. In 1547 Léonard produced a series of apostles for which Primaticcio himself provided the drawings and one of his assistants, Michel Rochetel, prepared the templates. An even more ambitious project was launched in 1553: two complex altarpieces destined for the Sainte Chapelle. Their design was one of the first tasks entrusted to Niccolo dell'Abbate upon his arrival in France—evidence of the extreme care devoted to these works. It also demonstrates that in such cases Léonard Limosin's role was strictly one of execution. Yet his ambition was surely to be considered a fullfledged artist. As early as 1536 he begins to sign his work "Leonardus Lemovicus inventor." In 1544 he tried his hand at a few etchings, adopting a rough technique and brisk handling, as practiced at Fontainebleau. However, they depict traditional religious subjects (the life of Christ, the Annunciation) that correspond to his sets of enameled plaques, several examples of which survive with variants. One wonders if Léonard did not have in mind a kind of catalogue of compositions that he might propose to clients at a distance. We even have a painting by the hand of the great enameler, an altarpiece representing Doubting Thomas. Made in 1552 for the church of Saint Pierre-du-Queyroix in Limoges, it is a painting in the Italian manner, hardly inspired but which testifies to a respectable competence in painting. Undoubtedly, Léonard Limosin, and to some extent his colleagues as well, cut the figure of real artists in their region. In 1564, we find them summoned to Bordeaux in order to take charge of the necessary decorations for the entry of Charles IX into the capital of Aquitaine.

328. Léonard Limosin, *Portrait of the Constable of Montmorency*, 1556.
Painted enamel on copper, 28 ⅓ × 22 in. (72 × 56 cm).
Paris: Louvre.

the German engravers. The motifs and compositions were freely adapted so that the results appear neither disparate nor incongruous. The art of the enameler consists in successfully adapting the composition he borrows to the form of the object he applies it to, so as to achieve a harmonious decorative effect. Yet the pictorial aspect of his work is not to be ignored, and different masters did not all paint in the same manner.

Léonard Limosin, doubtless because of his artistic ambitions and direct contact with court art, was the most versatile. Jean Pénicaud II, on the other hand, was more of an individualist, his workmanship less conventional. In him we get the sense of a true painter working in enamel, particularly successful in plaques with small, delightful scenes. He was a master of delicate variations in grisaille, and his best works achieve a distinctive classical feeling. Pierre Reymond mostly made luxury tableware and in this genre was without

329. Pierre Reymond, *Abraham Refusing Gifts from the King of Sodom*,
c. 1550. Copper platter with painted enamel.
Paris: Louvre.

Two things, however, betray the artisanal character of their work: the creation of several examples from a single prototype, and the consistent use of prints as models. This utilization of prints appears to have increased drastically with the transformation of Limoges enamelwork during the fourth decade of the sixteenth century; at least, known instances—as I pointed out above— are relatively rare in the earlier years. In the 1540s they became innumerable, to the extent that one is astonished *not* to find an engraved source for a motif. Meanwhile, during these years when classical taste reigned supreme, the vivid coloration characteristic of enamelwork lost ground to monochromatic grisaille. The prints of Marcantonio Raimondi and his school were appropriated on a regular basis, as were those from Fontainebleau, but never exclusively. In spite of the pervasive tendency to classicism in this period, our enamelers appear irreducibly eclectic. The motifs borrowed from Fontainebleau—from Étienne Delaune, Jacques Androuet du Cerceau, or Bernard Salomon—are integrated not only with Italian ones, but also with those of Lucas van Leyden and

equal for his grisaille decoration and use of ornamentation (fig. 329). His production was substantial, and one exceptionally well-documented work bears witness to his prestige. This is a large set of tableware that bears the date of 1558, made for a Nuremberg merchant, Linhard Tucher. Some of the items were crafted in Nuremberg by the famous goldsmith Wenzel Jamnitzer then dispatched, via Lyon, where the Tuchers had an office, to be enameled in Limoges. The works of

Pierre Reymond show an extraordinary talent for ornament: foliage, garlands, arabesques, masks, numerous motifs of diverse origins are incorporated into a design skillfully adapted to the shape of the object. Even in figurative compositions, such as the Old Testament episodes depicted on many plates, he imposes a distinct rhythm, articulating the surface—whether it be the belly of a ewer, the dimpled top of a jar, or just a plate.

Even more than the virtuosity of his workmanship, his mastery of rhythm is probably what makes Pierre Reymond one of the great artists of his time.

The patronage of Jean de Langeac in monumental art had no lasting effect in Limoges, but the aesthetic renewal in the enamel industry had consequences that were to last the remainder of the century in response to an insatiable appetite for sumptuous items among the wealthy.

Innovation in the Provinces

Despite the hegemony of Paris, remarkable initiatives took place in regions scattered all over the kingdom during the decisive years just before the middle of the century. One of the more surprising is the chapel at Vannes, previously addressed in Chapter I. Here, the introduction of the orders, and an architecture modeled on antiquity, form an isolated experiment inspired directly by Rome. There is no apparent connection with the art of the French court. More generally, the significant role played by prelates in the development of

classicism in France may be partly attributable to their ties with Rome. However, by and large, they belonged to the upper aristocracy and the sphere of the court. It is appropriate to insist on the important position occupied by prelates in the diffusion of court-inspired classicism. We have already encountered François d'Estaing and Georges d'Armagnac who successively contributed to making Rodez an epicenter of the French Renaissance. Geoffroy d'Estissac, bishop of Maillezais and benefactor of Rabelais, played

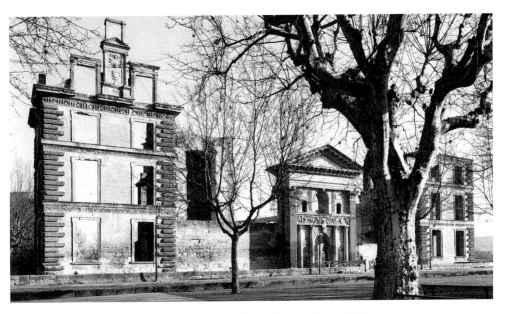

330. La Tour d'Aigues (Vaucluse, France), château, main façade, c. 1560–70.

315

331. Bournazel (Aveyron, France), château, façade, c. 1545.

a similar role in the region of Fontenay-le-Comte. He commissioned one of the first classical *jubés* for his cathedral; around 1540, he also ordered the construction of the château of Coulonges-les-Royaux on behalf of his ward Louis d'Estissac. The vestiges of this edifice, now all but destroyed, reveal a highly innovative monument. Substantial portions of the decoration were recycled and incorporated in the château of Terreneuve, and these attest to a highly refined and classicizing taste: the finesse and elegance of their execution competes with that of the most sumptuous constructions in Île-de-France. The patronage of the Cardinal de Givry at Langres and its effects will be examined later in some detail.

The château de Bournazel, near Rodez, is another precocious example of classicizing innovation (fig. 331). Both more ambitious and more successful than the chapel at Vannes, which it postdates by several years; the château belongs to what can already be described as a regional development. This monument of exceptional novelty and originality is generally perceived as stemming from the tenure of bishop Georges d'Armagnac in Rodez. The cultivated prelate, let us recall, had a secretary named Guillaume Philander, an architectural theorist who was also something of an architect himself (see Chapter I). The master at Bournazel, whether or not it was Guillaume Lissorgues, was clearly independent of the architects in Île-de-France, and his taste for ornaments strongly inspired by antiquity seem to me cultivated through the close study of the Roman ruins so common in the South of France. Not far from Bournazel, the château of Graves is a repetition of the same ideas on a smaller scale.[9] Twenty-five years after Bournazel, the château of La Tour d'Aigues in Provence shows signs of a

similar aesthetic sensibility (fig. 330). Here the recollection of the antique monuments of Provence is even more obvious. Without affirming a strict continuity, it is reasonable to assume some relationship between these buildings whose particular character seems reflective of geographic position. It would, however, be imprudent to speak of a "Southern School."

The southern French classicism of La Tour d'Aigues is a different phenomenon from that apparent at Lanquais in the Perigord. This château is entirely isolated and completely dissociated from any local tradition. Its sophisticated artistry suggests close kinship with the architectural practice of the king's works—especially, I think, that of Lescot. At a time when religious conflicts wreaked havoc in the kingdom, and on this region in particular, the château stands as a declaration of royal power.[10] It may be tempting to contrast local developments perceived on the one hand as the spontaneous assimilation of Renaissance forms, and, on the other, a radiating extension of a royal, or metropolitan style. Unfortunately this distinction is far from precise or easy to make; it seems clear that the classicism of Bournazel or La Tour d'Aigues, if not royal and centralizing in its resonance, implies at least a statement of class, since the new style presented itself as distinctly aristocratic.

There were great disparities among the provinces in their artistic production and each experienced different periods of achievement and stagnation. Breathtaking while its dukes were at the height of their power, Burgundy lost its position, but continued to produce a substantial quantity of sculpture. Yet, in the second half of the sixteenth century, the striking figure of Hugues Sambin defined an innovative style in Dijon that radiated all the way into Franche-Comté. Normandy experienced an exceptional period in the first three decades of the 1500s. At the château of Gaillon, Italian features were introduced at an early date and took root promptly; the Flamboyant art so dynamic there (Saint Maclou in Rouen

springs to mind) had no difficulty assimilating the imported elements in a creative synthesis. What is more, foreign influence was not restricted to Italy. Jean Lafond has succeeded in reconstructing the career of Arnoult de Nimègue, a master of stained-glass painting trained in the Netherlands, who dominated the art in Normandy through the first part of the century.[11] Hector Sohier completed one of the most significant works of the period: the choir of Saint Pierre de Caen, which deploys to its fullest possible extent the harmonization of Flamboyant construction and Italianate ornament. The concept of prismatic geometry is applied to the entire building, and accentuated by the ornamentation, which appears not only on the balustrades, as was traditional, but on the whole of the exterior. The full round fenestration and tracery are absolutely regular. The buttresses are in such slight relief that they appear reduced to spines whose vertical accents are extended at the top by narrow candelabra. This highly original formula imparts an abstract quality to the radiating chapels.

The first French Renaissance made enormous strides in Normandy and sustained its creative momentum until quite late. The hôtel d'Écoville in Caen, for example, built between 1535 and 1540 by Blaise Prestre, inflects the style of the Loire towards greater monumentality. Its decoration is already classicizing but bears no apparent relation to court art.[12] Valmont (see Chapter I) has a similar inspiration. Nonetheless, sometime around the middle of the century, this movement ground to a halt. Despite the presence of Jean Goujon around 1540, and the construction of several innovative works, such as Brezé's tomb and la Fierté de Saint Romain, Normandy failed to produce any really original art in the second half of the century. An exception must be allowed for the Norman part of the Vexin, with the remarkable façade of the church at Le Grand-Andely and that at Gisors. But we are here at the outer reaches of Normandy, and the whole of Vexin, both Norman and French, turned toward the Île-de-France for inspiration.

Three Provincial Centers: Toulouse, Lyon, and Troyes

Toulouse underwent an artistic development parallel to that of the Île-de-France. One of the furthest cities from the capital, its independence rested on the presence of both a strong local government (the *capitouls*) and a parliament representing the monarchy. The latter, jealously protective of its prerogatives, often opposed the *capitouls*, but occasionally made alliances with them to defend the autonomy of Toulouse.

The means for cultural development in Toulouse during the sixteenth century came as a result of the sudden and precarious wealth generated by the market for pastel—a plant yielding pigment for which there was a high demand at the time, before being superseded at the end of the 1560s by the discovery of indigo. The extraordinary growth of the pastel industry in the region owed its success to the combination of favorable climactic and geographical factors with an early capitalist system essential to its

production. Because the time between sowing the plant and selling the pigment is relatively long, the substantial investment necessary produced no returns for a minimum of two years. It was thanks to the expansion of the banking system, particularly in Lyon, and the initiatives of a few intrepid speculators, that Toulouse became for a short time spectacularly rich. Pastel producers and parliamentarians could thus for a time afford to spend generously on the patronage of original art.

One artist of great talent gave shape to this Toulouse Renaissance, and defined its character: Nicholas Bachelier. Of course, we should not accord him exclusive credit. The decoration at the hôtel de Bernuy, enlarged between 1530 and 1536, demonstrates that the new forms had already infiltrated Toulouse before Bachelier. Furthermore, it indicates what would become the favorite object of patronage: the *hôtel particulier*,

332. Toulouse (Haute-Garonne, France), hôtel de Bernuy, courtyard façade, 1530–36.

334. Toulouse (Haute-Garonne, France), hôtel de Bagis, door (detail).

333. Toulouse (Haute-Garonne, France), hôtel de Bagis, door, c. 1538.

The door of the main building, opening onto the straight-flight main staircase, is monumental, both erudite and forceful (fig. 333). It may well be the most famous Renaissance work in Toulouse—deservedly so, as it exemplifies Bachelier's expressive and animated manner. The flanking atlases have been compared to Michelangelo's *Moses* but this genealogy is as

335. Toulouse (Haute-Garonne, France), hôtel de Bagis, staircase (detail).

or townhouse, and occasionally the château, approached with the same attitude (fig. 332). Thus Bachelier, an altarpiece sculptor when he arrived, lost no time applying himself to architectural decoration. He was not a native of Toulouse. Born in Arras in 1500, he appeared in Toulouse no earlier than 1532, without any indication of what his training or previous endeavors had been. He very quickly became a dominant artistic personality. In him, the city found an artist able fully to express its exuberance and modernity, its unique character. For twenty-five years, until his death in 1556, no more than a few months elapse without mention of him in archival documents. It would appear that the forceful, opulent manner we are tempted to describe as typical of Gascony, was in fact perfected by a Northerner, though one who had presumably spent time in Italy, perhaps also Spain. By 1538, at the hôtel de Bagis, we already had a cogent example of his style.

specious as it is illustrious, and conceals a more likely kinship with the work of Giulio Romano (fig. 334). The acanthus volutes crowning the composition and the frieze on the architrave express a far stronger grasp of classical vocabulary than that wielded by the previous generation

319

working at the hôtel de Bernuy. Framing the emblem on the frontispiece, the *"cuir"* —a strap-work sheet of leather unfurled behind the crest— signals Bachelier's awareness of the latest fashions. Rosso had just invented the motif at Fontainebleau. As for the siren or angel figures arching into the frontispiece, they are a legacy of the Quattrocento, tinged perhaps with a hint of the Northern adaptations practiced by Lucas van Leyden and others. However, the traditional theme is approached by Bachelier with a curvaceous fullness and deftness exclusively his own. The coherent composition fully integrates the disparate ornamental vocabulary, which Bachelier masters completely. The modeling, almost comic in its excess, and the aggressive chiaroscuro effect are without precedent, and

337. Saint Jory (Haute-Garonne, France), château, fireplace (detail).

336. Nicolas Bachelier, *Adoration of the Magi*, bas-relief from the Dalbade altarpiece, 1544–45. Stone, 59 × 33 in. (150 × 84 cm). Toulouse: Musée des Augustins.

establish Bachelier as one of the period's most daring sculptors. But the artist did not restrict himself to decorative sculpture and his work at the Hôtel Bagis displays a concern with architecture in the strict sense.

Incorporating a straight-flight grand staircase into the main building was not unique in France at the time. François I's château at Villers-Cotteret proudly displayed this particular Italianism, but Bachelier handles it better. His staircase possesses greater majesty and sheds the picturesque but misplaced decoration featured throughout the royal building. Of course, the façade at Bagis still falters in places. Awkward hesitation affects the design of the windows, where traditional mullioned frames are supplemented with antique-style ornamentation. However, Bachelier exhibits great skill in juggling the interplay of stone and brick—a feature destined to remain characteristic of the Renaissance in Toulouse, and one deeply rooted in local traditions. Stone was expensive here, where it had to be imported, so the city was constructed almost entirely of brick. As a result, the local masons developed sophisticated bricklaying techniques.

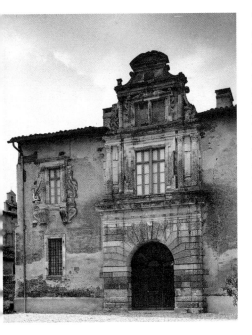

338. Saint Jory (Haute-Garonne, France),
château façade prior to restoration, after 1545.

They employed a variety of coursings that are precisely stipulated in surviving contracts, and used a layer of powdered brick gesso to mask irregularities. Alternating brick and stone was a traditional technique; it can be seen on the piers at Saint Sernin. There are also early examples where actual bricks have been plastered over and larger, simulated bricks painted on to make them visible at a distance. Bachelier fully engaged with this local tradition. In other regions where we encounter the combination of brick and stone, such as Vallery, the brick is used for economy. It is relegated to the parts of the wall we might call inert; Bachelier casts brick as a protagonist. On the second floor of the château de Saint Jory, the monumental brick and stone fireplace has a curved frieze and molding of brick cut like stone rather than molded (fig. 337). The doorway of the rear façade is similar: brick and stone combine in a complex pattern especially pleasing on the intrados.

Saint Jory's façade (fig. 338) is interesting for its own sake, but also because of a surviving contract from May 17, 1545. It describes what could be seen on a drawing (*"portraict & montre"*)

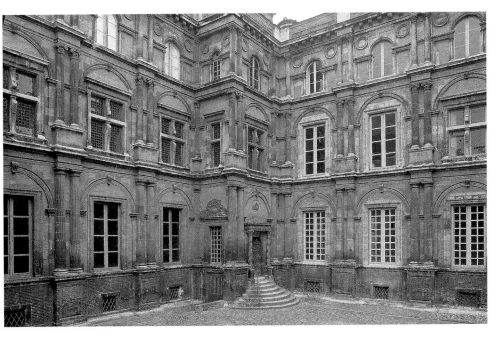

339. Toulouse (Haute-Garonne, France), hôtel d'Assézat, courtyard façade, c. 1555.

321

made by the hand of Bachelier. From it, we learn that on the ground floor the principal ornament of this updated façade, the portal, "will be made in a rustic style up to the architrave, of hard gray stone, dressed so it may look natural rather than artificial. The four columns standing above the pedestal will be Corinthian, with well worked capitals and bases, made to replicate those of the Rotunda in Rome, or exceed them if possible."[13] Obviously, the author is showing off his knowledge. Gébelin, a harsh critic, found that "this is the architecture of a docile student, and a student lacking in instruction at that."[14] He spared no pains in pointing out Bachelier's flaws, not to mention barbarisms, such as the idea of modeling colonnettes on the columns of the Pantheon. He found the crossettes of the windows too prominent, and the ornament altogether excessive. At the same time, he claimed to detect a threatening academic quality in the budding ambitions of this classicism. Might one not reverse the argument and tax his own critique with rigid academicism towards a contract that simply expresses enthusiasm for exploring an antiquity that was, so to speak, brand new at the time? In any event, it would be highly unwise to assume that these few words, whose value is ideological rather than theoretical, even begin to describe the full intentions of the artist and patron. Bachelier's task at Saint Jory was not to construct a new edifice, it was to bring an existing building up to date. This he did very skillfully. Gébelin may have been mistaken to conclude from the "inaccuracies" he found that Bachelier's knowledge of Italian art came only from books and that he had never spent time in Italy. Of course, knowledge of classical ornament by no means automatically suggests a visit to Italy: there were plenty of excellent examples in France, some in Toulouse itself. However, relief panels from the dismembered altarpiece of the Dalbade[15] (now in the Musée des Augustins, Toulouse) betray a complex artistic culture, comparable to that of Romanizing Netherlandish artists like Martin van Heemskerk. In the Dalbade *Adoration of the Magi*, there are—it appears to me—traces of the unfinished *Adoration of the Magi* by Leonardo. The influence may be direct or mediated, but nude horsemen astride rearing

mounts are hardly a commonplace motif, or one likely to be invented twice. I also believe that the Virgin in the *Adoration of the Shepherds* was inspired by Raphael's *Alba Madonna*, unless they shared a model Bachelier encountered directly in a Leonardo drawing (fig. 336).

There is no doubt that we must also give credit to Bachelier for designing the hôtel d'Assézat, and see it as the culmination of his classicizing and modernist ambitions. He died in 1556, a year after signing the work agreements for this urban residence of a wealthy pastel merchant. If Pibrac, sometimes attributed to Bachelier, is the "most Gascon of all the Gascon châteaux,"[16] then the hôtel Assézat is certainly the region's most French monument from the sixteenth century, and its most fashionable—assuming fashionable to mean Parisian-looking. Significantly, brick gives way to stone for the most part. Originally, the building had only two main wings at right angles joined in the corner by a block, which jutted forward to accommodate the straight-flight main staircase. To the right of the courtyard, the upper passage or gangway supported by brackets is a later addition, as are the street side main entrance and the portico. Yet these elements fully partake of Bachelier's ideas. The large Ionic brackets supporting the gangway, for example, are so close to his style they could be mistaken for his own. Such faithful adherence to his principles, even after his death, says something about the depth of his effect on Toulouse art.

The composition of the courtyard façade of the hôtel d'Assézat is magnificent (fig. 339). It has often been compared with Lescot's at the Louvre, at times deemed equal to it.[17] The façade's regular cadence, established by the paired columns, is somewhat more Italian in its inspiration than is the royal residence, where Lescot employs the motif to emphasize the projection of his antechapel, not for punctuating a continuous wall. The idea of housing the main staircase in a block extended forward from the corner is a traditional one, though rather unexpected in Bachelier, who had learned early on how to integrate a monumental staircase into the main building. In all probability, the constraints of a plot too small for the builder's ambitions led him to settle for this option. The fact

remains that the older architectural feature was difficult to integrate within a classicizing composition. As a result, the treatment is fairly strange and it is difficult to distinguish between calculated tradeoff, clumsiness, and eccentricity. Having adopted, or acquiesced to this idea of a corner stair tower, the architect elected to emphasize it by elevating that corner of the building above the rest. The upper portions are picturesque with a spiral stair turret in contrast with the classical orders. Below, on the other hand, he sought to integrate the building with the courtyard façade. The asymmetric extension created an additional challenge. Bachelier could not simply prolong the rhythm of bays flanked by paired columns; the short side of the pavilion is obviously too short. In the far right corner the architect used two columns, one to each side, as one would expect. But for the protruding angle, ostensibly to lighten the shorter wall, he moved both columns around to the longer side, with one of them at the corner itself. Finally, at the far left, he inserted a single column where the buildings meet, interrupting the rhythm of double columns but preserving symmetry on the short wall. It must be said that these compromises, which sound so strange, are actually quite pleasing to the eye. In final analysis, the architect succeeded in composing a single rhythm unifying the different façades.

It is not clear whether Assézat was much appreciated in Toulouse itself. Certainly the townhouse known as the hôtel du Vieux Raisin, which must postdate Bachelier's work, explores a radically different aesthetic. It manifests an extravagance of ornament and excess of figural decoration so absolutely contrary to all classical restraint that they cannot be attributed to mere lack of skill or ignorance. To invoke poor taste would be pointless: a reference to norms the author blatantly rejects. The execution is lively and the repertoire of motifs demonstrates knowledge of recent developments. The designer shows a predilection for dense, complex ornamentation suggesting a return to the ornate style of the early Renaissance, but enriched with a repertoire of motifs garnered from Fontainebleau. As such, this is not a unique, or even a particularly local characteristic. A heavily decorated style emerges all over the country after 1560. Nonetheless, the local references, particularly to Bachelier, are numerous and unmistakable. What we see is in fact the conjunction of a strong local tradition with a more general stylistic development.

If sixteenth-century Toulouse was the center with the most distinctive artistic consciousness, this was surely in part due to the extraordinary economic conditions referred to earlier. However, Toulouse also possessed a deeply-rooted and formidable attachment to local autonomy. It is harder to pinpoint the originality of Lyon, also a very wealthy city, more stably so in fact, because of its banking activities, printing presses, and other local industries. Lyon's position on the Rhine-Rhone axis made it a city of European stature, a practically unavoidable stopover between Northern Europe and Italy. This geographical advantage encouraged its development as a major mercantile center. The great financiers of Augsburg had branches in Lyon, as did the Florentine banks. Professions in Lyon were largely unregulated, making the city a haven for immigration from near and far, in stark contrast to Paris with its powerful guild system.

With Maurice Scève at the helm, Lyon's literary school produced a large body of work in the Renaissance, but relatively few archival documents pertaining to artistic activity survive. It is true that iconoclasm was virulent in the middle of the century. The stained-glass windows of the region's churches were systematically destroyed, as undoubtedly were many other works of art, both old and new. But these events are not a complete explanation of the lacunae, nor do they justify the relative poverty of architecture in Lyon, particularly in civic building. Philibert de l'Orme was from Lyon, and his first endeavor can still be seen in Rue de la Juiverie. There he enlarged the home of Antoine Bullioud shortly after returning from Italy in 1536 (fig. 340). Lyon, however, did not keep the architect, and he never returned to grace his native city with a monument of his design.[18] Serlio, who lived the last years of his life in the city, came there less as an architect than as the author of a treatise he was preoccupied with publishing. True, he was invited to provide designs for a projected stock

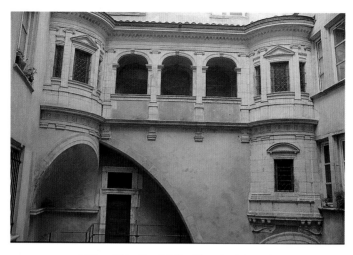

340. Lyon (Rhône, France), Bullioud House, Rue de la Juiverie.
The additions by Philibert de l'Orme date from around 1536.

exchange, but it was never built. Conservative and puritan by nature, and attracted to Protestantism and Lyon's bourgeoisie did not invest in ostentatious luxury.

It was printing—that modern invention so intimately bound to nascent capitalism and the rise of the middle class—which took pride of place in the cultural life of Lyon. Humanists like Étienne Dolet found work with the great publishing houses of Lyon. Rabelais himself came in 1532. Maurice Scève had embarked on a renewal of French poetry before anything of the sort appeared in Paris or the court. For the 1548 entrance of Henri II into Lyon, he organized the celebrations and wrote an illustrated account. Anticipating the famous Parisian entrance the following year, this event was already a manifesto of the classical Renaissance. Even in the visual arts, all creative efforts in Lyon seemed to revolve around books and printing. The city's most established and visible artist, Bernard Salomon, was in charge of festival decorations, and primarily a book illustrator. He served as *"conducteur de l'oeuvre de paincterie"*[19] for the entrance of Henri II, and presumably illustrated the associated booklet published by Scève.

Lyon, where printing developed early, remained a major center for publishing, especially for the production of illustrated volumes, throughout the sixteenth century. During the first half of the century, editors in Lyon maintained a close relationship with artists in Basel from whom they would receive entire series of woodcuts. Hans Holbein's *Dance of Death* was published in Lyon. The tiny masterpieces brought work by one of the period's great painters within reach of a comfortable urban middle class.

Bernard Salomon imparted a distinctive appearance to the illustrated book from Lyon by combining the finesse and close texture of the Holbein woodcuts executed by Hans Lutzelberger with certain aspects of Parisian art, notably a taste for small, slender figures like those in the vignettes of *L'Amour de Cupido et de Psiché mère de Volupté* (J. de Marneuf, Veuve de D. Janot, 1546, fig. 427). Jean de Tournes, a particularly creative and enterprising publisher in Lyon, distributed Salomon's art throughout Europe and beyond. Among his many illustrated publications, two especially met with extraordinary success. One of these consisted of illustrations from the Bible; the other was Ovid's *Metamorphoses* (figs. 342 and 343). Together they constitute a synopsis of the new culture: classical antiquity on one hand and on the other a renewed interest in sacred texts. De Tournes published a large number of illustrated Bibles, but most of his religious publications adhere to the characteristic form he also employed for Ovid. They are picture books

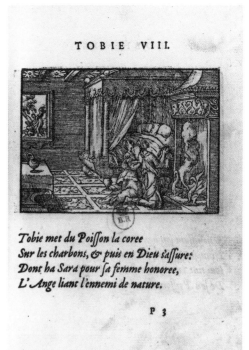

341. *The Double Arch at the Port Saint Pol*,
from the booklet for the triumphal entry of Henri II into Lyon, 1548.
Paris: Bibliothèque Nationale de France.

342. Bernard Salomon, *Story of Tobias*, from the *Quadrins historiques
de la Bible*, Lyon, Jean de Tournes, 1553.
Paris: Bibliothèque Nationale de France, Ra 19.

343. Bernard Salomon, *Perseus, Medusa, and Pegasus*,
from *La Métamorphose d'Ovide figurée*, Lyon, Jean de Tournes, 1557.
Paris: Bibliothèque Nationale de France.

in which the text is reduced to an enlarged caption, modeled on the emblem book. The images were intelligible to readers of any language; the short texts could easily be translated to accompany the existing plates. This system permitted Jean de Tournes to publish editions not only in French and Latin, but also in Italian, German, English and Spanish. He even printed a Flemish version of the *Metamorphoses*. English targeted a Protestant audience, while Spanish editions destined for a purely Catholic readership gained access to a rapidly expanding market in the New World. In this form, Bernard Salomon's art was produced primarily for export. To what

344. Jean de Gourmont, The *Nativity*, c. 1525–40. Engraving, diameter 7 ¾ in. (19.7 cm). Paris: private collection.

extent, if at all, did he work in other media for a local clientele? While archival documents refer to him as a *"peintre,"* there is no trace, excluding festival decorations, of his activities as a painter.

In fact, with the exception of portraiture, there is virtually no information at all about painting in Renaissance Lyon. However, a certain number of artistic personalities emerged in the domain of prints. The foremost of these is also the most difficult to pinpoint. What role did Jean de Gourmont play? The artist, originally from Normandy,

signed or monogrammed a number of engravings published in Lyon, where he had established himself. They share a highly characteristic aesthetic. The small-scale figures occupy a space defined by classicizing architecture. The play of light and shadow in this decor is highly original, and the drawing is extremely fine. Despite his penchant for Italian classicism, the artist shows a taste for decorative drapery and open spaces that invite comparison with Flemish art. The subjects of these prints are frequently familiar Christian

345. Jean de Gourmont, *Quarreling Apprentices*, c. 1525–40.
Engraving, 2 ¾ × 4 in. (7 × 10.6 cm).
Paris: Bibliothèque Nationale de France, Ed 4c.

346. Georges Reverdy, *Peasant Dance*, 1530–60.
Engraving, 6 × 7 ⅓ in. (15 × 18.6 cm).
Paris: Bibliothèque Nationale de France, Ec 33a rés.

themes such as the Virgin Mary adoring Christ (fig. 344). A few of them, however, represent less expected subjects such as the peculiar monkey tied to a column, or the apprentices' quarrel—the latter being a subject Schongauer had treated in the previous century (fig. 345). These small engravings have a singularly poetic quality.

This highly recognizable manner also appears in the work of two other engravers of unequal

merit. One is an anonymous master of no great talent known only by the pair of intertwined "C"s affixed to his plates.[20] The other, Georges Reverdy, about whom we know more, was also an illustrator of books. As an engraver, he adopted de Gourmont's manner on an occasional basis; whether he just imitated his colleague's style or reproduced de Gourmont's compositions is unclear. It would appear that Reverdy learned

347. Georges Reverdy, *Leda and the Swan*, c. 1540–50. Engraving, 6 × 10 in. (15.5 × 25.6 cm). Paris: Bibliothèque Nationale de France, Ec 33a rés.

348. Jean de Gourmont, The *Nativity*, c. 1525–40. Oil on wood, 36 ⅞ × 45 ½ in. (93.5 × 115.5 cm). Paris: Louvre.

engraving in Rome among the entourage of Marcantonio Raimondi; his engraving style is similar to that of Bonasone. However, a certain number of plates, probably made in Lyon, are more personal. Two versions of Leda and the Swan (fig. 347) brutalize Italian classicism in much the same manner as Jean Duvet (see later in this chapter). Some of his other engravings echo a vernacular style with a popular inspiration, especially a *Danse paysanne* that owes its composition to the *Amours de Gombaut et Macée* (fig. 346).

Next to this eclectic body of work, Jean de Gourmont's production seems highly unified; it would appear that this poetic handling of space and imaginary antiquity are indeed reflective of his personal style. Also attributed to him is a Nativity from Écouen, which displays precisely

the same motifs and lyricism (fig. 348). The flight of angels in the painting, coupled with the small figures, recalls the art of the Danube school to which some of Jean Cousin's drawings seem also to refer, but with a very different flavor. It has also been suggested that Jean de Gourmont was the author of one of the most mysterious panels of the period, the astonishing *Descent into the Cellar* from the Frankfurt museum (fig. 237).[21] The sense of space, the abrupt foreshortening, and even the figures are not incompatible with the manner of de Gourmont's engravings. However, great prudence is imposed by our complete ignorance. Where was this image destined to hang? It seems a whole, rather than a fragment. In spite of its small size, it would not appear to be the side element of an altarpiece depicting an episode from

349. Corneille de Lyon, *Portrait of Pierre Aymeric*, 1534. Oil on panel, 6 ¼ × 5 ½ in. (16 × 14 cm). Paris: Louvre.

the life of some obscure saint. Was it perhaps one of a series of images illustrating the months or seasons? Or might it simply have been an isolated scene of daily life, a genre piece? We do not know if it was a panel designed to take its place in a decorative composition like the paintings incorporated in the wainscoting of the cabinet des Grelots at the château de Beauregard.[22] In any case, the easily identified crest of the Dinteville family assures us of the interest they maintained in art far removed from the Fontainebleau style of painting. The presence of these two paintings with a distinctly provincial flavor in the collections of great houses is a precious indication of the eclectic nature of patronage among the aristocracy.

In Lyon, as in Paris, the only genre of painting surviving in quantity is the portrait. A large and distinctive group of these are known under a somewhat generic attribution as those of Corneille de Lyon. The painter in question was a native of the Netherlands, known originally as

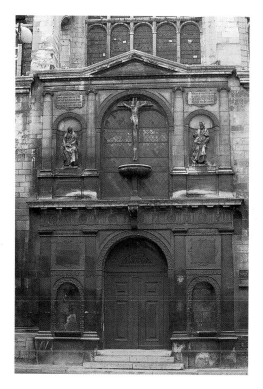

350. Troyes (Aube, France), church of Saint Nicolas, south portal, 1540.

351. Troyes (Aube, France), plan of the church of Saint Nicolas.

Corneille de La Haye. As early as the seventeenth century, Gaignières identified him as the author of the portraits mentioned above, and recent evidence confirms his hypothesis.[23] There is no reason to doubt that all of these portraits were indeed produced in his workshop, but this hardly signifies that each of them is his handiwork. Corneille surely did not himself produce all those little pictures any more than the Clouets painted all the work that bears their name. However, the tradition is probably accurate in associating Corneille's name with a formula for portraiture modeled on Dutch examples.

Always rather small, these portraits bestow a vivacious expression to their models that is charming but monotonous as it varies little from one individual to another. Backgrounds are neutral—generally blue or green. Corneille's sitters are turned more often than Clouet's from the three-quarter view to face the viewer. The quality of this large group of works is variable, but within fairly narrow parameters: there are no breathtaking masterpieces or ineptly daubed pictures. Once put in place, the formula could easily be applied by collaborators. Well established in Lyon, Corneille nevertheless had clients outside the region as well.[24] His models included great figures, and according to Brantôme's report, Catherine de Médecis herself once sat for the painter when the court passed through Lyon. Clearly, some of these images were painted for visitors who took them away with them. The bulk of this production, however, was presumably destined for the local market. The large numbers of unidentified models suggests that, in general, Corneille's clientele was of lesser social stature than that of Clouet.[25] The art of Corneille de Lyon is pleasant and not overly ambitious, and—at the risk of sounding anachronistic—I would be tempted to qualify it as "bourgeois." Regardless, the example of the portrait of Pierre Aymeric shows that the painter retained the same formula

whether he was painting the local gentry or great figures from the royal circle (fig. 349). In this, he was not a court portraitist in the way that the Clouets were.

This overview of art in Lyon is in large part a collection of gaps and question marks. Yet it suffices to allow a glimpse into an artistic production very different from that of Paris or Toulouse.

Though Troyes and southern Champagne did not present the resolutely local character that distinguished Toulouse, they enjoyed a period of intense artistic activity in the sixteenth century. The region still boasts a surprising abundance of sculpture and stained glass. Even painted panels are less rare than in the rest of France (except, as we have seen, in Provence and Picardy).[26] In 1524, a terrible fire destroyed the greater part of Troyes. Not only did local prosperity permit rapid reconstruction, the disaster seems to have conferred great energy to the artistic movement throughout southern Champagne. Perhaps, once they had organized in response to the need generated by the catastrophe, the region's workshops sought other outlets for their production. The fact remains that churches such as Rumilly-lès-Vaudes, Chaource, and especially Saint Florentin (on the border of Burgundy) are veritable museums.

The fire of 1524 may have inspired artistic activities to soar, but it marked no rupture with the past. In Troyes, the Italianate Renaissance came as a twist on what was already a brilliant and long-lived artistic tradition. As early as the thirteenth century, the church of Saint Urbain was a veritable laboratory where the elements of Flamboyant art took shape. The great cathedral building site displays perhaps better than anywhere else the dynamic continuity of Gothic art from the thirteenth century to the beginning of the sixteenth, the time at which Martin Chambiges began work on the façade.

The continuity of Champagne's artistic tradition is particularly apparent in its sculpture.[27] The artists of Rheims had successors. One discerns their legacy in many representations of the Virgin Mary, whose smile and slight slouch are ceaselessly varied to give fresh expressive nuances. Narrative sculpture developed through contact with adjoining Burgundian states, first Burgundy,

352. Jacques Julliot, *Meeting at the Golden Gates*, 1539. Stone, height 11 ½ in. (29 cm). Troyes: Musée historique de Troyes et de la Champagne.

then Flanders. It was long thought that among the many altarpieces preserved in Champagne, some had been imported, but it would appear instead that there was a local production of works similar to those exported by the southern Netherlands.

To speak here of medieval art is misleading, in spite of the deliberate continuity in architecture, or the obvious one in the case of sculpture workshops. The period of innovation beginning in 1400—whether we call it the Sluter revolution or trace it back to Charles V's sculptors in the Île-de-France—marked the beginning of a new era (this important point is developed in the next chapter). In Champagne, the transition was smooth, almost stealthy, perhaps because thirteenth-century sculpture in Rheims was exceptionally naturalistic and classically antique looking; "ahead of its time," one might say, it took the Renaissance as a teleological target, while in the fifteenth century the workshops of Troyes were basically conservative. Nevertheless, to use the single word, "Gothic," for both the Master of Chaource and the Rheims sculptors of the thirteenth century invites misapprehension. The choice of nomenclature suggests spiritual community, a protracted extension of the "Middle Ages," delaying the rupture caused by the "Renaissance" until halfway through the sixteenth century. In fact, France evolved toward the modern in parallel with Italy, if not exactly in the same manner, or at the same rate. This explains why we see no clear shift after the fire of 1524,

353. *Altarpiece of the Passion* (ensemble view and detail), 1533. Polychrome stone. Rumilly-lès-Vaudes: church of Saint Martin.

only an increase in activity. Even the arrival around 1540 of Domenico del Barbiere, who trained entirely in Italy, seems to have occurred in such a well-prepared environment that it modulated the traditions of Champagne without overthrowing them.

The church of Saint Nicolas de Troyes is one instance displaying the vigor of the late Gothic in religious art (fig. 350). Destroyed in the fire of 1524, the church was rapidly rebuilt. The building system is a very sober version of the Flamboyant. Two characteristics of the building merit attention: the flexibility of this construction system, and its ability to produce an original space. Saint Nicolas was peculiar in having its west end abutting the city fortifications in such a way that one gained access on this side through a chapel over a narthex. The main entrance was a portal on the south side towards the beginning of the nave. The architect adapted to these conditions quite gracefully. Additionally, by creating a very wide nave with tall side aisles and wide arches, he gave the impression of a completely unified space. The vaulting, highly original itself, reinforces the

effect. The large vaults are of the simplest type, while in the chapels they are rich and varied; they function as small ornamental appendages to the main space. At the middle of the century, the south entrance acquired a perfectly classical portal that the building accommodates nicely.

In Champagne, sculpture was the art of choice. Around 1500 what has been called "détente" dominated. The art of the Master of Chaource, referred to by Raymond Koechlin as the "workshop of Saint Martha," is still part of this trend, though he was capable of remarkably intense expression using this somewhat languid vocabulary. The following generation drew closer to the southern Netherlands, at least as concerns the narrative sculpture of altarpieces. The altarpiece at Rumilly-lès-Vaudes, dating from 1533 is a good example (fig. 353). At first sight, it might seem Flemish but traces of the Master of Chaource quickly emerge upon examination. It is beyond doubt a work of the Champagne region.

Documents show that the most visibly placed artist at the time of Domenico del Barbiere's arrival in Troyes was Jacques Julliot: certainly a fully trained master by then. He was a practitioner

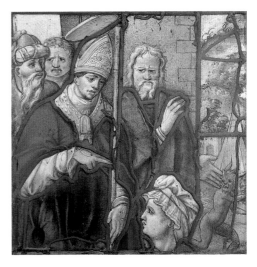

354. *Saint Rémi Exorcising a Possessed Soul*, 1550. Dismounted stained glass from Aulnay (Aube, France): church of Saint Rémi.

355. Anonymous, *Saint Crispin and Saint Crépinien* (ensemble and detail), mid-sixteenth century. Polychrome stone, height 45 ¼ in. (155 cm). Troyes: church of Saint Panthaléon.

of Flemish-style narrative sculpture, cutting deep into the stone to create an animated play of light and shadow (fig. 352). The figures are picturesque; their rich costumes have full rounded folds. The architectural settings remain mired in detail and antique vocabulary makes but a timid appearance. Generally speaking, the picturesque holds sway, and one could define the style as a continuation of the early French Renaissance, an aesthetic still closely related to Flamboyant art. In spite of his success, one cannot say that Julliot dominated his generation. Koechlin, who deeply admired Julliot's picturesque art, saw in it the true local tradition tailored to keep up with the times, as opposed to the classicizing art of the subsequent generation. However, he found it difficult to identify Julliot's individual contribution among a great many high-quality anonymous works. In other words, the large body of sculpture produced in the Champagne region was not highly personalized.

This did not really change with the advent of Domenico del Barbiere. The Florentine sculptor was probably virtually fully trained when he arrived at Fontainebleau, though he left no known works in his native country when he left. When he reached Troyes, he certainly brought with him the latest novelties of the court, especially as he continued to work at Fontainebleau, going back and forth between the royal château and his adopted city. Was he influenced by the milieu in the Champagne region? It is not easy to say. At Fontainebleau, Domenico was an executor without a distinct personality; only his prints would allow an examination of his own style, and these are difficult to date. Thus it is in Troyes that his individuality comes to the fore. Representations of the Virtues from the (now destroyed) *jubé* at Saint Étienne in Troyes have a coquettish grace not entirely foreign to Champagne tastes. Domenico may have adapted somewhat to the taste of his adopted compatriots. Having said this, the primary movement was in the opposite direction, and spectacularly so. The art of Champagne was one of readymade formulae, its value residing above all in the quality of its workmanship. The Italian suggested new ones that were immediately adopted by local sculptors with a virtuosity that was their own. It is not an easy task to distinguish

356. Domenico del Barbiere, *Virgin*, from the *jubé* at the church of Saint Étienne-de-Troyes, 1550–51. Troyes: Musée Vauluisant.

between the Florentine's work and that of his local emulators. The most famous among them, François Gentil, is even a figure of legend: almost all the best sculpture of Troyes from the later sixteenth century has been attributed to him, yet his only documented work—two prophets still in place on the portal of Saint Nicolas—is in the manner of Domenico, with no personal character (fig. 350). There is no doubt, though, that Gentil was indeed highly regarded; his many commissions are proof of this. Around 1560, it appears that the classicizing art of Domenico del Barbiere became the common language characteristic of the sculptors in Troyes, so that his personal style tends to dissolve into the collective sculptural inheritance of the Champagne region.

A comparable situation exists in the realm of stained glass: an extremely abundant production coupled with an absence of clearly defined individuality.[28] No other province, at any time, may have produced as many pictorial windows as Renaissance Troyes. Surprising numbers of them survive, while destruction as devastating here as elsewhere must be taken into account. In the first third of the century, Troyes windows were

characterized by an emphasis on narrative and brilliant colors. The method of constructing windows of small juxtaposed panels developed more fully in Champagne than elsewhere. Starting around 1540, tastes migrated gradually toward white glass, painted in grisaille with yellow highlights and, occasionally, hematite for flesh tones: glaziers in the Champagne region too were swept up by the classicizing wave. But colored windows did not disappear for all that (fig. 354).

Documentary evidence in archives is relatively rich. Nevertheless, even when the authors can be ascertained, no dominant personality emerges. Historians have always been struck by the semi-industrial aspect of stained-glass windows in Troyes, where patterns were systematically repeated over long periods of time. Among the masses of glassworks, several workshops can be distinguished. They vary in quality, although the level is generally high, probably because of their strong professional organization. But nowhere among them do we encounter an artist who was a decisive force, leaving his mark on the whole generation, a counterpart to the figure of Arnoult de Nimègue in Rouen, or Engrand Le Prince in Beauvais. Only at the very end of the sixteenth century would Linard Gontier emerge and impose a strong individual personality in the stained-glass production of Champagne, at a time when both economic and artistic conditions had changed radically.

All things considered, Troyes possessed what we may call a provincial school. By school, I mean a body of professional knowledge passed from generation to generation. It was provincial in both senses: this copious, enduring production has a character of its own, but also reverberates like a fainter echo of court art.

Langres, Jean Duvet, and the Cardinal of Givry

Jean Duvet may be the single most attractive artist of the French Renaissance for today's viewers. His art finds so strong a resonance in modern sensibilities that we might at first glance wonder whether his prominence is not altogether the product of our era. In the context of sixteenth-century art, Duvet seems to be extremely isolated. However, archival documents indicate that within the bounds of his provincial existence, he was the foremost artist of his time.[29] He worked in Langres, near the border between the Champagne and Burgundy regions, at the eastern edge of the kingdom. Very little is known about his life.

Fortunately, the frontispiece of the *Apocalypse figurée*, his masterwork, afforded the engraver an opportunity to reveal himself (fig. 357). An old man in a meditative pose, eyes closed, leans on a piece of furniture that evokes an altar more than

357. Jean Duvet, frontispiece of *L'Apocalypse figurée*, 1555. Engraving, 11 ¾ × 8 ½ in. (29.8 × 21.6 cm). Paris: Bibliothèque Nationale de France, Ed 1b rés.

a desk. He is draped in an antique costume and holds a stylus in his left hand. Before him are placed, to one side an open book, the *Apocalypse* of Saint John, to the other an arch-shaped plate and a burin. Surrounding him, all manner of beings,

persons, and things compete for attention with the insistence and incongruousness peculiar to allegory and especially Renaissance emblems. As in the latter, words play an important role next to the image. Almost halfway up on the right, between a swan and a tree stump from which the bird has broken away, the text is not even confined to a tablet or a leaf from a book, and combines freely with the representation: speech and image occupy the same plane. The entire scene is organized around its protagonist according to symbolic rather than rational logic. Duvet pays little attention to the laws of perspective or to verisimilitude. The table supporting the old man's elbow seems diminutive next to his massive figure. Fishermen in boats are minuscule next to the Parcae, and our ordinary conventions must be suspended to understand that they float on clouds, above the fishermen, instead of sharing the same lake.[30] At the same time, Duvet was capable of searing naturalism. In the left foreground, a dog and a cat, especially the latter, are rendered with a great sense of movement and liveliness.

The old man is clearly Saint John; he points at the book he has just completed. He resembles other portraits of evangelists as pictured in gospel books going back to the admirable Carolingian examples, modeled in their turn on ancient prototypes. But next to the book is a tablet with the artist's signature, and next to that, a burin. As the shape of the tablet is exactly that of the print itself, it is difficult to avoid seeing it as Duvet's copperplate and therefore to understand the engraver's tools as rather solemnly arranged on this altar/table as though to consecrate the artist's work. The tablet itself bears an inscription more informative than a simple signature: "*Jean Duvet orfèvre de Langres âgé de soixante-dix ans termina ces histoires en 1555*" (Jean Duvet, goldsmith of Langres, completed these stories in 1555 at the age of seventy). The image draws a striking parallel between the book and the plate, the text and the illustration. Accordingly, the image has always been perceived as a depiction of Duvet himself. The man lost in thought, if he is indeed Saint John, is also the engraver: Jean Duvet represents himself superimposed on his patron saint. Whence the autobiographical snippets: if seventy in 1555, he would

have been born in 1485. Was the frontispiece actually executed last? It is unknown, but unimportant: the image is presented as a retrospective meditation on the completed work: *grandeq. svadet opvs.*

Should one call this a self-portrait? Not if by self-portrait we imply a physical resemblance. The old man, no different from those figuring recurrently in Duvet's work, remains an archetype without individual features. The artist does not seem to identify with his patron saint by lending him his appearance, but by stressing the parallels between their situations. *Fata premunt trepidant manus iam lumina fallunt mens restat victrix grandeq. svadet opus.* The couplet applies to both, as we know that the author of the Apocalypse (long confused with John the disciple and evangelist) was said to have written the book at a very advanced age. As for Duvet, he himself declares he finished his work at seventy, and according to the copyright he worked at it for ten years, thus he had begun at the age of sixty. The age of seventy has a strong symbolic value relating to the Biblical text: "the days of our years are three-score years and ten."[31] Duvet certainly presents the *Apocalypse figurée* as his swan song. Death is ubiquitous in the frontispiece. The messenger of death holds in his beak an arrow pointing unmistakably at the old man with closed, visionary eyes. The good and evil demons behind him, inspiring him, are doubtless neo-Platonist, but they are also the angel and devil one sees in innumerable editions of the *ars moriendi*, the little manual for helping the dying to prepare their final departure, a genre immensely popular in Duvet's youth. On the subject of self-representation, it is appropriate to mention a print known only by the Vienna impression: *Saint John the Baptist and Saint John the Evangelist Adoring the Mystic Lamb* (fig. 456). The plate is unsigned, but its attribution is indisputable. Almost certainly the choice of these two saints who bear his name is another reference to Duvet himself. John the Baptist turns toward the spectator and meets his gaze: the only instance of this in the entire body of work he produced (not counting figures in hieratic frontal poses such as God the Father, His Royal Majesty, etc., whose gaze reaches out to infinity). The face is more

358. Jean Duvet, The *Annunciation*, 1520. Engraving, 9 × 6 ⅔ in. (23.1 × 16.8 cm).
Paris: Bibliothèque Nationale de France, Ed 1b rés.

developed, more characterized than usual, and one might ask if, in this case, Duvet was not attempting a genuine self-portrait. The date, 1528, is rather ostentatiously placed in the center of the image. As it figures on three other engravings by the artist, who very rarely dated his work, it may have had some personal significance unknown to us.

Duvet's artistic culture was that of an artisan. In many of his prints, he worked from engraved models, which he adapted liberally to his taste with the eclecticism common among enamelers and glaziers. This said, his Italianism was exceptionally precocious. Even before 1520, he appropriated the Raphaelesque repertoire of engravings by Marcantonio Raimondi, at a time when enamelers

were still unaware of them. The *Annunciation* from 1520 shows how much he retained from his models of the sense of grandeur, the weight of the figures he exaggerates somewhat, and the rhetoric of gesture and pose (fig. 358).[32] Raphael's *Lucretia* captivated him particularly: several times he replicated her characteristic hip thrust and the drapery clearly articulating the figure (fig. 359). He copied her quite scrupulously, transforming her into the Virgin of the Apocalypse (fig. 360), then for the *Annunciation*, he used her as his Archangel Gabriel in a freer and more individual manner.

On the other hand, he never fully accepted the science of perspective or its spatial logic.

337

359. Marcantonio Raimondi, *Lucretia*, after Raphael, c. 1511.
Engraving, 8 ⅓ × 5 in. (21.2 × 13 cm).
Paris: Bibliothèque Nationale de France, Eb 5rés.

360. Jean Duvet, *Virgin of the Apocalypse*, before 1520.
Engraving, 6 ¼ × 2 ½ in. (15.8 × 6.6 cm).
Paris: Bibliothèque Nationale de France, Ed 1b rés.

Not that he was unaware of them, or that he prac-
ticed an archaic, "medieval" art—when called to
do so he could show distance by relative size,
make the ground recede, and distinguish a suc-
cession of planes. He was evidently well enough
versed in contemporary art to understand at least
the essential principles of Renaissance perspec-
tive, but consistently rejected and mocked them.
As Colin Eisler rightly insists, Duvet composed
in the manner of tapestry designers, particularly
that of the Master of the "Hunt of the Unicorn,"
as known as the Master of Anne of Brittany
whose work he knew, at the least, by the books
of hours published by Simon Vostre. He too had
a gift for mimicry and gesture, a kind of natural-
ism in describing beings and things, and a taste
for arresting details. In Duvet, these qualities

361. Jean Duvet, The *Capture of the Unicorn*, c. 1545–55. Engraving, 9 ⅓ × 15 ½ in. (23.7 × 39.4 cm). London: British Museum.

coexisted oddly with the solemnity of Roman classicism.

Duvet was the son of a goldsmith from Dijon, but his relationship with Langres started very early, if indeed he began a reliquary for Saint Mammès cathedral by 1500.[33] Though known to us only as an engraver, Jean Duvet was a goldsmith and obtained, like his father, the title of master in 1509. He even enjoyed the title of goldsmith to the king under François I, who bought a damascened brass basin from him when passing through Dijon in 1529, and kept the distinction under Henri II. Duvet, then, had contacts at the court; according to the terms of the copyright granted him in 1556 for the publication of the *Apocalypse figurée*, his most ambitious work, it was undertaken "by our command and order, as much that of our Lord and Father as our own." While it is uncertain—though not improbable—that the series of engravings depicting the story of the unicorn, which earned him the title of *Maitre à la licorne* from the seventeenth century onward, contains—as has been so often maintained—references to Henri II and Diane de Poitiers, another group of plates about Saint Michael, unfinished and never published, refer unmistakably to the king and suggest, reasonably enough, a project commissioned for the royal order of Saint Michael that had its seat in Dijon. In spite of these contacts, Duvet's relationship with the court was not at all that of someone like Léonard Limosin. We can imagine the king and his entourage sufficiently intrigued by Duvet's work to take an interest in him, but he, for his part, never adopted the court's tastes.

We know Duvet only through his work as an engraver, yet this must have been only a—presumably secondary—portion of his work. He was primarily a goldsmith, though there is absolutely no work by him in this specialty known to us. What is more, his activities widely exceeded the usual bounds of a goldsmith. While the engraving of seals, like printmaking, was to some extent related to his professional training, he was also entrusted with decorations for royal entrées: in this he was unquestionably transcending his guild assignment. Like Bernard Salomon in Lyon, he was the foremost artist of the region. Did his

339

362. Jean Duvet, *Moses and the Patriarchs*, c. 1545–55. Engraving,
11 ¾ × 8 ⅓ in. (29.8 × 21.2 cm). Boston: Museum of Fine Arts.

363. Vézelay (Yonne, France), Church of the Madeleine,
pediment (detail), c. 1135–40.

work in other branches of art resemble his engravings? No available information can answer that question, and it is possible here to speak only of his works on paper.

In spite of certain artisanal features, Duvet's artistic culture was complex and independent. For example, echoes from monumental sculpture reverberate, as in *Moses and the Patriarchs* (fig. 362), where the composition suggests a church portal. But is there not an echo of Romanesque sculpture in the Christ in the *Vision of the Seven Candelabra*, reminiscent of the Vézelay pediment, especially in the arrangement of folds covering the legs (figs. 363 and 364)? Other works, *Annunciation in a Church*, and above all, the moving *Nativity with a Mouse*, recall instead the miniatures of books of hours without there being evidence of specific models.

364. Jean Duvet, *Vision of the Seven Candelabra*, c. 1545–55.
Engraving, 11 ¾ × 8 ½ in. (30.1 × 21.4 cm).
Paris: Bibliothèque Nationale de France, Ed 1b rés.

While Duvet's artistic culture may have been eclectic, this is not to say that his works are incoherent, and though he borrowed freely and blatantly, he lacked neither originality nor creativity. On the contrary, he gives the impression of an individuality affirmed with exceptional force and even violence. At the age of sixty, as he was beginning to engrave the *Apocalypse figurée*, he was sufficiently intrigued by new material to copy one of Primaticcio's compositions, an etching by Léon Davent; *Hounds Attacking a Stag*, a piece typical of court art, and one of the most beautiful of its kind. The copy, or rather the paraphrase by Duvet, *Hallali au cerf* (*Death of the Stag*), is a deeply personal work—part homage, part parody—like the penetrating and ironic transcriptions of Wagner by Chabrier (figs. 365 and 366). Duvet fully apprehended what was extraordinary about Primaticcio's use of arabesque, but he thoroughly rejected the Italian's principal virtue, which was to reconcile this seemingly arbitrary, decorative design on the surface with the most convincing suggestion of volume and space. The signification of the subject has also undergone radical alteration. Duvet pushes the primary group to the foreground, placing it in more direct contact with the viewer. He also brings the hunters sounding the death call of the animal right next to the stag. They are massive, vulgar figures, completely foreign to the spirit of the original. In the print from Fontainebleau, the heroic isolation of the stag, the atmosphere rendered poetic by bathing the scene in diffused light, everything in the image suggests the world depicted is that of a fabled antiquity, and this stag is none other than the unfortunate Acteon, devoured by his own dogs. The harsher light and more acerbic hand of Duvet emphasize the realities of the hunt. The engraver took a mythological dream vision and transformed it into a colorful genre scene, almost a documentary illustration.

However, familiar naturalism was by no means Duvet's principal vein. Earlier, we saw how, at the beginning of his career, he had assimilated certain elements of Raphael's grandiose eloquence. This rhetoric he employed to express an exalted lyricism. His mature works have a coherence, a persuasive force, and an expressive intensity that are bound to his mastery of the graphic language. Duvet approaches his plate as a goldsmith, and covers it almost entirely with intertwined motifs. At the same time, he handles his burin with a freedom and energy little in keeping with conventional ideas of an artisan's work. While he may have carefully perused engravings by Raimondi, he did not adopt their orderly style, the simple, lucid logic of their regular crosshatching network. His burin delves into the plate to create a wide variety of furrows, some light, others deep, short, straight, or hooked, others are very long and sinuous—both to define contours and also to suggest motion.

There are four plates by Duvet in which the design does not extend over the entire surface, and seems interrupted. They are among his most powerful works, and one may come to wonder whether they are, in fact, unfinished. One of them, representing *Saint Sebastian, Saint Anthony, and Saint Roch*—three protectors from plague—is one of the least rare of the artist's works and may have served as a sort of anti-plague poster, as did many loose sheets of its kind. It would appear that even in the sixteenth century, the plate was considered fit to print as it stood.[34] Even more surprising is the rendition of *Moses and Saint Peter*, a page almost entirely filled by two gigantic heads, and a striking confrontation between the two great founding leaders, one of Judaism and the other of the Roman Catholic Church (fig. 367). It remains a work of such strangeness and violent simplicity that no finishing touches could have tamed it. What could it have been intended for? Obviously, the tablets bearing the commandments, prominently displayed by Moses, had strong personal connotations for Duvet, who used them throughout his career as an emblem on which to affix his signature. The impression made by this work is less that of religious art and more that of a personal confession, the contents of which remain hidden, but moving nevertheless through the intensity of its expressive effort.

The most fascinating—and the most disturbing—of these "unfinished" works is the *Suicide of Judas* (fig. 324). Duvet addressed this rare subject twice, and a third time at the back of the *Deposition*—enough to suggest he was obsessed with it. The first version probably dates from around 1528.

365. Jean Duvet, *Death of the Stag*, c. 1544–46. Engraving, 7 × 11 in. (17.8 × 28 cm). Vienna: Albertina.

366. Léon Davent, *Hounds Attacking a Stag*, after Primaticcio, c. 1544. Etching, 9 ½ x 13 ¾ in. (24.2 × 34.8 cm).
Paris: Bibliothèque Nationale de France, Da 67.

The other, unfinished, is larger, more ambitious, and in all probability a later work. Certainly, in it Duvet tests the limits of his skill. The tiny rider whose horse drinks from the river is cut with stunning virtuosity. In all its history, an engraving burin has perhaps never left a mark conveying such an impression of spontaneity. The image itself is composed around a visionary logic. Judas appears twice, on an extremely large scale completely out of proportion with the environment, which seems miniaturized by comparison. On the right, seized with terror, he approaches a bridge no larger than his forearm. Is he contemplating drowning himself? On the other side, we see him hanging from a tree he almost equals in size. But through composition and an emphasis on the tension of the rope, Duvet succeeds in communicating the weight of the hanging body. Just below the body, a well is barely suggested, from which spring flames that intertwine with the roots of the tree. The horseman is a particularly disconcerting motif; in spite of his small size, he should be, according to the usual visual reading practices, at the front of the scene. Two scales wrestle in the representation—that of the main character and that of the environment (or rather the props, one might say). Irrational space, already prominent in the *Apocalypse* is here pushed to its extreme and produces an uneasiness reinforced by the expressionism of the graphic style and that of the subject and its staging. It would be difficult to say what public this image might have been addressed to; hard also to imagine what it might have looked like finished, and one wonders if Duvet did not intentionally lay his burin aside once he felt it had achieved his aim.

Since the engraving has no equivalents, to account for it scholars have turned to representations of mystery plays, where this episode, otherwise rare in Christian imagery, was prominently included. Some were enacted with startling realism; the actor would hide animal tripe under his tunic, letting them spill when the demons came to seize his soul. It is hardly doubtful that Duvet, who participated in the decoration for entrances and at least once in the stage design for mystery plays, was familiar with these effects and could have had them in mind. The infernal delivery in the foreground is well in the spirit of such performances.

367. Jean Duvet, *Moses and Saint Peter*, c. 1560 (?), engraving, 9 ¼ × 6 ⅓ in. (23.5 × 16.2 cm). London: British Museum.

But what exactly does this explain? Many other artists watched or participated in such spectacles, but none of them produced anything resembling Duvet's engraving.

Duvet's apparent isolation from his contemporaries is somewhat tempered by a few affinities that can be detected here and there. What paintings we still have from Burgundy and eastern France indicate some confluences or similarities with the great goldsmith-engraver, but these possible contacts are too elusive to permit any positive conclusions as to the artist's training.[35] A few engravings by Georges Reverdy, like his *Tarquin and Lucretia* or *Leda*, come close to Duvet's method in the caricatural manner in which they appropriate Italian classicism. The master known

368. Jean Duvet, *Henri II as Saint Michael*, 1548 (?).
Engraving, 11 ⅔ × 8 ¼ in. (29.6 × 20.9 cm).
Paris: Bibliothèque Nationale de France, Ed 1d rés.

incomprehension from rejection, this culture in search of itself, is not particular to Duvet but characteristic of French art, especially that of sixteenth-century provincial France.

In spite of this, Duvet remains to some extent an isolated figure, and by that very isolation he comes close to other artists of comparable vehemence, distant in time but close in spirit, such as the Master of the *Rohan Book of Hours*, one of the great mystic artists of all times, or William Blake, who was also very much of his time, yet irreducibly singular. This impassioned and fascinating aspect of Duvet's work touches us precisely because it derives from unconditional individualism and thereby appeals to modern aesthetics. Duvet's ecstatic expressionism is most visible in the *Apocalypse*, but is not exclusively tied to religious sentiment; the engraver exhibits the same passion, and an equal level of mystical fervor, in three magnificent plates dedicated to the majesty of Henri II (figs. 368 and 369). These were apparently elements for a project in connection with the order of Saint Michael, which evidently must have been abandoned, since no inscriptions were engraved on the plates, and one might wonder whether it was a simple matter of unfortunate circumstances, or if Duvet's excessive art alienated the commissioners, presumably at court.[36]

Duvet has been associated with the patronage of Claude de Longwy, Cardinal of Givry and Bishop of Langres from 1529 to 1562, a great prelate and important figure both for his social position and his ecclesiastical activities. He was one of the leaders of the Counter-Reformation in France. Anthony Blunt related the religious exaltation expressed by Duvet to the cardinal's fervent Catholicism. Colin Eisler developed the theme with a twist. He saw Duvet as hesitating between Protestantism and Catholicism, moving back and forth between Calvin's Geneva and Langres, a city where they enthusiastically burned Protestants. There is no reason, however, to uphold such an improbable hypothesis and Duvet is quite strange enough without it.[37]

A historian who encounters both an artist of Duvet's caliber and a powerful figure like the cardinal in a town such as Langres is obviously

by the monogram I♀V, discussed previously in connection with the school of Fontainebleau, also recalls the engraver from Langres in the expressive distortion of his most elaborately finished etchings. A case in point would be his bizarre rendering of Giulio Romano's *Madonna with a Cat* and, even more, a *Sacred Conversation* whose affinities with Duvet's art are quite striking. These affinities may be fortuitous, since there are no demonstrable or direct links between the artists. However, considering the artistic culture of the period, looking at its inveterate habits and the deep structure of its sensibilities, we may perhaps be able to sketch some kind of context within which to situate and understand Duvet. It is undoubtedly a difficult task, because Duvet laid outside the dominant culture of his time, but all the more valuable for that. The combination of skill and awkwardness, the constant curiosity towards Italian forms associated with a distortion in which it is not always easy to distinguish

369. Jean Duvet, *Saint Michael Slaying the Dragon*, c. 1545–55. Engraving, 11 ¾ × 8 ½ in. (29.8 × 21.4 cm). Paris: Bibliothèque Nationale de France.

tempted to seek a relationship between the two, and discern in the art of one the effects of the other's cultural activity. Yet, if we examine the facts, no single commission or document involves contact between the two men. There is not the slightest allusion to the cardinal in all of Duvet's engravings. If we turn our attention to the cardinal's patronage, does it support the hypothesis? As previously addressed, he looked to Jean Cousin for the design of tapestries subsequently executed by Parisian weavers. He evidently sought out work that was fashionable and metropolitan. Highly placed and close to the king, the cardinal was a member of the uppermost

370. Langres (Haute-Marne, France), cathedral of Saint Mammès, Amoncourt chapel, general view and tile detail, 1545–51.

aristocracy. While Langres was for a long time the object of his patronage, the city, which remained relatively isolated even in the sixteenth century, by no means circumscribed the prelate's cultural horizon. One project he undertook was a *jubé* for his cathedral. Like almost every other *jubé* of this kind, it was dismantled. However, enough dispersed fragments remain in the church to form an idea of its appearance: it certainly belonged to the classicizing style (fig. 372). After his niece married Louis de Bourbon, the cardinal

371. Langres (Haute-Marne, France), cathedral of Saint Mammès, Amoncourt chapel: vault.

commissioned stained-glass windows for the chapel of the château de Champigny-sur-Veude. These were mentioned in the previous chapter, again in connection with Jean Cousin. Here we are still within the realm of court art. The cardinal also commissioned a devotional kneeling statue of himself for the cathedral, and it has been suggested that Domenico del Barbiere was the artist selected to execute it.[38] In the cardinal's immediate entourage, his coadjutor Jean IV d'Amoncourt built a magnificent chapel attached to the cathedral (currently the baptismal chapel), one of the most accomplished works of ecclesiastical decor from the mid-sixteenth century (fig. 370). While its windows and sculpture, traditionally attributed to Jacques Pévost, have disappeared, the chapel remains impressive and is among the most beautiful of its kind. The architectural ornament is of exceptional quality. Rarely has the problem of reconciling window tracery with classical forms been so harmoniously resolved. The coffered vault (fig. 371) is as refined in its execution as it

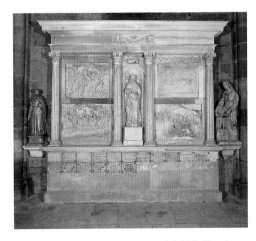

372. Langres (Haute-Marne, France), cathedral of Saint Mammès, reassembled elements from the *jubé*, mid-sixteenth century.

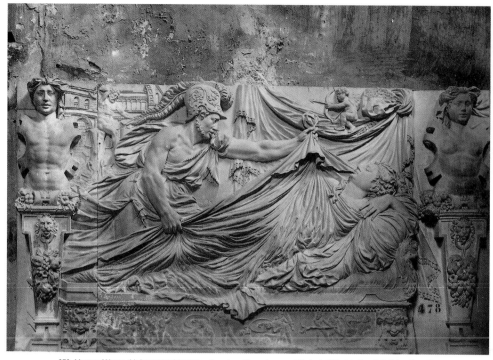

373. *Mars and Venus*, third quarter of the sixteenth century. Stone. Langres: Musée de l'hôtel du Breuil de Saint Germain.

is rich in invention. Its design responds to that of the polychrome tiles doubtless produced by the workshop of Masséot Abaquesne, the great faience maker from Rouen who also supplied the constable of Montmorency's project at Écouen, and Claude d'Urfé at his château La Bâtie. Like the Cardinal de Givry, Amoncourt did not restrict himself to local resources.

To which architect did he entrust this project? Clearly no local mason designed and directed this work of sophisticated design and exquisite execution. The name of Jean Bulland has been put forward. It is a very great name indeed, and caution is therefore advised, but prior to 1550, there were few artists capable of such a coherent design; few exhibited such a precise and controlled manipulation of classical vocabulary, such a deep understanding of French traditions, and the imagination necessary to reconcile these elements within a perfectly harmonious composition. The taste for forceful, slightly whimsical geometry, the use of

sharply cut stone to achieve precise, pronounced shadows, both are certainly traits visible in later, documented works by Anne de Montmorency's architect. The hypothesis is thus not absurd. What remains certain is that the architect of the Amoncourt chapel, in designing this exceptional monument, fully embraced the classical art that was taking shape at that very moment in the royal circle. In spirit it is profoundly different from the work of Duvet, who, in spite of his curiosity, was far from espousing Renaissance classicism unconditionally.

The art favored among the entourage of the Cardinal de Givry was that of the court and capital, and it had an immense influence on civil architecture. One of the most interesting monuments in Langres is a house with a courtyard façade whose frieze is an obvious reflection of the decoration at the Amoncourt chapel.[39] The handsome dwelling is a curious mixture of grand effects and pettiness. For the main staircase, the

designers relied on the habitual narrow spiral. In contrast, the aforementioned façade is amply treated, and the sunken courtyard denotes a certain level of ingenuity (perhaps its resemblance to the Villa Giulia in Rome is not strictly coincidental). Inside, a rather astonishing cabinet preserves its decoration of arches put into perspective and an ornamentation in which the ceiling and floor echo each other. A thoroughly Italianate *Mars and Venus* on display at the museum in Langres allegedly originates from the same home, where it is supposed to have adorned a fireplace mantle (fig. 373). The subject and style are quite visibly inspired by court art, though doubtless a slight stiffness deriving from an overly meticulous execution betrays a touch of provincialism. Nothing in these works however, is comparable to the almost parodic rendering of the Fontainebleau style produced by Duvet. Everything that remains of the patronage practiced by Givry and his entourage is classicizing in style, and belongs to the sphere of royal, court art. Givry was certainly a fervent Catholic and active defender of the faith, but nothing suggests that he found any aspect of the avant-garde classicism incompatible with his religious beliefs. Like Georges d'Armagnac and Philander in Rodez, he seems, on the contrary, to have enlisted it in the service of the Church Triumphant. Did he also appreciate the mystical tendencies and the kind of exaltation expressed in Jean Duvet's engraved works? It is not impossible, but no evidence confirms it: nothing in the archival documentation or the patronage of the bishopric allows us to situate Duvet's art within the sphere of Cardinal de Givry.

Although there are no substantiated links between Duvet and the famous prelate, there was definitely a connection between him and the city of Langres. In 1524, he engraved a silver seal bearing the town's coat of arms. In 1533, the municipality entrusted him with the preparations for François I's visit. As in other towns, conflicts often pitted the municipality of Langres against the bishopric and canons.[40] It is therefore quite possible that far from belonging to the sphere of the cardinal, Duvet's art represented the city, more or less in opposition to the court classicism promulgated by the prelate's patronage. If this hypothesis is deemed to be correct, what we see enacted in the language of forms is a dynamic resulting from confrontation between the centralizing force of the modern monarchy, and the vitality of social, political and cultural structures belonging to the town.

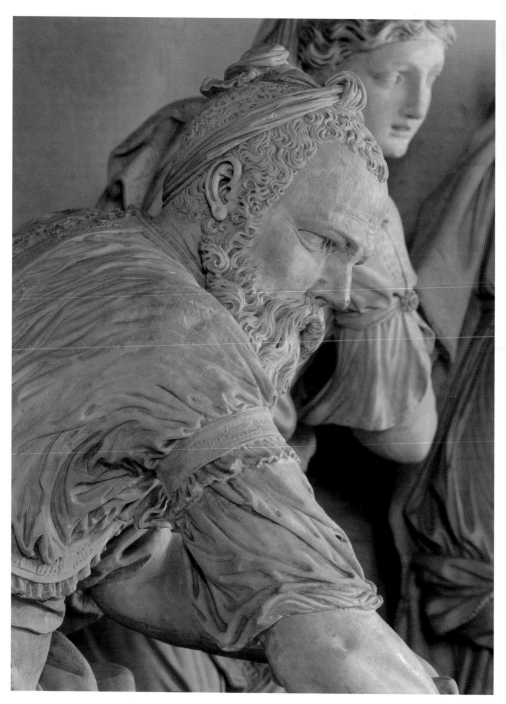

374. Anonymous, *Entombment: Face of Joseph of Arimathea*, c. 1560. Polychrome stone. Pontoise: church of Saint Maclou.

Chapter X

SCULPTURE AND DEATH

In 1835, the indefatigable author and *Inspecteur des Monuments*, Prosper Mérimée, paid a visit to Solesmes in the course of a tour through western France. "Suppressed after the Revolution, like other religious communities," he wrote, "the abbey at Solesmes has recently been reestablished. A group of priests has purchased the church and remaining buildings in order to reside there, and resume the rules and historic work of the Benedictines. Their superior, Abbot Guéranger, received me with polite grace, and brought me immediately to the church, the only building from the original abbey to have been preserved."[1]

In fact, there was no abbey; Solesmes had never been anything but a priory. As for the abbot, he was a thirty-year-old priest who had attracted a following of young monks hoping to reestablish the Benedictine order in France. Prosper Guéranger was from Sablé—a league away from Solesmes—and on July 11, 1833, the day of the translation of the remains of Saint Bernard, he established his new community in the priory he had known since childhood. It was to be the epicenter for Catholic Revival of the nineteenth century. Mérimée's error as to the institution's status is revealing; Solesmes must have already felt like an abbey when he was there. Shortly after Mérimée's visit, Guéranger went to Rome, equipped with several strident publications and powerful backing. On July 9, 1837, he obtained a grant from Pope Gregory XVI authorizing his community and its elevation to the status of an abbey. The institution would become the mother house leading the Benedictine Congregation of France—retroactively vindicating Mérimée.

The vast ensemble of Renaissance sculpture that originally drew Mérimée to Solesmes was catapulted into visibility as the abbey suddenly became a center of piety and religious life.

It attracted attention and inspired innumerable commentaries, both scholarly and pious. Mérimée's reaction, which predates these, is all the more valuable for its spontaneity.

The sculptures at Solesmes belong to two distinct groups (figs. 375 and 376). One is at the end of the south transept and dates from the end of the fifteenth century. The composition is an entombment in a recess that is unmistakably Flamboyant in style, despite the intrusion of a candelabra motif characteristic of the Italian Renaissance. The north transept houses the other: a truly amazing quantity of sculpture and ornament from the mid-sixteenth century.[2] While conscious of the differences in date and style, Mérimée considered the Solesmes sculptures as a single entity. Of the three aspects he distinguishes—architecture, ornament, and statuary—the ornamental motifs are the only one he considers changed between the two groups.

> One will note that almost all the decorative motifs are taken from the Gothic style, while all the details belong to Renaissance art.[3] Thus we see canopies, hanging keystones, consoles shaped like reversed cones; but instead of ribs and pinnacles, or crockets with luxuriant foliage, these portions offer the regular forms of the classical orders. The Gothic ornaments have disappeared, but one senses that this new architectural system is incomplete, that it does not yet possess a unified composition of its own.[4]

Mérimée was thoroughly captivated by the ornamentation, which he praised in terms we may gladly endorse:

> One cannot tire of admiring the grace and delicacy of the arabesques that all but cover the pilasters, the doorjambs, and almost every part of these façades. Never is the same ornament

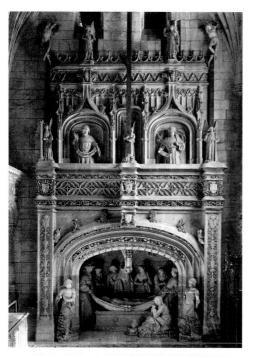

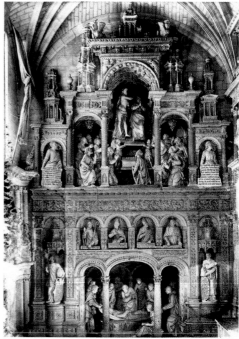

375. Solesmes (Sarthe, France), Abbey of Saint Pierre, abbey church,
south transept, c. 1495–1500.

376. Solesmes (Sarthe, France), Abbey of Saint Pierre, abbey church,
north transept, c. 1530–50.

repeated, and always the one last examined seems to surpass the others in elegance. Here, none of those conventional forms, trivial, sketched with a ruler and compass to be painfully executed by workmen without any understanding. Each part of the decoration seems the invention of an artist who, having discovered the motif, was himself its artisan."[5]

Our *inspecteur* is less satisfied with the statuary. Within the *Entombment*, he admires the head of Christ, and the Mary Magdalene figure, which is indeed striking (fig. 377). However, he judges the other figures to be "very much inferior," describing them as "short, fat, and encumbered with drapery." This does not prevent him from finding them interesting: "other than the genuine merit of their execution, these statues would be of great interest if only to acquaint us in detail with costumes from the end of the fifteenth century." Mérimée was sensitive to both the naturalism and the documentary value of the tomb's statues. In the later groups, especially

the *Dormition* and *Burial of the Virgin*, the defects he complains about are of a different order. "While there is grandeur in the style of the statues, they are all inaccurate and heavily mannered. Their costumes belong to no specific period, no country. They are, if one may say so: *impossible*."[6] Basically they invert the situation encountered in the older monument; what is gained in style is lost in naturalism. In spite of this contrast, which might seem fundamental to us, the sculpture at Solesmes appears coherent to Mérimée, who sees a single conception, a "system" common to both—one that seemed to him inherently defective.

In general, the arrangement of these groups of statues is only moderately picturesque, and the system of placing figures together to create a composition seems to me altogether unfortunate itself. Statues carved in the round, standing next to each other, conjure up an involuntary memory of the wax figures we saw along the boulevards during our childhood; and

because it seems that there is an attempt to trick us, we are less easily drawn in. Illusion, incidentally, is not the primary objective of art: before it cheats, it has to please. In every work of art, the artist asks the spectator to step into some convention, to judge his work according to some rule. Here, however, it is not so. The work comes so close to natural appearance that one judges the artist only against nature herself. And, having easily realized that these white figures are not alive, one no longer addresses them as works of art.[7]

Mérimée's reaction merits a detailed examination. The "Saints of Solesmes," to use their colloquial designation, involuntarily—that is to say irresistibly—recall for him the "wax figures" of his childhood. Today's equivalent would be Madame

377. *Entombment,* detail of Mary Magdalene. Stone. Solesmes, Abbey of Saint Pierre, south transept.

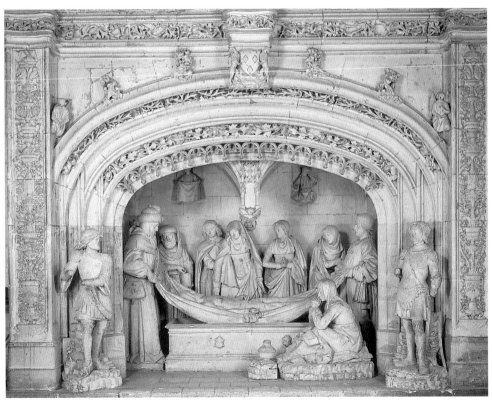

378. Workshop of Michel Colombe (?), *Entombment*, c. 1495–1500. Stone. Abbey of Saint Pierre, south transept.

Tussaud's, or any other wax museum, heirs to this figural tradition. He thinks he has stumbled on a vulgar, anti-artistic attempt at realism like that which, as early as the late fifteenth century, inspired scenes like those of the *Sacro Monte* at Varallo, whose aggressive polychromy, real clothing and natural hair unmistakably betray a conscious intention to blur the line between representation and reality. A contradiction emerges from Mérimée's text—at least on the surface of things—between his accusation of verism and the lack of realism that offends him in the sixteenth-century figures from the north transept. Is it possible to maintain that there is "an attempt to trick us," that "the work comes so close to natural appearance," and in the same breath complain about the lack of naturalism? Even in the south transept figures, which are more realistic, there is no trace of the kind of effects seen at Varallo. The kernel of Mérimée's unease resides rather in the "system of placing statues together to create a composition."

As I mentioned before, the prestige commanded by the location cast a bright light on this extraordinary work and drew considerable attention to it. Rendered explicit in the many inscriptions, the ambitious and complex iconographical project most attracted commentators, but so did the artistic importance of the sculpture. Naturally, great efforts were made to assign an author to the grand sixteenth-century ensemble. Outside the various legends involving students of Michelangelo, several names have been suggested. As early as the seventeenth century, Gilles Ménage invoked Germain Pilon. In the nineteenth century, the Antwerp workshop of the Floris,[8] Ligier Richier[9], and even Jean Goujon were brought up in succession. Léon Palustre, the zealous apostle of national art, abandoned these well-known names to suggest the idea of a local team, consisting of names retrieved from archival records: Jean Desmarais and Jean Guiffard for the sculpture, and Jean de Lespine as the architect. The hypothesis may seem less unreasonable than the others, but only for lack of available comparisons.[10]

In the twentieth century, the Catholic Revival lost its fervor, and while the *Entombment*, whether or not attributed to Michel Colombe, has remained an object of admiration at least among specialists, the sixteenth-century group of sculpture has lost its prestige. André Michel does not so much as mention it in his *Histoire de l'Art*, although he compiles a fairly exhaustive list of French sculpture during the period; nor does Anthony Blunt in his chapters on Renaissance France. Jacques Hourlier is the only scholar to have undertaken a study of the work in the recent past, but once again, for religious reasons.[11] It must be said that the monument does create a sense of discomfort. Given the level of expenditure, the high quality of the execution, the expansive compositions, and the finesse and delightful inventiveness of the ornamentation, the beholder should be filled with admiration and wonder, but the effect is perplexing rather than fulfilling. Is the work, as Mérimée would have it, a primitive kind of expression, and not an artistic one? Or are we dealing with a kind of art too far removed from what we are accustomed to for us to understand it? An attempt, perhaps a failed one, but worthy of our investigation because it is characteristic of Renaissance sculpture in France. The mere fact that in our time, such an important work commands so little attention says a great deal about the place of sculpture in our vision of art. Would a painted ensemble on this scale be equally neglected? French Renaissance sculpture—so abundant, and so beloved of its contemporaries—is admittedly difficult to appreciate today. Its principles are entirely foreign to those of the now dominant Italian tradition. Even as great a masterpiece as the tomb of Philippe Pot, displayed at the Louvre, attracts less attention than the least panel by the Master of Moulins.

The Renewal of Sculpture c. 1400

Mérimée's issue as to the grouping of "statues carved in the round" in order to create a narrative scene deserves careful analysis. The notion of what constitutes a statue occupies a central place

379. Dijon (Côte-d'Or, France), Charterhouse of Champmol, portal, late fourteenth century.

in the classical conception of sculpture. The term itself was enthusiastically reclaimed from antiquity by the humanist theorists of the fifteenth century, who conferred on it a strong civic connotation. Alberti's treatise on sculpture is entitled *De Statua*. Most important for us is the autonomy of the statue: isolated on a pedestal or in a niche, it defines its own imaginary space. Hence Alberti's clear antinomy between the statue and *l'istoria*— a narrative, which he presents as the core of painting. *Istoria* is not completely foreign to sculpture, of course. There are narrative relief sculptures, which present themselves as sculpted tableaux. Nevertheless, the distinction between *statua* and *istoria* remains an essential one. Artistic practice has occasionally succeeded in reconciling the two principles—as Verrocchio did in his *Doubting Thomas* group (Orsanmichele, Florence)—but the division remains deeply embedded in the classical tradition inherited by Mérimée. There would have been no foundation for the passionate debates over

the relative superiority of painting or sculpture that took place in sixteenth-century Italy within the more general context of the *paragone*, had there not been a deep seated feeling that they were different and relatively autonomous.

Even if the term *statua* was an innovation in the ancient style among fifteenth-century humanists, the Middle Ages were certainly acquainted with statues: of Christ, the Virgin, or saints. These images existed as a mode of representation differing fundamentally from narrative sculpture, whether as relief animating church façades, sculpted altarpieces, or Romanesque capitals. The statue has an iconic value; it is the effective and affective substitute for the person represented. Not coincidently, miraculous images are most often statues.[12] If for one reason or another there was cause to dispose of the statue of a saint, it was not to be destroyed, but interred. While narrative sculpture needed to be deciphered, the statue, especially when life-sized, would tend to establish an immediate relationship with the spectator. Carried in a procession, the statue came to life and joined the crowd. But in fact, what one might call the statue's freedom of movement was often restricted, until the fifteenth century, by its subjection to an architectural setting. Without being reduced to anthropomorphic column, or *statue-colonne*, Gothic statues of the thirteenth and even fourteenth centuries were closely aligned with the architectural logic of buildings.

Prior to the real emergence of the Renaissance in Italy, or that of great painting in Flanders, Burgundy experienced a spectacular artistic revolution. This phenomenon is generally associated with Claus Sluter, a sculptor from Haarlem, in Holland, who was called to Dijon by Philip the Bold, the duke of Burgundy. A distinct trend towards naturalism was already taking shape, particularly in Parisian art during the reign of Charles V. However, it seems to have been Sluter who, in a few decisive works, articulated the principles of a kind of sculpture that established a new relationship with the viewer. On the portal of the charterhouse of Champmol, the praying statues of the duke and duchess of Burgundy go over the edge of their supporting consoles. Freed from architectonic constraints, they enter into a dialogue with the Virgin on the pier. A line of

380. Anonymous, *Entombment*, early sixteenth century.
Polychrome stone. Chaumont: church of Saint Jean-Baptiste.

381. Anonymous, *Entombment: Face of a Holy Woman,*
early sixteenth century. Polychrome stone.
Chaumont: church of Saint Jean-Baptiste.

communication is established, linking the figures across the space of the porch—an ambiguous space both real and imaginary, shared by the visitor and statues (fig. 379). By endowing these actors with an insistent materiality, conspicuous individuality, and lifelike appearance, Sluter's art radically intensified the emotional bond between image and spectator. Painting demands an imaginary projection of the beholder into the space of its fiction—a space whose autonomy is secured by the frame. The new sculpture tends to elide the difference between the fictional space of representation and that of daily life of the spectator.

This dramatization of figural sculpture took place alongside the development of Flamboyant ornament (discussed in Chapter I). The visual effects of Flamboyant ornament are diametrically opposed to the dramatization of individual statues, which liberated them from the architectural frame. The swarming exuberance of Flamboyant

382. Anonymous, *Christ Carrying the Cross*, 1549. Polychrome stone. Chaource: church of Saint Jean-Baptiste.

ornament decreases the independence of figural motifs that nest in it. This ornamental sculpture, often of remarkable quality and virtuosity, does comprise delightfully naturalistic motifs, but they can only be appreciated at close range: as soon as we step back, they dissolve into the ornamental pattern. One must also remember that architectural sculpture, with its sharp edges and undercutting, articulates space by the fragmentation of light and shadow. Different as they are, these two kinds of sculpture—ornamental and theatrical—can be complementary, with ornamental sculpture creating less a frame than a separate architectural environment, transforming the real into

383. *Christ among the Doctors: Face of a Doctor (Luther?)*, c. 1550.
Stone. Solesmes: Abbey of Saint Pierre, north transept.
The figures in this scene retain their painted pupils.

a semi-imaginary space: a stage for theatrical statuary.

Monumental sculpture of the Romanesque and Gothic periods developed primarily on the façades of churches until the fourteenth century. Narrative relief scenes, like the Last Judgment, occupied clearly defined planes—tympani, lintels, and the embrasures of portals. Statues found their place in piers, at doorjambs, in arcaded galleries, applied to buttresses, or as their finials. The great cathedrals of Chartres, Bourges, Rheims, and Paris are the most complete examples of this arrangement. One can understand that commentators like Viollet-le-Duc discerned a civic element in these stone pronouncements by which the Church so publicly addressed the urban population. Flamboyant art transformed this economy of sculpture—both in its relationship to the building and in how it spoke to the faithful. The façade remained an opportunity for ostentatious display; however, figural sculpture no longer played the same role: it melded into the ornament. A few statues still stand

out, often at the pier, to announce the dedication of the church. But there are no more large compositions like those of the Gothic portals, with their complex iconographic statements. The façade ceased to be a book for the illiterate. This remained true as the Renaissance edged out Flamboyant vegetation. The church of Saint Michel in Dijon is an excellent example of how Italianate motifs were adapted to a Gothic portal.

Major figural sculpture took refuge inside the building. Sculpted altarpieces became common in the fifteenth and sixteenth centuries. Christ on the Cross, flanked by the Virgin and Saint John, was generally to be found atop the *jubé*. Statues were placed on consoles with their backs to piers, often with a canopy above. This custom was widespread in the Champagne region, which abounded in sculpture, but extended to other areas as well, such as Normandy, at the church of Notre-Dame-de-Louviers. In their elevated position, these statues have a somewhat distant character. Others, mostly emotive images—pietàs, Christ in chains, Christ carrying the Cross—which became very popular, were situated in a closer relationship with the worshipper, above an arcosolium or a door, or on a console against the wall or on a pedestal. Occasionally, they function as altarpieces; in all cases, they reach out insistently to the viewer. Altarpieces incorporating narrative sculpture, of which there were many, were also affected by the dramatization of sculpture taking place around 1400. High relief no longer satisfied. Instead, the figures detached themselves entirely from the plane and were arranged like figurines within a miniaturized architecture, as on a stage. The same principle applied to statues placed in narrative groups. Monumental Entombments, or the large groups of the Deposition, are characteristic of this sculpture, which one may refer to for the sake of convenience as "post-Sluterian."

Regardless of their material—stone, marble, wood, even bronze—the colors that were applied to these works have largely disappeared, or are in such poor condition that their effect is lost. This *étoffage* could involve partial accentuation through pigment and gilding, or might entail complete painting, but always served to animate the figures, compromising the frontier between sculpture and painting. There was a vast difference between the

colors used on the façades of thirteenth-century churches, where deterioration due to intemperate weather had to be accommodated (probably by periodically slathering on more paint), and the detailed finish of many post-Sluterian sculptures. The Holy Sepulcher at Chaumont (Haute Marne) has a polychrome surface sufficiently intact to give an idea of the intended effect: a refined finish, vivid, finely shaded flesh tones, and an extreme naturalism (figs. 380, 381, and 382). On the other hand, at Solesmes, no trace of polychromy has been found on any of the statuary, and it may be that, exceptionally, the stone was left bare. The eyes, however, were painted, and this accentuation sufficed to lend them an aggressive animation troubling to nineteenth-century sensibilities. Guéranger had this paint removed from the scenes he most admired, which happened to be those closest to the viewer and most emotionally affecting: the *Entombment, the Burial of the Virgin*, and *the Fainting of the Virgin*. Nevertheless, the painting on the eyes is still perfectly visible in *Christ among the Doctors*, as well as on the figures of the upper register (fig. 383).

In Italy, naturalist sculpture of the Quattrocento was also tempted by the rhetoric of participation. However, humanist theory emphasized the dignity of images, which implied a certain isolation. While promoting mimetic accuracy, the classical aesthetic remained suspicious of any process that might compromise the line between imaginary, artistic space, and that of everyday life. In this way, the statue is enclosed in a space of its own that it has conquered only by deliberate effort. A sculptor like Andrea Sansovino or even Michelangelo avoided accentuating the pupils, lest the statue's gaze, piercing the space inhabited by the spectator, accost the viewer too directly.

The entire development of art at the brink of the modern age takes on an entirely different aspect if one ceases to think of it as a history of painting. As early as 1400, sculpture very firmly established the basis of an artistic renewal whose principles would remain practically unchanged outside of Italy until the beginning of the sixteenth century. The *Entombment* at Saint Nizier, in Troyes, traditionally dated to the early sixteenth century, is more plausibly a work of the early fifteenth—this gives an idea of how strong the continuity was. Nearly a century later, the superb *Carrying of the Cross* in Chaource, bearing the date 1549 on its console, shares the same aesthetic (fig. 382). Christ, slightly larger than life, is bent under the weight of His Cross. His lowered eyes meet those of the worshipper standing just below in a way that is transfixing. With more assurance and fuller, more supple lines, the composition reiterates a formula found as early as the beginning of the fifteenth century. However, this work is archaic, and it would be wrong to see it as an example of belated Medieval art refusing to leave the stage.

Large-Scale Theatrical Sculpture

The sepulcher at Solesmes consists of eleven life-size figures (fig. 378). Two men are lowering a shroud into a sarcophagus; in it lies the body of Christ. The Virgin, weak with suffering, is supported by Saint John. Two holy women and Nicodemus stand behind, while Mary Magdalene is seated on the ground in front, the pot of ointment at her feet. Finally, two guards are posted next to the piers of the recess, on the nave side. Mérimée was right: what we see is a cluster of statues standing together, each figure preserving its autonomy. The activity is reduced to the absolute minimum necessary for the narrative content to be intelligible. Even the individuals placing Christ in his tomb are static. The most animated figures are the soldiers, who half-impinge on our space.

The monument belongs to a type that became immensely popular in France beginning in the fifteenth century. However, it remains exceptional for its visual quality— one of the best of its kind— and its organization, which stretches to their limits the spatial consequences of this "system," so objectionable to Mérimée as an inheritor of the

384. Workshop of the Maître de Sainte Marthe
(also known as Maître de Chaource), *Entombment*, 1515.
Polychrome stone. Chaource: church of Saint Jean-Baptiste.

385. *Saint Timothy*, c. 1540–50. Stone.
Solesmes: Abbey of Saint Pierre, north transept.

classical tradition. It would appear that the formula for these sepulchers was developed at the beginning of the fifteenth century in the eastern part of France, either Burgundy or Lorraine. Around the middle of the century, the genre spread through practically the whole country, reaching its greatest popularity in Burgundy, Champagne, the North, and the Southwest.[13] A few examples can be found in other countries (Germany, Italy, Spain), however, they remain exceptions, and the phenomenon was primarily a French one. This type of statuary was, however, successful in Franche-Comté and Savoie, which confirms that these areas belonged to the cultural sphere of France, though they were part of the Holy Roman Empire. These Entombments are related to the Holy Sepulchers that made their appearance in Germany as early as the thirteenth century, and to the Italian *mortori*, yet each of these three formulations is distinctive. Neither the Italian nor the German formula is, strictly speaking, an

360

386. *Burial of the Virgin*, c. 1540–50. Stone. Solesmes: Abbey of Saint Pierre, north transept.

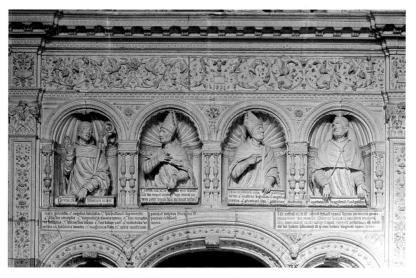

387. *Saints in Niches*, c. 1540–50. Stone. Solesmes: Abbey of Saint Pierre, north transept.
Note the correspondence between the miniature busts occupying niches on the canopy of Saint Timothy
and the saints over the arches.

Entombment. In the German type, the body of the Lord rests on top of the sarcophagus or the stone of unction, watched over by the holy persons, while the guards sleep up front. This arrangement is in keeping with the function of these works as accessories for liturgical drama. Often, there is a cavity in the body of Christ, a truly anthropomorphic tabernacle where the Host was kept during Holy Week. As for the Italian *mortori*, they portray the Lamentation, figures mourning over the body of Christ. What these three types have in common is their arrangement as a group, and their roughly life-like scale. The French Sepulchers are distinguished by restrained gestures and internalized emotion. In contrast, the best Italian *mortori*, like the one by Niccolo Dell'arca at Santa Maria della Vita in Bologna, are notable for their violent expressivity.

One could hardly call the popularity of Holy Sepulchers a mere fashion; it extended over too long a period, though one which is fairly clearly circumscribed. They began to emerge in France around 1420, and continued until the beginning of the seventeenth century. The height of production, at least in numbers, was during the first half of the sixteenth century. Many authors, including William Forsyth, who devoted a major book to the subject,[14] have seen the vogue for Holy Sepulchers as a phenomenon of the declining Middle Ages that the Renaissance first distorted, then eliminated. Would it not be more useful to view it as the indication of an historical unit—a period one might call the beginning of modern times, or the Renaissance, giving this term the more extensive meaning suggested by Courajod? Is it realistic to believe that the art of Northern Europe was more than a century behind that of Italy, a country with which it maintained close ties? Especially since Italy was open to the innovations of the so-called belated Middle Ages, as shown by, the enormous impact of the Portinari altarpiece by Hugo van der Goes on Florentine painting.

The Solesmes Sepulcher presents a number of innovations, compared to the traditional formula.[15] The most striking is the placement of figures in front of the sarcophagus. Mary Magdalene, here rendered exceptionally touching by her internalized intense anguish, is not standing behind the

sarcophagus, as is usually the case. Instead she is seated, prostrate on the ground in front of the scene, between the viewer and Christ. The Roman soldiers stand in front of the piers of the embrasure, outside the niche that normally encloses the whole composition. This disposition contradicts the role of frame performed by the arch of the arcosolium, and weakens the distinction between the fictional space of the narrative and the real space of the church. The worshipper is included in the sacred scene. Probably this is what convinced Mérimée that "there is an attempt to trick us."

Life-size figures occupy a privileged position in sculpture. The similarity of scale between the statues and our own body produces a spontaneous empathy that can be exploited to implicate the viewer. The very emotional piety of the period was particularly well suited to a mode of representation that rendered the humanity of Christ more present and almost tangible. Monumental Entombments were able to achieve this effect to a high degree through their arrangement of the figures. Most of these sculptures have lost their original setting, but a few monuments have remained in place. Among the most impressive are two exceptionally beautiful ones found in the Champagne region. The one in Chaumont (Haute Marne) is roughly contemporaneous with the Solesmes Sepulcher, while the other, in Chaource, is from a later date (fig. 384). In both the scene takes place in a separate space, below the level of the church floor, accessed by a few steps. At Chaource, guarding the door just inside this sepulchral chamber are two soldiers, one of whom is astonishing on account of his size (the statue must be some six and a half feet tall). Once inside the small chapel, one is literally inside the scene, surrounded by and on the same footing with its figures.[16] The donors, on the other hand, kneeling in prayer on consoles, are of more modest size. Though at Chaumont one is not among the actors of the drama, the proximity of the figures within the constrained space of the chapel draws the viewer just as effectively into the scene.[17]

Many Entombment groups were not installed on the ground, but at altar level. Not properly speaking an Entombment, the dead Christ at Puiseux is placed on the stone of unction, almost on the altar itself.[18] The liturgical significance and

388. *Christ among the Doctors*, detail of capitals, c. 1550. Stone. Solesmes: Abbey of Saint Pierre, north transept.

dramatic effect of this arrangement are not to be ignored. The officiating priest faced the body of the Lord, more present than represented, on the sacrificial table. Where the origin of these numerous monuments is known, it is almost always a private commission associated with the donor's place of burial. Chaumont, with its strictly private chapel, seems to be an exception. In most cases, the donor requested burial near the monument, in front of the altar where he had endowed masses for his salvation. However, the monument was accessible, and in some cases prayers were associated with indulgences.

Since the archives of Solesmes no longer exist, we have little information about the circumstances the construction of this Holy Sepulcher. We do know, however, that a small niche carved in the hanging keystone of the arcosolium was specifically created to display a relic from the Crown of Thorns. This utilitarian peculiarity of design merely underscores what is already distinctly apparent from the monument itself: the concerted effort to intensify an emotional relationship between worshipper and the drama of Incarnation, rendering it as present as possible. The Belle Chapelle in the north transept at Solesmes, built

around 1530 at the earliest, is visibly conceived in relation to the Sepulcher facing it from the south transept, and deliberately maintains a direct line of sight with its antecedent. The execution probably required a great deal of time and more than one sculptor, but the statuary in the Belle Chapelle is quite uniform; even the scene of Christ among the Doctors, sometimes considered to date from significantly later, shares the same spirit as the rest. Though this chapel was originally closed on the nave side (access was through the cloister), it was easily visible from the church as the barrier consisted only of an arc left open at a comfortable height, like the one surrounding the *Fainting of the Virgin*.[19] Standing at the crossing of the transept, one could see the *Burial of the Virgin* (fig. 386) responding to the *Entombment* (fig. 378). Both of these groups are at ground level with the faithful, the figures of the *Burial* even more so than the earlier monument, where a fragment of earthen floor creates a sort of base for the figures, isolating them from the tiles of the chapel. The author of the *Burial* even appropriated the general arrangement of the *Entombment* by placing a seated figure on the ground between the viewer and the sarcophagus, corresponding to Mary Magdalene

363

389. Solesmes (Sarthe, France), Abbey of Saint Pierre: sacristy door, originally placed between the cloister and the Belle Chapelle, 1540–50.

work, the architectural framework was thoroughly distinct from the statues, not just those of the *Entombment* itself, but the prophets, the angels bearing the instruments of the Passion, and the two thieves from the Crucifixion (the figure of Christ on the Cross has disappeared). In the north transept, one senses that the artists consciously sought to dissolve the frontier between ornamental and figural sculpture. Worth noting is the manner in which tiny busts on the canopy above the laterally placed Saint Timothy mimic, on a diminutive scale, the gestures of those saints located in niches beside them (figs. 385 and 387).

The extensive use of text within this ensemble only contributes to the feeling of uneasiness the monument engenders. The naturalism that developed during the Renaissance imposed a strict segregation of visual and textual representations. Writing could be incorporated only rarely, in limited quantity, and preferably in the form of a carefully elaborated fiction transforming it into the image of a text: a small signpost, a letter, or an inscribed epigraph. In the Belle Chapelle, the proliferation of text, and the absence of any serious attempt to integrate it within the visual

in the earlier work. True, none of the figures trespass outside the recess, but this is because the architectural conception has been modified so as to make the device unnecessary. The arch is divided in three, and therefore does not evoke a frame as it did in the *Entombment*. Instead, the columns introduce a simple division within what remains a continuous space. The niches lining the chamber in which the burial of the Virgin takes place are similar to those visible above the arch, reinforcing the impression of spatial continuity.

The sculptures in the Belle Chapelle belong to the same genre as those of the *Entombment*; but the result is very different. The imposing sixteenth-century ensemble leaves an impression of confusion. Solicited by so many details, the eye wanders, resting nowhere. Upon close examination, the statues are handsome, even touching. As soon as one steps back, however, the myriad folds of drapery—those "impossible" costumes lamented by Mérimée—meld with the swarming details of the architectural setting. In the older

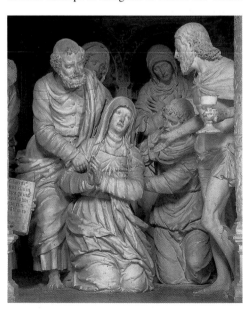

390. The *Fainting of the Virgin* (detail), 1540–50. Stone. Solesmes: Abbey of Saint Pierre, north transept.

391. *Burial of the Virgin*, detail of the sarcophagus, c. 1540–50. Stone. Solesmes: Abbey of Saint Pierre, north transept.

fiction, make writing an independent system of meaning. Intellectually, texts and figuration complement each other, but aesthetically the two are in competition. This severely compromises any awakening of the so-called visceral response so essential to the success of this kind of sculpture.

The art of the Belle Chapelle is obviously affected by ancient style, but rejects classicism's fundamental coherence. The situation is best revealed in the architectural decoration. The upper portions and the western side possess Corinthian capitals more correct than those of the first level, that is, better conforming to ancient models. However, a few are diagonally skewed to a forty-five degree angle (fig. 388). In the same way, the door that originally allowed access to the chapel (it now serves as an entrance to the sacristy) has Corinthian columns of a similarly pure type, also oriented on the bias, following the angle of the embrasure (fig. 389). This Gothic arrangement is incongruous for classical columns, but does it necessarily spring from ignorance on the part of the artist? The quality and ease of placement, the finesse of the detail—all suggest the contrary. The sculptors even manifest an acute stylistic awareness: the Virgin's sarcophagus is adorned with biblical subjects carved in relief against a plain background, contrasting with everything else (fig. 391). Was the idea to evoke an antique sarcophagus with almost archeological accuracy? In any case, these small reliefs are distinguished

from the rest of the sculpture in a way that appears deliberate and significant.

The *Fainting* is the sculptural group most touched by ancient style. The evenness of facial features, the anatomy of the Christ, the way that drapery clings to the figures, all evoke court classicism (fig. 390). Nonetheless, this classicism is introduced within a dramatic spectacle of the same order as the *Entombment*, one whose effect depends on the statues' physical presence in the semi-imaginary environment of the chapel. The sense of witnessing an unfortunate hybridization is almost inevitable.

Whatever reservations one has about the sculpture at Solesmes, it is impossible not to acknowledge the ambitious scope of the project, which invites a few comparisons. The choir enclosure at Notre-Dame of Chartres, another vast sculpted ensemble, is devoted to the iconography of the Virgin. Barely visible in the dim light, it goes practically unnoticed in spite of the cathedral's prestige (fig. 392). The lives of both the Virgin and Christ are depicted all the way around the immense choir in forty scenes set in a flamboyant decor. Begun in 1519, the sculpture was not finished until the eighteenth century. However, in spite of the obvious stylistic evolution, it seems as though the sculptors made an effort to retain the principles of the original project. The figures in the ensemble at Chartres are not life-size, like the ones at Solesmes and other Holy Sepulchers. However, they contrast sufficiently with the

392. Chartres (Eure-et-Loir, France), Notre-Dame cathedral, choir enclosure, shortly after 1514.

393. François Marchand, *Saphira before Saint Peter*, bas-relief from Saint Père de Chartres, 1543.
Stone, 33 ½ × 50 in. (85 × 127 cm). Paris: Louvre.

ornamental frame to produce the same dramatic effect.[20] The impression they make is one of independent characters, statues grouped on a stage, similar to the way a painter like Tintoretto might have employed wax figurines in a miniaturized decor for better visualizing a scene. It is instructive to compare François Marchand's *Massacre of the Innocents* (fig. 394), with bas-reliefs he created for the *jubé* that once stood at Saint Père de Chartres (its remains are housed in the Louvre and the École des Beaux-Arts, fig. 393). The bas-reliefs, some of them directly copied from engravings by Marcantonio Raimondi, are much more faithful to the principles of Italian classicism than are the scenes at Chartres; these, in spite of their regularity and idealized figural types, perpetuate effects belonging to the dramatized sculpture we have been discussing.

The Sepulcher at Pontoise (together with one by Ligier Richier at Saint-Mihiel) is one of the most classical sixteenth-century adaptations of this theme (fig. 395). The grandiose conception is compromised by uneven execution. One should consider this handsome piece in the context of an ensemble, one with a less exuberant setting than that of Solesmes, and less original in its iconographical program, but comparable in its artistic ambition to the Belle Chapelle. The work at Pontoise was commissioned for the chapel of the powerful Confraternity of the Passion, hence the theme of the decoration. It still contains two stained-glass windows, *Christ Carrying the Cross*, and a *Crucifixion*, dated 1545 (figs. 296 and 397). The design of these windows, each filled with a single composition, belongs to the finest classicizing style of the mid-sixteenth century. The participants in the drama are large enough in scale to affirm continuity between the two windows on the north wall and the monumental sculpture that constitute the primary ornament of this chapel. Fairly high on the wall, in stucco high relief, the three Mary's are represented making their way to Christ's tomb. Above the sepulcher is a polychrome wood depiction of the *Resurrection*. Every scholar since Lefèvre-Pontalis has repeated that this last group dates from the eighteenth century; however, it clearly belongs to the Renaissance composition. The *Three Marys* relief would be incomprehensible were it isolated

394. François Marchand, The *Massacre of the Innocents*, 1542. Stone. Chartres: Notre-Dame cathedral, choir enclosure.

in its situation, whereas the *Resurrection* justifies its placement perfectly. The Holy women are bound for Christ's tomb, which they will find empty, since He has risen: the narrative binds them together almost as a single scene. Thanks to parochial archival documents, we know that a *Descent from the Cross* was removed from above the altar during the eighteenth century. It was rotten and threatened to collapse.[21]

One can see the narrative cycle of the Passion clearly unfold as one circulates around the chapel. Beginning at the north, and following from left to right, we would encounter *Christ Carrying the Cross* and the *Crucifixion*. Over the altar on the East: the *Descent from the Cross*, if it still existed. Continuing on the South is the *Entombment*, and above it, the *Resurrection*, with the Holy Women on their way to the Sepulcher. While the iconography of the project is explicit and perfectly coherent, the scenes in fact produce different visual and emotional effects. Beautiful though they are, the windows do not affect us in the same way as the

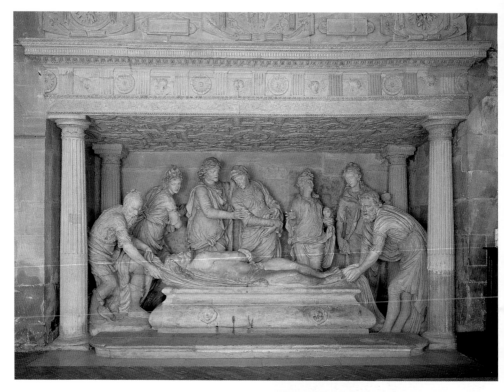

395. Nicolas Le Prince and anonymous, *Entombment*, c. 1560. Stone.
Pontoise: church of Saint Maclou, chapel of the Passion.

Entombment, with its slightly larger-than-life figures standing beside us. The *Descent* has disappeared, so judgment is at the mercy of imagination, but it must have created a deeply powerful impression, since its placement would have made the body of Christ seem to come down off the Cross, directly onto the altar where the priest officiated. The fusion of the scenic space of the sculptures and the liturgical space of the chapel could not fail to produce its dramatic effect.[22]

In this ensemble, only the *Entombment* has attracted much attention. In the eighteenth century, it was solicitously, and perhaps abusively, restored. It is possible that a polychrome surface was stripped off, and that the classical character of the statuary was emphasized. Whatever cosmetic treatment it was subjected to, this attractive monument often evokes the name of Jean Goujon, to whom it has—more or less tentatively—been attributed.

396. Anonymous, The *Resurrection* (detail), third quarter
of the sixteenth century. Polychrome wood.
Pontoise: church of Saint Maclou, chapel of the Passion.

In fact, a document long published but practically unnoticed suggests a completely different direction by furnishing us with the name of one of the authors: Nicolas Le Prince.[23] He came from the great Beauvais family of glaziers, of whom Engrand is the most illustrious representative. Le Prince was a glazier at the beginning of his career. As early as 1538, he worked on the stained glass in the north transept of Beauvais cathedral with Jean Le Prince. In 1551, he signed a contract of his own for the window in the south transept.[24] Even during this period, however, he was also a sculptor. It is not clear when he began to associate with Jean Le Pot, to whom we owe the magnificent doors of the south transept. But in 1556 he married Le Pot's daughter, and in 1558, documents place him

397. *Christ Carrying the Cross*, c. 1545. Stained glass.
Pontoise: church of Saint Maclou, chapel of the Passion.

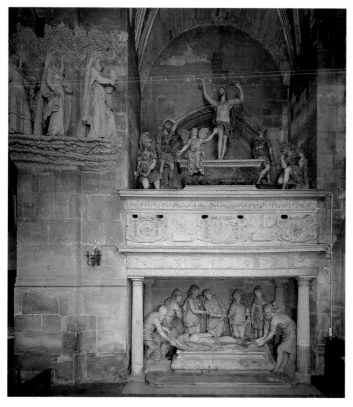

398. Pontoise (Oise, France), church of Saint Maclou, chapel of the Passion, c. 1560 for the sculpted decoration.

alongside his father-in-law for the execution of a Holy Sepulcher at the church of Marissel-lès-Beauvais. Le Prince does not appear to have worked as a glazier after 1552. The many contracts in which he is involved are for monumental groups, such as sepulchers, sculpted altarpieces, and statues. He worked in wood as well as in stone, but not in marble. In 1587, he accepted one last commission; his long career ended only with his death around 1589. The contract of direct interest dates from 1565. Nicolas Le Prince accepted to execute "a story of the Resurrection of our Savior, where there will be eight figures, who will be made of good, dry, oak wood, all according to the drawing made, and currently exhibited, which is signed by the aforementioned Le Prince and the aforementioned notary, and remains in the hands of the accountants. It should be in the same manner, the same height, size, and number of figures and as satisfactory as is a sepulcher present at the church of Saint Maclou de Ponthoise [sic], which was partially made by this same Nicolas Le Prince, and will correspond to the *Descent from the Cross* carved by the said Le Prince at the said church of Saint Laurent."[25] Le Prince was therefore responsible for a portion of the sepulcher at Pontoise. Perhaps Jean Le Pot was the author of the rest, since we have already seen him ready to collaborate with his son-in-law. Two points are significant here. First, the *Entombment* at Pontoise must have been considered exceptionally beautiful, since it was chosen as the reference despite being situated in a city some distance from Beauvais (usually contracts refer to models in the same city). The second point is more interesting still; this *Resurrection* was also part of a grand sculpted ensemble comparable to that of Pontoise. At Saint Laurent there was a Holy Sepulcher, which appears to have had stone statues whose *étoffage* was deferred.[26] This sculpted group was placed in a distinct architectural setting "of which the vault, in the Italian manner, is lined with azure, studded with gilded rosettes and floral ornament, sculpted in the round. All around the vault, the sides of the tomb are decorated with a kind of mosaic, or glass painted in compartments, giving it a handsome appearance." Canon Gabriel Boicervoise, who penned this description in the eighteenth century, added that "two other pieces of

sculpture are matched with it: the *Descent from the Cross*, in carved wood above [the *Sepulcher*], is the work of the famous sculptor Pilon; the *Resurrection of Our Savior* is the other piece, next to the *Descent from the Cross*, it is of inferior workmanship, though respectable and well esteemed. This one is by the sculptor Le Prince, who made it in 1590."[27] The three groups from the 1565 contract are easy to recognize; apart from the erroneous but suggestive attribution to Pilon, and a twenty-year mistake in the date, the information is correct.

The sepulcher has to be imagined in a vaulted recess, adorned with Italianate motifs, with the *Descent from the Cross* above it, placed much like the *Resurrection* at Pontoise. As for the Beauvais *Resurrection*, I am not sure whether to interpret Boicervoise's use of "next to" literally, or take it to mean "in addition." The arrangement at Pontoise was different (the *Descent from the Cross* was over the altar, and the *Resurrection* above the sepulcher)[28]; nonetheless, these two ensembles share strikingly similar features, even to the use of stone for the *Entombment*, while the higher placed figures are of wood. The term "*assorti*" (matched) employed by Boicervoise indicates that the coherence of the Beauvais ensemble did not escape him. Was the chapel of the Passion at Pontoise ever as unified? It is probable that its makers hoped it would be.

The *Descent from the Cross* at Saint Laurent-de-Beauvais, finished in 1565, before the sepulcher and *Resurrection*, was—if Boicervoise is to be believed—superior. His attribution of the piece to Pilon gives a stylistic indication compatible with the sepulcher at Pontoise: a distinguished appearance, and a style we would call Mannerist. Additionally, the canon's judgment implies a disparity between the different groups at Beauvais, all of which, however, issued from Le Prince's workshop. Might Pontoise have been a similar case?

Nothing remains of the grand ensemble that Nicolas Le Prince executed for Saint Laurent-de-Beauvais, a portion of which was deemed worthy of Germain Pilon in the eighteenth century. Nor is there any vestige of the sepulcher he carved for the church of Marissel-lès-Beauvais, or at Saint Sauveur-de-Beauvais, his proposed model.

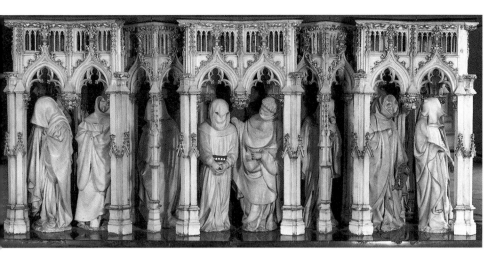

399. Jean de Marville, Claus Sluter, and Claus de Werve, *Tomb of Philip the Bold* (detail of mourners), 1390–1411. Marble and alabaster. Dijon: Musée des Beaux-Arts.

How many other monuments of this type have disappeared? It is difficult to say. However, one can assert that the grand theatrical sculpture, which first appeared around 1400, remained in favor halfway through the sixteenth century. At Chatres, Solesmes, Pontoise, and elsewhere, it adapted to classicizing tastes without fundamentally changing its character.

Tombs

To what extent did funerary art participate in the emancipation of figures sculpted in the round that we may call the "Sluterian revolution"? This question is complicated by the very nature of tombs.

Disfigured as it is, the monument of Philip the Bold remains nevertheless eloquent testimony of the daring art of Champmol. The iconography itself is not particularly novel. An effigy of the deceased lies supine on a sarcophagus whose arches shelter the figures of mourners. Except for the angels holding up the helmet, these are motifs one finds as early as the thirteenth century, on the tomb of Philippe of France at Saint Denis. The innovation lies in the execution. The larger scale enhances the tomb's monumentality; above all, the artist infuses the sculptures with life and confers an illusion of reality on the representation that deeply transforms its meaning. It would therefore be wrong to speak of it as a formally innovative treatment of a traditional iconographical program, as though it consisted of simply wrapping the same product in redesigned packaging. The genius of Claus Sluter is to have transformed the arcades of the sarcophagus into a real portico where, instead of an isolated and abstract row of symbolic figures, a genuine funeral procession winds its way around the casket (fig. 399). The effigy has unfortunately been damaged during the Revolution, and was almost completely remade by restorers. Nevertheless, it too must have been handled with vivid realism. The angels cautiously holding the helmet suggest a narrative element, while also firmly situating the deceased in the afterlife. The naturalistic representation of the funeral procession, almost playful with its earthly, even worldly, picturesque details, threatened to erode the distinction between the sphere of daily life and the other side of the tomb. The angelic presence serves to animate a static motif, and to anchor the scene in a supernatural space.

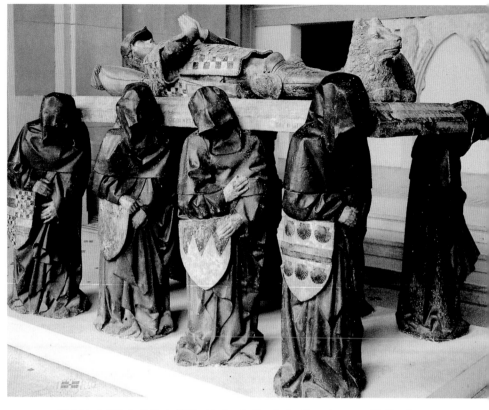

400. Antoine Le Moiturier (?), *Tomb of Philippe Pot*, from the abbey church at Cîteaux, last quarter of the fifteenth century. Polychrome stone. Paris: Louvre.

Funerary art tends to be conservative. Leafing through surveys prepared for Gagnières in the seventeenth century, before the devastation wrought by the Revolution, one realizes how monotonous even the most luxurious tombs are.[29] A few stand out, but for every kneeling statue like the ones of the Jouvenal des Ursins couple—for each rare outburst—there are innumerable stiff recumbent statues, endless slabs with engraved effigies, praying meekly with hands clasped, and surrounded with lacy flamboyant ornaments. Their tedious uniformity accentuates the audacity of the tomb of Philippe Pot (Louvre, previously at the abbey of Cîteaux, fig. 400). The entire monument is, so to speak, on the move. No sarcophagus, no arcading, no architectural frame other than the church: literally petrified, the funeral procession has itself become the monument.[30] One could

hardly envision a further fusion between the space inhabited by the spectator, and that of the representation; or a greater ambiguity between earthly existence and the afterlife. These same principles were extended a little later in a dynastic and transcendental direction at the tomb of Emperor Maximilian, whose sepulcher is surrounded with life-sized bronze statues of his ancestors. These characters standing isolated from each other, barely raised off the ground, reminded Heinrich Heine of "the figures of black wax from a fairground tent"[31]—the same effect that the statues in Solesmes had on Mérimée.

The classical sensibility, and revival of ancient forms in which Italy led the way dictated greater restraint. It also called for clearer boundaries between sculpture and architecture, and sculpture and painting: between real and fictional

401. Hans Holbein, *Praying Effigy of the Duc de Berry*, Drawing, 1540–50. Basel: Öffentliche Kunstsammlung, Kupferstichkabinett.

the iconographic themes nor the spiritual doctrine are much changed, but in the visual rendition, the rhetoric of participation yields to the idea of a more autonomous work of art: available to the gaze, but keeping to itself.

The kneeling effigy and what Panofsky has called "the activation of the effigy" evolved with the dramatization of sculpture. The deceased ceased to be represented lying on a parade bed. The older formula had the advantage of grace-fully articulating the passage from one life to another, recalling the exhibition of the corpse during funeral rites, while anticipating an awak-ening to eternal life.[34] Suddenly, the effigy drew itself upright and knelt in prayer. However, the statue did not pray in a void; these kneeling indi-viduals turn toward the altar and to the divine fig-ures placed on it. Such funeral portraits are only comprehensible within the transcendental space—both real and fictional—of the church, shared by the faithful and statues.

The kneeling effigy appeared earlier than Panofsky believed. He saw the tomb of Charles

space. However, even in fifteenth-century Flo-rence, this classical tendency was not exclusive; one senses Donatello torn between the drama of Sluterian sculpture and classicism.

As was seen in Chapter I, the funerary monu-ment of Duke François II and the duchess of Brittany explicitly takes the Champmol tombs as its model in the arrangement of the recumbent statues, the angels at their side, the strong cor-nice, and the contrast of black and white mar-ble.[32] But painting was abandoned, and the Gothic arcade of the sarcophagus replaced with niches. The large allegories of the Virtues on the corners of the monument are also imported from Italy, at least as an iconographical theme. How-ever, their oblique arrangement, opening the composition, is a Northern idea in the Sluterian tradition.[33] All things considered, this tomb—even more so that of the children of Charles VIII in the cathedral of Tours, originally in Saint Mar-tin's Basilica—herald a new direction. Neither

402. *Tomb of Charles VIII.*
Anonymous drawing from the seventeenth century.
Paris: Bibliothèque Nationale de France, Gaignières collection, Pe 1a rés.

VIII, designed by Mazzoni, as the first example (destroyed, this work is known through a drawing in Gagnières' collection, fig. 402). In fact, the design by Jean Fouquet for the tomb of Louis XI at Notre-Dame de Cléry had already portrayed the king on his knees in prayer, so the idea was not an Italianism introduced by Mazzoni.[35] Other cases must also be prior to the tomb of Charles VIII—such as the strange monument of Jean de Salazar and his spouse at the cathedral in Sens, where the deceased couple kneel on a platform so elevated, it places them higher than the altar before which they pray.[36] The kneeling effigy was to become a regular occurrence, particularly in the royal tombs from Louis XII to Henri II. Towards the end of the sixteenth century, it became commonplace as tombs oscillated between retrospection and eschatology.

The Tomb of Louis XII, a New Formula for the Royal Sepulcher

Jean Juste and his collaborators realized an exceptionally original monument for the sepulcher of Louis XII (fig. 403). The spark was probably kindled by Michelangelo, whose initial plans for the tomb of Julius II must have been in circulation. The tomb of Duke François II and the duchess of Brittany in Nantes already suggested one synthesis of the grand Burgundian and Italian funerary traditions. That of Louis XII, at the basilica of Saint Denis, borrowed from Michelangelo the idea of a freestanding monument consisting of not just a sarcophagus, but of an entire funeral chamber; to this concept it adds the Virtues present on the corners of the tomb in Nantes and the kneeling effigy. It also employs a formula developed primarily in England: the tomb on two levels with a *transi*, a representation of the worm-eaten corpse, on the bottom, and an effigy above.[37] On the other hand, the depiction of heroic exploits along the stylobate is entirely Italian.

Not since antiquity had the Western world seen such a grandiose individual tomb. Its realization is perhaps not entirely on a par with the idea, but let there be no mistake: the contrast between the slightly insipid idealization of the Prophets and Virtues and the striking realism of the portraits does more than reveal differences in nationality and talent among the executants. It highlights an opposition between two distinct categories of actors. Here, as with the tomb in Nantes, we must be careful lest the myopic judgments of connoisseurship cloud our appreciation of the true merits of this masterpiece. A handsome tribute to a genuinely popular ruler, this homage was also a means for François I—born a long way from the throne—to provide concrete emphasis of the dynastic continuity of the House of Valois, and the legitimacy of his own reign.

Two variations on this model of royal tomb punctuated the French Renaissance and indicated its phases. The monuments of François I and Henri II are both collaborative works; however, the roles of the principal sculptors involved in each project are not equal. While Pierre Bontemps, the main sculptor of François's tomb, remains a shadowy figure, Germain Pilon, who did most of the work on Henri's tomb, asserted himself as an artist in every sense of the word, and went on to prove his independence after completion of the royal tomb.

The Tomb of François I and the Work of Pierre Bontemps

Henri II chose Philibert de l'Orme to design the tomb of François I, and it is no surprise that the model developed a strongly architectural character (fig. 404). Between two piers at the Gothic basilica of Saint Denis, de l'Orme erected a triumphal arch. Its articulation is complex, consisting of three vaults of unequal heights and slightly different depths. The lateral bays are shallower

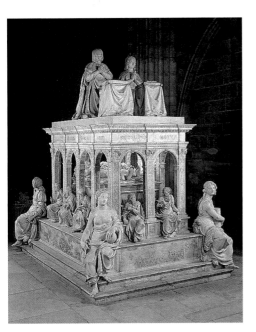

403. Jean Juste and collaborators, *Tomb of Louis XII and Anne of Brittany*, Marble. Saint Denis: basilica.

The evocation of a triumphal arch to symbolize the concept of triumph over death was a well-established motif of funerary art. But in the atmosphere of antiquity reigning over mid-sixteenth century France, an insistent return to classical forms combined with representations of the king's military victories on the pedestal seems to compromise the Christian theme of the motif, favoring a glorification of the military hero on the model of the Roman *Imperator*. Should responsibility for this ambiguity be ascribed to the stylistic preoccupations of the artist or the imperial ambitions of the king? Both factors may have found a serendipitous complementarity.

Reconstructed by Maurice Roy through archival documents, the history of the sculpted portions offers some instructive details.[38] Philibert first approached François Carmoy, a sculptor about whom we know little except that he was employed for stucco relief in the queen's bedchamber at Fontainebleau from 1536 to 1540, and thus was already a member of the teams working on royal constructions. He was based in Orleans, where work was to progress before moving the stones to Paris for finishing. Roy supposes that a general agreement between the architect and sculptor must have been reached at the end of 1547 or the beginning of 1548. On April 10, 1548, Carmoy signed a contract for the effigies of the king and queen (*transis* and kneeling figures). At the end of May 1548, Philibert had the praying figures that Carmoy had begun transported to Paris. Was it already clear that the sculptor would never finish them? Or was he going to follow them to Paris in order to do so? Either way, he died shortly thereafter. It was at this point that Pierre Bontemps appeared, accompanied by another sculptor from Orléans, François Marchand, whose work we have encountered earlier—the choir enclosure at Chartres. The sculptors accepted joint responsibility for Carmoy's contracts pertaining to the royal effigies. Marchand signed an individual agreement to carve the kneeling figure of little Louise, but perhaps already ailing, he entrusted its completion to Simon Leroy, another sculptor active at Fontainebleau and also responsible for the angels on the *jubé* at Saint Germain-l'Auxerrois (see Chapter V). Bontemps, who was engaged

than the central vault, which houses the sarcophagus. On top of that casket lie *transis* of the king and queen, contemplating the Resurrection and the Evangelists represented in bas-relief on the underside of the vault. The side bays create a passage from which the visitor may contemplate this macabre spectacle. The kneeling effigies of the king, queen, their two deceased sons, and little Louise are placed on the platform atop the monument. The great military events of François I's reign are depicted on the stylobate, as they were for Louis XII.

While preserving the general lines of the Louis XII tomb, Philibert transformed its character. The plan, strongly articulated by sixteen magnificent Ionic columns, lends a powerful expressivity to the architecture of this aedicula, while the crowning effigies, more numerous and less animated than those of the previous monument, have little emotional impact. The dimly lit *transis* can only really be seen when standing in the side aisles. The bas-reliefs on the vault, remain practically invisible without artificial lighting. Architectural conception trumps sculpture here.

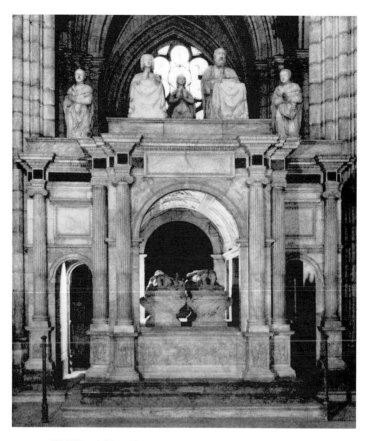

404. Philibert de l'Orme, Pierre Bontemps, François Marchand and François Carmoy, *Tomb of François I and Claude de France*, 1548–59. Marble. Saint Denis: basilica.

to finish the statue of the dauphin, discharged himself of this duty (except for polishing) by handing it over to the Lheureux brothers, who worked at the Louvre under Lescot. As for his collaboration with Marchand, the death of the sculptor from Orléans put an end to the relationship.

Who carved the beautiful bas-reliefs on the vault? They were part of a general agreement made with Ambroise Perret and Jacques Chanterel, but one might wonder if these practitioners, generally assigned only to ornament, were capable of such work. In any case, Pierre Bontemps does not appear to have been involved in this portion of the tomb.[39] However, he seems to have been the sole sculptor of the bas-reliefs on the stylobate. He also finished the *transis* that Carmoy had begun.

Finally, Philibert de l'Orme ordered sixteen funerary genies, dividing the work between two younger sculptors: Germain Pilon and Ponce Jacquiot. Primaticcio, who supervised the completion of the tomb when he succeeded Philibert after the death of Henri II,[40] did not use these gracious genie figures.

These admittedly tiresome details are necessary for understanding the division of labor and the role of the executants in the project. It appears that, for a statue to be so handed around between sculptors, not only must Philibert have exercised strict control over the project, but he also would have had to provide highly detailed models. The executants were numerous, but their names are familiar: sculptors who worked at the royal construction sites, under Rosso or Primaticcio at Fontainebleau,

or for Lescot in Paris. It is significant that they were able to make this transition from one site to another. Their contributions are not assertively individualized. It is true that Pierre Bontemps received the lion's share of commissions for the tomb of François I: he was sole sculptor for the pedestal relief and for a good part of the figural sculpture. He was by no means, however, free to impose a personal vision on the monument. If there was a unified artistic will, it was that of Philibert de l'Orme.

Nevertheless, let us try and sketch Bontemps's character from what is known about him and his works. As early as 1540 he was a trained practitioner carving a stone statue of Saint Barbara for the abbey of Saint Victor.[41] At Fontainebleau, he was from 1536 to 1540 among Primaticcio's team, working on stuccos for the queen's bedchamber. He was paid fifteen *livres* per month, and as such belonged to the second best paid category of artists. The highest paid (except the foremen) received twenty *livres*. François Carmoy, working alongside Bontemps, went from fifteen to twenty *livres* during that time. In the general accounts after 1540 (until 1550), Bontemps was also promoted to twenty *livres*. In addition to decoration, he participated in the major enterprise of casting ancient statues (see Chapter III). In particular, he was entrusted with the finishing work on *Laocoon*. In 1543 he also did this type of work for Cellini, who employed him in finishing the *Nymph of Fontainebleau*. After 1550, Philibert hired him for several commissions, by which time he was no longer paid a monthly salary. There was a substantial portion of the sculpture for the tomb of François I, but also the deceased king's *Monument of the Heart* for the abbey of Hautes-Bruyères, a statue of the king for the Palace of Justice, and a grand bas-relief representing the seasons for the king's bedroom at Fontainebleau. Other than the statue of Saint Barbara previously mentioned, he is also known to have executed several private commissions: the tomb of Étienne Poncher in 1555, the Maigny tomb in 1557, and that of Antoine IV Duprat at Nantouillet in 1561.[42]

The statue of Charles de Maigny is the only remaining documented work by Bontemps as an independent sculptor and our best opportunity to judge his talent (fig. 405). The monument was installed in the choir of the Celestins monastery in Paris. It consisted of a statue in a niche, placed high enough for an epitaph below. A slab carved with an inscription was placed on top of the actual sepulcher, in front of the monument. Only the statue has survived; now housed in the Louvre, it was the primary feature of the tomb. Maigny, captain of the guards of the king's chamber, sits in his armor, but his head is bare and rests in his right hand; his eyes are closed. In his left hand, he holds a blade. The usual explanation is probably correct: he is

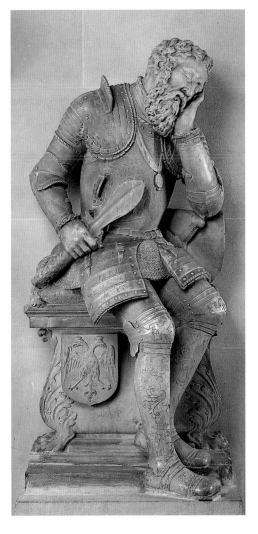

405. Pierre Bontemps, *Charles de Maigny*, 1557. Stone. Paris: Louvre.

406. Pierre Bontemps, *Monument for the Heart of François I*, from the abbey of Hautes-Bruyères, 1550. Marble. Saint Denis: basilica.

awaits the call of the Resurrection. Yet how far is this image of death from the stiff corpses of earlier effigies. It is not that religious concerns for salvation were abandoned—the many testaments including bequests to endow masses for the souls of the deceased leave no doubt of that. Nevertheless, one must admit that a glimmer of ambiguity has crept in: an appreciation for earthly life, regret for what one left behind, or perhaps the need to leave a mark, a desire to survive in living memory after passing on.

Whose was the idea for this unusual arrangement? Pierre Bontemps? Or was it Martienne, the captain's sister, who commissioned the tomb? Did Maigny express his wishes before dying? As always, the verbal exchanges between parties escape from a documentation that, even in the best of cases, is often incomplete. Maurice Roy has unearthed the legal record of the commission, which is detailed, but purely descriptive. One point is worth noting: contrary to custom, there is no mention of an existing drawing for use as a reference in case of conflict. This more or less excludes the possibility that Bontemps was executing a project by a different artist. Once the theme was invented, the composition was by no means complicated, and remained dominated by the statue, which would have been Bontemps' field of expertise. The execution is of a high quality, with no evident weaknesses, but is without any distinctively expressive character.

The small monument for the heart of François I that Bontemps carved according to Philibert de l'Orme's commission leaves a similar impression (fig. 406). Conceptually audacious, it is not a traditional tomb, but a cinerary urn in the ancient style. The rich decoration does not celebrate Christian virtues, but the king's patronage; his role as a restorer of the arts is allegorically memorialized in eight little bas-relief panels. The formal vocabulary is that of Fontainebleau in all its sensuality, where nudes abound with no mystical pretext. It is impossible to know how precisely de l'Orme dictated the project: are these allegorical compositions his? Did he solicit drawings from yet another artist, Primaticcio perhaps? How much of a free hand did the sculptor have? These are unanswerable questions. Like the statue of Maigny, the execution is

represented in the context of his official function, seated at the door to the king's bedchamber. However, care is needed, lest we perceive it as a genre scene exclusively commemorating the life of the deceased: one of those touching, familiar evocations addressed to posterity, in the nineteenth century. No doubt even the best guard of the sixteenth century occasionally lapsed in his vigilance, succumbing to momentary fatigue. However, it is impossible to believe that this moment of weakness would have been invoked for a monument honoring the memory of the deceased. Given what we know of the period, the reading should conform to Christian orthodoxy. Maigny's slumber is that of death: having remained at his post beside the king until the very end, it is in this position that he

sophisticated but uninspired. While Bontemps might be considered a leading member of the choir, he was no soloist. For that matter, he left no great reputation behind him when he died. Modern scholarship rescued him from oblivion. Completely forgotten, he reemerged in the process of archival research. One must wonder if he does not occupy a similar position to the masons, also exemplary practitioners, whom Palustre for a time attempted to portray as the architects of French châteaux. This period, the mid-sixteenth century, was a time at which the entire conception and organization of artistic production underwent radical change: an unstable moment during which relationships and responsibilities were still undefined. For this reason it is important to be cautious in matters of attribution. After unearthing Bontemps's name, scholars felt it their duty to amass a corresponding body of work. First and foremost came the famous statue of Admiral Chabot, when its attribution to Jean Cousin had to be regretfully abandoned. Then there was the tomb of Jean de Humières, and that of Guillaume du Bellay at the cathedral of Le Mans, as well as other assorted pieces of sculpture.[43] However, this enterprise was doomed in advance. The individuality of the sculptor is hazy at best. Other contemporary sculptors in similar circumstances are merely names to us, like the Lheureux brothers, who had careers comparable to that of Bontemps. Even Ponce Jacquiot who, unlike Bontemps, did leave a reputation, remains almost a complete mystery. Under the circumstances, are we informed enough to distribute the credit for anonymous works? And is the game worth playing? The very resentment Philibert de l'Orme provoked in his contemporaries leaves no doubt that he was a forceful artistic personality comparable to Rosso or Cellini. However, Bontemps's work sank into a comfortable anonymity from which it is perhaps not absolutely necessary to extricate it.

The Tomb of Henri II—Germain Pilon

Catherine de Médicis built the last and most brilliant of the royal tombs of the Renaissance for Henri II and herself (fig. 407). The arrangement is simpler than the preceding royal monument. Primaticcio, who was certainly responsible for the design, eliminated the narrative bas-reliefs. He also opened up the mortuary chamber, making the *transis* more visible. Ornamentation is kept to a minimum. Every aspect is calculated to show off the sculpture: the *transis*, the praying effigies, and the Virtues.[44] The *transis* are treated in a different manner from the earlier corpses: that of Henri II is deliberately taken from Renaissance representations of the dead Christ. The queen's corpse, almost voluptuous, suggests sleep rather than death. The Cardinal Virtues stand at the corners of the monument in the form of imposing bronze figures. Along the stylobate are arranged marble relief panels illustrating the theological Virtues. To fill in the fourth side, the first act of charity, offering water to the thirsty, was included.

The kneeling statue of the king on the upper level is posed in an unusual manner (fig. 408). The queen is praying with her hands clasped together, but Henri II is holding his right hand to his breast and reaching with the left towards his prayer desk and a liturgical book. Both of their prayer desks were melted down after the Revolution and never replaced, but they remain essential for understanding the king's gesture. Up until this point, figures kneeling in prayer had always been exclusively depicted with clasped hands. This convention continued to be rigorously observed until the end of the sixteenth century.[45] Obviously, the monument's departure from such an established tradition demands explanation.

In a spirit partaking of the nineteenth century, Jean Babelon, sensitive to innovation, presented the tomb almost as a genre scene: "The movement of the body, the heavy cloak, and ermine cape appear as if suspended, so much so that it seems as though Henri II were just taking his place before his prayer desk. The hands are about to clasp, and his head bows in a gesture whose accuracy is itself a triumph on the part of its sculptor."[46] This interpretation cannot be

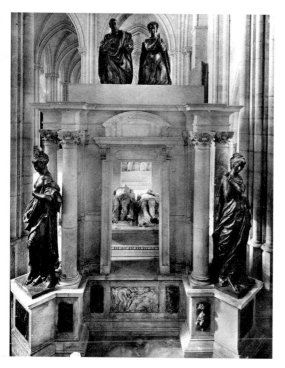

407. Primaticcio and Germain Pilon, *Tomb of Henri II and Catherine de Médicis*, 1561–73. Marble and bronze. Saint Denis: basilica.

accepted, as it fails to take into account the religious exigencies of Renaissance funerary art. In order to comprehend the meaning of this iconographic innovation, one must return to a more general question, which may not be easy to answer precisely: what is the status of these figures? Do they represent the living monarchs? Are they representations of the king and queen after the Resurrection? If so, are they shown before the Last Judgment, or do the statues represent an anticipated eternal life? Here the parallel between the tomb and the funeral rites practiced in the case of French kings—often proposed as a justification for double effigies—seems of dubious merit. True, in the very impressive funeral rites organized for François I and later for Henri II, an effigy was employed as a means of continuing the deceased monarch's earthly existence between the time of death and the moment of inhumation. The ritual of the king's meals was even scrupulously observed for the benefit of the mannequin.[47]

The praying figures on the tomb are a very different case. There is no question, of temporarily prolonging earthly life. On a tomb, representations of the deceased as alive imply a new, eternal life, especially when placed above a *transi*. Nevertheless the king and queen are shown to us in costumes appropriate to their station, accompanied by the symbols of their power. Like the innumerable bishops and abbots portrayed on their tombs wearing their sacerdotal robes, the king and queen wear coronation robes. Their royalty, like their souls, is eternal. They have become the trustees of the kingdom of France within the Kingdom of Heaven. No other interpretation satisfactorily explains this arrangement from the point of view of orthodoxy. With the rise of naturalistic representations beginning in the fifteenth century, the afterlife was imagined as an exact replica of earthly existence. As a result, the tombs of the mighty often insinuated an ambiguous conflation of the glorious Life Eternal with a glorification of their earthly lives.[48]

However, eschatological preoccupations were not abandoned, and the kneeling figures on tombs, like the donors on an altarpiece, await judgment from the Lord. Given these circumstances, an attitude of prayer seems not only normal, but indeed imperative. The decision to abandon this attitude in Henri II's effigy cannot have been taken lightly. But what does his posture signify? The gesture he makes with his right hand has a deeply emotional quality. The famous *transi* of René de Châlons, carved by Ligier Richier, strikes a similar pose, while his left hand lifts his heart to heaven (fig. 422). Raising the right hand to one's chest is certainly a clearly coded action, signifying a profession of faith, or an oath.[49] It may be that Girardon was thinking of the statue of Henri II when he designed the funeral effigy for Cardinal Richelieu. The prelate's image also combines a similar introverted gesture of the right hand with an extroverted movement of the left, also reaching toward a book—an action all the more striking here since the volume lies behind him. Might each of these two figures be presenting himself as the defender of orthodoxy? In the case of Henri II, at a time of violent religious conflict, the argument would have been a sufficient

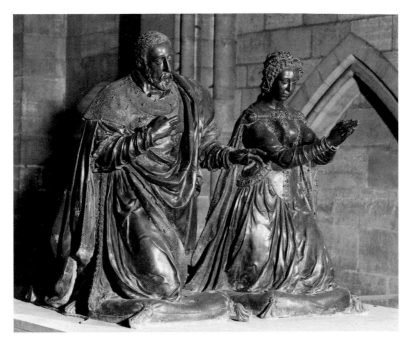

408. Germain Pilon, *Praying Effigies of Catherine de Médicis and Henri II*, 1565–66. Bronze. Saint Denis: basilica.

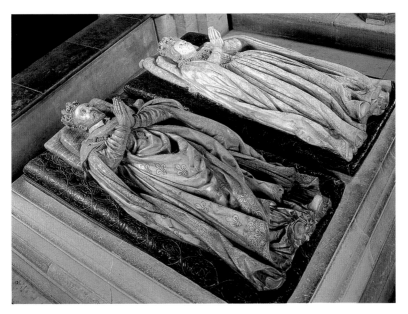

409. Germain Pilon, *Supine Effigies of Catherine de Médicis and Henri II in Coronation Robes*, 1583. Marble. Saint Denis: basilica.

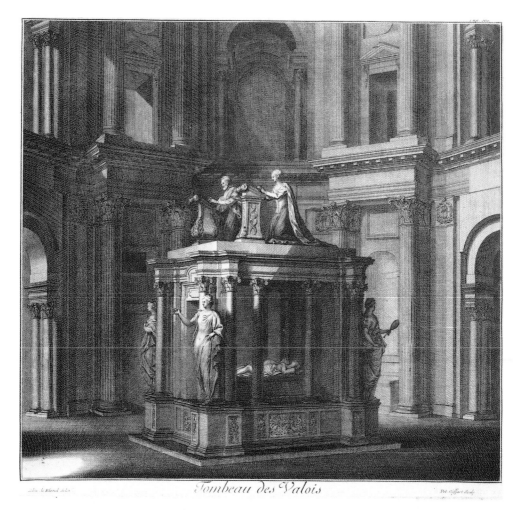

410. Pierre Giffart, The *Tomb of the Valois*, after Alexandre Leblond. Engraving from 1706.
Paris: Bibliothèque Nationale de France, Snr Giffart. The tomb of Henri II and Catherine de Médicis is here represented in its original position
at the center of the Valois rotunda, adjacent to the north transept of the basilica of Saint Denis.

justification for altering the position of perpetual prayer. Regardless, it is important to emphasize the magnitude of this iconographic innovation. Responsibility cannot be entirely attributed to either Pilon or Primaticcio: even if one of them had the idea, implementing it required consultation with the queen or her councilors.

Perhaps this anomaly is related to another: the addition to the Valois rotunda—the funerary chapel where the tomb of Henri was originally placed—of two supplementary and ostensibly superfluous effigies, two marble recumbent figures laid on bronze parade beds that Pilon began to sculpt in 1583 (fig. 409). At that time Primaticcio was long dead and the additional statues seemed to embody a call to order. The tomb of Henri II was infused with sensuality. What of the almost flirtatious grace of the Virtues, or the undisturbed beauty of the *transis* under the vault, who seem asleep rather than dead? In the midst of the storm brought on by the Counter-Reformation and the wars of religion, such a monument was bound to appear somewhat pagan. The additional statues, crowned and in their official robes, are as rigid as

effigies from the thirteenth century. At the same time, their brutal realism, especially the slightly puffy face of the queen, contrasts violently with the sensual idealism of the *transis* on the tomb. Placed right next to the main altar of the funerary chapel, these supine effigies pressed their palms together in uninterrupted, perpetual prayer, just as the priests of the abbey performed the innumerable prescribed memorial masses.[50]

In itself, the tomb of Henri II incorporates practically no motifs that are, strictly speaking, religious. The monument of Louis XII has the apostles surrounding the *transis*; in that of François I, the Resurrection is depicted as a bas-relief under the vault. For Henri II, only the theological Virtues are portrayed, and very discreetly. But rather than assuming this to be a deflection of orthodoxy, it is essential to consider the tomb in the context of the chapel it was destined for (figs. 410 and 411). At the tomb of François I the *Resurrection* is almost hidden from the visitor, but is directly in front of the *transis*: a spectacle reserved for the corpses waiting to rise and be judged. The arrangement is one of what I would call expediency. In the Valois rotunda, a grandiose *Resurrection* by Pilon was intended for the side chapel across from the kneeling king and queen. The plan, unfortunately abandoned, was certainly to integrate the royal effigies with other sculptures in a vast ritual scenography traversing the both literal and symbolic space of the rotunda and involving the visitor. In spite of the classical architecture and the elegant dignity of the statues, the fundamental principles governing large-scale sculpture had not changed very significantly since Sluter.

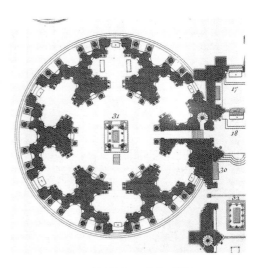

411. *Plan of the Valois rotunda*, from Félibien, *Histoire de l'abbaye de Saint-Denis*, 1706. Paris: Bibliothèque Nationale de France, Fol. LK⁷8647.

Originally, the execution of the tomb was to be distributed among several sculptors. Girolamo Della Robbia was commissioned to sculpt the *transi* of the queen. Ponce Jacquiot was asked to do the two Cardinal Virtues. The two remaining Virtues went to Germain Pilon, as well as the king's *transi*, while the kneeling monarch was entrusted to Domenico del Barbiere. *Charity* went to Frémyn Roussel, and other portions were to be completed by Laurent Renaudin. When he died, Della Robbia left the queen's effigy unfinished, but this was not a reason to abandon it and go to the expense of obtaining a new block of marble and undertaking a second statue (fig. 412). On the other hand, it is hard to imagine the emaciated cadaver by Della Robbia lying next to the athletic

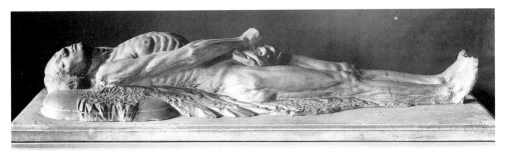

412. Girolamo Della Robbia, Transi *of Catherine de Médicis*, left unfinished in 1566. Marble, 11 ½ × 76 ⅓ × 26 in. (29 × 194 × 66 cm). Paris: Louvre.

383

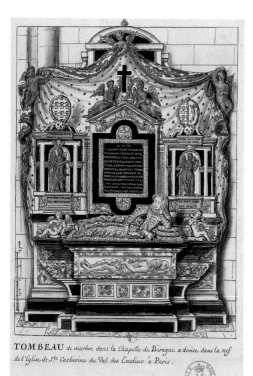

TOMBEAU *de marbre dans la Chapelle de Biraque a droite dans la nef de l'Eglise de S.te Catherine du Val des Escoliers à Paris.*

413. *Tomb of Valentine Balbiani.* Seventeenth-century watercolor.
Paris: Bibliothèque Nationale de France, Gaignières collection, Pe 11 rés.

corpse of Henri II as Pilon carved it. Nor was Domenico del Barbiere's kneeling figure of the king necessarily forsaken due to the sculptor's departure, the substitution probably resulted from the decision to change the king's pose. It would appear that the project was significantly modified while underway. These alterations were also the occasion for entrusting almost all of the sculpture to Germain Pilon. Was this because Pilon had a hand in the monuments' conception? Or did Primaticcio find him to be an exceptional interpreter? While the second hypothesis strikes me as more likely, the first cannot be excluded.

The harmonious nature of this collaboration can also be seen in the famous group of the three Graces on the monument for the heart of Henri II. Small in size, the audacity of this work extends and even exceeds that of the corresponding monument built for François I, and remains one of the highest achievements of French sculpture. François I's funerary urn has a slightly pedantic quality that seems to betray a disjunction between conception and realization. Pilon's *Graces*, on the other hand, gives the impression of a monument formed from a single impulse: as though inspiration flowed directly into the chisel's delicate strokes. Yet there is no question but that Primaticcio had prepared highly detailed instructions, since the lower part of the monument had been entrusted to Domenico del Barbiere.

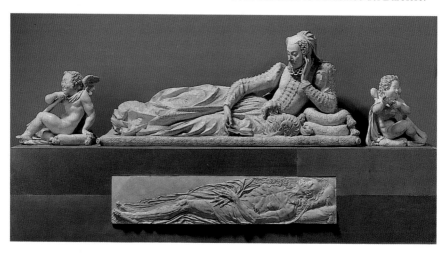

414. Germain Pilon, *Tomb of Valentine Balbiani*, 1573. Marble, 31 × 75 ¼ in. (79 × 191 cm). Paris: Louvre.

After the tomb of Henri II was completed in 1573, Pilon obtained many funerary contracts from private individuals. Some fifteen are documented, while none has been found dating from an earlier period. The works are varied—from plain slabs of marble with engraved coats of arms to highly elaborate monuments. This concentrated activity implies that Pilon was at the head of a workshop large enough and sufficiently competent to carry out a large portion of the labor. As master, he was probably content to create the design and check the quality of the workmanship. There cannot be any doubt, however, that for commissions where sculpture strictly speaking played an important role, Pilon himself intervened. It is by these key works that we may judge the breadth of his talent and the independence of his imagination.

The largest of these funerary monuments were the Birague's family tombs for their chapel at Sainte Catherine-du-Val-des-Écoliers. Fortunately, they are partially preserved at the Louvre, despite the destruction of the church. René de Birague was a man of great importance. Born in Milan in 1507, while the duchy was in the hands of the French, he remained faithful to France and carved out a brilliant career, first in Piedmont, then in Lyon, finally becoming chancellor of France and residing in Paris. He was even made a cardinal in 1578. The chancellor commissioned the tomb of his wife in 1573, then his own as well as a complete redecoration of the chapel. Both tombs were dismantled before the Revolution. Catherine Grodecki has

found and published the contracts signed by the sculptor for the work.[51] With these and the Gagnières survey of tombs from the seventeenth century, it is possible to form a good idea of their original appearance and genesis (fig. 413). The tomb of Valentine Balbiani, the chancellor's wife, was the first element of this ensemble (fig. 414). It was exceedingly complicated. The project appears to have developed as the result of an ongoing dialogue between Pilon and the chancellor—an exchange of ideas inaccessible to us, but to some extent discernable through the text of successive documents. The protracted elaboration of Valentine Balbiani's tomb is the result of mutual adaptation reconciling the imperious, but visually unformed wishes of the patron with the artist's visual imagination.

Pilon submitted a first draft of the project, which did not include the reclining statue of the deceased: it was enriched as early as 1573. About a year later, construction must have been well underway, as Pilon had been paid substantial amounts. However, the project had changed enough to justify a new contract. Two clay models accompanied the agreement. It also included the price, determined after a consultation with Jean Bullant, whose appraisal has been preserved. This document, perhaps the only one of its kind, owes its existence to the exceptional nature of the monument. In it Bullant insists on the difficulties of determining the estimate in advance, but recommends the impressive sum of three thousand *écus*. The contract allows eight

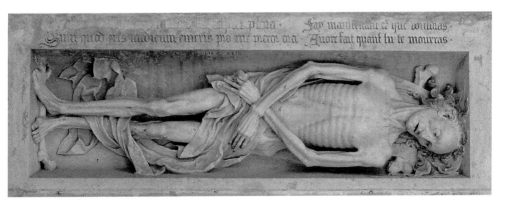

415. Gisors (Eure, France), *transi*, 1526, church of Saint Gervais-Saint Protais.

385

thousand seven hundred *livres*, or slightly less than the estimate, but nevertheless an extremely high price, especially since the chancellor was providing the bronze as well as the black and white marble. Even after this contract—the third—there were additional enrichments to the project, as can be seen by comparing the 1574 document with the Gagnières drawing of the completed monument. Only then, in the final phase, does one find a strikingly original motif: the huge armorial cloak held by three cherubs as a backdrop to the whole monument, and the upper pediment that appears to emerge from behind it. The new elements not only considerably increased the size of the tomb, but introduced a new spatial fiction as well. No doubt there are examples in Italy of large draperies in wall tombs, some of them very old; however, they were conceived either as a baldachin enclosing the tomb in

416. Germain Pilon, *Project for the Tomb of René de Birague*, 1578–79.
Pen and ink, wash, gouache, and gold.
Paris: Bibliothèque Nationale de France, Clairambault 1111, fol. 240.

417. Germain Pilon, *Kneeling Funerary Effigy of René de Birague*,
after 1583. Bronze, 55 × 82 ⅔ in. (140 × 210 cm). Paris: Louvre.

418. *Tomb of René de Birague*, seventeenth-century drawing. Paris: Bibliothèque Nationale de France, Gaignières collection Pe 11a rés.

place at the foot of many women's tombs, is here a lapdog cuddling up to its mistress. Panofsky was right in saying that the *transi* is not very frightening, despite the naturalism of its *"annothomie"* (that is, its designation in the contract). However, the cause he indicated—that bas-relief is inherently less realistic than sculpture in the round—is insufficient. Pilon made use of a motif that can be found in several isolated cases of *transis* carved in bas-relief; instead of lying flat on a tomb, they are carved in a slab set against the wall. The cadaver of Saint Gervais at Gisors, which dates from 1526, is a characteristic example, with its monitory inscription *"je suis ce que tu seras"* (what I am, you, too, will be) recalling the inevitable fate of one's own body. The monument's macabre expressiveness seems in no way diminished by the use of bas-relief (fig. 415).[53] It is, however, true that Pilon attenuated the gruesome aspect through the delicacy and softness of the relief carving. Above all, it is important to point out that, exceptionally for a double effigy tomb, the two effigies are not scaled alike: the small size of the *transi* is principally what robs it of emotional impact.

its own space, or as a curtain opened to reveal a celestial vision. On the contrary, Pilon's arrangement projects the tomb into the space—shared by the spectator—of the chapel. This last-minute element is more premonitory than retrospective, anticipating inventions of the seventeenth century, such as Bernini's monument for Maria Raggi, or the tomb of Julienne Le Bé by Le Brun and Tuby at Saint Nicolas-du-Chardonnet. The composition was appropriated almost in its entirety for the Harcourt mausoleum.[52]

The tomb boasts the figure of Valentine, more reclining than recumbent, propped on one elbow, lost in a melancholy reverie with a book in her hand and her pet dog beside her. Funerary sculpture has rarely ventured so far in equivocating between eschatology and commemoration; the chancellor's wife would seem to be represented in the intimate context of her daily life. The dog, a traditional symbol of fidelity that found a heraldic

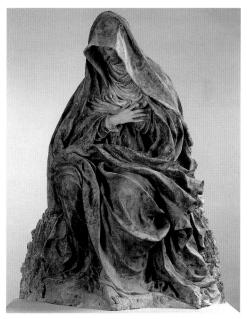

419. Germain Pilon, *Pietà*, c. 1585. Polychrome terracotta, 66 × 47 in. (168 × 119 cm). Paris: Louvre.

The tomb of Valentine Balbiani was a highly original and complex work, if a little artificial in its accumulation of many disparate elements. Perhaps, because of its sophistication, it deserves to be qualified as Mannerist. The monument dedicated to the chancellor himself was begun only after his death in 1584. But Grodecki has shown that there was definitely a project as early as 1577–78, for which the original drawing still exists (fig. 416). René de Birague's tomb did not follow the direction one would have expected—that of an edifice similar and complementary to that of his wife. Whether because the artist had evolved, or because the patron wished to have a monument entirely his own, Pilon's design contrasts emphatically with the previous tomb. The chancellor's is a radically simplified composition, in which the kneeling statue plays an essential role. It is an arresting work of art: the figure at prayer is amplified by the rippling folds of its enormous cloak, extended like a long musical cadenza across the breadth of the monument. The effigy occupies the entire platform, although it respects human scale. The slight diagonal gesture towards the chapel altar is sufficient for the figure to invade the space of the visitor, and with less fanfare and more power achieves the same result as the sophisticated arrangement of Valentine Balbiani's tomb.

The statue of Birague as it now stands in the Louvre is one of the most accomplished examples of art in bronze (fig. 417). Yet we know from the survey by Gagnières that the statue was entirely painted, largely in red, given the preponderant surface area of the cardinal's mantle (fig. 418). The painting of the statue is not a later

addition— included in Pilon's contract, it was not, however, planned from the beginning. The drawing mentioned earlier—one of few originals by Pilon to survive—does not represent a painted statue. What is more, in this first project Birague faces right, implying that the chapel was organized differently from the final design. It must have entailed placing the tomb of the chancellor against the west wall, with the altar on the north side in the Italian manner. It is likely that the decision to paint the statue was due to the poor lighting conditions of its new placement when the previous arrangement was abandoned in favor of the French custom, which located the altar on the east side, displacing the cardinal's tomb to the north wall, under the window.[54] However, this return to polychrome sculpture, which had been more or less banished by court classicism, remains significant. Nor is it the only example by Pilon; the terra cotta *Pietà* (fig. 419) he executed as a model for the marble statue that was to occupy the Valois rotunda (now at Saint Paul-Saint Louis), was *etoffée,* probably in Pilon's workshop. It was sufficiently admired to merit a place in the renowned Sainte Chapelle.[55]

Pilon's last great works can be understood either as a return to the naturalism of the fifteenth century, or as a first foray into the Baroque effects of the seventeenth century. However, one need not exclude the other. Near the end of his life, Pilon abandoned the restraint and dignified elegance of classical art, whose vocabulary he had acquired in the middle of the century. Like many, he turned to an earlier age seeking lessons for the future. By going back to the full theatricality and emotion of earlier sculpture, he anticipated the Baroque.

Ligier Richier

While it might appear traditional, the tomb of Philippe de Gueldre is both highly original and deeply moving (figs. 420 and 421). The statue is no ordinary funerary effigy. First, the silhouette is more strikingly drawn; the simple drape of the robe clothing its body contrasts with the rippling fabric at its feet. The rhythm of these folds continues through the habit of the mourning figure, uniting the two figures in spite of their drastically different sizes. The contrast of back and white, while not a rare device, is used here to superlative effect. Who could have imagined that the technique of applying colored wax over white stone to imitate marble would achieve such refinement? The face of the princess is devastating. The sculptor has turned it slightly toward us, attenuating the

stiffness of the cadaver and permitting the viewer to examine her features, roughhewn but grandiosely beautiful. Paul Denis was probably correct in thinking that the sculptor used a death mask for his model, but what freedom of interpretation. The artist also exploits the contradiction between this terrible visage and the charming physiognomy of the nun holding a crown at the foot of the princess. The nun's face, hidden in her veil, can be seen when one comes close, as if illuminated by her pallor, so regular and gentle it would be insipid were it not so perfect.

This magnificent sculpture has traditionally been credited to Ligier Richier and no one has contested this. However, the attribution is not confirmed by any document; neither is that of the most famous work associated with him, the astonishing skeleton at Bar-le-Duc (fig. 422). The very nature of this statue is open to discussion. It stood near the altar at the collegiate church of Saint Maxe in Bar-le-Duc, and it was undoubtably the monument of the heart of René de Châlons, prince of Orange. However the anecdote that the dying prince asked to be depicted as he would look three years after his demise seems implausible. Contemporary accounts relating the circumstances of his death make no mention of it. Perhaps the statue is an allegorical personification of "death himself," to quote Panofsky who endorsed this solution without further explanation, or is it actually meant as an effigy of the deceased? Several authors prior to the Revolution concur in describing the statue as holding a heart in its left hand.[56] Assuming this is correct, then the figure does indeed represent René de Châlons as a cadaver, risen from the grave and extending his heart to God above. Such

an extraordinarily bold invention is in the same tradition of theatrical sculpture that had already produced the tomb of Philippe Pot.

While the execution of princely tombs would make Richier comparable to sculptors like Bontemps or Pilon, the bulk of his work consisted of dramatic staging of statues, similar to the spectacular ensemble at Solesmes or the lost works of Nicolas Le Prince at Pontoise. Ligier Richier executed one of these vast ensembles for the princes' chapel at the church of Saint Maxe in Bar-le-Duc. Of the entire composition, only two heads and the Infant Jesus from the Nativity remain.

The contours defining the body of work by the Master of Saint Mihiel are difficult to bring into focus, since his principal documented works have all disappeared. A wooden sculpture depicting the *Fainting of the Virgin* preserved at the abbey

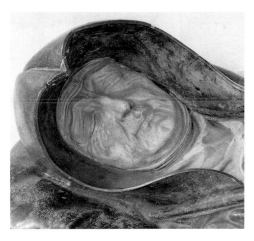

420. Ligier Richier, *Tomb of Philippe de Gueldre*, detail of Philippe's face, c. 1550. Stone with tinted wax patina. Nancy: Musée historique lorrain.

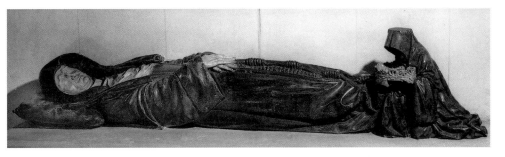

421. Ligier Richier, *Tomb of Philippe de Gueldre*, c. 1550. Stone with tinted wax patina. Nancy: Musée historique lorrain.

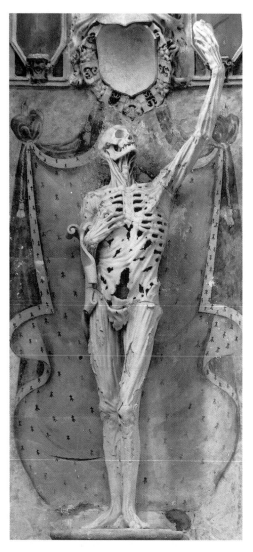

422. Ligier Richier, *Skeleton of Bar-le-Duc*, from the collegiate church of Saint Maxe, 1547. Polished stone, 69 in. (175 cm) tall. Bar-le-Duc: church of Saint Étienne.

Saint Étienne at Bar-le-Duc and that in the church of Saint Gengoult are generally agreed to be works by Richier. It should not be forgotten, however, that sculpture was abundant, and distinguished, in Lorraine. A masterpiece long credited to Richier, the *Christ Carrying the Cross*, at the church of Saint Laurent in Pont-à-Mousson, would seem to belong to the previous generation. Its author might be Gauvin Mansuy. The work has a sufficiently pronounced Germanic accent to recall the fact that in the sixteenth century, Lorraine was not yet part of France. Culturally, the region oscillated between the French kingdom and the Holy Roman Empire. An artist like Gabriel Salmon, whose woodcuts depicting the labors of Hercules are one of the triumphs of printmaking from the period, was primarily oriented towards Germany, but sculptors practiced their art in a style similar to that of the school of Champagne. If Richier is considered a French artist, it is not merely due to the annexation of the duchy, but because his art was indeed part of the French sphere of influence.

While undocumented, Richier's authorship of the famous Holy Sepulcher at Saint Mihiel has never been questioned (fig. 423). It would appear to be true that Ligier Richier, who was Protestant, fled to Geneva before this major work could be installed in the church of Saint Étienne. The current arrangement was obviously a makeshift solution and it is hard to imagine how he would have found a satisfactory placement for all thirteen existing figures in the shallow recess they now occupy. What then could have been the original project? In a genre usually characterized by the repetition of a prototype—Richier asserted an independence that was as much iconographical as visual, making it difficult to reconstruct his intentions. In the present arrangement, the group of soldiers rolling dice for the tunic of Christ, entirely unprecedented in this kind of monument, is practically invisible. One might wonder if these figures were really intended for the *Entombment*, where they fit poorly into the narrative. More likely, they were designed for a Crucifixion in an ensemble depicting several scenes of the Passion. The motif of the holy woman preparing the sarcophagus also has no parallel in other Entombments. It is quite possible that after the artist's departure, various statues that

church of Saint Mihiel is all that remains of a nine-figure Calvary scene, and even this vestige has lost its polychrome surface. In addition to the documented works, various dubious traditions attribute practically all the sixteenth-century sculpture in Lorraine to Richier, just as everything in Toulouse was said to be the work of Bachelier. Obviously, some rearrangement is in order. The *Calvary* of

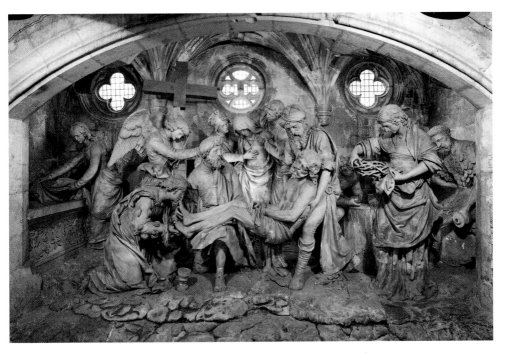

423. Ligier Richier, *Entombment*, c. 1560. Stone. Saint Mihiel: church of Saint Étienne.

were originally planned as part of a monumental ensemble including several scenes, like the one at Saint Maxe, were then assembled as a single rather incoherent scene placed in an inadequate space.

Whatever the case may be, the central portion of the *Entombment* indicates clearly that Richier abandoned the traditional static formula in favor of greater narrative intensity. The episode he selected is not the usual one in which Joseph and Nicodemus lay Christ into the casket. Nor is it the even more static version where Christ lies on the stone of unction (there were examples in Moulins, Nevers, and closer to Richer, in Varangéville near Nancy). Instead he chose a more unstable moment between the descent from the Cross and the actual Entombment: a brief pause while the corpse was being carried. The angel holding the Cross belongs to the vocabulary of devotional images, and angels bearing the instruments of the Passion are sometimes found at the margins of Holy Sepulchers (as at Solesmes). Richier, however, integrates the motif into the narrative framework, as one can see from the equivalent figure of the holy woman

holding the Crown of Thorns. The artist weaves the conservation of relics into the story (innumerable thorns, nails, and slivers from the Cross were venerated in different sanctuaries).

An attempt has been made to explain the originality of this monument, in the belief that the artist was inspired by mystery plays. We should be cautious about this theory, which has been invoked too often after Émile Mâle made it fashionable. It is preferable to consider the broad artistic culture that nourished the work and the fact that the artist has thoroughly assimilated its sundry elements. The region was rich in Holy Sepulchers, which probably encouraged Richier to depart from earlier models. He was undoubtedly acquainted with the monument at Pont-à-Mousson, and seems to place himself in direct competition with his predecessor, alluding to this work with his angel carrying the Cross. Did he really use Mantegna's famous engraved *Entombment*, as Forsyth believed?[57] While this is not impossible, Richier borrowed nothing specific: not the style of drapery, anatomy, poses, figural types, or movement. In Mantegna,

the two men are literally transporting the corpse; Richier's figures stand in one place. The position of Christ is the most significant similarity, but this had also been used by Dürer, whose work may have served as an intermediary. I am struck especially by the pictorial quality of the ensemble. An extensive knowledge of German Renaissance painting as well as sculpture cannot be excluded, but again, no identifiable element appears to have been appropriated. In this, Richier is very different from an artist like Jean Duvet, whose sources were, as we saw in Chapter IX, easily identifiable, and served only to accentuate his isolation.

What we know of Ligier Richier reveals a sculptor who worked primarily in large-scale sculpture, usually polychrome, theatrical, and appealing to the emotions. Within this traditional context he developed a new artistic ambition, partaking of the classicizing tendencies of the mid-century. It is understandable therefore that one would have suggested his name for the Belle Chapelle at Solesmes, even if the hypothesis appears fantastical, because the basic principles informing the two works are almost identical.[58] However, the perfect integration of Richier's appropriations, the extraordinary execution, the sophistication of design, and his knowledge of the body's movements transform the *Entombment* of Saint Mihiel, averting all the jarring effects of hybridization of Solesmes. Richier managed to become fully a Renaissance artist, without breaking with the tradition established by Sluter.

Death in the Garden

Death crops up in an unexpected manner as a theme of the *Fountain of Diana*, once in the gardens at the château of Anet (fig. 426). A mythological, pagan work, this statue of the goddess reigns today in the Louvre as the very symbol of French Renaissance art. It is the sculptural equivalent of Ronsard's *Amours* or du Bellay's *Antiquités de Rome*.

It is remarkable that such a work remains an orphan. Anthony Blunt ascribed it to a young Germain Pilon, but failed to convince. The name of Cellini, suggested by Maurice Roy, is even less plausible. As for the traditional, and most persistent, attribution, Jean Goujon, it rests on nothing more than Lenoir's enthusiasm. Pierre du Colombier did not include the statue in his catalogue, any more than the rest of Anet's sculpture. Recourse to "Jean Goujon's workshop" can only be seen as a subterfuge, hiding the embarrassment of our inability to determine the artist of such an exemplary sculpture.[59] For this figure, so gracious yet so imposing, certainly is a magnificent work that has become an emblem of sorts for the French Renaissance. Long exposed to the elements, and possibly damaged as a result of the French Revolution, *Diana* suffered much at the hands of restorers. The work by Beauvallet in

1799–1800, costing two thousand francs, must have been considerable. It would appear that the head of the statue was entirely remade.[60] Nonetheless, the conception of this powerfully articulated group, the way it organizes the space around it, the sophistication of its planes, and even some details of the original execution, all manifest an exceptional authority. If I were inclined to consecrated formulae, I would say it instills a feeling of work of a master. But which master? We are so far incapable of naming him, or knowing if he had his hand in other works.

The marvelous sculpture we admire today in the Louvre was the centerpiece of a fountain at the château of Anet to which Androuet du Cerceau devoted a full plate in his *Plus Excellents Bastiments de France*. Naturally, the subject was chosen to glorify Diane de Poitiers. Here again, as in the bedchamber of Madame d'Étampes at Fontainebleau, the fable unmistakably alludes to a contemporary situation. It is probably correct to reject the idea that the figure is a portrait the mistress of the house, even an idealized one—meaning by portrait a recognizable physical likeness. Though who can judge, now that the head has been replaced? On the other hand, there is absolutely no question but that it is a transposition

424. Jacques Androuet du Cerceau, The *Château at Anet* (detail of the frontispiece), prior to 1576. Pen and watercolor. London: British Museum.

The two works confirm and reinforce each other, like two fictional, yet eloquent accounts. It is impossible to imagine that the fountain was not conceived in response to the Cellini bronze, which acted as a sort of emblematic figure for the whole château. But the sculptural translation is profoundly different, because the marble of the fountain is carved in the round as emphatically as Cellini's work is a relief. Especially, because the bronze is in high relief in which the figures are three-dimensional: as a result, there is no perspective or illusion. We are not invited to imagine the back of the figures, and the animal's neck embraced by the nymph looks like that of a hunting trophy. Framed within Philibert's authoritative architecture, Cellini's *Nymph* presented itself as an image—a sign or emblem of the hostess. The marble of the fountain, on the other hand, subtly creates an oneiric, hallucinatory atmosphere. In the tradition of funerary monuments, it posits an altered environment: the simultaneously real and fictional space of a waking dream.

of her persona and her situation to the mythological plane. It is inevitable that one sees an allegorical representation of the king in the proud animal so docile to her touch. Here, the circumstances of the duchess's existence are not content to find a home in the myth: they transform it, forcing the creation of an unprecedented, and incredibly suggestive image. Was the duchess herself responsible for this outrageously daring conceit, a goddess embracing a noble but submissive stag? All the expressive force of the idea is in the precision with which it is realized, the delicate balance of pride and submission combining to maintain the animal captive (of the tender embrace), yet dominating due to its massive physical presence. These are effects of a plastic imagination beyond what a patron can dictate to an artist. Actually, Cellini had already established the motif in his celebrated *Nymph of Fontainebleau* (fig. 91). Originally created for the entrance to the château of Fontainebleau, the *Nymph* was unconnected with Diane de Poitiers. The large relief panel went unused after the departure of Cellini and the death of François I, and was requisitioned by Philibert de l'Orme, who used it for the entrance gate at Anet. This context conferred upon it a new and more percussive meaning, the nymph becoming Diana.

425. Jean Goujon (?), *Tomb of Louis de Brézé*, c. 1544. Rouen: Notre-Dame cathedral.

426. Anonymous, *Diana*, from the château at Anet, c. 1549. Marble, 83 × 101 ⅔ in. (211 × 258 cm). Paris: Louvre.

Though the identity of the sculptor who so sensitively carved this marble intrigues us, he would not have been the only author. Philibert de l'Orme, in charge of everything about Anet—just as Lescot was master at the Louvre—probably deserves a share of the credit. He must have drawn a project for the fountain that defined the subject matter, and the general outline of the composition. However, the distribution of authorship does not end here. The work adheres so completely to the personality of Diane de Poitiers that she exerted influence not only through specific expression of her wishes (the terms of a contract or oral communications), but simply by being who she was.

Chance played some part in fashioning this persona. The daughter of Saint-Vallier might have been a Jeanne, a Françoise or any common name. That her parents chose Diane was original in 1499. While she did not choose her mythological name, she chose to live the myth assigned to her, well beyond the usual reverence for a patron saint that a baptismal name customarily entailed. She presented a pale beauty and virginal sensuality even

as an elderly lady. Diane was thirty-two when her husband died in 1531, no longer a young woman. When her sensational liaison with the dauphin began, she was already thirty-seven. By the time that Henri II's ascent to the throne made her one of the most powerful individuals in the kingdom, she was nearing fifty. Was it a miracle of nature? Or a miracle of artifice? Her enemies suggested she owed her continued beauty not to the use of cosmetics, but to dangerous practices. Whatever her method, it remains that this remarkable woman made her own body a creative endeavor. She meticulously shaped her person, her body, into a living masterpiece. The *Diana* at Anet is perhaps as much the result of this self-mythology that Diane so fully mastered as it was a product of the professional skills of a sculptor or architect.

The base supporting the group is not the least astonishing feature of this altogether astonishing work: it is indeed a sarcophagus. There is no easy way to integrate this with the antique myth of Diana the huntress, unless one wishes to see it as an allusion to the death of Acteon, victim of his illicit spectatorship. Does it then announce our own death, we who unabashedly gaze at this splendid display of nudity? But there is another aspect, for this is not the only sarcophagus at Anet: the fireplace mantels reiterate the funerary theme. In the persona Diane forged for herself, an essential element—disregarded by the popular legend—was that of the inconsolable widow. After the death of Louis de Brézé, the Grand Seneschal's wife definitively adopted black and white as her shades of mourning. For Diane, the role of a new Artemis would have held some appeal. Anet is also, among other things, a mausoleum.[61] Having said this, the close relationship between the frontispiece of the château and the tomb of Brézé at the cathedral of Rouen can be understood in a new light. It no longer appears to be a mere formal appropriation, too literal on the part of Philibert de l'Orme, but a deliberate reference (figs. 424 and 425). The statue of Brézé (which has disappeared from the frontispiece now reassembled in the courtyard of the École des Beaux-Arts) recalled the memory of the Grand Seneschal to visitors arriving at Anet: the entire frontispiece, the primary decoration in the courtyard of the château, was a paraphrase and reminder of his tomb.

Chapter XI

A SENSE OF NATIONAL IDENTITY: PHILIBERT DE L'ORME

Even as debate over language was raging in the mid-sixteenth century, French had already been adopted as the sole legal and administrative language of the kingdom. Linguistic unification was well underway, and Rabelais, Marot, and Calvin all produced substantial literature in French. Yet it should not therefore be assumed that Joachim du Bellay's 1549 *Deffense et illustration de la langue françoyse* was belaboring an obvious point. As an aesthetic manifesto, his book was a pioneering, resolutely modernist plea for the vernacular and, simultaneously, for ancient culture. In my opinion, it should be seen above all as one manifestation, among many, of a dawning national awareness that affected all of French culture. The emergence in those years of the French word for homeland, *patrie*—which du Bellay did not coin but which the context of his *Deffense* brought into high relief—is significant. What the term conveyed was perhaps not new, but the very act of giving the concept a name shows that it was then assuming unprecedented importance and relevance. In a number of texts, including one by Philibert de l'Orme, the terms *pays, nation, patrie,* and *royaume* (country, nation, homeland, and kingdom) were used in quick succession with very similar meanings, which helps us to understand what was going on. The Italians already had a sense of identity, of course, for otherwise Pope Julius II's vow not to cut his beard until all foreigners were driven from Italy would be incomprehensible; and being

German meant something to a man like Dürer (the German character had been defined long ago, for that matter, by Tacitus). Yet Italy had no political coherence, while Germany's Holy "Roman" Empire was often little more than a fiction, especially once the Reformation drove a wedge between German princes. So only the king of France could boast that he was truly emperor in his own realm.

The difference in attitude between the du Bellay of the *Deffense* and the humanist printer Henri Estienne is revealing. An ardent supporter of the Reformation, Estienne was torn between his penchant for antiquity and his struggle to forge a national identity. Whereas du Bellay was ready to call on every resource—almost indiscriminately—in order to increase his vocabulary, Estienne stressed the richness of existing language and showed greater discrimination in his borrowings. To expand his vocabulary, Estienne looked to old French, the language of the thirteenth-century romance, the *Roman de la rose,* and to dialectal variants from the provinces. A sense of continuity, remaining true to oneself, and resistance to things foreign were dominant motifs for him. On the threshold of the age of regulatory academies, Estienne was caught between his lexical bulimia and a precocious desire for norms that might appear to be a kind of linguistic protectionism. More specifically, in those days a French sense of national identity necessarily meant anti-Italianism.

Language as the Catalyst of National Awareness

In his *Deux dialogues du nouveau langage françois italianisé*—a long diatribe against the

Italianization of the French language at court in the days when Catherine de Médicis was

queen—Estienne was concerned not only with language but with an entire culture. Thus one of the characters in his dialogues, Celtophile (whose name betrays his "Celtic" sympathies), concedes to Philausone the value of adopting certain Italianisms when French has no equivalent term and when the foreignness of the word appropriately reflects the origin of the thing it expresses. All of Celtophile's examples, however, turn out to be pejorative: charlatan, buffoon, poltroon, and so on (as for assassin, which he specifically defines as a hired killer, he goes beyond the Italian word *assassino* all the way to a Hebrew root). "At least," requests Philausone, "append three or four words belonging on the side of virtue." Celtophile: "My memory refuses to supply a single one. I know not whether none exist, or whether I simply cannot recall them."[1]

Predictably, Italians often displayed the reverse attitude. As discussed earlier, Benvenuto Cellini constantly attacked the French. The French themselves recognized Italy's leading role in developing a new culture, from which they wanted to profit even as they claimed equality—and, soon enough, superiority—for their own. In 1546, Jean de Maugin published a charming little book, *L'Amour de Cupido et de Psiché* (fig. 427), copied from a series of Roman engravings by Agostino Veneziano and the Master of the Die (fig. 428).[2] Produced on wood blocks much smaller than the originals, Maugin's booklet was typical of new publications in Paris. The tall, graceful figures were entirely redrawn, as completely translated and Frenchified as the original poetry (fairly mediocre, for that matter). Maugin's proud declaration in his foreword is not unjustified: "France today vaunts copies bolder and more worthy than Italy ever did with the originals."

Du Bellay himself, for his *Deffense*, copied entire passages from a *Dialogo delle lingue* by Sperone Speroni, who awarded primacy to Italian—or rather, to Tuscan. Yet du Bellay's borrowings were so smoothly incorporated into the weft of his argument that no one was aware of them until Pierre Villey uncovered them in 1908. Villey's discovery long cast a shadow over du Bellay's text, as though it had lost its originality. If, however, we consider that he was primarily involved in cultural

427. *Psyche Bathing*, from *L'Amour de Cupido et de Psiché, mère de Volupté*, Paris, J. de Marneuf, 1546.
Paris: Bibliothèque Nationale de France, rés. Y 95.
The French translation of the verses is on the facing page.

appropriation and digestion, du Bellay's marshaling of Speroni's text and arguments against the Italian's own thesis is wonderfully ironic and extraordinarily effective. Indeed, by swallowing Speroni's arguments, du Bellay annihilated them—once digestion is complete, nothing remains of the digested item. It turns out that du Bellay remains ever-present in French cultural awareness, whereas Speroni has been relegated to a ghostly existence.

In Italy, though, the language problem was posed differently, for debate simultaneously addressed the value of the vernacular and the primacy of Tuscan. On a peninsula divided into small independent states, each one clung to its own dialect; in France, however, there was no similar competition. The language used at court—that of Île-de-France and the Loire region—was imposed by royal government. In

428. Agostino Veneziano, *Psyche Bathing*, c. 1525.
Engraving, 7 ⅔ × 9 in. (19.4 × 22.8 cm).
Paris: Bibliothèque Nationale de France, Ta 39.

Italy, language was not terribly effective in forging a sense of national identity. A similar situation existed in Germany at the dawn of the sixteenth century, although Luther's Bible would soon become a powerful factor of linguistic unification (and distinction—the Plattdeutsch spoken in the Netherlands, long perceived as a simple dialectal variant of German, would become an autonomous language whose speakers no longer considered themselves German). I am not claiming that there was perfect correlation between linguistic unity and national identity—some French-speaking regions have never been considered French—but at the very least it was a crucial element in forming France's sense of nationhood.

Language made it possible to focus debate, to refine national awareness, and to shape the emergent, modern culture. The battle for French language and culture was fought on several fronts. On one hand, the French undermined the prestige of Latin—the West's scholarly language—by stressing the merits of Greek. Hellenism was highly developed in France, and served to oppose not only Italy, where Roman culture was felt to be the national heritage, but also, to a lesser extent, Germany with its pretensions to the mantle of the Holy Roman Empire; these respective claims fueled the old rivalry between pope and emperor, the apocalyptic consequence of which was the sack of Rome in 1527. Against these fractious

heirs, France aligned itself with the even older culture of Greece, to which the Romans themselves were indebted. Meanwhile, the French also managed to trace their royal lineage back to the Trojans. Finally, and above all, the French endowed the Gauls—who had so valiantly held out against Rome, winning verbal praise from Caesar (as the French liked to point out)—with precedence over all other peoples.[3] The great jurist, poet, and historian Étienne Pasquier covered all these points in a key work whose title already sets the agenda: *Recherches de la France*. Publication began in 1560 and Pasquier continued working on his "research into France" until his death in 1615.[4]

On the other hand, debate raged between the partisans of Cicero, such as Pietro Bembo in Italy and Étienne Dolet in France, who advocated a return to the purity of classical Latin, and the defenders of Erasmus, who preferred a more modern Latin. Because the former ultimately avoided any phrase or term that was not attested in Cicero, the latter had no trouble accusing them of trying to smother Latin. The Ciceronians were nevertheless arguing that language needed authentic cultural roots—Dolet called Erasmus a stateless wanderer with no real home. It was therefore not surprising, in the end, to see Bembo and Dolet, both champions of classical Latin, simultaneously defend the legitimacy of their respective vernacular languages.[5]

Through language, we can perceive the elaboration of a complex but fairly well articulated problematic, despite contradictions and paradoxes. In Italy, the Renaissance was ultimately a relatively straightforward affair: by reaching out to Virgil, Dante—whose prestige has never flagged—effected a transition to Christianity and made it possible to recuperate part of the medieval heritage. In France, as in other European countries, the sources of regeneration were more diverse. France rejected neither Latin nor Roman imperial culture, for the French language was all too clearly rooted in the Latin of the late empire. But France turned also to ancient Greece, the source of high culture, doing so all the more enthusiastically because the kingship of Alexander, that hero of heroes, enabled French kings to identify with him and thereby adopt a certain distance from Rome's imperial

C La mort

C Vous damp abel tout le premier
Jadis Vous saisiz comme mien,
Pour les desfertes premier
De Voftre pere adam au lien,
De la mort estes sans rien
Excepter. Reculfer np fault
Sil Vous desplaist qung tel assault
Vous donnap. Ce est pour neant
Faire Vous a faslu ce fault
Et estre reduit a neant

429. *Cain and Abel*, from the *Loups ravissans*, Paris, Vérard, c. 1505.
Paris: Bibliothèque Nationale de France, rés. Ye 851.

give their name to France, but Charlemagne was a national hero and it was through Francus that the royal line was putatively traced back to Troy.

The issues are less distinct when we turn to the visual culture of the day, for it becomes much harder to identify a French visual idiom. It is perhaps possible to distinguish a learned art from a vernacular one, as I have tried to do when discussing certain murals and tapestries. Suggestions of this distinction can also be found in prints. An odd, didactic book from the early sixteenth century, entitled *Les Loups ravissans,* includes a series of woodcuts of a totally vernacular nature (fig. 429), unmatched in expressive power except perhaps by the *Danse Macabre* at La Chaise-Dieu (fig. 250). It is hard to believe that work of such power and skillful originality was a completely isolated case. Perhaps Jean Duvet, with his contempt for perspective, recalled certain aspects of an art that left few traces of its own.

In Germany, landscape afforded the opportunity to give visual form to a sense of national identity. Long before Romanticism, the German forest with its mysteries and terrors had become a kind of national symbol.[6] Landscape was one of the prime ways that Dürer and his successors could adopt a clear stance vis-à-vis Italy and forge an art of their own. France, true enough, never produced anything comparable to Altdorfer's astonishing *Saint George in the Forest*. And yet, in less spectacular but equally precocious fashion, we come across images that manage to distinguish themselves simultaneously from German landscapes (despite borrowing some weepy

tradition. Meanwhile, the Celtic origins of France were invoked with equal conviction, and the culture of the Gauls and their Druids fired French imaginations. Finally, the contribution of the Franks could not be overlooked—not only did they

430. Étienne Delaune, *Bird Hunting*, third quarter of the sixteenth century. Engraving, 2 ½ × 8 ¾ in. (6.6 × 22.2 cm).
Paris: Bibliothèque Nationale de France, Ed. 4.

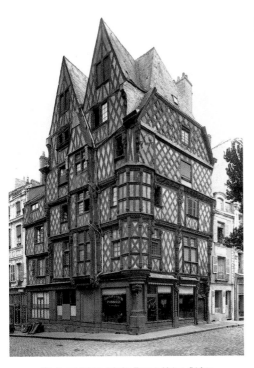

431. Angers (Maine-et-Loire, France), *Maison d'Adam*, first half of the sixteenth century.

432. Saint Germain-de-Livet (Calvados, France), château, 1584–88.

foliage), from Italy's geometrically organized nature, and above all from Flanders' fanciful mountains. These images of the French country-side—varied, cozy, and devoid of harshness—surface in modest genres such as the pages of illustrated books like the *Orus Apollo* of 1543, or in little engravings by Étienne Delaune, who ably conveyed the rustle of willow (fig. 430).[7] More ambitious still was Delaune's large series of *Months*, in which traditional agricultural tasks illustrated the signs of the zodiac, so that a famil-iar genre hoists itself almost imperceptibly toward allegory (fig. 433). Although these sheets, heir to a tradition extending back to the wonder-ful calendar pages of the Limbourg brothers' *Les Très Riches Heures du duc de Berry,* reflect the influence of Flemish art, the sensibility is not the same—French beholders of these prints would easily recognize their native land.

In the realm of architecture, people still speak of "vernacular" to refer, for example, to rural buildings. There can be little doubt that timber-framed buildings, still very common throughout the kingdom in the sixteenth century, appeared "coarse" compared to the classical models imported from Italy. Major architects, as far as we know, showed no interest in this vernacular style, nor did Philibert de l'Orme mention it in his *Architecture* or even in his *Nouvelles Inven-tions,* which discussed the use of timber con-struction devices. Nevertheless, a few less famous builders attempted to give monumental expression to this idiom. The Adam house in Angers, for instance, is an imposing edifice with lavish deco-ration and architectural aspirations that clearly turn their back on ancient-style humanism (fig. 431). Similarly, brick and stone construction could be used to picturesque effect when deployed on a fairly large scale, as seen for example at the château de Crainqueville in Dozulé and at Saint Germain-de-Livet (fig. 432), where the use of certain classical features betrays the builders'

433. Étienne Delaune, The *Month of July*, third quarter of the sixteenth century. Engraving, 7 × 9 ¼ in. (17.4 × 23.5 cm). Paris: Bibliothèque Nationale de France, Ed. 4

ambitions. Indeed, even the major representatives of learned architecture, Lescot and Philibert, did not totally reject certain vernacular features, such as pitched roofs (usually of slate) and mullioned windows.

Not least of Serlio's merits was an open-mindedness that allowed him to make room in his magnum opus for French architecture. In the sixth book of his treatise, which discusses private dwellings and was written at the end of his life, after a long stay in France, he emphasized France's tall slate roofs with dormer windows and acknowledged French superiority when it came to interior layout (to which Italians, more concerned with aesthetics and symmetry, attached less importance). Above all, Serlio compared buildings in the Italian style with their French counterparts (fig. 434), thereby revealing the distinctive physiognomy of French building. Yet he did not attribute this difference to a simple contrast between two nations. Instead, on one hand, there was good architecture, of indisputable value, as developed by Italian architects based on their knowledge of antiquity; and, on the other hand, there were local or vernacular habits and tastes dictated by climate and conditions, yielding an architecture whose value depended on local criteria. The popular nineteenth-century distinction between absolute and relative beauty was already taking shape.

As already discussed, Gothic architecture, called "modern" or "French," was distinct from "classical" architecture (which we might therefore be tempted to dub "post-modern"). The French received this new, "correct" and well-ordered architecture from the Italians, hence it was an imported product that, initially at least, seemed fairly exotic. What is more, the generation of 1540 discovered all stages of the Italian

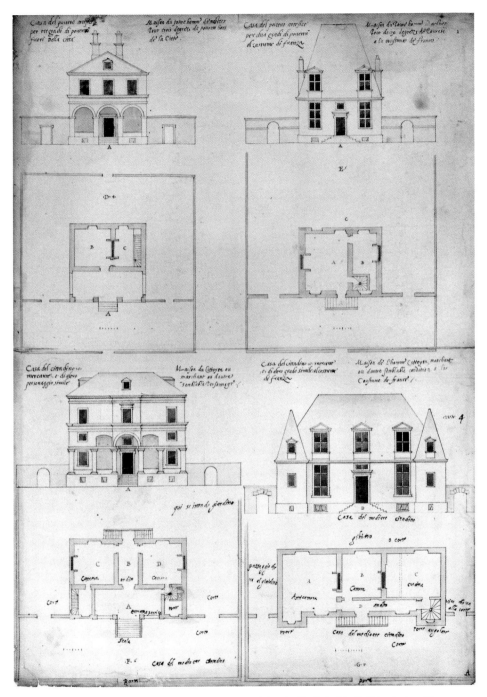

434. Sebastiano Serlio, *Artisan's workshop: plan and elevation*, c. 1550. Drawing. New York: Columbia University, Avery Library.
Serlio shows an Italian-style project (left), and a French one (right) in parallel.

Renaissance at once, from Quattrocento art (in which people were still interested) to the classical art of Raphael, and even to the sometimes eccentric developments of Michelangelo and the following generation, which we view today as anticlassical or Mannerist. Yet as I have already stated, what we see as anticlassical did not necessarily look that way to sixteenth-century Frenchmen. Phili bert de l'Orme may seem individualistic to the point of bizarreness to us, but just like Rosso, he surely appeared to his compatriots as the representative of "correct," clasically inspired art.

Philibert de l'Orme, French Author-Architect

Philibert de l'Orme was not only one of the most original architects of his day, he was also one of the most willfully French. His national identity was expressed with particular clarity in both his architecture and his texts, where he displayed lively talent as a writer. Thanks to this gift, readers are treated to a haughty character with a firm, distinct voice. Philibert was able to write himself forcefully into his texts, in such a way that his identity—professional, social, and national—informed his conception of architecture. He published two books: *Nouvelles Inventions pour bien bastir et à petit frais*, 1561, in which he presented his invention of structural frameworks made from assembled components; and the first book of *Architecture,* 1567, which was never followed by the promised second volume. To these publications should be added a more personal text—a short, private statement written at a time of crisis—in which his voice comes across in a particularly gripping way. After the death of King Henri II, Philibert's presumably numerous enemies glimpsed an opportunity to take their revenge. De l'Orme was replaced by Primaticcio as superintendent of royal buildings just two days after Henri died. In circumstances that remain unclear, there was a brawl in which Philibert and Jean (his brother and professional associate) killed two other men. Philibert's *Instruction,* or official statement, although written for an unidentified, powerful figure whose protection the architect was seeking, does not address this incident—more commonplace at the time than might be supposed—but rather allegations of embezzlement. After listing the advanatges that Henri II had bestowed on him, and having stressed the fact that he had never received any other remuneration

from the king, Philibert detailed his disbursements and services. He also emphasized his administration's success at cost-cutting—enormous, if he is to be believed—by rigorously monitoring contractors such as the famous mason Gilles Le Breton, the main builder at Fontainebleau (this rigor being an excellent way, of course, of making enemies). Here emerges one of the main themes that characterized de l'Orme's originality, namely the stress he placed on the technical competence of an architect. His predecessors in the office of superintendent of buildings had been aristocrats and administrators with no particular qualifications. De l'Orme's professional experience placed him in a very different position vis-à-vis contractors.

He then discussed his role as an architect, taking the opportunity to provide a spirited defense of his contribution to the French Renaissance:

> In addition to all that, have I not provided other services, to wit having brought to France the method of building well, eliminating barbarous methods and coarse joins, showing all and sundry how to observe the right measures in architecture, even training the finest workers of our day, as they themselves acknowledge? Let it be recalled how people worked before I began Sainct Mort [Saint Maur] for Cardinal du Belloy [Bellay]![18]

In this crucial passage, where he highlights the decisive impact of his first major commission, Philibert links his role as an architectural reformer in France with his efforts to train masons and other construction workers. In his view, the two things were indissolubly connected.

The first volume of *Architecture* represents a veritable theory of architecture, a treatise modeled after Vitruvius, as only Alberti had managed to

produce up to that time. Although Serlio's six-part book—an almost complete version of which had been published in those years—had met with great success, we have already discussed its intellectual shortcomings (and its originality, which consisted largely in the coordination between text and image). Philibert learned a good deal from Serlio, but his ambitions were greater. Alberti, meanwhile, was a humanist, a first-rate writer, an artist by temperament, and an occasional architect who was addressing a learned public; his readers were architects as he conceived them—intellectual and artistic—and the patrons with whom they had to deal. Alberti did not have a sustained theoretical discussion of execution—the social elevation to which he aspired for his architect implied an almost total divorce between architecture and construction. True enough, Alberti did devote one chapter to construction, but he focused almost exclusively on materials and the solidity of the building, with no reference at all to their implications for the architectural conception. For Alberti, although an architect could not ignore the work of the mason, the latter remained divorced from architecture. De l'Orme, however, was raised in the mason's trade and therefore wanted to incorporate that craft into architectural conception by turning the architect into a kind of "meta-mason." It was no coincidence that Bernard Palissy, who was not fond of Philibert, mockingly called him "the god of masons."

It is impossible to read de l'Orme's treatise without being struck by the way he put so much of himself into his text: not only did he write in the first person, but he often brought himself on stage, and his buildings served almost exclusively as illustration of his ideas. Yet it would be mistaken to interpret this approach merely as literary effect and personal vanity. It was the corollary of a philosophy and a method. For Philibert, experience was everything—theory was only of value in so far as it sprang from practice. It is because his architectural philosophy was the product of an entire lifetime that he had to incorporate himself into his text. This incorporation was nevertheless done as a function of the ideas he wanted to advance—biographical incidents were designed to serve as examples. It is worth

435. *Portrait of Philibert de l'Orme*, from Philibert de l'Orme, *Premier tome du livre de l'architecture*, 1626. Paris: Bibliothèque Nationale de France, V 1987.

recalling the well-known passage where he described meeting the future Pope Marcellus II:

Being in Rome in the days of my tender youth, I took the measures of buildings and antiquities according to the King's fathom and King's foot, as is done in France. There came a day when, measuring the triumphal arch of Santa Maria Nova, as several Cardinals and Lords were promenading among the vestiges of antiquities, and passing by the place where I was, the Cardinal of Santa Croce, then just a simple Bishop (but since made Cardinal, and Pope by the name of Marcellus, a most learned man in divers sciences and even in architecture, in which he took great pleasure at that time, indeed did make and produce designs and models, as he would shortly thereafter show to me in his Palace) said, in his Roman tongue, that he would like to know me, in that he had seen and observed me several times measuring divers antique edifices, as I was wont to do at great effort, cost, and expense, according to

my modest means, both for ladders and cords, as well as excavating foundations, in order to know them. Which I never did without a number of men following me, some to earn two Carlines a day, the others to learn, as they were craftsmen, wood-joiners, stonecutters and carvers and suchlike who desired to know how I proceeded, and to share the fruit of what I measured. This thing gave pleasure to said Cardinal, indeed so great that he begged me, being with a Roman gentleman named Signor Vincenio Rotholano, then living at the Palace of San Marco, that I go to see them, which I very willingly agreed to do. The aforesaid Lord Rotholano, a most learned man in letters and in architecture, took great pleasure in what I was doing, and for this reason displayed great signs of friendship, as did the aforesaid Lord Cardinal. In short, after having discoursed with them on several things concerning architecture, and having heard from whence I came, they begged me forthwith to visit them often at said Palace, which I did. In which place they advised me, among other things (after having learned the expenditures I was making to seek antiquities and to draw upon all things rare and exquisite in the art of architecture), that I no longer measure said antiquities according to the foot of France, being the foot of the King, in so much as they found it of less use than the Roman palm, according to which one could well and truly judge ancient edifices that had been built with that measure rather than any other, and most signally with the ancient foot, giving me forthwith one and the other with their measures, lengths, and divisions, such as I shall presently show them to you here.[9]

This passage, remarkable in many ways, is strategically placed at the start of the fifth book, when de l'Orme is about to begin discussing the classical orders. It represents a primal scene, a moment of revelation and initiation: the young Frenchman, in quest of true architecture, discovers Italian scholarship, which reveals to him the way to understand fully the fragments he is exploring. The documentary authenticity of this passage is very hard to assess, so strong are its

exemplary qualities.[10] What counts is the moral of the story: Everything becomes clear once ruins are studied in the light of scholarship.

Equally eloquent are Philibert's omissions. Notably, he has almost nothing to say about Italian Renaissance architects and architecture. During his stay in Rome and Italy he obviously took a good look at what his contemporaries were doing, because his own later work drew inspiration from it.[11] And yet, in his book, he completely ignores modern Italian architecture, alluding to it only to mark his distance from it.

Nor, curiously, does Philibert mention the many splendid Roman antiquities that could be seen in numerous parts of France itself. It is inconceivable that the architect, who grew up in Lyon, could have been unaware of ancient ruins in Vienne, only twenty miles away. And since the large buildings in Nîmes had already been published, and others in Provence were well known, he might at least have mentioned them. But for Philibert, the locus of classical antiquity remained Rome and Italy—where he encountered it and from whence he "brought [it] to France." Consciously or not, he simplified things the better to mark his position. For Philibert—at least in his treatise—classical antiquity meant Italy, while the Italians themselves were mere go-betweens; France, in contrast, was a land of masons, and we shall examine the importance this idea had for him.

If his book is to be believed, the young Philibert traveled to Rome and returned with the information needed to reform French architecture, which the stonemasons of his day had allowed to fall into decline (for the author did not spare his own country, where "people are scarce concerned to seek excellence and beauty in works"). He systematically overlooked modern Italy's crucial contribution to his education. His architectural output displayed an entire repertoire of motifs—particularly when it came to floor plans—that he could not have taken directly from either classical antiquity or French practice. In his theoretical texts, meanwhile, the integration, however imperfect, of masons' geometry into architectural philosophy would have been impossible without a coherent conception of space as expressed by Renaissance linear perspective. This contribution

was capital, and the fact that Philibert deliberately and almost totally omitted to mention this aspect of his education is equally so: French nationalism of the day almost always meant anti-Italianism. One of de l'Orme's rare allusions to Italian Renaissance architecture involves a criticism of Bramante (whom Philibert does not even bother to name, whereas he explicitly mentions several ancient architects). He begins by praising the delights of the Belvedere, "a place accompanied by an infinity of fine works and marble statues, as also of other fine antiquities, and signally a Laocoon and an Apollo, which are very admirable to see for being so divinely well done." As we see, specific praise is still reserved for antiquities, even though he cites, in general fashion, "handsome fountains, orange groves, lemon groves, and countless other things truly excellent and extremely pleasing." As to architecture properly speaking, the only work on which he dwells is Bramante's spiral staircase, which he carefully describes with its brick vaulting "that climbs most gently" and its openwork newel, the vault being supported on that side by columns, thus "showing itself to be a truly fine and well-done work." Philibert was not really satisfied, however. He continued:

> But if the architect who built it had harkened to the geometrical lineaments of which I speak, he would have angled everything, even down to the bases and capitals, that which he did all square, as if he wanted to make it serve a portico that is straight and on the level; over the capitals, and under the bases on the descending side, he placed stone quoins to compensate the slope of the ramp. Which thing shows that the workman who did it does not understand what an architect must understand. Because instead of making a vault of brickwork, he should have made it of dressed stone, with sloping arches between one column and another From which one would know that he had truly understood his art of architecture We have countless fair lineaments in France, of which no account is taken, for want of understanding and, what is worse, people are scarce concerned to seek excellence and beauty in works.[12]

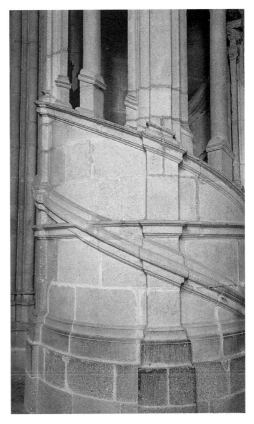

436. Limoges (Haute-Vienne, France), cathedral of Saint Étienne, *jubé* staircase (detail), 1533–34.
This detail showing the base of the column from an angle emphasizes the traditionally French *rampant* ornaments so dear to de l'Orme.

Philibert was being harsh, even brutal, by claiming that the architect of the Belvedere did not understand architecture. His criticism focused on two points: namely, the construction in dressed stone, which the Italians rarely used, whereas Philibert considered it indispensable to an architect's knowledge; and the way the bases and capitals were handled, that is to say, the coordination—or, if you will, the syntax—between the architectural elements. On this latter point, Philibert's opinion reflects a divergence in the two countries' respective practices: the French angled their capitals, reshaping them so that they followed the curve or ramp of the element they supported, while the Italians refused to

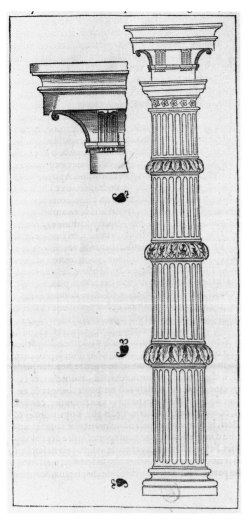

437. *Column*, from Philibert de l'Orme,
Premier tome du livre de l'architecture, 1567.
Paris: Bibliothèque Nationale de France, rés. V 365.

438. Philibert de l'Orme, *Column*, c. 1565. Stone.
Paris, Tuilerie gardens.

do so. Whereas the Italians respected the formal integrity of each element, the French preferred to follow what they considered to be the logic of construction, the overall coherence between elements and structure (fig. 436).

It was above all stonework that crystallized Philibert's sense of national identity. In Book I already, he complains of the exotic tastes of grand patrons who insisted on importing marble, even though France had ample construction materials.

Indeed! The singularities of one's own country and kingdom are always less prized, especially in France, than those of foreign lands. I am convinced that there is neither kingdom nor country, wheresoever, better furnished and endowed with divers stones for building, than this one here. Nature provided so well in this way that it would be hard to find a people with finer means for building than the French. But most of them are in the

habit of finding nothing good (as I have already said) unless it comes from strange lands and costs most dear. That is the way of the French, who in like cases place more value on the artisans and artifices of foreign lands than on those of their own homeland, even if they be very ingenious and excellent.[13]

This passage almost seems to echo du Bellay—in a tone that recalls the introduction to his *Deffense*—both in its chauvinist denunciation of the supposedly xenophile nature of the French and in its praise of France. Earlier in Philibert's treatise, when he was discussing the orders, it was once again the nature of French stone that justified the invention of "French columns" made of drums whose joins were masked by foliate decoration, such as the magnificent columns designed for Catherine de Médicis's palace in the Tuileries (figs. 437 and 438).[14]

Books III and IV (of nine books in all) are entirely devoted to construction in cut and dressed stone, or more precisely to *traits*, in other words the "lineaments" or technical diagrams used for cutting complex shapes such as stairs and vaults of all kinds. Bramante was disqualified for his ignorance of *traits*. Philibert's national identity finds its best expression in these pages on stereotomy, the art of stonecutting. In the prologue to Book III, he presents and explains a short allegory of a good architect. One might expect to find this passage at the front of the entire work, so it is all the more significant that de l'Orme placed it at this precise spot in his discourse where, diverging from the model of traditional architectural treatises, he begins a long discussion of stereotomy. It is the newest and most original part of his book, and he announces his approach in an introductory sentence that is particularly tangled, even by the standards of halting sixteenth-century prose:

> For such that this Third Book is almost entirely given over to the declaration and description of certain lineaments and tracings that we call geometric, most necessary to architects, master masons, stone cutters and dressers, and others, for knowledge and use thereof in the instances that we will propose, and according to methods that we will give and will be known by the discourse and

439. *Allegory of the Good Architect*, from Philibert de l'Orme, *Premier tome du livre de l'architecture*, 1567. Paris: Bibliothèque Nationale de France, rés. V 365.

reading of said lineaments which cannot be properly discovered nor certainly practiced unless with the aid and employ of the compass, I have for this reason decided to excogitate and familiarly describe the figure and image that you have herewith.[15]

Philibert was thus launching into a tribute to the compass, that traditional tool of architects. While the compass was the center of attention of the emblematic illustration (fig. 439), his commentary concerns above all the theme of prudence, thereby summing up previous chapters in which he extensively stressed the importance of preparation prior to building. In other words, every move had to be planned in advance; thus

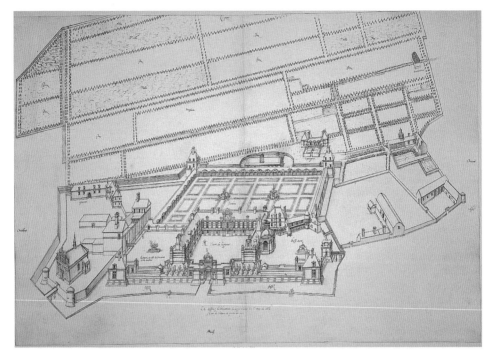

440. Jacques Androuet du Cerceau, The *Château of Anet: Bird's-eye View*, before 1576. Pen and ink wash, 19 ¾ × 29 ¼ in. (50.2 × 74.2 cm). London: British Museum.

mathematics enters the picture. The *trait*—a technical, geometrical diagram—was not only a plan, an anticipation and calculation of what was to be built, but also a technical tool used in execution. Philibert was thereby able to integrate practical building skills into architectural theory.

Drawing was also at the heart of Alberti's theory, for he considered architecture to be one of the *arti del disegno* (*disegno* meaning design, draftsmanship, or drawing, depending on context)—Vasari's famous use of the phrase was therefore profoundly rooted in Florentine tradition. The intellectual nature of architecture was linked to the practice of a certain type of drawn plans: scientific drawings (the systematic coordination of plans and elevations belongs to the same concept of space as linear perspective, invented and developed, as it happened, by Florentine architects), and also evocative drawings, "artist's renderings" that called on the imagination. In Book II of his treatise, Philibert warned against overly flattering drawings.

He preferred more austere depictions that involve rational calculation, "because provided that the measurements be well respected, these portraits cannot fail to show themselves well."[16]

Philibert was apparently suggesting that a coherent theory subtended the practice of stone-cutting *traits*. He must have thought that, by producing a mathematical theory, he could provide concrete materialization of the ancient idea according to which mathematics confers intellectual dignity on architecture—an idea that endured in Renaissance Italy in the specific form of harmonic proportions.[17] By integrating the geometry of stonecutting practices into architectural theory, Philibert would have given that theory a new and thoroughly French twist (figs. 442 and 443). But the difficulty of the undertaking daunted him and, in his book, he postponed the elaboration of this theoretical scheme. "Some people," he declared, "may say that without cause and for no purpose would I employ my time to review Euclid in order

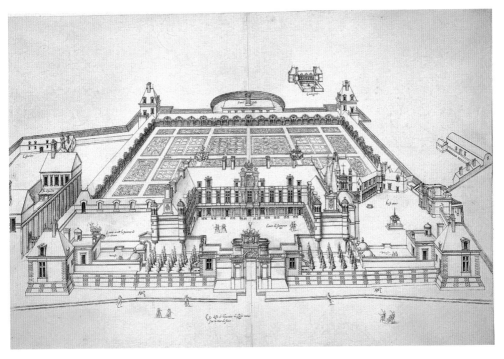

441. Jacques Androuet du Cerceau, The *Château of Anet: Perspective*, before 1576. Pen and ink wash.
London: British Museum.

to relate several propositions and demonstrations of his theory to the use and practice of our architecture, given that there are many learned men who profess to read and interpret divinely well the aforesaid Euclid." Paying tribute to those scholars, Philibert goes on to beg them, if possible, "to cut the ground beneath my feet, as the saying goes, that is to say to advance me in my pretension, which is to conjoin the practice of architecture with the theory of the aforesaid Euclid. In so doing they would relieve me of a great burden." As to the theory or "doctrine" of Vitruvius that should have fulfilled this need, Philibert finds it "so confused and indigestible in the books that we have" that he suggests the text may be corrupted; thus he once again "affectionately begs [scholars] to employ and devote some time to assembling and properly stitching the pieces of the gown of this great and incomparable author, scattered and cast here and there in evident disorder: which should be easy to distill in good order, given the

aid and effort of learned men. Should they refuse (as I thus said of Euclid), I must perforce labor upon it myself and devote whatever time it should please God to grant me."[18]

The confusion in Vitruvius was probably due, in fact, to the author himself rather than the corruption of his text. Whatever the case, Vitruvius was of little help here despite his authoritative status. The obscurity of his text was perhaps a stroke of good luck for the Renaissance, for it gave Philibert and others great latitude of speculation and action.

In his text on vaults in Book IV, de l'Orme distinguishes between vaults with Gothic ribbing and other, smooth vaults, to which he gives no name, but which might be described as "modern" stereotomy. Although Philibert did not invent the latter type, he certainly promoted it. As Jean-Marie Pérouse de Montclos has pointed out, such vaulting inaugurated a tradition that coincided—with striking exactitude—with French classicism.[19] These sophisticated vaults, whose smooth, seamless

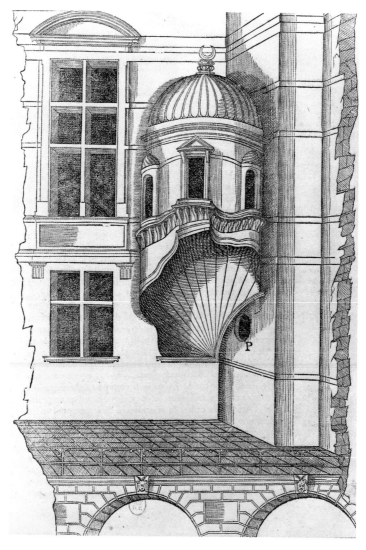

442. *Trompe at Anet*, from Philibert de l'Orme, *Premier tome du livre de l'architecture*, 1567. Paris: Bibliothèque Nationale de France, rés. V 365.

surfaces were often their only ornament, were the pride of Mansart and other seventeenth-century architects. Highly distinguished mathematicians would then study this art, just as Philibert had invited them to do—stereotomy inspired Gérard Desargues's projective geometry—that is, one of the most innovative developments in mathematics.

Pérouse de Montclos has suggested that modern stereotomy arose from the convergence of the practice of building Romanesque stone vaults, perpetuated by masons in the south of France, with the scientific theory of space that the Renaissance strove to develop. Whatever the case, this hypothesis accords well with the ideas of Philibert, for whom a synthesis of practice and theory constituted the very core of the new architecture; it was the necessary condition behind the new status of the architect, granting him superiority over

443. *Diagram ("trait") of the Trompe at Anet,* from Philibert de l'Orme, *Premier tome du livre de l'architecture,* 1567. Paris: Bibliothèque Nationale de France, rés. V 365.

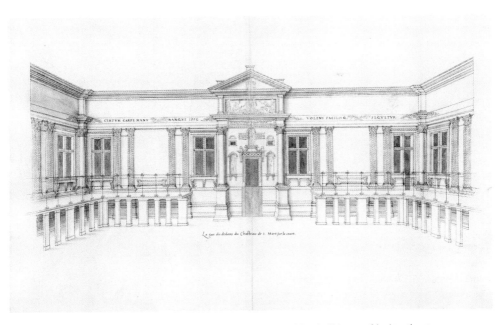

444. Jacques Androuet du Cerceau, The *Château of Saint Maur: Courtyard Façade,* third quarter of the sixteenth century. Pen and ink wash. London: British Museum.

masons (those traditional contractors he was supplanting), even though Philibert did not entirely possess the intellectual resources to achieve that synthesis completely. Prior to Philibert, the *trait*—that is to say, the elaboration of an architectural diagram with ruler and compass—was a complex and skilled practice, but was less a question of knowledge than of know-how handed down by craftsmen—the "masonic secret." Philibert was the first to incorporate it into a treatise drawn up on the model of Vitruvius and Alberti, thereby attempting to integrate it into a theory of the art of architecture.

When it came to Gothic architecture, Philibert was ambivalent. In so far as he presented himself as the man who encouraged France to adopt a regulated architecture and to return to antiquity, he was positioning himself against the Gothic. At the same time, however, he did not want to reject what he clearly considered to be a national tradition, since he stressed the fact that stonecutters referred to rib vaulting as the "*mode françoise,*" or "French manner." "Today," he wrote in a key sentence that provides a glimpse of his quandary, "those who have some knowledge of true architecture, no longer follow this fashion of vault, called by workmen the 'French manner,' which truly I would not scorn, but rather I confess that people made and executed most fine and difficult lineaments." A note in the margin underscores the contradiction implicit in the text: "The author approves the modern fashion of vaulting, yet does not avail himself of it."[20] The perplexity is clear.

It is easy to detect the aspects of de l'Orme's architecture that directly relate to the French "Flamboyant"—or late Gothic—tradition. In this respect, the château of Anet represents a retreat from Italianism compared to Saint Maur; it is a return to the symbolism of French châteaux and Gothic motifs, such as corner turrets and the pierced parapet over the gatehouse (figs. 441 and 446). However, this should not be seen as a regression but, on the contrary, as another step toward a modern French art finally freed from Italian tutelage. Was Philibert himself fully aware of this progression? Did his development reflect a true effort at synthesis or simply a pragmatic response to circumstances? He was never explicit on this matter,

except in one instance. That instance, however, proved to be capital: the dome at Anet. The chapel of the château of Anet, and notably its dome, are fundamentally Italian and antique in inspiration (fig. 453).[21] Nevertheless, it is not implausible to view the coffered ceiling of the dome as a crisscross pattern of spiral ribbing. In short, Anet is perhaps like many Renaissance chapels in France, where Italianate decoration was wed, as well as possible, to Gothic construction. In various works from the early French Renaissance, the traditional system of ribbing can be clearly sensed behind the pseudo-coffering of the vaults, as seen, for example, in the strange vaulting of the chapel in the

445. Door from the Château of Anet, after 1547. Wood. Paris: École Nationale supérieure des Beaux-Arts.

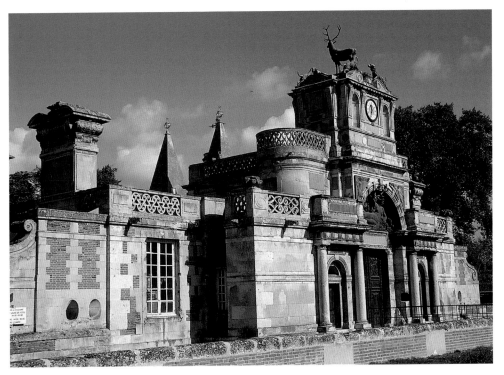

446. Anet (Eure-et-Loire, France), entrance gate, 1552.

choir of Notre-Dame-des-Marais in La Ferté-Bernard and, when it comes to civil architecture, in the large halls at Chambord. This interpretation of de l'Orme's dome might seem frivolous or strained, given the classical feeling that seems to inhabit the chapel, except that Philibert himself invites such an analysis. Having explained, not without a certain obscurity, the principle of a spherical dome, and having declared its advantages over the Gothic vault, our architect adds:

When you should wish to include compartments of moldings, with other kinds of works, you can do it much more richly than with the vault of which I formerly spoke. You can place below the pendentive similar sorts of branches that are found in French-manner vaulting, either ribs, liernes, tiercerons, or others, indeed with hanging bosses, and with greater grace than has yet been seen. Those who would take the trouble, will understand what I mean by the spherical vault that I have

built in the chapel of the château at Anet, with several kinds of branches that are climbing in contrast to one another, and forming by this same method compartments that are straight over and perpendicular to the plan and paving of said chapel, which creates and shows in one and the same way that which I present in the subsequent figure.[22]

Here Philibert removes any shadow of doubt: the vault at Anet is comprehensible simultaneously as a system of intersecting ribs ("branches") and as ancient-style coffers ("compartments"). It involves, for that matter, decoration independent of the structure, a stone vault that is neither Gothic nor antique. In so far as the decoration symbolizes a synthesis between antiquity imported from Italiy and home-grown Gothic tradition, Philibert's functionalist rationalism was suddenly held in abeyance: the ornamentation had nothing to do with the constructive logic of a dome, one of whose merits is precisely the ability to receive any

447. *Frontispiece of the Château of Anet*, after 1547.
Paris: École Nationale supérieure des Beaux-Arts.

he contribute to the design of the tapestry of Diana? It is impossible to say. In any case, he was proud of the château's stained glass, it being of a new kind he claimed as his own.[23] He certainly supplied the plans for the woodwork, executed by leading workshops. In his books he mentions the paneling in the ballroom at Fontainebleau as some of the work for which he was responsible, and the same was true at Anet. The doors now at the École des Beaux-Arts in Paris give an idea of the refined elegance of such work (fig. 445). Finally, although Philibert disapproved of excessive ornamentation, stone carving played an important decorative role at Anet, notably in the chapel and on the frontispiece of the main wing, now installed in the courtyard of the École des Beaux-Arts (fig. 447).

The relief carvings in the chapel, like the famous statue of Diana (see Chapter X), were long considered to be the work of Jean Goujon. Although now rejected, this attribution is worth recalling not in an effort to rehabilitate it but because the possibility of such confusion shows that Philibert's art was not as different from Lescot's as we tend to think. The bas-reliefs on the upper part of the frontispiece at Anet (fig. 448), so directly inspired by Roman antiquities that they almost seem to be a pastiche, are rather similar in spirit to the sculpture on the Louvre; furthermore, the very design of this frontispiece is highly similar to the one on the now-destroyed entrance to the château of Écouen, which has been plausibly attributed to Goujon (fig. 175).[24]

desired decoration. This example is characteristic of Philibert, who was highly attached to construction skills and had a taste for abstract forms that spring from the mason's craft, yet at the same time liked expressive motifs typical of a narrative and almost chatty architecture. Thus at Anet he multiplied emblematic allusions to Diana by introducing archer's bows as a framing motif on windows, and, as already pointed out, by terminating chimneys in the form of sarcophagi (thereby recalling that Diane de Poitiers was a widow).

At Anet, Philibert—like Lescot at the Louvre—oversaw all the decoration himself, and like Lescot he abandoned the wall painting that dominated at Fontainebleau in favor of traditionally French techniques: carved stone, woodwork, tapestries, stained glass, and even enamel for the chapel. It is likely that he planned for decorative tapestries, as suggested by his previously cited comment on the pointlessness of decorating the interior frames of doors because woven "doorhangings" would always mask them. But did Philibert play a more active role, in particular did

448. *Frontispiece of the Château of Anet*, detail of *Victory*, after 1547.
Paris: École Nationale supérieure des Beaux-Arts.

This apparent coherence might be seen as the result of reciprocal influences, but such a view would primarily reflect today's obsession with individual aesthetics. De l'Orme, despite a highly developed sense of his own importance, was extremely attentive to the demands of the noblemen who commissioned the buildings. His conception of architecture was inseparable from his sense of social order. Although he loudly proclaimed the right of architects to innovate even if it meant violating the authority of classical antiquity, he remained attached to the traditional order of French society, and never missed an opportunity to castigate the pretensions of nouveaux riches who built residences above their station. Ornamentation—and for Philibert, the classical orders were ornamentation—was basically reserved for the high nobility. In the prologue to Book V of his treatise, just prior to discoursing on the classical orders, he expresses himself most clearly on this issue of propriety.

For as it is plain to see, whenever Popes, Kings, and great lords produce excellent

449. Vallery (Yonne, France), château, interior of the loggia, c. 1555.

Lescot, meanwhile, despite the exuberant lavishness of his Cour Carrée at the Louvre, also appreciated more austere effects; it should not be forgotten that the exterior façades of the Louvre were as spare as possible. And the loggia along the courtyard at the château of Vallery, orchestrated by large niches, some of them cut with windows, obeys a geometric aesthetic arising from smooth stonework similar to that employed by Philibert on the cryptoporticus of Anet (figs. 449 and 450). During those decisive years, the main innovators—de l'Orme, Lescot, Goujon, and perhaps several others whose role is less clear—were certainly keeping a watchful eye on one another. Despite the assertion of strong personalities, these artists constituted what might be called, for the sake of convenience, a group or period style, an artistic idiom shared by a milieu and an era.

450. Anet (Eure-et-Loir, France), cryptoporticus of the château, c. 1550.

451. Anet (Eure-et-Loir, France), château chapel, 1549–52.

452. Anet (Eure-et-Loir, France), château chapel, interior view of dome, 1549–52.

magnificence in their castles and palaces, either in marble ornamentation or incrustations, in fine rooms, handsome gardens, or exquisite, lavish furnishings, then intemperate gentlemen, bourgeois officers, and others all want to produce the same, at mad expense and greater extravagance than those who [originally] did them. . . . May it please God, my devout wish is that the rich burghers, merchants, financiers, and others who enjoy a wealth of property in all affluence and beyond all measure, would sooner give themselves to the founding of hospices or colleges for relief of the poor and public utility, rather than build a mound of superb and magnificent houses that only bring them envy and misfortune, as usually transpires. I am often embarrassed by certain people who desire to make buildings unworthy of them, and ask my advice on their deliberations; to whom I respond that each must measure according to his own foot.[25]

Given its location in the text, this passage clearly means the following: classicism, which

Philibert "brought back" from his voyage to Italy and which he still views, to a certain extent, as exotic, is a manner—not to say a fashion—reserved for the highest stratum of society. It is a courtly art. The high nobility identifies with it and is identified by it, like the collective portrait of the court produced by the Clouets. Philibert is clear on one point: ornamentation, and especially the figurative symbolism of the overall decoration, is the prerogative of lords who commission buildings, and their demands must be met. In contrast, respect for the right proportions, the purely formal beauty generated by measurements and geometry remains independent, for Philibert, of the classical orders, and can therefore be applied to all building, irrespective of class—in this sphere, the architect is master. At the end of his career, de l'Orme came to believe in a divine order expressed by a system of proportions whose secret was to be found in the Bible. But he did not have time to develop this idea, planned for the second volume of his *Architecture*. Of course, this concern might in fact simply reflect a period

453. Anet (Eure-et-Loir, France), château chapel, interior of the dome, 1549–52.

DE PHILIBERT DE L'ORME. 206
ont de largeur,minutes huict , onces trois: le deſſus pour la haul-
teur de l'abaque, a minutes vnze , onces deux : la largeur par en-
bas au droit des cornes pres des fueilles des volutes, a minutes
trois, & ſon fillet quarré au deſſous,minutes dix, once & demie:
la haulteur des premieres fueilles du chapiteau, a palmes deux, *Pourfuite &*
minutes trois, onces deux: & ſa largeur, palme vn, minutes dix, *continuation*
onces deux.Les ſecondes fueilles ſont de meſme largeur, & vne*de ce que deſ-*
fois d'auātage pour leur haulteur.Ie vous deduirois bié plus par- *ſus.*
ticulierement toutes les autres meſures que i'ay trouuées en ce
chapiteau, mais ce feroit trop longue: ioinct auſſi que ſans
en faire plus long diſcours,les bôs eſprits les ſçaurôt bié trouuer.

454. *Capital: Cross Section*, from Philibert de l'Orme,
Premier tome du livre de l'architecture, 1567.
Paris: Bibliothèque de France, rés. V 365.

455. *Composite Capital*, from Philibert de l'Orme,
Premier tome du livre de l'architecture, 1567.
Paris: Bibliothèque de France, rés. V 365.

when religious strife was on every mind and affected every aspect of life. It is also appropriate, however, to see Philibert's belief as a determination to establish the new architecture on bases that transcended not only Italian classicism but also Greco-Roman antiquity.

It is impossible to perceive de l'Orme as the last Gothic mason with just a veneer of new fashions, for the simple reason that he was extraordinarily aware of his historic position: for Philibert as a Frenchman, the Gothic approach remained an alternative, a style that he could either adopt at will (in the chapel at Vincennes, for example), or reject, or adapt. What is more surprising, and perhaps unique to Philibert, is that he managed—almost—to achieve the same detachment vis-à-vis classicism, subordinating it to a more fundamental conception of architecture. Although he never really succeeded in formulating this basic conception

(perhaps the purpose of his second volume), he nevertheless suggested the possibility.

The case of Philibert de l'Orme is a wonderful one for assessing a phenomenon such as awareness of national identity, because the great architect was able to express himself verbally as well as through his buildings. He nevertheless serves here primarily as confirmation, so to speak, of all that has preceded, since the core of previous chapters really concerned visual expressions of that identity, or—to put it better—visual manifestations of a distinctly French culture.

An active awareness such as that displayed by de l'Orme is probably rare. Usually, the coherence that we perceive retrospectively and that allows us to speak of a French art at a given period, is concretized only at an unconscious—or more or less subconscious—level based on habits of mind and hand. That is why this coherence remains relative.

Jean Duvet and Jean Cousin, who were more or less contemporaries, were in many respects as different from one another as is possible. So which of the two was more French? Posed thus, the question is meaningless. Both were part of a configuration that is precisely the point of interest of the preceding pages, and to which this very inadequate illustration and this book, although not as complete as one might wish, have attempted to sharpen readers' eyes.

Early French Classicism

During the cultural upheaval that occurred in France in the mid-sixteenth century—for which the groundwork had long been laid and whose impact would last to the end of the Valois dynasty and beyond—the visual arts offered extremely varied solutions to the tasks at hand. This period of effervescence was also a period of uncertainty. Later eras, each according to its respective circumstances, would decide what kind of light—often fairly obscure—to shed on these works, thereby determining their historic fate. Seventeenth-century French classicism was exclusionary, emphasizing a limited corpus by endowing it with the extraordinary power of "the classics." Lescot's Louvre, despite heavy criticism, was adopted as authoritative. If Philibert's works now seem somewhat eccentric, it is precisely because of this later norm. In the context of 1550, they simply co-existed among the various possibilities and numerous solutions of the day; their later eclipse was a trick of fate. This did not prevent them from resurfacing when, in the nineteenth century, classical norms seemed overly restrictive for a dynamic rejuvenation of the French national spirit. Philibert's marked taste for technical innovation thus found a resolutely modern echo, and it is understandable why Henry Lemmonier, in 1898, could not resist comparing Philibert's boldest plans (the Montmartre convent, for instance) to recent metallic constructions such as the 1884 bridge over the Garabit River and the machine room of the Universal Exposition of 1889.

Returning for a moment to the contrast between Duvet and Cousin, we might recall the fate reserved for Cousin by the academic world, from Félibien down to the nineteenth century. He was a grand figure, but served above all as a mirror in which each period could read its own aspirations. The diffuse traces left by Cousin, for reasons I have tried to elucidate, are partly responsible for this historical process without, however, being entirely to blame. What remained of Duvet, whose engraved oeuvre never completely disappeared from view, did not lend itself to similar appropriation. Strongly marked by his manual intervention and by a fierce sense of his personal identity, Duvet's prints were usually judged harshly on the rare occasions that they inspired comment prior to the Romantic period; once their day had come, however, these qualities lent them exceptional value (fig. 456). Delacroix turned to them late in his career for the inspiration he was seeking for the angels in his *Expulsion of Heliodorus* in the church of Saint Sulpice in Paris. Since that time, the age of individualism has provided Duvet with a well-established if modest place in its pantheon of great and minor masters. He was not, as mentioned above, unfamiliar with the problems of classicism, but what he retained of it was closer to the Picasso of the 1920s than to Poussin. In contrast, Cousin, at the cost of a major distortion, could ultimately allow the French academic tradition to invent a sixteenth-century ancestor for itself.

Throughout this book, I have used the term "classicism" as though it raised no problem, as though everyone easily understood it. Worse, I have used it with quite different meanings, sometimes to discuss works inspired by Greco-Roman antiquity, sometimes in more general fashion to refer to an art that conveys a feeling of order, clarity, and stability, going so far as to posit the obviously contradictory notion of classical Gothic. I make no amends for this. This casual use corresponds to the reality of the instability of established values, a reality particularly tangible

456. Jean Duvet, *Saint John the Baptist and Saint John the Evangelist Contemplating the Holy Lamb*, 1528.
Engraving, 5 ½ × 4 in. (14 × 9.7 cm). Vienna: Albertina.

during the period under study. All definitions of classicism, once they refuse to be strictly conventional, are extremely relative. In the final analysis, it is a question of authority: classicism is the dominant art, namely the art of the dominant class. Musicologists, for example, tend to restrict the term "classical" to Mozart's time, but everyday language has never respected this definition, preferring to label as "classical" everything that might be called serious music—whether composed by Bach, Mozart, or Boulez—as distinct from "popular" music. The social implications are all too obvious: classical music is music of class, popular music is music "of the people." This does not prevent us, however, from asserting that Edith Piaf's rendition of *La Vie en Rose* is a "classic" of popular French music—a different context calls for a different authority.

Given what might be called this relativistic standpoint, how can we explain the undeniable glamour associated with the Greco-Roman model, with ancient classicism? The answer is

clearly not simple, but certain elements can be identified. First of all, ancient Greece and Rome were remembered as well-structured, powerful societies. What perhaps counted even more, however, was the possibility of taking the artistic vocabulary bequeathed by these societies to Western civilization and then anchoring that vocabulary in nature. A cultural phenomenon remains vulnerable in so far as it is imposed: the powers-that-be know full well that all it takes to eliminate them is a greater power. In order to forestall this threat, ancient Greece invented a naturalist rationalization of its artistic culture: a column was not just a support made more or less attractive by arbitrary ornamentation, for the decoration was a rational articulation of the expression of the mechanism of thrust (thus an astragal represents the slight bulge at the point where the capital weighs on the shaft); a column, regardless of what it was made from, was also understood as a tree and therefore gave the impression of having sprung up rather than being manufactured, even as it alluded to the origins of architecture; finally, a column was the image of a body, a human body whose ideal proportions it described. Understandably, various epochs sought to appropriate this system—apart from the value associated with ancientness and with fitness as demonstrated by its survival, Greek art claimed links to nature through two different paths: one symbolic (metaphors of tree and body), the other historic (a discourse on origins).

The sixteenth century was no exception to the rule, but it was a period when values were particularly unstable in France, when the political system—and, with it, all of French culture—was seeking its way, haltingly, all the keener to convince itself that its values were stable and faithful to the past—a past that it chose from among various possibilities. Thanks to unusual prosperity, sixteenth-century France displayed extraordinary dynamism. True enough, the economic situation had begun to deteriorate by the time cultural forms emerged most clearly, but this time-lag has often been observed and is unique neither to France nor to the sixteenth century. What makes the sixteenth-century milieu so fascinating are the stakes at play: what would be salvaged of

France's past, or who would inherit the glamour of classical antiquity with its claims of universality? The monarchy certainly identified with it; and even the Church, which was not always in league with antiquity, sometimes leaned that way. Also to be taken into account was an affluent urban class on the rise—the decorations for Henri II's ceremonial entry into Paris included an allegory of the social orders in which "Council," garbed in a "long gown," was seated alongside Church, Nobility, and Labor. The wealthy, industrious burghers of Paris were distinguishing themselves from the anonymity of the laboring "third estate."

Within this complex, shifting situation, it is fairly easy to identify classicizing trends—namely, the appropriation of the vocabulary of classical antiquity, usually via Italian interpretations. Yet which of these trends would become "classic" in the sharpest sense of an art that presents a picture of the stability of an established power? Once again, the decision would be left to history, rather than the moment itself. Although it would be pointless to ignore subsequent history, we can at least try to put it aside temporarily. Initially, around 1540—or even a little earlier—the use of classical orders spontaneously appeared in France in various parts of the kingdom; these scattered, isolated initiatives seem to reflect primarily the dynamism of scholars. Subsequently, when the great court architects developed a more articulated and richly decorated classicism, it looked as though this new art was being adopted for the benefit of royal government—Philibert's treatise seems fairly explicit on this point. This royal art then spread—though it is not always easy to distinguish between the natural extension of early, independent experiments and the deliberate dissemination of artistic manifestations of the newly absolute monarchy. Certain cases might even reflect the usurpation of power by other, rising classes: events had perhaps already overtaken Philibert when he castigated the pretensions of nouveaux riches who wanted to build like great aristocrats. The position of the kings themselves was not unambiguous—they never formally abolished feudalism, although they systematically sabotaged its mechanisms, and they

sustained the prestige of the old aristocracy even as they remained wary of it, placing their trust in new men whom they could break more easily instead.

The ideological significance of aesthetic choices is never straightforward. I have tried here and there to make its importance felt, without attempting to account for it systematically. Such an undertaking might have distorted more than it revealed of the history I wanted to recount. I have attempted to show, through specific examples whenever possible, the way in which the visual environment restructured itself at a crucial moment in French history, according to distinctions and criteria that are no longer current, yet can still be understood., and I have tried to discern—through texts but mainly through the works themselves—the status of the artisans of that transformation.

The "grand century" of French classicism remains Louis XIV's seventeenth century, whose rule-based, deliberately restrictive classicism rejected much of the more startling and heterogeneous culture of the preceding century. It would be an exaggeration to claim that this normative classicism was fully responsible for the demolitions that render an understanding of French Renaissance art so arduous today, but it certainly played a part. The more or less total eclipse, during Boileau's day, of much of sixteenth-century literature—Ronsard in particular—is significant. Fortunately, texts do not vanish as totally as buildings and images. Ronsard could be recovered more or less intact. In contrast, almost everything built by Philibert de l'Orme has been destroyed. The eighteenth century, already more curious and open than the seventeenth, republished Marot and even Villon—that is to say, preclassical literature. Ronsard's oblivion was all the more complete in that he could not be recuperated in the name of the "Gothic" picturesqueness of a bygone era. Because he represented a

different, irregular classicism, Ronsard would have to wait. Diderot was categorical: "This Ronsard, so vaunted by men of his time, no longer enjoys renown."[26] Yet nineteenth-century Romantic writers Nerval and Sainte-Beuve would discover unsuspected expressive possibilities in Ronsard, even if they limited themselves to his short lyric poetry, to the least dense part of a tentacular oeuvre whose tortuous obscurity eventually found fans in the sensibility of the twentieth century.

The visual arts of that period have suffered too much from time for us to be able to appreciate them with the same ease and completeness. Art and architecture were too closely tied to settings whose individual elements depended on the entire ensemble, now irrevocably altered. Yet all has not been lost. The interior of the chapel at Anet, as beautiful as any poem, is instantly moving even without explanation, without the scholarly exegesis that indeed reveals hidden aspects and subtleties missed by uninitiated visitors of today (as of the sixteenth century). The exterior of this same chapel, however, ripped from the wing of the château that once surrounded it, no longer has any relation to what it once was. Lescot's façade and Goujon's sculptures at the Louvre remain exquisite, but they have been seriously compromised by the extravagant enlargement of the Cour Carrée (not to mention the unhappy fate and dismantling of the Fontaine des Innocents). We are obliged to turn to highly laconic archive documents, to examine often unattractive fragments, to consult visual or verbal testimony that punctuates the history of manhandled works, and, above all, we are obliged to use these materials as the basis of hypotheses that are clearly fragile, yet crucial to providing a meaning—however precarious—to the monuments that have survived. In short, the visual culture of sixteenth-century France can only be recovered through an effort of imagination that I have tried to urge readers to make with me.

NOTES

CHAPTER I

1. François Rabelais, *Pantagruel*, ch. VIII.
2. On this point, see in particular Simone, 1949, *passim*.
3. The original edition of Francesco Colonna's *Hypnerotomachia Poliphili* was published in Venice by Aldus Manutius in 1499. The author of the illustrations remains anonymous. The French translation was published by Jacques Kerver in 1546 under the title *Hypnerotomachie, ou Discours du songe de Poliphile*. Reduced reproduction by the Club des librairies de France, 1963, with a preface by Albert-Marie Schmidt. Critical edition presented by Gilles Polizzi, Paris, Imprimerie nationale, 1994. (English translation by Joscelyn Godwin, London, Thames and Hudson, 1999.)
4. On the *Kalender*, see H. O. Sommer's introduction to his edition of the English text *The Kalender of Sheperdes*, London, Sommer, 1892.
5. Lacombe, 1907, nos. 150 and 166; there are a number of other editions of Hours by Kerver and his successors. For a long time, Kerver was the only publisher to print Books of Hours in Roman.
6. Mortimer, 1964, no. 511.
7. The hybrid is so called because it was somewhat contaminated by cursive writings, giving it some connection to Italic. Nevertheless, its appearance is much closer to Gothic; hence, Tory called it "modern" or "French" (see below), terms that relate to Gothic characters, as later Philibert de l'Orme would call Gothic construction "modern" or "French style."
8. The original French reads: "Ha faict, & faict faire certaines histoires et vignettes a lantique, et pareillement vnes autres a la Modern pour icelles faire imprimer, et seruir à plusieurs vsages dheures..."
9. Tory is yet to enjoy the comprehensive study that he deserves. One should refer to Bernard's old monograph, 1857. English translation by George B. Ives, *Geofroy Tory: painter and engraver, first royal printer, reformer of orthography and typography under Francois I*, Cambridge, MA, Riverside, 1909. To this must be added in particular the studies by Myra Orth, 1981 and 1988, who examined Tory's links to the production of manuscript Hours. All things considered, she seems to restrict Tory's participation as an artist to within very narrow limits. Though she made important contributions to the study of illumination in the first third of the sixteenth century, as far as Tory is concerned, her conclusions are neither always very clear, nor entirely convincing.
10. Oral communication from Bousquet to Bruno Tollon, 1985.
11. On this text, see Wiebenson in Guillaume (ed.), 1988, pp. 67–74, and Lemerle, 1994.
12. Blunt, 1983, p. 57.
13. See Panofsky, 1930; English text in *Meaning in the Visual Arts*, Garden City, NY, Doubleday, 1955; and Wittkower, 1974.
14. The pinnacles were probably raised after the pediment; they bear the arms of Jacques de Corneillan, Georges d'Armagnac's successor at Rodez. See Bion de Marlavagne, *Histoire de la cathédrale de Rodez*, Rodez/Paris, Didron, 1875, pp. 163–164. Nevertheless, these pinnacles were surely already planned earlier.
15. For the literary aspect, see Cave, 1979, and on the question of national consciousness, Chapter XI of the present volume.
16. However, Guillaume, 1976, 1983 and in Babelon (ed.), 1986, pp. 179–190, has laid out a new reading of this architecture, giving great promise to a forthcoming work on the châteaux of the Loire.
17. To define the extent of what can legitimately be called Gothic is truly a difficult question. Erwin Panofsky declared himself unable to understand how one could speak of Gothic painting, the term having significance only in architecture. Paul Frankl, even more demanding, doubted the term could be applied outside of ecclesiastical architecture. For all that concerns the debate on the Gothic, one should refer of course to Paul Frankl's rich work, *The Gothic: Literary Sources and Interpretations through Eight Centuries*, Princeton, 1959, in particular pp. 641–650, concerning the late Gothic. In his nationalist perspective, August Schmarsow set the beginning of the "German Renaissance" in 1351. We know that there were violent reactions to such assertions. I am not sure that Georg Dehio was correct when he affirmed, "that something completely new and original like the art of the van Eycks should *also* be called Renaissance will never be accepted by anyone with sound common sense." Frankl seems to endorse this phrase, which he cites (p. 646), but the idea of a Northern Renaissance,

which Courajod had articulated with such vigor, has made headway, at least with regard to Flemish painting. Architecture is another matter.

18. Villes, 1980, proposes a meticulous archaeological study in order to disentangle the very confused history of construction: work on the church began shortly before 1410, but there was a radical reworking of the initial project, which had been much less ambitious, in the sense of a greater monumentality after 1440. In particular, the elevation of the nave would have been transformed by the introduction of a triforium. The western façade, replacing an earlier, more modest façade situated at the end of the third present bay, would have been undertaken after 1470 and completed at the latest in 1509, the date of the beginning of work on the chevet.

19. One could cite a number of other examples. One of the most precocious, along with Vannes, is the bishops' chapel in the cathedral of Toul, built by d'Ailly and completed after his death in 1534. In the same church, the even more sumptuous chapel known as All Saints', built at the expense of the cantor Jean Forget who died in 1549, dates from a few years later. See Valléry-Radot, 1934. One finds an example of this—albeit a somewhat clumsy one—as far as Le Monastier, a rather obscure village in the Haute Loire.

20. The *jubé* was demolished, like so many others, in the nineteenth century, but a part of it can be seen reused inside the south portal; the remains of the enclosure— only two bays of which had been built around 1530— was used in the chapel of Saint Raphael.

21. When a *jubé* was removed for liturgical reasons, it was moved in order to serve as the organ loft against the western façade. The *jubé* dates from 1533–36. The date 1533 appears on a cartouche on the right pilaster of the left panel. Others go as late as 1536 and a document dated April 9, 1536 mentions statues of the Virtues that Jean Arnauld, "*imagier* [sculptor of figurines] of the city of Tours," was to complete within two months. The connection with the art of the Loire is thus well established. See the meticulous study by Cloulas-Brousseau, 1963.

22. One must however be wary of an overly linear interpretation of this development. The taste for solid walls probably never disappeared. See Stephen Gardner's studies on the different tendencies and competition in the Parisian region at the very moment of the formation of the Gothic.

23. This porch was undertaken in 1506 at the initiative of Guillaume Le Roux, lord of Bourgtheroulde, who, at the same moment, was beginning to build the famous Bourgtheroulde hotel in Rouen. See Verdier, 1983.

24. The upper ramp was added in the eighteenth century. It is a fine pastiche.

25. See Villes, 1980. It may be that the definitive design of the nave's elevation, the extension of the two bays and the Flamboyant project for the façade were contemporary, though this is not at all certain.

26. Sanfaçon's text, 1971, is the most sustained attempt to define an aesthetic of the Flamboyant in France. According to him, the Flamboyant, which materializes the aspirations of a Northern humanism in competition with the Italian Renaissance, expresses the spontaneous participation of radically free individuals. This allows him to appreciate the independence (perhaps more limited than he believes) of the members in relation to the whole and the exuberance of individual investigations and inventions. He does pick up on the return to twelfth- and thirteenth-century models but does not provide satisfactory explanation for it. According to him, the return to the past was due to the rejection of courtly mannerism; this explanation is not without some merit but does not account for specific choices.

27. The chronology of the construction of the chapel has not been established. It was probably planned some years after the foundation, since its art corresponds to that of the 1520s rather than to that of 1508. It may be therefore that the building of the porch was continuous with the completion of the chapel, as the presence of a very classicizing motif on the interior façade seems to indicate. Hautecoeur, 1965, dates the porch to 1570 and cites Toussaint Chesneau as its author, though provides no further evidence; this is repeated by A. Blunt, 1983, p. 58; Babelon corrected the date to "around 1550 or even later." We were unable to locate Hautecoeur's source. Chesneau's activity is not documented elsewhere, except for the years 1540–42. If Chesneau was indeed the mason, does this imply that he was also the architect? To date, nothing is less certain. According to Babelon, 1989, the "high Renaissance of the East – Pagny, Langres – seems present here, through the intercession of the Cardinal of Givry." The porch of Champigny is indeed not unrelated to the chapel of Amoncourt in Langres cathedral, discussed in Chapter IX. This sophisticated style does not seem to us particular to the east of France, but on the other hand the cardinal may well have played a role in the irruption of this refined classicism at Champigny.

28. Blunt, 1983, p. 58.

29. André Chastel had developed these ideas in detail in his courses at the Collège de France. Something of them passed into the second volume of his posthumous work on French art, which appeared after the writing of the present volume, see Chastel, 1994–96, (English translation by Deke Dusinberre, *French Art*, Paris/New York, Flammarion, 1994–96.) For a slightly different interpretation of the consequences of the first Italian campaign, see Scheller, 1981–82.

30. The principal exception is the major article by Guillaume, 1983.

31. See especially Vitry, 1901.

32. The miniature detached from the manuscript of *Complainte de la Nature à l'alchimiste errant (Nature's Lament to the Errant Alchemist)* was identified by Sharon Off in her master's thesis at

New York University and published by Sterling, 1963. Sterling's attributions on the basis of this miniature are not all equally convincing.

33. On Lannoy and Folleville, see Durand, 1906.

34. The chapel was not simply walled up—it was enlarged by the incorporation of the corresponding bay of the ambulatory. This was possible because the vaults of the ambulatory and the chapel were of the same height. In other words, the original layout was conceived as a continuous and wide-open space, without a marked rupture between the main area of the church and the chapel. On this monument, see the brochure by Mera, 1979, and Valléry-Radot, 1927.

35. For the documents concerning the chronology of this building, see Laborde, 1849, while we await Étienne Hamon's dissertation on Gisors and Flamboyant architecture in the Vexin. Mr. Hamon had the great courtesy to send me the chronology that he was able to establish from a much more complete documentation than that published by Laborde. The most important surprise was to see that the south tower was begun much earlier than was previously thought, around 1540, making it a thoroughly cutting-edge work.

36. This chapter was written before I had the opportunity to read Anne-Marie Sankovitch's thesis (forthcoming). Some of our conclusions are similar, notably concerning the retrospective aspect of the ecclesiastical architecture of the sixteenth century. Sankovitch shows in a convincing fashion that Saint Eustache is a work of great complexity and learning. I remain nevertheless not totally convinced of its aesthetic success.

37. Ibid., Sankovitch convincingly demonstrates that the supports, and in particular their different faces, were designed with the greatest care according to their function. Unfortunately, this intellectual exertion lacks visual effectiveness.

38. It is probably inappropriate to speak of *the* architect of Saint Eustache since there were in all likelihood several. Nevertheless, one feels in the monument, Viollet-le-Duc's comments notwithstanding, a coherent and unified architectural will. It is this erudite and well thought-out aspect of Saint Eustache that Sankovitch brings out so well.

39. It has been proposed to view both Saint Eustache and the north aisle of Pontoise as the work of the same architect. Sankovitch retains this hypothesis. I remain skeptical on this point. On Cravant, see Hautecoeur, 1965, p. 488.

40. Terrasse, 1922.

41. Contract published by Grodecki, 1985–86, no. 203. The original French reads: "Selon le portraict et devys anciennement faict pour lad. esglise Sainct Estienne."

42. The posterior face towards the chevet must have been reworked later, perhaps between 1570–80, when the chancel was decorated. The cherubim heads recall the art of Germain Pilon, who participated in this decoration. See Grodecki, 1985–86, nos. 223–225 and 227.

43. The attribution of this exceptional piece to Philibert proposed by Blunt, 1983, p. 48, has not found support. Perhaps one should not dismiss the possibility of his intervention too hastily.

CHAPTER II

1. Paul Frankl, *Gothic Architecture*, Harmondsworth, Penguin (Pelican History of Art), 1962, p. XV.

2. On the château, see Gébelin, 1927 and 1957; as regards more recent literature, one will profit from consulting Prinz and Kecks, 1985, and especially Babelon (ed.) 1986; Babelon, 1989, presents a much larger body of works than does Gébelin, with an updated bibliography.

3. On this point, see Weiss, 1953, passim; on Gaillon, see the basic monograph by Chirol, 1952, and Chastel and Rosci, 1963.

4. For the building history, see especially Martin-Demézil, 1986. The development of the project and the stages of construction still give rise to numerous debates, which we will not enter into here.

5. Dimier, "Les séjours de François Ier," *Critique et Controverse*, Paris, Jean Schemit, 1909, p. 36. There was one slightly prolonged stay of two weeks, the rest were only stopovers.

6. See in particular Chastel, 1989.

7. This similarity comes across particularly well in du Cerceau's *Les Plus Excellents Bastiments de France*, vol. I, 1576, in which the two monuments follow immediately after one another.

8. The arguments in favor of Leonardo are strongly developed by Guillaume, 1974; Pérouse de Montclos, 1993, puts forward the hypothesis that the similarities between the plate published by Palladio and Leonardo's drawings are not fortuitous, but that the architect had known an abandoned project for Chambord featuring four parallel ramps (instead of two) and occupying the entire central space where the rooms meet.

9. Du Cerceau, 1579. The original reads: "Où il se plaisoit tant, que y voulant aller, il disoit qu'il alloit chez soy."

10. For an overview of the history of the château of Fontainebleau during the Renaissance, one may refer again to Gébelin, 1927; Guillaume has advanced interesting hypotheses concerning a very precocious, large architectural project for the Cour du Cheval Blanc in Béguin, Guillaume, Roy, 1985.

11. Dimier, 1904, pp. 180–181.

12. There is considerable literature on Rosso: the monograph by Kusenberg, 1931, written in the Expressionist atmosphere that presided over the rehabilitation of mannerism, remains more interesting than Barocchi's, 1950; one will find numerous pieces, in particular on the drawings, with a rich bibliography in the catalogue *Rosso Fiorentino: drawings, prints, and decorative arts*, 1987; also to be consulted, most recently, is the very careful monograph by Franklin,

1994, which restricts itself to the Italian period and provides a great deal of new material.

13. Adhémar, 1954.

14. Elam, 1993, pp. 63–64 and 78–79. This careful study should also be referred to for the role of Della Palla.

15. Doubt has been cast on this suicide reported by Vasari. The fact that Rosso was buried in consecrated ground does not account for much, since on many occasions this sort of thing was arranged with the Church. I feel that Vasari, who speaks of Rosso with real affection, would not have accredited this version without cause.

16. On the gallery, the primary work is Béguin, Binenbaum, Chastel, Johnson, Pressouyre, Zerner, 1972; I was not able to use Joukovski, 1992, who arrives at certain conclusions close to mine, though by means of a very different approach.

17. Bondanella, 2002, p. 181; Cellini, 1980, ch. XLI: "Questo si era, come noi diremmo in Toscana, una loggia, o sì veramente uno androne; più presto androne si potrie chiamare perché loggia noi chiamiano quelle stanze che sono aperte da una parte."

18. Laborde, 1877–80, p. 43.

19. The date of the removal of the southern cabinet and the reasons behind it have caused a lot of ink to flow. The construction of the terrace on the south side creating an exterior circulation above ground (which allowed the gallery to be closed) did not require the cabinet to be abandoned, since documents reveal that its masonry still existed at a later date, though walled in on the gallery side. Some have gone so far as to argue that this cabinet was decorated and abandoned very late, even after Rosso's death. As I showed in Chastel (ed.), 1975, pp. 31–34, formal analysis clearly proves that the cabinet had been abandoned when the definitive project for the decoration was finalized. All the hypotheses based on the famous engraving of the *Nymph of Fontainebleau* are fantastical. In fact, absolutely nothing in the documentation allows us to believe that Rosso ever envisioned anything other than a single cabinet in his project for the decoration, no more than he retained the cross walls separating a "chapel" to the east and another "cabinet" to the west.

20. The number of these windows raises many questions. Pressouyre, 1970, pp. 18–19, maintains that the end bays were originally lit only to the south, as du Cerceau's engraved elevation presents only seven windows to the north. This hypothesis poses a serious problem, that is, how these blind bays would have appeared in the gallery. It would be important to see whether the stuccos on the east end of the north wall are original. I wonder if it was not du Cerceau who made an error. Pressouyre correctly notes that in the relief by d'Orbay, the exterior elevation of the southern façade shows the last bay blind, with a decorative niche in place of a window. This blinding is rather strange; perhaps it was linked to the alteration of the corresponding north bay for the opening of the Louis XIV staircase?

21. Cited after Johnson, 1972, p. 53. The expression "as before I have rehersed" refers to an earlier passage in the letter in which the ambassador reports a conversation with François I, who asked about Henry VIII's buildings: whereas the latter used much gilding, especially on ceilings, François I preferred the interplay of colored woods. "Modon" denotes Niccolo da Modena, an artist who had worked in the gallery under Rosso and then passed into the service of Henry VIII before the work was finished, and adapted the art of Fontainebleau in England. On this subject, see Béguin, 1970.

22. For this discovery at the National Gallery of Luxembourg, see Béguin, 1989. She rightly insists on the importance such a work must have had for Primaticcio. Besides, the appreciation expressed by Vasari, who had not seen the work himself, was almost surely the echo of what Primaticcio had reported to him.

23. Rosso's project for the gallery was more or less contemporary with the construction of the new kitchens along the southern side of the wing of the gallery surmounted by a terrace providing for circulation. It is ambassador Wallop who informs us that the gallery was locked (Johnson, 1972).

24. This is, in any case, what one may suppose from the text of Benvenuto Cellini's autobiography, in which he sets the presentation of his silver *Jupiter* in the gallery. On the value of this text, see Chapter III.

25. See on this subject André Chastel's observations in Béguin, Binenbaum, Chastel, Johnson, Pressouyre, Zerner, 1972, p. 146; unfortunately, his scheme of the distribution of painting and stucco, while correct for the cartouches, is in error with regard to the side sections.

26. The diagrams translate as:
King's cabinet. Chimneypiece.
IN Venus Frustrated
IS Battle of the Centaurs
II N Education of Achilles
II S Perpetual Youth
III N Shipwreck
III S Death of Adonis
IV N Semele (in the north cabinet) and bust of the king above the entrance to the cabinet
IV S Danae
V N Burning of Catania
V S Cleobis and Biton
VI N Elephant
VI S Unity of the State
VII N Sacrifice
VII S Ignorance Dispelled
W Venus and Cupid
E Venus and Bacchus
Upper case letters refer to the technique of the lateral panels: HR=Haut-relief (high relief) stucco; BR= Bas-relief (low relief) stucco; NP=Natural painting. Lower case letters refer to the lower cartouche: p=painting; s=stucco.

27. According to the restoration report, it is likely that this is a remnant of the encaustic painting of the nineteenth century, but I think that the invention was indeed Rosso's. Nineteenth-century restorers almost always had sufficient remains to guide their work.

28. One sees a false mosaic background between the frame and the garlands, which breaks with the system, since it is a matter of the surface of a painting. I do not know if this was an error on the part of the restorers or of those who originally executed it.

29. Chastel, in Béguin, Binenbaum, Chastel, Johnson, Pressouyre, Zerner, 1972, pp. 151–152, has suggested a connection between the specific form of the salamander and the theme of each compartment.

30. Address at the Tenth International Congress on Art History in Rome in 1912, "Italienische Kunst und internationale Astrologie im Palazzo Schifanoia zu Ferrara," *Atti del X congresso internazionale di storia dell'arte in Roma. L'Italia e l'arte straniera*, Rome, 1922, reprinted in *Gesammelte Schriften*, Leipzig/Berlin, B. G. Teubner, 1932.

31. The classic source is in Pliny's *Natural History* (36.35.85–87).

32. In order to facilitate the location of the subjects in the gallery, I have used references to the schema of the gallery in which the bays are numbered from east to west. Thus, I N refers to the first compartment on the north side. One will note that in Béguin, Binenbaum, Chastel, Johnson, Pressouyre, Zerner, 1972, p. 26, the schema is incorrect (the fresco of the *Nymph* has a number but does not appear on the list, which throws everything out of line).

33. Terrasse, 1949.

34. Panofsky, 1958.

35. Pressouyre, 1970, pp. 126–128, wants to view the figure carrying the old woman in the fresco as a woman and consequently, she returns to the interpretation of abbé Guilbert, who recognized the latter as Creusa. But in Virgil's story, Creusa was taken away by Aphrodite before the departure of Aeneas. It is true that no child is mentioned in the story of Catania while that of Aeneas's flight mentions his son Ascanius, who would be the child clutching his father's leg. Yet we are not aware of any other child of Aeneas and Creusa at the time of the flight, and the child saving his dog, which should probably be viewed as a humorous rather than a sentimental detail, seems just as important as the other. The presence of three successive generations is certainly what Rosso wanted to convey in the composition's central group.

36. Shearman, 1980.

37. Dan, 1642, pp. 93–94.

38. "There is no strict chronological sequence in the events alluded to, and we have little doubt that the whole scheme retained a certain flexibility even while work was going on so as to permit last-minute substitutions if something important occurred in the life of the king. The whole Gallery is, as it were,

a running commentary rather than the realization of a pre-established blueprint . . ." Panofsky, 1958, p.159.

39. Béguin, Binenbaum, Chastel, Johnson, Pressouyre, Zerner, 1972.

40. Chastel, 1968, pp. 186–188.

41. Not only could Rosso hardly have been unaware of this famous ensemble during his stay in Rome, but the fake gold mosaic background of the gallery was in all likelihood inspired by the precedent on the ceiling of the Segnatura.

42. In his treatment of the "monarchic program," he was certainly correct to construct two principal groups separated by the center of the gallery. He discovered a series of themes that, when read from west to east, give the sequence *Sacra-Imperium-Pietas/Infelices casus-Juventus perpetua-Bellum (Mars antistes Veneris)*. Chastel, in Béguin, Binenbaum, Chastel, Johnson, Pressouyre, Zerner, 1972, pp. 147–148, takes the precaution of stressing that these rubrics are suggested "in abeyance" and in an entirely hypothetical fashion, but the Latin names give the hypothesis a period flavor and an air of authenticity that risks promoting too much confidence.

43. It is a disconcerting fact that we have retained no original drawing by Rosso for the Galerie François I, although there must have been a great number of them. One of the chief merits of the work of Eugene Carroll is to have drawn attention to the documentary value of the copies in the absence of the originals. See most recently the catalogue *Rosso Fiorentino*, 1987, passim.

44. For an etching that probably reproduces a preparatory drawing by Rosso, see Zerner, 1988.

45. Shearman, 1980.

46. On the connections between text and image in the French Renaissance, one should refer to the authoritative piece by Marie-Madeleine Fontaine in the catalogue *La Gravure française à la Renaissance*, 1995, pp. 59–77.

47. See especially the very lucid exposé by Lecoq, 1975.

48. See Johnson, 1972, in which Wallop's text is reprinted pp. 52–54.

49. Cited after Marguerite d'Angoulème, in Génin (ed.), 1841, p. 382. The original French reads: "Je m'en voys devers vous pour obéir à tous les commandemens qu'il vous plaira me faire, et feusse plus toust partie, n'eust esté la grant envie que j'avois de veoir Chambort, que j'ay trouvé tel que nul n'est digne de le louer que celuy qui l'a faict, qui, par ses oeuvres parfaictes, faict admirer sa perfection. Vous merciant très humblement, Monseigneur, de ce qu'il vous plaist, qu j'aye ma part [en] la veue de Fontainebleau, ce que l'avois bien deslibéré, encores que vous eussiés faict votre Nouël à Paris. Mais je loue Dieu dont vous y demeurés jusques là, car voir vos édifices sans vous, c'est ung corps mort, et regarder vos bastiments sans ouïr sur cela votre intencion, c'est lire en esbreu." The letter, autographic according to the editor, is not dated; for circumstantial reasons, the editor has proposed the

date of 1542. The letter is cited by Vickers in the catalogue *La Gravure française à la Renaissance*, 1995, pp. 95 and 105. Catherine Wilkinson-Zerner had drawn my attention to this extraordinary text some time ago but I did not see its full importance at the time.

50. See Béguin's analysis in Béguin, Binenbaum, Chastel, Johnson, Pressouyre, Zerner, 1972, p. 167.

51. This last identification discovered by Lövgren is based on the fact that in his *Metamorphoses*, Ovid associates the story of the death of Adonis with the metamorphosis of Hippomenes and Atalanta. For the exegesis of this compartment, see Béguin, Binenbaum, Chastel, Johnson, Pressouyre, Zerner, 1972, pp. 130–131.

52. His 1731 text is cited in Béguin, Binenbaum, Chastel, Johnson, Pressouyre, Zerner, 1972, p. 131.

53. The state of conservation is generally considered to be excellent. Nevertheless Jestaz, 1973, believed he could establish that important pieces had been entirely rewoven. It is certain that the hanging was carefully restored at the end of the seventeenth century. Since its publication (after the exhibition of the school of Fontainebleau), I was able to examine the piece in Washington; the disparities within the tapestries indicated by Jestaz did not seem so obvious to me; Gruber, 1995, gives the results of a meticulous examination of the hanging, which confirms its satisfactory state. No important pieces were rewoven and the freshness of the colors, which are very vivid, is authentic. In fact, it is the parts in gray, which correspond to the stuccos, that are most damaged because of the fragility of light colored silks.

54. Dimier, 1921.

55. A sufficient amount of the original woodwork remains to allow us to affirm that what is in place corresponds to the definitive execution. On the other hand, it is uncertain whether the cornice represented in the tapestry was invented for this purpose or taken from one of Rosso's earlier projects that was later abandoned, perhaps because of delays in the execution? We do know that the paneling originally planned was much more sumptuous that what was put in place and required rare woods. This initial project was abandoned in order to move things along. It seems more likely, however, that the version of the paneling represented in the tapestry was invented specifically for this purpose.

56. Pressouyre in Béguin, Binenbaum, Chastel, Johnson, Pressouyre, Zerner, 1972, p. 108, related this tendency to the aesthetic of the tapestry. This is possible, yet it is not necessary, as she did, to resort to the intervention of the tapestry weavers, who were content to follow the cartoons as exactly as possible.

57. Jestaz, 1973, is correct to reject the idea that the tapestries were intended for François I himself and it is not unlikely that they had been intended for the emperor Charles V when he passed through Fontainebleau. I strongly doubt, on the other hand, that they were actually delivered to the emperor in

1544, much less in 1542, dates at which their production was probably not yet finished. Subsequently, relations between the two princes were too poor. Besides, it seems unlikely that François I would have sent the emperor a work that was clearly unfinished. It may be, as Carroll suggests (cat. *Rosso Fiorentino*, 1987, p. 246), that work had been interrupted by the death of François I; Gruber, 1995, also rejects the hypothesis that the tapestries were sent to the emperor Charles V and suggests that they arrived at Vienna under Charles IX, yet without presenting a decisive argument. The date and the occasion of the transfer to Vienna remain uncertain.

58. Grodecki, 1978, p. 215.

59. Much of this material is found in the catalogue *Rosso Fiorentino*, 1987.

60. On the iconography of these paintings, see Jean-Claude Lebensztejn, *Pontormo*, Paris, Aldine, 1992.

61. The drawing is analyzed in Béguin, 1989.

62. The Panofskys, 1958, suggested that this composition was an initial project intended for the panel of *Ignorance Dispelled* in the Galerie François I, whether in place of the principal fresco or as a related subject; –Carroll (cat. *Rosso Fiorentino*, 1987), then Brugerolles in the catalogue *Le Dessin en France*, 1994, (English translation by Judith Schub, *The Renaissance in France: Drawings from the Ecole des Beaux-Arts, Paris*, Cambridge, Harvard University Art Museums, 1995) clearly saw the rashness of this hypothesis despite the iconographic connection.

63. Grodecki, in Chastel (ed.), 1975, pp. 99–115.

64. Cited by Franklin, 1994, 268.

CHAPTER III

1. Quotations will be taken from the the English translation of the autobiography of Benvenuto Cellini by Bondanella, 2002, with the Italian text from Cellini, 1980, provided in the notes. His stay in France, beginning with the first aborted trip to Lyon, occupy the first fifty chapters of the second book of the *Vita*; on Cellini, see the excellently illustrated monograph by Pope-Hennessy, 1985. The author's thesis, according to which one should trust Cellini on all that is factual (except where proof to the contrary exists), is original but dangerous.

2. Bondanella, 2002, pp. 282–283; Cellini, 1980, ch. XLI: "Questo si era un vello sottilissimo; che io avevo messo con bella grazia addosso al dito Giove, perché gli accrescessi maestà: il quale a quelle parole io lo presi, alzandolo per di sotto, scoprendo quei bei membri genitali, e con un poco di dimostrata istizzia tutto lo stracciai. Lei penso che io gli avessi scoperto quelle partye per proprio ischerno."

3. Dimier, 1900, p. 69; *Id*. "Une pièce inédite sur le séjour de B. Cellini à la cour de France," *Revue archéologique*, 1902, pp. 85–95. Alvarotti's letter from Melun is dated January 29, 1545, placing the presentation of the *Jupiter* slightly before this date.

4. Grodecki, 1971, published a whole group of documents on Cellini's stay in France. They shed light on, among other things, the elaborate finishing work on the bronze cast of the *Nymph*, executed mostly by Frenchmen, notably Bontemps; Pressouyre, in Grodecki, 1971, contributes important further details on the conservation of the work. A well-finished drawing of the *Satyr* is either a presentation drawing or a *ricordo*; Pope-Hennessy, 1985, also reproduces a bronze in the Getty Museum that may be a rather late cast after a model.

5. Bondanella, 2002, p. 286; Cellini, 1980, ch. XLIV: "Gli è pure grandissima cosa, Benvenuto, che voi altri, se bene voi sete virtuosi, doverresti cognoscere, che qualle tal virtù da per voi non le potete mostrare; e solo vi dimostrate grandi mediante le occasione che voi ricevete da noi. Ora voi doverresti essere un poco piu ubbidienti, e non tanto superbi e di vostro capo. Io mi ricordo avervi comandato espressamente, che voi me facessi dodici statue d'argento; e quello era tutto il mio desiderio. Voi mi avete voluto fare una salira, e vasi e teste e porte, e tante altre cose, che io sono molto smarrito, veduto lasciati in dietro tutti i desideri delle mie voglie, e atteso a compiacere a tutte le voglie vostre."

6. See Laborde, 1877–1880, II, p. 329. In order to give us an idea of its dimensions, Cellini recounts moreover that the mistress of one of his apprentices lived inside the head, thus suggesting the presence of a phantom. The "great colossus" being "made of plaster stone," this story hardly seems believable.

7. A statue of Mars is indeed mentioned in the contract between Cellini and the founders Gilles Jourdain and Pierre Villan for the bronzes of the Porte Dorée, published in Grodecki, 1971.

8. Bondanella, 2002, pp. 268–269; Cellini, 1980, ch. XXXI: "Io sentitomi a questo modo offeso e a così gran torto, e veduto tormi un'opera la qualle m'avevo guadagnata con la mia gran fatiche, dispostomi di far qualche gran cosa di momento con l'arme, difilato me n'andai a trovare il Bologna. Trova'lo in camera sua, e inne' sua studii: fecemi chiamare dentro, e con certe sue lombardesche raccoglienze mi disse qual buona faccenda mi aveva condotto quivi. Allora io dissi: – Una faccenda bonissima e grande. Quest'uomo commesse ai sua servitori che portassino da bere, e disse: – Prima che noi ragioniamo di nulla, voglio che noi beviamo insieme; così e il costume di Francia."

9. Bondanella, 2002, p. 270; Cellini, 1980, ch. XXXII: "La qualle [faccenda delle monete] noi non fumo molto d'accordo; perché essendo quivi il suo consiglio, lo persuadevano che le monete si dovessin fare in quella maniera di Francia, sì come le séran fatte insino a quel tempo. Ai quali risposi, che Sua Maestà m'aveva fatto venire della Italia perché io gli facessi delle opere che stessin bene; e se sua Maestà mi comandassi al contrario, a me non comporteria l'animo mai di farle."

10. He was the architect of the Villa Farnesina and the Palazzo Massimi alle Colonne in Rome and was for a time the architect of Saint Peter's. The literature on Peruzzi is now considerable. As a painter and draftsman, his personality has been defined particularly by Philip Pouncey and John Gere, *Raphael and his Circle*, London, British Museum, 1962; on his role as an architect, one should refer to the various works of Christoph Frommel and Howard Burns.

11. Henri Zerner, in Guillaume (ed.), 1988, p. 282.

12. He worked at the end of his life on Books VI and VII, which treat respectively dwelling places and accidents, the plates of which he had time to prepare and have the woodblocks engraved in Venice. In 1551, he sold all this material to Jacopo Strada who did not publish Book VII until 1575, long after the architect's death, and left Book VI unpublished. The book on the military architecture of the Romans appeared as the eighth book, but it was a separate work that was not part of Serlio's original plan. Similarly, the collection of copperplate engravings, representing doors, published at Lyon in 1551 with a short introduction under the title of *Libro extraordinario*, was inserted into the posthumous editions as the sixth book, but this was only a ruse and the original title clearly indicates that this collection of models was not part of the treatise.

13. The drawing of the elevation bears on the reverse an annotation in Serlio's hand: "Con piu maturo consiglio jo lodo si faccia questa colonna piana di ordine Dorico: et sopra essa sia una fascia che rinciga tutta lopera," with a corrected detail of the elevation that corresponds well to the textual indication. Boudon and Hamon, in Chastel (ed.), 1966, believed that Serlio had been consulted on the drawing of another artist, perhaps Philibert de l'Orme. The manner of drawing conforms completely to that of the manuscript of Serlio's Book VI kept in New York and it seems to me that the drawing is by Serlio himself, the formula "con piu maturo consiglio" being better understood as a correction to his own project rather than an opinion on the work of another. This was also the opinion of François-Charles James in his address at the Serlio colloquium at Vicenza, which he did not publish in Thoenes (ed.), 1989. Having said that, it is not impossible that de l'Orme also furnished a project and that it was taken into consideration in the final execution of which some fragments remain in place.

14. Babelon, 1978.

15. This comes across from a piece of correspondence discovered by François-Charles James, presented at the Serlio colloquium at Vicenza, 1989, but not published in the acts, Thoenes (ed.), 1989. Since the original publication of this book, James has abandoned the identification of the church at Varzy; on this issue see Sabine Frommel, *Sebatiano Serlio*, Paris, Gallimard, 2002, p. 322 and p. 332 note 23.

16. These drawings constituted the starting point for Dimier's monograph of 1900, which remains the basic

work on the artist. Despite many corrections and additions, the catalogue he drew up has not been replaced. His 1928 monograph—illustrated and featuring a few new pieces—did not replace his 1900 thesis as a tool for research. One will find the most important supplements in Béguin, 1982.

17. Vasari, *Le Vite*, Milan, Rizzoli, 1971, p. 485 (author's translation).

18. Johnson, 1969, deserves credit for having reexamined the status of this drawing. F. Hartt's hypothesis (Hartt, 1958), according to which it would have been a project for the decoration of the stables of the Palazzo del Te, has now been abandoned.

19. See the outstanding clarification by Sylvie Béguin in Chastel (ed.), 1975, pp. 199–230.

20. Dimier, 1900, pp. 326–327. See most recently the stylistic distinctions within the stuccos proposed by Oberhuber in the catalogue *Giulio Romano*, 1989, p. 365.

21. Wardropper, 1983 and 1991.

22. The attribution to Primaticcio is due to Briganti in 1945, although the painting was recorded at the Hermitage under the name of Pellegrino Tibaldi. It was presented at the exhibition of *L'École de Fontainebleau* in 1972 (Sylvie Béguin's catalogue entry), and the name of Primaticcio was then almost unanimously agreed upon, though Anthony Blunt retained the attribution to Tibaldi (oral communication with the author). It seems to me that the comparison with the *Mystic Marriage of Saint Catherine* engraved by Giorgio Ghisi after Primaticcio reinforces Briganti's attribution.

23. Dimier, 1928, p. 98, also attributes to Primaticcio's hand the *Fainting Spell of Esther*, then at Wilton House and today in Providence, at the Museum of Art, Rhode Island School of Design. This painting had been entirely repainted—apparently by Reynolds—and was stripped by the restorers; so little remains that judgment is impossible.

24. No commissions for paintings are known. The old inventories rarely mention easel paintings by Primaticcio, and when they do, the works are known—they are paintings showing the influence of the artist but are definitely not by him, such as the Pseudo-*Justice of Otho* in the Louvre, today attributed to Luca Penni.

25. As for the portrait of the bishop of Auxerre, Dimier, 1928, p. 87, Primaticcio writes: "I took down in drawing his portrait for milord the cardinal of Guise, and colored it with my own hand, knowing that you will find it less deficient than the first." "I colored it" may mean made a painting from a drawing, but it could just as well concern the coloring of a drawing, perhaps with watercolors. In the next chapter we will examine the attribution, proposed by Charles Sterling, of a portrait representing the brother of the bishop.

26. Wardropper, 1983, also suggested the importance of a trip by Primaticcio to Italy in 1550–51, but we do not know if this trip took him beyond Milan and Ferrara.

27. On this work see Béguin, Guillaume, Roy, 1988, and Mignot, 1988.

28. See Théodore van Thulden, *Les Travaux d' Ulysse peints à Fontainebleau par le Primatice*, Paris, 1633.

29. Jestaz, 1963, was the first to discover documents confirming the presence of Primaticcio in Rome. We cannot, however, agree with the author when he suggests that the painter stayed in Rome continuously in the early 1540s.

30. Zerner, 1969, Fantuzzi 84–111 and Master L.D. (Léon Davent) 17–19. [English translation by Stanley Baron, *The School of Fontainebleau: Etchings and Engravings*, New York, Abrams, 1969.]

31. On the Fontainebleau casts, see Pressouyre, 1969; on the originality and importance of the enterprise, see Haskell, Penny, 1981, pp. 1–6.

32. The questionable identification of the subject of *Rebecca and Eliezer* is discussed by Boorsch in the catalogue *La Gravure française à la Renaissance*, 1995, no. 47; one should probably see reflections of Primaticcio's decorations in the prints of Davent, nos. 12, 13, 14, 15, 16, 38, 43, 44, 45, 48, 49, 59, 66 in Zerner, 1969.

33. Dimier, 1900, p. 333, with reference to Laborde, 1877–80, I, p. 204.

34. See Béguin's entry in the catalogue *L'École de Fontainebleau*, 1972, no. 154; Scailliérez, 1992, draws a parallel to the exterior decoration of the château of Saint Maur described by de l'Orme (1567, p. 250), in which one finds a bust of François I with Diana, the nine Muses and the three Graces. Primaticcio's collaboration at a château built for Cardinal du Bellay would be as interesting as it is unexpected. It is nevertheless hardly possible to identify, as Scailliérez suggests, the Saint Petersburg drawing with a project for Saint Maur; if one does recognize Diana and the Muses, the three other figures do not seem to represent the Graces; and while this detail would not be insurmountable, the arrangement described by de l'Orme is entirely different from that seen in the drawing: though the bronze bust of the king does indeed occupy the pediment, the other figures in bas relief are not grouped around the bust, but on a separate rectangular table below the pediment. The iconographic coincidence remains suggestive.

35. If Dimier, 1900, pp. 309–310, does not have much trouble demolishing the thesis of Palustre, 1879–85, vol. I, p. 221, who wanted to view the construction of the grotto and its exterior decoration as prior to the arrival of the Italians at Fontainebleau and consequently the work of a French mason, the attribution of the façade to Primaticcio has not always been accepted and some have preferred to view it as the work of Serlio (as M. N. Rosenfeld does in Serlio, 1978). It seems to me that Léon Davent's etching (Zerner, 1969, L.D. 60) reflects a drawing by Primaticcio (who was certainly in charge of the interior decoration). Kühbacher, 1989, also stressed the close connection to the *rustica* of the ducal palace

of Mantua by Giulio Romano and does not hesitate to identify Primaticcio as the author.

36. Ancy-le-Franc is one example among many of mural decorations (see Regond, 1983, for examples in Auvergne). The grotesques were widely diffused by prints. Jacques Androuet du Cerceau, especially, published several series of them, but also Domenico del Barbiere, Marc Duval, and Delaune, who adapted them to the metallic arts.

37. Ronsard, *Livret des folastries*, 1533, see the edition by Laumonier, vol. V, Paris, Hachette, 1928, pp. 53–76.

CHAPTER IV

1. I respond here to Jean Adhémar's criticism: "Zerner seems not to realize that there were two schools of Fontainebleau, the one he studies, and another to be placed around 1550–60, which developed in Paris and Orleans (the large city of the Loire valley, where the Estates-General would take place in October-December 1560)." Adhémar, 1969, p. 118. (My translation).

2. Dimier, 1905, p. 30, cited by Béguin in the catalogue *L'École de Fontainebleau*, 1972, p. XXXVII.

3. One is in the Metropolitan Museum in New York, the other in a private collection. On the first, see Charles Sterling, *A Catalogue of French Paintings XVth-XVIIth Centuries*, New York, Metropolitan Museum of Art, 1955, pp. 50–51. The painting once in the Seillière collection was published by Barbet de Jouy, *Gazette des Beaux-Arts*, 1861, II, pp. 7–12.

4. The principal regrouping was done by Béguin, 1961.

5. I discussed this subject previously in Zerner, 1972.

6. Sylvie Béguin studied the history of the term in the catalogue *L'École de Fontainebleau*, 1972, pp. XXIX–XXXIX.

7. On the question in general see Zerner, 1964 and 1969. The conclusions are accepted by Boorsch in the catalogue *La Gravure française à la Renaissance*, 1995, which contributes additional information.

8. Jestaz, 1993, asserts in a peremptory fashion that stylistically the Italians of Fontainebleau did not take into account any of the local art whatsoever. This radical position seems to me to rest on a very disputable ontology of style and greatly to underestimate the outside pressures and constraints necessarily exerted on artistic production.

9. Boorsch, in the catalogue *La Gravure française à la Renaissance*, 1995, pp. 82–84 and 232–235, is particularly interested in this artist. She proposes identifying him with Jean Viset, present at Fontainebleau in 1536 according to an archival document that makes him the brother-in-law of Noël Garnier, designated in the document as a painter and known today from his engravings. It would be tempting then to view him as the initiator of the group since he was designated as an engraver at Fontainebleau as early as 1536, but this seems unlikely to me: the formula "present at Fontainebleau" implies that he was passing through and that he resided in Fontenay-le-Comte (it was he who inherited his late father's house in that city); Viset was the brother-in-law of a very conservative artist, judging by his prints, and he belonged to an artisanal milieu of goldsmiths. It is not impossible that his designation as a "*tailleur d'histoire en cuivre*," a rarely used formulation, refers to the engraving of copper plates for impression in relief, a rather common technique in book illustration. Jean Adhémar has suggested Jean Vaquet, who is found employed at Fontainebleau in the records. This identification is unverifiable given the current state of our knowledge. Boorsch judiciously noted that the sign ♀ in the monogram was the symbol not only of Venus, but also of copper, which may explain its presence on these plates.

10. For all aspects concerning Domenico del Barbiere, see Wardropper, 1985.

11. On this question, see most recently David Landau and Peter Parshall, *The Renaissance Print*, New Haven/London, Yale, 1994, with an excellent bibliography.

12. On this subject, see the very accurate analysis of Carroll in the catalogue *Rosso Fiorentino*, 1987.

13. The relation between the three forms of ornamentation is maintained by Berliner, 1925–26; on the "Floris style," one should refer to Schéle, 1965.

14. To this day there is no monograph on Thiry, but over the years he has been accredited with many drawings attributed either to Rosso or to Boyvin. A satisfactory regrouping is proposed in the entries on the drawings studied by Brugerolles in the catalogue *Le Dessin en France au XVIe siècle*, 1994, pp. 92–129. (English translation by Judith Schub, *The Renaissance in France: Drawings from the École des Beaux-Arts, Paris*, Cambridge, Harvard University Art Museums, 1995, pp. 92–129.)

15. See Béguin, 1969, and Grodecki, 1989.

16. Béguin, 1969, published a drawing from the Victoria and Albert Museum that corresponds rather precisely to Fantuzzi's etching, and indeed seems to be by the hand of Leonard Thiry, whose name it bears in the same ancient calligraphy as several others. It seems to me to be a copy of a drawing by Rosso.

17. Boorsch, Lewis, 1985.

18. See Béguin, 1987, and Grodecki, 1987; in her study of the series of *Vices* engraved by Léon Davent, Wilson-Chevalier, 1996, has shown how Penni adapted himself to an urban bourgeois public by taking inspiration from S. Brandt's *Ship of Fools*.

19. Béguin, 1987, suggested attributing to him a *Deposition of Christ*, a slate painting kept at Auxerre cathedral. I am not completely convinced. The connection that she establishes with a drawing that seems to be by Penni is certainly correct, but there are also considerable differences between the two works, and this connection does not necessarily mean the painting should be attributed to the same artist. The painting is much more reminiscent of Andrea del Sarto than anything else we know by Penni.

20. Attributed and published by Béguin, 1975; Béguin, 1987, proposed a new series of attributions that do not seem entirely convincing.

21. See most recently the catalogue *La Gravure française à la Renaissance*, 1995, no. 87 (entry by David Acton).

22. Sterling, cat. *Le Triomphe du maniérisme européen*, 1955, no. 101, pp. 86–87. According to the entry, the execution "was probably entrusted to a close collaborator, an excellent painter."

23. Dimier, 1900, viewed this as François I in the form of Mars, but it seems instead to be related to the figure of Julius Caesar that was painted in pendant to the allegory of Strength on the doors of the armoires of the king's cabinet at Fontainebleau. See Scailliérez, 1992, no. 8.

24. Béguin, 1961.

25. Shearman, 1966.

26. See Guillaume in Chastel (ed.), 1975, and by the same *Le Galerie du grand écuyer: l'histoire de Troie au château d'Oiron*, Chauray, Éditions Patrimoines, 1996.

27. See Lecoq in Chastel (ed.), 1975, pp. 161–173.

28. On Caron, the essential works are catalogued and reproduced in Ehrmann, 1986; on the Beauvais museum's *Resurrection*, which Ehrmann rejects, see Béguin, 1964.

CHAPTER V

1. In the eighteenth century the building was described as *"le portrait du caractère de la Nation"* by Lafont de Saint Yenne, *L'ombre du grand Colbert*, (1749) 2nd ed. 1752, p.5, cited by Pérouse de Montclos, 1982, p.238.

2. Pérouse de Montclos, 1982.

3. The bibliography is considerable. Beyond what is to be found in the copies of the accounts published by Laborde, 1877–80, the essential documents are to be found in Aulanier, 1951 and Grodecki, 1984.

4. Sauval, 1724, vol. 2, p. 16

5. On this subject, see the remarks of Chastel, 1967. He was not apprised of Lowry's (unpublished) thesis of 1956.

6. Lowry (1956, chap. 5) has conclusively shown that the manuscript project at the Avery Library in New York is specifically adapted to the Louvre site.

7. This is the hypothesis offered by Lowry, 1956. He provides an analysis of the Destailleurs plans that is both brilliant and punctilious. His work remains of great value, but the demonstration is insufficient to support the claim that there was a "grand scheme" during the reign of Henri II. It is true that some seventeenth century texts imply this, but their authority does not necessarily weigh heavily enough to prove the theory.

8. Gébelin, 1923, p. 191.

9. Myra Nan Rosenfeld, "The Royal Buildings Administration from Charles V to Louis XIV," in *The Architect: Chapters in the History of the Profession*, Spiro Kostoff ed., Oxford University Press, 1977, p.161–179.

10. Du Colombier, 1934.

11. As early as 1975, Laure Beaumont-Maillet, *Le Grand Couvent des Cordeliers de Paris*, Paris Champion, 1975, p. 268–271, concluded that this drawing did not represent the *jubé* at the Cordeliers, but did not forward an opinion as to its veritable nature. I gave a talk at the *Société d'Histoire Française* in 1983 where I presented my position on the drawing and the conclusions it led to regarding the relationship between Goujon and Lescot. Since then, Perouse de Montclos, 1989, p.94, has published the drawing as representing the *jubé* at Saint Germain-l'Auxerrois, having independently arrived at a similar conclusion. Brugerolles, in cat. *Le Dessin en France*, 1994, no. 71, who seems not to have known either my paper, or Perouse de Montclos's book, also arrived at the same conclusion. She believes she can date the drawing between 1550 and 1580 based on the paper (a plausible date, though the argument is a bit thin, since the watermarks of paper from Troyes were very similar for a long time). This would exclude the possibility of its being a project drawing. However, in this case the deviations with respect to the actual monument are difficult to explain. We cannot exclude the possibility that it is the copy of a project.

12. Mr. Jean-Claude Boyer has published this drawing: "Un dessin retrouvé du jubé de Saint Germain-l'Auxerrois," *Gazette des Beaux-Arts*, October 2002, pp. 195–98.

13. The account is given in full in Laborde, 1877–80, p. 275–290; Laborde, 1850, gives a very approximate quotation from the first payment to Goujon, and mistakenly cites the date as 1542 instead of 1544, hence Hautecoeur's error.

14. Le Fèvre de la Boderie, in *La Gaillade*, 1578, mentions the decoration of the Louvre and the Vitruvius illustrations in his paltry verses.
[…]Et toy Goujon encores,
Qui de rares pourtraits ce bel Autheur decores,
Et decores aussi par ton nom decoré
Nostre terroir du North en cest art honoré,
Toujours tesmoignera du Louvre la fabrique
De combien ton ciseau fut heureux en pratique;
Ensemble tesmoignant de quel esprit garny
Fut l'honneur de Paris, le docte de Clagny,
Celuy qui a conçeu au rond de sa cervelle
L'Idée, et le dessin d'une fabrique telle.
(Text from the 1582 edition, as reproduced in the critical edition edited by François Roudaut, Paris, Klincksieck, 1993, p. 337).
The second-rate poet underlines the contrast between Goujon's chisel and Lescot's brains, the executant and the designer; Blaise de Vigenère who refers to Goujon as "Clagny's right [hand]" already gives a great deal of credit to the sculptor. He is also the first to name him as the author of the Fontaine des Innocents which was, he says, "by the hand and direction" of Goujon;

this would imply that he was also the architect, but du Colombier, 1949, p. 54, perspicaciously pointed out that Vigenère uses the same terms in referring to Saint Germain.

15. Du Colombier, 1948, p. 22.

16. This date is provided by A. Deville, *Les Tombeaux,* 1833, p. 125. He writes (my translation): "It is established that it had been finished in 1544, as a manuscript in Rouen from that date transcribes the tomb's inscriptions." Since I am unacquainted with the manuscript I cannot judge its validity, but the date is perfectly plausible.

17. It is worth mentioning the remarkable similarity between this lost figure from the Brézé tomb and the three-quarter figure from the monument of the canon Yver at Notre Dame de Paris representing Yver rising from the dead. The monument is reproduced by Cohen, 1973, pl. 19.

18. On this important work and its history, see the excellent assessment by Jean-Pierre Willesme, 1979.

19. Ibid., pp. 47–50.

20. Du Colombier, 1949, p. 157, no. 507.

21. See Michèle Beaulieu in cat. *L'école de Fontainebleau,* 1972, no. 507.

22. Willesme's affirmation that nothing is known of Berton during the ten years between 1546 (when he is consulted by the *marguillers* at Villiers-le-Bel) and 1555 (when he appears in the *Comptes* published by Laborde) should be disregarded. He thought this because the Louvre appears in these incomplete extracts only after 1555, but the construction documents without exception associate Pierre de Saint Quentin and Guillaume Guillain from the beginning of the work.

23. On the subject of this anecdote see, most recently, Johnson, Graham, 1968, p. 7–17. The story does not first appear in the *Élégie* by Ronsard, but in a Latin poem in homage to the poet included in the fourth part of the *Odes,* published in 1555. We find it again with slight changes in the two editions of *La Vie de P. de Ronsard* by Claude Binet, printed in 1586 and 1597. It seems to me somewhat futile to attempt as they do (p. 11) to date a conversation that is in all probability fictional. In any case it is perfectly implausible for this homage to Ronsard to have actually been part of the iconography intended for the façade of the Louvre, all the more so because the program must have been formulated, for the ground floor in any case, before Ronsard's reputation was well established. This is significant because the example helps in understanding the attitude of the time towards iconographical interpretation.

24. According to a document dated June 8, 1547 mentioned in Campardon, Tuetey, 1906, no. 2446. Another brother, Leon Lescot seigneur de Lissy, was councillor in the Parliament in Paris and *marguiller* (parish official) at Saint Germain-l'Auxerrois, suggesting that he had something to do with the commission of the *jubé.* He built the Château de Lissy in 1540. See Grodecki, 1985–86, no. 123.

25. Bodin mentions a canvas by Lescot at Fontainebleau in his *Réponse de Jean Bodin d M. de Malestroit* (1568). Paris, Armand Colin, p. 19 and pp. 96–97.

26. The attribution of the château at Vallery to Lescot had been long suggested, and supported by Pierre du Colombier (du Colombier 1937) and Louis Hautecoeur (Hautecoeur 1965, pp. 278–280). However, Gébelin's authoritative opinion (Gébelin, 1927) which was, oddly, in favor of Philibert de l'Orme, kept the debate open for a long time. Samaran, 1921, suggested the name of Primaticcio, whom a letter indicates as having been called down to Vallery for a day regarding masonry; but it was almost certainly only a momentary involvement. Although the documents published by Grodecki concern only the garden and not the palace *per se,* there is little doubt as to Lescot's role as architect of the château. For a biography of the Maréchal de Saint Andre, see Lucien Romier, *Un favori, Jacques d'Albon de Saint-André, maréchal de France,* Paris, Perrin, 1909.

27. This is what we see on the remaining wing. A drawing by Henri Sengre made for the prince of Condé in 1682 is reproduced in du Colombier, 1937 and in Planchenault, 1963. There seem to have been no important additions between the construction date and the drawing by Sengres. The plates in du Cerceau do not show any difference between the wall of the pavilion and that of the residence proper, but they do not clearly show the texture of the brickwork either. The text is not explicit; it mentions the brick/stone contrast, though without commenting on whether this applies only to the pavilion or to the whole structure. However, it continues: "This pavilion […]" which suggests that he was thinking specifically of the pavilion. If the red brick had indeed been visible only on the pavilion, this would have accentuated its effect.

28. Gébelin, 1927, p.177

29. The château of Fleury-en-Bière is another example of classicizing architecture in a combination of stone and brick dating from the mid-sixteenth century and perhaps it too should be attributed to Lescot. Although vast in surface, it is less complex in its detail, and more modest in its execution than that of Vallery. These two monuments, unparalleled in the sixteenth century, were undoubtedly important models under Henri IV, when brick and stone architecture became a dominant theme. See Babelon, 1989.

30. On this question, see du Colombier, 1939, pp. 41–51.

31. Du Colombier, 1939.

32. Du Colombier, 1949, p.159, note 70, already makes this association but only timidly advances an hypothesis by which the author of the reliefs at Chantilly might be "one of the companions that Goujon had brought with him."

33. *Histoire générale de Paris. Registres des délibérations du bureau de la Ville de Paris,* Paris, 1886, vol. 3, p. 164.

34. Miller, 1968.

35. Du Colombier, 1949, p. 64.

36. The full text by Quatremère was reproduced after a study of his intervention to save the fountain by Edouard Pommier, in Fleury, Leproux eds., 1991, pp. 145–157.

37. See: Babelon ed., 1986, and Chatenet, 1987.

38. Jean Guillaume and François-Charles James, in Babelon ed., 1986, p. 210.

39. It is worth noting that the existence of these *"arceaux"* on the ground floor originates in a technical necessity; in the initial project, the ballroom on this floor was to be vaulted, requiring a wall of extremely strong masonry to resist the pressure of such a large vault. Later, the vaults were abandoned in favor of a ceiling, and the vaults we see today were added in the seventeenth century. It may be that this technical problem suggested or accentuated the visual effect that Lescot obtained, but it does not explain it since Lescot could just as well have chosen another solution, such as continuing the wall in line with the outer face of the buttressing masonry.

40. It is worth observing that this progressive receding of the façade from one floor to the next also figures in Serlio's project, although it is a system more usual in Gothic than in Renaissance architecture. See Serlio, 1978, fig. 73a (pl. LXXIIIa).

41. See mainly Guillaume, in Guillaume, Chastel eds. 1985.

42. Regarding the Louvre of Charles V, see Mary Whiteley, "Le Louvre de Charles V: dispositions et fonctions d'une residence royale" in, *Revue de l'art,* no. 97, 1992, pp. 60–71.

43. These are: Etienne Carmoy for the second *"voute rampante,"* François Lheureux, Jean Christien and Hemond Bidollet for the fourth. See Aulanier, 1951, pp.89–90. These two contracts were finalized the same day (August 30, 1553). It seems noteworthy to me that one of the two commissions went to an established master, Etienne Carmoy, while the other was made directly with a group of journeymen. Contracting a work of this kind with mere journeymen seems unusual to me and may be a sign of Lescot's desire to train young collaborators. François Lheureux eventually became a master, and we can follow his career for thirty years. He continued to work at the Louvre in association with his brother Pierre. We should underscore the fact that Hemond Bidollet was probably none other than the stone sculptor Raymond Bidollet who signed a year's contract on June 22, 1551 with Jean Goujon for "services and training." He must already have been at the end of his apprenticeship, since Goujon housed and fed him, and paid him twelve *livres*. See Grodecki, 1985–86, no. 584. This confirms the role of Goujon as model and initiator for the other executants, as suggested below.

44. Du Colombier, 1949, attributes the vaults over the staircase to "Jean Goujon and his workshop"; Hautecoeur, 1965,p. 273, took heed of the contracts for these pieces, but wanted to save Goujon's authorship: it "seems clear that these artists were working under Goujon." But in what capacity? By whose order? In the accounts, Goujon is always and only paid for precise tasks, such as the caryatids or the reliefs on the façade. He was a contractor working independently without a salary or title from the royal administration.

45. Sauval, 1724, II, p. 35.

46. Roy, 1929–34, vol. I, pp. 419–424.

47. Laborde, 1877–80, I, p. 356.

48. Sauval, 1724, II, p. 36.

49. Carmoy comes to mind, since he did the models for the sculptural motifs. No other payments to him exist from 1559, but the accounts are not necessarily complete and we do not know whether or not their realization was postponed; the musicians' balcony in the ballroom should make us wary of this. However the fact that he made the models is in no way proof that he carved the sculptures. It should be noted that the du Cerceau etching corresponds exactly to the contract with the cabinetmakers: the figurative portions are left blank, suggesting that the engraver worked from a drawing by Lescot which did not include the portions to be executed by the sculptors.

50. Sauval, 1724, II, p. 36.

51. Ibid., p.35.

52. We should be cautious when assessing the documentary value of du Cerceau's graphic works—while many elements are confirmed by other sources, others rest only on his authority.

53. Laborde, 1877–80,I, pp. 357–358.

54. During a seminar in which I presented my conclusions, Jean Blécon and Françoise Boudon, who were preparing an in-depth study of the sixteenth century Louvre, suggested that the original eight columns might have been arranged in groups of four. This hypothesis seems to me to be improbable.

55. Sauval, 1724, II, pp. 357–358.

56. Ibid, p. 35.

57. Ibid, p. 31.

CHAPTER VI

1. The study of the Renaissance portrait in France has hardly advanced since the works by Moreau-Nélaton, 1924, and especially by Dimier, 1924–27; the drawings at Chantilly and the Bibliothèque Nationale have been published respectively by Broglie, 1971, and Adhémar, 1973; the work by Mellen, 1971, on Jean Clouet, is useful for its high quality reproductions. Since the original publication of the present volume one must add Anne Dubois de Groër, *Corneille de la Haye dit Corneille de Lyon*, Paris, Arthéna, 1996, and C. Scailliérez, *François Ier par Clouet*, Paris, 1997 and the review by A.-M. Lecoq in *Bulletin monumental*, 154, 1996, 389–391.

2. As a result, beginning in the seventeenth century, there has been total confusion between the two artists, so that the name of Janet Clouet became a mythical artist whose career lasted from the early years of François I

to the reign of Charles IX. Thanks to archival documents, Léon de Laborde eventually succeeded in reestablishing the distinction between the two generations. For the similar case of Jean Cousin, see the following chapter.

3. Apart from the Louvre's *Charles Orland* and in all likelihood the young girl in the Lehman collection in the Metropolitan Museum in New York, Jean Hey's portraits all belong to a religious context.

4. Charles Sterling, 1963, credits Perréal with an entire series of painted portraits that seem completely disparate. As the only possible attribution to this artist on a documentary basis is a miniature, it is quite difficult to restore his oeuvre to him. The portrait of Pierre Sala in the manuscript of his *Énigmes* (Manuscript Stowe 955, British Museum), already attributed to Perréal for circumstantial reasons (Ring, 1949, no. 331), is not incompatible with the miniature of the *Dialogue of the Alchemist*.

5. Should, for example, the two small panels at Chantilly (Ring, 1949, no. 247), which are probably correctly attributed to the Master of Saint Gilles, be considered French or Netherlandish? It is not certain that these are independent portraits.

6. The name recurs often in northern France and Flanders under various forms—Clowet, Cloet, etc. Jean Clouet was still considered a foreigner at his death in c. 1540–41, since François I declined his *droit d'aubaine*. For the various hypotheses—all somewhat gratuitous—on Clouet's family, the date of his birth and that of his arrival in France, see Mellen, 1971, pp. 10–12.

7. A persistent hypothesis, repeated once again by Pope-Hennessy, 1985, p. 187, identifies Jean Clouet, known as Janet, with the Jean Hey mentioned by Jean Lemaire de Belges in 1509. Not only is this hypothesis in itself most improbable, but today we know that Jean Hey was indeed the author of a painter, the author of an *Ecce Homo* at the Royal Museum of Fine Arts in Brussels, today identified with the Master of Moulins.

8. François I's companions, called the Worthies of Marignano (Preux de Marignan), are represented in the miniatures of a manuscript whose illustration dates for the most part from 1518–19 (*Les Commentaires de la guerre gallique*, Paris, Bibliothèque Nationale, fr. 13429). The manuscript is dated 1519. Mellen, 1971, p. 31, is probably correct to believe that the drawings are posterior to the return from Marignano.

9. Mellen is probably correct not to place his birth before 1485. That he knew the French tradition of the court portrait seems evident, but this does not necessarily mean that he did his apprenticeship in France. He could have trained in Flanders and familiarized himself with the tradition of his adopted country.

10. The portrait of Oronce Finé engraved in André Thévet's *Hommes illustres* after Jean Clouet is cut at half-length, but this is probably an adaptation by the engraver.

11. The state of the question is well summarized by Mellen, 1971, pp. 237–239. It was attributed to Mabuse at the end of the eighteenth century, then returned to the Clouets and specifically to Jean in light of the archival discoveries made by Laborde, 1850–55, pp. 18–23; Dimier, "Notes sur les portraits du XVIᵉ siècle," *Chronique des arts*, 1904, pp. 171–172, rejects this attribution and views the work as by the hand of a third-rate Italian working off of a pencil drawing by Jean Clouet; Hélène Adhémar, *Portraits français, Louvre*, Paris, 1948, p. 147, proposed the name of Pellegrino; Blunt, 1953, p. 240, note 34, finds the painting incompatible with the rest of Jean Clouet's oeuvre and holds that the author should be sought from southern Germany. In the editions posterior to 1967, he comes around to the opinion of Sterling, 1967, who, in an article of the Blunt *Festschrift*, attributes the painting to the young François Clouet still in his father's studio. Scailliérez 1997 returns the painting to Jean Clouet.

12. The painting was in the royal collection, and the face is based on a pencil drawing by Jean Clouet that must date to around 1525. The most economical and most likely solution is that the painting came out of Jean Clouet's studio. I see no real reason to introduce the intervention of François Clouet, which would oblige us to push the date very late and to presume the use of a drawing which was already old.

13. See the very careful analysis by Dimier, 1924–27, vol. III, pp. 5–87.

14. See the entry by Cynthia Burlingham in the catalogue *La Gravure française à la Renaissance*, 1995, no. 161; to my knowledge, no full-length portrait in sixteenth-century France exists of anyone but the sovereign. We know of a painting of Catherine de Médicis with her children that can hardly be considered an exception since it concerns the royal family. On the other hand, the portrait of the three Coligny brothers by Marc Duval, known through a drawing and an engraving by the hand of the same artist, is truly an exception. A painting kept at the Hague (Mauritshuis), seems to have been made after the print, as Dimier thought, rather than the reverse, as has been proposed since. In this instance, we are dealing with a work of Protestant propaganda and it is not surprising that it eludes the ordinary protocol of the court portrait. It may be that Marc Duval was influenced by the German Lutherans' militant use of the portrait; the painting at The Hague is not necessarily a French work.

15. See most recently Cynthia Burlingham in the catalogue *La Gravure française à la Renaissance*, 1995, pp. 139–151.

16. Kernodle, 1944.

17. Bonnaffé, 1874.

18. In particular Adhémar, 1945, p. 193. Philippe Erlanger goes even further: "A painting attributed to François Clouet shows one of the newborns [of Catherine de Médicis] presented to the favorite who seems to accord it her divine protection. Catherine mopes in the background, Henri is absent." *Diane de Poitiers*, Paris, 1955, p. 230.

19. Trinquet, 1967.
20. Ronsard, *Livret des folastries*, *op. cit.*, vol. VI, pp. 152–160. Here I must thank Peter Goldman for his observations on Ronsard's poem and for allowing me to benefit from his knowledge of Latin poetry. After the writing of these notes, I became aware of an article by Françoise Joukovsky, "*L'Élégie à Janet* de Ronsard, portrait 'mental'," *Le Portrait*, CAEL, Publication of the University of Rouen, 1987, pp. 21–36. Without entering into details on the convergences and differences, I would like at least to call attention to Joukovsky's insistence on the depersonalized—so to speak—aspect of the portrait of Cassandra by Ronsard. The poet clearly goes further in this direction than does the painter. Joukovsky finds that mythology and moral allegory are superimposed onto the portrait of Cassandra; this is an important point on which her remarks regarding the poem meet mine on Clouet's painting.
21. Verses 123 to 132.
22. On this point see M.-M. Fontaine and F. Lecercle in Rémy Belleau, *Commentaire au second livre des Amours de Ronsard*, Geneva, 1986, p. XXXIII.
23. See John O'Brien's work on Anacreon in the Renaissance. One will find the results of his research in Rémy Belleau, *Odes d'Anacréon*, in the first volume of Rémy Belleau, *Oeuvres poétiques*, Paris, Champion, 1995.
24. Saunders, in Céard, Fontaine, Margolin (ed.), 1990, showed that contrary to what one generally reads, the *blasons* were more or less all composed at once and are almost all found in the 1536 edition, the changes from one edition to the other marking a choice rather than innovations. In 1555, not only were they no longer a fad, but these little poems, which belong to the school of Marot, must have seemed rather old-fashioned. Must this be viewed on the part of Ronsard as the conciliatory act of a victor? In any case, it is literary coquetry.
25. Cited after Sylvie Béguin in the catalogue *L'École de Fontainebleau*, 1972, p. 207, who is in turn taking up P. D. Roussel, *Histoire et description de château d'Anet*, Paris, 1875, p. 126. The Louvre's *Diana the Huntress* would correspond to the description. Dimier, 1900, p. 125, scorns this painting, in which he recognizes Gabrielle d'Estrées. But his opinion has not been retained and restoration has revealed a high quality work. The identification of the Louvre's *Diana* with the Anet painting has generally been rejected because the work is supposed to have come from Fontainebleau. Yet this provenance is based solely on an assertion in the catalogue of the Lebreton sale in 1840. However, one finds no trace of the painting at Fontainebleau, which is surprising. One should perhaps be skeptical of the sale catalogue's assertion and consider the identification with the Anet painting in a more positive fashion.
26. The best study remains the excellent book by Pierre Champion, *La Dame de beauté, Agnès Sorel*, Paris, 1931. Champion is very restrained and clearly distinguishes the little that is known of the person from the legend, the development of which he carefully retraces. Recently, Robert Philippe, in *Agnès Sorel*, Paris, 1983, sought to reestablish Agnès's date of birth as much earlier than that accepted by modern historians, which would reopen the possibility of a career much longer than the six or seven years generally granted to the reign of the favorite. In this curious book, quite well informed but not very convincing, the historian seems driven more by his hostility towards Joan of Arc than by his admiration for Agnès Sorel.
27. This is the opinion of Pierre Champion, *La Dame de beauté, Agnès Sorel*, *op. cit.*, pl. XIII. The painting was presented at the exhibition of French Primitives in 1904. I have not seen it.
28. It is recorded in an inscription from 1775 on the back of the Antwerp *Virgin*. See Ring, 1949, p. 210.
29. Before even Leonardo, one should mention Giorgione and his delicious *Laura* preserved in the Kunsthistorisches Museum in Vienna. One generally accepts the authenticity of the inscription on the back of the painting, which names Giorgione as the author and the date of 1506. This is surely a portrait and not an imaginary representation of Petrarch's Laura; Egon Verheyen, "Der Sinngehalt von Giorgiones *Laura*," *Pantheon*, 1968, p. 220, maintains that it is a marriage painting. This is not impossible. This woman uncovering one breast is not strictly speaking nude, and it is not an erotic portrait in the same way as are those in the series to be discussed presently.
30. I agree with David Brown's hypothesis. For the documentation, which is extremely complex, one should refer to his study in David Alan Brown and Konrad Oberhuber, "*Monna Vanna* and *Fornarina*: Leonardo and Raphael in Rome," *Essays Presented to Myron P. Gilmore*, Sergio Bertelli and Gloria Ramakus ed., vol. II, Florence, 1978, pp. 25–86.
31. The painting, known through photographs, was at one time in the Muir-Mackenzie collection in London; present location unknown. This painting and the Chantilly cartoon present a visage so generalized that one has difficulty considering it a portrait.
32. See Brown, in "*Monna Vanna* and *Fornarina*," p. 36.
33. For all concerning this painting, one should consult above all Konrad Oberhuber's study, ibid.
34. A painting in the Palazzo dei Conservatori in Rome, clearly a variation on the *Fornarina*, is attributed to Girolamo Sisciolante da Sermonetta. In this instance, too, we are clearly dealing with a portrait.
35. The painting in the Germanisches Nationalmuseum in Nuremberg measures 28 x 21 cm. It has been suggested identifying the portrait's model as Katharina Jabach: see Hildegard Zesthoff-Krummacher, *Barthel Bruyn der Ältere als Bildnismaler*, Deutscher Kunstverlag, 1965, no. 114 in the catalogue, pp. 182–184; she dates the painting to around 1535–36.
36. See the entry by Béguin in the catalogue *L'École de Fontainebleau*, 1972, no. 243.

37. This motif is so close to that of the *Venus of Urbino* that it is almost certain that the author of the Worcester painting knew the Venetian work, probably through a copy.

38. See Béguin, *L'École de Fontainebleau*, 1972, nos. 244 and 245, and the catalogue *La Dame à sa toilette*, 1988.

39. One will find a good biographical entry on Gabrielle d'Estrées by Roman d'Amat in the *Dictionnaire de biographies françaises*, Paris, vol. XIII, 1975, col. 151–153.

40. These are the terms from the period employed by Olivier de la Marche, cited by G. du Fresne de Beaucourt, *Histoire de Charles VII*, vol. III, Paris, 1885, pp. 279–293. Beaucourt endeavors to destroy the legend that made Agnès Sorel the quasi-liberator of the kingdom. He demonstrates that she could hardly have played a role before the end of 1443. The notoriously unreliable Brantôme, who popularized this legend, borrowed his text almost word for word from the *Histoire de France* by Bernard de Girard, lord of Haillau, a respectable historian. Besides, one already had a sketchy form legend in the verses of the portrait collection in the Méjane library. The historic role of the royal mistress seems therefore to have been accepted in the sixteenth century.

41. See Madame de Bolly's entry in the *Biographie Michaud*.

42. Historians have often taken on this role for themselves: Étienne Pasquier, for example, and even later Pierre Bayle, who denounces the intrigues, real or imaginary, of the Duchess d'Étampes (ÉTAMPES article in his *Dictionnaire*).

43. The *Venus of Urbino* has given rise to interpretations that are not unrelated to this discussion. It has already been mentioned that some have sought to view it as a portrait of the Duchess of Urbino. More recently, Charles Hope, *Titien*, London, Jupiter Books, 1980, p. 82, advanced the idea that it is not of Venus at all, nor of any goddess, but simply of a nude woman, a "pin-up," an erotic nude with no other justification. This hypothesis does not seem acceptable, if only because the reference to Giorgione's sleeping Venus is too insistent.

44. See in particular D. Stone, *From Tales to Truths: Essays on French Fiction in the Sixteenth Century*, Analecta Romanica, Heft 34.

45. One can connect to this tradition a composition known through two small paintings that probably only reflect a lost original. The better one is in a private collection (it is reproduced in *Le Musée sentimental de Bâle*, ed. Barbara Huber-Greub and Stephan Andreae, Musem für Gestaltung, Bâle, 1989–90, p. 222). The other, kept in the Musée des Ursulines in Mâcon, seems slightly later. A woman is represented nude, full-length, a mirror in hand, with the objects of her toilette placed on a small piece of furniture nearby. In her left hand she holds a veil, in a gesture similar to that of Giulio Romano's painting in Moscow. In the better example, this veil covers the *pudenda* without truly hiding them. One wonders in this case if Ronsard's *Élégie à Janet* might have served as inspiration for him. The preserved versions do not allow us to say whether it was initially a portrait, or if Clouet himself had painted the original, though this is certainly not at all impossible.

46. The still lifes of food and flowers are among the earliest. See Charles Sterling, *La Nature morte de l'Antiquité à nos jours*, Paris, 1952, p. 42. (English translation by James Emmons, *Still Life Painting from Antiquity to the Present Time*, New York, Universe, 1959.)

47. See Edvard Fuchs, *Illustrierte Sittengeschichte vom Mittelalter bis zur Gegenwart. Renaissance*, Munich, Albert Langen, 1909, in which one will find numerous examples pp. 440–462.

48. A. M. Hind, *Early Italian Engraving*, London/New York, 1938, vol. II, pl. 122.

49. The original French reads: "Un tableau fort beau, où estoy représentées force belles dames nues qui estoyent au bain, qui s'entretouchoient, se palpoyent, se manioyent et frottoyent, s'entremesloyent, se tastonnoyent, et, qui plus est, se faisoyent le poil tant gentiment et si proprement, en monstrant tout, qu'une froide recluse ou hermite s'en fust eschauffée et esmeue."

50. The most precise information is found in Joseph Garnier, *Les Étuves dijonaise*, Dijon, 1867.

51. These representations are found in certain manuscripts of the French translation of Valerius Maximus, the most interesting of which are in the Stadtsbibliothek in Berlin and in that of Leipzig.

52. Poggio, secretary of the papal court, accompanied John XXIII to the Council of Constance (1414–18). The text is cited by Paul Négrier, *Les Bains à travers les âges*, Paris, Librairie de la construction moderne, 1925, p. 143.

53. Eschenfelder, 1992, proposes a reconstruction, which is probably more accurate, with seven rooms in a row. It is indeed quite likely the dressing room would have come before the entrance to the steam room.

54. What one sees in François d'Orbay's cross-section does not correspond exactly to Dan's description. Yet, as the latter gives precise dimensions, one should probably believe him. Perhaps the basin was partially filled in over the course of the seventeenth century. It is likely, on the other hand, that the steps represented in the cross-section corresponded to reality since this would have rendered the basin more easily accessible.

55. Some seventeenth-century drawings discovered a few years ago allowed Eschenfelder, 1993, to show that several rooms had an illusionistic ceiling decoration—which she links to some drawings by Primaticcio.

56. This was the opinion of Dimier, 1900, p. 284, who seems perfectly justified. The lunette form would only have suited a vaulted room. The date of the print is probably 1543 or 1544, which fits with the chronology of the work.

57. The exact list of paintings that were installed in the bath apartments seems uncertain to me. It is not altogether sure, for example, that Leonardo's *Mona Lisa* and *Virgin of the Rocks* were to be found there. On this point, one can refer in general to Dimier, 1900, pp. 281–282, though one should be cautious. The list that he gives is that of the copies executed under Henri IV to replace the originals installed in the paintings cabinet. He cites them all, with the exception of two paintings: the *Holy Family of François I* by Raphael and the *Visitation* by Sebastiano del Piombo, which were to be found on the main altars of the chapels of the Cour Ovale. But one can only truly be sure of what reoccurs in Dan's work. The *Leda*, *Saint John the Baptist*, and an *Abduction of Proserpine* by Leonardo, Rosso's *Judith*, Andrea del Sarto's *Charity* and a portrait of Gaston de Foix by Pontormo. Dan does not mention the *Saint Margaret* or *Portrait of Jeanne d'Aragon* by Raphael, Andrea del Sarto's *Holy Family*, Leonardo's *Virgin of the Rocks* or *La Belle Ferronnière*, nor Titian's *Magdalene*. Nevertheless, since the copies of these other paintings are not found elsewhere in the château either, it may well be that the originals and then the copies found their way to the bath apartments. On the other hand, what were the works that Dan mentions in the meeting room? It does not seem that these were decorations painted onto the wall but rather hung paintings like those mentioned above. Were these works placed there under Henri IV, or had they indeed been there since François I? Dan, unfortunately, only gives their subjects.

58. Fortunately, most, if not all, were in the resting rooms rather than in the steam and bathing rooms proper, but they had nevertheless suffered from the humidity to the extent that they had to be restored under Henri IV. The originals were then replaced by copies and installed in a location more favorable to their conservation.

59. Bonnaffé, 1887.

60. Eschenfelder, 1992, attacks this conclusion, which I published in an earlier version of my text in Céard, Fontaine, Margolin (ed.), 1990, pp. 95–111. She rightly drew attention to the Moorish baths of Granada where emperor Charles V ordered work to begin as early as 1528 and which had a direct access to the apartments installed in 1537. François I was probably aware of this installation and it may be that his constant competition with the emperor played a role. In a more general fashion, the Oriental tradition of baths inherited from antiquity should be brought into the equation that produced the Fontainebleau ensemble. I do not believe I have ever suggested that the baths of Philippe de Clèves were "the model" for those of Fontainebleau, but simply one of the northern precedents. One should not forget how attached the emperor Charles V himself was to all that concerned Burgundian traditions, which was perhaps not unrelated to his decision to restore the Moorish baths. Without underestimating the interest of Eschenfelder's

contribution, it seems to me that she exaggerates the role of the Granada baths, and I see no reason to abandon my previously published conclusions.

CHAPTER VII

1. Dimier, 1904, pp. 178–180.
2. Roy, 1929–34, vol. I, p. 1, is the text of a paper read at the Académie des Inscriptions on January 22, 1909 and published the same year in the *Publications de la Société archéologique de Sens*.
3. Félibien, 1666–88, vol. II, pp. 314–315. The original French text for each translated citation from Félibien is provided hereafter. " […] l'on peut dire qu'ils ont esté les premiers qui ont apporté en France le goust Romain, & la belle idée de la Peinture, et de la Sculpture antique. Avant eux tous les Tableaux tenoient encore de la manière Gottique, & les meilleurs estoient ceux, qui à la manière de Flandre, paroissoient les plus finis, & de couleurs plus vives. Mais comme le Primatice estoit fort pratiqué à desseigner, il fit un si grand nombre de desseins, & avoit sous luy, comme je vous ay dit, tant d'habiles hommes, que tout d'un coup il parut en France une infinité d'Ouvrages d'un meilleur goust, que ceux qu'on avoit veûs auparavant. Car non seulement les Peintres quittérent leur ancienne manière, mais mesme les Sculpteurs, & ceux qui peignoient sur du verre, dont le nombre estoit fort grand. C'est pourquoy l'on voit encore des vitres d'un goust tres-exquis, comme aussi quantité de ces Emaux de Limoge, & des vases de terre, peints, & émaillez, qu'on faisoit en France aussi-bien qu'en Italie. Il se trouve mesme des Tapisseries du dessein du Primatice."
4. Ibid., vol. II, p. 318. "Lors que Cimabué et Giotto commencerent à le faire revivre, on le pratiquoit au-deçà des Monts aussi-bien qu'en Italie, où l'on peut dire que depuis Constantin les Ouvrages de Sculpture & de Peinture n'estoient pas d'un meilleur goust dans Rome que ceux qu'on faisoit icy."
5. "A short time ago, there came into my hands an old book on parchment by a French Author, the characters & language of which attest to its being from the twelfth century."("Il m'est tombé depuis peu entre les mains un vieux livre en parchemin d'un Auteur François, dont les caractères & le langage témoignent estre du douzième siècle.") Ibid., vol. II, p. 318.
6. Ibid., vol. II, p. 319. "Il y a long-temps que l'on pratique la Peinture en France ; nos anciennes vitres en sont des preuves, & je vous ay mesme dit que le premier qui fut peindre à Rome sur du verre estoit natif de Marseille. Aussi comme les Peintres de France travailloient beaucoup sur le verre, & qu'ils estoient tout ensemble Peintres & Vitriers, on voit que dés l'an 1520. il se faisoit beaucoup de vitres dans les Eglises d'un goust tres-excellent, & dont les couleurs sont admirables ; je ne dis pas seulement pour la beauté & l'éclat de la matiére, j'entens pour le mélange des couleurs, & ce que les Ouvriers nomment

l'apprest. Les noms néanmoins de ces excellens hommes ne sont point venus jusques à nous, & l'on ne sçait pas quels estoient ceux qui travailloient avant que le Roy François I. eust fait venir d'Italie Me Roux, & les autres Peintres que j'ay nommez."

7. In the fifth *entretien*, Félibien returns to the windows more specifically and he repeats the date 1520. He seems therefore to be referring to the same works, but in this passage, which immediately follows that on Jean Cousin, he is less enthusiastic: "You might have seen in several Churches in Chartres windows painted since the year 1520 that were of a good taste of design & of a beautiful effect." ("Vous pouvez avoir veu dans plusieurs Églises de Chartres des vitres peintes depuis l'an 1520 qui estoient d'un bon goust de dessein & d'un bel apprest.") Félibien, 1666–88, vol. III, p. 133.

8. Ibid., vol. III, p. 126. "Il y avait encore JANET, qui faisoit fort bien des portraits […] Ronsard a parlé avantageusement de luy dans ses poësies."

9. "M. le Févre," Félibien's note, op. cit., vol. III, p. 130.

10. Ibid., vol. III, pp. 128–132. "Mais un des plus considérables de tous les Peintres François qui travailloient alors & dont sans doute la réputation n'est point encore si grande qu'elle le mérite, a esté Jean Cousin. Il estoit de Soucy proche de Sens, s'estant appliqué dés sa jeunesse à l'estude des beaux arts, il devint excellent geometre & grand desseignateur. Comme en ce temps-là on peingnoit beaucoup sur le verre, il s'adonna particulièrement à cette sorte de travail, & vint s'establir à Paris. Après y avoir fait plusieurs ouvrages, & s'estre mis en réputation, il fit un voyage à Sens ou il épousa la fille du sieur Rousseau qui en estoit Lieutenant Général. L'ayant amenée à Paris, il continua les ouvrages qu'il avoit commencez & en fit quantité d'autres. Un des plus beaux que l'on voye de luy est un tableau du jugement universel qui est dans la sacristie des Minimes du bois de Vincennes, & qui a esté gravé par Pierre de Jode Flamand excellent desseignateur. Par ce seul tableau on voit bien il estoit sçavant dans le dessein, & abondant en belles pensées & en nobles expressions ; aussi est-il mal-aisé de s'imaginer la grande quantité d'ouvrages qu'il a faits, principalement pour des vitres, comme l'on en voit à Paris dans plusieurs Eglises, lesquels sont de luy ou d'aprés ses desseins. Dans celle de S. Gervais il a peint sur les vitres du Chœur le Martyre de S. Laurent, la Samaritaine, & l'histoire du Paralitique.

"Son bien estant scitué aux environs de Sens, il passoit dans cette ville-là une grande partie de l'année, & c'est pourquoy l'on y voit plusieurs peintures de sa façon. Il y a une vitre dans l'Eglise de Saint Romain où il a représenté le Jugement universel ; & dans l'Eglise des Cordeliers il a peint aussi sur une vitre Jésus-Christ en Croix, & l'histoire du Serpent d'airain; Et sur une autre un miracle arrivé par l'intercession de la Vierge.

"Dans la Chapelle du Chasteau de Fleurigny qui n'est qu'à trois lieuës de Sens, il a représenté la Sibylle qui montre à Auguste la Vierge qui tient entre ses bras son fils environné de Lumière, & cet Empereur prosterné qui l'adore. On voit encore dans la ville de Sens plusieurs tableaux de sa main, & quantité de portraits, entre autres celuy de Marie Cousin fille de cet excellent peintre, & celuy d'un chanoine nommé Jean Bouvier.

" Il y a chez un Conseiller du Présidial de Sens 9, un tableau de ce Peintre, où est représentée une femme nuë & couchée son long. Elle a un bras appuyé sur une teste de mort, & l'autre allongé sur un vase entouré d'un serpent. Cette figure est dans une grotte percée en deux endroits differens. Par l'une des ouvertures on voit une mer, & par l'autre une forest ; au dessus du tableau est écrit Eva prima Pandora. Tous ces différens ouvrages sont assez considérables pour faire juger que Jean Cousin estoit un des sçavants Peintres qui ayent esté. La Nature & l'étude avoient également contribué à le rendre habile ; car on voit dans ce qu'il a fait une facilité, & une abondance que l'on ne peut acquerir par la seule étude, & on y remarque un correct dans le dessein, une exacte observation de perspective & d'autres parties que la Nature ne donne point. Aussi a-t-il laissé des marques de son sçavoir dans les livres que nous avons de luy, où il donne des regles pour la Geometrie, pour la perspective, & pour ce qui regarde les raccourcissements des figures. Ce dernier a esté jugé si utile pour apprendre les principes de la Peinture, qu'il est dans les mains de tous ceux qui professent cet art ; & la grande quantité d'impressions qu'on en voit, est un témoignage de sa bonté, & de l'estime qu'on en fait.

"Outre tous ces talens nécessaires dans sa profession, il avoit encore celuy de plaire à la Cour où il estoit fort aimé, & où il passa une partie de ses jours auprés des Rois Henri II. François II. Charles IX. & Henri III. Comme il travailloit fort bien de Sculpture il fit le tombeau de l'Amiral Chabot, qui est aux Celestins de Paris dans la Chapelle d'Orléans. Il y en a qui ont voulu faire croire qu'il estoit de la Religion Prétenduë Réformée, à cause que dans la vitre où il a représenté le jugement universel, dont j'ay parlé, il a peint la figure d'un Pape, qui paroist dans l'Enfer au milieu des demons ; mais c'est un fondement bien foible pour avoir donné lieu à mal juger de la foy de ce Peintre, qui n'a pas été le seul, comme nous l'avons remarqué ailleurs, qui ait peint de semblables choses, pour apprendre à tout le monde qu'il n'y a point de condition qui puisse estre exempte des peines de l'autre vie, joint que tous ses autres ouvrages, où il a pris plaisir de représenter des sujets de piété, & particulièrement la vie qu'il a toujours menée, le justifient assez de ces soupçons si legers & si mal fondez. L'estime qu'on doit avoir pour un si grand homme m'a souvent fait informer de sa vie & de ses mœurs. mais je n'ay rien oüy dire de luy que de tres-avantageux : Il m'a esté impossible de sçavoir en quelle année il est mort, seulement qu'il vivoit en 1589, véritablement fort âgé."

11. One is struck by the vindicating tone of the rediscovery, which anticipates the phenomena described in Haskell, 1993.

12. Dézallier d'Argenville, *Abrégé de la vie des plus fameux peintres*, 4 vols., Paris, De Bure, 1762, vol. IV, p. 5.

13. On Papillon's role, see Marius Audin, *Essai sur les graveurs de bois au XVIIIᵉ siècle*, Paris, Crès, 1925.

14. Le Vieil, 1774.

15. We have already seen that stained-glass painting, which was hardly practiced in Italy, was considered by the Italians to be a French specialty. It is true that woodcut had enjoyed a surge in popularity in Venice in the first third of the sixteenth century, and Titian himself had found it worthy of his attention. But the vogue did not last beyond the middle of the century and never won over the rest of the Peninsula. On the other hand, woodcut had a particularly brilliant history in Germany, where Dürer and Holbein were only the most astounding among a number of artists of the book—yet the sense of identity of the French was generally expressed in terms of their differences with Italy.

16. Dimier, 1965, p. 46.

17. Alexandre Lenoir, *Description historique et chronologique des monuments de sculpture réunis au musée des Monuments français*, Paris, Year V (1797), p. 13. In 1810 he writes, "Jean Cousin, nicknamed the French Michelangelo, a friend of Jean Goujon, was the eminent master of all the arts. Celebrated as a sculptor and painter, a learned anatomist and a skilled engraver of medals, he has left us perfect monuments in the various genres in which he worked."

18. These ramblings are reproduced without comment by Firmin-Didot, 1872, p. 69.

19. On this work, see Beaulieu, 1978.

20. Gault de Saint Germain, 1808. The author, who died in 1842 at the age of eighty-six, had begun a career as a painter under Louis XVI, which was interrupted by the Revolution. Biographical entry by M. Schoeffler in the *Dictionnaire de biographies françaises*, vol. XV, Paris, 1982.

21. Miel, 1821, p. 131, cited by Firmin-Didot, 1872, p. 65, who added David's name to avoid all ambiguity.

22. I give here Cicognara's text on Cousin *in extenso* for its eloquence: "Fra tutti gli artisti francesi del secolo XVI, quelgli che si accostò meglio d'ogni altro al bel fare italiano, e che meno d'ogni altro cadde nel manierato si fu Jean Cousin. L'estensione del suo ingenio brillo a preferenza nelle pitture sul vetro, per le quali la Francia supero sempre ogni altra nazione; e malgrado le distruzioni e i danni che hanno sofferti simili fragilissimi monumenti ne rimane pertanto un bel numero che attestano bastantemente fino a qual punto giugnesse questo elegante artificio e quale fosse il merito di un tale celebratissimo artefice. Egli dipinse con larghezza di stile, disegnò con rigore, e colorì con forza e con transparenza come se fosse levemente arruotato. Egli visse contemporaneamente à mégliori italiani che lavorassero in Francia, e sebbene fosse egli assai giovane al tempo di Leonardo, si trovò però col Rosso, col Primaticcio, col Fattorino, con Giov. Battista Bagnacavallo, col Cellini, con Matteo del Nassaro, e con tutti quegli altri moltissimi che ajutarono questi sommi maestri; tal che puo dirsi che nutrido di esquisiti elementi, esciti tutti dalle scuole di Leonardo, del Bonaroti e di Rafaello, egli tenesse di mira il bello in tutta la sua purità, imitando e lavorando anche sui cartoni di questi valentissimi artisti, sicome di alcuni lavori, si sa con certezza, e di alcuni altri con ragione si presume dall'ispezione sulle opere medesime: quantunque si vegga evidentemente essersi appropriato un buon stile, poiche anche i lavori di tutta sua invenzione non peccano di affettazione, o di minutezza. La statua del maresciallo Chabot da noi riportata alla Tav. LXXXII, crediamo di poter giudicarla la miglior opera dello scalpello francese in quest'epoca. Severità di stile, bellezza di forme, natura ad arte associata con felicità, e sopratutto una meravigliosa semplicità che tanto è necessaria nelle opere di questo genere, tutto vi si scorge unito a un bel tocco di scarpello, che particolarmente nella testa si vede, non indegna delle più belle teste di Michelangelo. Più durevoli memorie del suo bel'ingenio ci avrebbe lasciato Jean Cousin se più ai marmi che a'vetri avesse atteso, e non a Germain Pilon, o a Jean Goujon sarebbersi datti i fastuosi titoli di *Fidia* o di *Corregio* francese."

23. Firmin-Didot, 1872 and 1873.

24. Pattison, 1879.

25. See the biography by Betty Asquith, *Lady Dilke: A Biography*, London, Chatto & Windus, 1969, and especially Elizabeth Mansfield's unpublished dissertation at Harvard University, *Art, History, and Authorship: The Critical Writings of Emilia Dilke*, 1996.

26. The dominant influence of Hegel has often been emphasized in the historiography of German art (especially A. Hauser, *Philosophie der Kunstgeschichte*, Munich, C. H. Beck'sche Verlagbuchhandlung, 1958); more recently, thanks in particular to Michael Podro's publications, such as *The Critical Art Historians*, London/New Haven, Yale University Press, 1982, we have realized that the Kantian and Neo-Kantian currents did play a large role as well, but the impact of Hegel on the whole phenomenon of historicism during the nineteenth century should not be minimized.

27. *Archives de l'art français*, vol. I, 1851, p. XIV.

28. A. Hauser, *Philosophie der Kunstgeschichte, op. cit.*, pp. 206–228.

29. "This entry contains only the expression of my regret for having vainly sought this great name in the documents, as well as my conviction that such a skilled brush, such a firm chisel cannot have been ignored by the sovereigns under whose reigns Jean Cousin lived." Laborde, 1851, p. 308.

30. In fact, long before Roy's discovery, Jules Guiffrey

had already known of the crucial document concerning the pension given by Cousin the father to his son for his studies in 1542 and had clearly posed the question as to whether this son had continued the work of his father, a question repeated by Henri Monceau in "Les Cousin de Sens," *L'Art*, 1884, I, pp. 106–109, yet this had had no impact. Only with the proof furnished by Roy of the first Jean Cousin's death in 1560 could the question be settled.

31. Dimier, 1904, pp. 178–180. Dimier retains the Louvre's *Last Judgment*, the *Livre de perspective*, Domenico da Sera's *Livre de broderie*, two compositions engraved by Étienne Delaune, and the *Vulcan's Forge* engraved by L. Gaultier in 1581. Dimier's book was published only in English translation. The very fact that it did not appear in France is an indication of the resistance the author's antinationalist ideas met there. Curiously, Dimier was also one of the founders of the Action Française, which advocated "*nationalisme intégral.*" See my introduction to the anthology of his writings, Dimier, 1965.

32. Dimier, 1904, p. 180.

33. Here is how an author as distinguished as Charles Blanc expressed himself: "Jean Cousin is, if you wish, the Michelangelo of our temperate regions. He probably had neither the sublimity of the Florentine nor his heroic failings; but he was, a century before Poussin, the most powerful and the most French personification of our art; I say the most French, although his color and manner are Italian, because his paintings, his sculpture, his architectural works, bear that character of elegant sobriety, have that grace, that measure, that grand taste which are the distinctive traits of French art, even when it borrows the language of others in order to express its own thoughts." *Histoire des peintres de toutes les écoles*, vol. 1: *École française*, Paris, Jules Renouard, 1862, p. 7.

34. The attribution is due to Charles Sterling in the catalogue *Le Triomphe du maniérisme européen*, 1955, no. 45; The attribution is maintained by Sylvie Béguin, cat. *L'École de Fontainebleau*, 1972, no. 57, with a likely dating before *Eva*.

35. Georges Hulin de Loo regrouped works by this eminent artist on the occasion of the exhibition of French Primitives. Dimier did not believe in the coherence of this regrouping in which, not long ago, Madeleine Huillet d'Istria still saw the hands of several painters, among them Bourdichon. However, the corpus is hardly debated today and most scholars seem to have come around to the identification with Jean Hay since Charles Sterling, 1968, after much hesitation, upheld it; Zerner, Katic, 1966, had already come out in its favor.

36. This continued until around 1570. After the disappearance of François Clouet, at the end of the Valois and under Henri IV, the situation was more complex and would require a meticulous study that is beyond the scope of this book.

37. Cat. *La Peinture en Provence au XVIe siècle*, 1987–88. The works exhibited ranged from around 1500 to the 1620s. The authors of the catalogue made a very strenuous effort to locate works, in particular in the churches of Provence, the results of which are listed in an index of preserved works not on display (pp. 193–211); it has ninety-eight entries, but it should be noted that beyond no. 70, one is already in the seventeenth century. With the exhibited paintings, this makes little more than one hundred works for the entire century, many of which are worse than mediocre. A colloquium held at Avignon (May 9–11, 1988) confirmed the great care with which the inventory had been performed. A few panels sold off here and there will probably be rediscovered, but it does seem that most of the preserved works from Provence are now itemized.

38. The dating is difficult. The year traditionally given, 1505, cannot be retained, as Leonelli correctly notes, unless it refers to the date of a commission implemented only much later. The proposed dating is based in part on the study of the style and in part on circumstantial reasons. The figures of the apostles at the bottom of the *Assumption* do seem to be a group portrait, comparable to that found in the painting of Geertgen tot Sint Jans, *Julien the Apostate Ordering the Burning of the Bones of Saint John the Baptist*, which Riegl views as the origin of this typically Dutch genre. This is in accord with the very Netherlandish character of the *Adoration of the Magi*. The panels of the right side are unfinished and their execution is distinctly inferior to that of the *Adoration of the Magi*; yet the preparatory drawing of the faces that were not painted is not incompatible with the style of the *Adoration*. As for the *Annunciation*, which is painted in gray monochrome on the reverse of the shutters, it displays an authority in its conception of space, a science of foreshortening, that only a thorough knowledge of recent Italian art could account for, yet the ornamental quality of the phylacteries is not Italian. These versos were not completely finished, since the inscription of the phylactery is only in its initial stages. The attribution of this *Annunciation* to Henri Guigues, suggested in the exhibition catalogue, seems to me difficult to endorse. I would not be surprised if it were by the same master as the *Adoration of the Magi*. Guigues must have carefully studied this exemplary work. One will note lastly that the fragments of the original frame revealed by the recent restoration are of exceptionally high quality, in complete accordance with that of the painting. The entry in the catalogue *La Peinture en Provence*, 1987–88, no. 14, that concerns the *Adoration of the Magi*, inverts the right and left panels, an error that appears again in the illustration on p. 71.

39. Today one can retain the following works: *Holy Kinship*, Avignon, Calvet Museum, signed and dated 1543; the *Adoration of the Shepherds*, Avignon, Calvet Museum, signed and dated 1548; the *Bearing*

of the Cross, Aimargues (Gard), Saint Saturnin Church, signed and dated 1548; the *Entombment*, Villeneuve-lès-Avignon, museum, signed and dated 1552; the *Resurrection of Christ*, Les Bauz-de-Bédouin (Vaucluse), parish church, signed and dated 1552 (the reading of this date is uncertain and Leonelli believes it to be 1532, the date of the painter's first appearance in Avignon; I think that the reading of 1552 is probably correct). According to the restorer who handled the work, the flesh was repainted, with the exception of the sleeping soldier to the left; the *Crucifixion Between Saint Roch and Saint Sebastian*, Avignon, Grand Séminaire, signed and dated 1557. This work makes rather a poor impression; perhaps the bad state of its conservation is to blame, rather than a possible collaboration; the *Incredulity of Saint Thomas*, Paris, Louvre, signed and dated 1535. This is the outer side of the shutter of an altarpiece painted in grisaille; the recto, which is quite damaged, represents the *Noli me tangere* with a donor; *Mater dolorosa* and an *Ecce Homo*, Rome, Borghese Gallery. The first is signed and dated 1543; both are copies after Andrea Solario; the *Descent from the Cross*, Avignon, Calvet Museum, signed and dated 1550. At the top, the artist has borrowed the motif of angels bearing the instruments of the Passion painted in the lunettes at the top of the Last Judgment by Michelangelo in the Sistine Chapel, probably through the intermediary of an engraving; the *Resurrection of Christ*, Uzès, cathedral, signed and dated 1500; the *Resurrection of Lazarus*, Uzès, cathedral, signed and dated 1550. The figure of Lazarus is repeated from the altarpiece by Sebastiano del Piombo for Perpignan, though the rest of the composition is different. In addition to these signed works, Marie-Paule Vial has retained the *Adoration of the Shepherds* in Saint Pierre Church in Avignon; despite the technique, a little smoother than in the other works, this attribution seems quite likely to me.

40. The composition was known in France, since there is an etching of it by the Master I[ǫ]V. This very curious print, with its abrupt, rather barbaric, graphic style, is like a caricature of Raphael's style. This was certainly not the source for Simon de Châlons, who was much more faithful to the original motif.

41. See on this subject the catalogue *La Peinture en Provence au XVII^e siècle*, Marseille, 1978.

42. On this group of paintings, see Laclotte, 1967, and the catalogue *La Peinture en Bourgogne au XVI^e siècle*, 1990.

43. Having noticed this handwritten signature, A. Bartsch regrouped a certain number of etchings around his name. They have since been attributed to Jean Mignon.

44. See Louis Berthomieu, *Catalogue descriptif et annoté des peintures et sculptures*, Toulouse, 1923, pp. 33–34 and pl. VI. The author gives the precise date of 1603, without indicating that the work is dated—probably a simple oversight.

45. To give at least one example, one can refer to a panel of the *Annunciation* preserved in the beautiful Romanesque church of Menat. This painting is not without quality. Other examples are generally more modest.

46. The remarkable article by Jacques Thuillier, 1961, treats this group of paintings. Thuillier demonstrated that Félix Chrestien, François Dinteville's secretary, was not a painter, and that works by completely different hands were grouped under his name. This is a fine example of the fantastical imagination of historians anxious to rediscover the lost "masters" of the French Renaissance.

47. The attribution to Luca Penni, Béguin, 1987, should not necessarily be retained.

48. The copy reproduced by Firmin-Didot belonged to the Prosper de Baudicourt collection and has not been found.

49. F. Herbet described two of these sheets in his catalogue of the engravers of the school of Fontainebleau (1901, IV, p. 51, nos. 1 and 2), but Jean Cousin's name is not mentioned in his entry. The third piece has appeared since then (see the following note). One can attribute to the same team a fourth etching, *Jupiter and Antiope* (Herbet, no. 62 of the anonymous works, to be discussed below). These four very remarkable prints are each known only through a single proof. It is thus possible that other pieces have disappeared entirely.

50. The only known proof is in Amsterdam. It was published as an anonymous Italian and with the monogram interpreted convolutedly as I. H. in Marijke De Jong and Irene de Groot, *Ornamentenprenten in het Rijksprentenkabinet, I, 15de & 16de eeuw*, Amsterdam, 1988, no. 663. Peter Fuhring (review on the catalogue in *Print Quarterly*), to whom I had pointed this out, made the correction and mentioned a reversed copy, which I own. This copy presents a variation that makes a fountain of the object represented. Fuhring thinks this indication to be correct and that the author of the copy used an original drawing; it seems to me, on the contrary, that it reveals the copyist's mistake as to the nature of the object.

51. On the complexity of the theme, see Guillaume, 1972.

52. Some, like Blunt, 1983 (French ed.), advanced the idea that the painting was prior to 1538 because it was located in Sens and Cousin moved to Paris around this date. The argument is as weak as the dating is improbable.

53. Gébelin, 1924.

54. On this unpublished etching, see Prouté, 1996.

55. Firmin-Didot had already attributed this piece to Jean Cousin, but he interpreted the monogram as a variation on that of Cousin—which is not only in itself unlikely, but also incompatible with the rest of this master's oeuvre. Herbet described the piece without commenting on Firmin-Didot's attribution, which has thus remained a dead issue.

56. The subject has been identified by Beaudoin Ross, 1978.
57. Published by Béguin, 1976, p. 90, fig. 19.
58. A document published by Grodecki, 1985–86, vol. II, no. 759, proves that the earlier editions mentioned by Firmin-Didot, among others, never existed, although Cousin the Elder had announced such a publication as early as 1560.
59. Benesch, 1939–40.
60. Wanklyn, 1979.
61. In the catalogue of the Fort Worth exhibition, The *School of Fontainebleau*, 1965, p. 7, Marian Davis asserts on the contrary that it was the father, without giving specific arguments.
62. See respectively Souchal, 1973, and Reynaud, 1973.

CHAPTER VIII

1. On trade organization in Paris, see Lespinasse, 1892.
2. Regarding this point, see Marianne Grivel in cat. *La Gravure française à la Renaissance*, 1995.
3. Grodecki, 1985–86, vol. II, pp. 155–214.
4. Quoted from Roy, 1929–34, vol. I, p. 11. The original text reads: "Oultre ce il estoyt entendu a la sculpture de marbre, comme le tesmoigne assez le monument du feu admiral Chabot en la chapelle d'Orléans, au monastère des Célestins de Paris, qu'il a faict et dressé, et monstre l'ouvrage l'excellence de l'ouvrier."
5. Félibien, 1666–88, vol. III, p. 131.
6. Alexandre Lenoir, *Musée imperial des monuments français*, Paris, 1810, p. 11. The original French text reads: "Jean Cousin, dans la sculpture, fut le rival de Jean Goujon, dont il se fit un ami, et pour lequel il avait les égards qu'un sentiment pur lui dictait. Jean Cousin, considéré comme sculpteur, avait moins d'élégance de style, et moins de finesse dans l'exécution que le savant auteur de la fontaine des Innocens. Il voyait sans jalousie la supériorité de son contemporain dans un art qu'il aimait passionnément ; modeste autant que juste, il entreprit très peu de sculpture ; s'adonna particulièrement à la peinture sur verre, et rendit plus rares, par cette raison, les sculptures que nous avons de sa main." See also page 64, concerning sculpture, there is a similar text, with one interesting variation: "The inventions of Jean Cousin are no less gracious than those of Jean Goujon, but they are less tame and more mannered." ("Les inventions de Jean Cousin ne sont pas moins gracieuses que celles de Jean Goujon : mais elles sont moins sages et plus maniérées.")
7. Sauval, 1724, vol. I, p. 461.
8. A document from June 7, 1549 mentions Baptiste Cousin, the younger son of Jean Cousin, "*quant il vivoyt, ymagier en bosse.*" (In his lifetime, a sculptor in the round.) See Campardon, Tuetey, 1906, item 3130.
9. Thus Thomson, 1984, p. 188, who knows of the Celestine commission, believes that it refers to the painter Jean Cousin, and uses it to suggest that Cousin, on the same occasion, "could have been the architect of the cloister." For his part, Pérouse de Montclos, 1989, p. 94, finds it "tempting to attribute this important work of the 1540s to Pierre Lescot."
10. Archives nationales, Minutier central XXXII, 21. The document is analyzed in Coyecque, 1905–23, vol. II, item 3843. It is a financial agreement of no great interest except that it shows that the artist concerned is definitely the Jean Cousin we mean, since the house in question was the one he owned at the corner of the Rue de Seine and the Rue des Marais.
11. Roy, 1929–34, pp. 113–120, knew of a document attesting that the admiral's statue was put in place during the year 1565. Furthermore, an inscription composed by Étienne Jodelle and engraved on the back of the monument can be dated to the years 1570–72. His hypothesis is based on this information. Jacques Thirion, in cat. *L'École de Fontainebleau*, 1972, p. 382, rightly observes that "it is difficult to accept, as has been done, that the statue of the admiral erected, according to the document, in 1565, was placed in an empty cavity, and that the ornamental frame was executed at the same time as the epitaph, between 1570 and 1572. It is more likely that [the epitaph] was added later."
12. Beaulieu, 1978, pp. 82–83, continued to attribute the secondary sculptures of the tomb to Cousin the Younger; however, she has revised her opinion (1982, pp. 35–48). To support her attribution of the Chabot monument's design to Jean Cousin the Younger, Beaulieu compares it with the cartouches in the *Livre de la Fortune*. She also makes a very pertinent comparison with the modest monument of Canon Philippe Hodoart at the cathedral in Sens. Perhaps it is her attribution of its design to the younger Cousin that causes her to doubt the date 1552 inscribed on this work.
13. This detail is not very well established, and may have been difficult to see on the monument. The Gaignières drawing shows the lion's paws, while Louis Aubin Millin (*Antiquités nationales ou Receuil de momumens pour servir à l'histoire générale et particulière de l'empire François*, Paris, Drouhin, 1790–99), though somewhat indistinctly, seems to indicate a drapery here. This arrangement strikes me as highly implausible.
14. The frame is composed of multiple moldings. Starting from the inside, they are: a row of alternating beads, three round, one oval; eggs and darts; a smooth black element; a wide molding with *chabots* (a fish of that name was used as a heraldic device by the admiral).
15. Adhémar, 1976.
16. Reproduced in Beaulieu, 1982. She attributes the design to Jean Cousin the Younger.
17. This was called *tapisserie de basse-lice* and was woven on horizontal looms.
18. Roy, 1929–34, p. 50.
19. Coyecque, 1905–23, vol. I, p. 319.

20. Lesure, 1947.

21. For more on engraved sources, see Beaudoin Ross, 1978.

22. At the château of Anet, the *Denizens of Lucia Changed into Frogs, Death of Meleager, Diana Kills Orion*, and *Diana Rescues Iphigenia*; at the Musée départemental des Antiquités in Rouen, *Diana Begs Jupiter for the Gift of Chastity*; at the Metropolitan Museum in New York, *Niobe's Blasphemy* and *Drowning of Britomartis*. For a discussion of these tapestries, see Edith Standen in Chastel ed., 1975. Since this was written, the four pieces at Anet have been destroyed in a fire.

23. Brugerolles, in cat. *Le Dessin en France*, 1994, n° 51.

24. Roy, 1929–34, p. 9.

25. Ibid., p. 71.

26. The contract for Saint Germain specifies that the border is to be an inch wide only. One might ask the reason for this clause. I think it is because the border was purely ornamental, and therefore less valued than a scene with figures.

27. I infer this from a contract published by Grodecki, 1985–86, n° 832, in which Michel Rochetel, another painter known from accounts at Fontainebleau, accepts to paint a canvas of the *Rape of Helen*. He was furnished with a preparatory drawing such as tapestry artists received, and was to deliver the work "*prest à enchasser en boys*" ("ready to be framed in wood").

28. For example, one finds among the articles sold by tapestry master Guy Laurens to Marin Laurens on January 10, 1551: "*plusieurs patrons de toile et pappiers*" (several models of cloth and paper). See Grodecki, 1985–86, n° 446.

29. These cloths are currently at the Rheims museum.

30. This lexical detail is given by Lafond, 1988, p. 54, who does not supply a date of origin for the term. It may only go back as far as the nineteenth century, when Jean Cousin's prestige was at its height.

31. We know today that these windows were executed by Nicolas Beaurain. The contract is published in Roy, 1929–34, pp. 223–224. The author of the compositions is not mentioned. It is not inconceivable that Philibert de l'Orme himself drew the initial models. The cartoons, of course, were undoubtedly by Beaurain. The document is not very explicit, but the "*pourtaictz et patrons de ce fait*" (drawings and models made of it) seem to me to indicate cartoons already completed, otherwise the document would mention their making, especially since the "*coulleurs*" (colors) are indicated.

32. Grodecki, 1985–86, n° 255.

33. Published by Grodecki, 1985–86, n° 256. Note that the document is dated November 29, and not September, as Grodecki indicates.

34. The usual term was "*vitrier*," or "*maître vitrier*" depending on whether the practitioner had acceded to the title of master or not. It is the term almost always used in Parisian glass contracts. In a contract from 1557 (Grodecki, 1985–86, n° 312), Thomas Letourneur is called "*peintre et verrier*," (painter and glazier), however, he was established in Auxerre, where the trade organizations may have differed in structure from those of the capital. In Paris, to my knowledge, only François Bunet is ever defined as a "*peintre et verrier*," probably because he practiced both crafts. The reference occurs in an apprenticeship contract (Grodecki, 1985–86, n° 291), where he commits to teaching "*l'art de peinture, de verrerie, et tout ce dont il s'entremect*" ("the art of painting, glassmaking, and all that it entails"). The mention of "*paintres en verrieres*" in 1564 seems exceptional and suggests the idea of a painter-glazier. Only at the end of the century did artists like Nicolas Pinaigrier seek to be called "*peintres sur verre.*" See Leproux, 1988.

35. See the excellent analysis of stained-glass techniques in Lafond, 1988 (the version illustrated and revised by Françoise Perrot). In it one may find examples of several virtuoso techniques such as the striated colored glass known as "Venetian" or "chef-d'oeuvre" cutting, where a smaller piece of colored glass was inset within another piece.

36. Grodecki, 1985–86, n°s 285 and 286, has published two other contracts, one from 1547, the other from 1550, which present these features. The projects were much more precise at the time of signing in these cases, than was the goldsmith's chapel arrangement, and their drawings themselves were signed by the notaries *ne varietur*. In a third contract with the goldsmiths, dated March 10, 1559 (n° 258), the "*portrait*" was transmitted to Aubry at the time of signature. The design's author is not specified, but if it had been a drawing by Aubry himself the formulation would have been different. It may have been by Jean Cousin again.

37. The original French reads: "Il est mal-aisé de s'imaginer la grande quantité d'ouvrages qu'il a faits, principalement pour des vitres, comme l'on voit à Paris dans plusieurs Églises, lesquels sont de luy ou d'après ses desseins. Dans celle de S. Gervais il a peint sur les vitres du Choeur le Martyre de S. Laurent, la Samaritaine et l'histoire du Paralitique." Félibien, 1666–88, vol. III, p.129.

38. Françoise Perrot has pointed out to me that its architecture contains a piece "*en chef-d'oeuvre,*" which more or less guarantees its authenticity. She assures me that modern stained-glass makers hardly ever use this exceedingly difficult technique.

39. It is not possible to get an idea of its appearance from the chromolithograph published by Firmin-Didot in his *Atlas*, 1873, plate 13. 2003: I only saw the original under mediocre conditions. Guy-Michel Leproux, *La peinture à Paris sous le règne de François Ier*, Paris, 2001, p 144–45, black & white reproduction, p. 146, may be right that the design was the elder Cousin's, but the suggested date of 1532 seems to me improbably early.

40. This large (approx.18.5 × 14.5in) ink-and-wash drawing on parchment is at the Louvre. The old inscription, "Daniel Dumoûtier," derives almost

certainly from the confusion of two family members, and may signify that the document remained in the family. The attribution to Geoffroy dates from 1869, in F. Reiset, *Notices des dessins, cartons, pastels, miniatures et émaux exposés dans les salles du premier et troisième étage du musée impérial du Louvre,* and has not been contested since. The etchings signed by this artist are the basis for all the attributions proposed thus far. The primary scene has been described as Christ Preaching (Béguin, in cat. *L'École de Fontainebleau,* 1972, nᵒ 118); however, the glory surrounding the figure of Christ suggests a scene after the Resurrection. Perhaps it represents the resurrected Christ appearing to the disciples in Galilee, according to the last verse of Matthew 28:16. The central lancet of the tympanum probably does represent the Assumption rather than the Magdalene's ascension to heaven, but the leftmost scene is not necessarily the Visitation, as Béguin would have it. She does not offer an opinion on the right-hand scene.

41. This style is found in church windows. Two panels from the church of Saint Acheul in Écouen, the *Visitation* and the *Nativity,* were even included in the school of Fontainebleau exhibition. See cat. *L'École de Fontainebleau,* 1972, nᵒˢ 495 and 496. In her entry therein, Ms. Perrot associated these works with Dumoûtier. In the case of the *Visitation,* a similarity to the upper-left-hand motif in Dumoûtier's drawing is less obvious to me than it seems to Ms. Perrot. The *Annunciation* just above the *Visitation,* dated 1544 (color reproductions of both are found in *Saint-Acheul d'Écouen fief des Montmorency [XVIᵉ siècle],* by Fernand Feugère, 1970, p. 11), strikes me as having the same feeling as the engraved *Annunciation* by Jean Cousin. The *Virgin of the Apocalypse,* on the other hand, at the top of the end window of the north transept, is absolutely consistent with Dumoûtier's manner. It is very hard to say whether he provided models specifically for these windows, or if their author simply based the windows on Dumoûtier's works.

42. The complex drapery on the Virgin, knotted above and below the waist, was not unique to Cousin: similar motifs are found in Jean Goujon and elsewhere, but the way it is used here is very close to what appears in the Saint Mammès tapestries, and elsewhere in Cousin's work. The figure of Saint John the Baptist recalls the one in a drawing of the *Virgin between Saint John and Saint Luke* at the Louvre, which seems definitely to be by Cousin (see Béguin, 1976, fig. 19). The face and elaborate hairstyle of the Magdalene also belong to his repertoire. The Cardinal de Givry made a present of the windows in this chapel and it would not be surprising that he turned to Cousin, since he had employed him for tapestry designs.

43. See the detailed study of this window in cat. *Vitraux parisiens de la Renaissance,* 1993, pp. 92–119.

44. I am referring only to the molding divided by consoles just below the scene. Unfortunately, the architectural base occupying the two lower rows is entirely the

work of the nineteenth-century restorer, as are the intermediary lozenge-shaped spandrels between the main panel and the scenes of the tympanum. It is possible that the restorer found indications in what remained of the window. However, as Leproux remarks in cat. *Vitraux parisiens de la Renaissance,* 1993, pp. 95–96, these portions almost certainly contained heraldry obliterated by the Revolution.

45. This glasswork was commissioned in 1551 by Philibert de l'Orme from Nicolas Beaurain, a glazier of great reputation who accumulated a number of royal contracts. There is every reason to believe that Philibert himself prepared the designs and gave them to the glazier with the commission. As Roy suggests, 1929–34, pp. 206–214 and 223–224, these preliminary drawings probably included the architectural frame and the subjects, summarily sketched, and inspired by previous depictions of the Apocalypse. These windows have been so heavily restored that it is difficult to say anything about the design beyond the general composition. However, Perrot, 1974, has succeeded in identifying several original fragments that give an idea of the handsome workmanship and splendid appearance of these figures.

46. For information on Jean Chastellain, see Leproux, 1988, and in cat. *Vitraux parisiens de la Renaissance,* 1993, pp. 122–145. The author cautiously advances the hypothesis that Chastellain should be identified as the *"Maître de Montmorency,"* a glazier active from 1520–30 for whom he supplies a list of works (cat. *Vitraux parisiens de la Renaissance,* 1993, pp. 83–90). The *Solomon* stained glass at the church of Saint Gervais is also attributed to him (see Grodecki, 1985–86, nᵒ 209).

47. What we call the *"vitrail de cabinet"*—small secular stained-glass panels designed to be seen close up and examined like a painting—though popular in the Netherlands, Switzerland, and Germany, do not seem to have achieved the same success in France. French secular stained glass, of which only a very few examples remain, was essentially armorial and ornamental.

48. See the exhaustive study by Thomas, 1977, especially vol. I, pp. 751–970. The collection is almost certainly incomplete. Drawings that appear to have belonged to the same group have been found in several other locations. Mr. Wanklyn has drawn to my attention two drawings from the Destailleurs collection, which found their way to the National Gallery in Washington (reproduced in the sales catalogue, *Dessins anciens. Collection de M. et Mᵐᵉ M. L.,* Marc Ferri auctioneer, Paris, Drouot, room 1, March 15, 1989, nᵒˢ 12 and 44). A project for a breastplate belongs to a group of sheets considered to be by Delaune. The other drawing—a design for a helmet—exhibits Cousin's repertoire. While more timidly drawn, it is close enough to the chamfron project in Munich to share the same author, which suggests an original by Cousin. I cannot, however, venture an opinion on the matter, not having examined the actual drawing.

49. A large number of masks of this general type can be found in drawings for armor from the collection, but I have found no instance where the motif is reproduced exactly. This does not, however, mean that it was not used, since the sets are by no means complete.

50. George Wanklyn, who has extensive knowledge of Delaune, independently arrived at the same conclusion (conversation with the author). 2003 addendum: With time and the questioning of the whole drawn corpus of Delaune, I have come to wonder whether this great drawing is not indeed by the elder Cousin himself.

51. Wanklyn, 1979.

52. Eisler, 1995, has expressed doubt that the etching dated 1545 is a goldsmith's model, and prefers to view it as a funerary monument, which strikes me as improbable. Naturally, it is not necessarily the same kind of celebratory object as the present for the king. One may note that no example is known from this period of a print depicting a tomb. Androuet du Cerceau, who published models of all kinds, provides none at all. In any case, the other etching, preserved in Amsterdam, is clearly a goldsmith's model.

53. The only general study remains the monograph by Bernard, 1857.

54. Brun, 1969, p. 33.

55. Orth, 1981.

56. Brun, 1969, p. 51.

57. Ibid., p. 57.

58. *Usage et description de l'holomètre, pour sçavoir mesurer toutes choses qui sont soubs l'estandue de l'oeil: tant en longueur qu'en hauteur et profondité.* Invanté par Abel Foullon, Vallet de chambre du Roy, Paris, P. Beguin, 1555. The author, Abel Foullon, is also mentioned in a document published by C. Grodecki, as the owner of a portion of the rights to the *Livre de perspective* by Cousin, at the time of its publication (Grodecki, 1985–86, nᵒ 757). It is not known why he owned any of the rights. In any case, this proves that there were close ties between the two men, constituting circumstantial evidence in support of the attribution. Brun, 1969, p. 192, is reserved and describes the two principal plates in this book as being "*dans le style attribué à J. Cousin.*" On the other hand, he considered a certainty the attribution to Cousin of illustrations in the work by André Thévet, *Les Singularitez de la France antarctique, autrement nommée Amérique*, published in 1558. Some plates bear the initials I.C. and the work is dedicated to the Cardinal of Sens. Is this evidence sufficient to uphold the claim of Jean Cousin's authorship? The illustrations are somewhat heavy-handed, with little character, and their design is rather academic. It is possible that the engraver who cut the blocks largely erased the drawings' character. However, even much deformed, I would be at pains to recognize here the hand that drew the *Livre de perspective*. If there is a Cousin involved, it might be the son. The illustration of the monster of Sens—also initialed I.C.—is no better than those of the *Singularitez*, and in this case

there is circumstantial evidence for an attribution to the younger Cousin.

59. Firmin-Didot, 1872, pp. 200–201, and 1873, fig. 84, believed, because of the motifs employed, that this woodcut was used in the musical editions of Ballard—however, no such publication has been located so far, and this impression remains unique.

60. Brun, 1969, p.223.

61. This relationship is pointed out by Brun, as is its possible attribution to Cousin. However, Brulé, *L'Amateur d'estampes*, 1933, p. 138, whom he refers back to, says nothing of the kind.

62. Brun, 1969, p. 55, is clear: "A precious document discovered by Maurice Roy has permitted the indisputable attribution to the celebrated sculptor of the illustrations for the book recounting the triumphal entry of Henri II into Paris." ("Un document précieux, découvert par Maurice Roy, a permis d'attribuer avec certitude au célèbre sculpteur l'illustration du livret relatant l'entrée d'Henri II à Paris") Still more precisely in note 24, he writes: "We know from the accounts that Goujon had traced by his hand on wooden tables the figures that were to be engraved there." ("On sait par les comptes que Goujon avait tracés de sa main sur des tables de bois les figures destinées à être gravées.")

63. The original text reads : "Pour avoir faict paindre sur les tables de boys les figures des arcs obelisques, pont N.D. et autres choses faictes esd. Entrées pour les faire imprimer."

64. Roy, 1929–34, p. 184.

65. One may ask whether the matter at hand was only the drawing, or if the carving of the blocks was also included. The sum of forty-five *livres* seems rather large for the drawings alone. Of course, once again, even if the sum was to include the cutting, it in no way signifies that Goujon completed the task himself.

66. This idea was developed by Gébelin, 1924. For a study and facsimile of the book, see McFarlane, 1982.

67. For Renaissance festivals and their artistic and cultural importance, see various volumes of the collection "*Les fêtes à la Renaissance,*" edited by Jean Jacquot of the Centre National de la Recherche Scientifique (CNRS), and also research by Lecoq.

68. A document published by Grodecki, 1985–86, nᵒ 759, finally answers a question that has long preoccupied specialists. It is a contract from 1589 between Cousin and Jean Leclerc for the drawings in the *Livre de pourtraicture*. The contract shows that the 1571 edition, cited by Brunet and since irretrievable, never existed; neither did that of 1589, as Firmin-Didot suspected (taken from the 1878 *Supplément* to Brunet's *Manuel*). The 1595 edition, for which the copyright was granted in 1593, was the first edition of the drawing manual, whose extraordinary success was to last until the nineteenth century. The document also proves that the book was prepared for publication by Jean Cousin the Younger; however, he may have used elements left to him by his father.

CHAPTER IX

1. Clouet left Tours for Paris between the end of 1525 and the summer of 1527. See Mellen, 1971, pp. 11–12.
2. Studies on Renaissance art have often struggled to demonstrate the independence of regional schools. Émile Mâle (in Michel, 1911) organized his overview of Renaissance stained glass by province, seeking to distinguish the uniqueness of each "school." Forsyth, 1970, in his work on the development of monumental Entombments proceeds in the same manner, but perceives in the Renaissance phenomenon, which he assimilates to sixteenth-century Italianism, the death throes of the specific local characteristics belonging to late medieval art.
3. The question of the interplay between universalism and local character has been discussed especially well by Pérouse de Montclos, 1982.
4. See Leonard N. D'Amico, 1996, and the exhibition catalogue *Bernard Palissy, mythe et réalité*, 1990.
5. Taburet, 1981.
6. As is well known, faïence became a great specialty of Rouen from the seventeenth century onward, but there does not appear to be any continuity between Abaquesne's workshop and the sustained production of later centuries.
7. For all questions regarding champlevé enamelwork, consult the work of Marie-Madeleine Gauthier, particularly *Émaux meridionaux: catalogue international de l'oeuvre de Limoges*, Paris, CNRS, 1987.
8. Basset, 1955, reproduces scenes of the Apocalypse decorating the tomb, which are simplified and classicized adaptations of Dürer woodcuts.
9. The documentary evidence assigns the château of Graves to a certain Guillaume Lissorgues, and Bournazel is often attributed to the same master; this is the opinion of Pérouse de Montclos, 1982. It appears to me that Graves has a different tenor, more ostentatious and more likely to be by a follower of the anonymous architect of Bournazel. Having said this, the buildings at Graves indicate that they were subjected to major reconstructions and alterations; great discretion is therefore required when making claims.
10. For this interpretation, see Chastel, 1982.
11. Lafond, 1912 and 1942.
12. It is important to stress here the huge success of the Loire style as applied to the townhouse, a fashion that spread throughout the kingdom to Riom and Rodez as well as Normandy.
13. Douais, 1904, pp. 134–135.
14. Gébelin, 1927, p. 167.
15. It is particularly unfortunate that we preserve only the sculptures from the high altar at Dalbade, as they were integrated within a huge, three-tiered architectural framework almost thirty feet tall, making it even larger than Pierre Berton's altar at Saint Méry (see Chapter V). It was probably also of the same type.

Judging by the highly classicized architecture Bachelier includes in the narrative scenes, it was a cutting-edge work.
16. Gébelin, 1927, p. 159.
17. The courtyard façades appear relatively well preserved; however, they did undergo some transformations. The mullions in the window frames of the first two levels were sawed off during the classical period. They remain in place only on the corner block. Some of them were reinstalled on the second floor, modeled on those of the corner building, but there is no guarantee that they were identical, as the somewhat insistent ornamental motif may have been reserved for this bay in order to emphasize the frontispiece of the main staircase—as do the Solomonic columns flanking the entrance. It is not known whether the ground floor originally had single or double window crossings. The classicizing effect of the composition as a whole would have been augmented or diminished, according to the crossings used.
18. It is, however, not impossible that he had a hand in Saint Nizier, see cat. *Philibert De l'Orme lyonnais*, 1993.
19. Rolle, 1861, p. 425.
20. Robert Dumesnil, 1835–71, vol. VI, provides a catalogue of his prints. The engraver has often been identified with Corneille de Lyon. For reasons that escape me, but perhaps because of the double "C," he continued for a long time to be referred to as Claude Corneille. Corneille was his first name, to which contemporary sources generally appended his place of origin: Corneille de la Haye. The master of the double C's engraved at least some of the plates that make up the collection of doorways published by Serlio in 1551 (see Chapter III).
21. Ragghianati, 1972, p. 22, presents the attribution of this painting as the only generally accepted one (he ignores the *Nativité* at the Louvre). He makes his own suggestions for attributions, which cannot be accepted without reservations (figs. 15 and 19).
22. It has been suggested that these works should be attributed to Niccolo dell'Abbate, at least the design, and possibly the painting as well. Labie, 1986.
23. Béguin, 1978; Groër, 1978.
24. Regarding Corneille de Lyon's social status, see Davis, 1980.
25. Identifications are difficult. Dimier remains the reference of choice, 1924–27. It is rare to find multiple copies of a single portrait in the case of great nobles, unlike in Clouet's workshop, where a sketch was likely preserved for use in executing future commissions. It is also perplexing that not a single sketch remains that can be linked to one of the Corneille de Lyon portraits, suggesting that he worked directly on the surface to be painted.
26. See Monique Barbier, *Le Beau XVIᵉ Siècle troyen, aspects de la vie politique, économique, artistique, littéraire, et religieuse à Troyes de 1480 à 1550*,

Troyes, Centre troyen de recherche et d'études Pierre et Nicolas Pithou, 1989, pp. 163–211.

27. The fundamental text remains Koechlin, Vasselot, 1900.

28. For stained glass in the Champagne region, see "Mémoire de verre; vitraux champenois de la Renaissance," *Cahiers de l'Inventaire*, 22, 1990. There is a useful bibliography.

29. These documents have been reissued by Eisler, 979, in Appendix E: I am not sure why documents n^os 22–25 are missing. It should be noted that Eisler also includes all the documents pertaining to Jean Duvet de Genève, who is, in our opinion, a different person from the Langres engraver, probably his nephew.

30. This was noted by Carroll, 1995, p. 303.

31. Psalms 90:10. I feel that the strictly documentary value of the date of 1485 should be treated with caution; it is calculated back from the age of seventy years, which has strong symbolic value, making it somewhat suspicious. However, the date must be more or less correct; it is compatible with his acquiring of the title of master in 1509, even if Duvet needed to make himself appear older to attain this venerable age.

32. One detail is disturbing. One hand of the cherub we see to the right of the Virgin's head reaches behind a pilaster to grasp hold of it. It would appear that Duvet had not understood the difference between a pilaster and a column.

33. This date comes from a manuscript written in 1563 by Claude Demongeot and transcribed by the canon Henriot. The text is in Eisler, 1979, p. 337; Julien de la Boullaye, who published it, thought that this early date was the result of an error in transcription, probably for 1510.

34. Heitz and Schreiber, *Pestblätter des xv. Jahrhunderts*, Strasbourg, 1901.

35. Eisler 1979, Chapter V, has made suggestive comparisons.

36. One of the plates, *Saint Michael Slaying the Dragon*, is known only in the form of a single proof in the Bibliothèque de Dijon. The others were printed, but left blank the cartouches obviously reserved for inscriptions.

37. See my review of Eisler's book in *Art Bulletin*, LXIII, 1981, pp. 332–334.

38. Hypothesis suggested by Wardropper, 1985.

39. The house is referred to as the *Maison de Diane de Poitiers*, 20 rue Cardinal-Morlot.

40. See, for example, Ferdinand Claudon, *Histoire de Langres et de ses institutions municipales jusqu'au commencement du XVIe siècle*, Dijon, Association des sociétés savantes, 1954, particularly pp. 129–130, regarding the confrontations over merchant rights from 1439 to 1469.

CHAPTER X

1. Prosper Mérimée, *Notes de voyage*, Paris, Pierre-Marie Auzas, 1971, pp. 283–284.

2. The arcades closing the chapel on the nave side, now moved against the wall of the south transept, bear the date 1553. It is plausible to assume this is the date of completion; however, it calls into question the chronological relationship between the lower (up to the large lintel) portion of the chapel, and the sculpted groups on the upper level. The architectural and ornamental parts of this level are significantly different and appear to be from a later period. It is possible that the date 1553 applies only to the lower one. Yet it is difficult to place the upper portions much later in the century. For one thing, the statuary above is very similar to that below, and furthermore, the prior of Solesmes who commissioned the work, Jean Bougler, died in 1556.

3. "*Il faut excepter une seule niche dont il est parlé plus bas,*" ("except a single niche that is discussed below") reads a note here by Mérimée. It is clear that for him, the older part is distinguished from the newer only by its "*détails.*"

4. Mérimée, *Notes de voyage*, op. cit., p. 284.

5. Ibid., pp. 284–285.

6. Ibid., p. 286.

7. Ibid., p. 286.

8. Cartier, 1877.

9. Souhaut, 1883.

10. Palustre, 1879–1885, vol. III, p. 138. There is an altogether discouraging comparison with the tomb of Champeaux, a work for which J. de Lespine is the documented author.

11. Jacques Hourlier, "Josse Chlichtove et Jacques Lefèvre d'Étaples à Solesmes", *Revue du Maine*, XLIX (1969), pp. 71–95.

12. On the subject of miraculous images, see especially Freedberg, 1989.

13. This is the thesis offered by Forsyth, 1970. He hesitates between Burgundy and Lorraine as a point of origin, but favors Lorraine. In this case, the *Entombment* at Pont-à-Mousson, one of the oldest still in existence, would represent a type close to the original, an intermediate step between the German formulation and the later French Entombments. The Burgundian hypothesis appears more probable at this time. One would have to imagine that the invention emanated more or less directly from the workshops in Champmol, and that the Pont-à-Mousson version represents a sort of compromise between the two formulations competing in these frontier regions. Finally, if the *Entombment* at Saint Dizier in Troyes does in fact date from around 1420, and not from the sixteenth century, as is generally accepted today, this new evidence would be of enormous significance. It might be necessary to envisage the possibility that the invention took place in Champagne.

14. Ibid.

15. One peculiarity is difficult to explain. Usually, Joseph of Arimathea holds the shroud at the head, and Nicodemus the shroud at the feet of Christ. Not so at Solesmes, where the lower extremities of Christ are

supported by another figure, whom many consider to be a portrait, though no agreement exists as to his identity.

16. There are two entrances, the one I have described, which opens on the north side-aisle, and a door directly into the choir. Perhaps the procession entered on one side and filed through, exiting on the other?

17. It should not be forgotten that this was a private chapel accessible only to the chaplain and the family of its donors. Helga D. Hoffmann, in "Die Grablegung von Pont-à-Mousson: ein Meisterwerk der Sluter-Nachfolge und die thematisch verwandten Gruppen in Lothringen," *Annales Universitatis Suraviensis (Philosophie)*, 8, Saarbrücken, Universität des Saarlandes, 1959, pp. 299–323, fig. 14–35, mentions two guards in front of the chapel at Chaumont.

18. Forsyth, 1970, believes that this is the original placement. At Auch, where the monument certainly remained unaltered, it is definitely an *Entombment*. Later, a tabernacle was installed right against the sarcophagus, in such a way that the Holy Sacrament literally issues from the tomb (fig. 183). This arrangement was clearly not part of the original intent, since it hides a motif on the casket. However, it demonstrates the liturgical implications of the work well.

19. It has been moved and now stands against the east wall of the south transept.

20. A design change clearly occurred while production of the ornamental framework was underway. Work began on either side of the *jubé* (now destroyed) and moved toward the chevet. The first bays on the west side have purely Flamboyant decoration. Next, Italianate motifs appear on the stylobate while the lace on the baldachin remains Gothic. In spite of these differences, the framework, executed within a narrow timeframe, lends a strong sense of coherence to the ensemble.

21. The text published by Lefèvre-Pontalis, 1888, p. 168, specifies that "most of the figures, ladders, and other attributive elements of the subject matter have not only lost their gilding and colors, but are rotten as well." ("La plupart des personnages des échelles et autres ustensiles attributives au sujet sont non seulement dédorés et les couleurs passez, mais encore pourris.") It is reasonable to assume, then, that the composition was a monumental wood polychrome group, though the term "rotten" may possibly also apply to stone.

22. The holy women are portrayed in the classicizing style, but lack character. The stucco seems slightly mushy. The composition is not a group of statutes but a high relief, with background elements suggesting a landscape. It would appear that the faces of the figures were painted.

23. The document published by Leblond, 1921, p. 161, entirely escaped attention, with the exception of one reference by Baudoin, 1992, p. 301.

24. It is quite certain that the initials N.L.P. refer to the artist in question, since on August 4, 1550, he received a payment of 120 *livres* relating to the contract "*pro confectione vitrinae partis meridionalis cruciatae ecclesiae.*" Quoted in Leblond, 1921, p. 7.

25. Quoted in Leblond, 1921, p. 161.

26. The contract for painting the chapel of the Holy Sepulcher and the *étoffage* of the statues was signed by the painters Jean and Nicolas Nitart, and involved the considerable sum of 360 *livres*. A document dated August 21, 1570 indicates that a "*visitation*" found the work unfinished; after the parish accountants sued the painters, Nitart promised to finish the work by All Saints Day, and to return 100 *livres* to the vestry—more than a quarter of the total price. See Leblond, 1921, pp. 168–170.

27. Quoted in Leblond, 1924, pp. 17–18.

28. The three Marys are not mentioned in the documents from Beauvais, but it is not impossible that they were present. This is even likely because the contract for the *Resurrection* mentions eight figures, which is more than one would expect for this subject alone. The group at Pontoise, with its four guards, already seems a little redundant.

29. Adhémar, 1976.

30. The author of this outstanding work from around 1480 remains unknown. Baudoin, 1983, supports an attribution to Antoine Le Moiturier, whom he also credits with the magnificent *Holy Sepulcher* at Semur-en-Auxois. Camp, 1990, pp. 194–197, refutes this claim (a document shows that Le Moiturier could not find work in Dijon at the time the tomb would have been sculpted) and suggests attributing it to Guillaume Chandelier instead, a sculptor who appears to have been important in Dijon, but for whom we have no documented works. The suggestion is therefore only a hypothesis, but does merit attention: Camp also ascribes the Semur *Sepulcher* to Chandelier. If true, it would make him the greatest Burgundian sculptor of the late fifteenth century.

31. Quoted by Panofsky, 1964, p. 62.

32. Michel Colombe would later refer to these tombs, and there is no doubt that Péréal, who designed the project at Nantes, was aware of them. Vitry, 1901, pp. 487–490, provides the text of the agreement Colombe signed with Margaret of Austria on December 3, 1511 for the tombs at Brou. Regarding an alabaster quarry in which Jean Lemaire de Belges seems to have had an interest, the sculptor affirms that "of it are made none of the tombs of their late lordships, the dukes of Burgundy, even those produced by the superlative image carvers Master Caux and Master Anthoniet, whom I, Michel Coulombe, was previously acquainted with." ("En ont esté faictes aux Chartreux de Dijon, aucune des sépultures de feuz messeigneurs les ducz de Bourgoigne, mesment par maistre Caux et maistre Anthoniet, souverains tailleurs d'ymaiges, dont je Michel Coulombe, ay autreffoy eu la cognoissance.") In spite of Vitry's reservations, there is most certainly no reason to particularly doubt that Colombe spent time in Dijon.

33. We shall see that the idea was retained for the tomb of Louis XII.

34. Among traditional corpse effigies, there is a distinction between those with their eyes closed, who await the Resurrection, and figures whose eyes are open, indicating that they have already awakened to the new eternal life.

35. It is reasonable to assume that there is a continuity linking kneeling donor figures and the funerary effigies that adopted the same attitude. Formally, the similarity is absolute: there is no difference between a tomb effigy and the kneeling statues of the duke of Berry and his wife, which were in the Sainte Chapelle in Bourges. It should not be forgotten, however, that these praying figures, without being part of the tomb itself, were integrated into a funerary context: the sepulcher was close to them within the chapel. One can make out a transition from representations of the deceased in prayer before the Virgin—a common theme often painted above the corpse effigy—to the sculpted group of the duke and duchess of Berry praying before Notre-Dame la Blanche, and finally, the kneeling figure facing the altar placed on the tomb. The terra-cotta statue of a man (Giovanni or Andrea Pellegrini) praying in front of the altar in the Pelligrini chapel of Santa Anastasia in Verona is of the same type as the Bourges figures. The figure is close to the sepulture, but not properly speaking part of the tomb. Nevertheless it functions in much the same way as a funerary effigy.

36. Nothing remains of the tomb but the platform. Its original state is known from a drawing in the Gagnières collection. See Adhémar, 1976, n⁰ 1243.

37. For information on the *transi*, see Cohen, 1973: Chapter VI is devoted to French tombs of the sixteenth century.

38. Roy, 1929–34, pp. 157–168.

39. Laborde, 1877, p. 293. The attribution to Germain Pilon suggested by Gaehtgens, 1967, has not been accepted. It may deserve a second chance.

40. Much ink was spilled in the past over these sculptures, four of which remain. One is currently at the Musée de la Renaissance in Écouen. Three others were used for the monument of the heart of François II at the Celestins monastery, later moved to Saint Denis. For a long time it was believed that Dimier's theory was correct: the figure at Écouen was by Pilon, while the three others belonged to the series by Ponce. This idea was called into question at the colloquium devoted to Pilon in October 1990. Participants were given an opportunity to examine and discuss the figures at Saint Denis. No unanimous opinion was reached. In the published version of the colloquium—Bresc-Bautier ed., 1993—Anthony Radcliffe, who worked on Ponce, concluded that all four pieces were by Pilon. Jacques Thirion, on the other hand, distinguishes among the figures at Saint Denis, designating the one with a more pained expression as the work of Ponce. I cannot agree with this assessment. If one of them is by another hand, it would seem to me most likely the one with slightly long hair whose figural type is rather different from the others. Finally, we are so poorly acquainted with the work of Ponce Jacquiot that it is practically impossible to give a convincing answer to this question. Are we even sure that the *putto* at Écouen is by Pilon rather than Ponce? It does not seem to me very far removed from the ones in the *Salone degli Stucchi* at the Sacchetti palace in Rome, a documented work by Ponce (see fig. 74 in Bresc-Bautier in particular). In fact, we remain uncertain as to the respective ages of these two sculptors. What we do know is that there exist documented works by Ponce prior to the Saint Denis commission, whereas there are none for Pilon. The lesson here may well lie in our irremediable uncertainty itself. It is not, I believe, entirely due to a lack of information, but rather to the nature of sculpture at this moment in the sixteenth century. Since the sixteen figurines were destined for the same monument, it was important that they were homogeneous: the execution of such works required complete submission of the *tailleur* to the leadership of the worksite, and an assimilation on his part of a collective style attenuating individual expression.

41. Grodecki, 1985–86, n⁰ 540.

42. For Duprat and Poncher, see Grodecki, 1985–86, n⁰ˢ 276 and 541 respectively. For Maigny, see Roy, 1929–34, pp. 394–397.

43. See Beaulieu, 1982.

44. Of course, the royal tomb was dismantled after the Revolution, as were all the monuments at Saint Denis. The nineteenth-century reconstruction did alter it somewhat, but all the sculpture was saved. By a stroke of luck, even the bronzes escaped, except for the praying desks, which were melted down. I fail to understand why Viollet-le-Duc did not have them replaced. The most grievous alteration to the project was the placement of the Cardinal Virtues on pedestals that are oriented along the diagonals, whereas the bases of the figures were originally in line with the tomb. Thomas Lersch, in Bresc-Bautier ed., 1993, pp. 97–99, has shown that this change does not date from the nineteenth century, but occurred in the eighteenth, when the monument was transferred from the rotunda to the basilica. He seems to conclude that the Virtues themselves were originally placed along the longitudinal axis of the tomb (the east-west axis), and not obliquely as they are today, or as were the figures on the tomb of Louis XII. This theory strikes me as unlikely. Visual evidence, particularly the Giffart engraving, which predates the tomb's disassembly, does not show Strength on an axis parallel to the kneeling figure of Catherine de Médicis, but facing the corner instead. Similarly, the Marot print shows Justice on an oblique, with her feet facing the outside corner of the pedestal. One may also note that the old Howard monument at Dover that derives directly or indirectly from the Saint Denis tomb

presents protruding pedestals parallel to the tomb, on which the Virtues are nevertheless diagonally placed (see the survey of this monument in Levkoff, ibid., p. 80, fig. 9).

45. Printed in 1588 when Pilon was still alive, the engraving by Jean Rabel in the publication by Bonfons (continuing the work of Corrozet on the *Antiquités de Paris*), while otherwise accurate, normalizes the effigy's pose by joining the king's hands in prayer: an indication of how deeply rooted the custom was.

46. Babelon, 1927.

47. Geisey, 1960, maintained that the ritual served primarily a semi-legal function: prolonging the earthly being was necessary to avoid any lapse of royal continuity until the succession actually took place, which happened only when the deceased monarch was buried and had literally disappeared. Anne-Marie Lecoq expressed doubts about this generally accepted hypothesis in a talk she gave at the Centre de la Renaissance in Tours, pointing out the large number of non-reigning individuals who were given funeral rites that incorporated an effigy. Some reservations regarding the theory can also be found in Alain Bourreau, *Le Simple Corps du roi: l'impossible sacralité des souverains français. XVIᵉ-XVIIIᵉ siècles*, Paris, 1988.

48. Mâle, 1908, Part 2, Chapter III, was a severe critic of these tombs. He perceived them as betraying incomprehension of the idealized effigies with wide-open eyes from the thirteenth century. This seems to greatly exaggerate the secularization of Renaissance art, and to underestimate a culture that understood Church doctrine perfectly well, while at the same time expressing new aspirations.

49. By coincidence, the gesture is described and interpreted in the book devoted to Henri II's triumphal entry into Paris in 1549, folio 4, verso. The actor is the third *Fortune* decorating the *fontaine du Ponceau*: "the third denoted that of the populace, and held her right hand near her stomach, in an expression of fidelity and innocence." ("La tierce denotoit celle du peuple, & tenait sa main droitte dessus son estomach, en signe de fidélité et d'innocence").

50. Panofsky, 1964, p. 80, insists rightly on the neo-medieval quality of these statues. I do not, however, understand why he asserts, contrary to documentary evidence, that these supernumerary effigies were ordered for the basilica itself, rather than the rotunda.

51. Grodecki, 1981.

52. This is known from an engraving reproduced in s'Jacob, 1954.

53. The *transi* at Gisors is very similar to the more famous one at Clermont-d'Oise, which is not dated. Cohen, 1973, p. 73, is certainly correct to see these monuments as veritable tombs, and not cenotaphs inserted for purely didactic purposes as suggested by Baltrušaïtis (*Le Moyen Âge fantastique*, Paris, A. Colin, 1955, p. 236). The inscription *"je fus en ce lieu mis l'an 1526"* ("I was placed here in the year

1526"), engraved on the Gisors monument, applies to the deceased, rather than the sculpture. The *transi* at Clermont is reproduced in Cohen, 1973, fig. 22.

54. This was Courajod's hypothesis, *Germain Pilon et les Monuments de la chapelle de Birague*, Paris, 1885. He published the original drawing. The decision to paint the bronze would have been made to counteract the poor lighting conditions of the monument when placed below a window. Grodecki, 1981, rejects the theory because the coloration was provided for in the contract; however, her objection does not constitute an argument since the document in question was signed after the tomb had been moved to the north wall.

55. See Bresc-Bautier ed., 1993, pp. 215–229. On restorations to the work, see Chataignère, ibid., pp. 237–254.

56. The problem presents itself because the hand was amputated during the disassembly of the monument; it was moved from its original setting and Saint Maxe itself was demolished. A first attempt at restoration had the figure holding an hourglass, making it an allegory of death. In Cohen, 1973, p. 178, note 142, there are references to several texts, notably that of De Maillet from 1767: "The heart of René de Châlons was taken to the church of Saint Maxe de Bar; it is there enclosed in a red heart-shaped box that a marble skeleton, close to the main altar to the side of the Evangelists, holds in its left hand." Other texts seem to indicate that the entrails and heart of the prince had been buried in front of the altar at the collegiate church. It is therefore not certain whether the heart was actually in the palm of the *transi*. This, however, does not change the meaning of the work.

57. Forsyth, 1970, p. 161.

58. For the attribution to Richier, see Souhaut, 1883.

59. This is the solution endorsed by Beaulieu, 1978.

60. For the history and the restoration of *Diana*, see Beaulieu, 1978. I have Geneviève Bresc to thank for having drawn my attention to the poor condition and radical restorations of the famous statue.

61. The funerary theme of the fountain, and its relationship to the iconography of Anet is treated thoroughly by Miller, 1977, pp. 146 *et seq.*

CHAPTER XI

1. Henri Estienne, *Deux dialogues du nouveau langage françois italianisé*, 1889, p. 111.

2. The book was published by Jeanne de Marnef, widow of Denis Janot. See Brun, 1989, pp. 112–113, for reprints and copies. The artist who designed the French woodcuts is anonymous (on reforms in the production of illustrated books in Paris, see Chapter VIII). The Cupid and Psyche series engraved by Raphael's entourage was highly popular in France; the motifs were thus copied in a famous set of stained-glass windows at the château of Écouen (now at the Musée Condé, Chantilly), a rare example of non-ecclesiastical stained glass in France.

3. Fontaine, 1984, pp. 554–556, has demonstrated the link between *Les Illustrations de Gaule et singularitez de Troie* by Jean Lemaire de Belges and the curious romance published by Barthélmey Aneau in 1560, *Alector, ou le coq*. The title of Aneau's romance speaks volumes: not only is the cock France's national symbol, but Alector means cock in Greek; furthermore, Alector's father is called Fran-Gal. See also Fontaine's critical edition of Aneau, *Alector, ou le coq: Histoire fabuleuse* (Geneva: Droz, 1996).

4. The 1724 edition of Pasquier's *Oeuvres*, published in Amsterdam in two volumes, is the one generally consulted.

5. On this point, see especially the excellent analysis in Cave, 1979, pp. 48–55.

6. On this subject, see Christopher Wood, *Albrecht Altdorfer and the Origins of Landscape* (London: Reaktion Books, 1993), especially Chapter Three, "The German Forest."

7. See Golson, 1969.

8. The original French text for each translated citation from Philibert is provided hereafter. "Et oultre tout cecy, n'ay-je pas faict d'autres services, quant ce ne seroyt que d'avoir porté en France la façon de bien bastir, osté les façons barbares et grandes commissures, monstré à tous comme l'on doibt observer les mesures de architecture, tant que j'ai faict les meilleurs ouvriers qui sont aujourd'huy, comme ils confessent ? que l'on se souvienne comme l'on faisoyt quand je commençoys Sainct-Mort pour Mons. le cardinal du Belloy !" Anthony Blunt, *Philibert de l'Orme* (London: A. Zwemmer, 1958), p. 148. The French text of the entire *Instruction* is reprinted on pp. 146–151.

9. "Estant à Rome du temps de ma grande jeunesse, je mesurois les edifices & antiquitez, selon la toise & pied de Roy, ainsi qu'on faict en France. Advint un jour que mesurant l'arc triumphant de saincte Marie nove, comme plusieurs Cardinaux & Seigneurs les pourmenois visitoient les vestiges des antiquitez, & passoient par le lieu ou j'estois, le Cardinal de saincte croix lors simple Evesque seulement (mais depuis Cardinal, & Pape sous le nom de Marcel, homme tresdocte en diverses sciences, & mesmes en Architecture, en laquelle pour lors il prenoit grand plaisir, voire jusques à en donner & faire desseings & modelles, ainsi que puis apres il les me monstra en son Palais) dit en son langage Romain, qu'il me vouloit cognoistre, pour autant qu'il m'avoit veu & trouvé plusieurs fois mesurant divers edifices antiques, ainsi que je faisois ordinairement avec grand labeur, frais & despens, selon ma petite portée, tant pour les eschelles & cordages, que pour faire fouiller le fondements, à fin de les cognoistre. Ce que je ne pouvois faire sans quelque nombre d'hommes qui me suyvoient, les uns pour gaigner deux Carlins le jour, les autres pour apprendre, comme estoient ouvriers, menuisiers, scarpelins ou sculpteurs & semblables qui desiroient cognoistre comme je faisois, & participer du fruict de

ce que je mesurois. Laquelle chose donnoit plaisir audict seigneur Cardinal, voire si grand qu'il me pria estant avec un gentilhomme Romain qu'on nommoit misser Vincencio Rotholano, logeant pour lors au Palais de sainct Marc, que je les voulusse aller voir, ce que leur accorday tresvoluntiers. Ledict seigneur Rotholano homme fort docte aux lettres & en l'Architecture prenoit grandissime plaisir à ce que je faisois, & pour ceste cause me monstroit, comme aussi ledit seigneur Cardinal, grand signe d'amitié. Bref apres avoir discouru avec eux de plusieurs choses d'Architecture, & entendu d'ou j'estois, me prierent de rechef de les visiter souvent audict Palais, ce que je fis. Auquel lieu ils me conseillerent entre autres choses, (apres avoir cogneu la despense que je faisois pour cercher les antiquitez, & retirer toutes choses rares & exquises en l'art d'Architecture) que je ne mesurasse plus lesdictes antiquitez selon le pied de France, qui estoit le pied de Roy, pourautant qu'il ne se trouveroit si à propos que le palme Romain, suyvant lequel on pouvoit fort bien juger des ancien edifices qui avoient esté conduicts avec iceluy plutost que avec autres mesures, & signamment avec le pied antique, me donnant lors & l'un et l'autre avec leurs mesures, longueurs, & divisions telles que je vous les proposeray cy après." De l'Orme, 1567, fols. 131–131vᵒ.

10. When it comes to Ionic volutes, Pauwels, 1992, pp. 230–231, has demonstrated the disparity between the passage in his treatise where Philibert presents his solution to this particularly difficult problem as a sudden revelation, and the progressive apprenticeship revealed by study of the architect's works.

11. Blunt, 1958, carefully traced Philibert's sources. On Anet in particular, see Hoffmann, 1973, pp. 132–134 and passim; on de l'Orme and Michelangelo, see Guillaume, 1987.

12. "Mais si l'Architecte qui l'a conduicte eust entendu les traicts de Geometrie, desquels je parle, il eust fait tout remper, je dy jusques aux basses & chapiteaux, qu'il a faict tous quarrez, comme s'il eust voulu faire servir à un portique qui est droit & à nyveau : par le dessus des chapiteaux, & au-dessous des basses du costé de la descente, il a mis des coings de pierres pour gaigner la hauteur du rempant. Laquelle chose monstre que l'ouvrier qui l'a faicte n'entendoit ce qu'il fault que l'architecte entende. Car au lieu qu'il a faict la voute de brique, il l'eust faicte de pierre de taille, & d'une colomne à autre des arcs rempants. [...] Par là on eust cogneu qu'il eust bien entendu son art d'Architecture. [...] Nous avons une infinité de beaux traicts en France, desquels on ne tient aucun compte, pour ne les entendre, & que pis est, lon ne se soucie gueres de chercher l'excellence et beauté des œuvres." De l'Orme, 1567, fᵒ 124vᵒ.

13. "Mais quoy ? les singularitez de son propre païs & royaume sont toujours moins prisées, principalement en France, que celles des estrangers. Je crois certainement qu'il ne se trouvera royaume ne païs, quel qui soit, mieux meublé & garny de diversité de pierres pour

bastiments, que cestuy cy. De sorte que nature y a si bien pourveu qu'il me semble qu'on ne sçaurait trouver nation qui ait plus beau moien de bastir que les Français. Mais la pluspart d'eux ont telle coustume, qu'ils ne trouvent rien bon (ainsi que nous avons dit) s'il ne vient d'estrange païs, & couste bien cher. Voila le naturel du François, qui en pareil cas prise beaucoup plus les artisans & artifices des nations estranges, que ceux de sa patrie, jaçoit qu'ils soient tresingenieux & excellents." De l'Orme, 1567, f° 27.

14. On the French order, see Pérouse de Montclos, 1977. It is worth mentioning the two columns in Saint Maclou in Rouen by Jean Goujon: one is in two sections, the other in three (including a very narrow one). Goujon masked the joins with highly elegant gilded ornamentation. This decoration is now scarcely visible, but it was noted and meticulously described by Vesly, 1904, who failed however to see its suggestive relationship to Philibert's French order.

15. "Pour autant que ce Troisieme livre est presque tout employé à la declaration & description de certains traicts & lignes que nous appellons Geometriques, fort necessaires aux Architectes, maistres maçons, appareilleurs de pierres, tailleurs et autres, pour s'en sçavoir & pouvoir ayder aux lieux que nous proposerons, & selon les façons que nous en donnerons & se cognoistrons par le discours & lecture desdicts traicts, qui ne peuvent estre proprement trouvez ny asseurément pratiquez, sinon par l'ayde & maniment du compas, je me suis pour ceste cause advisé de excogiter & familierement descrire la figure & image que vous avez cy apres." De l'Orme, 1567, f° 22v°.

16. "Car pourveu que les mesures soient bien gardées, ses portraits ne sçauroient faillir à se bien monstrer." De l'Orme, 1567, f° 22v°.

17. Despite the debate it has provoked, the crucial work on this point remains Rudolph Wittkower's amply illustrated *Architectural Principles in the Age of Humanism* (London, Studies of the Warburg Institute: 1949, plus numerous subsequent editions, notably Academy Editions, 1988).

18. "… les priant affectionnément de vouloir employer & donner quelque temps pour assembler et proprement recoudre les pièces de la robbe de ce grand & incomparable auteur, par-cy, par-là, semées et respandues, sous evident desordre : qui sera facile à estre reduict en bon ordre, moiennant l'ayde & le labeur des doctes. Au refus desquels (ainsi que j'ay dit d'Euclide) ie me parforceray d'y travailler & employer quelque temps, ainsi qu'il plaira à Dieu m'en faire grace." De l'Orme, 1567, f° 62.

19. Pérouse de Montclos, 1982.

20. "Aujourd'hui, ceux qui ont quelque cognoissance de la vraye Architecture, ne suivent plus ceste façon de voute, appellée entre les ouvriers La mode Françoise, laquelle véritablement ie ne veux despriser, ains plustost confesser qu'on y a faict & pratiqué de fort bons traicts & difficiles. . . . L'auteur approuver la

façon moderne des voutes, toutefois ne s'en vouloir ayder." De l'Orme, 1567, f° 107.

21. The half-dome of the Temple of Venus in Rome has been cited, not unreasonably, as a precedent for Philibert's highly original coffering. See Blunt, 1958, p. 42 and pl. 25b.

22. "Quand vous voudrez y mettre des compartiments de moulures, avec autres sortes d'ouvrages, vous le pourrez faire beaucoup plus richement que aux voutes dont je vous ai parlé cy-devant. Vous pouvez encore faire par dessous le pendentif de même sortes de branches, que l'on faict en la voute de la mode Française, soit en façon d'ogives, liernes, tiercerons, ou autres, voire avec des clefs surpendues, & de plus grande grace que lon n'a point encores veu. Ceux qui voudront prendre la peine, cognoistront ce que je dy par la voute spherique laquelle j'ai faict faire en la chapelle du chasteau d'Annet, avecques plusieurs sortes de branches rempantes au contraire l'une de l'autre, & faisant par mesme moyen leurs compartiments qui sont à plomb & perpendicule dessus le plan & pavé de ladicte chapelle, qui faict et monstre une mesme façon & semblable à celle que je propose par la figure subsequente." De l'Orme, 1567, f° 112.

23. De l'Orme, 1567, f° 30.

24. Note that Anthony Blunt, in *Art and Architecture in France, 1500–1700* (Harmondsworth, Middlesex: Penguin, 1970), pp. 77–78, dates this part of Écouen to about 1555, attributing it to Jean Bullant and describing it as a "variant on de l'Orme's central motive [sic] at Anet."

25. "Car on verra à l'œil, & se trouvera que les Papes, Roys & grands seigneurs, ne font aucunes magnifiques excellences en leurs chasteaux & palais, soit en ornements de marbres ou incrustations, en belles chambres, beaux jardins, meubles exquis & riches, que incontinent les gentilshommes, bourgeois officiers, & autres n'en veuillent avoir le semblable, avec tres-folles despenses, & autrement demesurées que ceux qui les font. […] Pleust à Dieu, & à ma volonté, que les riches bourgeois, marchands, financiers, & autres qui jouissent des biens de fortune en toute affluence & outre mesure, s'adonnassent aussi tost à faire & fonder quelques hostels-dieu, ou colleges pour le soulagement des pauvres, & utilité du bien publique, que edifier un tas de superbes & magnifiques maisons qui ne leur servent que d'envie & malheur, ainsi qu'il se voit ordinairement. Je suis souventefois honteux de plusieurs qui desirent faire bastiments indignes d'eulx, & me demandent conseil sur leur deliberation : ausquels je responds qu'un chacun se doit mesurer selon son pied." De l'Orme, 1567, f° 329v°–330.

26. See Diderot's entry for Contemporain" (contemporary) in the *Encyclopédie*.

BIBLIOGRAPHY

Adhémar, Jean. *Inventaire du fonds français. Graveurs du XVI^e siècle.* Vol. 2. Paris: Bibliothèque nationale, 1938.
———. "French Sixteenth Century Genre Paintings." *Journal of the Warburg and Courtauld Institutes* (1945): 191–195.
———. "Aretino: Artistic Advisor to Francis I." *Journal of the Warburg and Courtauld Institutes* (1954): 311–318.
———. "Ronsard et l'école de Fontainebleau." *Bibliothèque d'humanisme et Renaissance* (1958): 344–348.
———. "Henri Zerner et les étapes de l'école de Fontainebleau." *Gazette des Beaux-Arts* (1969): 117–120.
———. "Les portraits dessinés du XVI^e siècle au cabinet des estampes." *Gazette des Beaux-Arts* LXXXII (1973): 121–198 and 327–350.
———. "Catalogue des tombeaux de Gaignières." *Gazette des Beaux-Arts* July–September (1974): 1–1085, and July–August (1976): 1086–1837.
Amico, Leonard N. *Bernard Palissy: In Search of Earthly Paradise.* Paris and New York: Flammarion, 1996.
Association Claus Sluter, ed. *Actes des journées internationales Claus Sluter.* Dijon: Association Claus Sluter, 1992.
Aulanier, Christiane. "Le palais du Louvre au XVI^e siècle. Documents inédits." *Bulletin de la Société de l'histoire de l'art français* (1951): 85–100.
Avery, Charles. *Sculpture from Troyes in the Victoria and Albert Museum.* London: Victoria and Albert Museum, 1974.
Babelon, Jean. *Germain Pilon.* Paris: n.p., 1927.
Babelon, Jean-Pierre. "Du Grand Ferrare à Carnavalet. Naissance de l'hôtel classique." *Revue de l'art* 40–41 (1978): 83–108.
———. *Nouvelle histoire de Paris: Paris au XVI^e siècle.* Paris: Hachette, 1986.
———. *Châteaux de France au siècle de la Renaissance.* Paris: Flammarion, 1989.
Babelon, Jean-Pierre, ed. *Le Château en France.* Paris: Berger-Levrault, 1986.
Bardon, Françoise. *Diane de Poitiers et le Mythe de Diane.* Paris: PUF, 1963.
Barocchi, Paola. *Il Rosso Fiorentino.* Rome: Gismondi, 1950.
Baron, Françoise. "La Mise au tombeau dans la sculpture française du Moyen Âge." *Niccolò dell'Arca, Atti del Convegno. 26–27 maggio 1987*, 213–219. Bologna: Nuova Alfa Editoriale, 1989
Basset, André. *Scènes de l'Apocalypse. Tombeau de Jean de Langeac à la cathédrale de Limoges.* Limoges: Bontemps, 1955.
Baudi di Vesme, Alessandro. "Reverdino incisore cinquecentista." *Maso Finiguerra* 15–16 (1937): 187–205, and 16–17 (1938): 122–155.

Baudoin, Jacques. *La Sculpture flamboyante—Les grands imagiers d'Occident.* Nonette: Éditions Créer, 1983.
———. *La Sculpture flamboyante en Champagne-Lorraine.* Nonette: Éditions Créer, 1991.
———. *La Sculpture flamboyante en Normandie et Île-de-France.* Nonette: Éditions Créer, 1992.
Beaudoin Ross, J. "Jean Cousin the Elder and the Creation of the Tapestries of Saint Mamas." *Art Bulletin* (1978): 28–34.
Beaulieu, Michèle. *Description raisonnée des sculptures du musée du Louvre.* Vol. 2 of *Renaissance française.* Paris: Réunion des Musées nationaux, 1978.
———. "Pierre Bontemps et les Cousin Père et Fils, artistes sénonais de la Renaissance." In *Mélanges offerts à Jacques Stiennon.* Liège: n.p., 1982.
———. "Ligier Richier (vers 1500–1567). Chronologie et attributions." *Bulletin de la Société de l'histoire de l'art français, année 1986* (1988): 7–23.
———. *L'École de Fontainebleau. Le maniérisme à la cour de France.* Paris: Gonthier-Seghers, 1960.
———. "Le Maître de Flore de l'école de Fontainebleau." *Art de France* I (1961): 300–305.
———. "Niccolo dell'Abbate en France." *Art de France* II (1962): 113–146.
———. "Une « Résurrection » d'Antoine Caron." *Revue du Louvre et des Musées de France* (1964): 203–213.
———. "Compte rendu du livre d'Henri Zerner « L'École de Fontainebleau—Gravures »." *Revue de l'art* (1969): 103–107.
———. "À propos d'un dessin de Nicolas da Modena récemment acquis par le Louvre." *Revue du Louvre et des Musées de France* XX (1970): 9–14.
———. *Il Cinquecento francese.* Milan: Fabbri, 1970.
———. "Un tableau de Luca Penni." *Revue du Louvre et des Musées de France* (1975): 359–366.
———. *Le XVI^e Siècle français. Dessins et aquarelles des grands maîtres.* Paris: n.p., 1976.
———. "Contributo al studio dei disegni del Primaticcio." *Bolletino. d'Arte* 15 (1982): 27–52.
———. "Luca Penni peintre: nouvelles attributions" and "Il se rendit en Italie." In *Études offertes à André Chastel*, 243–257. N.p.: 1987.
———. "New Evidence for Rosso in France." *Burlington Magazine* (1989): 828–838.
———. "À propos de Luca Penni." *Disegno. Actes du colloque du musée des Beaux-Arts de Rennes, 1990*, 9–18. Rennes: n.p., 1991.
Béguin, Sylvie et al. *La Galerie François Ier au château de Fontainebleau. Numéro spécial de la Revue de l'art.* Paris: Flammarion, 1972.
Béguin, Sylvie, Jean Guillaume, and Alain Ray. *La Galerie d'Ulysse à Fontainebleau.* Paris: PUF, [1985].

Benesch, Otto. "Jean Cousin fils, dessinateur." *Prométhée* (December 1939–January 1940): 271–280.

Berliner, Rudolf. *Ornamentale Vorlageblätter des 15. bis 18. Jahrhundert*. 3 vol. Leipzig: Klinkhardt & Biermann, 1925–26.

Bernard, Auguste Joseph. *Geoffroy Tory, Painter and Engraver, First Royal Printer, Reformer of Orthography and Typography under François I: an Account of His Life and Works*. Translated by George B. Ives. Cambridge, Mass.: Riverside Press, 1909.

Bimbenet-Privat, Michèle. *Les Orfèvres parisiens de la Renaissance (1506–1620)*. Paris: Commission des travaux historiques de la Ville de Paris, 1992.

Bimbenet-Privat, Michèle and Fabienne Le Bars. "New Documents on Sixteenth-Century Printmaking in Paris." *Print Quarterly* (1994): 151–155.

Blamoûtier, Nadine, trans. *La Vie de Benvenuto Cellini écrite par lui-même — 1500–1571*. N.p.: Scala, 1986.

Blunt, Anthony. *Art and Architecture in France 1500 to 1700*. 4th ed. London: Penguin , 1980.

———. *Philibert de l'Orme*. London: Zwemmer, 1953.

Bondanella, J.C. and P. Bondanella. *My Life*. Oxford: Oxford University Press, 2002.

Bonnaffé, Edmond. *Inventaire des meubles de Catherine de Médicis en 1589*. Paris: Auguste Aubry, 1874.

———. *Le Meuble en France au XVI^e siècle*. Paris and London: n.p., 1887.

Boorsch, Suzanne, Michael Lewis and R.E. Lewis. *The Engravings of Giorgio Ghisi*. New York: Metropolitan Museum of Art, 1985.

Boullaye, Julienne de la. *Étude sur la vie et sur l'œuvre de Jean Duvet, dit le Maître à la licorne*. Paris: G. Rapilly, 1876.

Bourciez, Édouard. *Les Mœurs polies et la Littérature de cour sous Henri II*. Paris: Hachette, 1886. Reprint 1967, Geneva: Slatkine Reprints.

Bresc-Bautier, Geneviève, ed. *Germain Pilon et les Sculpteurs français de la Renaissance, Actes du colloque, 26–27 octobre 1990*. Paris: La Documentation française, 1993.

Broglie, Raoul de. "Les Clouet à Chantilly. Catalogue illustré." *Gazette des Beaux-Arts* I (1971): 261–340.

Brown, Elizabeth A. R. and Richard C. Famiglietti. *The "Lit de Justice" : Semantics, Ceremonial, and the Parlement of Paris 1300–1600*. Sigmaringen: Jan Thorbecke, 1994.

Brun, Robert. *Le Livre français illustré de la Renaissance*. Paris: Picard, 1969.

Camp, P. "Les imageurs bourguignons de la fin du Moyen Âge." In *Cahiers du Vieux Dijon*. Dijon: n.p., 1990.

Campardon, Émile and Alexandre Tuetey. *Inventaire des registres des insinuations du châtelet de Paris: règnes de François Ier et Henri II*. Paris: Imprimerie nationale, 1906.

Carroll, Eugene A. *The Drawings of Rosso Fiorentino*. New York and London: Garland, 1976.

———. "Printmaking in Renaissance France." *Print Quarterly* XII (1995): 299–303.

Cartier, E. *Les Sculptures de Solesmes*. Paris and Le Mans: V. Palmé / Monnoyer, 1877.

Cave, Terence. *The Cornucopian Text: Problems of Writing in the French Renaissance*. Oxford: Clarendon Press, 1979.

Céard, Jean, Marie-Madeleine Fontaine and Jean-Claude Margolin, eds. *Le Corps à la Renaissance, Actes du XXX^e colloque de Tours, 1987*. Paris: n.p., 1990.

Cellini, Benvenuto. *Opere*. Turin: UTET, 1980.

Chastel, André. *Culture et demeure en France au XVI^e siècle*. Paris: Julliard, 1989.

———. *French Art*. Translated by Deke Dusinberre. Paris and New York: Flammarion, 1994–95.

Chastel, André, ed. "La chapelle Saint-Éloi des orfèvres." *Bibliothèque d'humanisme et Renaissance* XXVIII (1966): 427–438.

Chastel, André, ed. *L'Art de Fontainebleau*. Paris: CNRS, 1975.

Chastel, André and Marco Rosci. "Un château français en Italie. Un portrait de Gaillon à Gaglianico." *Art de France* III (1963): 103–113.

Châtelet, Albert and Jacques Thuillier. *French Painting: From Fouquet to Poussin*. Translated by Stuart Gilbert. Geneva: n.p., 1963.

Chatenet, Monique. *Le Château de Madrid au bois de Boulogne*. Paris: Picard, 1987.

Chirol, Élisabeth. *Le Château de Gaillon*. Rouen and Paris: Lecerf/Picard, 1952.

Claudin, Anatole. *Histoire de l'imprimerie en France au XV^e et au XVI^e siècle*. 5 vols. Paris: Imprimerie nationale, 1900–15.

Cloulas-Brousseau, Annie. "Le jubé de la cathédrale de Limoges." *Bulletin de la Société archéologique et historique du Limousin* XC (1963): 101–188.

Cohen, Kathleen. *Metamorphosis of a Death Symbol: The Transi Tomb in the Late Middle Ages and the Renaissance*. Berkeley and Los Angeles: University of California Press, 1973.

Colas, René. *Les Styles de la Renaissance en France*. Paris: René Colas, 1928.

Courajod, Louis. *La Part de la France du Nord dans l'œuvre de la Renaissance*. Paris: Imprimerie nationale, 1890.

———. *Leçons professées à l'école du Louvre (1881–1896)*. Paris: Picard, 1899–1903.

Coyecque, Ernest. *Actes notariés*. Paris: Imprimerie nationale, 1905–1923.

Dan, Pierre. *Le Trésor des merveilles de la maison royale de Fontainebleau*. Paris: Sébastien Cramoisy, 1642.

Daragon, Éric. *Maniérisme en crise. Le Christ en gloire de Rosso Fiorentino à Città di Castello (1528–1530)*. Rome: Ed. dell'Elefante, 1983.

Davis, Nathalie Z. *Society and Culture in Early Modern France*. Stanford: Stanford University Press, 1975.

———. "Le milieu social de Corneille de La Haye (Lyon, 1533–1575)." *Revue de l'art* 47 (1980): 21–28.

De L'Orme, Philibert. *Traités d'architecture*. Introduction by Jean-Marie Pérouse de Montclos. Paris: Laget, 1988.

Denis, Paul. *Ligier Richier – L'artiste et son œuvre*. Paris and Nancy: Berger-Levrault, 1911.

Devauchelle, Roger. *La Reliure. Recherches historiques, techniques et biographiques sur la reliure en France.* Paris: Filigranes, 1995.

Dimier, Louis. *Le Primatice, peintre, sculpteur et architecte des rois de France.* Paris: Ernest Leroux, 1900.

———. *Les Impostures de Lenoir.* Paris: Sacquet, 1903.

———. *French Painting in the Sixteenth Century.* London and New York: Duckworth & Co./Scribners, 1904.

———. "La Tenture de la Grande Galerie tissée sous François Ier à Fontainebleau." *La Renaissance de l'art français et des industries de luxe* IV: 152–162.

———. *Histoire de la peinture de portrait en France au XVI⁰ siècle*: 3 vols. Paris and Brussels: Van Oest, 1924–27.

———. *Le Primatice.* Paris: Albin Michel, 1928.

Dimier, Louis. *L'Art français.* Henri Zerner, ed. Paris, Hermann, 1965.

Douais, Célestin. *L'Art à Toulouse.* Toulouse and Paris: Privat / Picard, 1904.

Du Colombier, Pierre. "Les jubés des Cordeliers et de Saint-Germain-l'Auxerrois." *Gazette des Beaux-Arts* II (1934): 144–147.

———. "L'énigme de Vallery." *Bibliothèque d'humanisme et Renaissance* IV (1937): 7–15.

———. "La chapelle d'Écouen." *Gazette des Beaux-Arts* II (1939): 79.

———. *Jean Goujon.* Paris: Albin Michel, 1949.

Dumont, Catherine. *Francesco Salviati au palais Sacchetti de Rome et la décoration murale italienne (1520–1560).* Rome: Institut suisse de Rome, 1973.

Durand, Georges. "Les Lannoy, Folleville et l'art italien dans le nord de la France." *Bulletin monumental* 70 (1906): 329–404.

Ehrmann, Jean. "Le tableau de la Résurrection du musée de Beauvais et la satire politique au XVI siècle." *Bulletin de la Société de l'histoire de l'art français* (1966): 49–59.

———. *Antoine Caron. Peintre des fêtes et des massacres.* Paris: Flammarion, 1986.

Eisler, Colin. "Étienne Delaune et les graveurs de son entourage." *L'Œil* (December 1965): 10–19.

———. *The Master of the Unicorn: The Life and Work of Jean Duvet.* New York: Abaris, 1979.

———. "Seeing Through Prints." *Print Collector's Newsletter* (1995): 50–55.

Elam, Caroline. "Art in the Service of Liberty: Battista della Palla, Art Agent for Francis I." *I Tatti Studies: Essays in the Renaissance* 5 (1993): 33–109.

Eschenfelder, Chantal. "Les appartements des bains à Fontainebleau. Conception et origine." *Histoire de l'art* no. 19 (1992): 41–49.

———. "Les bains de Fontainebleau: nouveaux documents sur le décor du Primatice." *Revue de l'art* 99 (1993): 45–52.

Febvre, Lucien. *Au coeur religieux du XVI⁰ siècle.* Paris: Sevpen, 1957.

Febvre, Lucien. *The Problem of Unbelief in the Sixteenth Century: the Religion of Rabelais.* Translated by Beatrice Gottlieb. Cambridge, Mass.: Harvard University Press, 1982.

Félibien, André. *Entretiens sur la vie et les ouvrages des plus excellens peintres anciens et modernes.* 5 vols. Paris: P. Le Petit, 1666–88.

Fergusson, Margaret W. "The Exile's Defense: Du Bellay's *La Deffence et illustration de la langue françoyse.*" *Publications of the Modern Language Association* (1993): 175–189.

Firmin-Didot, Ambroise. *Étude sur Jean Cousin suivie de notices sur Jean Leclerc et Pierre Woeriot.* Paris: Firmin-Didot, 1872.

———. *Recueil des œuvres choisies de Jean Cousin.* Paris: Firmin-Didot, 1873.

Fleury, Michel Fleury and Guy-Michel Leproux, eds. *Les Saints-Innocents.* Paris: Délégation à l'action artistique, 1991.

Fontaine, Marie-Madeleine. "« Alector » de Barthélémy Aneau, ou les aventures du roman après Rabelais." In *Mélanges sur la littérature de la Renaissance à la mémoire de V.-L. Saulnier,* 547–566. Geneva: Droz, 1984.

———. "Jean Martin, Traducteur." In *Mélanges Robert Aulotte, Prose et prosateurs de la Renaissance,* 109–122. Paris: SEDES, 1988.

Forsyth, William H. *The Entombment of Christ: French Sculptures of the Fifteenth and Sixteenth Centuries.* Cambridge, Mass.: Harvard University Press, 1970.

Franklin, David. *Rosso in Italy: the Italian Career of Rosso Fiorentino.* London and New Haven, Conn.: Yale University Press, 1994.

Freedberg, David. *The Power of Images: Studies in the History and Theory of Response.* Chicago: University of Chicago Press, 1989.

Gaehtgens, Thomas W. *Zum frühen und reifen Werk des Germain Pilon. Stilkritische Studien zur französischen Skulptur um die Mitte des 16. Jahrhunderts.* Thesis, University of Bonn, 1967.

Gault de Saint-Germain, Pierre. *Les Trois Siècles de la peinture en France, ou Galerie des peintres français depuis François Ier jusqu'au règne de Napoléon, empereur et roi.* Paris: Belin, 1808.

Gébelin, François. "Le Louvre de la Renaissance: les origines du grand dessein; la part de Jean Goujon." *L'Architecture* (July 10, 1923): 191.

———. "Un manifeste de l'école néoclassique en 1549 : l'entrée de Henri II à Paris." *Bulletin de la Société de l'histoire de Paris et de l'Île-de-France* 51 (1924): 35–45.

———. *Les Châteaux de la Renaissance.* Paris: Les Beaux-Arts, 1927.

———. *The Chateaux of the Loire.* Paris: Éditions Alpina, [1950].

Geisey, Ralph E. *The Royal Funeral Ceremony in Renaissance France.* Geneva: Droz, 1960.

Génin, F., ed. *Lettres de Marguerite d'Angoulême, sœur de François Ier, reine de Navarre.* Paris: J. Renouard, 1841.

Geymüller, H. de. *Les Du Cerceau, leur vie et leur oeuvre.* Paris and London: Jules Rouam / Gilbert Wood, 1887.

Giroux, H. "Essai sur la vie et l'œuvre dijonnais d'Hughes Sambin." *Mémoire de la commission des antiquités du département de la Côte-d'or* XXXII (1982): 361–413.

Golson, Lucile. "Landscape Prints and Landscapists of the School of Fontainebleau, c. 1543–c. 1570." *Gazette des Beaux-Arts* I (1969): 95–110.

Grivel, Marianne. "La réglementation du travail des graveurs en France au XVIᵉ siècle." In *Le Livre et l'Image en France au XVIᵉ siècle (Cahiers V. L. Saulnier 6)*, 9–27. Paris: Presses de l'École normale supérieure, 1989.

Grodecki, Catherine. "Le séjour de Benvenuto Cellini à l'hôtel de Nesle et la fonte de la nymphe de Fontainebleau d'après les actes des notaires parisiens." With an additional note on the Nymphe de Fontainebleau by Sylvia Pressouyre. *Bulletin de la Société de l'histoire de Paris et de l'Île-de-France* 98 (1971).

Grodecki, Catherine. "Le graveur Léon Davent, illustrateur de Nicolas Nicolay." *Bibliothèque d'humanisme et Renaissance* (1974): 347–351.

——. "Sur les ateliers de Fontainebleau sous François Ier." *Bulletin de la Société de l'histoire de Paris et de l'Île-de-France* (1976–77, 1978): 211–215.

——. "Les marchés de Germain Pilon pour la chapelle funéraire et les tombeaux des Birague en l'église Sainte-Catherine du Val des Écoliers." *Revue de l'art* no. 54 (1981): 61–78.

——. "Les marchés de construction pour l'aile Henri II du Louvre (1546–1558)." *Archives de l'art français* XXVI (1984): 19–38.

——. *Documents du Minutier central des notaires de Paris. Histoire de l'art au XVIᵉ siècle (1540–1600).* 2 vols. Paris: Archives nationales, 1985–1986.

——. "Luca Penni et le milieu parisien à propos de son inventaire après décès », « Il se rendit en Italie." In *Études offertes à André Chastel*, 259–277. N.p.: 1987.

——. "Le bâton cantoral de Notre-Dame de Paris." *Bulletin de la Société de l'histoire de l'art français* (1989): 17–19.

Groër, Anne Dubois de. *Corneille de La Haye, peintre de Lyon*. Thesis, École des Chartes, Paris, 1974.

——. "Nouvelles recherches sur Corneille à la lumière du portrait de Pierre Aymeric." *Revue du Louvre* I (1978).

——. "Le peintre Corneille de La Haye propriétaire." *Bulletin de la Société de l'histoire de l'art français, année 1984* (1986): 31–35.

Gruber, Gerlinde. "Les tentures à sujets mythologiques de la Grande Galerie de Fontainebleau." *Revue de l'art* no. 108: 23–31.

Guillaume, Jean. "Cleopatra nova Pandora." *Gazette des Beaux-Arts* LXXX (1972): 185–194.

——. "Léonard de Vinci et l'architecture française. I : Le problème de Chambord." *Revue de l'art* no. 25 (1974): 71–84.

——. "Azay-le-Rideau et l'architecture française de la Renaissance." *Les Monuments historiques de la France* no. 5: 65–80.

——. "L'ornement italien en France. Position du problème et méthode d'analyse." In *La scultura decorativa del Primo Rinascimento, Atti del I Convegno. Internazionale di studi, Pavia 16–18 settembre 1980*, 207–212. Pavia: Tipografia del Libro, 1983.

——. "De L'Orme et Michel-Ange" and "Il se rendit en Italie." In *Études offertes à André Chastel*, 279–288. N.p.: 1987.

——. "Les Français et les ordres 1540–1550." In *L'Emploi des ordres dans l'architecture de la Renaissance, Actes du colloque de Tours du 9 au 14 juin 1986*. Paris: Picard, 1992.

——. "La galerie dans le château français : place et fonction." *Revue de l'art* no. 102 (1993): 32–42.

——. *La Galerie du Grand Écuyer. L'histoire de Troie au château d'Oiron*. Chauvay: Patrimoines et Médias, 1996.

Guillaume, Jean, ed. *Architecture et vie sociale. L'organisation intérieure des grandes demeures à la fin du Moyen Âge et à la Renaissance, Actes du colloque de Tours du 6 au 10 juin 1988*. Paris: Picard, 1994.

Guillaume, Jean, ed. *Les Traités d'architecture de la Renaissance*. Paris: Picard, 1988.

Guillaume, Jean and André Chastel, eds. *L'Escalier dans l'architecture de la Renaissance, Actes du colloque de Tours du 22 au 26 mai 1979*. Paris: Picard, 1985.

Hall, J. T. "Primaticcio and the Court Festivals." *Bulletin of the John Rylands University Library of Manchester* Vol. 58 (1976): 353–377.

Hanley, Sarah. *The "Lit de Justice" of the Kings of France: Constitutional Ideology in Legend, Ritual and Discourse*. Princeton, N.J.: Princeton University Press, 1983.

Haskell, Francis. *La Norme et le Caprice*. Paris: Flammarion, 1993.

Haskell, Francis and Nicholas Penny. *Taste and the Antique*. London and New Haven, Conn.: Yale University Press, 1981.

Hartt, Frederick. *Giulio Romano*. New Haven, Conn.: Yale University Press, 1958.

Hautecœur, Louis. *Histoire de l'architecture classique en France*. Vol. 1, *La Formation de l'idéal classique*. Book 1, *La Première Renaissance (1495–1540)*. 2d ed. Paris: Picard, 1963.

——. *Histoire de l'architecture classique en France*. Vol. 1, *La Formation de l'idéal classique*. Book 2, *La Renaissance des humanistes*. 2d ed. Paris: Picard, 1965.

Herbet, Félix. "Les graveurs de l'école de Fontainebleau." *Annales de la Société historique et archéologique du Gatinais*, 1896–1902. Reprint 1969, Amsterdam: B.M. Israël.

——. *Le Château de Fontainebleau, les appartements, les cours, le parc, les jardins*. Paris: Champion, 1937.

Hoffmann, Volker. "Philibert Delorme und das Schloß Anets." *Architectura* (1973).

——. "Le Louvre de Henri II: un palais imperial." *Bulletin de la Société de l'histoire de l'art français, année 1982* (1984): 7–15.

Hubert, Jean. "Le mausolée royal de Saint-Denis et le mausolée impérial de Saint-Pierre de Rome." *Bulletin de la Société des antiquaires de France* (1961): 24–32.

Jammes, André. "La typographie française du XVIᵉ siècle." *Het Boek* 33 (1958–59): 224–228.

Jenkins, Marianna. *The State Portrait: Its Origins and Evolution.* New York: College of Art Association, 1947.

———. "The Imagery of the Henry II Wing of the Louvre." *Journal of Medieval and Renaissance Studies* (1977): 289–307.

Jestaz, Bertrand. "L'exportation des marbres de Rome de 1535 à 1571." *Mélanges d'archéologie et d'histoire de l'école française de Rome* LXXV (1963): 415–466.

———. "La tenture de la galerie de Fontainebleau et sa restauration à Vienne à la fin du XVIIᵉ siècle." *Revue de l'art* no. 22 (1973): 50–56.

———. "Les Italiens à Fontainebleau." In *Kunstlerischen Austausch.* Vol. I, 93–101. Berlin: Akademie Verlag, 1993.

Johnson, William McAllister. "Primaticcio Revisited: Aspects of Draughtsmanship in the School of Fontainebleau." *The Art Quarterly* (1966): 245–268.

———. "Les débuts du Primatice à Fontainebleau." *Revue de l'art* no. 6 (1969): 9–18.

———. "On Some Neglected Usages of Renaissance Diplomatic Correspondence." *Gazette des Beaux-Arts* no. 79 (1972): 51–54.

Johnson, William McAllister and Victor E. Graham. "Ronsard et la « Renommée » du Louvre." *Bibliothèque d'humanisme et Renaissance* 30 (1968): 7–17.

Jones-Davies, M. T., ed. *Le Roman de chevalerie au temps de la Renaissance, Actes du colloque de Tours.* Paris: Touzot, 1987.

Jouanna, Arlette. *Ordre social. Mythes et hiérarchies dans la France du XVIᵉ siècle.* Paris: Hachette, 1977.

Joukovski, Françoise and Pierre Joukovski. *À travers la galerie François Ier.* Paris: Champion, 1992.

Kauffmann, H. "Der Manierismus in Holland und die Schule von Fontainebleau." *Jahrbuch der Preußischen Kunstsammlungen* 44 (1923): 184–204.

Kavaler, Ethan Matt. "The Jubé of Mons and the Renaissance in the Netherlands." *Nederlands Kunsthistorisch Jaarboek* 45 (1994): 349–381.

Kernodle, G. R. *From Art to Theater: Form and Convention in the Renaissance.* Chicago: University of Chicago Press, 1944.

Knecht, R. J. *Francis I.* Cambridge: Cambridge University Press, 1982.

Koechlin, Raymond and J.J. Marquet de Vasselot. *La Sculpture à Troyes et dans la Champagne méridionale au XVIᵉ siècle.* Paris: A. Colin, 1900.

Kühbacher, Sabine. "Giulio Romano e la grotta di Fontainebleau." In *Giulio Romano: Atti del Convegno internazionale di studi su Giulio Romano e l'espressione europea del Rinascimento,* 345–360. Mantua: Accademia nazionale virgiliana, 1989.

Kusenberg, Kurt. *Le Rosso.* Paris: Albin Michel, 1931.

———. "Zeichnungen von Rosso und Léonard Thiry." *Zeitschrift für bildende Kunst* 65 (1931–32): 85–90.

———. "Autour de Rosso." *Gazette des Beaux-Arts* II (1933): 158–172.

Labie, Claude. "Le château de Beauregard." *Congrès archéologique, session de 1981* (1986): 160–161.

Laborde, Léon de. *Gisors. La tour du prisonnier et l'église Saint-Gervais et Saint-Protais, documents inédits tirés du trésor de l'église.* Paris: J. Claye, 1849.

———. "Documents sur Jean Goujon et ses travaux, trouvés sur la reliure d'une ancienne collection du *Journal des débats.*" *Journal des débats* (March 12, 1850).

———. *La Renaissance des arts à la cour de France; études sur le XVIᵉ siècle.* 2 vols. Paris: L. Potier, 1850–55.

———. *Les Comptes des bâtiments du roi (1528–1571).* Paris: J. Baur, 1877–80.

Laclotte, Michel. "Quelques tableaux bourguignons du XVIᵉ siècle." In *Studies in Renaissance and Baroque Art Presented to Anthony Blunt on his 60th Birthday.* London and New York: Phaidon, 1967.

Laclotte, Michel and Dominique Thiébaut. *L'École d'Avignon.* Paris: Flammarion, 1983.

Lacombe, Paul. *Livres d'heures imprimés des XVᵉ et XVIᵉ siècles.* Paris: Imprimerie nationale, 1907.

Lafond, Jean. "Études sur l'art du vitrail en Normandie. Arnoult de la Pointe, peintre et verrier de Nimègue, et les artistes étrangers à Rouen aux XVᵉ et XVIᵉ siècles." *Bulletin de la Société des amis des monuments rouennais, 1911* (1912): 141–172.

———. *La Résurrection d'un maître d'autrefois : le peintre-verrier Arnoult de Nimègue.* Rouen: n.p., 1942.

———. "Jean Lécuyer un grand peintre-verrier de la Renaissance." *Médecine de France* no. 123: 17–32.

Lafond, Jean. *Le Vitrail. Origines, techniques, destinées.* 3rd ed. With notes by Françoise Perrot. Lyon: 1988.

La Tremblaye, Martin Coutel de. *Solesmes. Les sculptures de l'église abbatiale 1496–1553.* Solesmes: Imprimerie Saint-Pierre, 1892.

Lavallée, P. *Le Dessin français du XIIIᵉ au XVIᵉ siècle.* Paris: G. Van Oest, 1930.

Leblond, V. *L'Art et les Artistes en Île-de-France au XVIᵉ siècle (Beauvais & Beauvaisis).* Paris and Beauvais: Champion / Imprimerie départementale de l'Oise, 1921.

———. "Un artiste beauvaisin au XVIᵉ siècle. Nicolas Le Prince, verrier et tailleur d'images." In *Mémoires de la Société de l'histoire de Paris et de l'Île-de-France.* Vol. XLVIII. Paris: Champion, 1924.

Lebœuf, François. "Les saints de Solesmes, Sarthe." *Images du patrimoine* no. 69 (1990).

Lecoq, Anne-Marie. "La salamandre royale dans les entrées de François Ier." In *Les Fêtes de la Renaissance III,* 93–104. Edited by Jean Jacquot. Paris: CNRS, 1975.

———. "La symbolique de l'État. Les images de la monarchie des premiers Valois à Louis XIV." In *Les Lieux de mémoire.* Vol. 2, *La Nation.* Edited by Pierre Nora, 146–192. Paris: Gallimard, 1986.

———. *François Ier. Imaginaire—Symbolique & politique à l'aube de la Renaissance française.* Paris: Macula, 1987.

Le Fèvre de La Boderie, Guy. *La Galliade, ou de la révolution des arts et sciences.* 2d ed. Paris: Guillaume Chaudière, 1578. Reprint 1993, Francois Roudaut, ed. Paris: Klincksieck.

Lefèvre-Pontalis. *Monographie de l'église Saint-Maclou de Pontoise.* Pontoise: Amédée Paris, 1888.

Lemerle, Frédérique. "Genèse de la théorie des ordres : Philandrier et Serlio." *Revue de l'art* no. 103: 33–41.

Lemonnier, Henry. "Philibert De L'Orme." *Revue de l'art ancien et moderne* III (1898): 123–124.

Leproux, Guy-Michel. *Recherches sur les peintres-verriers parisiens de la Renaissance.* Geneva: Droz, 1988.

Lespinasse, René Leblanc de. *Les Métiers et Corporations de la ville de Paris. XIV⁰-XVIII⁰ siècles.* Vol. 2, *Histoire générale de Paris.* Paris: Imprimerie nationale, 1892.

Lesure, François. "Blaise de Vigenère et Jean Cousin (1550)." *Bibliothèque d'humanisme et Renaissance* (1947): 109–113.

Lévêque, J.J. *L'École de Fontainebleau.* Neufchatel: Ides et Calendes, 1984.

Le Vieil, Pierre. *L'Art de la peinture sur verre et de la vitrerie.* Paris: L. F. Delatour, 1774. Reprint 1973, Geneva: Minkoff Reprints.

Levron, Jacques. *René Boyvin, graveur angevin du xvie siècle.* Angers: Jacques Petit, 1941.

Lieure, Jules. *L'École française de gravure des origines à la fin du XVI⁰ siècle.* Paris: Renaissance du livre, 1928.

Linzeler, A. *Inventaire du fonds français. Graveurs du XVI⁰ siècle.* Vol. 1. Paris: Bibliothèque nationale, 1932.

Lowry, Bates. *Palais du Louvre, 1528–1624: The Development of a Sixteenth Century Architectural Complex.* Thesis, University of Chicago, 1956.

Mâle, Emile. *The Gothic Image: Religious Art in France of the Thirteenth Century.* Translated by Dora Nussey. New York: Harper, 1958.

McFarlane, Ian. *The Entry of Henri II into Paris, 16 June 1549.* Binghamton: n.p., 1982.

Marcel, L. E. *Le Cardinal de Givry, évêque de Langres (1529–1561).* Vol. 1, *La Réforme.* Dijon: H. Davantière, 1926.

Marcel, Pierre. *Jean Martin.* Paris: Alcan, 1927.

Martin-Demézil, Jean. "Chambord." *Congrès archéologique, 139e session en 1981* (1986): 1–115.

Matthews Grieco, Sara F. *Picturing Women in Renaissance and Baroque Italy.* Edited by Geraldine A. Johnson. Cambridge and New York: Cambridge University Press, 1997.

Mellen, Peter. *Jean Clouet: Complete Edition of the Drawings, Miniatures and Paintings.* London: Phaidon, 1971.

Mera, B. *L'Abbaye de Valmont (Seine-Maritime).* Association de l'année des abbayes normandes: n.p., 1979.

Metman, Yves. "Un graveur inconnu de l'école de Fontainebleau : Pierre Millan." *Bibliothèque d'humanisme et Renaissance* I (1941): 202–214.

Michel, André. "La Renaissance en France." *Histoire de l'art* IV: 491–814.

Michelet, Jules. *Oeuvres complètes.* Vol. 7, *Histoire de France au XVI⁰ siècle. Renaissance et Réforme.* Robert Casanova, ed. Paris: Flammarion, 1911.

Miel, François. "Jean Cousin fondateur de l'école française de peinture." In *Galerie française ou collection de portraits des hommes et des femmes qui ont illustré la France, dans les XVI⁰, XVII⁰ et XVIII⁰ siècles.* Vol. I. Paris: 1821, 119–134.

Mignot, Claude. "Fontainebleau revisité: la galerie d'Ulysse." *Revue de l'art* no. 82 (1988): 9–18.

Miller, Naomi. "The Form and Meaning of the 'Fontaine des Innocents.'" *Art Bulletin* (1968): 270–277.

———. *French Renaissance Fountains.* New York and London: Garland, 1977.

Montaiglon, Anatole de. "Diane de Poitiers et son goût dans les arts." *Gazette des Beaux-Arts* II (1878): 289–304, and I (1879): 152–177.

Morand, Kathleen. *Claus Sluter: Artist at the Court of Burgundy.* Austin: University of Texas Press, 1991.

Moreau-Nélaton, Étienne. *Les Clouet et leurs émules.* 3 vols. Paris: Laurens, 1924.

Mortimer, Ruth. *French 16th Century Books.* 2 vols. Cambridge, Mass.: Belknap Press, 1964.

Orth, Myra D. "Geoffroy Tory et l'enluminure: deux livres d'heures de la collection Doheny." *Revue de l'art* 50 (1981): 40–47.

———. "French Renaissance Manuscripts: The 1520s Hours Workshop and the Master of the Getty Epistles." *The J. Paul Getty Museum Journal.* XVI (1988): 33–60.

Palustre, Léon. *La Renaissance en France.* 3 vols. Paris: A. Quantin, 1879–85.

Panofsky, Dora and Erwin Panofsky. *Pandora's Box: the Changing Aspects of a Mythological Symbol.* New York: Pantheon, 1956

———. "The Iconography of the 'Galerie François Ier' at Fontainebleau." *Gazette des Beaux-Arts* II (1958): 113–190.

Panofsky, Erwin. *Idea: a Concept in Art Theory.* Translated by Joseph J. S. Peake. Columbia, S.C.: University of South Carolina Press, 1968.

———. *Tomb Sculpture.* New York: Abrams, 1964.

Papillon, J. M. *Traité historique et pratique de la gravure en bois.* 2 vols. Paris: P.G. Simon, 1766.

Pattison, Mrs. Mark (Lady Dilke). *The Renaissance of Art in France.* 2 vols. London: Kegan Paul, 1879.

Pauwels, Yves. "Philibert de L'Orme et l'ordre ionique." In *L'Emploi des ordres dans l'architecture de la Renaissance, Actes du colloque de Tours du 9 au 14 juin 1986.* Paris: Picard, 1992.

Pérouse de Montclos, Jean-Marie. "Le sixième ordre d'architecture ou la pratique des ordres suivant les nations." *Journal of the Society of Architectural Historians* XXXVI (1977): 223–240.

———. *L'Architecture à la française XVI⁰, XVII⁰ et XVIII⁰ siècles.* Paris: Picard, 1982.

———. "Du toit brisé et de quelques autres gallicismes de l'aile Lescot du Louvre." *Bulletin de la Société de l'histoire de l'art français, année 1980* (1982): 45–51.

————. *Histoire de l'architecture française. De la Renaissance à la Révolution.* Mengès: 1989.

————. "Nouvelles observations sur Chambord." *Revue de l'art* no. 102 (1993): 43–47.

Perrot, Françoise. "Quelques vitraux conservés au musée du Louvre." *Bulletin de la Société nationale des antiquaires de France* (1974): 111–113.

————. "Chefs-d'œuvre méconnus de la Renaissance: les vitraux de l'église d'Écouen." *Dossiers de l'archéologie* no. 26: 76–85.

Planchenault, René. "Les châteaux de Vallery." *Bulletin monumental* (1963): 250.

Pope-Hennessy, John. *Cellini.* New York: Abbeville Press, 1985.

Pradel, Pierre. *Michel Colombe : Le dernier imagier gothique.* Paris: Plon, 1953.

Pressouyre, Sylvia. "Les fontes de Primatice à Fontainebleau." *Bulletin monumental* (1969): 223–239.

————. "Les fresques nouvellement restaurées de la galerie François Ier à Fontainebleau." *Bulletin de la Société nationale des antiquaires de France* (1970): 123–137.

Prinz, Wolfram and Ronald G. Kecks. *Das französische Schloss der Renaissance: Form und Bedeutung der Architektur, ihre geschichtlichen und gesellschaftlichen Grundlagen.* Berlin: Mann, 1985.

Prouté, Michèle and Hubert Prouté. "À propos de quelques estampes inédites de l'école de Fontainebleau." In *Mélanges offerts à Roseline Bacou.* Rimini: Editrice, 1996.

Ragghianti, Carlo L. "Pertinenze francesi nel Cinquecento." *Critica d'arte* XXVII (1972): 3–96.

Raggio, Olga. "Problèmes bellifontains." *Revue de l'art* 23 (1974): 73–78.

Ranum, Orest. "Strengthening the Noble Male Body: Guillaume du Choul on Ancient Bathing and Physical Exercise." In *Essays in Honor of J.M.H. Salmon*, 35–51. Rochester, N.Y.: University of Rochester Press, 1994.

Regond, Annie. *La Peinture murale du XVIᵉ siècle dans la région Auvergne.* Clermont-Ferrand: Institut d'études du Massif Central, 1983.

Renaudet, Augustin. *Préréforme et humanisme à Paris pendant les premières guerres d'Italie (1494–1517).* 2nd ed. Paris: Librairie d'Argences, 1953.

Renouvier, Jules. *Des types et des manières des maîtres graveurs, pour servir à l'histoire de la gravure en Italie, en Allemagne, dans les Pays-Bas et en France.* Montpellier: De Boehm, 1853–1856.

Reynaud, Nicole. "Un peintre français cartonnier de tapisseries au XVᵉ siècle: Henri de Vulcop." *Revue de l'art* no. 22 (1973): 7–21.

Ring, Grete. *La Peinture française au XVᵉ siècle.* London: Phaidon, 1949.

Robert-Dumesnil, I.P.F. *Le Peintre-graveur français.* 11 vols. Paris and Leipzig: n.p., 1835–1871. Reprint 1967, Paris: F. De Nobele.

Rolle, F. "Bernard Salomon (le Petit Bernard) peintre et graveur sur bois." *Archives de l'art français* (1861): 413–436.

Rondot, Natalis. *Bernard Salomon, peintre et tailleur d'histoires à Lyon au XVIᵉ siècle.* Lyon: Mougin Rusand, 1897.

Rosci, Marco. *Il Trattato di architettura di Sebastiano Serlio.* Milan: Itec, 1966.

Roudié, Paul. *L'Activité artistique à Bordeaux, en Bordelais et en Bazadais de 1453 à 1550.* Bordeaux: Sobodi, 1975.

Roy, Maurice. *Artistes et monuments de la Renaissance en France.* 2 vols. Paris: Champion, 1929–34.

Samaran, Charles. "Le Primatice et les Guises." *Études italiennes* (1921): 129–136 and 187–200.

Santfaçon, Roland. *L'Architecture flamboyante en France.* Quebec City: Presses de l'Université Laval, 1971.

Sartor, M. *Les Tapisseries, toiles peintes et broderies de Reims.* Rheims: L. Michaud, 1912.

Saulnier, Verdun L. "Sebillet, Du Bellay, Ronsard. L'entrée de Henri II à Paris et la révolution poétique de 1550." In *Les Fêtes de la Renaissance*, 31–59. Edited by Jean Jacquot. Paris: CNRS, 1956.

Saunders, Alison. *The Sixteenth-Century French Emblem Book: A Decorative and Useful Genre.* Geneva: Droz, 1988.

Sauval, Henri. *Histoire et recherches de la Ville de Paris.* 3 vols. Paris: Charles Moette et Jacques Chardon, 1724. Reprint 1973, Geneva: Minkoff Reprints.

Scailliérez, Cécile. *François Ier et ses artistes dans les collections du Louvre.* Paris: Réunion des Musées Nationaux, 1992.

Schéle, Sune. *Cornelis Bos: A Study of the Origins of the Netherland Grotesque.* Stockholm: Almquist & Wiksell, 1965.

Scheller, Robert. "Imperial Themes in Art and Literature in Early French Renaissance: the Period of Charles VIII." *Semiolus* 12 (1981–82): 5–69.

————. "Ensigns of Authority: French Royal Symbolism in the Age of Louis XII." *Semiolus* 13 (1983): 75–141.

————. "Galia Cisalpina: Louis XII and Italy 1499–1508." *Semiolus* 15: 5–60.

Seguin, Jean-Pierre. *L'Information en France de Louis XII à Henri II.* Geneva: Droz, 1961.

Serlio, Sebastiano. *On Domestic Architecture.* With an essay by Myra Nan Rosenfeld. Cambridge, Mass.: MIT Press, 1978.

Serlio, Sebastiano. *Architettura civile: libri sesto, settimo e ottavo nei manoscritti di Monaco e Vienna.* Edited by Tancredi Carunchio and Francesco Paolo Fiore. Milan: Il Polifilo, 1994.

Shearman, John. "Le XVIᵉ siècle européen." *Burlington Magazine* (February 1966).

————. "The Galerie François Premier: A Case in Point." *Miscelanea Musicologica: Adelaide Studies in Musicology* (1980): 1–16.

Simone, Franco. *La Coscienza della rinascità negli umanisti francesi.* Rome: Edizioni di storia e letteratura, 1949.

s'Jacob, Henriette. *Idealism and Realism: a Study of Sepulchral Symbolism.* Leyden: Brill, 1954.

Souchal, Geneviève. "Un grand peintre français de la fin du XVᵉ siècle: le maître de la « Chasse à la licorne »." *Revue de l'art* no. 22: 22–49.

Souhaut, Abbé. *Les Richier et leurs oeuvres.* Bar-le-Duc: Contant-Laguerre, 1883.

Sterling, Charles. "Une peinture certaine de Jean Perréal enfin retrouvée." *L'Œil* (July–August 1963): 2–15.

———. "Un portrait inconnu de Jean Clouet." In *Studies in Renaissance and Baroque Art Presented to Anthony Blunt on his 60th Birthday.* London and New York: Phaidon, 1967.

———. "Jean Hey et le Maître de Moulins." *Revue de l'art* 1–2 (1968): 26–33.

———. "La peinture sur panneau picarde et son rayonnement dans le nord de la France au XVᵉ siècle." *Bulletin de la Société de l'histoire de l'art français, année 1979* (1981): 7–49.

Taburet, Marjatta. *La Faïence de Nevers et le miracle lyonnais au XVIᵉ siècle.* Paris, 1981.

Terrasse, Charles. "Les œuvres de l'architecte Nicolas de Saint-Michel en Parisis au XVIᵉ siècle." *Bulletin monumental* (1922): 165–188.

———. "Sur deux peintures de la galerie François Ier à Fontainebleau." *Bulletin des Musées de France* (1949): 176–178.

Thomas, Bruno. *Gesammelte Schriften zur historischen Waffenkunde.* 2 vols. Graz: Akademische Druck-u. Verlagsanstalt, 1977.

Thoenes, Christof, ed. *Sebastiano Serlio, Sesto Seminario Internazionale di Storia dell'Architettura.* Milan: Electa, 1989.

Thomson, David. *Renaissance Paris—Architecture and Growth 1475–1600.* London and Los Angeles: Zwemmer / University of California Press, 1984.

———. *Les Plus Excellents Bastiments de France par Jacques Androuet du Cerceau.* Paris: Sand & Conti, 1988.

Thuillier, Jacques. "L'énigme de Félix Chrestien." *Art de France* I (1961): 57–75.

Tollon, Bruno and B. Bennassar. "Le siècle d'or (1463–1560)." In *Histoire de Toulouse.* Toulouse: Privat, 1974.

Trinquet, Roger. "L'allégorie politique au xvie siècle: la « Dame au Bain » de François Clouet (Washington)." *Bulletin de la Société de l'histoire de l'art français, année 1966* (1967): 99–119.

———. "L'allégorie politique dans la peinture française au XVIᵉ siècle: les « Dames au bain »." *Bulletin de la Société de l'histoire de l'art français, année 1967* (1968): 7–25.

Updike, Daniel Berkeley. *Printing Types, their History, Forms, and Use: a Study in Survival.* 2d ed. 2 vols. Cambridge, Mass.: Harvard University Press, 1951.

Valléry-Radot, Jean. "Valmont." *Congrès archéologique de France, LXXXIXᵉ session* (1927): 387–404.

———. "Toul." *Congrès archéologique de France, XCVIᵉ session* (1934): 229.

Verdier, François. "L'église paroissiale Notre-Dame de Louviers." In *Congrès archéologique de France,*

CXXXVIIIᵉ session. Paris: Société française d'archéologie, 1983.

Verdier, Philippe. *Catalogue of the Painted Enamels of the Renaissance: The Walters Art Gallery.* Baltimore: The Trustees of the Walters Art Gallery, 1967.

Vesly, Léon de. "Jean Goujon architecte. Les colonnes de Saint-Maclou et du mausolée de Louis de Brézé à Rouen." *Réunion des Sociétés des Beaux-Arts des départements* 28 (1904): 67–75.

Vickers, Nancy. "The Mistress in the Masterpiece." In *The Poetics of Gender.* Nancy K. Miller, ed. New York: Columbia University Press, 1986.

Villes, Alain. "Notre-Dame de l'Épine, sa façade occidentale." In *Congrès archéologique de France (Champagne 1977).* Paris: Société française d'archéologie, 1980, 779–862.

Vitry, Paul. *Michel Colombe et la sculpture française de son temps.* Paris: Librairie centrale des Beaux-Arts, 1901.

Vitry, Paul and Gaston Brière. *Documents de sculpture française: Renaissance.* Paris: D.-A. Longuet, 1911.

Wanklyn, George A. "Le présent offert à Henri II par la Ville de Paris en 1549." *Revue de l'art* no. 46 (1979): 25–30.

———. "La vie et la carrière d'Étienne Delaune à la lumière de nouveaux documents." *Bulletin de la Société de l'histoire de l'art français, année 1989* (1990): 9–16.

Wardropper, Ian. "Le voyage italien de Primatice en 1550." *Bulletin de la Société de l'histoire de l'art français, année 1981* (1983): 27–31.

———. *The Sculpture and Prints of Domenico del Barbiere.* Ph.D. thesis, New York University, 1985.

———. "Le mécénat des Guise : art, religion et politique au milieu du XVIᵉ siècle." *Revue de l'art* no. 94 (1991): 27–44.

———. "New Attributions for Domenico del Barbiere's Jubé at Saint-Étienne, Troyes." *Gazette des Beaux-Arts,* 118 (1991): 111–128.

Weiss, Roberto. "The Castle of Gaillon in 1500–1510." *Journal of the Warburg and Courtauld Institutes* (1953): 1–12.

Whitley, J.J.L. "Drawings by the Master of the 'Médaillons historiques.'" *Master Drawings* XXX: 174–184.

Willesme, Jean-Pierre. "Le retable de Pierre Berton de Saint-Quentin (1542)." *Bulletin du musée Carnavalet (Paris au XVIᵉ siècle et sous le règne d'Henri IV)* (1979): 45–56.

Wilson-Chevalier, Kathleen. "Women on Top at Fontainebleau." *The Oxford Art Journal* (1993): 34–48.

———. "On the Other Side of the Renaissance: Sebastian Brant, Luca Penni, and the 'Justice and the Seven Sins.'" *Art Bulletin* (1996): 236–263.

Wingert, P.S. "The Funerary Urn of Francis I." *Art Bulletin* (1939): 383–396.

Wittkower, Rudolf. *Gothic vs. Classic: Architectural Projects in Seventeenth-Century Italy* New York: Braziller, 1974.

Yardeni, Myriam. *La Conscience nationale en France pendant les guerres de religion (1559–1598)*. Louvain and Paris: Nauwelaerts, 1971.

Zerner, Henri. *The School of Fontainebleau: Etchings and Engravings*. Translated by Stanley Baron. London: Thames & Hudson, 1969.

Zerner, Henri. "Observations on the Use of the Concept of Mannerism." In *The Meaning of Mannerism*. Hannover, N.H.: University Press of New England, 1972.

———. "An Unknown Etching after Rosso." *Print Quarterly* (1988): 403–405.

Zerner, Henri and Sharon Katic. *Il Maestro di Moulins*. Milan: Fabbri, 1966.

EXHIBITION CATALOGUES

Le Triomphe du maniérisme européen: De Michel-Ange au Greco. Amsterdam: Rijksmuseum, 1955.

François Ier et l'art renouvelé au xvie siècle dans les collections du château de Chantilly. Chantilly: Musée Condé, 1972.

L'École de Fontainebleau. Paris: Grand Palais, 1972–1973.

Le Puy et le Velay au xvie siècle. Le Puy: Musée Crozatier, 1984.

Ligier Richier et la sculpture en Lorraine au xvie siècle. Bar-le-Duc: Musée, 1985.

Rosso Fiorentino: drawings, prints, and decorative arts. Washington: National Gallery of Art, 1987.

La Peinture en Provence au xvie siècle. Marseille: Musée des Beaux-Arts, 1987–1988.

La Dame à sa toilette. Dijon: Musée des Beaux-Arts, 1988.

De Nicolo dell' Abate à Nicolas Poussin: Aux sources du classicisme, 1550–1650. Meaux: Musée Bossuet, 1988.

Giulio Romano, Mantoue: Palais du Té/Palais Ducal, 1989.

Bernard Palissy, mythe et réalité. Agen/Niort/Saintes, 1990.

La Peinture en Bourgogne au xvie siècle. Dijon: Musée des Beaux-Arts, 1990.

Philibert De L'Orme lyonnais. Lyon: Archives Municipales, 1993.

Les Manuscrits à peintures en France. 1440–1520, Paris: Bibliothèque Nationale, 1993.

Vitraux parisiens de la Renaissance. Paris: Rotonde de la Villette, 1993.

Livres d'heures royaux: La peinture de manuscrits à la cour de France au temps de Henri II. Écouen: Musée national de la Renaissance, 1993.

Le Dessin en France au xvie siècle. Paris: École Nationale Supérieure des Beaux-Arts, 1994.

Les Trésors du Grand Écuyer: Claude Gouffier, collectionneur et mécène à la Renaissance. Écouen: Musée National de la Renaissance, 1994.

Le Dressoir du prince: Services d'apparat à la Renaissance. Écouen: Musée National de la Renaissance, 1995.

La Gravure française à la Renaissance à la Bibliothèque nationale de France. Los Angeles: Grunwald Center/New York: Metropolitan Museum of Art/Paris: Bibliothèque Nationale de France, 1995.

INDEX OF NAMES

TOPOGRAPHICAL INDEX

PHOTOGRAPHIC CREDITS

ACKNOWLEDGMENTS

In this book I have used material previously published elsewhere, but which in most cases, has been entirely rewritten.

This book has taken shape over many years and I could not possibly thank all those who have contributed to its development. I have particularly benefited from the observations of many students who took my classes on the subject. I could only mention a few whose contribution has remained clearly in my memory. Conversely, I owe a great deal to André Chastel, who before becoming my friend was my teacher; his posthumous book on French art at the time of the Renaissance (*French Art*, vol. 2) appeared when I had almost finished writing mine. I chose not to read it until I had handed in my own work to be printed.

The following individuals have helped me in various ways, which I do not have the space to list in detail: Anne Anninger, Joseph Baillio, Sylvie Béguin, Anthony Blunt, Graeme Boone, Françoise Boudon, Emmanuelle Brugerolles, Cynthia Burlingham, Charis Clift, Patrick Fischer, Christine Flon Granveaud, Marie-Madeleine Fontaine, David Franklin, David Freedburg, Peter Führing, Etienne Hamon, Dominique Hervier, François-Charles James, Gisèle Lambert, Jean-Claude Lebensztejn, Anne-Marie Lecoq, Amaury Lefébure, Claude Mignot, Stephen Murray, Jean-Marie Pérouse de Montclos, Maxime Préaud, Hubert and Michèle Prouté, Jacques Rossiaud, Matthew Rutenberg, Stuart Pyhrr, Mme Saint-Germier, Willibald Sauerländer, Jeremy Strick, David Thomson, Eric Wolf, Ian Wardropper, Christopher Wood, Monique Zerner.

Others require a more specific mention: Bruno Tollon, whose major work on the Renaissance in Languedoc is still awaiting publication, introduced me to the art of Toulouse, by way of unforgettable visits to its monuments; Bates Lowry lent me his unpublished dissertation on the Louvre; Geneviève Bresc-Bautier enlightened me on several issues regarding sculpture; I have hugely benefited from the views of Françoise Perrot who has so greatly contributed to the study of stained glass; Ethan Matt Kavaler shared with me his exceptional knowledge of 16th century Flemish sculpture; Georges Wanklyn gave me the benefit of his understanding of Etienne Delaune and his relation to Jean Cousin; Catherine Grodecki has on several occasions informed me of archival discoveries ahead of publication and checked several documents for me; Marianne Grivel generously agreed to read the whole manuscript; a long friendship binds me to Jean Guillaume, our conversations together as well as his remarkable conferences in Tours have nourished my thoughts, he was also generous enough to read my whole book with care thus saving me from a number of foolish mistakes; finally without the encouragement and advice of Catherine Wilkinson Zerner I would not have dared meddle with architecture.

I enjoyed a year of leave thanks to a grant from the American Council of Learned Societies. I began writing this work in 1997 at the Institute of Advanced Studies of Princeton, where I was welcomed by Irving Lavin, and the chapters of this book began to take shape at the College de France, where I gave a series of lectures upon the invitation of Jacques Thuillier.

At Flammarion, my project was first conceived in accord with Francis Bouvet who unfortunately could not see it realized. Since then, Jean-François Barrielle has been infinitely patient and I am deeply grateful for the confidence he placed in the project. I also owe much to the team of Claire Rouyer, Sabrina Rozet and Dominique Grosmangin who have done everything possible to make the process an agreeable and effective one.

The paperback edition, although essentially identical to the hardcover, required considerable work. I am deeply grateful to Claire Lagarde for having taken it on, as well as to Stéphanie Lhez who performed an enormous task in collating this edition.

This translation would not have been possible without the help of several people. I owe a great deal to those who took on the onerous task of translating the text: Scott Wilson undertook a rough translation at my request before any commitment was made to publish and has translated more than half of the book. Rachel Zerner translated the rest except for the last chapter which was expertly done by Deke Dusinberre. Sue Schneider edited and improved the translation. At Flammarion, Sophy Thompson undertook the project

when in charge of foreign language publications and Katie Mascaro saw it through with equal enthusiasm when she took over that department; Jane Riordan was unfailingly cheerful and efficient in coordinating everything and looking after all the details of publication.

The translation is based on the text published in 1996 with only very minor changes and corrections. I have not had the time or energy to take into account the observations of reviewers who have been extremely generous and my own dissatisfaction with some aspects of the text. To mention but a few, I am well aware that Serlio does not get his due and I can only send the reader to the publications of Mario Carpo, Alina Payne, and Sabine Froml as well as an important conference organized in Lyons by Sylvie Deswaerte. The book does not even mention Gianfrancesco Rustici, a great Florentine sculptor who spent many years in France, because I was too unclear about his possible contribution. Philippe Senechal has now produced an authoritative monograph, which should be published shortly. Jacques Androuet Ducerceau will soon be the subject of a major exhibition that will undoubtedly make his role much clearer. I hope that in spite of all this the book remains useful.

For Charles Rosen

Translated from the French by
Deke Dusinberre
Scott Wilson
Rachel Zerner

Copyediting
Sue Schneider

Typesetting
Studio X-Acte

Proofreading
Joshua Parker
Chrisoula Petridis

Color Separation
Exegraph

Previously published in French as *L'Art de la Renaissance en France*
© Éditions Flammarion, 1996, 2002
English-language edition
© Éditions Flammarion, 2003
26, rue Racine
75006 Paris

03 04 05 4 3 2 1

FC0420-03-XI
ISBN: 2-0801-1144-2
Dépôt légal: 11/2003

Printed by Canale in Italy